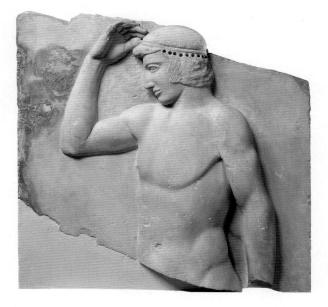

GREEK ART AND Archaeology

ANOTHER QUALITY USED BOOK USA DOOKSTORE

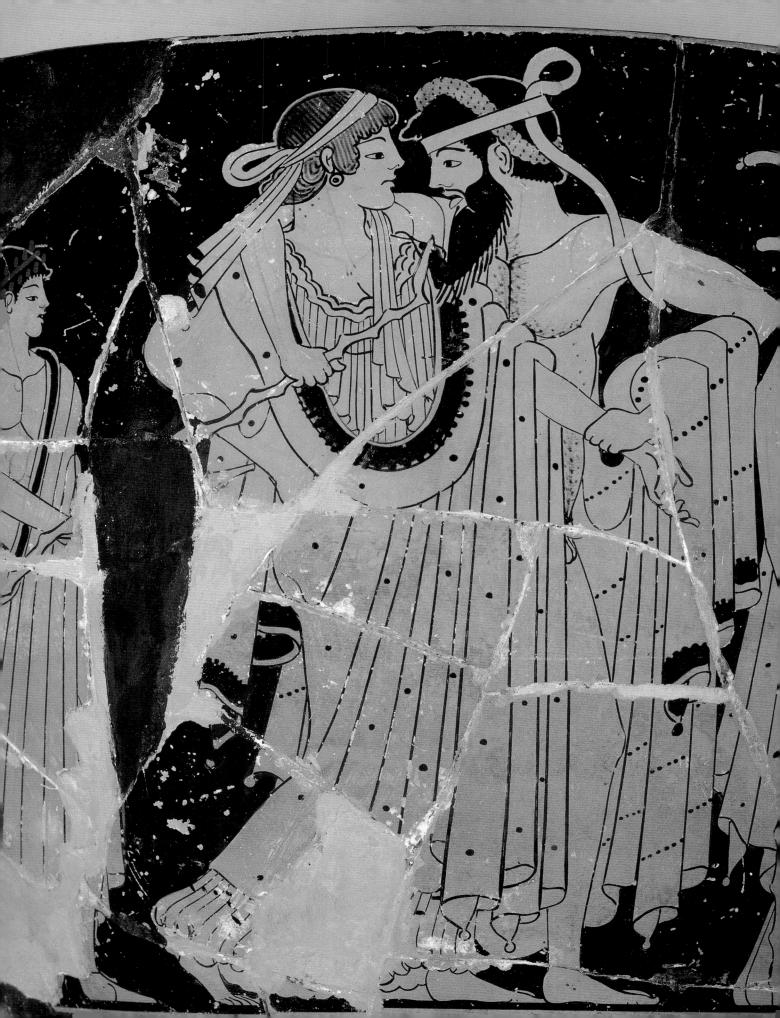

GREEK ART AND Archaeology

Fourth Edition

JOHN GRIFFITHS PEDLEY

Upper Saddle River, New Jersey 07458

Library of Congress Cataloging-in-Publication Data

Pedley, John Griffiths
Greek art and archaeology / John Griffiths Pedley.—4th ed.
p. cm.
Includes bibliographical references and index.
ISBN 0-13-238062-5 (case)—ISBN 0-13-240934-8 (pbk.)
1. Greece—Antiquities. 2. Art, Greek. I. Title.

DF130.P44 2007 938—dc22

2006050322

Editor in Chief: Sarah Touborg Sponsoring Editor: Helen Ronan Editorial Assistant: Jacqueline Zea Senior Managing Editor: Lisa Iarkowski Manufacturing Buyer: Sherry Lewis Director of Marketing: Brandy Dawson

Credits and acknowledgments of material borrowed from other sources and reproduced, with permission, in this textbook appear on page 400.

Copyright © 2007, 2002, 1998, 1993 Prentice Hall Inc.

Published 2007 by Pearson Education, Inc., Upper Saddle River, New Jersey, 07458. Pearson Prentice Hall. All rights reserved. Printed in China. This publication is protected by Copyright and permission should be obtained from the publisher prior to any prohibited reproduction, storage in a retrieval system, or transmission in any form or by any means, electronic, mechanical, photocopying, recording, or likewise. For information regarding permission(s), write to: Rights and Permissions Department.

Pearson Prentice $Hall^{TM}$ is a trademark of Pearson Education, Inc. Pearson[®] is a registered trademark of Pearson plc. Prentice $Hall^{®}$ is a registered trademark of Pearson Education, Inc.

Pearson Education Ltd. Pearson Education Australia PTY, Ltd. Pearson Education Singapore, Pte. Ltd. Pearson Education North Asia Ltd. Pearson Education, Canada, Ltd. Pearson Educación de Mexico, S.A. de C.V Pearson Education–Japan Pearson Education Malaysia, Pte. Ltd.

This book was designed and produced by Laurence King Publishing Ltd, London www.laurenceking.co.uk

Every effort has been made to contact the copyright holders, but should there be any errors or omissions, Laurence King Publishing Ltd would be pleased to insert the appropriate acknowledgment in any subsequent printing of this publication.

Commissioning Editor: Kara Hattersley-Smith Editor: Robert Shore Designer: Andrew Shoolbred Picture Researcher: Sue Bolsom

Title page: Relief showing young athlete crowning himself, from Sunion. c. 470 BC. National Museum, Athens

Frontispiece: Detail of an Attic red-figure cup by the Brygos Painter: a reveler and companion. c. 490 BC. Musée du Louvre, Paris

Contents page: Kore, No. 674, from Athens. c. 500 BC. Acropolis Museum, Athens

1098765432 ISBN 0-13-240934-8

CONTENTS

Preface 8

INTRODUCTION 10

The recovery of antiquity 13 The eighteenth century 16 The nineteenth century 16 The twentieth century 20 The twenty-first century 22

Literary sources 26

The development of classical archaeology 27

CULTURE AND SOCIETY Harriet Boyd Hawes: American pioneer 18 MAP The Greek world 12

1 THE AEGEAN IN THE THIRD MILLENNIUM c. 3000–2000 BC 30

Chronology 32

Crete 34 Architecture 34 Pottery and stonework 36

The Cyclades 37 Architecture 37 Sculpture 37 Pottery and stonework 40

Greece 40 Architecture 41 Pottery 43

CONTROVERSIES AND ISSUES Heinrich Schliemann: Scholar or rascal? 34

MAP Minoan Crete and the Bronze Age Aegean 32

2 THE MIDDLE BRONZE AGE c. 2000–1550 BC 44

Crete 46 Architecture 46 Sculpture 48 Pottery 52

The Cyclades 54 Architecture 54 Pottery 54

Greece 54 Architecture 54 Pottery 55

Troy 56

CONTROVERSIES AND ISSUES Art and the Market: Forgery 50

CONTROVERSIES AND ISSUES Priam's Treasure: Doubts and Difficulties 57

3 THE LATE BRONZE AGE c. 1550–1100 BC 62

The shipwreck off Uluburun 64

Crete 65 Architecture and wall painting 65 Sculpture and pottery 72 Scripts 77 Minoan Religion 79 The LM III period 82 The Cyclades 83 Keos 83 Melos: Phylakopi III 83 The Minoan thalassocracy 83 Pottery 83 Thera 85 The volcanic eruption 87 Melos: Phylakopi IV 87

Greece 88 The grave circles at Mycenae 88 Architecture and wall painting 91 Sculpture and pottery 96

Troy and the end of the Bronze Age in Greece 101

CULTURE AND SOCIETY Linear B and its decipherment 78

4 THE DARK AGE AND GEOMETRIC GREECE c. 1100–700 BC 104

Architecture 107

Sculpture 112

Pottery 116

Colonization 122

CULTURE AND SOCIETY Burying the dead 118 MAP The Greek world to c. 400 BC 106 MAP South Italy and Sicily 123

5 THE ORIENTALIZING PERIOD c. 700–600 BC 124

Pottery 125 Corinth 126 Athens 130 East Greece and the Islands 133

Architecture and architectural sculpture 134

Sculpture 141

CULTURE AND SOCIETY Drinking and dining: The symposium 129

Culture and Society Food 138

6 ARCHAIC GREECE c. 600–480 BC 150

Athens 151

Architecture and architectural sculpture 153 The orders 153 Doric temples 154 Ionic temples 159 Sanctuaries 162 Doric and Ionic treasuries 163 Sicily and South Italy 168 Athens 173 Sculpture 176

Pottery 192 Athens 193 Corinth 198 Laconia, East Greece, and the West 200 Athenian red-figure 203

CONTROVERSIES AND ISSUES The Getty kouros: Is it for real? 184

CULTURE AND SOCIETY Connoisseurship 199

MAP Greece and the Aegean 152

7 THE PERIOD OF TRANSITION c. 480–450 BC 210

Athens and the Western Greeks 211 The women's world 212

Architecture and architectural sculpture 214 Olympia 214 The Olympic Games 221 Sicily and South Italy 223 Athens 226

Sculpture 228

Pottery and wall painting 242

8 THE HIGH CLASSICAL PERIOD c. 450–400 BC 248

The Peloponnesian War 250

Architecture and architectural sculpture 251 Athens 251 Sicily and South Italy 274

Sculpture 276

Pottery and wall painting 281 CONTROVERSIES AND ISSUES Lord Elgin and the Parthenon marbles 263

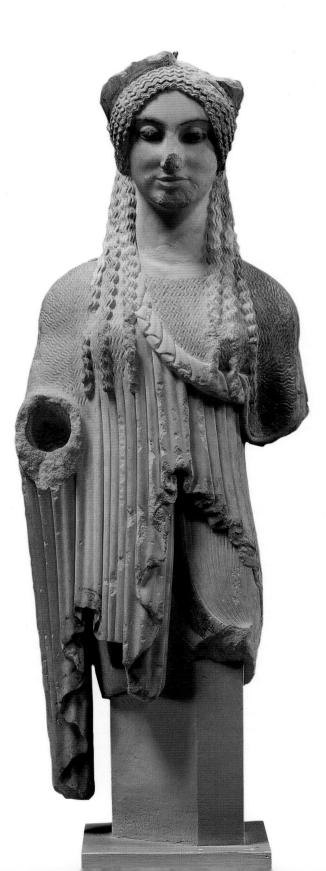

9 THE FOURTH CENTURY c. 400–300 BC 288

Architecture and architectural sculpture 292 Bassae 292 Epidauros 294 Athens 297 Olynthos 299 Priene 300 Halikarnassos 302

Sculpture 305 Alexander the Great 311

Pottery 316

Wall painting and mosaics 320

Macedon 325 Vergina 325 Pella 331 Lefkadia 333

CONTROVERSIES AND ISSUES The theater at Athens: Were women in the audience? 324 MAP The Greek world. c. 400–30 BC 291

10 THE HELLENISTIC PERIOD c. 323–31 BC 336

Rome and Greece 338 Architecture 338 Pergamon 338 Kos 341 Magnesia and Didyma 341 Athens 344 Miletus 347 Syracuse 350

Sculpture 350

Wall painting and mosaics 376

Pottery 383

CULTURE AND SOCIETY Salvage archaeology 348

Conclusion 386 Chronology 388 Glossary 389 Select Bibliography 392 Photographic Credits 394 Index 396

PREFACE

The main purpose of this book is to introduce beginning students, whether at university or at home, to the major monuments of Greek archaeology. Questions of terminology are important. By definition, archaeology includes art, and yet it is often thought to refer only to excavated materials and objects that may be more artefactual than aesthetic, or to the process of recovery of information rather than the study of accumulated evidence. By convention, the visual arts are often thought to comprise painting and sculpture, but not always architecture. Since the basic themes of this book are the developments in architecture, architectural sculpture, painting, and pottery (some of which is painted, some not) it seemed best to give the book the title it has.

Another purpose is to make the principal documents of Greek art and archaeology more easily accessible. Hence, there is emphasis on the range of the illustrative material, and the text has been planned in a systematic chronological framework to allow users to find their way about easily. Each chapter begins with a section on the historical background. In chapters 1-3 the art and archaeology of Bronze Age Greece is explored by region, focusing in turn on Crete, the Cyclades, mainland Greece and Troy. The remaining chapters (4-10), covering the periods from c. 1100-c. 31 BC, are divided by categories of evidence - architecture, sculpture, wall painting, mosaics, and pottery. Architecture and architectural sculpture are examined together to give a more cohesive picture of individual buildings. Boxes, some of which focus on culture and society and others on controversies and issues, are included

in most chapters. A glossary at the back of the book explains some of the more unfamiliar or technical terms.

The book stems from my teaching a course in Greek archaeology to undergraduates, and has been helped by my experience of fieldwork both in Greece and at other Greek and related sites in Italy, Turkey, and Libya. It is proper to focus on the mainland of Greece as the center of artistic production – Athens, Corinth, Olympia, and Delphi, for instance, obviously played major roles. But significant advances took place elsewhere too, so that it also seemed proper to include the achievements of other Greeks, not least those who lived in Sicily and South Italy. Similarly, in chronological terms, it seemed useful to begin at the outset of the Bronze Age, so that undergraduates and other interested beginners might, in a single volume, have an account of the whole period from about the year 3000 to 31 BC, however schematically.

Questions of what to include and what to omit, and choices of emphasis, are difficult. Inevitably, given the constraints of time and space, some objects or monuments, doubtless considered of great importance by some commentators, will have been omitted. For these omissions, I apologize. Yet the book is after all an introduction, a framework to be filled in by other work or other reading. As to emphasis, there are constant tensions between the different purposes to which archaeological evidence may be put – to the understanding of social history, or economic history, or political history, or art history and so on. Sometimes these purposes overlap, and normally the tensions are creative. Here the emphasis is, in the main, on the use of the evidence for art history and architectural history, and accordingly, in that context, on form and function. There is a particular difficulty with the Bronze Age material, where current research tends to focus on the use of archaeological data for the analysis of social systems, demographic patterns, land use and state formation, rather than for the comprehension of architectural and artistic change. Yet, to maintain a coherent focus and coherent themes throughout the book, I have treated this material also largely in terms of artistic transformations.

The question of the spelling of Greek names, both of places and persons, is a constant problem – whether to use the ancient Greek names or their perhaps more familiar Latinized or Anglicized forms. For the most part, I have tended to use Latinized or Anglicized forms where such forms are part of the English language (e.g. Athens, Rome, Mycenae, Corinth) and where these forms are more familiar to me (e.g. Miletus). Elsewhere the Greek form of a name is used. However, I doubt whether any author achieves consistency and I suspect there are cases of inconsistency in this book. But those familiar with the difficulty will not, I hope, be irritated, and I doubt whether anyone will be misled.

In this 4th edition of the book new sections explore topics such as ancient Greek sanctuaries, the role of women in ancient Greece, the Olympic Games, and the work of Winckelmann, while due note is taken of recent discoveries, the unplundered Archaic temple on the island of Kythnos, for instance, and the group of Archaic marble sculptures from the Kerameikos in Athens. There is more detailed examination of specific problematic structures (e.g. the temple of Apollo at Thermon) and more attention paid to contextual discussion. There are new boxes on Priam's Treasure, Harriet Boyd Hawes, connoisseurship, and salvage archaeology, and there are sidebars introducing the reader to relevant literary sources. There are more maps, more line drawings and many more color photographs.

ACKNOWLEDGMENTS

In the several editions of the book I have been helped by many friends and colleagues who have saved me from foolish mistakes, have generously replied to many questions of fact and opinion, and have offered valuable advice and criticism. I offer warm thanks

accordingly to Fred Albertson, Susan Alkana, Bjorn Anderson, Rebecca Ammerman, Barbara Barletta, Geoff Compton, Diane Conlin, Mary Ann Eaverly, Elise Friedland, Mark Fullerton, Jennifer Gates, Sharon Herbert, Meg Hiers, Jim Higginbotham, Gail Hoffman, Cathy Keesling, Lori Khatchadourian, Greg Leftwich, Yannis Lolos, Brenda Longfellow, Miranda Marvin, Carol Mattusch, Alexander Mazarakis Ainian, Lisa Nevett, Nassos Papalexandrou, Alex Pappas, Martha Payne, David Potter, Adam Rabinowitz, Nancy Ramage, Jane Rempel, Fiona Rose, Helen Sanders, Rebecca Schindler, Andy Stewart, David Stone, Molly Swetnam-Burland and Laurie Talalay. I also wish to acknowledge the help of the following friends and scholars on whose work I have drawn: J. Camp, J. Chadwick, A. Dalby, S. Ebbinghaus, S. Goldhill, M.A. Griffiths, K. Lapatin, J. Luce, F. McCoy, R. Osborne, P. Rockwell, B. Rose, L. Schofield, and N. Spivey. I owe a special debt of gratitude to Jerry Rutter who, a decade ago, with unstinting kindness steered me clear of numerous pitfalls in the unfamiliar (to me) territory of the Bronze Age. I am also grateful to the anonymous readers of the Press for countless suggestions and corrections.

On the editorial and production side I am happy to acknowledge the help of Shannon Corliss at Prentice Hall, and am very grateful for the interest of Lee Greenfield and Kara Hattersley-Smith at Laurence King Publishing in London. I am especially indebted to Sue Bolsom and Robert Shore at Laurence King: their thoughtful and skillful work has brightened and freshened the book immeasurably. In Ann Arbor, I am particularly grateful to Lorene Sterner, whose graphic skills made light work of many of the drawings and to Michelle Biggs who has provided indispensable administrative help. Flaws of fact, style, and opinion that remain are entirely my own.

In matters of organization, logistics, and morale I continue to be enormously indebted to my wife, and for particular matters about which she knows: the book could not have been written without her. It is dedicated to two teachers. To Felix Dowson, of Kirkby Lonsdale, Westmorland (as it was then) who first opened my eyes at a very tender age to the delights of the Greek language, and by whose kindness I was first able to visit Greece. And to George Hanfmann, a more recent mentor, whose critical judgment and generosity of heart have corrected and supported numerous students among whom I am privileged to count myself.

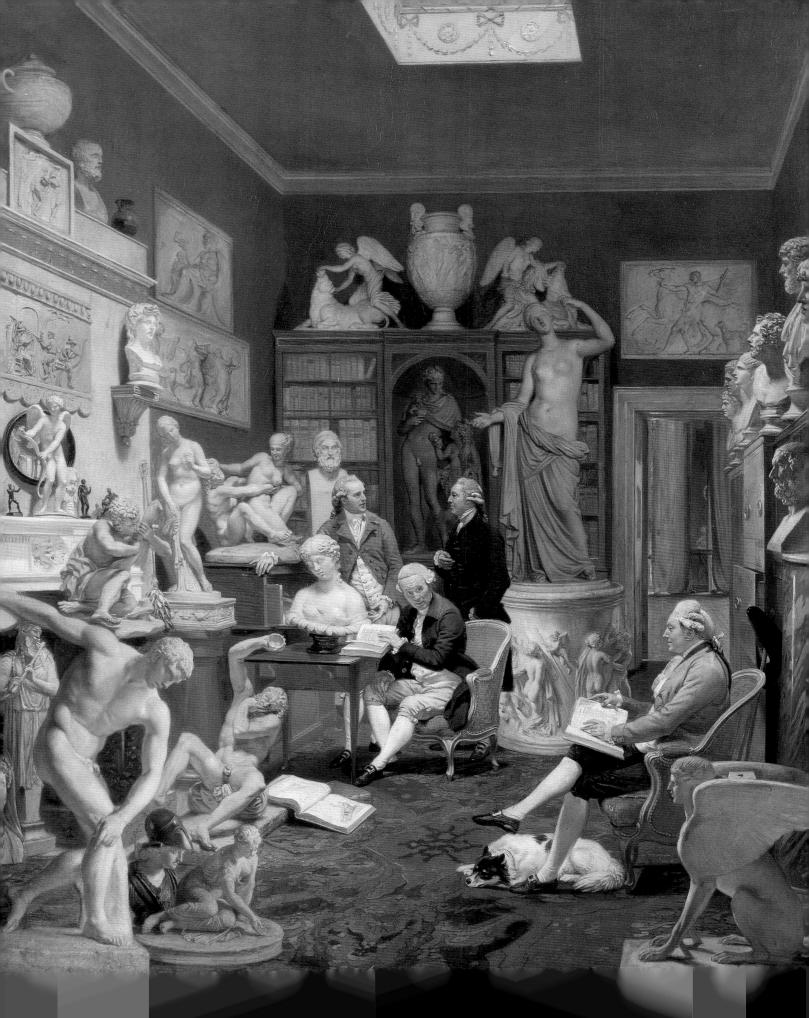

INTRODUCTION

hat image does the phrase "Greek art and archaeology" conjure in most people's minds? Most probably think of the ACROPOLIS and the Parthenon in Athens, and the Elgin Marbles, which once decorated the Parthenon but were removed in the early nineteenth century to the British Museum in London. These monuments, in fact, mark the culmination of a long period of artistic development and reveal an early civilization of extraordinary achievement. For in Greece lie the foundations of much of our Western civilization. Its great philosophers, historians, poets, dramatists, architects, sculptors, and painters still influence the way we think and act and create today.

As far back as the fifth century BC, the Greeks of Athens were being entertained by the tragedies of Aeschylus, Euripides, and Sophocles, and the comedies of Aristophanes. Thucydides was analyzing historical events, and Socrates was developing his philosophy. The greatest of Greek sculptors, Phidias, the architect Iktinos, and their colleagues were at work on the Acropolis.

Athens was the first place to develop a democracy, though it relied heavily on slaves, and women were very much treated as inferior. It was also this newly democratic state that almost singlehandedly drove back the Persian invasion at the Battle of Marathon in 490 BC. It played a major role in the Greek victory over the Persians at the naval battle of Salamis in 480 BC, and in 479 BC took part in the victory over the Persian army at Plataea. It is not surprising, then, that many will immediately think of Athens and the Acropolis when they hear the words "Greek art and archaeology."

But the Athens of the fifth century BC is far from the whole story. Evidence of art and archaeology in Greece can be traced back to the beginning of the Bronze Age (c. 3000–1100 BC, the period during which the metal bronze comes slowly into use) and even beyond. Material evidence of human activity in the Bronze Age is considerable, especially of the Minoan and Mycenaean civilizations of Middle and Late Bronze Age Greece. Moreover, people in Greece in the Bronze Age, and perhaps even before, spoke Greek. This book begins, then, at the start of the Bronze Age, that is about 3000 BC.

The periods during which written records existed are conventionally called "historical" periods. Where there are no significant written documents (with certain exceptions), the periods are termed "prehistoric." In Greece, the Bronze Age is considered prehistoric. Among the major prehistoric centers were Mycenae on the mainland and Knossos on Crete.

Although Athens, with its fortified Acropolis, had been a political center in the Bronze Age, it did not have anything like the power of Mycenae. The city is still important in the period between the end of the Bronze Age and the Greek renaissance of the seventh century BC, since remains of pottery in

^{0.1} Johann Zoffany, *Charles Townley and Friends in the Park Street Gallery, Westminster*. AD 1781–3. Oil on canvas. 50×39 ins (127×99 cm). Towneley Hall Art Gallery and Museums, Burnley, England

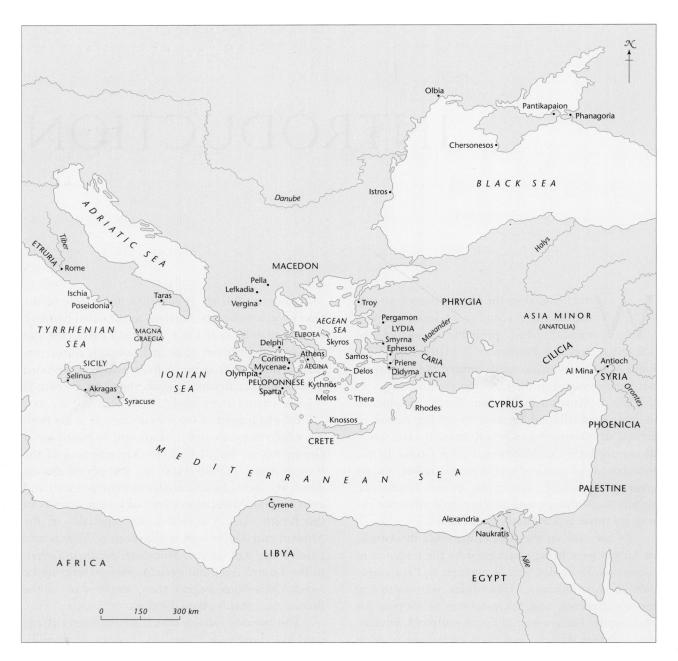

0.2 The Greek world

the cemeteries show that people lived there continuously from the eleventh to the eight century BC. But for different reasons other city-states have as much or more importance up to and including the seventh century BC. Among these are Corinth and Samos, the Greek states in Asia Minor, like Smyrna, and the Greek states to the west of mainland Greece, like Syracuse in Sicily. Thus, the geographical range of this book is wide (fig. 0.2).

The Eastern Greeks include both those who settled on the coast of Asia Minor from the end of the Bronze Age, and those who ventured further afield, to Cyprus, Cilicia, and Syria. These Greeks made contact with Phrygia, Lydia, and other cultures further east. It is through these contacts, and those of other Greeks in Egypt, that new ideas came into Greece toward the end of the Dark Age. Since these are the Greeks who initiated the cultural revival, and were responsible for example for the reappearance of stone architecture and sculpture in Greece, they are quite rightly a focus of attention, and their contributions form a significant part of this book.

The Western Greeks, those who left Greece and established themselves in Sicily and South Italy from the eighth century BC onward, are not often mentioned in books on Greek art and archaeology. This is because their contribution to developments in Greek sculpture was minimal and to vase painting only small, until, that is, their great burst of creativity in the fourth century BC. However, Western Greek experiments in temple architecture are astonishing, and the Western Greeks may well have pioneered some aspects of architectural sculpture. They were among the first to decorate friezes with sculpted METOPES; and they introduced Ionic forms into the Doric order, thus anticipating by a generation or so developments in Greece that were ultimately used in the design of the Parthenon itself.

In the fifth century BC, the city of Syracuse in Sicily certainly saw itself as the cultural rival of Athens, both in the visual arts and in literature. It may have been this, along with Syracuse's great riches and commercial prosperity, that provoked Athens's ill-fated attack in 415 BC, ending in the death or capture of so many Athenians in 413 BC. Thereafter, it is for vase painting that Western Greeks are best known. The major centers of Greek vase painting in the fourth century BC are in South Italy, and it is here that Greek vase painting enjoyed its final flourish in the third century BC. So the Greeks in the west play a considerable role, and their achievements are included in this book.

THE RECOVERY OF ANTIQUITY

How and when did the material remains of Greek art and archaeology come to be known by us? An awareness of the fascination this material has exercised in the more recent past, the excitement of recovery and research, and delight in the retrieval of the visual counterparts of ancient Greek literature and philosophy, may help explain current enthusiasms.

Some ancient Greek buildings have always remained visible, while parts of them – some visible, some not – have for long periods of the last 2,500 years been incorporated into newer structures. On the Acropolis at Athens, the PROPYLAIA (fig. 0.3) was built into a fort, while the Parthenon (fig. 8.3, p. 251) and the Erechtheion (fig. 0.4) became churches. Near the AGORA, the civic center of Athens, the Hephaisteion (figs. 0.8 and 8.33, p. 270), too, became a church, and in the Agora the STOA of Attalos (fig. 0.9), or parts of it, were built into the city's defenses. At Agrigento in Sicily, which the Greeks had called Akragas, and in South Italy at Paestum (fig. 0.5), called Poseidonia by the Greeks, Greek temples stood abandoned or were converted into churches.

By the second century BC, rich Romans had begun to collect Greek art and artefacts as prestige objects. Fourteen hundred years later, as the Renaissance got under way in thirteenth-century Italy, Greek works of art again began to attract interest. For instance, the four gilded bronze horses that used to stand above the entrance to St. Mark's in Venice (fig. 0.6) were brought from Constantinople in 1204. These horses had originally been taken to Constantinople from the Greek island of Chios, perhaps as early as the fifth century AD. They may be the work of a late Classical sculptor or they may be Roman adaptations. Italians at this time also began to collect ancient Greek coins and pottery for private pleasure.

By the fifteenth century, important statues had come to light and formed the nucleus of what became the great Italian collections. These were in the possession of the pope and of aristocratic Italian

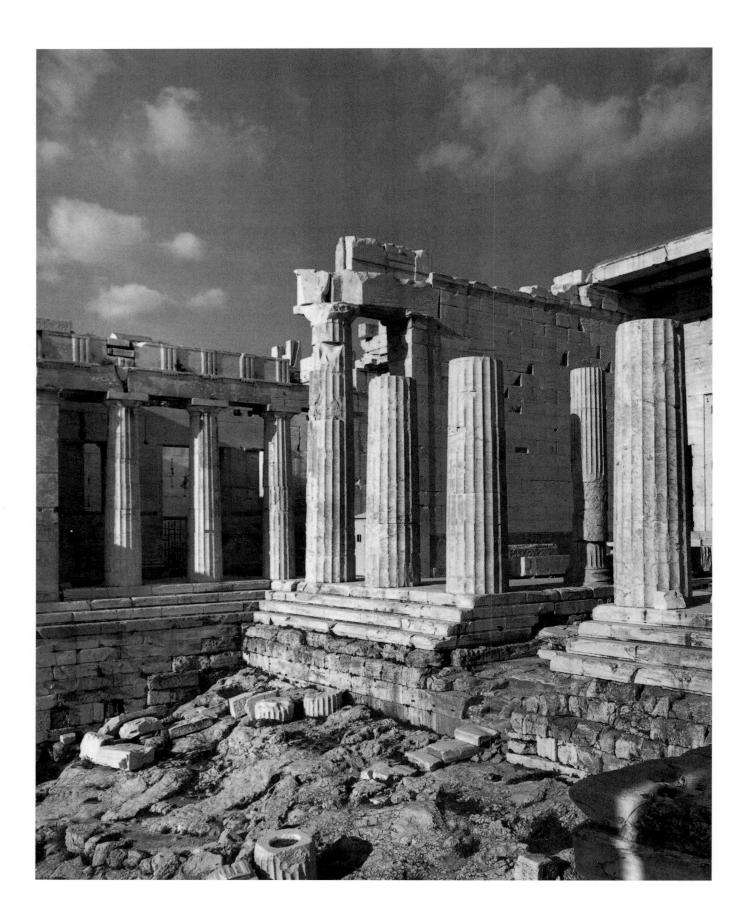

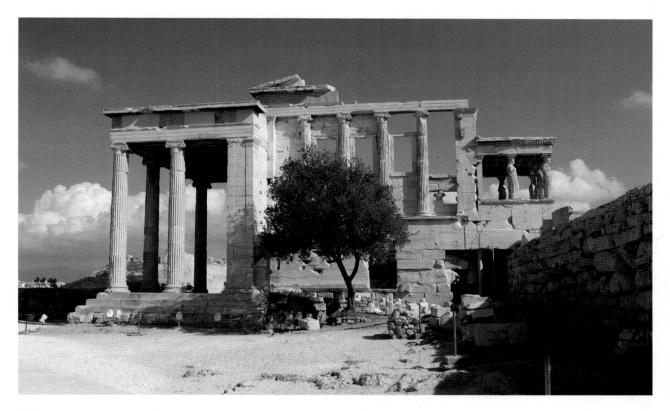

 $0.3~\ensuremath{\textit{Opposite}}$ The Propylaia, Athens, from the southwest. 437–432 $_{BC}$

 $0.4~\mbox{Above}$ The Erechtheion, Athens, from the west. 430s–406 $_{BC}$

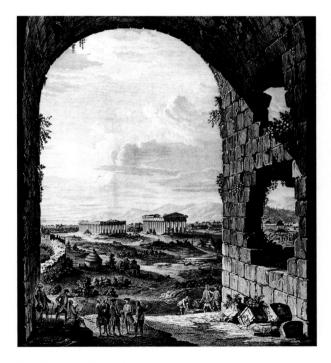

0.5 The city of Poseidonia (Paestum), from the east gate. Engraving (detail) by Thomas Major, AD 1768

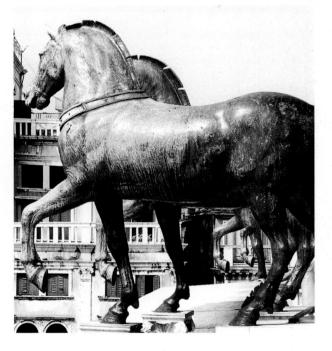

0.6 QUADRIGA, formerly over the entrance to St. Mark's, Venice. Possibly Greek of the 4th century BC, or perhaps adaptation. Gilt-bronze. Museo di San Marco, Venice

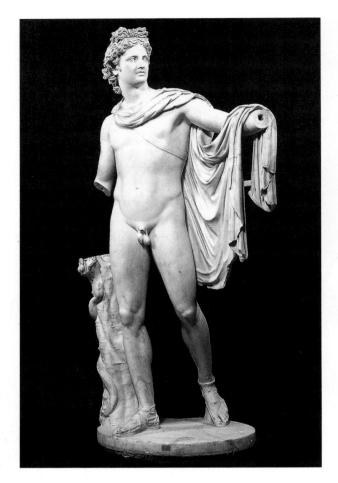

0.7 Apollo Belvedere. Roman copy of a Greek bronze original of the later 4th century BC. Marble. Height 7 ft $4\frac{1}{2}$ ins (2.24 m). Vatican Museums, Rome

families: the Medici, the Farnese, the Barberini, the Borghese, and the Ludovisi. One such statue was the Apollo Belvedere (fig. 0.7), so called for the villa and courtyard in the Vatican where it was displayed. It is a Roman marble copy of a Greek bronze original made during the last years of the fourth century BC. Because of its visibility in the Cortile del Belvedere, the Apollo became well known in Europe, and was soon joined in the courtyard by the famous Laocoön group (fig. 10.42, p. 368). The discovery of the Laocoön group presented European culture with a superb example of what was then thought to be Classical art. Both were later admired by the influential eighteenth-century critic J. J. Winckelmann, who was the first to draw distinctions between Greek and Roman art and to classify Greek art into the periods still used today.

The Eighteenth Century

The Greek temples at Akragas (Agrigento) in Sicily (fig. 8.39, p. 274) were explored and their plans and elevations published in 1732, those of Paestum (e.g. fig. 6.36, p. 171) in 1764. Winckelmann saw the Paestum temples in 1760 and made them the starting point for his Remarks on the Architecture of the Ancients, while Giovanni Battista Piranesi made a set of engravings that ensured that knowledge of them became widespread. Sir William Hamilton, an English diplomat appointed to the court of Naples in 1764, developed an interest in Greek vases which were then being recovered in large numbers from tombs of the sixth and fifth centuries BC. Within a few years he had amassed a large collection which was sold to the British Museum in London in 1772, so becoming the foundation of one of the most significant collections of Greek vases in the world.

At about the same time, interest in Greece itself increased. In 1750, two Englishmen, James Stuart and Nicholas Revett, were sent to Athens by the London Society of the Dilettanti to measure and draw the ancient buildings. Their drawings were published in several big folio volumes entitled *Antiquities of Athens* (1762–1816). The French, as usual, were quicker. Le Roy visited Athens in 1754 and published *Les Ruines des plus beaux monuments de la Grèce* in 1758.

Collections of Greek and Roman sculptures became status symbols among the English gentry, and Rome was the source for such works of art. There, entrepreneurs were busy prying loose old Italian collections from needy nobles and organizing excavations for treasure-hunting. Perhaps the most influential of these English gentlemen-collectors was Charles Townley (1737–1805). Townley's collection was put on display at his townhouse in London (fig. 0.1) where it received many visitors. It is all now in the British Museum.

The Nineteenth Century

The Parthenon marbles, sometimes known as the Elgin marbles (e.g. fig. 8.12, p. 256, and see Box, p. 263), were acquired by the British Museum in 1816, following a flurry of controversial diplomatic activity in Constantinople involving Thomas Bruce, seventh Earl of Elgin, and Selim III, Sultan of Turkey

0.8 *Right* The Hephaisteion, Athens, from the east. c. 450–415 BC

0.9 *Below* The Stoa of Attalos, in the Agora of Athens, from the northwest. c. 150 BC; reconstructed AD 1956 largely through the generosity of J.D. Rockefeller

CULTURE AND SOCIETY

HARRIET BOYD HAWES, AMERICAN PIONEER

mong pioneer American archaeologists working Ain Greece, Harriet Boyd (Boyd Hawes after her marriage) stands out (fig. 0.10). She was the first American to excavate in Crete and the first woman of any nationality to direct an excavation and publish the results in a professional manner. Yet she was as interested in contemporary issues, in social justice, and humanitarian work as she was in scholarship. She served as a nurse in the Greco-Turkish War of 1897, in the Spanish-American Wars, and in World War I, again in Greece. She was an active proponent of the rights of disadvantaged workers, and she wrote countless letters to Presidents of the United States and other politicians of every stripe and rank both for and against American diplomatic activity abroad and freewheeling legislation at home. She was also the mother of two children.

Born in 1871, she graduated from Smith College in 1892, and attended the American School in Athens in the year 1896-1897. Spurred on by news of discoveries in Crete, she went to the island determined to find and excavate a site and use part of her School Fellowship to pay for it. She was at Knossos in April of 1900 on the very day when Arthur Evans and his team discovered the ceremonial chair for which the Throne Room (fig. 3.3, p. 66) is named, and she reported that Evans had already found Linear B tablets. Shortly afterward, accompanied by a botanist friend, Jean Patten, and a Greek foreman, she began the ride eastward from Phaistos (newly uncovered by Italian archaeologists) on muleback. She discovered Iron Age houses and a cemetery at Kavousi on the heights above the gulf of Mirabello, and published the results rapidly in the American Journal of Archaeology (1901).

But she was already drawn to survey the isthmus between the gulf of Mirabello in the north and the port of Hierapetra in the south, recognizing that it would have been simpler in the Bronze Age for goods to make their way back and forth across the island on land rather than risk the hazardous sea journey around the east of the island. Such use of the isthmus, she reasoned, implied the presence of settlements along the way. She was not disappointed in her findings, and the outcome of her rides was the discovery and excavation of the town of Gournia (fig. 3.10, p. 71 and fig. 3.11, p. 72). The town sits on a small rocky hill at the northern end of the isthmus where the valley opens out and a stream flows northward

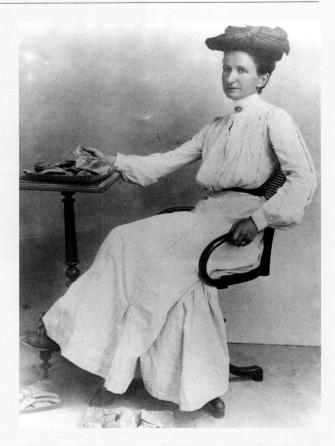

0.10 Harriet Boyd Hawes in contemplative mood, c. 1900

into the sea. It is so called from the name of the valley – in Greek, *gorni* (a drinking trough for animals, and hence a basin of any kind), and is well positioned to profit from commerce across the island, from maritime traffic, port activities, fishing, and farming. There is evidence (pottery) of activity here in the EMI and EMII periods, but it is the LMI period town which catches the imagination.

This is the site which Harriet Boyd and her Cretan workers excavated in the years from 1901 to 1904, and published with exemplary speed and accuracy. During this period she also taught at Smith, as she did later at Wellesley College, where she earned a reputation as a tireless and sympathetic teacher. She was an example, without equal, of the intellectual and social value of education in the liberal arts. (Greece was part of the Turkish Empire at the time). These sculptures rapidly came to influence European and American artists and scholars in their views about Greek sculpture. At about the same time, the pedimental sculptures of the Temple of Aphaia on Aegina (fig. 6.14, p. 159) were sold to the Prince of Bavaria and may now be seen in Munich.

Although Americans were visiting Italy in the years prior to the Civil War, and although Greek and Roman architecture had had an evident impact in the United States, as for example in the buildings of the University of Virginia at Charlottesville, only small collections of Greek artefacts were being assembled. Not until after the establishment of substantial metropolitan museums like the Boston Museum of Fine Arts in 1876 and the Metropolitan Museum in New York in 1880 did Greek materials begin to travel across the Atlantic in any quantity. But they were not at first bound for private collections. They were to be in the public domain, their purpose being to direct and improve taste and act as models for American artists.

In the second half of the nineteenth century, a more systematic form of excavation began in the cemeteries of Etruria and South Italy. Notable discoveries of Greek sculpture were made on the Athenian Acropolis by Greek archaeologists. The newly independent government of Greece encouraged Germansponsored excavations at Olympia, which continue to this day. Archaeologists were unearthing great quantities of other materials at these and other sites, and realized the need to classify their findings of bronzes, TERRACOTTAS, pottery, lamps, and so on into types and periods. Thus, the antiquities of Greece of the historical period - the period illuminated by written sources - gradually came to the attention of the world: slowly in Italy from the thirteenth century on, more rapidly by far after the middle of the eighteenth century.

Though the Lion Gate at Mycenae (fig. 0.11) had remained visible since antiquity, its age and meaning were unknown, and almost nothing was known of the archaeology of prehistoric Greece until the excavations of Heinrich Schliemann (see Box, p. 34). Schliemann came to archaeology late in life. Throughout his career as a businessman, he had kept an interest in Homer and was convinced that the poems reflected historical events. Scholars had discussed whether Homer's narrative in the *Iliad* could be true,

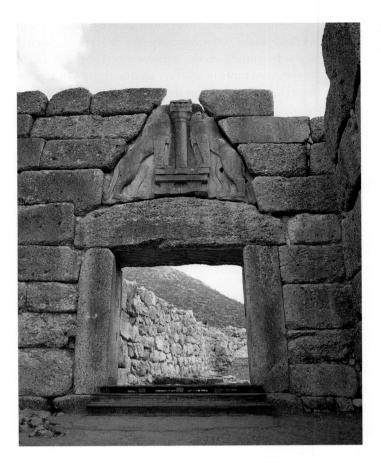

0.11 Lion Gate, Mycenae, from the northwest, c. 1250 BC

but it was Schliemann's work at Hisarlik (the site identified by him and others as Troy) that showed that history might be found in the poet's work.

Schliemann was led to the site by Frank Calvert, an English businessman, farmer, diplomatic agent, and archaeologist who had lived many years nearby. Calvert had identified many of the ancient sites in the region and had already (in 1863) excavated at Hisarlik, 50 percent of which was owned by his family. He had himself concluded that the site might well be identifiable as Troy, and therefore deserves much more credit than he has generally received for his contributions to discussions about Troy. Calvert did not however have the means to conduct a large excavation and willingly handed over the site to Schliemann. Schliemann's unwillingness to recognize Calvert's generosity, his subsequent manipulation of the Calvert family's good will and his later disparagement of Calvert do him little credit.

Schliemann first excavated at Troy in 1870 and worked there intermittently for the next twenty years. Beginning on the mainland of Greece in 1874, he followed hints in a surviving description of Greece written by Pausanias in the second century AD, and in 1876, while excavating inside the walls of Mycenae, he found SHAFT GRAVES belonging to a royal family. Subsequently he worked at Tiryns and Orchomenos. He had already made exploratory trenches on Ithaca. His work revealed a whole new civilization, termed "Mycenaean." Its geographical distribution seemed to tally nicely with the account of the states involved in the expedition against Troy as given in Homer's catalogue of ships in Book Two of the *Iliad*. But how old was this civilization?

Archaeologists were now able to identify characteristic pottery from this, Mycenaean, civilization and, most importantly, were finding it alongside Egyptian artefacts, which could be dated. Moreover, they realized that Egyptian tomb paintings of the Eighteenth Dynasty portrayed Mycenaean objects; as a result, approximate dates could be given for the latter. They were able to conclude that this Mycenaean civilization had flourished between about 1600 and 1300 BC.

Further excavations were made in the 1890s on the islands of the CYCLADES, and hundreds of tombs were recovered. They yielded stylized idols and new varieties of pottery; from these scholars were able to identify yet another civilization, the "Cycladic," which once more could be dated alongside the Egyptian chronology. What they now wanted to know was whether this was the direct precursor of the Mycenaean culture. Some eyes were already turned to Crete, where Schliemann wished to excavate but had been denied permission.

The Twentieth Century

The English scholar Arthur (later Sir Arthur) Evans originally went to Greece to carry out research on sealstones and early writing. Thanks to his aggressive support of Balkan states' independence from Austria and Turkey in the 1870s, and his fundraising work for the Cretans in the years prior to their independence in 1898, he had friends in high places and was able to buy the hill known as Knossos on Crete and begin excavations in 1900. Within a few years he had uncovered most of the palace and discovered clay

tablets bearing writing in what he termed a "Linear B script." He continued to excavate until 1932 and published the monumental four-volume Palace of Minos at Knossos between 1921 and 1935. Evans was able to show that this new prehistoric civilization, which he called "Minoan" after the legendary King Minos, was the main precursor of the Mycenaean culture on mainland Greece. By examining the sequence of archaeological layers (stratigraphy) of earth, artefacts, and debris, he worked out a relative chronology of prehistoric Crete. The very same year in which Evans began his work at Knossos (1900) saw the Italians begin excavations at a second palace at Phaistos, while a third palace at Mallia, discovered by the Greeks in 1915, has been investigated by the French since 1922. In 1901, the intrepid American archaeologist Harriet Boyd (Hawes) braved the wilds of eastern Crete to begin work at the town of Gournia (see Box, p. 18).

In the 1920s, another American, Carl Blegen, began to investigate the predecessors of the Mycenaeans on mainland Greece, and again by careful stratigraphic work he was able to unravel the chronology of Greece right back to the beginning of the Bronze Age. He termed the various phases of the chronology "Helladic," after the word Hellas, which meant "Greece" in antiquity, as it still does today. In 1939, with the Greek archaeologist Kouroniotis, Blegen also discovered the Mycenaean palace at Pylos. Here they found more Linear B tablets and these were eventually to lead to the decoding of the script in 1952 by Michael Ventris (see Box, p. 78). The decipherment of Linear B as an early form of Greek is among the great intellectual feats of the second half of the twentieth century. Many other sites have been discovered, including Lerna on the mainland, Thera (Akrotiri) in the Cyclades, and other palaces on Crete, including Zakro. More recent work suggests the existence of palatial complexes at Arkhanes, Chania, Galatas, Kommos, and Petras.

Sites of the historical period have been excavated systematically throughout the twentieth century, thereby uncovering the major sanctuaries and urban centers. Delos, Delphi, Samos, Olympia, Athens, Corinth, and Sparta in Greece, and Pergamon, Priene, Didyma, and Miletus in Asia Minor are all examples of such sites. In fact, work first began at most of these in the last quarter of the nineteenth century and has continued ever since. Syracuse, Seli-

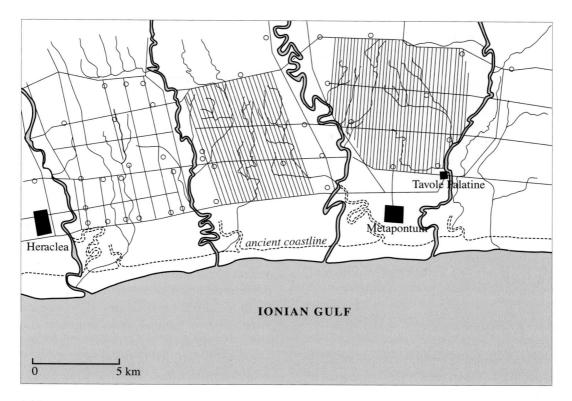

0.12 Plan showing field systems (parallel lines represent ditches) around Metapontum and Heraclea in South Italy, with coastline, rivers , farmsteads (circles), and the sanctuary known as the Tavole Palatine. c. 450 _{BC}. Ditches replaced an earlier system of droving lanes.

nus, Akragas, and Gela in Sicily, and Metapontum, Poseidonia, and Taras in South Italy were also quickly discovered and excavated by archaeologists. Among the more recently explored sites, Lefkandi in Greece and Ischia in Italy have yielded important new information, while the Macedonian tombs, notably the complex at Vergina, have been revelatory. Both these newer excavations and those at the older complexes are far from finished. In 1980 Samos yielded more over-lifesize marble statues of the sixth century BC (fig. 6.58, p. 186), while a Carthaginian sanctuary at Motya in Sicily produced the astonishing marble charioteer (fig. 7.37, p. 239). In 1994 a Late Archaic marble sarcophagus decorated with figural reliefs which included the rarely depicted sacrifice of Polyxena, daughter of King Priam, was found near Troy (see pp. 191-2). Chance finds, too, can be informative. The discovery in 1972 of the two big bronze warriors (figs. 7.32 and 7.33, p. 236) in the sea near Riace in South Italy revolutionized thinking about styles of Greek sculpture in the mid-fifth century BC.

At the same time, in both Greece and Italy, extensive surveys and excavation of country areas have produced important information of a more general kind. For example, the survey of the territory of Metapontum in South Italy has been revelatory. The city controlled good farmland that stretched behind the coastline between two rivers (fig. 0.12). It had been laid out to a grid plan in the mid-sixth century BC, and the construction of Doric temples – both within the city walls (the Sanctuary of Apollo) and outside – and of an "ekklesiasterion," or meeting place for the assembly, testify to the city's prosperity in the sixth century BC. Moreover, a treasury was dedicated at Olympia, and golden ears of corn were

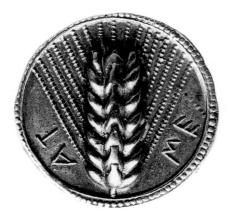

0.13 Silver coin of Metapontum: the ear of barley, symbolizing the richness of its land, appeared on Metapontum's coinage from the 6th to the 3rd century BC. National Museum, Collezione Gagliardi, Syracuse

sent to Delphi. An impressive silver coinage struck by Metapontum (fig. 0.13) in these years, which carries the emblem of an ear of barley, makes obvious reference to farming as the source of the city's wealth.

Aerial photography and surface surveys of the land behind the city have identified some five hundred sites in an area of about 15 square miles (40 sq km), by no means all of the land available for agriculture. These include sanctuaries, cemeteries, and farmhouses, which range chronologically from the sixth century BC to the third. The countryside was evidently widely inhabited, with people living in isolated farmhouses of modest shape and dimensions: square buildings with small rooms. Not until the fourth century BC does the large farmhouse with a central courtyard, known in Greece, put in an appearance.

Some details pertinent to the working of the land, such as the size of farms, are not always revealed by survey and excavation, and in this context epigraphic documents often prove invaluable. The bronze tablets from Heraclea (Metapontum's neighboring city to the west) record in amazing detail the results of the work of a committee charged with investigating property lines and incomes of two sanctuaries. They disclose facts about farm sizes, units of measurement, lines of land division, percentages of woodland and cropland, and other similar information. These inscriptions date to the end of the fourth century BC and extend the picture of Metapontum's agricultural economic base. The land was obviously what mattered here.

Further afield, the survey of the Greek settlement at Chersonesos in the Ukraine is yielding new information, for example about systems of land division among the Greek settlers on the northern coast of the Black Sea.

The Twenty-First Century

The year 2000 saw the discovery in a cemetery on the island of Thera of the earliest known example (c. 640 BC) of an over-lifesize marble female figure (see p. 148). This was followed in 2002 by the remarkable discovery on the island of Kythnos of a small temple of the seventh/sixth century (fig. 0.14) hidden since antiquity. The temple (probably destroyed by earthquake since there are no signs of burning) consisted of two parallel main chambers and a back room (an adyton). In the main chambers little has survived undisturbed above the floor. The back room, however, tells a different story. Here, many votive objects, fallen from collapsed wall shelves and tables, and perhaps also from a wooden cult statue now perished, were found on the floor and in the destruction strata immediately above it. Some 1500 objects, mostly of the seventh and sixth century in date, have been recovered, including jewels and amulets of gold (fig. 0.15) and gilded silver pins and earrings, bronze bracelets, objects of bone and ivory, necklace beads of rock crystal, faience, and glass paste, and many female terracotta figurines. There is a good deal of painted pottery (Corinthian, Attic black figure, and East Greek), many of the shapes connected with dining and drinking. Egyptian scarabs and Phoenician glass beads are also present. The importance of these discoveries is clear. The findspots of the objects allow a reconstruction of the exact appearance of the interior of the inner sanctum of an early Greek temple. The objects themselves by their rarity, richness, and provenance will compel a reassessment of the historical importance of ancient Kythnos. And the recovery of part of the building in its unplundered condition will prompt further thinking about the function of the adyta of archaic Greek temples.

Another extraordinary discovery, also in 2002, was made by a team of German and Greek archaeologists working in the Kerameikos cemetery of anci-

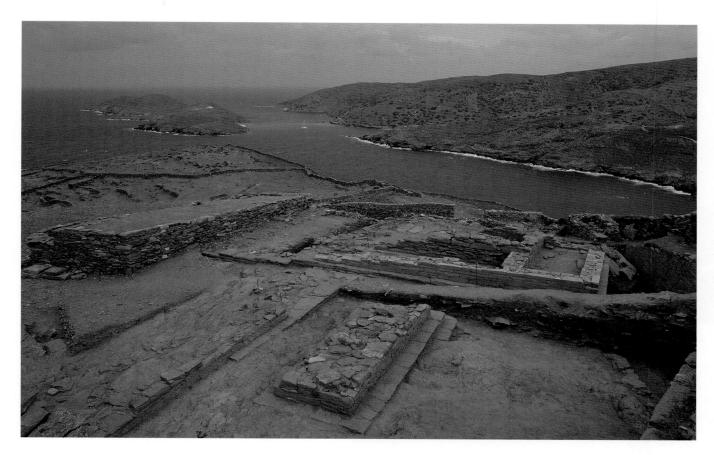

0.14 Kythnos, view of the temple, from the south with modern animal pen to the west: altars in the foreground, with beyond the unplundered adyton at right, main chambers, and ruined front of building (facing west). c. 650 BC. Stone (schist) walls, terracotta rooftiles. Adyton, c. 10 ft x 6 ft 6 ins (3 x 2 m); preserved cella, c. 10 ft x 16 ft 6 ins (3 x 5 m)

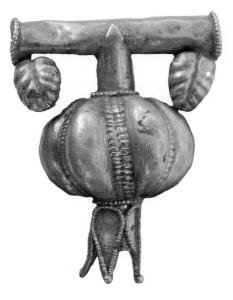

0.15 Multi-petal rosette (above) and pendant in the form of a pomegranate (melon?), from Kythnos, Archaic temple. 7th–6th century BC. Gold and gilded silver

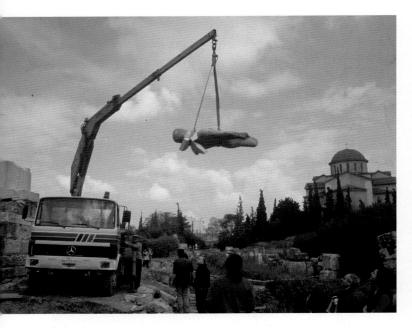

0.16 Kouros (from the Kerameikos) in course of recovery, AD 2002

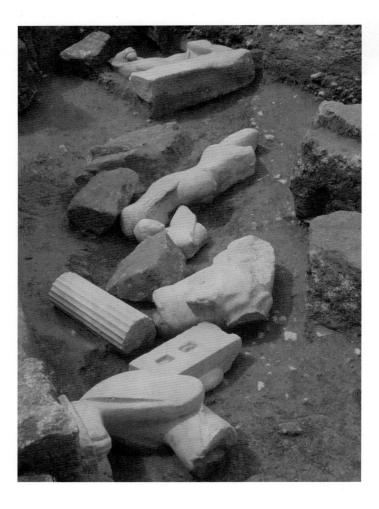

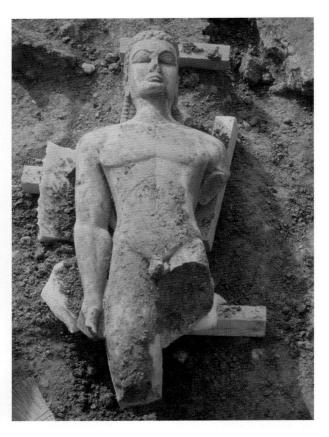

0.17 *Above* Kouros, from the road bed associated with the Sacred Gate in the Kerameikos, Athens. c. 600–590 Bc. Marble. Height 1.45m (as preserved). Kerameikos Museum, Athens

0.18 *Left* Athens, Kerameikos. Cache of Archaic objects as found in AD 2002, view from the northwest. From the top: lion, c. 560–550 BC; kouros, c. 600–590 BC; head and upper part of a sphinx, c. 560 BC; front part of second lion (headless), c. 560–550 BC; column fragment; lonic capital, c. 575–550 BC; hindquarters of second lion, c. 560–550 BC. All marble. Also (not shown in the illustration) a Doric capital, c. 580–570 BC, of limestone. Kerameikos Museum, Athens

ent Athens. Seeking to refine the architectural phases of the Sacred Gate in the city wall, the archaeologists uncovered a road associated with the first phase of the Gate (c. 478 BC). And beneath the earth surface of the road they found a spectacular deposit of sculptures. Broken in all probability in the course of the Persian invasion of 480/479 BC, these consisted of a kouros (fig. 0.16), a sphinx, two lions, and two capitals (all of marble with the exception of one limestone capital). Doubtless funerary in function in the sixth century, these striking examples of early archaic Greek art were recycled in the fifth century BC as foundation materials for a road (fig. 0.18). The lions

were probably a matched pair, used originally to mark and protect a family plot in the cemetery. The sphinx also has a twin, found long ago near the Sacred Gate and now in the National Museum, and the two may also have guarded a grave precinct. The kouros too (fig. 0.17), given its provenance, surely functioned originally as a funerary monument. Its size and style are so similar to those of the New York Kouros (see p. 176) that this discovery will surely allay any doubts which may still exist about the authenticity of the statue in the Metropolitan Museum. It serves, too, to underscore the style and productivity of the workshop active in Athens in the first years of the sixth century, and to differentiate it from the workshop which produced the statues found in the sanctuary at Sunion (fig. 6.43, p. 177), and indeed the styles of other ateliers active in sixthcentury Greece.

In 2005, in Marseilles (ancient Massalia) in the south of France, the foundations of a Greek temple were uncovered during the construction of a parking lot in the area known as the Old Port. This is the zone in which the remains of a Greek theater had been recovered shortly after World War II. Since modern Marseilles sits on top of much of the old city, this new discovery was a rare event, and confirms the view that the Old Port was a central area of the ancient city. The temple's massive foundations are dated on the basis of associated pottery to the earliest years of the Greek colony, c. 580 BC, and contribute significantly to our knowledge of the oldest Greek settlement in France.

And in 2006 a Late Bronze hilltop palatial complex was revealed on the island of Salamis. This fortified complex, complete with adjacent houses and workshops (as at Mycenae) is identified by the excavator as the residence of Ajax, the hero and champion warrior of the Greeks, famous for his exploits at Troy as described in Homer's *Iliad*. It was abandoned c. 1200 BC. Year by year, the earth continues to yield her secrets. There is much still to be found.

There are other intriguing developments too. In 2003 a lifesize bronze statue of a young male figure, a Sauroktonos (Lizard-Slayer), appeared on the art market (fig. 0.19). Pliny describes such a type as the work of Praxiteles, and Roman versions, in marble, have been identified. This newly discovered statue is, however, without an ancient context and therefore presents challenging problems: there will

0.19 Sauroktonos (Lizard-Slayer): bronze, copper and stone inlay. Possibly Hellenistic or Roman, and, if so, c. 275 $_{BC-AD}$ 300. Height c. 5 ft (1.52 m). Cleveland Museum of Art

continue to be lively discussion about its provenance and authenticity. Nevertheless, it clearly embodies the stylistic traits that scholars associate with Praxiteles and his followers (see pp. 307–9) and it fits well with Pliny's description. It is unlikely to be a Greek original of the 4th century which has miraculously survived (though there's always an outside chance), but it could well be one of many Hellenistic or Roman versions, or it may, one supposes, be of more modern origin. We await the outcome of the scientific and scholarly enquiries. Stay tuned. What criteria of investigation would the disinterested observer bring to bear?

LITERARY SOURCES

Little relevant written material has survived from the Classical and Hellenistic periods. No treatise written on architecture or sculpture has come down to us, though we know that such treatises were written. Chance references, such as the mention in Euripides' play Ion of the façade of the Temple of Apollo at Delphi, are scarce. From the first century BC on, however, several sources become useful. The geographer Strabo, who wrote in the late first century BC and early first century AD, is illuminating about the topography and history of the Greek world of his time. Cicero, writing in the first century BC, reveals contemporary Roman attitudes toward art. When he requests friends in Athens to send him Greek statues, he does not ask for specific statues or sculptors, but rather for works that will suit the various rooms of his villa.

Vitruvius was a Roman architect of the later first century BC whose handbook on architecture has survived till today. It offers a useful description of contemporary techniques, defines architectural terms, and puts forward recommendations about proportions for temples, though no temple has been found that corresponds in every respect to his specifications. Through Vitruvius we discover that in wall painting perspective first appeared in stage scenery of the fifth century BC. Both Vitruvius and other Roman sources drew liberally on Greek or Hellenistic predecessors.

Pliny the Elder, who died in the eruption of Vesuvius in AD 79, wrote a *Natural History* which covered numerous topics. He is most interesting in the

attention he gives to Greek sculpture, devoting separate sections to bronzes, terracottas, and marbles. The section on bronze statues is by far the largest. He lists sculptors and their most famous works, dating them by Olympiads (periods of four years), and makes critical judgments on statues that probably reflect the view of his Hellenistic source. Through his descriptions experts have been able to identify Roman copies of Greek originals, though using this method can be controversial. His writing on painters and paintings is similarly of great interest. He lists the titles of important Classical paintings and says that large-scale mythological groups like "Perseus freeing Andromeda" (fig. 9.49, p. 323) were especially popular in Greek times and were favored again in his own time.

Pausanias's *Description of Greece*, written in the second century AD, is an account of his travels. He described the sites he visited and the statues and other objects he saw. His detailed walks through Olympia or the Athenian Agora, to name but two, are invaluable, but also maddening. Where his information can be verified, he sometimes makes errors, which leads us to believe that he relied on hearsay. Yet he gives important news: his description of Polygnotos's paintings in the Lesche (clubhouse) of the Knidians at Delphi, for example, is critical to our understanding of how Polygnotos suggested depth in space on the flat surface of a wall.

Writing other than that of a literary kind is also an important source. The decipherment of the Bronze Age Linear B script of Knossos as an early form of the Greek language told us that the Greeks were in Knossos in the Late Bronze Age and that the tablets themselves were archives (mostly inventory lists). Inscriptions on pots and sherds of the later eighth century BC tell us when the skill of writing was learned again in Greece after its Dark Age. Writing was later used on pots to identify characters in painted scenes and for the signatures of potters and painters. An inscription in stone from the fifth century BC gives details of expenditures on the Erechtheion at Athens, while another of the fourth century BC gives the costs of the construction of the Temple of Asklepios at Epidauros. Others record the inventories of the treasures of particular temples. Statue bases yield information about the identity of the donor and sculptor of the statue. In the sixth century BC, such inscriptions even appear on the statue itself.

THE DEVELOPMENT of classical Archaeology

The monuments and objects of antiquity that attracted the earliest students were temples, statues, coins, and inscriptions. Accordingly, historians of architecture and urbanism, historians of art, NUMISMATISTS, and EPIGRAPHERS were in the forefront. Analysis of styles and ICONOGRAPHY were of major importance from the start.

The leading early exponent of the study of style and iconography was Johann Joachim Winckelmann (1717-1768) (see p. 16). Son of a German shoemaker and a prodigious schoolboy student of Greek and Latin, he was fascinated by the worlds of Greece and Rome. Mythology and sculpture were to become his special interests. After moving to Rome in 1755, he worked day and night at the study of antiquity, converted to Catholicism, and ingratiated himself with the papal hierarchy. Appointment as a papal antiquary and access to the Vatican collections enabled him to forge ahead with his work. He published his most famous work, History of the Art of Antiquity, in German in 1764. In this book he was the first to articulate a theory of the history of Classical art, and hence he is known in some quarters as the "father of art history." A number of ideas are spelled out: a vision of ancient art as a development, with definable phases of progress; a predilection for Greek art; the importance of studying originals rather than copies; a preference for sculpture over other art forms. His framework of chronological development has had a lasting influence and has been applied not only to Greek art but to other art histories too. Some scholars praise this theorizing, but others dislike it and say it is too biased. In other writings, Winckelmann concentrated on the identification of statues with mythological figures, categorization of statues by type, and the Greek introduction of the idea of "beauty" to art. His revelation of the component of "beauty" in Greek art led to the concept of the Greek ideal, and contributed significantly to the persistent impact of Greek art in the analysis of later Western art.

Once artefacts began to be recovered through excavation, the field expanded to include other

aspects of cultural history, especially those involved not with high art but with daily life. Archaeological evidence began to be used to tell us about social and economic history, and people started to realize just how important pottery was, both as art when painted and as artefact when plain.

Pottery breaks easily, but it is not easily destroyed entirely and survives in the earth. When broken into sherds, a pot has little intrinsic value. Fragments often remain buried in the ground where they were initially discarded. Since making pots from fired clay was the commonest craft in antiquity and since pots had many uses - for cooking, eating, drinking, and storage purposes, and for making offerings at sanctuaries and tombs - pottery provides the largest category of archaeological evidence that has survived. It is not perishable like textiles and woodwork, which have virtually disappeared from the record, though we know they existed. Unlike bronze or marble statues, it is not likely to be recycled. Artisans could burn marble for lime, or melt down bronze. So pottery has survived in large quantities and is invaluable evidence for social history. The uses to which pottery was put are studied, as are its painted scenes, which depict customs, beliefs, and rites. How the wares were distributed - trade connections and patterns - tell us about economic history. And pottery can also tell us about its evolution as an art form.

Such are the quantities that have come down to us that scholars have been able to work out the stages of development of various shapes of vessels and systems of decoration, and have been able to relate these stages to historically recorded events. Accordingly, pottery has become a critical tool for dating archaeological contexts and for dating buildings or objects by stylistic analogy. Coins are another useful dating tool since they exist in large numbers and are often dated themselves by internal evidence; hence, they can help date the context in which they are found. Historical records, pottery, and coins are therefore the more traditional means of establishing a chronology. More scientific methods such as DENDRO-CHRONOLOGY, THERMOLUMINESCENCE, and RADIO-CARBON DATING (see p. 34) are helpful but costly.

A relatively recent field of activity is underwater archaeology. Many ancient coastal sites are now submerged, or partially so, and exploring them and their harbor installations is yielding much valuable new information. Similarly, the careful excavation of shipwrecks is revealing cargoes that greatly expand our knowledge of trade and chronology.

Most ships sank because they hit land. So new information is more likely to come from shallowrather than deep-water wrecks, and is less costly to retrieve. Yet the use of new technologies - such as remote-control high-definition cameras, robots flexible enough to lift ancient storage jars, and satellite communication systems capable of beaming images and data from the sea floor to archaeologists thousands of miles away - is making the exploration of deep-water wrecks feasible and productive. Such data gathering has already taken place off the coasts of Turkey, Sicily, and Israel. A good example of the recent (1999-2001) complete excavation of an important Greek wreck is the ship found off Teos on the west coast of Turkey. That the vessel was carrying a cargo of wine was unsurprising. But the dating of the wreck to the 5th century BC allows a first-hand look at patterns of trade and communication at the height of the Athenian empire, a period for which evidence has so far been restricted to just a couple of other vessels. Another good example from another era is provided by the Late Bronze Age wreck off Uluburun in southern Turkey (see p. 64).

Another recent area of activity is salvage archaeology. Construction projects in city centers and in coastal locations, new networks of roads, and new airport facilities have disturbed ancient remains in many parts of Greece. This development has necessitated close collaboration, often at the last minute, between archaeologists and construction engineers to ensure both the timely completion of building projects and the preservation of the historical material. It is well exemplified by the wonderfully successful recent work which accompanied the installation of the new underground stations and subway lines in Athens (fig. 0.20). See Box, pp. 348–9.

Research in the field is now equally divided between excavation and survey. In any excavation, all artefactual material and bones must be kept, soils, seeds, and pollen collected, and the sites themselves conserved. Excavation is often preceded by an aerial photographic survey mapping the site; modern computer-aided transcription methods enable fields and landscapes to be plotted in some detail. A RESISTIVITY SURVEY, too, is often helpful. A field-walking survey of the zone where excavation is to take place and its immediate surround is then carried out.

Regional survey aims at covering much larger tracts of ground and seldom involves excavation: it is labor-intensive and often addresses different kinds of questions than those traditionally posed by architecture, sculpture, coins, pottery, inscriptions, or other evidence retrieved by excavation. Such questions are concerned more with settlement patterns, demographic studies, agriculture, animal husbandry, and other types of land use. These problems require a very wide range of technical skills and demonstrate the broad scope of the categories of evidence and questions covered by archaeology today.

Accordingly, successful archaeological projects require interdisciplinary teams of scholars covering different areas of expertise. They need not only specialists of the kind historically associated with classical archaeology projects - pottery experts, experts in ancient architecture, terracotta figurines, metal objects, coins, glass, and so forth, photographers, graphic artists, architects, draftspeople - but also geomorphologists, soil scientists, palaeobotanists, physical anthropologists, osteologists, biochemists, and statisticians. Experts in information technology too play an increasing role in the analysis, storage, and presentation both of artefactual and artistic materials. Such teams address many types of information and enquiry, some answering questions about landscape changes over time, about land use, about the physical traits of populations, about their sicknesses and injuries, about how they lived and how they died, others explaining the social behavior of a group, yet others focusing on the skills and aspirations of individuals. How, for example, did Greek farmers farm their land? How did a master craftsman like Exekias paint an AMPHORA?

In the realm of art, students pay increasing attention to a work's social, political, and religious contexts, and to its purpose. Why was a particular image or object or monument chosen? Who chose it? Who commissioned it? What relation do monuments have to political events? What role did social competition play in the display of dedications in sanctuaries? How do we explain the vast communal investment in temple building and decoration? What myths and episodes of myths were thought to have the greatest impact? Can we imagine what the ancient viewer thought or discern the intentions of

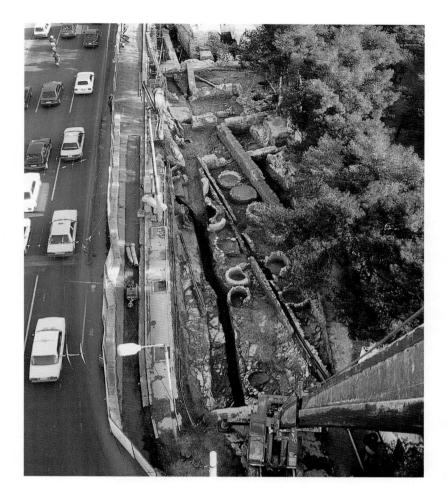

0.20 Athens, excavation on the southwest edge of the Zappeion Gardens (near the junction of Amalias and Olgas Avenues) preparing a ventilation shaft for the Metro system. c. AD 1995

the ancient artist? Can we be free of our own innate biases, or are we, like the ancient and the secondary written sources on which we draw, compromised by our own contexts and objectives?

Archaeologists and historians of ancient art who work on Greek materials seek to find and analyze the material manifestations of a culture which was the springboard for many aspects of Western civilization. "Not everything was written down," as a Middle School student said when asked why she thought archaeologists do what they do. Specific discoveries have had specific impacts. The appearance of the Elgin Marbles in London revolutionized European and American notions of sculpture and human beauty; the Aphrodite of Knidos initiated the theme of the female nude in Western art; Greek columns have stood as symbols of authority from the Parthenon to Monticello to Wall Street. The more we know of the cultures that shaped the foundations of our own culture, the more easily we can enlist the aid of Greek thought and Greek experience in understanding current problems.

This book concentrates on description and chronological sequence, which are the first, but only the first, steps in understanding ancient monuments and objects. Combined with exploration of the broader contexts, this study should lead to a fuller comprehension of the workings of Greek minds and their essential concerns.

THE AEGEAN IN THE THIRD MILLENNIUM c. 3000-2000 bc

Humans had inhabited Greece for many thousands of years before the Bronze Age. They lived by hunting, fishing, and gathering fruit, nuts, berries, and wild grains. They were living in Epirus in northwest Greece (fig. 1.2) perhaps as early as 40,000 BC. One important early site is the Franchthi Cave in the Argolid (near Argos in the Peloponnese), which people were using by 20,000 BC at the latest. OBSIDIAN, volcanic glass used to make cutting and scraping tools, was found on the Franchthi site with other materials dating to around 10,000 BC. It originally came from the island of Melos some 90 miles (145 km) away, which shows that there was communication across the Aegean Sea at that time.

New peoples arrived about 6000 BC, and at the same time a new style of existence based on permanent settlements and dependent on agriculture and domesticated animals was introduced. To judge from the heavy distribution of their sites in the east of Greece and from similarities between some of their artefacts and contemporary materials found in Anatolia, the newcomers must have migrated from Anatolia. People now lived either in caves, which offered ready-made shelters and often a supply of water, or in settlements in open countryside suitable for animals and crops.

In some areas, those who lived in settlements in the open built the walls of their houses of wattle (a frame of timber stakes interwoven with twigs and branches), with wooden posts to support the roof, and in others they used stone and mudbrick. Soon after 6000 BC, they began to use fired pottery instead of wood or basketry vessels. They also made stone or terracotta (baked clay) figurines, many of which, according to the traditional view, represented the Mother Goddess, the miraculous giver of life to humans (and by extension to animals and crops). She had exaggerated breasts, thighs, and buttocks, suggestive of fertility. This was evidently a society whose religious beliefs were rooted in the human and agricultural miracles of birth and growth. The first, fragmentary evidence for metalworking can be dated to around 4000 BC.

There seem to have been further population movements around 3000 BC, the date that loosely marks the beginning of the Bronze Age. In Greece, the transition from the Final NEOLITHIC Age, characterized by primitive farming methods and the use of polished stone and flint tools and weapons, to Early Bronze was smooth, but there were new-comers in the Cyclades, who may have traveled from mainland Greece, and others in Crete, who may have arrived

31

^{1.1} Beak-spouted jug, from Aghios Onouphrios. EM I. Height 11 ins (28 cm). Iraklion Museum, Crete

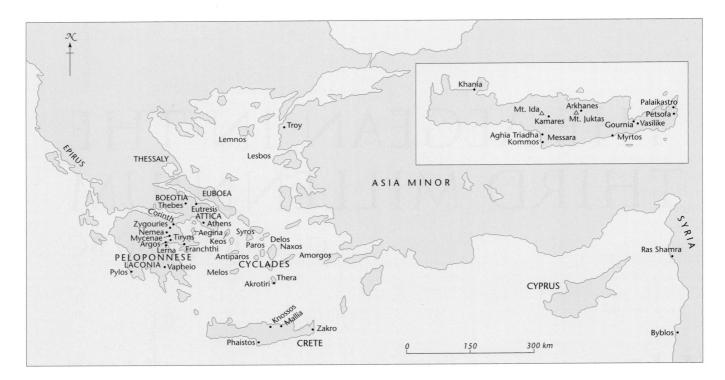

1.2 Minoan Crete and the Bronze Age Aegean

from Anatolia. (Archaeologists have made these suppositions after comparing their pottery styles.) Soon after these movements, people began to cultivate olives and grapes as well as cereals. Their knowledge of metals advanced rapidly in the first part of the third millennium. Artisans now made implements both from copper, an element that can be made into a rather soft tool, and from bronze, an alloy (consisting principally of copper, but mixed, usually, with tin) that produces a much harder and more durable tool. These were better than stone tools for woodworking, ship-building, construction, and agriculture. Copper and bronze were also a form of wealth, and as such were a source of competition. Individuals or groups who controlled access to metals, and who employed specialist artisans, came to possess tougher weapons and prestigious items including brilliant jewelry, which they could use for display, exchange, or gift. These developments evidently encouraged the acquisition of personal wealth and stimulated the birth of social hierarchies. It was around 2900 BC that some such individual or group oversaw the building of the first city of Troy on the coast of Asia Minor, guarding the approaches to the Black Sea.

Settlers had arrived in Crete by about 6000 BC, in boats large enough to carry cattle, goats, sheep, and pigs. They established themselves at Knossos. A depth of over 19 feet 6 inches (6 m) of Neolithic stratification was unearthed beneath the west court of the Bronze Age palace, and beneath the central court excavators found remains of houses. Small, rectangular, cell-like units and small cobbled areas cluster into what may have formed a pair of dwellings. Walls were of stone in the lower part and mudbrick above. Interiors were furnished with benches and platforms. As on the mainland of Greece, the life of the inhabitants changed little for 3,000 years. Then, when the new peoples arrived around 3000 BC, a new phase began. It is at this time that metal artefacts begin to appear in Cretan graves.

CHRONOLOGY

Through examining the stratification at Knossos and the pottery found in it, early excavators began to associate pottery styles with chronological phases, and thus to establish a relative chronology. An Egyptian chronology had already been made in three parts: the Old, Middle, and New Kingdoms (fig. 1.3). By finding what looked like correlations between these periods and the strata at Knossos, the excavators identified three major prehistoric periods of human activity on Crete after the Neolithic period. These were described as Early, Middle, and Late Minoan, taking their name from Minos, an early legendary ruler of Crete mentioned in Homer and subsequent Greek writers. These three periods were then subdivided, in accordance with pottery styles, into Early Minoan (EM) I, II, and III; Middle Minoan (MM) I, II, and III; and Late Minoan (LM) I, II, and III. These phases were broken up yet further, using the letters of the alphabet, when subtler distinctions became discernible, for example, LM IA and LM IB. Subsequently, similar systems were adopted for the Cyclades (Early, Middle, and Late Cycladic) and the mainland (Early, Middle, and Late Helladic), and similar abbreviations came into use: EC, MC, and LC, and EH, MH, and LH. Crete, the Cyclades, and mainland Greece are the three major

BC 3000 -	CRETE	CYCLADES	GREECE	EGYPT	
2800 -				ARCHAIC	П
2600 -	EMI	ECI	ΕΗΙ		
2500 -				OLD	
2400 -	EMII	ЕСИ	EHII	KINGDOM	v
2300 -	E 191 I I	ECH	спП		VI
2200 -	E M L L Z	D OLLI		lst	VII - X
2100 - 2000 -	EMIII	ЕСІІІ	EHIİI	INTER	XI
1900 -	ММІ	M C I		MIDDLE KINGDOM	XII
1800 -	MMII	мсн	МН		
1700 -				2nd INTER	XIII - XVII
1600 -	MMIII	MCIII			
1500 -	L M I A L M I B				XVIII
1400 -	LMII	LC	LHIIIA	NEW KINGDOM	
1300 -	LMIIIB	20	LHIIIB		
1200 -	LMIIIC		LHIIIC		XIX - XX
1100 - 1000 -	DARK AGE			LATE PERIOD	XXI
900 -				I	L

1.3 Chronological table of the Bronze Age in Crete, the Cyclades, mainland Greece, and Egypt. MM II almost only at Knossos and Phaistos. LM II only at Knossos

geographical zones of settlement in the Greek Bronze Age. Close to the Greek world, and of great importance, was the site at Troy in Asia Minor.

The Early Minoan, Early Cycladic, and Early Helladic periods are more or less contemporary, as are Middle Minoan, Middle Cycladic, and Middle Helladic. Likewise, Late Minoan, Late Cycladic, and Late Helladic are, generally speaking, contemporary. EM, EC, and EH represent the Early Bronze (EB) Age in the Aegean; MM, MC, and MH represent the Middle Bronze (MB) Age; and LM, LC, and LH the Late Bronze (LB) Age. Unfortunately, pottery styles do not always follow one another neatly, and sometimes they overlap chronologically. On Crete, an alternative dating system exists, based on the destruction levels of the palaces, but many commentators continue to use the older one, and it will be used here. At Troy, the chronology first unraveled, if erratically, by Schliemann is defined by the seven cities built on top of one another on the site. Troys I-V correspond in general terms to the EB period, Troy VI lasts from the start of MB to well into the LB period, and Troy VII covers the last two centuries of the Bronze Age.

The "relative chronology" achieved by examining the stratification of a site establishes that certain artefacts were made earlier - that is to say, further away in time from the present day - than others. An "absolute chronology" will yield dates in years BC and is much to be preferred, though it is more difficult to arrive at. It depends largely on Egyptian and Mesopotamian "synchronisms" (when firmly dated foreign objects appear in Greek contexts, or Greek objects appear in firmly dated foreign contexts, the Greek object or context may be dated to the same time as the already dated foreign material). The civilizations of Egypt and Mesopotamia, which kept written records, give a generally reliable absolute chronology as far back as the third millennium. Accordingly, dated Egyptian objects found in a Cretan context will help give a date for that context. Such synchronisms are more reliable in the MM period, but earlier Egyptian seals of the First Intermediate Period appear in tombs in the south of Crete and help to establish a date for them. There are of course pitfalls. Such objects may be heirlooms and give nothing more than a terminus post quem (an earliest possible date) for the context in which they appear.

HEINRICH SCHLIEMANN: SCHOLAR OR RASCAL?

Schliemann explored several Aegean sites, but is best known for his excavations at Mycenae and Troy. He has acquired a twofold reputation: on the one hand as the first uncoverer of Bronze Age cultures of the Aegean, and on the other as a roque. What are we to make of the dubious reputation of this energetic and inspired man?

Born in Germany in 1822 into a poor family, he entered commercial school at the age of eleven. He

was phenomenally good at languages, mastering Latin, French, English, and Russian (aside from his native German), before being sent to St. Petersburg at the age of twenty-four as the agent for a Dutch firm. As well as working for them, he set up his own business in cotton, tea, and indigo, learned more languages (Italian, Spanish, Portuguese), and made a fortune. In 1864 he retired from business, visited China and Japan, and went to Paris to learn Greek and archaeology. With Pausanias and Homer in hand (early passions of his learning), he visited Troy and Mycenae for the first time in 1868 and began excavations at Troy in 1870. All his excavations and

publications, which followed swiftly, he funded himself.

He has his detractors, and not without reason. He visited America and fraudulently became an American citizen. In 1869 he bribed members of the Indiana state legislature to prevent divorce law changes. In Russia, his advancement in the commercial judiciary, though he was without legal training, seems suspicious. Bribery here too? His autobiographies and diaries are riddled with

> inconsistencies and seem as concerned with self-promotion as with veracity. Discrepancies in his various accounts of the so-called "Priam's Treasure" show that he meddled with the evidence to inflate its importance.

> Yet, here is the man who, selftaught, in the twenty years from 1870 to 1890 revealed the material existence of the prehistoric Aegean world. Without him the discovery would have been delayed a generation. Some achievement! Was he a genius or a scoundrel? What do you think?

1.4 Heinrich Schliemann (1822–90)

Another means for arriving at absolute dates for organic objects is radiocarbon dating. This measures the amount of carbon 14 (C14) left in any object. Since we know the amount of C14 in any organic object, and since, after death, the C14 decays at a fixed rate, it is theoretically possible to measure the amount of C14 in, for example, an animal bone or wooden object and thus to determine when the animal perished or the tree was cut down. This method has been improved by tree-ring dating (dendrochronology). By dating ancient trees using both C14 and tree-ring dating, scholars discovered that C14 dates were often too young. A graph has been produced to correct C14 results, and this yields dates that are effective all the way back to the sixth millennium. Yet there are still considerable differences between dates provided by many C14 samples. As other sources of chronological information - coins,

inscriptions, correlations with written records become available in the historical period, the C14 technique becomes less useful. Yet for the third millennium - and earlier - it is crucial.

The chronological framework set out in figure 1.3 is a simplified scheme and there is much uncertainty about many dates. In the third millennium, inaccuracies of up to two or three hundred years may still be expected.

CRETE

Architecture

The Early Minoan phase of greatest activity and creativity is the second (EM II, c. 2500-2200 BC). In the east of the island, close to the south coast, a

community of farmers and artisans lived in the village of Myrtos (fig. 1.5). Stone-built dwellings, set on the hilltop, resemble rooms or cells more than houses. Sharing party walls, they call to mind the buildings of Neolithic Knossos. The scale of the individual spaces is tiny. Streets, little more than passages - two people cannot walk abreast here link different parts of the village. Different zones have different functions. There are storage areas with rooms of PITHOI (large clay containers), living areas and working areas, and a shrine. There is much evidence of agricultural and industrial activity. The inhabitants grew barley, wheat, olives, and vines, and reared all the usual domesticated animals: sheep, goats, pigs, and cattle. They made pots, terracotta and stone figurines, and loom-weights. They wove and decorated textiles and painted their own pots. The site presents a compelling picture of a protourban Minoan society.

The dead were often buried in CIST graves, rectangles cut in the earth and lined with stone slabs, or they were deposited in CHAMBER TOMBS, which consisted of two or three stone-built rooms, constructed in this phase entirely above ground and

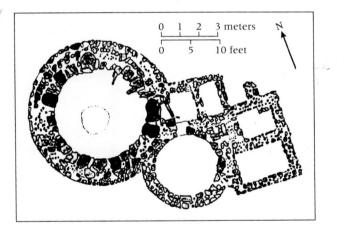

1.5 Top Plan of Myrtos. EM II

1.6 Above Plan of tholos, Lebena. 3000–1700 BC

therefore always visible. In the south of the island in the plain of the Messara, another type was popular: the THOLOS (pl. THOLOI) or circular tomb (fig. 1.6), the popularity of which lasted until the end of the millennium. These structures were of monumental size, and like their north Cretan house-tomb counter-

1.7 Above Jug, from Mochlos.
 EM II. Stone. Height 4³/₄ ins (12 cm).
 Iraklion Museum, Crete

1.8 Above right Seal, from Platanos. EM II. Ivory. Length $1\frac{1}{3}$ ins (3 cm). Iraklion Museum, Crete

1.9 *Right* Vasilike ware cup and jug, from Vasilike. EM II. Height (cup) 2½ ins (6 cm); (jug) 5½ ins (14 cm). Iraklion Museum, Crete

parts, they were built entirely above ground. How they were roofed remains uncertain. These massive stone-built chambers appear to have served whole communities for centuries.

Pottery and Stonework

The Early Minoans' experience in working stone extended to making vases in brightly colored alabaster, breccia, schist, serpentine, and steatite (fig. 1.7), mostly stones native to Crete. This flourishing technology was adopted from Egypt and the Cyclades, where it was widely used. The interior of the vase was worked with a tubular copper drill, powered by a bow, and using an abrasive powder, probably emery from the island of Naxos. The exterior was modeled by being beaten with stone hammers and polished with emery or sand. The range of shapes is very broad, perhaps even broader than that in the contemporary Cyclades, where working in stone was highly favored. The sophisticated use of the veining of the stone to create flowing designs and effects of movement is striking. Most vases seem to be miniatures, perhaps purpose-made for use in tombs. Some are equipped with lids, and some stone lids have handles in the form of greyhounds. An ivory seal from a tholos tomb at Platanos (fig. 1.8), with its handle in the form of an ox, reveals the same interest in naturalism and in rendering lifeless forms as animate ones.

Pottery is the most familiar material of the first phase of Early Minoan (EM I, c. 3000-2500 BC), and Aghios Onouphrios ware (fig. 1.1), so called from the place where it was found, is perhaps the best known of its styles. Round-bottomed jugs are characteristic, decorated with dark paint on a light ground. This decoration sometimes includes crosshatching of diagonal lines to form lozenges, which are repeated around the surface of the pot. The typical pottery style of later EM II is the so-called "Vasilike ware." Characteristic shapes are the longspouted jug and cup (fig. 1.9). The decoration relies on a mottled effect, thus imitating the surface of stone vases. A lustrous reddish-brown wash covers the surface and forms the background for the darker floating forms of the principal decoration. These darker spots, or passages, are sometimes arranged symmetrically, as in figure 1.9, and here they are balanced by the painted linear ornament on the spout. There are several ways the mottled effect could have been achieved: by holding a hot stick against the surface while the pot was fresh and still warm from the kiln, or by an early form of the three-stage firing process used later (see p. 193). Typically Minoan is the sense of movement and the freedom of decoration, artistic traits that have been taken to imply the freedom and mobility of society itself. Pellets of clay attached to the spout on either side have been taken to suggest the eyes of birds and thus introduce a ZOOMORPHIC, or animal, element into the ornament.

THE CYCLADES

The islands of the southern Aegean, called the Cyclades, almost belie their name, derived from the word *kuklos*, a "circle," since they can only with some generosity be described as forming a circle around Delos. However, from the earliest times, when the sea was as much a highway as a barrier, they did provide a chain of anchorages and watering-holes between Asia Minor, Crete, and Greece. It was certainly by this route that Asiatic cultures reached Europe. They also formed part of early patterns of communication, as obsidian from the island of

Melos found on Neolithic sites shows. Newcomers who probably came from the West (mainland Greece) arrived at the beginning of the Bronze Age. After a slow start, the immigrants discovered metals, marble, emery, and obsidian, and like EM II Crete, EC II (c. 2500–2200 BC) was a period of great prosperity.

Architecture

On Syros, a double fortification wall of stone some 77 yards (70 m) long can still be seen. It was built at the site of Khalandriani to protect a small town. The inner wall was guarded by five horseshoe-shaped towers, and the space left between the inner and outer walls was very cramped. Entrance through either was difficult; the planners evidently knew their business. Similar arrangements appeared on Naxos and simultaneously on the mainland at Lerna (fig. 1.16), while contemporary Troy (fig. 2.19, p. 58) boasted a fortification system beside which all others pale. Fortifications are unknown on Crete until the MM period (Aghia Photia, p. 48). Houses on the islands began to be built of local stone, though walls were insubstantial (a thickness of 191/2 inches [50 cm] is exceptional), and roofs made of branches and clay needed the support of wooden posts. Plans were either rectangular or curvilinear, according to the lie of the land and the availability of space.

Cemeteries were often located on slopes of nearby hills. Graves, like houses, were either rectangular or curved in plan, and constructed of stone, either in slabs (so-called cist graves) or in smaller flat stones like bricks, built up in CORBELED fashion until a single slab could close the opening at the top. Graves did not vary appreciably in size, and relatively few – except on Syros – were reused. No precise orientation of these Cycladic graves is discernible.

Sculpture

The Cyclades of the third millennium are most famous for their marble sculpture. Important quarries, especially on Naxos and Paros, were exploited to provide material for the largest of the figures, though most of the smaller figures and figurines could well have been worked from ordinary beach pebbles and larger stones. There are three major themes: female figures, male figures, and musician figures.

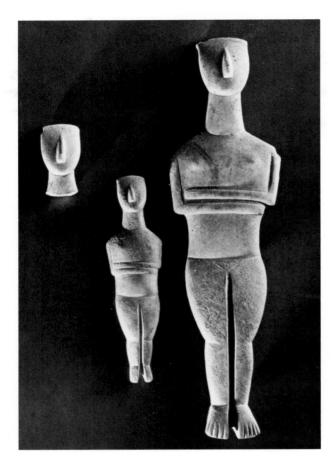

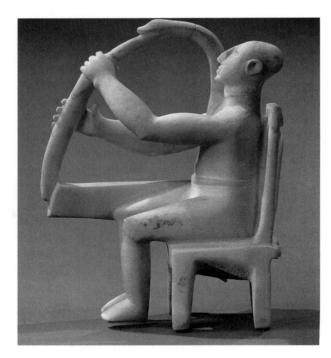

It is in EC II that the Cycladic sculptors enjoyed their heyday. They worked from thin rectangular blocks of marble using tools of bone and copper and the powerful abrasive, emery. They knew that the large-grained brilliant marble would split easily and so concentrated on essential forms, leaving details to the painting stage. Thus, they produced an uncompromisingly abstract style. The vast majority of the figures represent females shown in a schematic manner (fig. 1.10). But most striking for their exploitation of the marble and for their artistic freedom and virtuosity are the musician figures: seated harpists (fig. 1.11) and standing pipers. There are also warrior figures, some wearing helmets, others with BALDRIC and dagger, presenting a military theme that remained current throughout Greek sculpture.

Among these Cycladic figures, a number of different types have been distinguished.

Those of the Spedos type (fig. 1.10) are so-called "folded-arms figurines" characterized by a backward-leaning head, an oval face, a pronounced ridge for the nose, a long neck, sloping shoulders, abbreviated arms folded one above the other, slim hips, curving contours, and legs bent at the knee. The eyes, mouth, ears, and hair are often rendered in paint. A few heads have cheeks decorated in paint with red vertical stripes (fig. 1.12). This emphatic rendering has suggested that the heads originally belonged to mourning figures used in funerary contexts. An ingenious new theory proposes that such figures may have been painted more than once with designs chosen to reflect other important rituals too: so, for example, the same figure could have been used in a marriage ritual and recycled later for use in a funerary rite.

Another type, that of Khalandriani (fig. 1.13), also uses the folded-arms formula, but offers angular shapes, with a square torso, the shoulders at right angles to the neck, a triangular head, and short legs.

So great a variety in form, especially within the Spedos type, and such artistic freedom are displayed

1.10 Above left Cycladic figures and head. Spedos type. EC II. Marble. Height (smaller figure) 13 ins (33 cm); (larger figure) 25 ins (63.4 cm); (head) 4% ins (11.2 cm). Museum of Cycladic Art, Athens

1.11 *Left* Harpist. EC II. Marble. Height 11½ ins (29.5 cm). Metropolitan Museum of Art, New York

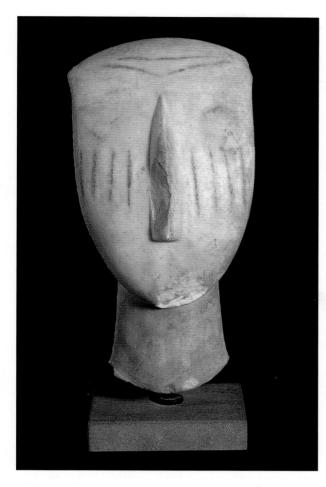

1.12 Cycladic head with painted decoration. EC II. Marble. Height $9\frac{3}{3}$ ins (24.6 cm). National Museum, Copenhagen

that commentators have identified a number of stylistically definable subgroups of figures. These are regarded as evidence of the existence of different studios and studio traditions, and individual artists have even been isolated. It is also now clear that these prehistoric artists used standard proportions over a thousand years before the sculptors of the Archaic and Classical periods. The canon in use later in Archaic Greece, however, was derived from Egypt, rather than inherited by some miraculous means from these island precursors.

The figures range in size from miniatures just under 8 inches (20 cm) in height to a few giants almost 5 feet (1.52 m) tall. They are as popular today for their powerful abstract quality as they were in the Bronze Age Aegean and have unfortunately therefore attracted the attention of forgers. There was demand in Crete and on mainland Greece, where examples

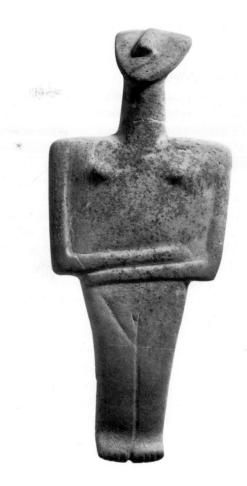

1.13 Female figurine. Khalandriani type. EC II. Marble. Height 12 ins (30.5 cm). Museum of Cycladic Art, Athens

have been discovered. They are found mostly in graves, as companions of the dead; some even had to be broken to fit into the grave. Some have also appeared in domestic contexts. A number of theories have been advanced to explain their function, none wholly convincing. Were they servants of the dead, or respected ancestors, or playthings, or even substitutes for sacrifice? Alternatively, were they heroes, nymphs, or divinities? It seems most likely that the female figures were a new version of the Neolithic Mother Goddess, the spontaneous naturalism of the plump Stone Age fertility figures giving way to schematic, conceptualized, rigid forms. They exploit a new material - marble - and a new scale. These are not figures to be carried about, stroked, and handled like their predecessors. They are idols, magically imbued, created to dwell with their owners both in life and death.

Pottery and Stonework

The Cycladic marble workers also made vases, whose elegant, simple designs echo their pottery counterparts. Collared jars, beakers with lugged handles, and handleless footed cups are favored shapes.

Many shapes of EC II pottery emulate contemporary stone vessels, like the collared jar with spreading foot and copious belly; others owe nothing to such stoneware vessels, and include the lidded cylindrical box, a cosmetic container, and the socalled "frying pan" (fig. 1.14). Potters used incised decoration, often in spiral designs inlaid with a chalky white substance; impressed triangles are popular too. The underside of the "frying pan" illustrated here shows an oared ship, with a prowornament (or is it the stern?) in the form of a fish and interconnected spirals representing waves. Terracotta pans like this have been interpreted as fertility charms in the form of wombs, with the smaller decorative area at the bottom taken to represent female genitalia, as on some marble figures. Yet the pan, which has a rim that is raised several inches above the main body, is evidently intended as a container.

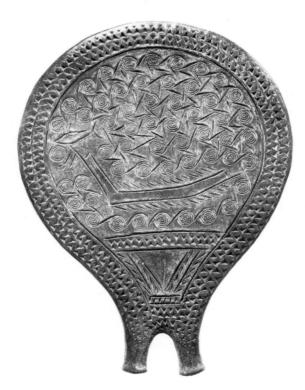

1.14 Pan, from Syros. EC II. Terracotta. Height 2[%] ins (6 cm); diameter 11 ins (28 cm). National Museum, Athens

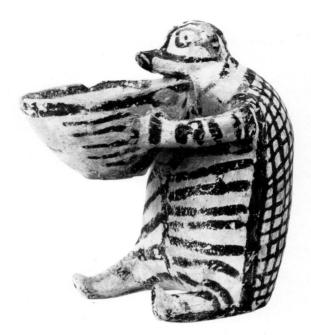

1.15 Hedgehog, from Syros. EC II. Terracotta. Height 4¼ ins (10.8 cm). National Museum, Athens

Did these pans hold water and act as mirrors? Some pots are painted, sometimes in angular patterns set against a buff ground, sometimes in a dark monochrome covering their entire surface.

Potters, like their counterparts working in stone, were interested in zoomorphic forms, such as the terracotta hedgehogs (fig. 1.15) from Syros, Corinth, Naxos, and Aghia Eirene on Keos, which show both humor and naturalism. Representational art is the special strength of the Cyclades, varying from stonework and zoomorphic forms to decorated terracotta. In this respect, Cycladic culture was the most advanced, with Crete coming a distant second, and the mainland lagging far behind.

GREECE

Around 3000 BC a new people traveled from western Anatolia into northern Greece, to judge from similarities between the pottery produced there and that of early Troy. But theories vary as to when newcomers arrived further south on the mainland. It is possible that the population did not change appreciably there until the violent end of the EH II culture.

Small, scattered communities have been revealed by surface survey in Laconia and near Corinth. Larger townships have been found in Boeotia and Euboea, where considerable evidence points to the working of obsidian imported from Melos. Some settlements, like the village at Tsoungiza near Nemea, existed throughout the whole of the EB period. Others, like Lerna with its two large buildings, flourished only in EH II. Imposing buildings, such as those at Lerna, imply a centralized authority in the zones they dominated. Elsewhere, the countryside was dotted with villages of apparently equal size and status, and with more isolated, scattered farms or groups of rural buildings.

Architecture

Like EM II in Crete and EC II in the Cyclades, EH II (c. 2500–2200 BC) is a period of rapid development in mainland Greece. Lerna, near Argos in the Peloponnese, is among the more informative sites. Its two big buildings successively occupied the same spot (fig. 1.16). The excavators called the earlier of the two "Building BG" and its successor the "House of the Tiles."

The two buildings show similar techniques of construction, each having a tile roof, similar shapes of rooms and corridors, and similar proportions. But associated with the first building, BG, is a number of closely packed houses with gravel streets between them, all arranged haphazardly, with little sense of planning. The dense little town was protected at this stage by a ring of fortifications provided with towers, similar to those at Khalandriani on the island of Syros.

Still within the EH II period, the House of the Tiles was built over the ruins of BG at a time when the fortification circuit had fallen out of use. The new building (fig. 1.17) measured approximately 27×13 yards (about 25×12 m) and was almost rectangular. Entrances on all four sides gave access to corridors and rooms arranged with some degree of symmetry, while staircases at north and south led to at least one upper story. The foundations are of stone, floors are of hard tamped clay, and walls are of mudbrick over 3 feet (1 m) thick. The roof is of both terracotta and schist tiles; since these are rectangular and were designed, like slates, to carry rain-

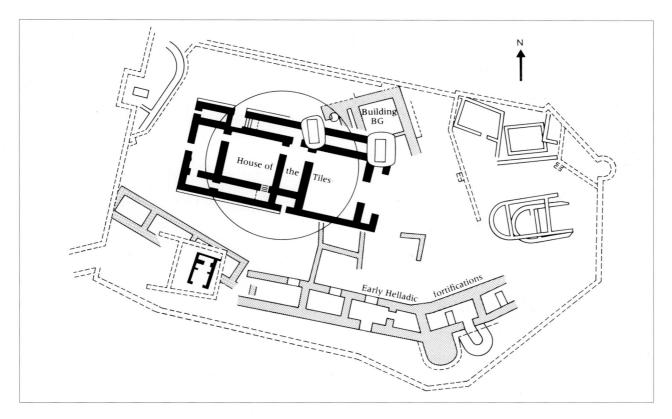

1.16 Plan of Lerna. EH II

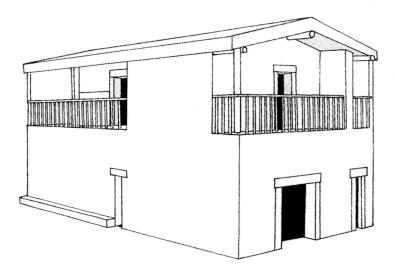

1.17 Reconstruction drawing of the House of the Tiles, Lerna. EH II

water off an angled, sloping surface, they imply a gabled roofing system. Most walls were stuccoed, but a few built of fieldstones laid in herringbone fashion left their patterned surfaces visible. The house was itself suddenly destroyed around 2200 BC. The ruined site was left untouched for several generations, though it was eventually built over. How were these buildings used? Were they centers of government, markers of social and political power? Were they palaces? Or do the several entrances to the House of Tiles suggest a more practical purpose, perhaps as warehouses serving the whole community?

So-called "corridor" houses, like the House of the Tiles, have been found elsewhere in the Aegean world. They represent an important architectural tradition, as significant perhaps as the later traditions of palatial architecture on Crete and fortress architecture in LB Greece. The sheer size of the buildings is striking, and the use of tiles – to be forgotten for over fifteen hundred years – was a precocious innovation.

Large, central buildings are not, however, usual in EH Greece. Other sites of densely packed townships, like Eutresis in Boeotia or Zygouries in the Argolid, do not have similar buildings. At Tiryns, however, a large circular structure, more than 30 yards across (about 28 m) and with two floors, was built of mudbrick on stone foundations. It seems to have been supported by horseshoe-shaped buttresses. For this staggering building, a circumference of no less than 96 yards (88 m) has been proposed. Remains of terracotta and schist tiles have been found here, so the roof was evidently tiled, though how rectangular tiles would have been fitted onto a conical roof remains problematic. Equally puzzling is the function of this building: Was it a communal granary? A contemporary example of a building for grain storage is the stone model of a multiple granary, said to be from Melos (fig. 1.18).

Other structures at Tiryns included an obsidian workshop. Lead was also being imported, probably from Siphnos or from Thorikos in Attica, where silver and perhaps copper were being mined as well at this time. Thus, the flourishing metallurgical industry was supplied with ores, and the success of skillful EB artisans is evident at many sites across the Aegean, such as Troy, and Mochlos in Crete. Rich finds from the tombs on Mochlos include gold diadems, hair ornaments in the shape of petals and leaves, beads, and pendants.

How people buried their dead at this time can be seen in the cemetery at Aghios Kosmas (near the old Athens airport at Helleniko). Here, stone-lined cists, some built in the earth, some above ground like minuscule houses, show a Cycladic influence. They contained multiple corpses, and pots were buried with the bodies. A similar phenomenon appears at Marathon in eastern Attica, while at Zygouries in the northern Peloponnese pit graves were used, and bodies were accompanied by pots and some jewelry. Rounded underground chamber tombs appear occasionally. There is little evidence for sculpture –

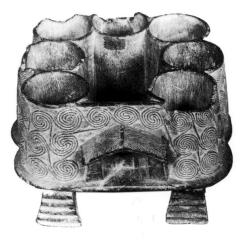

1.18 Model of a multiple granary, said to be from Melos. EC II. Stone. Height 4 ins (10 cm). Staatliche Antikensammlungen, Munich

1.19 Pottery "sauceboat," from Lerna. EH II. Height 7% ins (20 cm). Argos Museum

beyond clay figurines and a number of marble figurines imported from the Cyclades – either here, as grave offerings, or elsewhere.

An important development in architecture is found in the final phase (EH III, c. 2200–2000 BC) in the Peloponnese. This is the long house, with either an APSIDAL or a rectangular plan. The long house had appeared earlier in Thessaly and at Thebes, and is the architectural antecedent of the LH MEGARON, also a type of long house with a porch and a long hall, which dominates the Mycenaean fortresses.

Pottery

New shapes include the "sauceboat" (fig. 1.19), obviously some kind of pouring vessel – though some claim it could be used for drinking. Beak-spouted jugs and saucers were also in vogue. The surfaces are finished with a dark, shiny gloss, often described by the German term *Urfirnis* (original finish). The ubiquitous "sauceboats" were thin-walled and fired until they were very hard, the glossy finish perhaps suggesting a metal prototype. Examples of metal "sauceboats" have, in fact, come to light. Another suggestion has been that the sauceboat shape is derived from an obliquely sliced GOURD. If so, could the *Urfirnis* have followed the color of the gourd?

 $1.20\,$ Tankard, from Lerna. EH III. Height 4% ins (11.7 cm). Argos Museum

The appearance of the fast-turning potter's wheel made of stone, fired clay, or wood called for an apprentice to control it, whether by stick or hand. The wheel was turned by the apprentice, and the potter was thus free to use both hands to lift and form the clay. The wheel probably appeared in the later phases of EB II, but, perhaps surprisingly, was hardly used until the Late Bronze Age on mainland Greece.

A typical assemblage of EH III pottery seems mostly to consist of solidly painted or plain, dark, burnished wares. For the rest, there are patterned pots, painted in both light-on-dark and dark-onlight designs in the form of interlocking triangles, lines winding continuously backward and forward (MAEANDERS), and CHEVRONS, ornaments in the shape of an inverted "V." A familiar shape is the two-handled tankard (fig. 1.20). There are also large jars with trumpet mouths and lug handles, and small cylindrical cups, dubbed by their excavators as "ouzo" cups from their similarity to the glasses that Greek tavernas still use today. But wheelmade pottery has also been found in small quantities at one or two EH III sites in the Peloponnese. This is the ancestor of the so-called gray "Minyan ware," which was to become important in MH Greece.

THE MIDDLE BRONZE AGE c. 2000–1550 bc

Great changes appear toward the end of the third millennium. Crete rapidly grew prosperous, while independent development was checked and conditions deteriorated in the Cyclades. On mainland Greece, some sites, like Lerna, were destroyed at the end of EH II and others during EH III; such waves of destruction suggest the arrival of new population groups. Where these came from remains uncertain, but similarities between some aspects of the pottery of MB Greece and that of MB Troy have been used to argue that these people must have come from western Anatolia. At this time, across the Aegean at Troy itself, the sixth city to be built on the site was rising up.

The construction of palaces in Crete shows that profound political and social changes took place at the end of the third millennium. In the absence of comprehensible written records – a hieroglyphic script, as yet undecoded, was used in the first palaces – this situation is not entirely easy to understand. In Egypt, a single central monarch had already controlled the country for almost a thousand years. The presence of several palaces on Crete, however, suggests that political power was dispersed. The villages of the EM period, like Myrtos, gave way to the MM palatial complexes, and power seems to have resided in these regional centers. This implies a much tighter control on agriculture and the economy than existed before. Legend, however, records that the great ruler of Crete, Minos, expelled his brothers from the island, a story that may contain a grain of truth. It could suggest that at some moment in the MM period one leader gathered all power to himself and unified the island under the leadership of Knossos.

In the Cyclades, though life seems to have gone on largely uninterrupted at the end of the EB age, the level of achievement of the third millennium was not maintained, and the islands were increasingly influenced by Crete. Marble idols were no longer made. Was this because Crete was coming to dominate the Aegean? Or was it that the social function they performed was no longer required?

In mainland Greece, the influx of new peoples toward the end of the third millennium interrupted life and introduced a period of cultural torpor. These new peoples were evidently unambitious in terms of architecture and the arts, and indeed other aspects of their living conditions. The evidence that survives of their culture contrasts sharply with that of Crete and Troy. At Troy, the MB period was to see the building of a new fortified citadel, Troy VI.

^{2.1} Snake goddess or attendant (head and left forearm modern restorations), from Knossos. MM III. Faience. Height $11\frac{1}{2}$ ins (29.5 cm). Iraklion Museum, Crete

2.2 Phaistos, west court of first palace (MM), showing theatral area and raised walkways, with façade of second palace (LM) beyond

CRETE

Architecture

Somewhere around 2000 BC, great palaces were built at Knossos and Phaistos. At Mallia and Zakro, we cannot be certain whether the LM palaces copied MM predecessors whose plans significantly resembled the structures of the LM period. At Zakro, however, there may have been a central court. The first palaces at Knossos and Phaistos and the buildings at Mallia and Zakro were destroyed by an earthquake in around 1700 BC. At Knossos and Phaistos the palaces were repaired and expanded, and at Mallia and Zakro comparable palaces arose on the debris of the ruined structures. The spectacular remains of these second palaces can still be seen today.

The ruined palaces mask much of the earlier structures beneath them, so that it is difficult to discuss their original design in precise detail. Yet Knossos and Phaistos do show a large rectangular central court with access on all four sides and a considerable court outside to the west. At Knossos, a group of separate architectural units seems initially to have surrounded the central court and then been linked together into a single complex. A façade was added to face the west court, with storage units behind, and an approach road from the south was built. The palace had a complex drainage system using terracotta pipes throughout.

At Phaistos, the central court was flanked by a COLONNADE. Direct access from the paved exterior west court (fig. 2.2) to the central court was through an entrance corridor, running from the center of the west façade. Many corridors and small cell-like units lay behind this impressive west façade. Some were used for religious purposes, others for storage, while others still were evidently living rooms equipped with much splendid pottery.

At Mallia, there was a different and more significant architectural development. A large structure to the west of the later palace has many rooms with stuccoed walls, staircases, and storage units filled with pottery. Clay sealings and hieroglyphic inscriptions on vases suggest an administrative purpose for this building. Rooms with significant deposits of metal objects existed on the west side of the later court, but it is uncertain whether there was a court in this phase. Separate, uncoordinated buildings existed elsewhere, for example, around the so-called Agora. It seems likely that a palatial organization functioned from separate architectural units, and that no integration took place until after the earthquake in around 1700 BC.

In these first palaces, façades were constructed of dressed stone, walls of RUBBLE and mudbrick, and columns of wood. Here can be found the earliest use of cut stone in the southern Aegean, especially in the large slabs (ORTHOSTATES) used to form the lower course of the walls of the west façades and in the projecting plinth course on which they sat. Dowels were employed for the first time to attach the wooden beams, used as leveling courses, to the top surfaces of the orthostates. Small rectangular spaces with steps leading down to them (LUSTRAL BASINS), and small courtyards (shafts) designed to let in light and air, called LIGHT-WELLS, made their first appearance at Mallia. The first paved causeways and storage silos can be seen in the west courts at Phaistos and Knossos. And these palaces show the first significant use of columns in the southern Aegean (previously in evidence in Troy II).

At Knossos and Phaistos the great central court is the major feature. It emphasizes the Minoan interest in the free flow of air, light, and people within the palace. The absence of restrictive palace fortification walls allowed the gradual expansion of the complex as the need arose, so that the architecture is in a sense organic. The plan – as far as is discernible – suggests

connections with Near Eastern palaces, many of which enjoyed large central courts, corridors, and many rectangular units. One such was that of Zimrilim at Mari on the Euphrates. This palace dates to the eighteenth century BC in the state in which it is best known, but incorporates parts of a complex of the earlier twenty-first century BC. Differences are that oriental complexes were heavily walled, and expansion was therefore restricted. The accent was more on keeping out the sun and heat than on admitting light and air. Minoan and Mesopotamian palaces were similar, then, in their function of controlling independent city-states, but different in the spirit of their architecture. (Useful comparison may also be made with the contemporary palace at Beycesultan in Anatolia and with Egyptian buildings.)

Increased contacts with Egypt and the Near East doubtless influenced the Minoan planners, who then modified the rigidity of their plans by introducing features that allowed for freedom, movement, air, and light. They may also have blended in local architectural traditions, whose elementary architecture used corridors and small rectangular units.

After the palace, the French archaeologists at Mallia went on to excavate the private houses nearby. Here again, though most housing dates to after the earthquake of around 1700 BC, plans of individual rectangular houses with several rooms may be discerned. To get some idea of the external face or ELEVATION of private houses, the so-called "Town Mosaic" from Knossos is helpful. The term is misleading since it is not a mosaic, but a group of

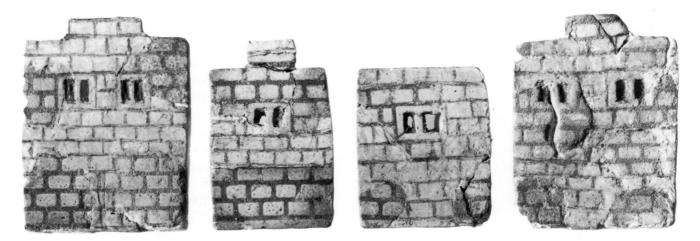

2.3 Plaques in the shape of houses, perhaps inlays from furniture, from Knossos. MM II. Faience. Height $1\frac{1}{-2}$ ins (3–5 cm). Iraklion Museum, Crete

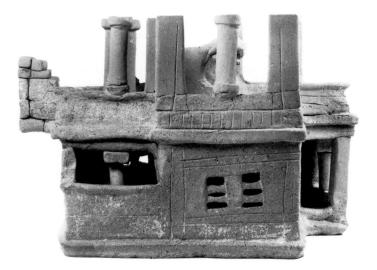

2.4 Model of a house, from Arkhanes. LM I. Terracotta. Height 9¼ ins (23.5 cm). Iraklion Museum, Crete

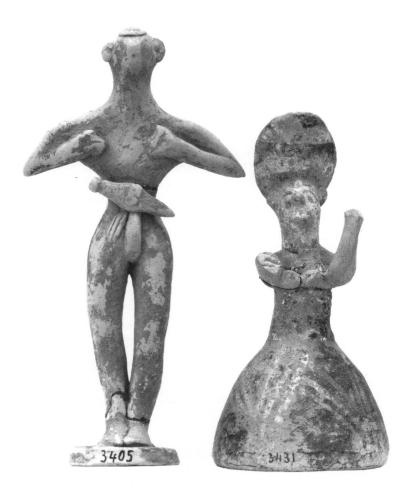

2.5 Figurines, from Petsofa. MM I. Terracotta. Height (female) $5\frac{1}{2}$ ins (14.3 cm); (male) $6\frac{4}{3}$ ins (17.5 cm). Iraklion Museum, Crete

small polychrome plaques made from FAIENCE, which may originally have decorated the sides of a wooden chest. Found beneath the flooring of the rebuilt palace at Knossos, these plaques date from the time of the first palace there. They show (fig. 2.3) the façades of houses with two or three stories, a symmetrical arrangement of windows, sometimes shuttered, and flat roofs. They are built of brick and timber, with beamheads often visible. The many windows again speak for Minoan interest in air and light for ventilation. The terracotta model of a house (fig. 2.4) found at Arkhanes – though of a later phase – gives more good evidence for the upper stories of houses and shows staircases opening out onto the flat roofs.

An intriguing structure was built at Aghia Photia on the northern coast of the island. Rectangular in shape, it measured approximately 30×21 yards (27) \times 19 m) and consisted of more than thirty rooms arranged around a narrow court laid out on an east-west axis. The plan somewhat resembles that of Minoan palaces, and the early date (around 2000-1900 BC) is significant since it may mean that the palatial plan was an indigenous development. The building's function is unclear. It was not a palace since there was no provision for storage in pithoi (large clay storage vessels). Nor is there differentiation of use between groups of rooms. A freestanding wall protecting the site on the seaward side is unique on Crete, but is somewhat reminiscent of defensive arrangements at EB Khalandriani on Syros.

Sculpture

From the hilltop sanctuary at Petsofa come some of the earliest (MM I) examples of Minoan sculpture (fig. 2.5). These terracottas represent human figures, animals, and even human limbs, evidently offerings to the divinity. The tallest is no more than 9 inches (23 cm). Male figures stand to attention, arms raised to the chest in an attitude of respect, and wear nothing beyond a belt, a codpiece, and occasionally a dagger. Female figures have arms raised and extended in front of them, wear bell-shaped skirts and elaborate hats, and have their breasts bared. The treatment of the heads is impressionistic, with facial features, other than nose and chin, hardly delineated. These naïve figurines nonetheless reveal an attention to proportions – slender waist, broad shoulders –

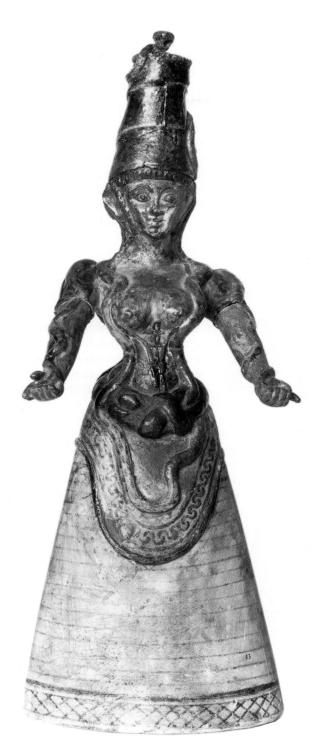

2.6 Snake goddess or attendant (face, left arm, and skirt modern restorations), from Knossos. MM III. Faience. Height $13\frac{1}{2}$ ins (34.5 cm). Iraklion Museum, Crete

2.7 Acrobat, from Knossos. MM III. Ivory. Length 11½ ins (29.9 cm). Iraklion Museum, Crete

and conventions of posture, gesture (for female figures), and garments that were to continue for many centuries in Crete.

The high point of Minoan sculpture of this period is the group of female faience figurines of snake goddesses or attendants found at Knossos in stone-lined pits, the so-called "Temple Repositories." Sealed below debris of an earthquake that took place near the end of the MM period, they are accordingly MM III in date. The largest figurine (fig. 2.6) is 13¹/₂ inches (34.5 cm) tall and is one of the largest surviving examples of Minoan sculpture in the round. She wears a bell-shaped, flounced skirt, a tight belt, and a short apron; her breasts are bare. Snakes curl down and along her arms and around her waist and shoulders, while another circles her lofty hat. The other figures (fig. 2.1) display similar posture, proportions, and clothing, brightly colored with shades of red, blue, and green. This figural style, dependent on geometric shapes - cones (skirts), cylinders (arms, waists) - shows demonstrable links with earlier Near Eastern and Mesopotamian figures. Formality and naturalism coexist, with geometry, symmetry, and elaborate decoration countering the evident interest in naturalism.

An acrobat in ivory (fig. 2.7), 11^t/₈ inches (29.9 cm) in length, also found in the palace at Knossos

ART AND THE MARKET: FORGERY

C ollecting art began in a big way in Europe with the Romans and was widely practiced by the Italian nobility from the fifteenth century on (see p. 13). Later came museums. These new institutions pursued acquisitions as vigorously as collectors did. National and regional competition has been fierce. Where there is collecting and capitalism, there will be a market; and where there's a market, there are bound to be dealers. In the realm of ancient art there are also those who excavate illegally to supply the market, and there are forgers.

Minoan art has not been free from this. From the moment when Sir Arthur Evans revealed a new culture on Crete, collectors were keen to add Minoan objects to their possessions. Interest centered on objects made of luxury materials, and the discovery in the palace of Knossos in 1902 of small ivory acrobats (fig. 2.7), and in the following year of large parts of faience female figures (figs. 2.1 and 2.6) wearing elaborate costumes, bare-breasted, and handling snakes, was bound to cause a stir. Before long, similar figures appeared on the market, which, though without excavated provenance, were snapped up by buyers. Purchasers would have profited from conversation with Leonard Woolley, the famed explorer of Mespotamian Ur, who participated in a police raid on a forgers' place of business in Candia (on Crete) in 1922. In this case, restorers employed by Sir Arthur Evans had developed another source of income.

They knew the genuine articles from their work for him, and copied them for the market.

Modern scrutiny compares the excavated pieces with the unexcavated for iconography, style, and technique. It notes, for example, discrepancies between garments worn by the excavated and those by the unexcavated pieces; also that excavated ivory figures are joined together from many pieces while the unexcavated are made from only one or two. It notes the results of C14 analysis (p. 34), which can assess the age of ivory and which has revealed that in some instances the ivory itself is modern.

> Unless scholars remain vigilant, it must be obvious that the production and sale of forgeries will seriously skew their perception of other cultures. Only when objects can be shown indisputably to be authentic can they be used to shed light on the social conditions and artistic skills they purport to represent. What is your view of all this? Should museums that possess forged pieces or pieces that are dubious continue to display them, and how might such a policy be justified?

2.8 "Minoan" figurine, knowingly acquired as a fake in 1928. Museum of Classical Archaeology, University of Cambridge

and also MM III in date, reveals Minoan mastery of other materials, as well as interest in both naturalism and movement. He seems to be in movement in midair, and may have belonged to a group of figures depicting the bull sports, representations of which have survived in a wall painting of the LM age from Knossos (fig. 3.6, p. 68) and in a bronze group in the British Museum. If so, he leaps between the horns and over the back of the bull in a daring somersault maneuver. Details of musculature, fingers, and veins are all minutely shown with realistic modeling. This diminutive vaulting jumper gives a first glimpse of the notion of the sanctity of athletics that was to permeate the SANCTUARIES and festivals of the Greeks of the historical period. In Minoan Crete, however, the figure is shown in streamlined movement in a captured moment, while later victorious athletes appear in more concrete, static poses.

Another acrobat – part sculpture, part weaponry - appears on the eighteenth-century BC gold covering of the pommel of a great ceremonial sword (fig. 2.9) found in the palace at Mallia. The circular covering of the pommel, worked in raised REPOUSSÉ relief, is entirely filled with the body of the acrobat, so arched that the tips of his toes touch the hair of his head. Realistic in representation from the curls of his hair to his belted kilt and knobbly knees, the circular motif and willowy shape of the youth are typically Minoan. Another sword from Mallia has a pommel of rock-crystal and a hilt of gray limestone covered with gold foil, so it appears that these weapons were elaborately decorated. (Crete, incidentally, produced the first swords of the Aegean world, fragile bronze rapiers, many of which were used as offerings to deities.)

Also from Mallia, also naturalistic and also hybrid – in this case, sculpture and jewelry – is a gold pendant (fig. 2.10), which shows two hornets confronting each other over a honeycomb, with three granulated discs suspended below. New techniques of working gold are employed: FILIGREE, that is, decorative metalware made of thin wire; GRANULATION, where globules of gold or silver were soldered onto jewelry; and EMBOSSING, a technique of decoration raising the surface into projecting knobs or studs (bosses), doubtless acquired through new contacts with Syria and the Near East. Not much gold is found in palatial Crete, but vessels of silver existed, as is shown by a deep, two-handled drinking cup (KANTHAROS) found at Gournia. The paucity of sculpture in the round or in relief, on any substantial scale, may be explained by the accidents of survival or of discovery. It may also be because the Minoans preferred miniature figural art, an interest that found expression in seal-engraving.

Rings and seals were used to stamp the clay with which knots of rope (which bound boxes and chests of goods) were secured, thus identifying as well as fastening the goods. Seals were also thought to have magical powers, and they were admired for the colors and shapes of their stones, as well as for the designs engraved upon them.

In the EM phase – from around 2300 BC – materials used for seals were bone, steatite (a stone soft enough to be carved with a copper knife), and ivory. The variety of shapes is enormous, including animals with engravings on the base (fig. 1.8, p. 36), as is the

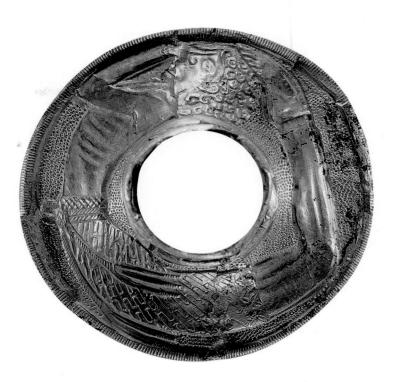

2.9 Cover for a sword pommel, decorated with a repoussé acrobat, from Mallia. MM III. Gold. Diameter 2³/₄ ins (7 cm). Iraklion Museum, Crete

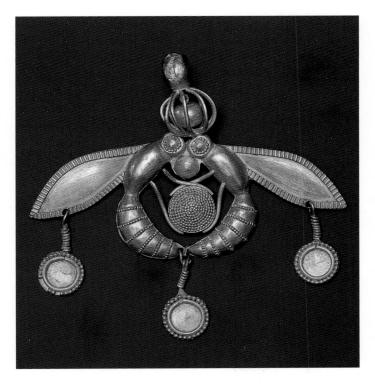

2.10 Pendant, from Mallia. Hornets and honeycomb: embossing, filigree, and granulation. MM III. Gold. Height 1³/₂ ins (4.6 cm). Iraklion Museum, Crete

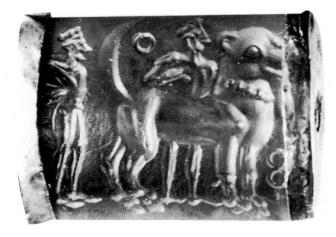

2.11 Seal, in the shape of a cylinder, showing two men and a huge dog. LM I. Chalcedony mounted in gold. Length $10\frac{1}{2}$ ins (26.5 cm). Iraklion Museum, Crete

range of subjects engraved - animals again, humans, abstract designs. Spirals and wavy lines of the Aegean ornamental vocabulary are used alongside a figural repertoire, surely derived from Egypt or the East. In the period of the first palaces, the materials used included rock-crystal, jasper, agate, and carnelian. Flat or convex disks and prisms were popular shapes, and topics in favor were animals, geometric designs, and hieroglyphs. From around 1700 to 1550 BC, the range of shapes continued to expand to include the "amygdaloid" (an almond-shaped stone) and the flattened cylinder. Topics engraved - animals, humans, and religious scenes - reflect the contemporary enthusiasm for naturalism. Signet rings in bronze and gold appear. Production continued unabated in the new palaces after 1550 BC, and the seal in light blue CHALCEDONY mounted in gold provides a fine example of the work of the time (fig. 2.11).

The engravers of these rings and seals were highly skilled and their output was huge. The materials on which they worked were small in size and required of both the artists and their audiences a delight in figural art on a tiny scale.

Pottery

The building of the palaces was matched by a new style of pottery and new technology: the potter's wheel. The palaces seem to have allotted considerable space to the workshops of artisans, not least potters, and they evidently encouraged, and perhaps even enforced, the centralization of artistic production. High on the side of Mount Ida, overlooking the palace at Phaistos, was a sanctuary called the Kamares cave. This is where the new pottery was first found by archaeologists, and it is from the cave that the pottery has taken its name.

Kamares ware (MMII) was distinctly palatial, and is rarely found on Crete outside Knossos and Phaistos. It may be the product of only very few workshops. There are two fabrics: an eggshell-thin tableware and a heavier, coarser ware for storage and pouring vessels. Shapes that are popular are the single-handled cup, the spouted jar, and the beakspouted jug. Decoration is in white-on-black with much added yellow, red, and orange in what constitutes a true polychrome style, while designs range from abstract spirals to natural forms. Motifs, whether spirals, coils, petals, or leaves, are repeated around the pots, urging the eye to move. Human figures are excluded altogether.

Raised designs of diagonal ridges and patterns of dots, bosses, or prickles – so-called "barbotine decoration" – show that decorators explored texture as well as color. Architecture also reveals an interest in texture, as shown in the variation introduced into the west façades of palaces by multiple recesses, and in the use, in a single wall, of cut stone (for orthostates), exposed beams, and mudplastered rubble.

Eggshell ware (fig. 2.12) is the most famous pottery type of the period, mostly found in the teacup shape, of which there are numerous varieties. Its manufacture requires skillful manipulation of the wheel followed by skillful firing. A white scale pattern encircles the illustrated cup in repeated and linked REGISTERS, accompanied by motifs drawn from the natural world of abstracted floral buds in orange and white.

The repetition of design motifs around the pot and the linkage of motifs also occur on a beakspouted jug (fig. 2.13) made of the coarser fabric. The decoration is as energetic and vibrant – pairs of spirals are linked by repeated oval motifs, all situated diagonally on the surface. Pellets of clay on the spout follow the convention of EM II Vasilike ware in suggesting the eyes of birds, thereby introducing zoomorphic elements into the decor. Sometimes designs on Kamares ware become so complicated it seems that the surface is decorated **2.12** Kamares ware cup, from Phaistos. MM II. Diameter 4¹/₄ ins (12 cm). Iraklion Museum, Crete

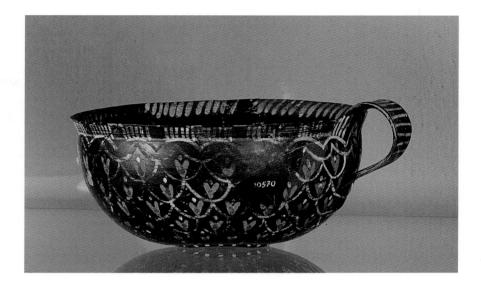

2.13 Kamares ware beak-spouted jug, from Phaistos. MM II. Height 10³/₈ ins (27 cm). Iraklion Museum, Crete

with a firework-like display. The variety in MM pottery is astonishing.

Interestingly, in this period, though artisans used painted plaster, they do not seem to have applied figural art to walls, or if they did it has not survived or been recovered yet. Painted pottery, on the other hand, achieved perhaps the status of high art, and some of the finest artists applied themselves to pottery. Yet, at a more humdrum level, they were also prepared to repeat their designs on vessels of different shapes to produce matching groups.

Kamares ware continued after the reconstruction of the first palaces in the new palaces of MM III. Its design became calmer and more naturalistic, yet developed a certain stiffness and formality. Vegetal motifs – lilies, grasses, and palm trees – were elegantly repeated around the vases' surface. Kamares ware was popular outside Crete. It was shipped to mainland Greece, the Cyclades, Syria, and Egypt, and in Egypt a Kamares ware vase took pride of place in a burial group found at Abydos.

THE CYCLADES

Architecture

The second town at Phylakopi on Melos provides important evidence of the MC phase. Excavation revealed a good portion (some 87×55 yards [$80 \times$ 50 m]) of this settlement, uncovering winding, narrow streets and houses with many rooms that were built of local stone. MM pottery was imported here, as was Minyan ware from mainland Greece. At Aghia Eirene on the island of Keos, there is only fragmentary architectural evidence for an EB settlement. After a gap in occupation at the end of EB, this was superseded by a settlement surrounded by a gateway and a towered fortification. Here both mainland and Minoan pottery were imported. A second phase of MB Aghia Eirene saw a stronger fortification wall replacing the earlier circuit somewhat after the collapse of the first palaces at Knossos and Phaistos.

Pottery

The pottery at first shows little change from EC, but in MC II it comes into its own. The favorite shape is the beak-spouted jug, decorated with the same matte paint used on the wares of the mainland. The decoration is, however, more ambitious, displaying spirals and curls (fig. 2.14), as well as bands of horizontal lines and groups of dots, often referred to as ROSETTES. Lines emphasize the neck and belly of the jug in a typically sparse arrangement. Relief breastlike forms appear below the neck and are emphasized by paint; sometimes a pair of eyes painted on the spout intensifies the zoomorphic feel of the pot. Spiral designs echo Kamares ware, but the exaggerated beak-spouted shape seems to have had its origins in Anatolia.

This dark-on-light style flourished especially on Melos, where in MC III vegetal motifs, birds, and fish were introduced into the decorative vocabulary. Birds in flight (fig. 2.15) are especially favored, the dark matte paint often enlivened by patches of red. They float on the surface of the pots, as if the tight design of earlier periods had been freed under the influence of Minoan style, creating a new interest in movement and the natural world. Cycladic painters made the bird their particular motif, and some of these vessels were admired enough to find their way as exports to the Minoan and Mycenaean centers.

GREECE

Architecture

Some towns continue on the site of EH settlements while others are new. All are characterized by narrow, three-roomed houses, apsidal or rectangular in plan, built of mudbrick, with roofs of reeds and clay supported by timbers. These tripartite houses with long halls (megara) were already present in Greece in EH III. The main room of the house has a hearth and sometimes benches against walls, while the back room has storage bins. Characteristic sites are Eutresis in Boeotia, Lefkandi in Euboea, and Lerna. The site at Kolonna on Aegina was already fortified in the EH III phase, and by the beginning of the MH period, these walls were the largest fortifications in the Aegean world, after those at Troy. Later in the period defensive walls were added at Argos but not, curiously, at coastal Lerna.

Burial customs were reasonably standard. "Intramural burial" (burial beneath house floors) was typical for infants and very young children.

2.14 Beak-spouted jug, from Thera. MC. Height 10¼ ins (26 cm). Musée du Louvre, Paris

Older children and adults were usually buried in individual cist graves or pits, sometimes within the settlement but, increasingly as time passed, in graveyards outside the town walls. Groups of graves often became formalized into "tumuli" (burial mounds), holding dozens of cists, pits, and pithos burials. Such tumuli doubtless formed the burial place of members of the same family or other social group. Grave gifts were poor, but became richer toward the end of the period. On the island of Aegina, a sword, dagger, spear, and pottery (both local and imported) were found in a shaft grave. Graves like this announced the social standing of the buried person by the wealth of the accompanying gifts and anticipated the great richness of the shaft graves of Mycenae.

2.15 Jug, from Melos. MC III. Height 10¹/₄ ins (26 cm). National Museum, Athens

Pottery

"Minyan ware" – so named by Schliemann after he discovered it at Orchomenos, home of the legendary king Minyas – is the pottery often regarded as characteristic of this period, though it was not found at all sites. It had first appeared in EH III at Lerna, but it is in the MH period that it is best known. The fabric is fired very hard and has few or no coarse, heavy particles of clay in it. The surface is glossy and has a greasy feel. The color used initially is gray (Gray Minyan), then later yellow (Yellow Minyan), but it is always monochrome. Shapes are few: thick-stemmed goblets (fig. 2.16) and two-handled bowls (kantharoi) are popular. They are sharply profiled,

2.16 Minyan ware goblet, from Mycenae. MH. Height $7\frac{1}{2}$ ins (19 cm). British Museum, London

2.17 Matte-painted storage jar, from Lerna. MH. Height 24⁴/₂ ins (63 cm). Argos Museum

reflecting the use of the fast wheel. It is worth repeating here that the wheel was only infrequently used for many centuries. The matte-painted pottery made alongside the Minyan is quite different, being handbuilt, decorated with unadventurous geometric designs (fig. 2.17), and coarse of fabric. Beak-spouted jugs, huge storage jars, and kantharoi are popular shapes.

The limited repertoire of pottery shapes, the poverty of the architecture, and the absence of sculpture do not say much for the artistic aptitudes or aspirations of these peoples. It is often plausible to associate breaks in the archaeological profile of a country or zone, such as those toward or at the end of the third millennium, with the arrival of new peoples. Since the Greek language was in use in the Late Bronze Age, as shown by the Linear B tablets (see pp. 78-9), and since there is no break in the profile between the beginning of the MH period and the end of the Bronze Age, many take the view that the MH peoples were the first Greek-speakers to dwell in Greece. A recent theory has proposed, however, that even in Neolithic times the residents were speaking an early form of Greek. Pottery very similar to Minyan has come to light in Troy in contexts contemporaneous with MH Greece, and this has suggested to some that the Trojans and Greeks of the MB period may be of the same racial stock. Alternatively, it might simply suggest social or commercial contacts between Troy and Greece. What is surprising, however, is the sharp difference between the cultural poverty of Greece and the might of Troy.

TROY

The site excavated as Troy by Schliemann in the later nineteenth century, by the University of Cincinnati in the 1930s, and most recently by Manfred Korfmann of the University of Tübingen is located in northwestern Asia Minor (fig. 1.2, p. 32). Inspired by episodes in the story of the great war between Greece and Troy recorded in the Homeric poems and in later authors, and guided by geographical clues in Homer, Schliemann excavated a hillock known as Hisarlik and identified it as Troy.

The site stands in a commanding position, at the end of the land route from Asia to Europe traveled by many migrants, and was thus a recognizable

CONTROVERSIES AND ISSUES

PRIAM'S TREASURE: DOUBTS AND DIFFICULTIES

Priam's Treasure is the name given by Schliemann to a group of gold (fig. 2.18) with group of gold (fig. 2.18), silver, bronze, and copper objects which he says he found at Hisarlik in 1873 - in Homer's Iliad, Priam is king of Troy. It turns out, however, that the objects are of Middle Bronze date and cannot therefore be contemporaneous with the archaeologically documented Late Bronze citadel at the site identifiable as Priam's Troy. So the name of the treasure is misleading. According to Schliemann himself, all these objects were removed surreptitiously from the site and within a week were smuggled from Turkey to Greece. These furtive acts ran counter to Schliemann's agreement with the Turks, whereby, in accordance with Ottoman antiquities legislation, the home country was to keep 50 percent of the finds. Furthermore, there is still some doubt as to whether this aggregation of objects – a large copper cauldron, bronze daggers, axes, chisels, and spearheads, and gold and silver goblets, gold bracelets, headdresses and earrings and more than 8,000 gold beads - come from a single deposit or whether Schliemann added objects from elsewhere to an original assemblage.

Schliemann published the treasure almost at once, and almost at once the Ottomans launched lawsuits against him. These were, however, withdrawn in 1875 when Schliemann paid compensation and the Ottomans renounced their claim. Schliemann then began hawking

the treasure, which had been hidden in the French School in Athens, around Europe. It was on view in London between 1877 and 1880 and Schliemann hoped the British Museum would buy it. This plan, along with others, didn't work out and in 1881 a frustrated Schliemann handed the treasure to the people of Berlin as a gift. At the end of World War II in 1945, the treasure was not to be found, and many concluded that it had been looted by Russian troops and dispersed. In fact it had been taken to Moscow as an act of retaliation (one among many) for the German removal of art from Russia during the war. Finally, in 1996, it surfaced in the Pushkin State Museum of Fine Arts in Moscow and was put on display. Priam's Treasure provides an excellent example both of Middle Bronze Age Aegean metalwork and of a serious issue concerning the ownership of cultural property. Should this much-traveled treasure remain in Russia?

2.18 Beaker, flask, and sauceboat from Priam's Treasure, Troy. MB. Beaker: height $2\frac{3}{4}$ ins (7 cm); diameter (at mouth) $2\frac{1}{2}$ ins (6.5 cm); flask: height $5\frac{3}{4}$ ins (13.75 cm); diameter $5\frac{1}{3}$ ins (13.5 cm); sauceboat with two spouts and two handles: height $3\frac{3}{4}$ ins (8.7 cm), length $7\frac{3}{4}$ ins (18.5 cm). Gold. Pushkin State Museum of Fine Arts, Moscow

2.19 Plan of Troy VI, with Troy I and II, showing comparative sizes

Troy I, EB I 1 Megaron 2 South gate

Troy II, EB II 3 Southwest gate 4 Southeast gate

Troy VI, c. 1800–1300 BC 5 West gate 6 South gate 7 East gate

- 8 Northeast bastion and water supply

2.20 Below Troy II. Paved ramp leading to southwest gate

channel for cultural ideas. It was also handily situated to control shipping making its way through the Dardanelles from the Aegean to the Black Sea and vice versa. Schliemann discovered the remains of several citadels, one on top of another, to which he gave sequential numbers, Troy I being the lowermost settlement retrieved. His assertion that Troy II should be equated with the Troy of the Homeric poems has been shown to be misguided, but this need not detract from recognition of his achievement. Almost singlehandedly, Schliemann began the recovery of the Bronze Age cultures of the Greek world. Nonetheless, there are aspects of his work that fall short of accepted standards of scientific inquiry.

Troy was fortified from the beginning. Troy I was furnished with huge, stonebuilt (in their massive lower courses) walls, which are still visible today. A projecting bastion with sloping walls protected the south gate, which was little more than a narrow passage through the bastion. Within the walls, inhabitants lived in dwellings of rectangular plan with a porch. Walls were built of mudbrick and timber above a stone socle (plinth).

Troy II is even more massive and brings to mind the fortified sites of Greece and the Cyclades built during the same period, that is, the Early Bronze Age. It covers an area of some 9,500 square yards (8,000 sq m) (fig. 2.19). A huge fortification wall built of stone and mudbrick was strengthened by numerous

towers and bastions; paved ramps (fig. 2.20) led to the gateways, providing entrance to the citadel. Within, several smaller residences were overshadowed by the central unit, a megaron, larger than the House of the Tiles at Lerna. The building had a porch, a hall twice the size of the porch, and in all probability a back chamber too. Walls were almost 5 feet (1.52 m) thick; foundations were of stone, the walls themselves of mudbrick and timber above a stone socle course. A courtyard stood in front of the entrance, the whole complex giving an impression of great space and ease. Dressed stone blocks were used for the broadened end of the flanking walls, the ANTAE of the megaron in one of its phases, and for column bases in the courtyard. Comparably advanced urban planning may be seen nearby in the northeastern Aegean at Thermi on Lesbos and at Poliochni on Lemnos. At the same time, the citadel complex at Troy is a far more impressive statement of the power of the local ruler than anything on the Greek mainland or in the Cyclades.

The inhabitants of Troy II were energetic potters and produced numerous monochrome shapes that were sometimes embellished with clay human faces below the rim. They also wove textiles. They are probably best known, however, for their metal goods: gold, silver, and bronze cups and bowls, and much jewelry. Goldsmiths' techniques of filigree, sheet-cutting, and repoussé work were known else-

2.21 Troy VI, stretch of eastern fortification wall from the south

where in the Aegean world, but are nowhere better exemplified than here. Priam's Treasure alone is an eloquent testimony to the wealth of the city and the experience and specialist skills of its craftsmen.

The relatively short-lived citadels of Troy III and IV show a decline in prosperity from the brilliance of Troy II, while Troy V represents the final stage of the EB citadel. In the MB period the site at Troy expanded to about double the size of the thirdmillennium citadel. It is now known as Troy VI - that is, the sixth city built on the site – though it does not appear to have taken the monumental form in which it is best known today until the very end of the phase. The top of the site was shaved down by builders of later (Hellenistic and Roman) times, so that the disentangling of buildings and archaeological levels has been a daunting task. Despite Schliemann's inventive efforts (fig. 2.22), much of the systematic refinement of the phasing and chronology was carried out by the University of Cincinnati in excavations conducted in the 1930s.

Troy VI lasted from the beginning of the MB age in Asia Minor well into the Late Bronze. The excavators give dates of around 1800–1300 BC for this city, detecting eight strata and three chronological phases. The top of the hill was doubtless crowned by large buildings from the beginning of the MB age, all trace of which was lost in later remodeling. A fortification

wall (fig. 2.21) was built at the outset and was constantly under repair so that different stretches of it correspond to the three phases of the city itself. It took its massive form toward the end of Troy VI, enclosing houses that stood individually, at any rate on the lowest terrace close to the wall. The wall itself was built, in its lower courses, of squared masonry, presenting a sloping face and vertical offsets toward the enemy. The plan (fig. 2.19) shows the main gate (6) at the south, flanked by a protective tower, with other gates through the wall to east (7) and west (5). The gate to the east was formed from overlapping walls, while another exterior defensive tower stood close by to the south. To the north a great masonry bastion protected the water supply (8). A stretch of the paved road leading from the main gate into the citadel and pointing to the top of the hill suggests a spoke-like plan of streets within the fortress, all emanating from the palace on the top and leading down to the gates.

The sophistication of the military architecture at Troy can be compared with that of the palatial architecture in Crete. It is surely the proximity of these rapidly advancing cultures, along with profound social changes on the mainland itself, that ensured that Greece could not remain much longer in its MH doldrums.

2.22 Opposite Schliemann's excavations at Troy: walls of Troy VI exposed

THE LATE BRONZE AGE c. 1550-1100 bc

n Crete, the palaces now enjoy their period of maximum prosperity, and they all show similar arrangements and a similar elasticity of plan. None was ever fortified. They were destroyed around 1450 BC, along with all other major sites on the island. Only Knossos, less seriously damaged, was repaired and continued in less grand circumstances until around 1375 BC. Knossos is the largest of the palaces, though they are all evidently taken from a single design. They have central courts of about the same size, about 51 yards long by 25 yards wide $(47 \times 23 \text{ m})$, with the exception of Zakro, which is smaller. The plan at Knossos is very complicated, and it is this complexity that may have given birth to the legend of the labyrinth there. The palace, which alone covered about 3 acres (1.2 ha.), was the center of a city, of which a number of houses and villas have been excavated. But the population figures and the density of the population, in spite of hints from Homer (Iliad 2.649), remain unknown.

For about a hundred years, the influence of Crete continued to spread. In the Cyclades, islanders maintained some of their own traditions, keeping the typically Cycladic shapes and decorations for their pots. Yet imports increased, and architectural forms and wall paintings derived from Crete begin to appear. The site of Akrotiri on Thera provides good evidence of the mingling of Cretan and Cycladic elements in the years prior to around 1500 BC. After about 1450 BC the Cyclades fell wholly into the orbit of mainland Greece.

The shift in mainland Greece from MH to LH life is signaled by the grave circles at Mycenae. During the LH I-II period a group of leaders emerged to seize power and establish a feudal (that is, a hierarchical) society. From the evidence of the shaft graves of Circle A, they were warriors. These LH Greeks, it seems, enjoyed both an indecent appetite for war and a mastery of navigation. They entered into contact with foreigners and, around 1450 BC, appear in Knossos. Elsewhere in the Aegean their presence is documented by their commerce in painted pottery. It seems logical to conclude that some of the larger pots will have contained wine or oil for sale or exchange. During the fourteenth century BC LH "Mycenaean" wares were exported eastward to Cyprus, the Syro-Palestinian coast, and to Egypt. Materials recovered from the fourteenth-century BC Uluburun shipwreck off southern Turkey suggest what was expected in return.

The term "Mycenaean" is used both as an adjective applied to the city of Mycenae itself and, more frequently, as equivalent to "Late Helladic." In the latter instance, it is applicable to all artefacts made by LH Greeks. Mycenaean Greeks, in this sense, do

^{3.1} Female head, perhaps a sphinx, from Mycenae. LH IIIB. Painted plaster. Height 6½ ins (16.8 cm). National Museum, Athens

not necessarily come from Mycenae but might equally well come from Tiryns, Pylos, or elsewhere. At home, they built great fortress citadels, like Mycenae, which stand witness to the continuity of their centralized power. The image of their societies and bureaucracies appears vividly in the Linear B tablets. Other highly organized social units revealed by archaeology include Tiryns, Pylos, Athens, and Thebes, the relative size and power of which are echoed in Homer's catalogue of ships in Book Two of the *Iliad*. At Athens, a section of the fortification wall can still be seen on the Acropolis, and the line of the rest of the original wall has been traced.

The Shipwreck off Uluburun

The wreck was found in 1982 by a spongediver. Excavation at depths of between 40 and 60 yards (36.6 and 54.9 m) was difficult and dangerous, and took over a decade. The seabed sloped sharply, but the center part of the vessel had stayed approximately where it sank. Undersea exploration had to be limited to ten-minute spells, rotated among a team of several divers; doctors had to be on hand; six-hour breaks between dives were obligatory. But the 20yard-long (18.3 m) ship has shed dazzling new light on the movement of luxury goods in the eastern Mediterranean in the Late Bronze Age, and has important implications for an understanding of the character of LH society.

The cargo included gold from Egypt, almost a ton of tin INGOTS, perhaps from Afghanistan, and ten tons of copper ingots, 354 in all, some as much as a yard in length, the isotopic analysis of which suggests that almost all came from a single deposit on Cyprus. There was also pottery from the Levant, Canaanite gold pendants, an Old Babylonian and a Kassite cylinder seal, gold and silver jewelry and scrap metal, bronze tools and weapons, daggers, swords, arrowheads, chisels, tongs, drill bits, adzes, and axes, amber from northern Europe, a dozen stone anchors, and, from tropical Africa, hippopotamus and elephant ivory, ostrich eggshells, and ebony. So precise and careful was the work that a number of very small scarabs were retrieved: among them, and not measuring more than a third of an inch by half an inch (0.8 cm \times 1.2 cm), was a minute gold scarab inscribed in hieroglyphics with the name of Nefertiti, Akhenaten's queen. This is a very rare find. Royal persons and high court officials

of the Amarna period preferred rings to scarabs for their finger decoration, and this is the only gold or silver scarab that we have so far for Nefertiti. How did it come to be on board? After the end of the Amarna period, objects associated with the dismissed ruling family would have had little other than symbolic value. Other gold and silver objects from the wreck were damaged or discarded scrap, and it seems possible that the Nefertiti scarab was such an object, intended for sale or barter either for its intrinsic value or as a trinket. Stored in Canaanite amphoras, and therefore likely to have been loaded at a Phoenician port such as Ugarit (Ras Shamra in modern Syria), were olives, about a ton of terebinth (a resin used in perfume), numerous glass ingots, and in one amphora there was a folding wooden writing tablet. This spectacular find consisted of two wooden leaves (c. $4 \times 2\frac{1}{2}$ ins $[10 \times 6 \text{ cm}]$) linked together by an ivory cylindrical hinge. The inner side of each leaf was recessed and the flat surface of the recess scratched to hold the soft wax poured in. The wax would then have solidified and formed hard surfaces for writing. This writing tablet has obvious implications for our knowledge of Bronze Age literacy, is six hundred years older than other examples of its kind, and brings to mind Homer's mention of a folding wooden writing tablet (Iliad 6.169). Other commodities - figs, grapes, pomegranates, almonds, cumin, coriander, safflower - suggest the range of cuisine available for passengers and crew, while firewood found on board has been dated to 1327 BC by dendrochronology, and C14 dating suggests the ship went down in around 1316 BC.

The far-flung origins of the materials on board might suggest that these were the possessions of a merchant ship captain coasting around the Mediterranean littoral. But the richness of the goods argues against this. The preponderance of luxury items and the location of the wreck indicate that this was a tailormade cargo bound for a destination somewhere in the Aegean. It may have been headed north, but its roster of goods chimes well with the tastes of Mycenaean lords and reflects the upper echelons of highly stratified LH society. The great majority of the materials from the wreck are of Egyptian, Cypriot, and Levantine origin, and the amount of metal on board, about 15 tons by weight, is enormous. The written evidence from contemporary royal archives suggests that cargoes of this kind may well have been materials for gifts or exchange. For example, Linear B

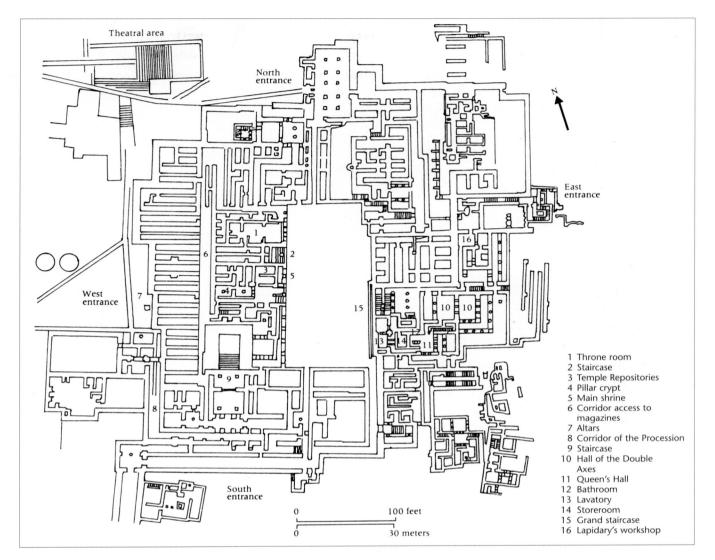

3.2 Plan of the palace at Knossos. LM

tablets from Mycenaean palaces mention every one of the raw materials on the wreck, and at Pylos the texts speak of many bronzesmiths employed in making and repairing weapons and armor. Moreover, a text from Amarna, Akhenaten's ill-fated capital in Egypt, refers to ingots of glass. These look like materials for consumption by a princely society. The ship is unlikely then to have been engaged solely in coastal commerce (though the scrap metal on board speaks for such a function), and its primary purpose was probably as a princely vessel carrying materials for gift and exchange. For wealth of information about late fourteenth-century society, the Uluburun shipwreck is matched only by the Linear B tablets.

CRETE

Architecture and Wall Painting

Knossos The plan (fig. 3.2) shows the four main entrances at the points of the compass. The names of rooms in the palace are, of course, modern. The west court offers the most pleasing point of arrival. It was furnished with altars (7) for sacrifice and has analogies in the west courts at Mallia and Phaistos. On arrival, the visitor would have been directed down the Corridor of the Procession (8), the walls of which were painted with processions of people bringing offerings. A circuitous route led to the staircase up to

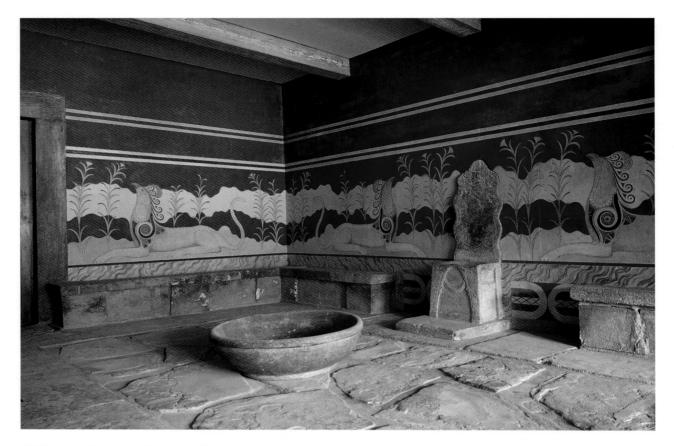

3.3 Knossos, "throne room" as restored by Evans. LMI

reception rooms on the second floor: the longer and more meandering the approach, the greater the impact at the moment of arrival.

An alternative route could take the visitor into the central court. Here, the west side is the major façade, comprising three floors and rising to a height of 15 yards (14 m). The main staircase (2) to the upper floor(s) was flanked by the so-called "throne room" (1) and the main shrine of the palace (5).

The "throne room" (fig. 3.3) is small and intimate, not built to impress. It may have served more as a shrine than as a royal reception room. Immediately to the left, on entering, there is a small rectangular space with steps leading down into it, a so-called lustral basin. The function of this space may have been associated with initiation rites. Against the right-hand wall stood an ornate highbacked chair, the "throne," flanked by FRESCOES depicting huge GRIFFINS heraldically arranged on either side. The main shrine, signaled by HORNS OF CONSECRATION, stylized representations of bull's

horns which marked a sacred place, is small. It was from here that the faience figures of the snake goddesses were retrieved from the Temple Repositories (3), pits lined with stone, at a lower level. Here there was also a pillar crypt (4), that is, a chamber with two pillars decorated with incised images of double axes. Scholars conjecture that this chamber was used for ritual purposes. Behind these public rooms and the state apartments above, a long corridor (6) provided access to numerous magazines, or storage units. Here, in huge pithoi (fig. 3.4), olive oil and grain (some of which may represent tax payments) were stored. The ability to gather and distribute large quantities of agricultural produce was evidently a key factor in upholding the legitimacy of the ruling elite.

Outside the palace proper, but linked to it by raised paved walkways across the west court and to the north entrance, was a rectangular area with what appear to be steps on two sides. These were in fact seats, so that this is an *al fresco* theater, or "theatral area." The north entrance of the palace is marked by a pillared hall, from which a narrow passageway led up to the central court: monumental, forbidding entrance below, pleasant, painted porticoes above.

To the east of the central court were workshops, a lapidary's (16) for example, and to the south, the residential apartments of the monarch (10-14). The slope of the hill on which the palace stood was cut into to accommodate these apartments, which descended in several stories from the level of the central court. Access to this domestic quarter from the central court was by means of a grand staircase (15). The staircase descended alongside an open air shaft, ending at ground level in a small court (fig. 3.5). Such courts, not always accompanied by staircases, were open to the heavens and are termed light-wells. At the foot of the staircase was another light-well, forming the first unit of the Hall of the Double Axes, named after the motif of double axes incised on its walls. Eastward from there was the Hall itself (10),

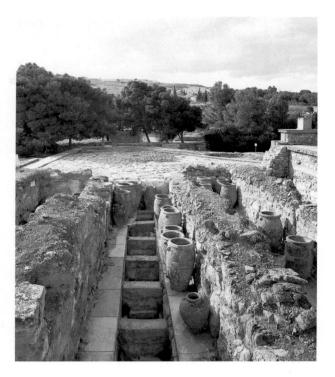

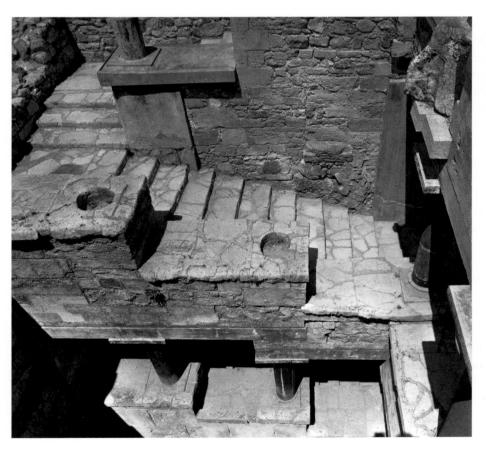

3.4 *Above* Knossos, basement storerooms (magazines) from the east, showing storage vessels. LM I

3.5 *Left* Knossos, grand staircase adjacent to the royal living quarter. LM I

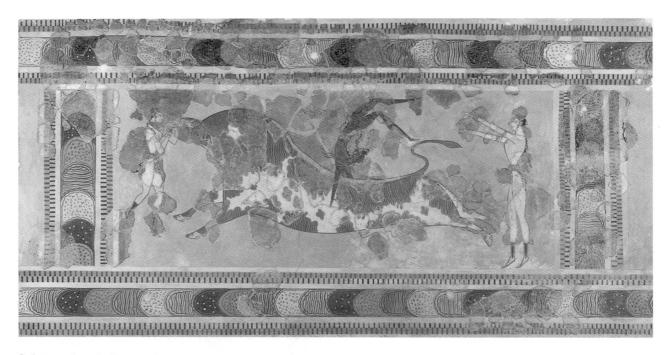

3.6 Scene from bull sports, from Knossos. LM I. Fresco (restored). Iraklion Museum, Crete

with its PIER-and-door construction. Piers alternating with doors in three separate rows allowed for great variety in the amount of space used, and for the amount of air and light. Doors could be open or shut, and the space curtailed or expanded accordingly. To the south more light-wells ran along the side of another smaller hall (11), called the Queen's Hall by some, next to which were rooms with a bath tub (12) and a lavatory (13). Water was supplied from nearby wells and outlying springs. Residents could also count on running water carried beneath the floors in terracotta pipes. These were tongued to fit snugly into one another. An early pressure system thus contributed to the water supply. For water and waste disposal a stone-built drainage system also ran beneath the floors.

The palace walls were decorated with fresco paintings. Unlike true frescoes, which were painted on the plaster while it was still wet, these were painted on already dry surfaces, and a binding agent was used to fix them to the walls. Only the smallest fragments have survived from the painting of the first palaces. Most of the surviving legible fragments come from the reconstructed palaces, but even these are fragmentary and many paintings have been heavily restored, sometimes on rather flimsy evidence. Colors used were red, yellow, black, white, green, and blue, while motifs were derived from the natural world and the courtly life of the palace. Scenes were bordered by decorative geometric FRIEZES.

At Knossos, one fresco shows a scene from the bull sports (fig. 3.6). Here, one figure grasps the bull's horns in preparation, as another completes a somersault over its back, while a third is in midvault. Traditionally, and by analogy with the red/ male, white/female color conventions of Egyptian painting, two of these figures have been thought female. But this view has been challenged recently: different colors may have been used as social markers, or for painterly compositional purposes, and there may be no compelling reason to view any of these bull leapers as female. The bull's position, with all four hoofs off the ground, is termed the "flying gallop," while movement and naturalism are characteristic of the bulljumpers too. Other frescoes, known as the Miniature Frescoes, of which the socalled Grandstand Fresco provides a good example, are less detailed (fig. 3.7). Impressionistic, rapid brushstrokes create visions of massed dancers, chattering crowds, landscape elements, and architectural features. Occasionally, fresco painters rendered their figures in plaster in low relief before painting them, thus lending a third dimension to their scenes.

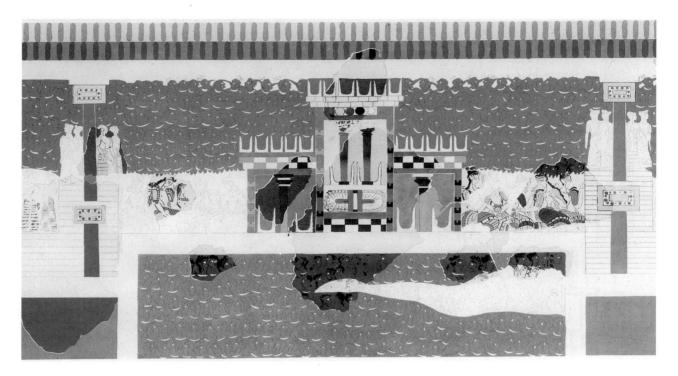

3.7 Reconstruction of the Grandstand Fresco. From the Knossos Fresco Atlas, after Sir Arthur Evans. LM I. Fresco (restored). Original in Iraklion Museum, Crete

Fragments of wall paintings, Minoan in iconography and theme, have recently come to light in Egypt in sixteenth-century BC contexts. Work at the site of Tell el-Dab'a in the Nile delta has revealed evidence of contacts with Crete (Kamares ware pottery) in the early eighteenth century BC, and the thousands of wall-painting fragments signal the renewal of these contacts some two hundred years later. Landscapes and flora echo the naturalism of Minoan art. Rivers are awash with papyrus plants, lilies, reeds, fishes, and aquatic birds; hills and valleys are the home of various fowl and all sorts of animals. Colors are bold and bright: lions and leopards pursue their prey amid foliage painted blue, while red-collared dogs hunt antelope. Human figures also reflect Minoan types: there are acrobats who wear Minoan boots and garments, fragments of the flounced dresses of women, and scenes of bulljumpers and bulls. There are no other Minoan materials from the site at the time of the wall paintings to suggest that Minoans were actually living at Tell el-Dab'a. At the same time, Minoan-style paintings have also come to light in the Levant (e.g. at Alalakh), and this has suggested the possibility that Minoan painters traveled widely around this part of the Mediterranean.

The Knossos palace walls were built of stone, either carefully dressed ASHLAR blocks or large rubble. Rubble walls were heavily plastered, and all walls were secured with huge horizontal and vertical wooden tiebeams. GYPSUM was used for the orthostate course of some important walls: the exterior of the west wall, for example. Wood was used for the plentiful columns, tapering in shape. There were numerous colonnades and windows, and roofs were flat. The architectural vocabulary consisted of courts, stairways, light-wells, porticoes, narrow rooms, corridors, theatral areas, lustral basins, all arranged around a central court and designated in advance for ceremonial, storage, residential, and workshop use.

Today, Knossos is heavily restored, mostly on secure archaeological evidence, but with several questionable points. Arthur Evans himself – relying for elevations on the evidence of depictions of buildings on wall paintings as well as on the actual excavations – was responsible for much of the controversial restoration, but students should be aware of the limitations of the meager conservation techniques that were available to him in his day.

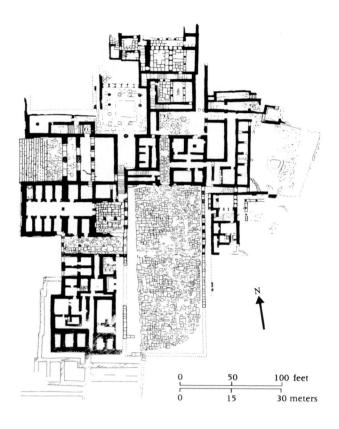

3.8 Above Plan of the palace at Phaistos. LM

Phaistos Minoan palaces show variations in siting, combinations of spaces, and placement of architectural units. At Phaistos (fig. 3.8), the new palace combined the theatral area with the west court, and replaced the weaving labyrinthine approach of Knossos with a huge staircase. The central court (fig. 3.9) was aligned north–south on Mount Ida. To the west, as at Knossos, were storage units opening off a corridor. The thickness of their walls implies the existence of upper stories. To south and east, much of the palace is lost, but to the north lay the residential quarter, located here to catch the prevailing summer breeze.

The central court had colonnaded porticoes on both east and west sides. There were doors protecting all the entrances onto the court, and a puzzling masonry platform in the northwest corner. At Mallia, cuttings in the STYLOBATE (the course of masonry on which columns stood) of the colonnade on the east side of the court and in the sides of surviving blocks of piers show that there were temporary barriers between piers and columns. It may be that so-called bull sports took place in the central

3.9 Below Central court of the palace at Phaistos, from the south with Mount Ida in the background

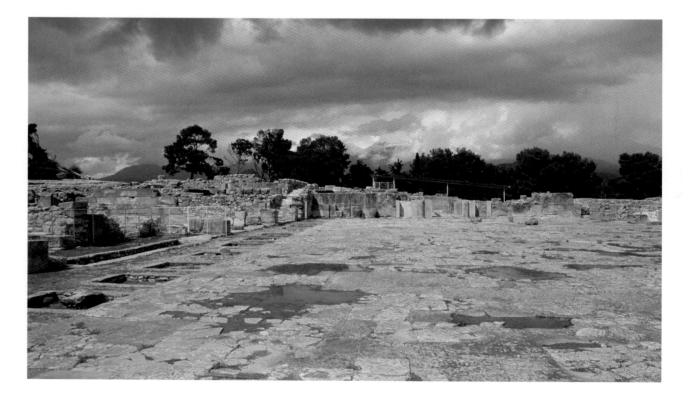

courts. The barriers would have kept bulls from swerving into the colonnade, and the masonry platform would have enabled athletes to execute a particularly tricky leaping maneuver.

At the north, access to the domestic quarter was gained through an elaborate doorway. ENGAGED halfcolumns stood on either side, each flanked by a rectangular niche and piers. Beyond the passageway was a PERISTYLE courtyard with a surrounding colonnade, a pier-and-door construction giving access northward, and a further rectangular unit with an alabaster floor, light-wells, and further pier-and-door arrangements. Basically similar in plan to Knossos, this palace introduced new features: an impressive entrance staircase, porticoes on two sides of the central court, a monumental approach to the living quarters, and a peristyle court. As at Knossos, there is no trace of fortification; but unlike Knossos, there are few of the riches associated with a functioning palace.

Aghia Triadha (or Hagia Triada) This villa, so named after the nearby church of the Holy Trinity (*Aghia Triadha* is the Greek for the Holy Trinity), and some 2 miles (3 km) from Phaistos, has yielded examples of much of the rich paraphernalia of palace life: fresco fragments, stone vases with relief scenes, copper ingots (measures of weight and wealth), and evidence of writing – clay tablets inscribed in the Linear A script.

The plan of the site is difficult to read, since it was built over in the LM III period. To the west, however, narrow porches and colonnades lead to a residential quarter equipped with stairs, light-wells, pier-and-door construction, lustral basins, and vestiges of a peristyle court. Gypsum and alabaster are used lavishly for paving and veneering of walls and benches, while fresco fragments evoke the vitality and energy of the natural world. Was this also a residence of the prince of Phaistos?

Gournia A complete Minoan town was excavated at Gournia in the east of the island by Harriet Boyd Hawes (see p. 18) in the early years of this century and the findings published with exemplary speed. The plan (fig. 3.10) shows the town at the time of the new palaces, in LM I; it was without fortification. Characteristic of Crete in being built on rocky ground to preserve arable land, the site covers about

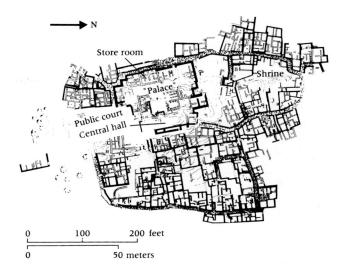

3.10 Plan of Gournia. LM I

6½ acres (2.6 ha.). Circular, winding streets were connected by other, stepped streets to a central hub, the "palace" or residence of the governor and the public court with its theatral steps to the north. There is a small shrine identified by cult objects. The miniature palace (fig. 3.11) is demarcated by cut ashlar masonry and is thus set apart architecturally, yet there is no separation of the palace from the houses nearby except by a narrow street, implying a close relationship between governor and governed. Houses were built on two levels up the slope of the rocky knoll, perhaps with shops below and living quarters above. The tools of many artisans were found here - of blacksmiths, carpenters, and potters - promoting the notion that this was a city of craftsmen. Gournia has a comfortable and intimate feel about it, in striking contrast to Mesopotamia, where shrines were not embedded in the fabric of towns, but were separate, raised, and massive. It is different, too, from Egyptian towns for workmen, which were built in grim, standardized, grid-controlled blocks.

Mansions As well as palaces like Knossos or Zakro which were surrounded by large houses, and towns like Gournia with smaller houses, there existed independent mansions or villas of grand dimensions. Examples include the country mansion at Vathypetro where olive-pressing and wine-making took place, the coastal mansion at Nirou Chani which stored

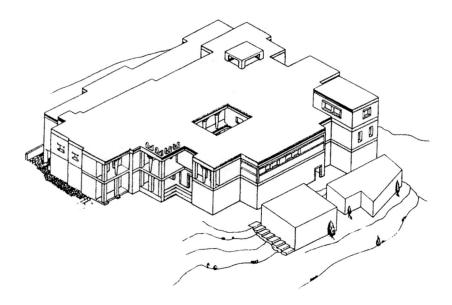

3.11 Reconstruction drawing of the "palace" at Gournia. View from the southeast. LM I

bronze double axes and other ritual objects, perhaps preparatory to shipment, and the mansion at Nerokourou in the west of the island. A terracotta model (fig. 2.4, p. 48) from Arkhanes of a Minoan villa gives a good idea of the elevation of such mansions with staircase, light-well, columned roof, and balcony.

Sculpture and Pottery

Sculpture The tradition of working ivory exemplified by the MM acrobat (fig. 2.7, p. 49) continued, as can be seen in the statuette found at Palaikastro (fig. 3.12). Torso, arms, legs, and feet were made of ivory (hippopotamus teeth). Fragments of gold foil still attached to the ivory and gold sandals found nearby show that this was originally a CHRYSELE-PHANTINE (gold and ivory) figure. The head was carved from gray serpentine with eyes of rock-crystal and eyebrows and ears of ivory. This rich panoply of materials and the unusually large size (the figure stood some 19½ inches [50 cm] high) suggest that this was a cult image. However, no other securely identified cult images have been found, not even where they might have been expected (e.g. in shrines in palaces). Accordingly, the question of whether the figure represents a deity (a young Zeus has been suggested) or was a votive dedication remains open. Arms and hands hold the posture first articulated in Petsofa terracottas centuries before, while the left foot, slightly advanced, adopts a walking stance.

The male and female types, first expressed in terracotta in the Petsofa figurines, appear in bronze too (fig. 3.13). Proportions, scale, posture, garments, and even the impressionistic handling of the facial forms follow the Petsofa prototypes. The gesture is changed. The right hand is now raised to or toward the forehead in the worshipers' gesture of salute, while the left arm (of males) is held by the side. This style is different from that of the faience female figurines of MM date from Knossos (fig. 2.1, p. 44 and fig. 2.6, p. 49) with their oriental overtones, and may represent a more indigenous tradition.

The surface of these bronzes is commonly quite rough. This may be due to the low percentage of tin in the metal, which often means that it is nearly one hundred per cent copper, or the deliberate absence of retouching of the cast bronze, or the undetailed modeling of the wax using the CIRE PERDUE or lost-wax method. This consisted first in modeling the object in wax, covering the wax model with clay, and heating the clay so that the wax melted away through holes left in the now hard clay. Molten bronze was then poured into the hollow clay mold and allowed to cool. Finally, the clay was broken away to reveal the bronze figure, cast solid.

A number of stone ritual vases (RHYTA, sing. RHYTON) were decorated with relief scenes. Some have been found with flakes of gold leaf still attached, so that it is probable that all were originally gilt. One, depicting a hilltop sanctuary, comes

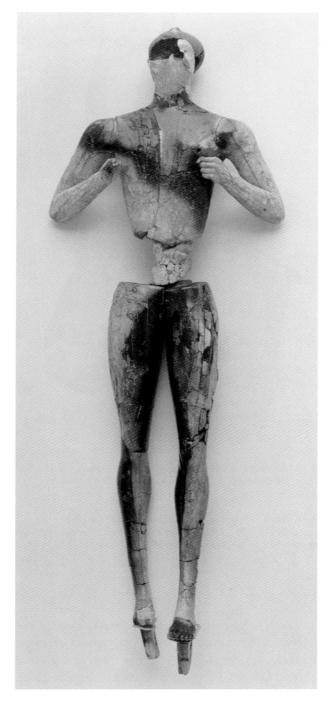

3.12 Statuette, from Palaikastro. LM I. Gold and ivory (body and garments), serpentine and rock-crystal (head and eyes). Height 19½ ins (50 cm). Siteia Museum, east Crete

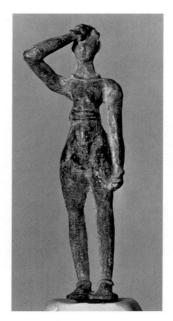

3.13 Statuette of a worshiper, from Tylissos. LM I. Bronze. Height 6 ins (15 cm). Iraklion Museum, Crete

from Zakro and is discussed below (p. 81), while three other important examples come from Aghia Triadha: the Chieftain Cup, the Boxer Vase, and the Harvester Vase (figs. 3.14 and 3.15).

The Chieftain Cup has been interpreted variously as showing a Minoan prince issuing instructions to a military figure, or, according to a more recent theory, young Minoans engaged in a ceremony marking the transition to manhood. The Boxer Vase shows a series of sporting events in four registers. The Harvester Vase is a rhyton made of steatite and in the shape of an ostrich egg, but only the upper part is preserved. The sculpted scene shows an elderly man with long hair, ceremonial dress, and staff, leading a procession of workmen. They carry winnowing fans for the harvest. At the back of the vase (fig. 3.15) a figure shakes a SISTRUM (a musical instrument, an actual example of which has recently been found at Mochlos) with his right hand, keeping time with his left, while behind him a trio join him in song, mouths wide open. Twenty-seven figures appear in all. Aside from the main ones, they are grouped in pairs, one figure slightly in advance of another, as if distanced from the viewer in spatial recession. The general hilarity and sense of move-

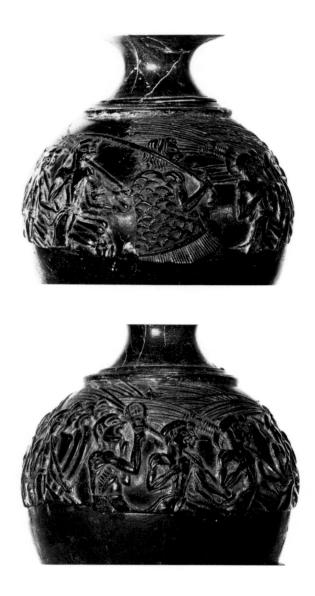

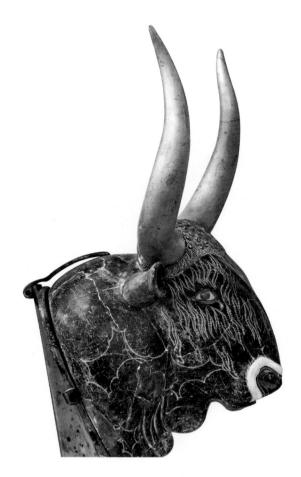

3.14 Above left, **3.15** Left Harvester Vase, from Aghia Triadha. LM I. Steatite rhyton. Diameter 4½ ins (11.5 cm). Iraklion Museum, Crete

3.16 Above Rhyton in the shape of a bull's head, from Knossos. LM I. Serpentine, limestone, and rock-crystal. Height 10¼ ins (26 cm). Iraklion Museum, Crete

ment disguise the fact that figures in the further plane are no smaller in size.

Rhyta were sometimes entirely zoomorphic, as is the case with the bull's-head rhyton from Knossos (fig. 3.16), where a hole in the mouth acts as the spout while another in the neck is used for filling. The stone is SERPENTINE, the eyes of rock-crystal are set in a pinkish stone to give a bloodshot appearance. A white band of shell surrounded the nostrils and the horns were of gilt wood. Curls are engraved between the bull's horns, as are the long straggling hairs of his coat down the face and neck. This rhyton is full of naturalism and energy. Bulls, and their capture, are the subject of the famous gold cups found on mainland Greece at Vapheio, in a context dating them to around 1500–1450 BC. There are two cups, each consisting of two sheets of gold, the outer decorated and the inner plain, with a gold handle riveted on. One cup (fig. 3.17) shows a bull caught in a net, in a perspective close to a bird's-eye view and known in Minoan wall painting. The third dimension is absent, and objects or landscape elements in the vertical plane appear to float in space, unconnected realistically to the scene of which they are a part. Two bulls escape, one on either side, the first kicking up his rear

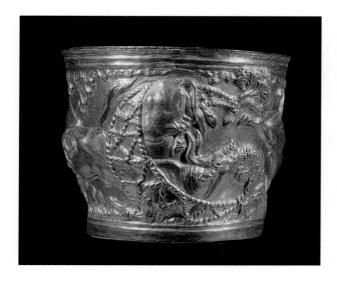

3.17 Cup embossed with scenes of capture of a bull, from Vapheio. LM I. Gold. Diameter $4\frac{1}{4}$ ins (10.8 cm). National Museum, Athens

hoofs and making off at a "flying gallop," the other tossing a lithe Minoan, as another man falls to the ground, arms outstretched. The second cup shows a quieter capture in a landscape setting, where again the third dimension is missing. Recent opinion suggests that one of these cups is of mainland Mycenaean manufacture. Yet many still believe that both represent the high point of Minoan metalwork, and indeed of relief sculpture. They are full of movement and naturalism, showing conscious use of light and shade to create the effect of shape and mass, a technique known today as CHIAROSCURO.

In the period after the destruction of the palaces, a series of terracotta female figures preserved the tradition of female deities or adorants. These figures, so-called "household goddesses," are characterized by wheelmade lower bodies, hands held aloft, and complicated headdresses, sometimes, as here (fig. 3.18), embellished with poppies. Some stand as tall as 2 feet 6¼ inches (77 cm). Their popularity lasted some three hundred years, and they were followed by a similar Dark Age type (fig. 4.4, p. 108).

Pottery Before the destruction of the palaces around 1450 BC, the pottery of Late Bronze Age Crete is characterized by dark-on-light decoration rather than the light-on-dark favored in the first palaces. The Pattern Style and the Floral Style, both designated LM IA, were popular in the first phase. The Pattern

Style used abstract motifs such as linked spirals, derived from the borders of wall paintings, while the Floral Style concentrated on naturalistic motifs such as grasses and flowers. A fine example of this Floral Style (fig. 3.19) has papyrus plants coiled in spirals repeated around the pot. This echoes a design that first appeared in Crete in EM I (fig. 1.1, p. 30). Common shapes for either style are jugs with horizontal spouts, large egg-shaped storage jars, and the teacup.

Around 1500 BC, the Marine Style, designated LM IB, is added to the Pattern Style and Floral Style of LM IA. Cuttlefish, dolphins, nautili, starfish, and octopuses sprawl across the surfaces of pots, interspersed with seaweed, shells, and rocks, in lively, free-floating arrangements. Favored shapes include

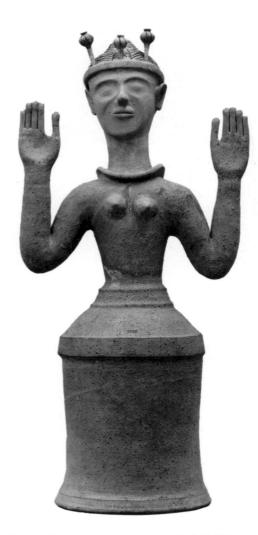

3.18 Household goddess statuette, from Gazi. LM III. Terracotta. Height 2 ft 6¼ ins (77 cm). Iraklion Museum, Crete

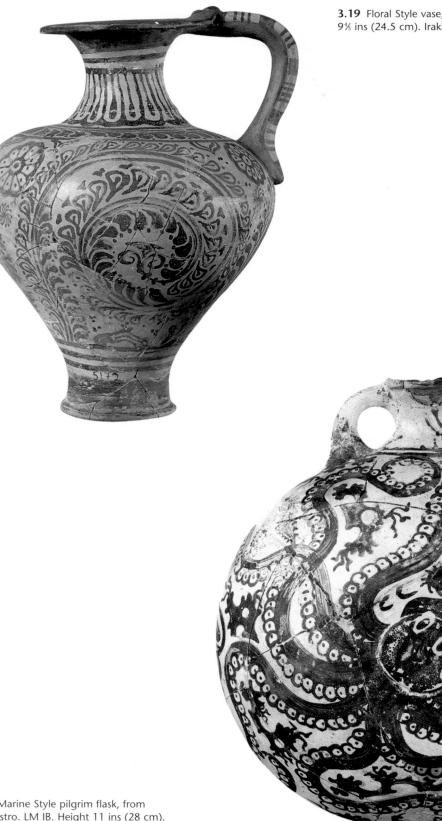

 $3.19\,$ Floral Style vase, from Palaikastro. LM IA. Height 9% ins (24.5 cm). Iraklion Museum, Crete

3.20 Marine Style pilgrim flask, from Palaikastro. LM IB. Height 11 ins (28 cm). Iraklion Museum, Crete

the pilgrim flask, the ewer (a horizontally spouted jug with one handle), and the rhyton. The pilgrim flask from Palaikastro in the east of the island (fig. 3.20) may be the most famous example of the Marine Style: the head and body of the octopus are placed on a diagonal axis of the pot, while tentacles writhe freely, giving a sense of continuous movement.

After the widespread destruction in the middle of the fifteenth century BC, the Palace Style, which is known only in Crete at Knossos, makes its appearance. It is taken as evidence of the presence of Greeks in the damaged palace. Really a mainland Greek style, referred to in Crete as LM II, it adapts Minoan motifs, both floral and marine, to its own stylistic preferences. The decorations of the pot are now often in panels, which confine the naturalistic motifs, so that they present stylized, anchored octopuses or stiffened, motionless plants (fig. 3.21). While LM II pottery was popular at Knossos, it is possible that LM IB was still being made elsewhere on the island. Great chronological difficulties and uncertainties still surround the pottery styles of Crete in the fifteenth and fourteenth centuries BC.

Greeks in Knossos and the Linear B Tablets The question of the presence of Greeks in Knossos is complicated. Palace Style pottery is only part of the evidence for establishing that they were there from around 1450 BC. There were also new kinds of tombs in which weapons suddenly appear, and a new style of fresco painting, characterized by motionless, rigid figures. A new writing system, known as Linear B, was deciphered as an early form of Greek by Michael Ventris in 1952 (see Box, p. 78), and is the clearest evidence for the Greeks in Knossos, but the date of its introduction is unclear. The decipherment revolutionized our thinking about the history of Bronze Age Greece. Previously, since the vast majority of tablets in Linear B had come to light in Crete, and far fewer had appeared in mainland Greece, historians had advanced the theory that the language of the Linear B tablets must be Minoan, and that Minoans might have controlled the mainland. The decipherment changed all that.

Scripts

It is to be expected that a culture sophisticated enough to build mighty and lavishly decorated

3.21 Palace Style three-handled amphora, from Knossos. LM II. Height 2 ft $6\frac{1}{3}$ ins (78 cm). Iraklion Museum, Crete

palaces would have the capacity to write, and it did. The earliest script used in the first palaces was hieroglyphic, and it has been found on clay tablets, on vases, and on stone seals (see p. 52). It was apparently copied from Egyptian prototypes. The hieroglyphic system was evidently thought too cumbersome and so was simplified and linearized to become the script now called Linear A (to distinguish it from Linear B, which was to come later). By the time of the new palaces, only Linear A, which was a syllabary (a set of symbols, each of which represented a different spoken syllable), was in use. As well as at Aghia Triadha, tablets inscribed in Linear A have been found in the palaces at Phaistos and at Zakro, in townhouses at Khania - in fact, at over twenty Minoan sites. But scholars have as yet been unable to decipher it.

LINEAR B AND ITS DECIPHERMENT

rthur Evans (p. 20) began work at Knossos on March $A_{23, 1900, and within a month tablets were in his$ hands. On April 15 he wrote: "the great discovery is whole deposits of clay tablets with inscriptions in the prehistoric script of Crete." In all, over three thousand were found. Evans figured out that most were lists or accounts, but in spite of the attention of several scholars little progress toward decipherment was made until midcentury. By then, Carl Blegen had found another archive of tablets at Pylos on mainland Greece. Blegen's very first trench, opened on April 4, 1939, ran through the archive room of the palace. Some six hundred tablets came to light in that first season, but no further work was possible at the site until after the end of World War II in Europe (1939-45) and the civil war in Greece that followed. The tablets, however, were deposited in a bank in Athens; and in 1940 photographs of them reached the United States on the last American boat to leave the Mediterranean before Italy entered war. When work at the site resumed in 1952, a further six hundred tablets were found.

As a schoolboy Michael Ventris heard Evans speak about Knossos and the tablets (in 1936, when he was fourteen). He subsequently wrote an article on the script which was published in the American Journal of Archaeology (to whose editors he did not reveal his age) in 1940. During World War II he served as a bomber navigator in the Royal Air Force, and afterwards trained and practiced as an architect. Throughout these years he kept up his interest in Linear B, always searching for patterns in the script, and from 1950 on he circulated notes to a group of interested scholars. The famous Worknote 20 (June 1, 1952) was presented by Ventris as "a frivolous digression" and titled "Are the Knossos and Pylos Tablets Written in Greek?" He followed this with an equally famous radio broadcast in which he stated that the language of the tablets must be Greek. Almost at once he began a collaboration with John Chadwick, a noted Cambridge philologist and expert in early forms of Greek, which resulted in the magisterial Documents in Mycenaean Greek (Cambridge, 1956). Sadly, Ventris died in a car crash the very same year.

Further work by Chadwick and others has yielded much more information on the society represented in the tablets. There were kings (as in Homer) and princes (second in command) and generals of the army called "followers." At Knossos, some thirty per cent of the tablets deal with sheep and textiles. Separate offices dealt with offerings to the gods, with armor and weapons, and with personnel. At Pylos, the tablets reveal the organization of the kingdom - two provinces and sixteen administrative districts - and the size of the territory. The principal industry was metallurgy: one list gives the names and addresses of some four hundred bronzesmiths. As with other ancient archives, naming and counting were the prime concerns of these inventories. There were archives at Mycenae (fifty tablets) too, at Tiryns (scraps only), and at Thebes (more than 230 tablets so far).

3.22 Michael Ventris in 1952

3.23 Phaistos disk. MM III/LM I. Terracotta. Diameter 6½ ins (16 cm). Iraklion Museum, Crete

Scholars are also mystified by the so-called Phaistos disk (fig. 3.23). This terracotta disk is inscribed with figural and abstract signs, each separately with a stamp, and arranged in groups in panels. The signs seem to begin their message at the edge of the disk and to run spirally to the center. This disk, as yet undeciphered, was found alongside Minoan pottery and a Linear A tablet, and may well be as important for its place in the history of printing as for what its message was.

The Greeks used a new script, Linear B, for their archival records. The Linear B tablets are made of clay fashioned into page-shaped leaves or thin labels. They are flat, gray-brown, and have been baked hard by the fires that ruined the palaces. Upward of four thousand of these Linear B tablets were found at Knossos, but it was only after the discovery of significant quantities of them at Pylos on mainland Greece that the decipherment was made. It seems that the Greeks adapted the Linear A system they found to their own use. About twenty Linear A signs ceased to be used, and their place was taken by ten new ones. There are eighty-nine signs in all in Linear B, too many for an alphabet, and too few for a fully pictographic script. The system therefore is a "syllabary," each sign representing a syllable. However, alongside the syllabic system used on the tablets,

MTV: 川州氏穴YHP:2X、近いA354月7:5Y,B727/A553YHP:2XTMA3445 GT VIII 〒4.194A@H2 びごT4A:MAB2A ジリ〒4.1947の6H2び SまPAT.MY2 び」〒4.1946円州米2 ジ」

3.24 Linear B tablet, so-called "tripod tablet," from Pylos. LH IIIB. Terracotta

there were ideograms (fig. 3.24), of great and obvious help in the decipherment. The tablets are mostly inventories, lists of flocks and herds, of olive trees and saffron, of chariots and weapons. Thus, they are the recording system of a bureaucracy, detailing amounts of taxed goods, movements of men, and commodities. They also shed some light on the religion of these Late Bronze Age Greeks. Though it displays some similarities with Minoan religion, it is unlikely to have been identical. Of the later Greek Olympians, Hera, Zeus, and Poseidon appear, but there are more mysterious figures, too: Pipituna and Potnia Dapuritojo, for example. The gifts they received included barley, fennel, coriander, oil, honey, and wool. In contrast with the evidence of the Aghia Triadha sarcophagus, their sacrifices were bloodless.

The Linear B tablets from Knossos are associated with a violent destruction of the palace, though the actual date of this particular conflagration is debated. Some scholars associate the tablets with destruction levels of about 1200 BC, while others prefer to point to destruction contexts of the early years of the fourteenth century BC.

Minoan Religion

The Aghia Triadha Sarcophagus There is much conjecture about the complicated and difficult topic of Minoan religion, since much of the evidence is inconclusive. The Aghia Triadha sarcophagus may be a suitable starting point. This painted limestone coffin is dated to around 1400 BC and is important evidence both for Minoan painting and for religion.

One longer side (fig. 3.25) shows two scenes, though the background is divided into three sections. To the left, a woman pours a libation (a liquid offering) into a large vessel. This is positioned between posts crowned with double axes, on which birds perch. Behind her come an attendant, carrying further vessels slung across her shoulder, and a man playing a lyre. The other scene moves in the opposite

3.25 *Top*, **3.26** *Above* Sarcophagus, from Aghia Triadha. c. 1400 BC. Painted limestone. Height (of figured scene) 6 ins (15 cm). Iraklion Museum, Crete

direction: three men, carrying models of animals and a boat, approach a stepped altar, a tree, and a cloaked figure in front of a tomb. Is this the dead man rising as a phantom from the grave? Or is he gazing at rituals that are expediting his passage to the next world? Is this evidence for a funerary cult, or for a cult of the dead? Linear perspective might account for the size of the smaller figure in front of the tomb; he may be thought of as further away from the spectator than those carrying offerings. The painter's interest in spatial illusionism is obvious. Images (birds and headdresses) explode beyond the controlling frame. There is much overlapping. The woman pours her libation behind the sacred post, the musician's lyre is partly hidden behind the attendant's pail, legs of the model animals of the adjacent frame overlap each other. Are we intended to envision figures advancing abreast, flattened out into single file for us to see?

The other longer side (fig. 3.26) shows a procession of women, led by a man playing the double flute, a trussed ox on a sacrificial table beneath which are two terrified animals, and a woman who stands in front of an altar rolling her eyes heavenward. The altar stands in front of a bird perched on a double ax supported by a post, behind which is a shrine in front of a tree. In the background, a basket of fruit and a Kamares ware jug complete the scene. Sacrifices and offerings to the dead seem to be the subjects depicted on both sides of this sarcophagus. One leg of the sacrificial table is drawn in front of the animal victims with the other leg beyond so that the head of the ox may be thought of as in a more distant plane than the rump, while the tree standing behind the façade of the shrine offers similar suggestions of space. Are we intended to imagine a rectangular space enclosing the altar, with the shrine forming one side and the sacrificial table, parallel to the shrine, another?

Cults The evidence of the Aghia Triadha sarcophagus, along with objects of daily use found in tombs, has suggested a Minoan belief in life after death. Some scholars have also maintained that the dead were deified and received divine rites, that is, that there was a cult of the dead.

VOTIVE OFFERINGS (objects dedicated or vowed to a deity), especially of human and animal figurines and of pottery, show that divinities were worshiped in hilltop sanctuaries and caves, and in small shrines in villas, palaces, and towns. A household shrine in EM Myrtos was furnished with a terracotta female cult figurine set on a stone stand. By the end of the millennium, sanctuaries were being built on mountain tops. Caves such as the Kamares cave and the Diktaion cave received worshipers from the beginning of the MM period. Hilltop sanctuaries proliferated all over the island, good examples being those at Petsofa and on Mount Juktas. A hilltop sanctuary is depicted in low relief on a fifteenth-century BC rhyton of serpentine found in the palace at Zakro (fig. 3.27). The door of the shrine is decorated with spirals, altars stand in front, and the walls are decked with numerous "horns of consecration," symbols of power. Two pairs of mountain goats recline on the roof, flanking a sacred image, while others skip down the mountainside. Hawks fly overhead, no human is to be seen, the divinity is within, and birds and animals rule the mountain.

Some shrines in palaces and villas were supported by pillars, incised with the double-ax sign. These pillars were doubtless the manmade versions of the extraordinary natural rock formations that attracted worship in caves. Pictures of religious activity often show altars, shrines, and trees together, and often the tree or trees become the focus of attention. So, trees and rock formations, mountains, and pillars were apparently objects of worship.

The evidence of rings and gems points in another, but overlapping direction. A female figure, accompanied by women attendants, often takes pride of place and appears in control of wild animals or trees. Is this the old Mother Goddess - the goddess of fertility - descended from Neolithic times? She is sometimes shown with her son or consort, a boygod. On rings and sealstones she can appear in motion and bareheaded, her hair floating in the wind. The faience statuettes from Knossos (fig. 2.1, p. 44 and fig. 2.6, p. 49) present a more refined version. As a divinity or divinities of nature, earth, trees, and wild animals, she or they may have been thought of as being present in rocks, caves, and on mountain tops, and when pillar crypts were built she may have been thought of as the establisher of houses. Whether she was a single divinity who took many aspects (as mistress of animals, household goddess, goddess of fertility) or many different goddesses is a matter of debate. She was certainly closely identified with a

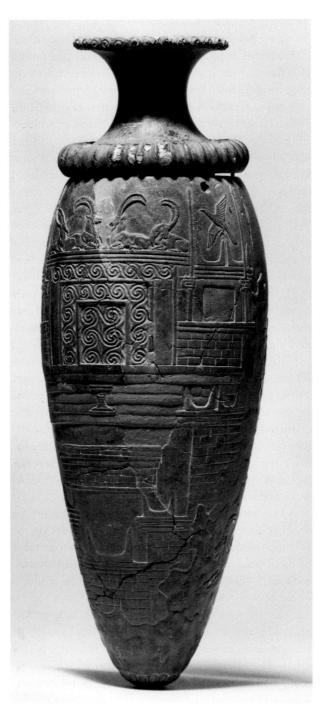

3.27 Rhyton showing hilltop sanctuary, from Zakro. LM I. Serpentine. Height $9\frac{1}{2}$ ins (24 cm). Iraklion Museum, Crete

vegetation cult and with the fertility of the earth and those who lived off it.

Practices Shrines in palaces and villas often had benches around the walls and offering tables of stone or terracotta, some perforated with holes to take the liquid offerings poured presumably for a spirit beneath the earth. Other equipment included stone and terracotta storage vessels, lamps, shells, and painted pottery. A mainstay of religious practice was evidently the giving of gifts, whether terracotta figurines, pottery, fruit and grains, liquids, or animals.

There is ample evidence of animal sacrifice. The Aghia Triadha sarcophagus shows a sacrificial scene, and mountain sanctuaries have revealed the residue of numerous sacrifices of animals, as well as the terracotta vessels used for pouring liquids. Human skeletons were found in the ruins of a shrine on Mount Juktas, one of which, on a low platform, seems to provide evidence for human sacrifice at the moment of the building's collapse around 1600 BC. Further evidence comes from Knossos and Arkhanes perhaps, where human remains suggest the sacrifice of children around 1450 BC.

Wall paintings that decorate a lustral basin and an adjacent chamber at Akrotiri on Thera point to the use of these basins for initiations. The paintings show women engaged in ceremonial activities; the painting above the dado of the basin itself shows a seated woman holding her bleeding foot, while another beside her gazes at an altar with blood dripping from it. On the wall of a room above the basin, women gather crocus stamens and offer them to a seated deity.

While the purpose of altars, offering tables, and rhyta to pour libations is clear, what are we to make of the "horns of consecration"? What of the double axes, incised in pillars or frequently found as votive offerings in caves?

The LM III Period

The period around 1375–1100 BC (LM III) remains hazy. Did Crete become a dependency of the great Mycenaean (mainland Greek) warlords? It was a quiet period with a certain degree of good fortune, for the island seems to have avoided the far-reaching round of destruction that began to strike the mainland around 1200 BC. The site of Kommos in the south of the island reveals a large public building of the LM I–II period, identified as a STOA by the excavators, with a pebble courtyard and flanked by paved roadways leading to the Libyan Sea. This stood intact, though derelict, in LM III, while at the same time the largest LM III building so far recovered in Crete was built. This was made of coursed ashlar masonry, or of ashlars and rubble in a timber framework. It had long galleries with windows and flat roofs. Cypriot and Canaanite materials found in LM III Kommos point to the existence of a trade network, and this building has been identified as a warehouse for commodities. Alternatively, it could have been used as a shed for ships.

THE CYCLADES

Keos

At Aghia Eirene on Keos, additions were made to the fortification system in a period approximately equivalent to that of the grave circles at Mycenae (see p. 88). In the period of prosperity that followed, chronologically parallel to LM IB in Crete, much building took place. This included part of a sanctuary where a large number of terracotta figures (fig. 3.48) were found. This sanctuary, which first saw life in the MB period, continued in use, intermittently perhaps, for some eight centuries.

Melos: Phylakopi III

Massive fortifications of polygonal masonry were built to protect the third town on the site at Phylakopi, similar now to the fortified site at Aghia Eirene on Keos. Streets, as at Gournia on Crete, were almost 5 feet (1.52 m) wide, but little more than footpaths with flights of steps. Construction techniques vary, but most walls were of rubble and about 27 inches (70 cm) thick. Blocks of limestone and basalt occur occasionally, and there is ample evidence that timber was used to stabilize walls. Houses have two or three rooms, and some suggest Minoan influence. A pillared room, for example, looks very much like a pillar crypt.

One major building, larger by far than other houses, doubtless had a special function. The discov-

ery close by of an inscribed clay tablet, apparently listing commodities, suggests the existence of an archival system, and that this large structure served an administrative purpose. All the fragmentary frescoes from Phylakopi may be considered of this phase. They include the flying fish fresco (fig. 3.28) depicting blue and yellow fish in circular motion among stylized rocks and the spray of the sea. In style and subject matter, this fresco is wholly Minoan. There is ample evidence of Minoan influence on local vase painters too, again in terms of style and subjects.

The Minoan Thalassocracy

So distinctly Minoan are some of these features that it can be stated with reasonable certainty that Minoans lived at Phylakopi, some as traders, some perhaps as administrators, some certainly as builders and artists. A similar situation occurs on the islands of Rhodes and Kythera, and at Miletus the evidence for a Minoan presence is particularly strong. In and around a courtyard archaeologists have found altars and storage and cult buildings of Minoan type, decorated with frescoes in Minoan style. Tablets written in the Minoan Linear A script and large quantities of Minoan pottery have also come to light. It is possible, then, that there may be some truth behind the report by the fifth-century BC historians Herodotos and Thucydides that Minos, the legendary ruler of Knossos, developed a thalassocracy (control of the seas). It is worth recalling how widespread the popularity of Kamares ware pottery was. LM I pottery also enjoyed a wide vogue, being exported to Cyprus and Egypt, as well as to mainland Greece, Aegina, Thera, Naxos, Keos, and Melos.

Pottery

Cycladic potters continued producing vases until around 1450 BC, becoming more and more influenced by Crete. The beak-spouted backward-leaning jug, equipped with "breasts," a hallmark of MC, continued to be made, though it now became more globular in shape. The "askos," a baggy-shaped, low pouring vessel, stayed in production, as did spouted jars and singlehandled jugs. However, at the same time the rhyton and some varieties of cup shapes were introduced from Crete. Birds remained popular as decorative emblems, supplemented now by Minoan-

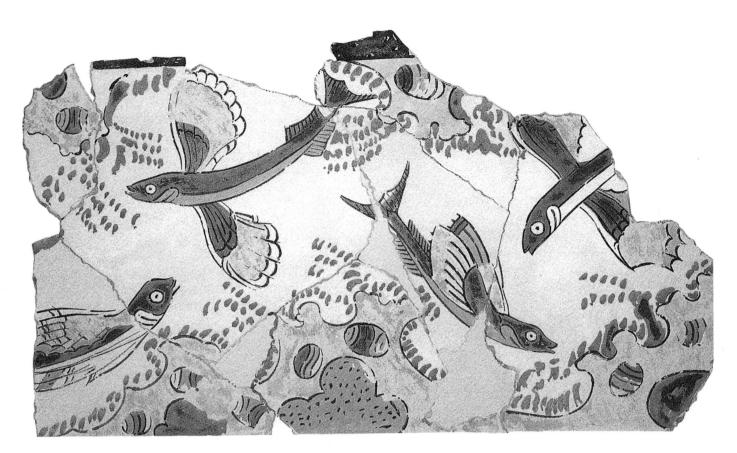

3.28 Restored wall painting showing flying fish, from Melos. LB I. Fresco. National Museum, Athens

3.29 Above Cup, from Thera. LB I. Height 4¼ ins (11 cm). National Museum, Athens

3.30 *Right* Jug, from Thera. LB I. Height 17 ins (43.5 cm). National Museum, Athens

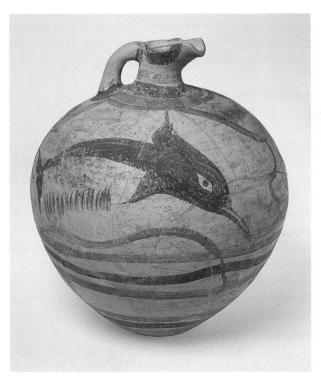

inspired marine and vegetal motifs (fig. 3.29). The plump-bodied jug (fig. 3.30) from Thera introduces a Cretan marine motif, the dolphin, uncharacteristically bold-eyed, however, and sharp of snout.

Thera

New evidence for the Cyclades has come from excavations at the site of Akrotiri on Thera. Much of a LC town, shrouded in the debris discharged by a volcanic eruption that changed the shape of the island, has been excavated. It has justly been called an Aegean Pompeii. As to architecture, houses are two-, three-, and four-roomed with plenty of windows for light and air and have adjoining walls. Some are several stories high. Streets show little organization. No "palace" or similarly imposing building has yet come to light. Nonetheless, there is clear evidence of Minoan presence in the extensive use of pier-anddoor construction and light-wells, and in the lustral basin in the house known as Xeste 3.

Lower levels at the site, surprisingly, show no contact with Crete and Greece in the third millennium. MC Akrotiri, however, has yielded Kamares pottery from Crete and matte-painted pottery from the mainland. The site was destroyed by earthquake in MC III at about the same time as the MM III destruction of Knossos.

As to wall paintings, the scrupulous excavation of the LC town has allowed the reconstruction of entire rooms. The techniques, colors, and conventions of the paintings are similar to those on Crete. Some themes are entirely new - children boxing, antelopes - while others emulate Crete - the appearance of blue monkeys, for example. One painting shows a young priestess (fig. 3.31) wearing a long, heavy garment, earrings, bracelets, a necklace, an elaborate coiffure, and carrying a clay incenseburner. In another, more Minoan in tone, people are absent and all three of the preserved walls celebrate nature - polychrome rocks, vigorous bichrome lilies, and mating swallows (fig. 3.32). Pottery at Akrotiri, both local and imported, is a poor match for this blaze of wall painting. As with the pottery, however, the origins of the wall-painting traditions remain

3.31 Portrait of a priestess, from Thera. LB I. Fresco. National Museum, Athens

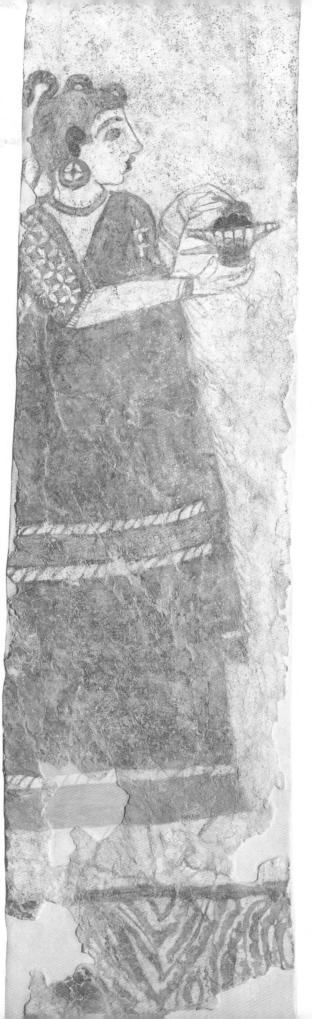

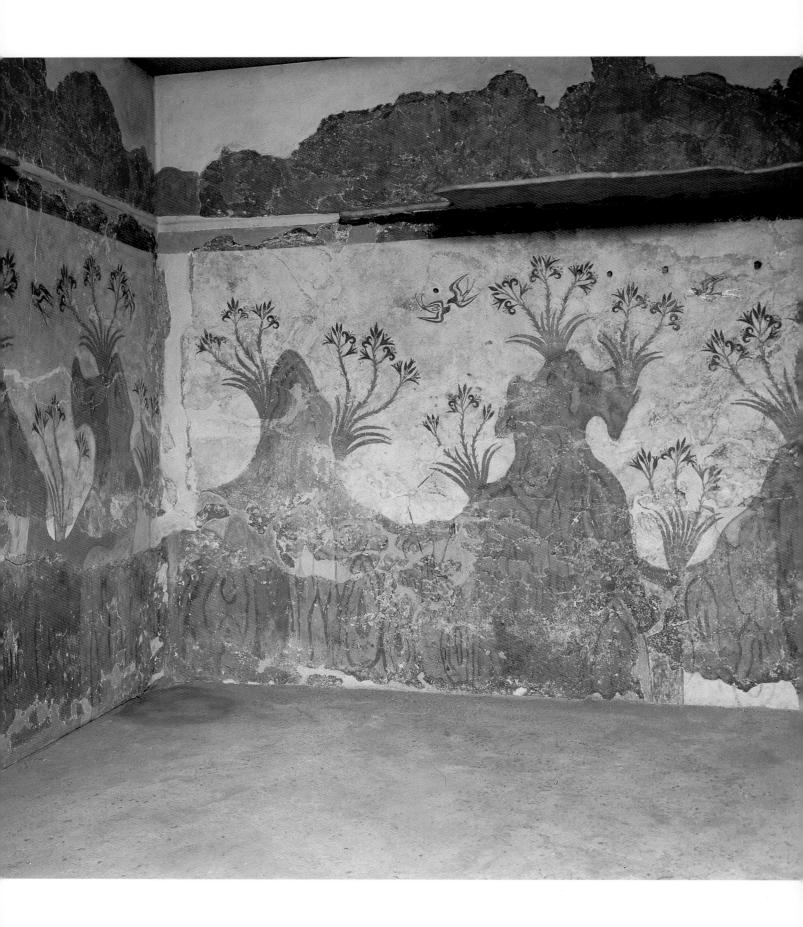

enigmatic. How strong the local Cycladic elements are, and how strong the influence of Crete was in the culture of Akrotiri, is debatable, but there is little doubt that the site reflects Minoan culture at its height.

The Volcanic Eruption

Recent geophysical and geological research has clarified the progress of events. The inhabitants were not unaware of the dangers around them: the countryside was dotted with hot springs, landslides were common, and an earthquake had damaged Akrotiri some sixty years before the eruption. The first volcanic signal was an ash discharge which settled as a thin layer over the south of the island. Some Therans left, but then came a period of quiescence, sufficient to encourage some to return and begin the clean-up and repairs. The big blast followed. Earthquakes shook the island and a plume of gas loaded with PUMICE and ash shot up to an altitude of about 22 miles (35 km). Pumice and ash settled back down at a rate of about 1 inch (3 cm) a minute, burying houses, covering the whole island, and instigating a general exodus. Then the middle of the island caved in, the sea rushed into the yawning mouth of the volcano and a tremendous explosion ensued. Thunderstorms crashed out from the plume, accompanied by sheets of rain, falling volcanic debris, and huge stone boulders blasted from the volcano's mouth. Flows of mud, lava, and rain dislodged the landscape as they made their way toward the sea. The island broke into three: the center disappeared and was replaced by the mouth of the volcano, now flooded by the sea to a depth of some 437 yards (400 m). The depth of pumice and ash that covered the land measured up to 60 yards (55 m). Ash fell most thickly on the islands of Kos and Rhodes to the east, but deposited only about 2 inches (5 cm) on parts of Crete. It did, however, reach as far as the Black Sea to the northeast and Egypt to the south. This was an eruption of gigantic force, double that of the well-known eruption of Krakatoa in 1883.

Did the volcanic eruption of Thera destroy the palaces and other sites on Crete? The chronology

does not support this. According to the excavator of Akrotiri, the eruption took place around 1500 BC. Yet earlier dates, based on tree-ring and radiocarbon dating and going back to 1645 BC, have been proposed, whereas the destructions on Crete are thought to have occurred around 1450 BC. The eruption, with its accompanying aerial blasts and tidal waves, did some damage to Crete, and repercussions in terms of destruction of ships and disruption of trade will have been widespread, but it seems that something yet more dreadful (the Greeks?) was responsible for the calamitous events of around 1450 BC. Research on the island of Mochlos off the coast of Crete has recovered remains of a number of houses, contemporaneous with the palaces in their LM phase. One of these houses is of LM IB date. Beneath the floor, a stratum of volcanic debris from Thera was found, and beneath the ash, pottery of LM IA. Accordingly, LM IA and LM IB appear to be wholly distinct chronologically, at any rate in certain zones of the island. It seems, then, the volcano blew up during LM IA and that Crete continued to flourish during LM IB.

Melos: Phylakopi IV

From the middle of the fifteenth century BC, the Cyclades fell under the influence of mainland Greece. Cycladic pottery styles lost their identity and became submerged in a uniform Mycenaean (Late Helladic) style, which spread right across the Mediterranean. At a number of sites there is evidence of the arrival of Mycenaeans. The fourth town at Phylakopi on Melos, built atop the ruins of Phylakopi III, boasted some houses that stood individually and a dominant central building displaying Mycenaean characteristics: a megaron with flanking corridor and a court in front. This megaron, built in the early years of the fourteenth century, was positioned directly on top of, but was even larger than, the big building of Phylakopi III. Some distance away, a small shrine was built, the finds from which are largely Mycenaean in character and include typical terracotta figurines. A new stretch of fortification wall reinforced the existing system. This is the period (around 1400-1200 BC) when Mycenaean (LH) culture spread right across the Aegean and beyond. Among the first to fall into the mainlanders' sphere of influence were the communities in the Cyclades.

^{3.32} Opposite Landscape with swallows, from Thera. LB I. Fresco. National Museum, Athens

GREECE

The Grave Circles at Mycenae

The transition from MH to LH Greece and from cultural torpor to energetic engagement with other communities outside Greece is marked by the grave circles at Mycenae. There are two: Circle A was discovered by Schliemann in the nineteenth century, and Circle B was unearthed in 1952. Both were originally outside the citadel's wall, but Circle A (fig. 3.33) was incorporated inside when the wall was extended in the thirteenth century BC. A few graves in Circle B are earlier than the royal shaft graves of Circle A, though most are contemporary. In general terms, they cover the period from around 1650 to 1450 BC.

Almost all the graves in these circles are cist or shaft graves. A cist grave is a shallow rectangular grave lined with four stone slabs, with a fifth slab used for the lid. A shaft grave is also rectangular but much deeper, with a floor of pebbles, walls of rubble masonry, and a plank roof some distance below the surface of the earth.

The graves in Circle A are surrounded by a double ring of limestone blocks with rubble between them, capped by flat slabs. The wall surrounding Circle B is of rough stones only. Graves in both circles were marked by upright rectangular limestone blocks called STELAI (sing. STELE), or grave markers, some of which were sculpted. Grave Circle B, some 142 yards (130 m) west of the Lion Gate (the main entrance to the citadel in the thirteenth century BC), consisted of twenty-four graves, of which fourteen were shaft graves, similar to those of Circle A, one was a stone-built vaulted tomb, and the others simple MH inhumations in cist graves. Funerary gifts in Circle B were poorer than those in Circle A. The extent to which the materials from these graves were imported or influenced by imports or imported craftsmen – especially from Crete – remains a lively topic.

Grave Circle A enclosed six shaft graves, of which grave IV, the largest, measured about 21 feet 3 inches (6.5 m) in length and about 13 feet 6 inches (4.1 m) in width. Nineteen people in all were buried in these graves, from two to five in each shaft – men, women, and children. It is the funerary gifts that take one's breath away in a great blaze of gold and weaponry. There are gold masks laid over the faces of the dead (fig. 3.35) – their individuality suggests attempts at portraiture – gold signet rings with scenes of human combat and the hunt (fig. 3.34), a gold lion's-head rhyton, gold panels to decorate a wooden box, gold cups, and gold jewelry of every

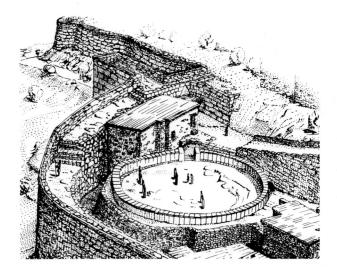

3.33 Reconstruction of Grave Circle A, Mycenae, c. 1650–1450 BC, and extension of fortification wall, c. 1250 BC

3.34 Signet rings, from shaft grave IV at Mycenae. LH I. Gold. Diameters 1%, 2 ins (3, 5 cm). National Museum, Athens

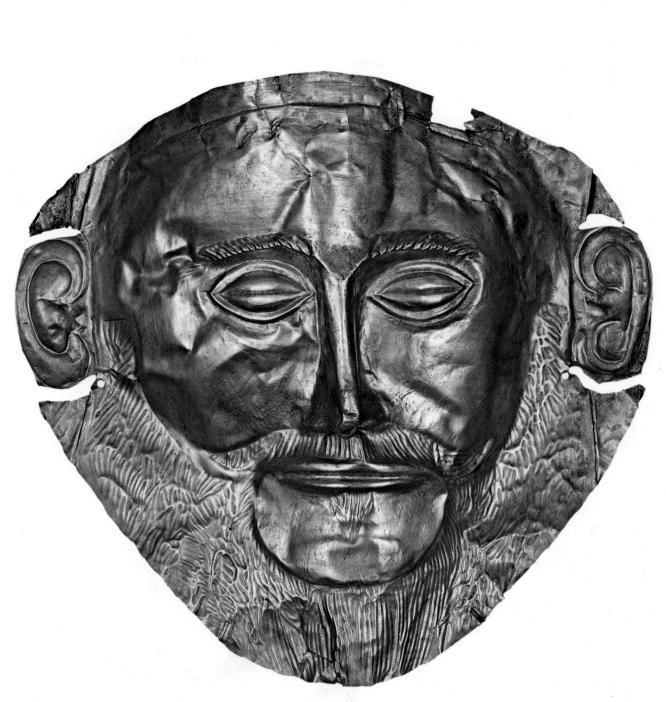

 $\bf 3.35\,$ Mask, from shaft grave V at Mycenae. LH I. Gold. Height 10½ ins (26 cm). National Museum, Athens

>

3.36 *Right* Dagger blades, from shaft graves IV and V at Mycenae. LH I. Bronze, with gold, silver, and NIELLO inlay. Length 6%, 9%, 8% ins (16.3, 23.8, 21.4 cm). National Museum, Athens

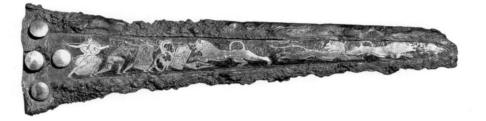

description: earrings, diadems, pendants, armbands, legbands, beads, and cut-out ornaments sewn to the garments of the dead. Other dazzling gifts include ornate ceremonial daggers (fig. 3.36) decorated with scenes of the hunt, or lions, or with NILOTIC (riverlife) scenes made in a technique thought to be derived from Syria, and a bull's-head rhyton made of silver, with nostrils, horns, and ornamental rosette of gold. Lastly, there were the instruments of war: many great bronze swords, over 3 feet (1 m) long, of both slashing and thrusting varieties.

The sudden accretion of this wealth to Mycenae remains problematic. The weaponry underscores the people's warlike nature, so the wealth may have come from direct pillage or mercenary activities. Some commentators think that Mycenaean Greeks fought as mercenaries in Egypt c. 1550 BC and that they were paid in gold. This notion offers one possible explanation of their wealth, and might also explain the Egyptian influences, such as the Nilotic scenes, which appear in some of the grave goods. It does not seem to imply new peoples in Greece, since there are no archaeological interruptions on sites.

3.37 *Right* Three-handled amphora, with panelized marine ornament, from Kakovatos. LH II. Height 30³/₄ ins (78 cm). National Museum, Athens

There may have been commerce with the north, suggested, for example, by the presence of Baltic amber in Grave Circle A. What is certain is that Minoans played a part in creating the artefacts that enriched the Mycenaeans' lives. The bull's-head rhyton was obviously inspired by Crete. The Minoan motif of the "flying gallop" is found both on a ceremonial dagger and on gold panels. The figures hunting lions on a ceremonial dagger are clean-shaven and narrow-waisted in the Minoan tradition. Yet there is much that is non-Minoan, too: masks for the dead, scenes of combat and hunt, and mainland vase shapes. Minoan craftsmen probably exported their objects for the new market at Mycenae, executed commissions for Mycenaeans requiring their own kinds of objects and decorated scenes, and also trained Mycenaean apprentices.

The oldest pottery in the grave circles is Minyan and matte-painted ware of the MH tradition. During LH I–II, Cretan shapes and ornaments flooded into Greece, though the exuberant naturalistic motifs of LM IA and IB seem to have lost vitality in the transfer (fig. 3.37). Vessels painted with such decoration appear in the shaft graves, and it seems inescapable that Minoan pot-painters were at work in Greece.

Two characteristics of this phase of LH culture, then, are continuity from the MH world and a mix of foreign and mainland ideas in its arts and crafts. A third is the clearly defined appearance of a stratified society, the elite of which enjoyed great personal wealth, strong physiques, and a propensity for battle.

Architecture and Wall Painting

Although little evidence of settlement architecture exists for the period around 1550–1400 BC, pottery proves that settlement was widespread and dense. The Mycenaeans' ability to capture Knossos in about 1450 BC is also an indication of the size of the population and their power.

Mycenae Mycenae (fig. 3.38) commands the plain of Argos. It was not just a palace, for houses were also protected by the massive fortification. Yet most of the town lay outside the wall (fig. 3.39), which did

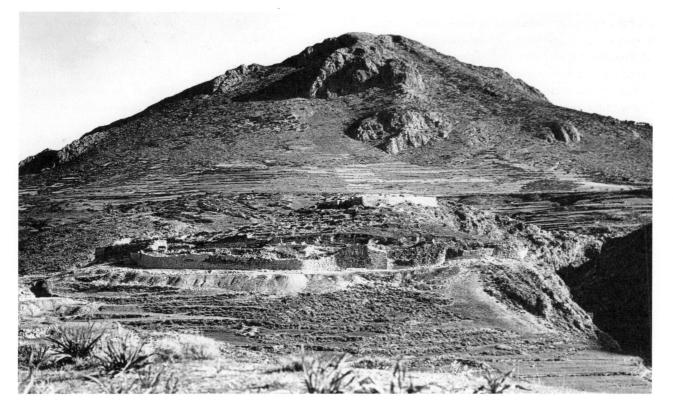

3.38 The citadel, Mycenae, from the south

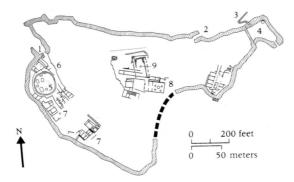

3.39 Plan of the citadel, Mycenae. 13th century BC

- Lion Gate
 Postern gate
 Steps to cistern
 Northeast extension
 Grave Circle A
 Ramp up to palace
 Houses
 Palace
- 9 Later Geometric period Greek temple

not originally include the Lion Gate or the northeast section. The former was added in about 1250 BC, when the wall was extended to include Grave Circle A. Fifty years later, the wall was further extended in a loop at the northeast corner to guard the water supply. Built partly of roughly dressed, but carefully fitted, CYCLOPEAN masonry (blocks so large that it was believed that only the giant Cyclopes could move them!), and partly of coursed ashlars, the wall is almost 20 feet (6 m) thick and follows the lie of the land. The Lion Gate defended the citadel's entrance by projecting a bastion forward some 15 yards (14 m) on one side, so that an advancing enemy would be vulnerable. The gate itself consists of four massive blocks: threshold, LINTEL, and jambs. The lintel alone is said to weigh around 20 tons. On top of this sat the thin triangular block, only 27½ inches (70 cm) thick, depicting the lions. The empty space behind the triangular block (fig. 0.11, p. 19) is termed a RELIEVING TRIANGLE, since it relieves the lintel of unnecessary weight. There is large ashlar masonry on either side. A small POSTERN gate to the north echoed the plan of the Lion Gate, while the north-east extension safeguarded the underground passage, which ran beneath the wall, before zigzagging down in sawn limestone steps to the subterranean cistern far below.

The palace was sited on top of the hill. It is a good example of a mainland megaron: rectangular in shape, with the entrance in the center of the short side, a porch with two columns IN ANTIS (i.e. between the antae, the broadened ends of walls), a vestibule, and a larger room equipped with a throne, a hearth, and columns. A corridor flanking the megaron to the north gave access, while a court in front could be approached either directly or by a staircase to the southwest. There are similarities between Homer's description of the palaces of his heroes and this. His "aithousa," "prodomos," and "domos" find correspondences in the Mycenaean porch, vestibule, and throne room. The differences between Minoan and Mycenaean halls, however, could not be more pronounced. The Minoan type is infinitely expandable, using pier-and-door construction to this end, and welcoming light and air. The Mycenaean type, on the other hand, is immutable and static and puts warmth before ventilation.

Outside the palace, on the slope of the hill within the fortification, was a shrine area, equipped with female terracotta figurines and coiled terracotta snakes. One room was decorated with frescoes, including a painting of an elegant lady, about halflifesize, holding what have been interpreted as wheatsheaves; other motifs included the Minoan "horns of consecration." Another room contained LH IIIB vases, partly worked ivories, and a cult area. As in the Cretan palaces, places of religious worship in Mycenae were not accorded great visible prominence.

The princes who lived in the palace at Mycenae obviously required that their tombs should also reflect the glory of their lives, for a new kind of tomb appears there. This was a specially built, domed chamber, sometimes termed a beehive tomb or a tholos. It appears first in Greece, in the western Peloponnese, in the mid-sixteenth century BC, and arrives at Mycenae around 1500 BC. Its origins are obscure. Some say it may have developed from the circular tombs of the third millennium in Crete. Others maintain that tholoi are translations of the native chamber tombs into more lasting form. Yet another view argues that the dome of the tholos represents in miniature the vault of the heavens over the open precincts of the graves, as at the grave circles at Mycenae.

There is a sequence of nine tholoi at Mycenae, of which the mistakenly named "Treasury of Atreus"

provides the best-preserved example (fig. 3.40). It was built around 1250 BC on a hillside and is approached by a long passage about 114 feet (35 m) long and 19 feet 6 inches (6 m) wide, cut out of the rock and lined with ashlar walls. The door, almost 16 feet 6 inches (5 m) high, tapering inward toward the top, gives access to a corridor beneath two massive lintel blocks, which leads to the vaulted interior (fig. 3.41). A relieving triangle above spared the lintels the gigantic weight of the superstructure. The interior measures nearly 48 feet (14.5 m) across and is 43 feet (13.2 m) high. It has a corbeled dome, built of cut masonry within the contour of the hill at the lower courses, and then, when the dome emerged above the ancient surface, it was continually buttressed on the outside by earth.

Against the façade stood engaged columns in red and green marble, the half-columns appearing to project from the wall – a pair in red above a larger pair in green (fig. 3.42). Those below were carved with Minoan chevron and spiral motifs and supported capitals, which were also of Minoan type with similar decoration. This façade brings to mind the façade of the north end of the central court at Phaistos (fig. 3.9). The functional, heavy Mycenaean stone architecture contrasts strikingly with the ornamentalism of the Minoan decorated

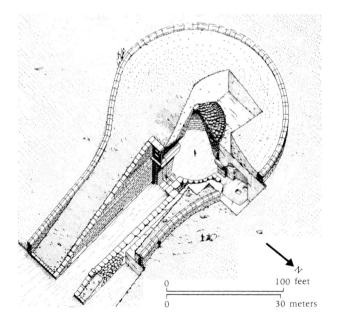

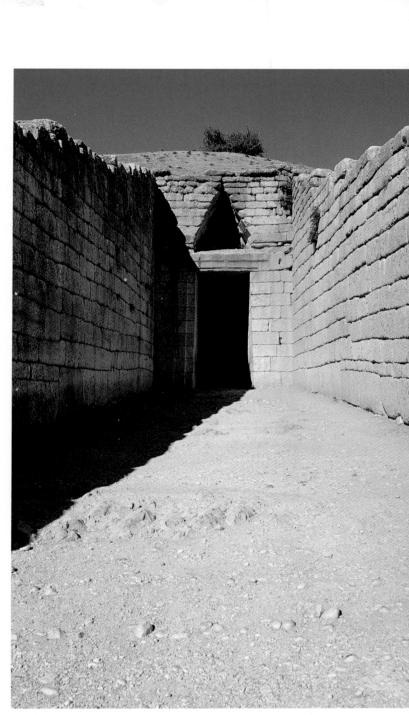

3.41 Treasury of Atreus, Mycenae. Approach passage, door, and relieving triangle, from the east. LH IIIB

3.40 Isometric drawing of the Treasury of Atreus, Mycenae. c. 1250 $_{\text{BC}}$

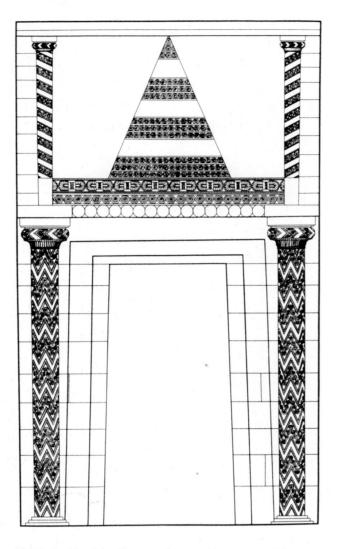

3.42 Façade of the Treasury of Atreus, Mycenae. c. 1250 BC

columns, designed originally for spacious courts and halls, and here slapped unceremoniously onto the exterior of the Mycenaean tomb as a decorative counterweight. This shows another striking contrast between Mycenaean and Minoan attitudes to architecture. Mycenaeans favored what might be termed a MEGALITHIC possession of space, using massive, irregularly shaped blocks in the construction of their fortresses, and what might be termed a megalomaniac enclosure of it in their tombs. Minoans, by contrast, treated space flexibly in unfortified palaces, which were almost whimsically expandable in their exteriors, and labyrinthine in their interiors. **Tiryns** At the other end of the plain of Argos from Mycenae stood the fortress of Tiryns (fig. 3.43). Located close to the sea in a position of no great geographical prominence, Tiryns enclosed an area of some 5 acres (2 ha.) in a circuit of walls about 766 yards (700 m) long.

What remains of these walls dates from the thirteenth century BC. They are built of Cyclopean or ashlar masonry, as at Mycenae. Within the fortress, in the lower citadel to the north, excavation has revealed considerable construction of LH IIIB-C date, including a number of shrines and provision for access to two underground cisterns. As at Mycenae, the water supply was the vulnerable point. To the south, a well-preserved megaron of the thirteenth century BC is approached by a winding route. The tripartite megaron is flanked by a smaller one. The planners evidently enjoyed doubles: there are also two gates with narrowed approaches, and two PROPYLA (sing. PROPYLON) - monumental columned gate-houses - linking three courts. Massive vaulted galleries (fig. 3.44) supported bastions in the walls. A large porticoed courtyard stood in front of the megaron, and frescoes decorated the walls. Tiryns emerges as the finest extant example of Mycenaean military architecture. It is a large, suitably decorated megaron with dependencies, spacious columned courts, and monumental gatehouses. And it is all systematically arranged within a carapace of Cyclopean galleries, bastions, and walls.

Pylos The palace at Pylos in the southern Peloponnese seems rural by comparison. Built, lived in, and destroyed within about a century, perhaps around 1300-1200 BC, it was unfortified. There was a megaron, preceded by a court and a single-columned entrance (fig. 3.45). By the entranceway is the archive room where the Linear B tablets were found. The domestic unit to the west was probably the earliest to be built and lived in, while the separate unit to the east consisted of a shrine and a repair depot for chariots, armor, and weapons. Walls were built mostly of rubble, with much timber framework and tiebeams. Timber was also used liberally for ceilings and columns, while ashlar limestone blocks were adopted for wall exteriors and reinforced corners. Floors were of plaster, often decorated with abstract patterns. Interior walls were also heavily plastered and richly painted, and it is Pylos that has

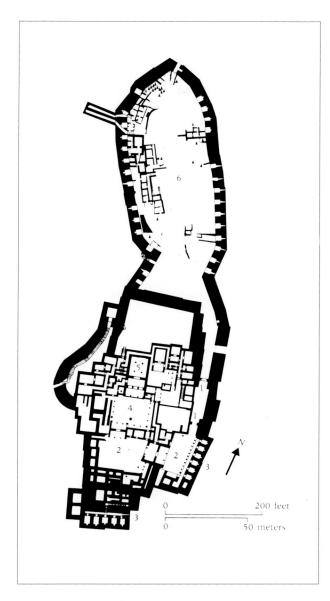

3.43 Plan of the citadel of Tiryns. 13th–12th century BC

- Gates
 Propyla
 Vaulted galleries
 Courtyard
 Megaron
 Lower citadel

3.44 Tiryns, vaulted gallery in southeast bastion of citadel wall. LH IIIB

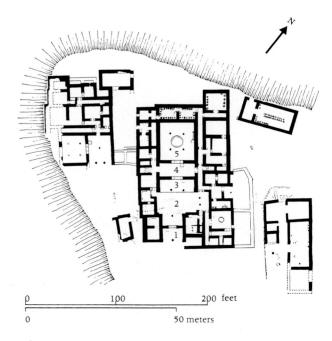

3.45 Plan of the palace at Pylos. 13th century BC

- 1 Propylon
- 2 Court
- 3 Porch
- 4 Vestibule
- 5 Hall

yielded the most information we have about Mycenaean frescoes.

The fresco painters evidently drew on Minoan sources for some of their motifs. These included cycles of processions, architectural façades, court figures chattering, mythological beasts (fig. 3.47), musicians, and even bulljumping. Figures, on the other hand, seem stiffer and less free, just as Minoan motifs on pots had become more rigid by this time. Some scenes, moreover, are wholly Mycenaean in flavor. Scenes of the hunt and of humans in combat (fig. 3.46), bizarrely falling about against multicolored backgrounds, find no parallels in Crete and are characteristically Mycenaean.

Destruction c. 1200 BC The prince at Pylos came to regret the absence of fortifications, for the site was destroyed by fire and the sword shortly after 1200 BC. Mycenae and Tiryns were luckier; they were badly damaged by earthquake, according to evidence discovered by the excavators, but continued to function. Both were extensively rebuilt and reoccupied,

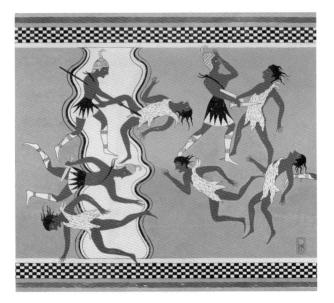

3.46 Reconstructed wall painting showing warriors, from Pylos. LH IIIB

though it seems that the palaces and their bureaucracies disappeared and that the townships were organized otherwise politically in the twelfth century BC. Many other sites were destroyed, while some were simply abandoned.

Sculpture and Pottery

Sculpture In Grave Circles A and B at Mycenae, the whereabouts of shaft graves was signaled by stelai (fig. 3.33). Some of these, though not all, were decorated with relief sculpture. The topics represented were typically Mycenaean (the hunt, warfare) and may have been intended to suggest the favored pastimes of the deceased.

The most impressive instance of the Mycenaean sculptor's skill is the famous relief after which the Lion Gate is named (fig. 0.11, p. 19). Created around 1250 BC, the relief is almost 10 feet (3 m) high, and shows a pair of lions or lionesses, in profile view, arranged heraldically on either side of an architectural column which supports the abbreviated ENTABLATURE (i.e. the horizontal members of the superstructure of the building). The column stands, as do the front feet of the animals, on a pair of Minoan altars, similar to one found at Arkhanes on Crete. The lions' heads, worked separately in a pre-

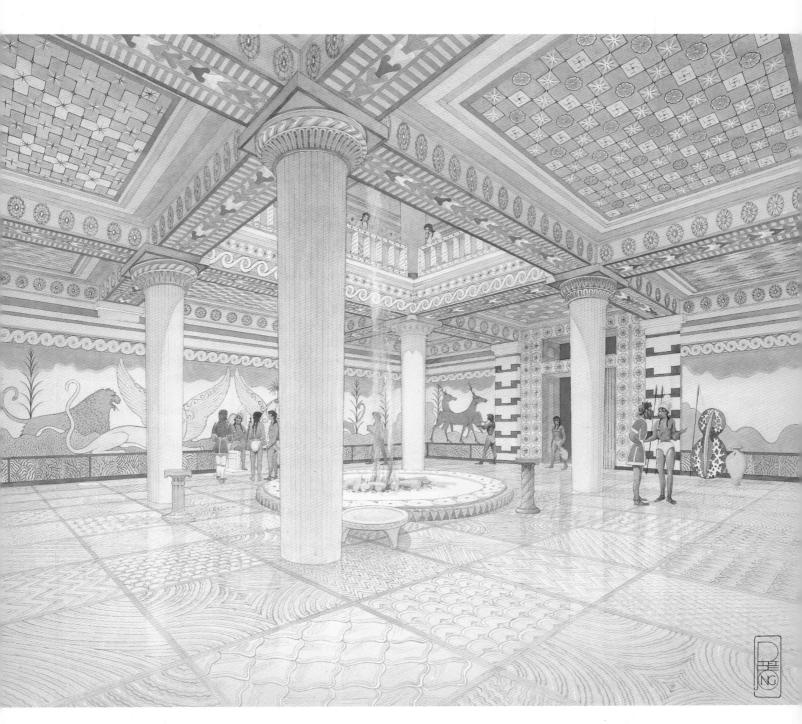

3.47 The palace at Pylos. Reconstruction of the hall of the megaron showing the columns, hearth, and throne. 13th century $_{BC}$

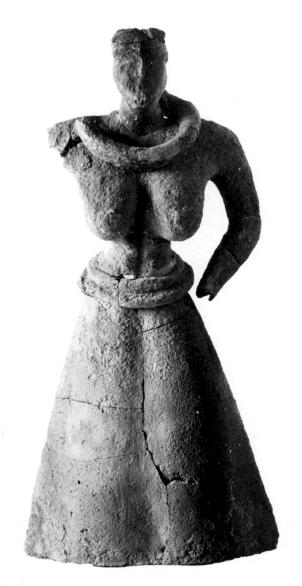

3.48 Female figure, from Keos. LH II. Terracotta. Height 38 ins (98.8 cm). Keos Museum. Courtesy of the University of Cincinnati

cious material and fixed on by means of tenons, are now lost. There are similar scenes on Minoan gems and seals, but the lion is characteristically a mainland motif, and the enlargement from a miniature scale on the Lion Gate would thus appear to be the work of a Mycenaean. Nothing has survived in Crete to challenge the successful marriage of architecture and sculpture exemplified by the Lion Gate, the earliest example of monumental Greek sculpture to have come down to us. It is surprising that no trace has yet emerged of commemorative sculpture or historical reliefs, given these autocrats' enthusiasm for mighty architectural statements in their citadels and tombs.

A sanctuary on the island of Keos, just off the coast of Attica, has yielded fragments of numerous (perhaps as many as fifty) terracotta female figures, which range in height from about 27¹/₂ inches (70 cm) to almost lifesize (fig. 3.48). Traces of color on the surface show that they were brightly painted in white, red, and yellow. Some may date from as early as the MB Age, others from the fifteenth century BC. Most wear a flattened skirt and a heavy belt, baring their breasts. Proportions, shapes, and garments call to mind their Minoan counterparts. Yet similarly attired and proportioned figures appear in mainland frescoes, as for example at Pylos in the thirteenth century BC. Though the Keos sanctuary was destroyed around 1400 BC, the head of one of the figures was used again in a shrine of Dionysos on the same spot in the eighth century BC. Thus, the religious function of this site continued into the Dark Age, and the sanctity of the Bronze Age image was preserved for centuries.

From Mycenae came the painted plaster head of a female, perhaps a sphinx (fig. 3.1), dated to the thirteenth century BC. Almost lifesize, it was first painted white and then enlivened by bright reds and blues. Her hair is bound by a red fillet and her eyes are blue like those of the warlike goddess Athena, as described by Homer. Her hat is pale blue. Cosmetic beauty spots decorate her cheeks and chin with dot rosettes; her mouth is scarlet. The coloring is dramatic, while hypnotic eyes and sardonic mouth create a distinctive, even fearsome, impression. The terracottas from Keos and the head from Mycenae are the only examples of large-scale sculpture in the round to have survived.

On a smaller scale, ivory was a popular medium. There are small figurines and groups of figures but most carved ivories are in relief and were used for cosmetic boxes, mirror handles, furniture inlays, and other *objets de luxe*. Topics chosen for decoration include sphinxes, griffins, combats, and a warrior wearing a boar's-tusk helmet like that described by Homer (*Iliad* 10.261–5).

Also on a small scale is the lead figure of a youth from Laconia (fig. 3.49) normally dated to the fourteenth century BC. Dress and proportions are Minoan, but the gesture, with the hands held horizontally, the detailed treatment of the facial features, and the quizzical smile suggesting individuality, are not. Moreover, though the Mycenaean figure adopts the posture of the Minoan types (fig. 3.12), he seems quite different from his Minoan counterparts. For the Minoans, the contour was like a restless arabesque, to be valued for itself and for its quality of motion. For the Mycenaeans, however, it defined the volume of the figure. The Minoan figure moves in space, while the Mycenaean figure seizes it.

By far the commonest examples of Mycenaean sculpture are the terracotta female figurines (fig. 3.50) of the fourteenth and thirteenth centuries BC. They have been found far and wide at Mycenaean sites – both in houses and tombs – all the way from South Italy to Syria. They range in height from about 2 inches (5 cm) to 5 inches (13 cm). There are two principal types of figurine, named "psi" and "phi" after the letters of the Greek alphabet that they resemble. Psi figurines hold their arms aloft, phi hold theirs lowered in front of them. A triangular head sits atop a circular or "lunate" torso, supported by a cylindrical stem. Details such as clothing, hair, the nose, and eves are added in paint; pellets of clay represent breasts. Occasionally, a figurine is portrayed cradling a child. These highly stylized, diminutive, doll-like figurines are a far cry from contemporary figures in ivory or bronze, and can barely be called works of art. There is nothing Minoan about them, and their popularity marks them as distinctively Mycenaean. They were made by the same artisans who created the pottery.

Pottery The pottery of the period LH IIIA and B (c. 1400–1200 BC) is known for its sparse decoration and fine fabric. Technically it is sophisticated, if aesthetically humdrum. It was exported all over the Mediterranean and enjoyed a wide vogue. Shapes became uniform and were endlessly repeated: tall-stemmed drinking cups (KYLIKES) (fig. 3.51), tankards, STIRRUP JARS (fig. 3.52), so-called from the stirruplike handle next to the spout, KRATERS (mixing bowls), and ALABASTRA (ointment containers) were popular. Decoration became repetitive: the naturalistic motifs of LH II (fig. 3.37), which were already constrained, became more and more rigid, until they were reduced to severe abstractions. Horizontal bands of paint began to dominate the surfaces.

The transition from LH IIIB to LH IIIC (1200–1100 BC) is marked by the Warrior Vase (fig. 3.54), a

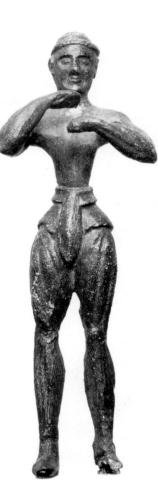

3.49 Figurine of a youth, from Laconia. LH IIIA. Lead. Height 4³⁄₄ ins (12 cm). National Museum, Athens

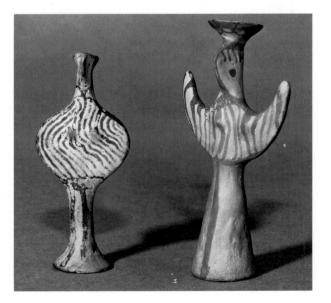

3.50 'Phi' (*left*) and 'psi' (*right*) figurines, perhaps from Melos. LH IIIA. Terracotta. Height 3 ins (8 cm). British Museum, London

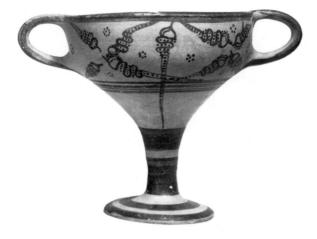

3.51 Stemmed cup, from lalysos. LH IIIA–B. Height 6 ins (15.5 cm). British Museum, London

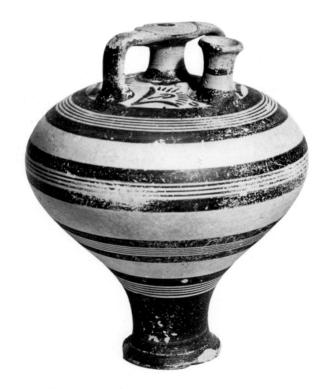

3.52 Above Stirrup jar, from Aegina. LH IIIA–B. Height 7^s/₄ ins (20 cm). Ashmolean Museum, Oxford

3.53 *Right* Stirrup jar. LH IIIC. Height 10¼ ins (26 cm). Metropolitan Museum of Art, New York, Louisa Eldridge McBurney Gift Fund

Pictorial Style krater from Mycenae. It is a unique example from this era of narrative decoration of a vase. It shows a line of armed warriors marching in single file and in somber mood to the right, while a woman at the left bids them farewell. The standardization of shapes and decoration of the two preceding centuries now breaks down, and though shapes remain largely unchanged in LH IIIC, the period is characterized by variety of decoration, of which there are two major styles: the Granary Style and the Close Style.

The Granary Style, named after the building at Mycenae where it was first found, hardly catches the eye. It is a style of restricted imaginative scope, consisting almost exclusively of horizontal dark bands and the occasional wavy line. The Close Style, on the other hand, covered the surface with closely packed, crosshatched net patterns or files of swans and other water-happy birds. The octopus came to the fore again, sometimes a melancholy reflection of his vigorous LM IB predecessor, and sometimes more flamboyant and accompanied by other ocean denizens (fig. 3.53). There is a bizarre exuberance about this style, the last gasp of the Mycenaean world before the end of the Bronze Age.

3.54 Warrior Vase, from Mycenae. LH IIIB-C. Height 16 ins (41 cm). National Museum, Athens

TROY AND THE END of the bronze age in greece

The palace at Pylos was violently destroyed around 1200 BC. At about the same time, it seems that Athens was attacked (houses at the foot of the Acropolis were destroyed), and Mycenae and Tiryns were felled by earthquake. Many other sites perished or were abandoned, though some, including Athens, Lefkandi, and Nichoria in Messenia, survived. Greece entered a period of uncertainty, in which populations moved away from vulnerable areas, going either inland (for example, to Achaia in the Peloponnese), or to the coast, or to the islands, or to Cyprus. All this destruction and upheaval occurred in the context of a wider disturbance in other Mediterranean lands. Toward the end of the thirteenth century BC, Egypt came under attack from the "Sea Peoples," about whose identity there is no agreement. In an inscription of 1208 BC, however, the fifth year of the Pharaoh Merneptah, they are named as Shardana, Lukka, Meshwesh, Teresh, Ekwesh, and Shekelesh. But we do not know where they came from, nor whether they were conquerors, refugees, deserters, or buccaneers. Attacks were repeated in the twelfth century BC. Meanwhile, the Egyptians and Hittites were at one another's throats, and warfare continued intermittently between them until the Hittite empire collapsed in the twelfth century BC. The Hittite records speak of the Ahhijawa, taken by many to be Greeks, making a nuisance of themselves in Asia Minor, and it is possible that they may have been involved in the destructions that overtook both Troy VI and Troy VIIa.

Recent work at Troy has dramatically changed our understanding of the site. There were large structures built up against the outside of the citadel wall from early in the Troy VI phase, and surface scatters of Troy VI pottery reached as far as 437 yards (400 m) southward. The magnetometric survey of the zone suggested the subsurface existence of further structures and a deep ditch to protect them (fig. 3.55). The existence of these buildings and of the rock-cut ditch was confirmed by excavation in 1993. This zone accordingly turns out to have been the Lower City, and the site hitherto known as Troy was its fortified citadel. No trace of a fortification wall for the Lower City has come to light and, given the existence of the ditch system, a defensive wall may not have been thought necessary. It seems that there were two ditch systems, one of the fifteenth and the other of the twelfth century BC, and that the earlier included a gate and a palisade in front of the ditch. The Mycenaean pottery found here is both of better craftsmanship and more plentiful than that in the citadel itself: this may suggest frequent contact with the Aegean world, so that it is surely in this Lower City that more information about ancient Troy is to be found. What functions did buildings here perform? Are there commercial or administrative documents to be found, similar to the Linear B tablets of the Mycenaean world or the tablets of the Hittite archives? Is it time to think of Troy less in terms of Homer and legend, and more as a Hittite commercial center?

The new work has extended the area of the whole site from the 4 acres (1.60 ha.) of the citadel to some 49 acres (20 ha.). It transpires, then, that the site known as Troy was one of the largest fortified cities of the Aegean Bronze Age, easily the equal of Mycenae, and far larger than Tiryns.

It was chronologically after a few Greek pots of the LH IIIB style had reached Troy that the citadel of Troy VI was destroyed. The fortification wall was damaged and houses collapsed. But the site was not

3.55 Plan of Troy VI/VIIa, showing fortifications

looted, nor was it burned, so that the view that this was the city described in the account of the Trojan War in the *Iliad* is unlikely to be correct. Yet speculation remains, some commentators holding that Troy VI was destroyed by earthquake, others believing that humans were responsible.

It was succeeded by Troy VIIa, a citadel of exactly the same size as its precursor. The disturbed walls of Troy VI were repaired; houses were now squeezed together, sharing party walls and butted up against the interior of the citadel walls. These were new departures in terms of the planning of the citadel, without precedent in any phase of Troy. They suggest that space was in short supply and that people were crowding together. Moreover, uniquely in this phase, pithoi used for the storage of oil and grain were sunk into the floors of houses to save space. Conditions in Troy VIIa were consistent with a city under siege. Accordingly, though we are uncertain about the true facts of the Trojan War and modern thinking takes the view that archaeology can rarely prove specific events, it is possible that Troy VIIa was the city destroyed by the Greeks, an episode firmly embedded in the Greek mind. However, only a handful of pots were imported into the citadel of Troy VIIa, which makes the date of the destruction a matter of controversy. Proposed dates range from around 1260 BC to the end of LH IIIB, but it must at any rate have been before the destruction of Pylos in Greece.

The pottery styles of LH IIIC were thus produced in a period of international political and social uncertainty. The disasters in Greece at the end of LH IIIB were not terminal for Mycenaean civilization, but they were a harbinger. Between about 1200 and 1100 BC, the period during which LH IIIC pottery was produced, the Mycenaean world went into slow decline. There were more destructions and dispersals of people throughout the century, and by the end Lefkandi and Argos, among others, had been abandoned. At Koukounaries on the Cycladic island of Paros, in the course of the twelfth century a settlement was built, and lived in, and burned, and destroyed by human agency. Yet Mycenae and Tiryns continued to be occupied into the eleventh century BC. So the twelfth century BC witnessed both widespread movement of peoples and continued substantial occupation of the old centers of Tiryns and Mycenae. The Mycenaean world was not yielding easily.

The identity of those who wrought havoc intermittently in Greece during this century is a vexed question, to which there may be several answers. The mysterious Sea Peoples may have played a part, especially at sites vulnerable from the sea like Pylos. The myth of the Seven Against Thebes preserves a tradition of war in early times between Greek municipalities, so that civil war may have been an element. The most insistent tradition is, however, of the arrival of a new wave of Greeks, who spoke a Doric dialect. The language of the Linear B tablets contains no such elements, yet in later Greece the Doric dialect is securely established. So it is logical to think of its arrival at the time of the great upheaval, and of Dorian Greeks taking advantage of the weakness of the Mycenaean world. The withdrawal of survivors to villages in the hills, which had begun during LH IIIC, now accelerated. It is in such villages, in the diaspora across the sea, and in Athens, the only one of the great Mycenaean feudal centers to survive, that are found what shreds of cultural continuity survived into the Dark Age.

THE DARK AGE AND GEOMETRIC GREECE c. 1100-700 bc

Using the Bronze Age, three principal cultures were discernible in the Greek world: those of Crete, the Cyclades, and mainland Greece. The third millennium BC was the period of greatest difference between the three. This was followed by an era when Cretan culture was paramount and began to influence the others, and then by a period of mainland Greek supremacy. Accordingly, the archaeological and artistic evidence falls conveniently into major geographical regions.

Such divisions are no longer pertinent after the beginning of the Iron Age, when the evidence of major cultural developments begins to come not only from Greece, Crete, and the Cyclades, but also from further afield – from Asia Minor at first, and later from Sicily and South Italy (fig. 4.2). So it seems best to present the evidence as a coherent chronological narrative arranged in familiar categories – architecture, pottery, and sculpture – but taking in important examples of regional development where they are significant. At first in isolation, and later under influence from the East and Egypt, Greek communities developed separate answers to common problems. One example is the bewildering complexity of the earliest Greek epichoric (regional) alphabets, devel-

4.1 Horse. c. 750–700 BC. Bronze. Height 7 ins (17.6 cm). Metropolitan Museum of Art, New York

oped in the eighth century BC. Another is that of the differing approaches taken by pot-painters to decorating their pots.

Innovation At some point during the eleventh century BC cremation of the dead was introduced at Athens, and sometime during the same century ironworking skills appeared in Greece. We do not know whether these important innovations occurred at the beginning of the Dark Age, but some commentators have suggested that the new practice of cremation burial was connected with the catastrophe at the end of LH IIIC and the appearance of new peoples in Greece. Did the destructions at the end of LH IIIC mark the arrival of Dorian-speaking Greeks, who brought with them the practice of cremation? Were they also versatile enough to work iron, or were these developments entirely unrelated? We cannot say for sure. But we do know that Greece now passed from the Bronze Age into the Iron and, in spite of this watershed event, lapsed into severe decline.

Transition With the destruction of the Mycenaean palaces went the social system of which they were the centers. Kings, subordinates, scribes, and the knowledge of writing all disappeared. With them was also lost the knowledge of masonry and construction using cut blocks, of wall painting, the working of ivory, precious metals, and sculpture in stone. In a

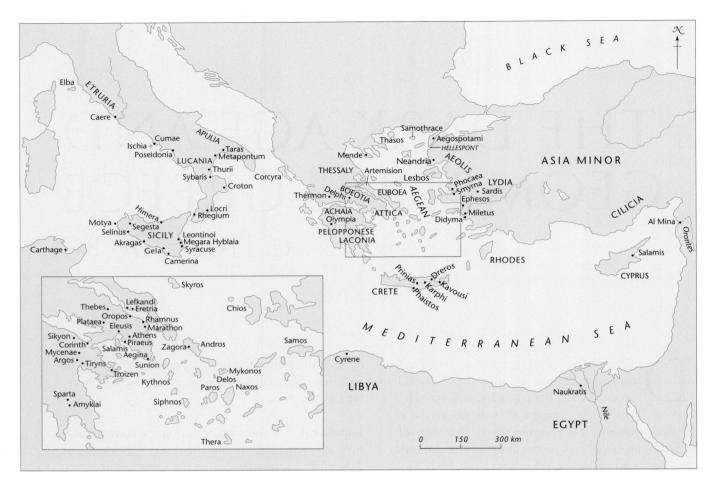

4.2 The Greek world to c. 400 BC

word, all the sophisticated achievements of the Greek Bronze Age vanished. Society was decapitated and then dispersed. Mycenaean survivors made their way inland, to the islands, to Crete, to Asia Minor, and to Cyprus. The so-called Dark Age, a period that was to last some two hundred years, closed in. The revival began slowly in the later tenth century BC and gathered pace during the eighth. This span of two centuries (c. 900–700 BC) is termed the Geometric period, from the mathematically precise way in which pot-painters decorated their vases.

Continuity Little or no archaeological evidence has been found to reveal links between the Mycenaean world and the Dark Age. The Lion Gate at Mycenae stayed visible thoughout, and the shattered remains of fortresses and palaces might have provided some stimulus to architects. However, though echoes of

Mycenaean architecture can be detected in the later Classical temples, in the immediate aftermath there is little evidence of influence. Pottery shows some continuity, of a bedraggled sort, between the Granary Style of LH IIIC and a style suitably called "sub-Mycenaean," which used LH III shapes; but these pots are badly thrown and shakily decorated. After this came a new style, the Protogeometric, in around 1050 BC. Later writers claimed that Athens survived the destructions at the end of the Bronze Age, and a continuous series of graves there, ranging from sub-Mycenaean through Protogeometric in style, lends some support to this. Sculpture in terracotta continued to be made, not so much of the widespread phi and psi types of female figurines as of a LM III "goddess" type on Crete. Peoples, language, and some aspects of religion also survived - to judge by the historical Olympians, some of whom we saw had

appeared in the Linear B tablets (p. 79) – so tenuous strands of continuity may be perceived. The poems of Homer, originally recited from memory by professional bards, and first written down perhaps in the later eighth century BC, contain descriptions of the material world of the Bronze Age (e.g. boar's-tusk helmets, *Iliad* 10.261–5), the Dark Age, and the Geometric period, and to that extent they may be said to connect the periods.

Conditions Most people lived in ramshackle hovels, built of mudbrick and thatch or fieldstones, in small rural communities that were not conducive either to art or architecture. They depended on a subsistence economy and were controlled by landowning aristocracies. No one could read or write. Warfare was endemic, and hostilities between neighbors frequent. Contact with the outside world was spasmodic, though the site of Lefkandi has provided evidence both of an ambitious building project and of imports from abroad (p. 110). Newly excavated sites on the island of Skyros, too, have shown evidence of flourishing communities and of contact with the wider world. Tombs of the Protogeometric period (c. 1050-900 BC) have yielded necklaces of faience and gold jewelry fully the equal of those of Lefkandi. The Dark Age, at any rate in the Aegean islands, is getting brighter all the time.

Then, after three centuries, Greece emerged in the eighth century BC with new political regions. These were the "poleis," independent city-states that were at first controlled by landowning and horserearing aristocrats. They included countryside as well as townships, and were defined by natural frontiers, that is, mountains, rivers, and oceans. The polis of Athens, for example, included all the territory of the peninsula of Attica as far south as Sunion and as far east as Marathon.

Sanctuaries, which varied in size and appearance and are found both inside towns and in the countryside, played an important role in the development of the polis. While they functioned primarily as centers of worship, they also served as places for social and commercial activity. They were meeting places and places of exchange, and some acted as territorial markers. In various ways, then, they served to shape the identity of the polis.

Another great change in the eighth century was the transformation of one or two smallish local sanctuaries into Panhellenic sanctuaries (sanctuaries for all the Greeks). The sanctuary of Zeus at Olympia, where the games began sometime in the course of the century (the traditional date is 776 BC), was one of these. The sanctuary of Apollo at Delphi, where the oracle began dispensing advice, was another.

Populations now grew rapidly. Agriculture and economic conditions improved. Trading centers were set up in the east (in particular Syria) and in the west, where the lure of metals was a powerful magnet. These changes were not, however, equal to the needs of the increasing populations. As the century advanced, more and more Greeks left to seek their fortunes overseas.

ARCHITECTURE

Around 1100 BC, refugees scrambled up to a hilltop in the east of Crete and built themselves a new town on the site of Karphi. The small and congested dwellings were primitive, and the plan (fig. 4.3) shows the random nature of the building. Houses huddled cheek by jowl, apparently uncoordinated in plan. Yet streets or pathways were cobbled and there was both a Great House (the excavators' terminology) with associated courtyard and storage units, and a shrine equipped with altar

4.3 Plan of a section of the settlement, Karphi. 11th century BC. 1 Shrine 2–3 Great House

4.4 Female figurine, from Karphi. c. 1000 BC. Terracotta. Height 26% ins (67 cm). Iraklion Museum, Crete

and terracotta statuettes (fig. 4.4). Crudely constructed tholos tombs provided for the needs of the dead, which some connect with Mycenaean burial practice, while the settlement as a whole shows similarities with LM Gournia. There are some distant echoes of Bronze Age architecture in the Dark Age after all: at least in Karphi. The site was abandoned around 1000 BC.

Recent excavations near Kavousi in Crete promise more information. In one zone, a settlement of LM IIIC (1200–1100 BC), furnished with pottery kiln and a shrine with more statuettes like those from Karphi, provided buildings used in the eighth century BC as a burial plot: no continuity then is visible yet here. In another zone, however, excavation of buildings has shown stratification from LM IIIC through Geometric times, and suggests the site was continually occupied from the Bronze Age through the Dark Age.

In Crete, people made for the hills. From Greece, they made their way across the Aegean to Asia Minor, as well as to the islands and to Cyprus. In Asia Minor, they established coastal settlements which can be recognized from finds of Protogeometric pottery, imported (or brought with them) from Athens, and locally made. One such site is at Smyrna, near modern Izmir. The refugees arrived here about 1000 BC. Excavations have revealed the relics of a small late tenth-century BC house (fig. 4.5). This single-room structure was oval - or double apsidal - built of mudbrick on a stone socle, and probably thatched. It is one of the earliest post-Mycenaean houses yet found, and may hark back to Bronze Age predecessors. The house was built over in the ninth and eighth centuries BC by other houses, all rectangular in plan, which were encircled by a fortification wall, unparalleled in mainland Greece at this time, but again echoing Bronze Age structures.

The discovery of the stone foundations of a large building at Lefkandi in Euboea, and its adjacent cemetery, has given us a glimpse of a richer world. Apsidal in plan (figs. 4.6 and 4.7), the structure was almost 55 yards (50 m) long and 11 yards (10 m) wide. Buried within this huge building were a warrior (cremated), a woman, and a number of horses.

4.5 Plan and reconstruction of an oval house, Smyrna. 10th century BC

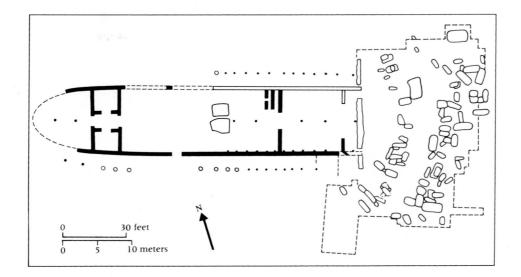

 $4.6\,$ Plan of heroon and cemetery, Lefkandi. Heroon 10th century $_{BC}$ Cemetery 9th century $_{BC}$

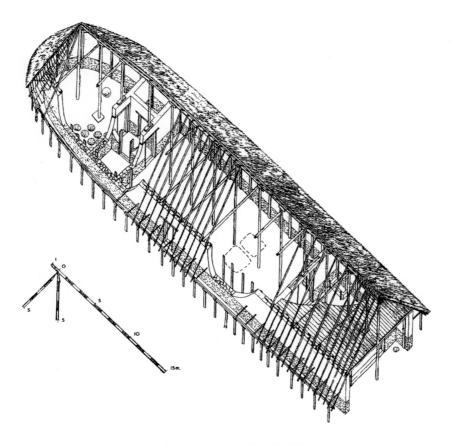

4.7 Reconstruction drawing of the heroon at Lefkandi. 10th century BC

In an age of cavalry warfare, these animals were indispensable for the rich, and were powerful symbols of status and splendor. The size of this tenthcentury building and the burials within suggest that it functioned as a HEROON, a site for the worship of a hero, a semidivine person such as a prince or leader heroized after death. Clustered in an arc around the east end of the heroon was a cemetery with sixtynine tombs and twenty-three pyres. (Both cremation and inhumation were practiced.) The graves were mostly shaft graves. There was another horse burial, and the graves of children were confined to one corner. The whole cemetery is thought to date to the ninth century BC. Bronze and faience bowls imported from the Near East and Egypt were found, revealing contact with these more flourishing cultures. Objects of gold and jewellery also suggest that the occupants of these graves were wealthy and important. This looks like the burial place of a local dynastic family, part warlike, part mercantile, already in touch with the East. Comparable Protogeometric tombs on the central Aegean island of Skyros shed further light on prospering Dark Age communities. Gold jewelry and faience necklaces speak for the wealth of some individuals and for contact with the wider world across the Aegean.

Worship of the gods took place in the open air, in sanctuaries defined only by an enclosure wall and a hallowed spot, sometimes recognized by an altar. Gifts of votive offerings - sometimes tiny terracotta figurines, sometimes more prestigious goods - made in the hope of reciprocal favors from the god, were routine. During the Geometric period the Greeks began to house the images of their gods. A temple of the tenth century BC at Kommos in Crete still has its rectangular plan. An eighth-century model (fig. 4.8), found in the Sanctuary of Hera at Argos, may represent the first temple there. It is rectangular in plan, with a pair of single posts forming the porch, and separate roofing systems for porch and chamber. At Eretria, in Euboea, a diminutive structure, built around 800-750 BC and found beneath a later Temple of Apollo, was probably a temple (fig. 4.9). Horseshoe in plan, the elevation was almost entirely of wood and other perishable materials. A more imposing building, a hundred footer (i.e. a HEKATOMPEDON, one hundred feet [30.5 m] long), was built nearby in the middle years of the century. Both apsidal and rectangular plans echo Bronze Age predecessors.

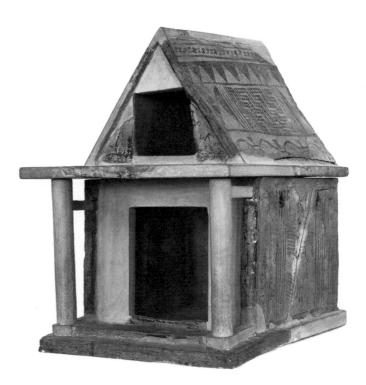

4.8 Model of a shrine, from Argos. Later 8th century BC. Terracotta. Length 14 ins (36 cm). National Museum, Athens

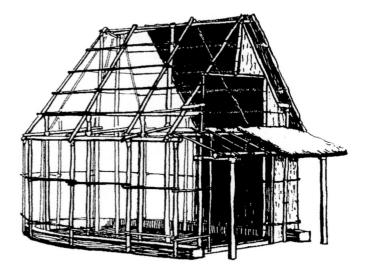

4.9 Reconstruction drawing of early temple at Eretria. c. 800-750 BC

In the rural sanctuary at Kommos the rectangular Temple B (c. 800 BC) is equipped with interior benches and a series (over time) of hearth/altars: here, offerings of bronze and terracotta animal figurines were placed. A small shrine with three taper-

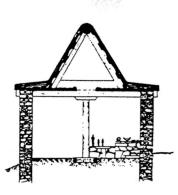

4.10 Dreros temple, Crete. Plan and section. Later 8th century BC

ing pillars, close by the hearth/altar, also received offerings (some Egyptian); this shrine is not only reminiscent of earlier pillar worship on the island (see p. 81) but also readily associated with Phoenician patterns of worship. Remains of the eighthcentury temple at Dreros in Crete (fig. 4.10) which faced north preserve the rectangular plan of a stonebuilt structure, with a central hearth flanked by two stone bases for wooden posts and a bench against the back wall. The Temple of Artemis Orthia in Sparta also has a back wall bench (about 700 BC). Was this bench, on which, at Dreros, three bronze statuettes were found (fig. 4.11), the prototype for cult statue bases? Was it, in later temples, pulled away from the wall to become the freestanding cult statue base? The interior arrangement of hearth and posts, as at Dreros, reminds one of Mycenaean megara with their hearths, chimneys, and columns. At Mycenae (fig. 3.39, p. 92) and Tiryns themselves, early temples were built directly over the sites of Mycenaean megara. Thus temporal power was superseded by divine.

We cannot be certain of the early history of the important Sanctuary of Hera on the island of Samos. The first temple may have been built in the eighth century BC, and it may have been a long, skinny building of mudbrick, with a central row of wooden

4.11 Statuettes, from Dreros. c. 700 BC. Bronze. Height (female) $15\frac{1}{2}$ ins (40 cm); (male) 2 ft $7\frac{1}{2}$ ins (80 cm). Iraklion Museum, Crete

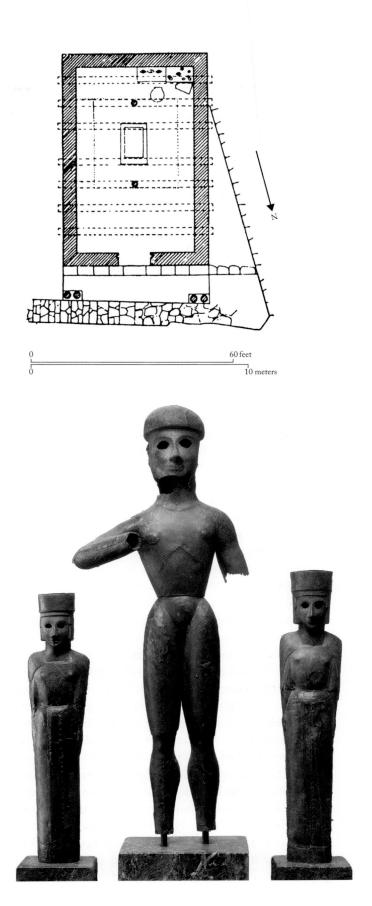

4.12 Conjectured plan of the first Temple of Hera, Samos. Probably 8th century BC. Altar 8th century BC

posts (fig. 4.12) as roof supports. But these posts would have hidden the cult statue if the stone base for the image had not been nudged into the north aisle. On the other hand, the remains of the conjectured first temple may simply be the foundations of what is called the second temple. In any event, a temple of more advanced plan existed by around 650 BC. Such a temple implies the existence of an eighth-century predecessor, whether on the same spot (which is likely) or not.

Evidence for early sanctuaries has been found in the islands of the Cyclades too. On Thera two sanctuaries of eighth-century date, one for Demeter and another for Aphrodite, have come to light. On Naxos there is a series of temples in the sanctuary at Yria, the earliest of which (for Dionysos?) is ninth century in date, while in the sanctuary at the Melanes quarries the oldest sacred building is of the eighth century.

The Geometric settlement at Oropos on the northern border of Attica provides good examples of secular buildings of the period. A pair of compounds, each consisting of an enclosing rectangular wall and apsidal or oval and round houses, has been found by archaeologists. Adjacent are industrial installations where metalworking took place and pottery was made. Zagora on Andros offers another good example. Here a settlement of the eighth century BC used local island stone to build houses packed close to one another. They have two basic plans: one is the megaron arrangement with columned porch in front of a main room with hearth and posts, while the other is a square house equipped with benches or sleeping platforms. Such benches were often used to support large pithoi storing agricultural produce. It seems that cult activities took place around an altar in an open courtyard in front of a house of imposing size, perhaps that of the ruler. There was no temple here until the sixth century BC. Towns similar to Zagora existed on other islands, notably on Chios and on Siphnos.

SCULPTURE

Though the skills necessary to produce work like the Lion Gate (fig. 0.11, p. 19) had been lost, sculpture in terracotta continued, especially in Crete. The female figures from Karphi (fig. 4.4) - perhaps divinities, perhaps worshipers - followed a LM fourteenth- and thirteenth-century predecessor (fig. 3.18, p. 75). The similarities are obvious. The cylindrical body and upraised arms are the same, but the headgear is different, and in the Dark Age example, the legs and feet of the figure are included. Note the "horns of consecration" on the headgear of the example from Karphi, which are another sign of continuity from the Bronze Age. The head and arms were added, handmade, to the wheelmade cylinder of the body, while legs, also made separately, were slung beneath. The whole sculpture was then fired like a vase, so that figures like these were as much the work of potters as of sculptors.

The repertoire of these potter-sculptors also included animals and hybrid creatures, of which the late tenth-century (about 900 BC) centaur from Lefkandi (fig. 4.13) is a famous example. Human torso, head, and legs are solid and made by hand, while the cylindrical horsy horizontal part of the body is wheelmade. Ears have centrally pierced holes (one wonders why), and the circular hollows of the eyes were inlaid with bone or shell. Was this Dark Age image from the world of Greek myth a specific centaur? There is no doubt that he was highly prized: the head and the body were found in separate graves, both serving as needed companions after death.

As the population grew and living conditions improved, the Greeks converted some local shrines into PANHELLENIC sanctuaries, and to these – at

4.13 *Opposite* Centaur, from Lefkandi. 10th century BC. Terracotta. Height 14 ins (36 cm). Eretria Museum

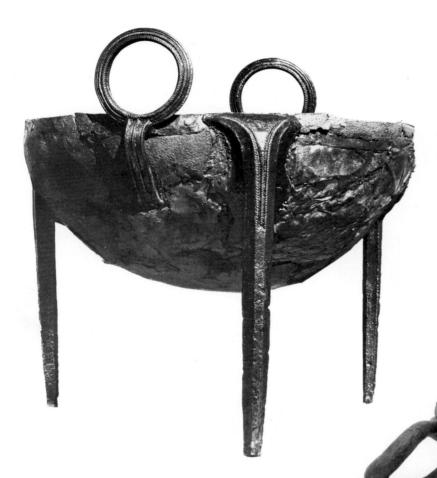

Olympia, Delphi, Delos – were brought multitudes of votive offerings of terracotta and bronze. Olympia has been a particularly rich source of bronzes, and many date from the eighth century. Animal figures – mares and foals, deer and fawn, birds, and bulls – were at first cut out from bronze or copper sheets. Later, they were hammered flat, until the technique of solid casting was introduced. Thereafter, figures were manufactured in molds and made of solid bronze. But they were still formal in appearance, as, for instance, the horse in figure 4.1. Figures like this sometimes stand on openwork plaques; some may have been suspended from trees. Others served as attachments to the handles of big bronze tripod cauldrons (fig. 4.14).

Such tripods, enlargements of valued household objects, were used both as offerings and as prizes in the games at Olympia and elsewhere (and probably as both; first a prize, and then an offering). Some were huge, even mansize. While the cauldron itself was hammered, the legs and ring handles, sometimes decorated with geometric designs (concentric circles **4.14** *Left* Tripod cauldron, from Olympia. 8th century BC. Bronze. Height 2 ft 1½ ins (65 cm). Olympia Museum

4.15 Below left Warrior, from the Acropolis of Athens. c. 750–700 BC. Bronze. Height 8¼ ins (21 cm). National Museum, Athens

4.16 Below right Charioteer, from Olympia. c. 750–700 BC. Bronze. Height 5¾ ins (14.5 cm). Olympia Museum

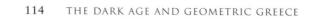

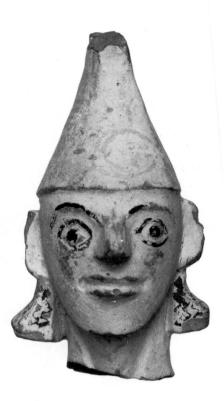

4.17 *Left* Female figurine, from Athens. c. 730 BC. Ivory. Height 9½ ins (24 cm). National Museum, Athens

4.18 Above Head of a warrior, from Amyklai. c. 700 BC. Terracotta. Height 4¾ ins (12 cm). National Museum, Athens

and zigzags, for example), were cast. Molds for making tripod legs, found at Lefkandi, show that cauldrons were being made in Greece as early as around 900 BC.

Among human figures, the warrior was a common type. The example shown here was cast solid (fig. 4.15). But arms were subsequently hammered to take a spear on the right, and a shield on the left. Like the animal figures, some were suspended in sanctuaries, some attached to cauldrons, and others were freestanding. Occasionally votive offerings celebrated a victory, like the belted and helmeted charioteer from Olympia (fig. 4.16). This is a theme that was to be made famous by Polyzalos's dedication at Delphi some 250 years later (fig. 7.30, p. 233). Others may have been cult statues. Two female figures and one male figure, from Dreros in Crete (fig. 4.11; see also p. 111), provide evidence of another technique, sometimes known as SPHYRELATON. This technique may have consisted of hammering bronze plates over a wooden core – in which case these figures echoed the earliest cult statues of which we know, which were called XOANA by later writers and were made of wood. Another view holds that sphyrelata were hammer-embossed from the inside.

Similar in proportions to the Dreros figures is the ivory figurine of a young woman (fig. 4.17), found with four similar companions in a grave in Athens, dated by its accompanying pottery to around 730 BC. The reappearance of ivory in Greece suggests oriental sources, as does the nudity of the figure, which emulates the Near Eastern Astarte. Her long legs, triangular torso, sharp features, and her maeander-decorated POLOS (hat), however, indicate a Geometric Greek sculptor at work, borrowing from abroad and emending to local taste. Terracotta remained a popular medium: the head of a warrior from Amyklai (fig. 4.18) near Sparta provides a good example. The conical helmet was decorated, like the hat of the ivory from Athens, with maeander design, while the clay elsewhere was covered in painted details.

These representations of divinities or devotees, of animals such as horses and bulls (either commemorating successes in the games or standing as substitutes for sacrifices) offer the first glimmerings of Greek sculptural invention after the devastation at the end of the Bronze Age.

POTTERY

The Mycenaean fortress on the Acropolis at Athens seems to have escaped the worst depredations at the end of the Bronze Age. Many refugees from the destructions elsewhere evidently made their way to Attica and Athens, and thence across the sea to Asia Minor. It is in Athens that developments in pottery first took place. Numerous examples of pottery (fig.

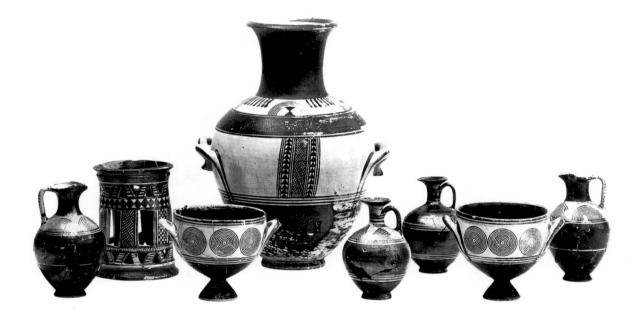

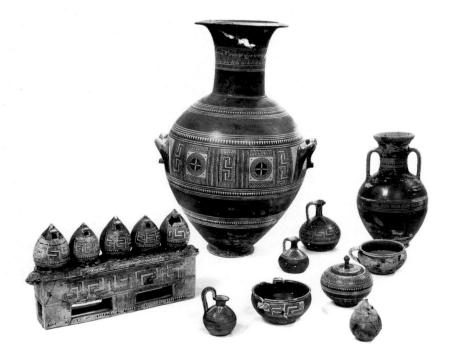

4.19 Above Protogeometric pots from the Kerameikos cemetery, Athens. Late 11/10th century BC. Height (of skyphos) 6 ins (15.5 cm). Kerameikos Museum, Athens

4.20 *Left* Geometric vases from the burial shown in fig. 4.21. 9th century BC. Agora Museum, Athens

4.19) of this period have come to light in the KER-AMEIKOS (fig. 8.35, p. 272) cemetery. The style known as Protogeometric appeared in Athens around 1050 BC and lasted till about 900 BC. It was followed elsewhere – in Argos and Boeotia, for example – and there are sufficient variations in products from different centers for us to identify the quirks and tastes of different workshops. Athens, however, was the mainspring.

Shapes of Protogeometric pottery mostly derive from Mycenaean, the commonest being the amphora (for storage), the krater (for mixing wine and water), the OINOCHOE (for pouring), and various shapes of cups. These pots were now being made on a faster wheel, with the result that their contours were crisper and more precise. However, their decoration was still limited. Groups of concentric circles or semicircles, precisely drawn with multiple brushes or compasses, replace the freehand, error-prone wavering lines of sub-Mycenaean decoration. There are also crosshatched triangles, panels, and zigzags symmetrically arranged. Decoration is there to emphasize form.

The full Geometric style developed from the Protogeometric, in the years after 900 BC. Again Athens took the lead, once more followed by regional workshops. The sharply defined amphora, krater, oinochoe, and cup, with their taut, clean lines, remained the most important shapes. In decoration, the maeander became the dominant device. Of various shapes (key maeander, battlement maeander) and sizes, it was accompanied by the familiar battery of crosshatched or wavy-lined lozenges, squares, and triangles. It became something of a requirement to paint the whole surface, either leaving some zones completely dark, to set off the geometric friezes, or simply placing geometric friezes one after the other.

A ninth-century burial from the Agora of Athens has yielded a remarkable group of pots (figs. 4.20 and 4.21). A large amphora, in which the bones and ashes of the deceased were found, has foot, body, neck, and lip parts that are firmly distinguished. Analysis of the bones has revealed that the dead person was female, and pregnant. The main decoration, with motifs arranged in vertical panels, was placed between the handles. An unusual PYXIS, lavishly decorated with maeanders, has five beehive-shaped objects (representations of granaries?) atop, similarly decorated. More than fifty other pots found in this burial provide a rare gallery of geometric shapes and decorations of

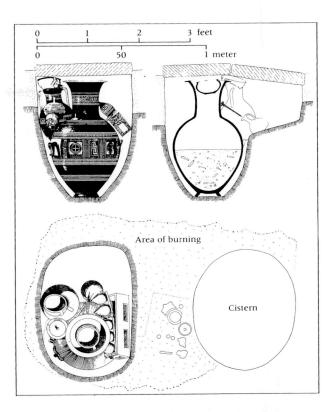

4.21 Cremation burial with Geometric vases, Agora, Athens. 9th century BC

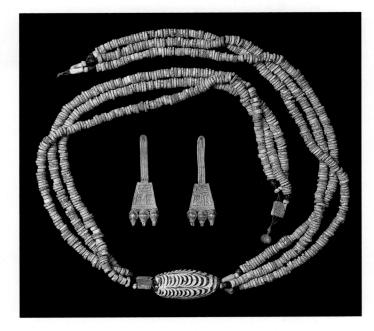

4.22 Geometric necklace and earrings, from the Athenian Agora. c. 850 BC. Gold (earrings), glass and faience (necklace). Agora Museum, Athens

CULTURE AND SOCIETY

BURYING THE DEAD

A funeral presented a fine opportunity for a rich family to honor its dead and display its wealth and pride. The funeral consisted of a series of rituals, and painted pottery gives us a glimpse of some of these. The huge commemorative vases mentioned in the text (figs. 4.24 and 4.25) show two, the PROTHESIS (the display of the corpse on a ceremonial couch surrounded by mourners tearing their hair and singing laments) and the EKPHORA (the procession amid mourners to the cemetery). These ceremonies were preceded by the ritual washing, anointing, dressing, and garlanding of the body. Later (Hellenistic) custom involved the provision of coins for the boat fare across the Styx. At the cemetery, the cremation or burial took place, sometimes attended by ritual slaughter: skeletons of horses have been found in burials (e.g. at Lefkandi, see p. 108), and Herodotos (6.103) tells us that in the later sixth century BC Kimon, father of Miltiades, was buried with his prizewinning mares. Libations – wine, wine mixed with water, wine with honey and water, milk (tears were also considered libations) – were offered to the dead, and gifts deposited either in the grave or in a trench nearby. Other rituals included a funerary banquet and the purification of the deceased's home. A monument as tall and as precisely decorated as the Dipylon amphora (fig. 4.25) standing on the grave of the dead sent a clear signal of family wealth; and such status was doubtless signalled also by the grandeur of processions, the brilliance of garments, and the

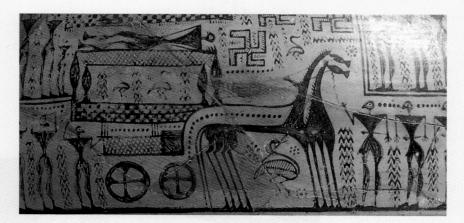

abundance of food at the feasts. In the Archaic and Classical periods individual graves or family plots of the wealthy were marked by prestigious monuments – freestanding marble statues of humans, sphinxes, or lions (see fig. 0.18, p. 24), or reliefs (see fig. 8.45, p. 280). This was conspicuous consumption all right.

4.23 The procession to the burial ground (ekphora), as shown on a Geometric krater. Detail of fig. 4.24. National Museum, Athens

the ninth century BC. Jewelry (fig. 4.22) was found in this grave too: gold earrings and a necklace of glass and faience are conspicuous and, taken together with the number of the pots and the quality of the painting, tell us that this was the burial of a wealthy person. Funerals (see Box, above) were public events and opportunities for displays of status: though all these objects were interred beneath the earth at the moment of burial, they were on show at the funeral and presented visible claims to social superiority.

In the eighth century BC, painted human and animal forms became popular. Animals appeared in stylized repeated forms: grazing deer, feeding birds, recumbent goats looking backward encircle vases like the abstract friezes that accompany them. They are not visualized as living organisms, but are repeated as patterns. At long last, groups of human figures begin to be the focus of attention; they are sticklike silhouette figures, with elongated legs, triangular torsos and dabs of paint for heads (later the eye is shown). Mourners tear their hair by funeral biers, showing their lamentation through their gestures. Charioteers' bodies are hidden behind their shields, while they ride in airborne chariots, both wheels shown in curious perspective. Similarly, horses, whose stylized forms, with their cylindrical bodies and trumpet-shaped heads, reminiscent of their sculpted bronze counterparts, show all their legs.

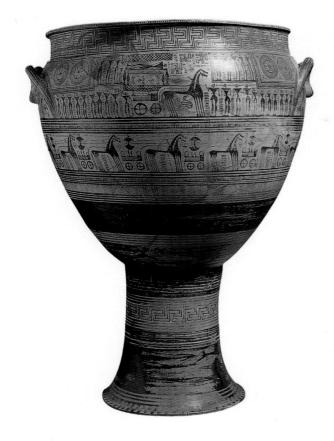

4.24 Geometric krater, from Dipylon cemetery, Athens. c. 750 BC. Height 4 ft (1.22 m). National Museum, Athens

A number of large vessels decorated in this way were used as gravemarkers and were found in part of the Kerameikos cemetery called the Dipylon, after the city gate nearby. They stood for all to see atop the graves they marked, signalling the status of the dead and echoing key funerary events in the scenes they displayed. The Dipylon krater (fig. 4.24) shows the funeral procession, with the dead man laid out on a bier atop a horsedrawn carriage, making its way to the cemetery through the mourning crowd. The public event itself is celebrated, and the deceased and his family too are celebrated. The point is underscored by the frieze of chariots, warriors, and horses below. This scene operates on a number of levels. It draws attention to the dead in his capacity as a warrior, accentuating a key role by which he and his social counterparts asserted their claim to virtue, service to the state, and aristocratic identity: it is significant that he is portrayed with glorious accouterments (shield and chariot) which belong to a Homeric and heroic past. The scene also evokes other Homeric episodes – those of chariot races at funeral games, again competitions of privilege and power.

The mid-eighth century Dipylon amphora (fig. 4.25) is monumental in scale (5 feet, 1 inch [1.55 m] high). There are bands of dark paint around the foot, the lip, and the joint of neck and body. Decorative friezes of geometric designs and files of grazing deer and seated goats - each image an abbreviated symbol - run continuously around the pot and cover the rest of the surface. The panels between the handles show the most important scene, that of prothesis, the laying out of the dead body on the funeral bier. The shroud is raised to reveal the corpse: arms, fingers, and all. The dead person here is a woman, the figure gendered by the skirt she wears (compare the male corpse on the Dipylon krater); in fact, amphoras are common for female burials, as kraters are for males. The associations of the krater, a mixing bowl for wine and water, are with the symposium, a social gathering of particular significance for males, male competition, and male solidarity; those of the bellyand-shoulder-handled amphora are with household matters, storage of grain and olive oil, and with the carrying of water.

The artist paints not what is visible but what he thinks is there. The mourners, carefully separated from one another and enveloped in filling ornaments (no space was to be left undecorated), tear their hair. The coordination of paint and pot (the bands of paint which set off the lip from the neck, the neck from the shoulder and the narrowing to the foot, the figural scene between the handles emphasizing the broadest part of the pot) and the precise mathematical rendering of the geometric designs are surely the visual counterparts of the formulas of Homeric narrative: together they seem to articulate an underlying sense of striving for social and political order.

Some scenes introduce the concept of narrative; some carry specific allusion. The oinochoe from a grave in the Athenian Agora (fig. 4.26) shows two joined warriors (even their helmets are linked) mounting a chariot. It is difficult not to see here a reference to the Moliones, Siamese twins of whom both Homer (*Iliad* 11.709–10) and Hesiod speak. Other images have suggested more familiar mythological themes. A Late Geometric krater (fig. 4.27) made in Athens depicts a huge oared ship, fully manned.

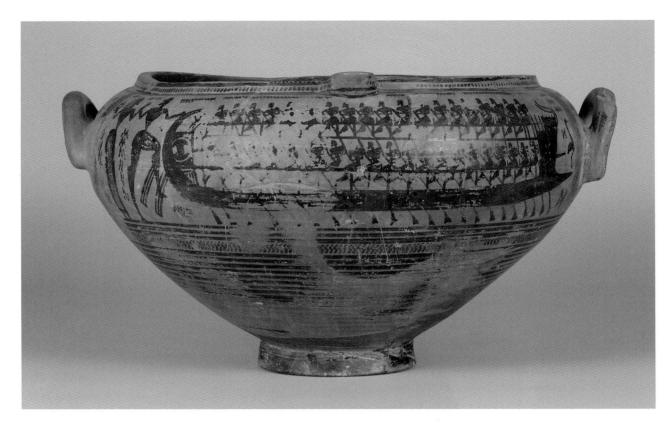

4.27 Late Geometric krater, from Thebes. c. 730 BC. Height (of figured panel) 3½ ins (9 cm). British Museum, London

A male figure still on dry land holds the wrist of a female companion with his right hand and starts to climb on board. Is this Theseus and Ariadne, as some have proposed? Or Paris and Helen? Or a generic scene of abduction? Or even a farewell scene? Identification is still uncertain.

COLONIZATION

If the Moliones oinochoe seems to allude to the world of the *Iliad*, others perhaps evoke that of the *Odyssey*. A krater found at the site of Pithekoussai, on the island of Ischia (fig. 4.28) off the coast of Italy near Naples, presents a complex scene of shipwreck: capsized boat, sailors floating or swimming in a dangerous sea crowded with fish, one wretched fellow with his head in the jaws of a shark. Such shipwrecks occur in Homer's narrative of the *Odyssey* (e.g. 7.249–52), and such incidents would not have been unknown to the oceangoing Greek adventurers of

the eighth century BC, who were already busily exploring the Mediterranean.

Greeks were at Pithekoussai on Ischia as early as the second quarter of the eighth century BC, and this seems to have been the earliest long-lasting Greek settlement in Italy. But they were not alone. Egyptian faience objects and scarabs, Syrian flasks, and pottery made locally but inscribed in Aramaic and Phoenician tell of Near Easterners on the island, too. What was the great attraction? Excavation has produced evidence of early ironworking - including slag, bellows, and BLOOMS – and this provides one explanation. The search for metals had been resumed. Iron was being mined on Etruscan Elba to the north, and Ischia may have been the closest that Greeks and others could get. The recently discovered Greek settlement on the other side of the island, first inhabited in the second half of the eighth century BC, shows clearly enough, however, that farming and fishing were also prime concerns of the settlers. Together with early colonial pottery from other parts of the

4.28 Above Detail of a Geometric krater with shipwreck scene, from Ischia, Italy. c. 725–700 Bc. Ischia Museum

4.29 Right South Italy and Sicily

island, this suggests that the territory of Pithekoussai extended over the whole island, and that it was not only the proximity of metal that sparked the interest of the settlers.

The settlements on Ischia were followed rapidly by others (fig. 4.29). Opposite Ischia, on the mainland of Italy, Cumae was settled in about 740 BC. In Sicily, Naxos was founded about 735 BC, and Syracuse – soon to become the greatest of Greek cities in the west, and in the fifth century a rival to Athens itself – was founded around 733 BC from Corinth. Sybaris was settled in about 720 BC from Achaia and Troizen in the Peloponnese, and Taras from Sparta in the last decade of the century. So numerous were the Greek settlements in Sicily and South Italy, and so powerful did many become, that the area came to be called MAGNA GRAECIA, "Great Greece."

The search for metals was not the only reason for establishing these settlements. Population growth and shortage of land, combined with drought, famine, and oligarchical systems of land tenure, were also powerful motivators. The new settlers did not come from parts of Greece blessed with ample tracts of land like Thessaly, but from areas pinched between the mountains and the seas: from Corinth, Achaia, and the Argolid, and from the islands. Trade, too, and the search for new commodities and ideas played their part.

The Greeks who settled at Pithekoussai came from the island of Euboea, and it is the Euboeans who had taken the lead in exploring the opening world. They had gone east as well as west. In their search for commerce they had already, by the ninth century BC, established a presence at the mouth

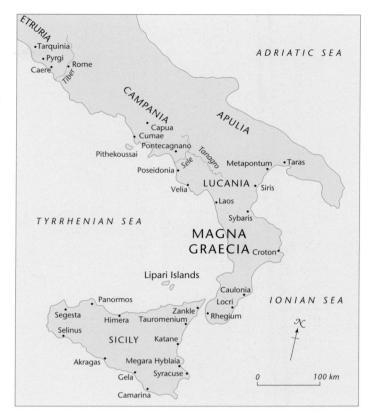

of the river Orontes in Syria at a site called Al Mina. Here they lived and traded alongside Cypriots and others, and it was through Al Mina and similar small sites nearby and in Cilicia that Eastern objects and ideas began to be channeled into Greece. In the course of the eighth century BC, objects decorated in new styles, wholly different from those of Greek Geometric art, made their way into Greece and were to have a profound impact. Eastern artisans, too, it seems, came to Crete and Greece, bringing with them materials, motifs, and techniques that were new to the Greek world. Parallel with these developments in the spheres of metalworking, ivory-carving, pottery, and jewelry, an alphabetic script was introduced to Greece for the first time. This may have arrived via an area with a mixed population such as Pithekoussai in the west. Whether this was the point of contact and transmission or not, the signs of the new Greek alphabet are unmistakably Semitic in origin. Its arrival resulted both in the appearance of chaotic local scripts and in the epics of Homer being written down from their oral predecessors. Under this energetic oriental stimulus, the Greek world reawakened.

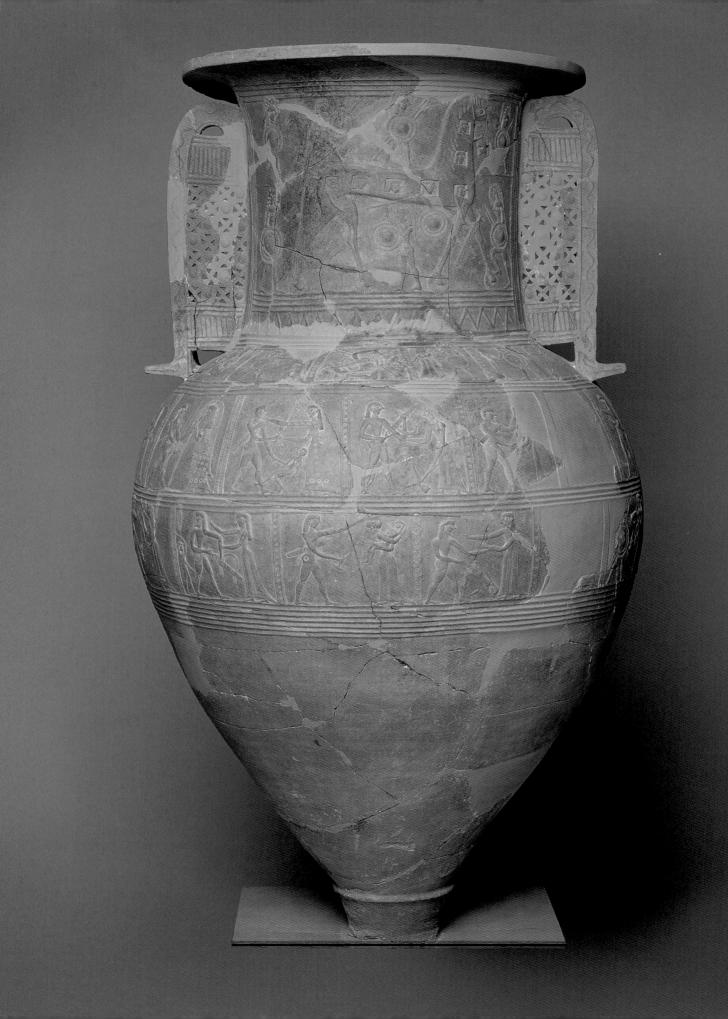

THE ORIENTALIZING PERIOD c. 700-600 bc

The pace of life quickened in the seventh century BC. Greek prose and poetry came to life; new techniques of working raw materials produced a new kind of sculpture, a new architecture, and a new metallurgy; and new oriental designs changed the face of Greek pottery. Eastern ideas had their greatest impact on the Greeks during the seventh century BC, which is therefore often referred to as the "Orientalizing period." Egyptian ideas also had an impact, particularly on the creation of buildings and statues in stone. However, the Greeks always seem to have modified their borrowings according to their own sense of proportion, form, or pattern.

In the previous period, some Greeks had been driven to find their livelihoods abroad in a series of colonizations, and they were already well ensconced in Sicily and South Italy. These migrations continued in the seventh century BC. New Greek cities were founded at Gela in Sicily, Poseidonia (Paestum) in South Italy, Cyrene in Libya, and Naukratis in Egypt. Some Greeks also headed northward to the Black Sea coast, where they settled at sites like Istros and Olbia. Those who stayed behind found themselves clustered together in discrete geo-

graphical zones, in which towns and their dependent stretches of countryside functioned institutionally as "poleis" (plural of "polis"), or city-states. During the course of the seventh century BC, many poleis fell into the hands of individual masters, called "tyrants," a term which for Greeks at that time carried no negative overtones. A tyrant was a powerful individual who held all constitutional and military power. Many states, notably Corinth, flourished under tyrants. Trade, industry, and public works were all encouraged. At the same time, Greek states, notably neighbor with neighbor, were vying with one another for land and business, so that complex alliances sprang up between distant cities. Thus, the spirit of competition, fear, and envy, which was to culminate in the long rivalry between Athens and Sparta in the fifth century BC, was nurtured.

Since oriental ideas appear most copiously as designs on pottery, and since the chronology of Protocorinthian (c. 725–625 BC) and Corinthian (c. 625–550 BC) pottery is the key dating tool for the Orientalizing and early Archaic periods, this chapter will deal with the pottery first.

POTTERY

5.1 Relief amphora, from Mykonos. c. 650 BC. Terracotta. Height 4 ft 5 ins (1.35 m). Archaeological Museum, Mykonos

Broken pottery is by far the most common material recovered in excavations. Since pottery broke easily

and, once broken, had no intrinsic value, it was discarded. Nonetheless, as well as using pots, Greeks also admired them. Prized pieces were placed in tombs as gifts for the dead, alongside other specially made, brand-new, but coarser pots, and whole pots have thus come to us from the excavation of ancient cemeteries. Through studying the sheer volume of sherds and intact pots retrieved, grouping them according to shape and decoration and so establishing a sequence for developments in style and technique, and through the study of the strata in which they were found, we are able to give approximate dates for their manufacture, and hence for the context in which they were found. For 700-500 BC, the margin of error in dating pots narrows from about twenty-five years to as little as a decade. For archaeologists, pottery is of prime importance for this ability to date contexts. But it is also valued for what its uses - storage, mixing, pouring, drinking, etc. reveal about social and economic activity. It can also tell us about vase painters, their places of work, the range of their trade, the development of local styles and taste, and the popularity of the various themes they painted.

Orientalizing influences on vase painting can be seen in Corinth as early as the eighth century BC. They are readily recognizable in the animal and curvilinear designs which supplant the bands and geometric ornament of earlier eighth-century pots. Many of these pots were exported to the Greek West (that is, Sicily and South Italy), or were carried there by settlers. The discovery of sherds of Protocorinthian and Corinthian pottery in the lowest levels of the colonial sites has helped provide the dates for the pottery types. The starting point for the chronology of these colonies is the narrative found in Book VI of the work of the fifth-century BC historian Thucydides and what it says about the settlement of Syracuse and other early settlements in Sicily, in particular Naxos, Megara Hyblaia, and Leontinoi. Thucydides (VI.3-5) gives the foundation dates for these settlements in relation to one another (e.g. Syracuse was founded one year after Naxos). In narrating the expulsion of the citizens of Megara Hyblaia by the Syracusan tyrant Gelon - an event known to have taken place from other sources in c. 483 BC – Thucydides mentions that the inhabitants had lived there 245 years, i.e. that Megara Hyblaia was founded in c. 728 BC. A date for the foundation

5.2 Protocorinthian aryballos. c. 720 $_{BC}$. Height $2\frac{3}{4}$ ins (6.8 cm). British Museum, London

of Syracuse of c. 733 BC arrived at in this manner is confirmed by other sources. Pottery from the lowest levels at Syracuse is of the first phase of the Protocorinthian style. This phase of Protocorinthian may then be dated around 725–700 BC.

Corinth

A geometric style of pottery was being produced in Corinth in the eighth century BC, but it lacked both the figural decoration and the longevity of the Athenian Geometric. Vase painters in Corinth were therefore more open to innovation than Athenians. Their city, which had harbors opening both east and west from the isthmus linking the Peloponnese to the rest of Greece, was well placed for communication and commerce. Orientalizing motifs appear in Corinth around 725 BC. The style that they exemplify was applied first to the decoration of pots called Protocorinthian (the precursor of the "Ripe" Corinthian style), the vogue for which lasted about a hundred years.

Popular shapes of Protocorinthian pottery are the ARYBALLOS (a perfume or oil flask), the OLPE (a broadlipped jug), the oinochoe (another pouring vessel), and the KOTYLE (a cup). Orientalizing motifs include floral and vegetal designs, and animals of all

shapes and descriptions. There are "panthers" (lionlike or other felines shown with frontal face), lions, boars, bulls, birds, dogs, geese, hares, and hybrids (for example, the siren, a bird with the head of a woman). The filler most conventionally used was the dotted rosette. At first, the figures were drawn either in the old-fashioned Geometric silhouette manner or in outline; an aryballos (fig. 5.2), made in the last quarter of the eighth century BC, shows a central stylized oriental Tree of Life drawn in curved lines, flanked by a horse drawn in silhouette (with an outline human behind), and an outline bird. There are other echoes of the Geometric style here in the bands of paint encircling the foot of the flask and in the crosshatched triangles rising from the baselines of body and shoulder decoration.

Later, however, all figures were drawn in black silhouette against the reddish clay, but with anatomical details picked out by INCISION with a needle-like instrument. This allowed the color of the clay to appear in thin, sharp lines and thus to suggest forms. Patches of red and white were also used as an extra means of detailing. This technique - using silhouette with incision and added color - is termed BLACK-FIG-URE. It was introduced in Corinth almost a century earlier than in Athens and relied heavily on clear, crisp draftsmanship, on precise contour, and the effects of color. An olpe (fig. 5.3), made around 650 BC, displays the characteristic registers of black-figure animals (hence the style is known as the Animal Style), the dotted rosette fillers, and the upwardpointing triangles at the base, a last vestige of the Geometric tradition.

Human figures appear much less frequently than animals, but two pots from the middle years of the seventh century BC display warriors in action. These represent, perhaps, the high point of the Protocorinthian style. The so-called "Macmillan" aryballos (fig. 5.4) is a very small vase, only about 2³/₄ inches (7 cm) high. The upper part is rendered as a lion's head, and there are no fewer than five registers of decoration beneath. There is a luxuriant floral design drawn in curved lines on the shoulder, striding and collapsing warriors in combat on the body, a cavalcade (or procession on horseback), hare and hounds, and upward-pointing triangles (or rays) at the foot. The figures are all drawn in a single plane, with no thought of perspective. The Chigi olpe (fig. 5.5), now in the Villa Giulia Museum in Rome, is rather larger,

5.3 Protocorinthian Animal Style olpe. c. 650–625 BC. Height 12³/₄ ins (32 cm). Staatliche Antikensammlungen, Munich

about 10¼ inches (c. 26 cm) high. In a dashing display of polychrome painting, the artist depicted three registers of figures. The lowest shows a scene of humans, hounds, and hares. Above it, a procession of chariot and horsemen and a lion hunt are separated on one side (the front) by a double-bodied sphinx, and on the other (the back) by a mythologi-

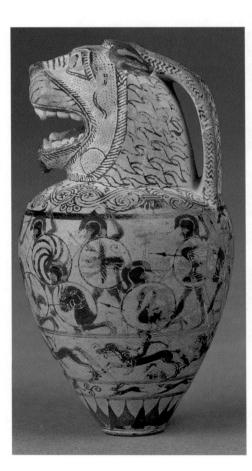

5.4 Protocorinthian aryballos, the "Macmillan" aryballos. c. 650 BC. Height 2¼ ins (7 cm). British Museum, London

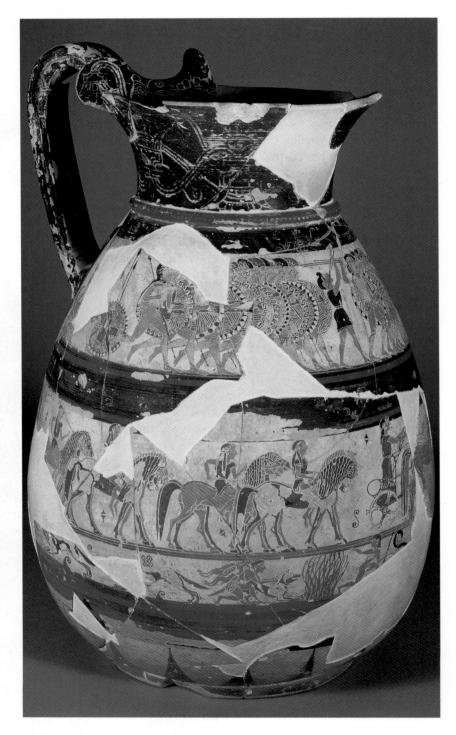

 ${\bf 5.5}\,$ Protocorinthian olpe, the Chigi vase. c. 650 $_{BC.}$ Height 10½ ins (26 cm). Villa Giulia Museum, Rome

CULTURE AND SOCIETY

DRINKING AND DINING: THE SYMPOSIUM

G atherings for drinking and dining had taken place in the Dark Age, but in the Orientalizing period they took on fresh life, introducing furniture (couches) and furnishings (pots) from Lydia and the East. Participants drank, sang songs, told stories, and enjoyed sexual encounters, each person trying to outdo the others. SYMPOSIA are often depicted on Athenian cups of the sixth and fifth centuries BC, and paintings on the walls of the Tomb of the Diver also provide a welcome guide to activities.

The parties were private and privileged. Men reclined on couches arranged around the walls of the ANDRON, while youths filled and refilled their cups from a krater. This vase, without which the symposium could not happen, took pride of place in the room. A steward (some kind of master of ceremonies) took charge of the mixing and dispensing of the wine and water. The walls of

the Tomb of the Diver show characteristic activities. One short wall (fig. 7.47, p. 246) shows the krater prominently displayed on a table. The two long sides show scenes similar to one another. On one (fig. 7.48, p. 247) the bearded figure at the left raises his cup to greet new visitors. Next to him, a younger (unbearded) man prepares to sling the dregs of his wine from his cup, either at a target on

5.6 Homoerotic activity at a symposium as shown on the Tomb of the Diver. Detail of fig. 7.48. Paestum Museum

cal scene, the Judgment of Paris, much of which is unfortunately lost. But it is the main frieze on the shoulder that catches the eye. Greeks fight Greeks: lines of heavily armed footsoldiers (HOPLITES), wearing crested helmets equipped with oblong metal plates to protect the cheeks, bronze CUIRASSES and GREAVES, and carrying spears and emblazoned shields, are on the point of engagement, egged on by a small musician (a boy?) playing pipes that are strapped to his mouth. More lines of hoplites follow. Yellows, reds, and whites are the colors used. The wealth of incised detail adds to the intensity. The frieze of anithe wall or to attract the attention of another guest. The other one of the central two, cup in hand, gazes admiringly at the homoerotic action developing between the younger and the older man at the right: the lyre the youth holds is now ignored as the pair fix their dizzying stares on one another.

Participants drank, played music, sang songs, played games, told stories, and flirted, all in a spirit of competition and conquest. They competed in self-discipline, in wit and argument, in poetry and learning, and in eroticism, while strutting their wealth, status, and social solidarity. Usually the drinking parties were all-male, but sometimes female flute-players were hired to spice things up (they are shown on pots performing in the nude); and some vases show heterosexual drinking partners, where the emphasis seems to be on drinking and gaming as preambles to sex.

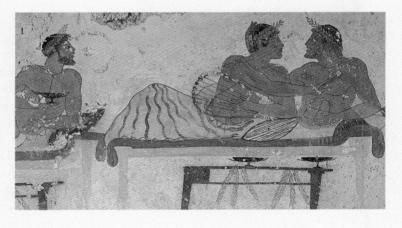

mals, so popular in Protocorinthian, is omitted in this masterpiece. This vase gives us important information about military history, showing as it does the beginning of the ascendancy of drilled footsoldiers over cavalry. But, most importantly, it exemplifies, both in terms of technique and style, the very best of Protocorinthian vase painting.

Around 625 BC the Protocorinthian style gave way to full or "Ripe" Corinthian. Orientalizing animals and mythological beasts were still used as decoration, though beasts were now enlarged and less carefully drawn. Splinter rosettes replaced dot

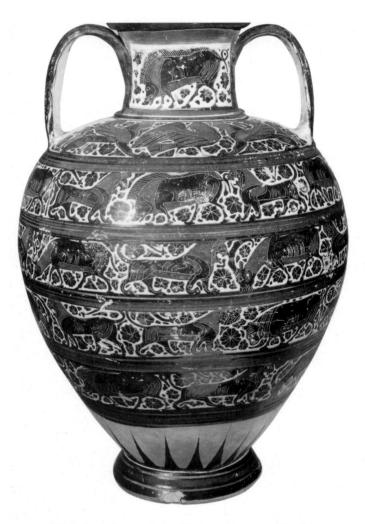

5.7 Early Corinthian Animal Style amphora. c. 625–600 вс. Height 13³/₄ ins (35 cm). British Museum, London

rosettes as fillers and began to clutter the background (fig. 5.7). The first phase of the Corinthian style (around 625–600 BC) was very popular, not least in the West, and it was widely copied.

Athens

In Athens the pottery of the Orientalizing period is called "Protoattic." It does not use the black-figure technique of Corinth until the end of the century, nor does it enjoy the popularity of Protocorinthian. It is rarely found abroad. The amphora and krater are important shapes, though the oinochoe and SKYPHOS (a two-handled drinking cup) are also popular. Smaller, closed shapes were evidently imported from Corinth – a preference that hampered local production. Painted scenes are much larger than in Protocorinthian and continue the monumental scale of the Attic Geometric tradition. There are fewer Eastern animals and hybrids than at Corinth. Vase painters seem to have focused more on human figures, with all the inherent opportunities they offer for storytelling and genre scenes.

An amphora by the Analatos painter (fig. 5.8), so called after the place where one of the vessels painted by him was found, was made in around 700-675 BC and represents the early Protoattic style. A register of sphinxes, painted partly in silhouette and partly in outline, encircles the zone beneath the lip. A second figural scene on the elongated neck of the pot shows male and female dancers with a piper, again part silhouette, part outline. A third register shows a chariot procession, a motif used during the Geometric period but here modernized by incising details of the horses' manes. Some of the other elements also derive from the Geometric style - long legs and angular bodies, the clouds of fillers - while others, such as the mythological beasts, the outline drawing, and the rosettes and spirals, are more attuned to the seventh century BC.

There was an increasing interest in mythology as the century advanced. A huge amphora of about 650 BC, found at Eleusis (fig. 5.9) and so sometimes referred to as the Eleusis amphora, depicts the GOR-GONS in pursuit of Perseus in the main frieze on the body. The hero has just decapitated their sister Medusa and is making off with her head. The figure of Perseus is fragmentary, as is that of Athena, who is hindering the Gorgons. But the Gorgons themselves are majestic. Drawn in outline, with some added white paint, they offer toothy, snaky heads and torsos, frontally, with profile legs, as they advance, firmfooted on the GROUNDLINE, their steps in unison. Here, then, is a scene from a well-known myth, recognizable by any self-respecting seventh-century BC Greek, conveying its message of the triumph of the Greek hero over the world of malignant monsters. An animal combat, with silhouette boar and outline lion, decorates the shoulder. On the neck, Odysseus and his companions blind Polyphemos, the Cyclops who had imprisoned them in his cave (Homer, Odyssey 9.870ff.). The literary inspiration is clear, while Geometric influence can still be seen in the silhouette figures. The body of Odysseus and the faces

5.8 Protoattic amphora, the Analatos amphora. c. 700–675 βc. Height 31½ ins (80 cm). Musée du Louvre, Paris

5.9 Protoattic amphora, the Eleusis amphora.c. 650 BC. Height 4 ft 9 ins (1.44 m).Archaeological Museum, Eleusis

of his comrades, on the other hand, are painted white, and Polyphemos's face is left the color of the clay. Incision is used for fingers, toes, and Polyphemos's beard, while fillers have only a minor role. The image has combined two episodes into one: Polyphemos howls as the stake penetrates his eye, yet he still has the winecup in his hand with which the Greeks had stupefied him before blinding him while he slept. Thus, different incidents are squeezed together, and time is compressed. This amphora, then, shows two approaches to narrative, one on the neck and one on the body, with the single episode (Perseus and the Gorgons) standing for the entire fable, and the synchronized image (Odysseus, Polyphemos, and Greeks) incorporating two different episodes. So well

5.10 Late Protoattic/early black-figure amphora, the Nessos amphora. c. 625–600 BC. Height 4 ft (1.22 m). National Museum, Athens

planned a composition with large figures, however awkwardly drawn, suggests an already existing tradition of narrative wall or panel painting. This amphora, like many of its predecessors in the eighth century BC, served a funerary purpose. It was a burial jar for a child. Were its images especially appropriate?

In the last quarter of the century (around 625-600 BC), the black-figure technique was introduced to Athens and was used for large-scale scenes of figural narrative. The Nessos amphora (fig. 5.10) is similar to the Eleusis amphora (fig. 5.9) in function and similar in having non-functional handles, with the space between handles and neck instead being filled in to provide a decorative or perforated surface. The arrangement of narrative scenes is also similar, but the pot itself has a less swollen body and a firmer foot. The now winged Gorgons, tongues protruding and fangs flashing, run one after the other to the right. Their posture, which resembles kneeling or almost kneeling on one knee (so-called knielauf), is the usual manner in early Greek art of expressing a figure in rapid motion. Though Perseus himself is not shown, a frieze of dolphins below, moving in the opposite direction to the Gorgons, emphasizes the speed of the chase across the ocean. The shoulder of the vase has an Orientalizing, convoluted floral design, rather than animals as on the Eleusis amphora. A file of geese plod round the rim, and other birds occupy the filled-in zones between handles and neck, notably the Athenian owl. On the neck itself the struggle between Herakles and the centaur Nessos is identified by inscriptions, an early example of the combination of figures and inscriptions that was to become common in vase painting. The centaur - part man, part horse, and thus midway between the human and the bestial world - had tried to violate Herakles' wife, Deianira. The Greek hero invokes full punishment and is again victorious in his entanglement with a dangerous monster. Herakles grabs Nessos by the scalp, thrusts his left leg into the small of the centaur's back, and prepares to kill him with the sword that he is holding in his right hand. Nessos implores Herakles for mercy, his arms outstretched to touch his beard, the conventional gesture of supplication and submission.

This provides evidence of the black-figure technique beginning to be established in Athens. Fillers are now negligible, though the Protoattic hook spiral is still present, as well as the dotted rosette filler imported from Corinth. The Nessos amphora can be dated either to the end of the Protoattic tradition or to the beginning of Attic black-figure; perhaps most accurately, however, it should be seen as transitional between the two.

East Greece and the Islands

Corinth and Athens were two sites where pottery evolved dramatically in the seventh century BC, but there were interesting developments in the islands, too. On Rhodes and on the coast of Asia Minor, a style of decorating pots using animal outlines grew up about mid-century. The favorite beast was the goat (fig. 5.11), hence the style is called "Wild Goat." Numerous pots are decorated unimpressively with files of often cheerful, bright-eyed goats and other animals. More striking are the calligraphic friezes of lotus and bud that appear beneath. A jug found on Aegina (fig. 5.12) demonstrates several influences at work. From the Geometric tradition come the panels on the shoulder, the grazing horse, the maeander frieze, and the crosshatched lozenges and triangles. However, the motif of lion and prey and the spirals embellishing the triangles toward the base are Eastern in origin. Making part of the pot as an animal or human head was popular in Crete and the Cyclades, so this jug is perhaps the work of a Cycladic artist, dating to around 675-650 BC.

Potters in the islands were also making large pots, decorated not with paint, but with panels of figured scenes in relief. An example found on the island of Mykonos in 1961 (fig. 5.1), about 4 feet 5 inches (1.35 m) high, is datable to about 650 BC, and had been used as a cinerary urn. On its body it shows a series of incidents from the capture of Troy, arranged almost in the manner of a strip cartoon. Greek heroes menace Trojan women, and infants are slaughtered. On the neck, the wheeled Trojan horse is shown with the heads of Greeks visible inside, as if seen through windows - as one commentator has observed, like passengers in a train. Some of the Greeks inside are handing down huge swords; another hands down a shield, and another a helmet. Those outside are already fully armed, some walking on top of the horse, another still clambering down. By exploiting relief, the potter emulated the sculptor, and the two skills overlapped.

5.11 Wild Goat Style oinochoe, from Rhodes. c. 625 BC. Height $12\frac{3}{2}$ ins (32 cm). Staatliche Antikensammlungen, Munich

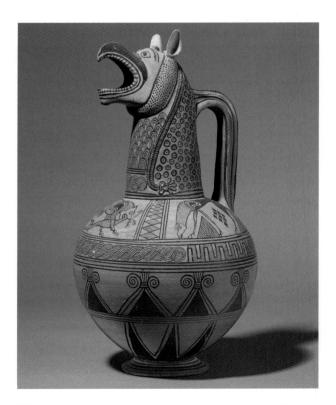

5.12 Griffin jug, from Aegina. c. 675–650 BC. Height 15% ins (39 cm). British Museum, London

CULTURE AND SOCIETY

FOOD

N ot all Greeks could afford great chunks of meat such as we see in the illustration below (fig. 5.20), carved with a cleaver and given to a youth to serve at a symposium (p. 129). Such portions were for the privileged few. But all Greeks paid attention to food. Homer rhapsodized about the fruit trees of Alkinoos (*Odyssey* 7.114–21), and food books make an early appearance. Aristotle didn't think much of Philoxenos's dithyrambic The Banquet, but Plato, tongue in cheek perhaps, lists the art of cookery alongside music and medicine. And the writers of Greek comedy resorted to food as topic and metaphor frequently.

It was in the West that the tastiest ingredients were to be found. The seas around Sicily teemed with fish; South Italy was so thick with fields of barley that the city of Metapontum put an ear of barley as its emblem on its coinage (fig. 0.13, p. 22). Cattle and sheep flourished on the rich riverine plains to the point that Hellanikos, a Greek historian of the fifth century BC, mistakenly derived the name "Italy" from the Latin vitulus, a calf. Archestratos, a famous fourth-century Sicilian chef, wrote out his recipes (in verse!), enthusing about fish especially – where the best gray mullet and sea bass were to be found, and how they were to be cooked. But his interests were in the tables of the wealthy; the poor could not afford his meals. The Romans were not slow to pick up luxurious tastes, and Greek cooks were soon at work in second-century Rome. Some of them we know by name. One, Paxamus, has left his name in that modern staple of the Greek breakfast, the barley biscuit paximadi.

Though the literary sources are biased toward the experiences of the rich, information about the diet of the less well-off can be ferreted out. For the poor, we're told that lentils, peas, onions, garlic, and fruit were favored items, and the main source of carbohydrate was not bread but porridges of barley spiced up with salt, onions, garlic, cheeses, wild greens, pomegranates, and figs. When they could find them, small fish provided animal protein. The army wasn't much better off. The soldiers' food consisted mainly of kneaded, unleavened bread (according to Archilochos writing in the seventh century BC), and hadn't changed much by the time of Xenophon in the fourth. Military equipment included portable handmills so that soldiers could grind grain to flour for themselves, mix it with water, roll out the dough, twist it around sticks, and bake them in the ashes of campfires. Not too appetizing, even with salt, onions, cheese, and sometimes garlic, wine, and fruit. Recent research has suggested that, both for soldier and peasant, the Greek diet consisted of 70 percent cereals, 20-25 percent fruit and vegetables, and 5-10 percent oils, meat, and wine. Most Greeks lived easily without meat, but grain was a necessity.

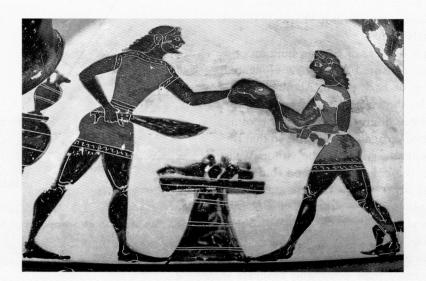

5.20 Preparation of food for a symposium. Detail from an Early Corinthian column krater, from Cerveteri (Etruria). c. 600 BC. Musée du Louvre, Paris

one of the most frequently used architectural types for the Greeks, equally adaptable to religious and secular purposes and therefore commonplace in Greek sanctuaries and market places.

On Naxos in the Cyclades another small religious structure appeared in the sanctuary at the Melanes quarries, and at Yria the third temple of Dionysos went up. The plan of this building with its narrow central aisle has prompted the suggestion that the first phase of the famous OIKOS of the Naxians on Delos, similar in plan, may also be dated to the seventh century. On Paros, so far the only example of a seventh-century sacred building is the temple of Athena at Koukounaries.

Megara Hyblaia in Sicily and Smyrna on the coast of Asia Minor provide good examples of domestic architecture and town planning. Megara

5.21 Right Megara Hyblaia, Sicily. Plan of agora and adjacent streets and houses. c. 650-625 BC

5.22 Below Plan of Poseidonia, Italy, showing the outline of the city wall, the regularized street plan, the urban sanctuaries of Athena and Hera, the agora, the suburban sanctuary of Aphrodite at Santa Venera (and the site of the later Roman forum). c. 500 BC

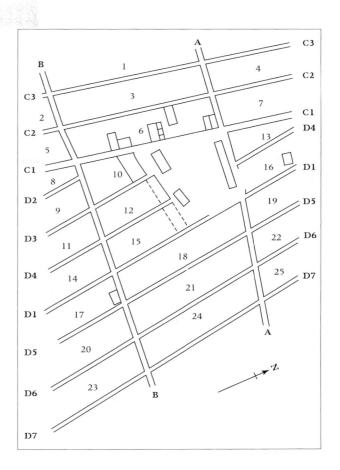

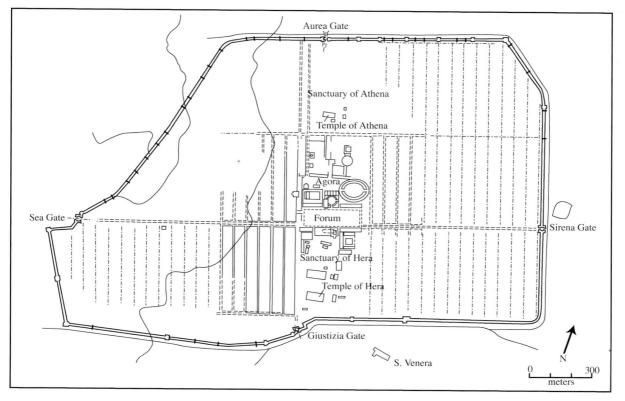

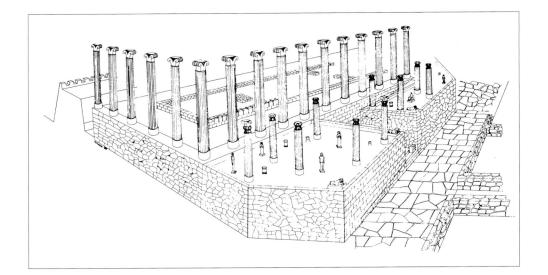

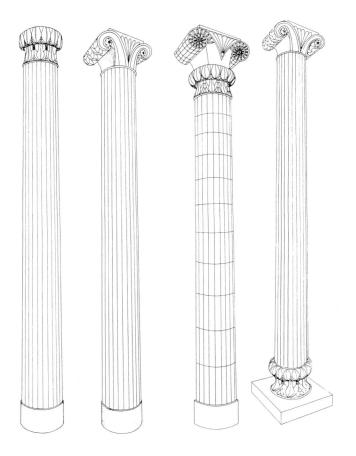

5.23 Above Hypothetical reconstruction of the Temple of Athena, Smyrna, showing terracing with votive columns and statues, the approach road, and the wall beyond. c. 600 BC

5.24 Left Reconstruction of the columns, capitals, and bases of the Temple of Athena, Smyrna. c. 600 $_{BC}$

5.25 *Below* Temple of Athena, Smyrna, "mushroom" capital. c. 600 Bc. Limestone. Izmir Museum, Turkey

Hyblaia (fig. 5.21) was a new colonial foundation of the later eighth century BC and, as such, was probably planned more systematically than older towns, which had been allowed to grow randomly. Excavation here has recovered the plan of a 650–600 BC town laid out in blocks around an open agora, the principal political space of the polis. This regularization of space is not yet the rational town planning which developed in the late sixth century at sites such as Poseidonia in Italy (fig. 5.22). It culminated in the gridlike arrangement of streets and the zoning of urban space for varying social functions associated with Hippodamos of Miletus (see p. 299).

Smyrna had first been occupied by refugees from Greece during the tenth century BC. The Orientalizing settlement here was protected by a huge fortification wall, within which streets were laid out in an approximately rectangular grid plan, following a north–south, east–west orientation. Within the grid, houses were built facing south to catch the sun in winter, and separated from one another by narrow alleys. They were mostly stone-built with polygonal masonry, but with upper courses of mudbrick.

The inhabitants were right to protect themselves with heavy ramparts; though, when the blow came, they were of little avail. Alyattes, king of Lydia, built an enormous siege mound and took the city in around 600 BC. Both the domestic quarter and the Sanctuary of Athena suffered badly. Yet the excavators took the view that there was no serious interruption in temple activities, and work on expanding the temple continued. More recent critics suggest that the temple was either left unfinished or was dismantled in the years around 600 BC. However that may be, the temple stands as a good example of Greek construction around 620–590 BC, marking the transition from the Orientalizing to the Archaic period.

The excavator's hypothetical reconstruction (fig. 5.23) shows the terraced sanctuary, with its retaining wall of polygonal masonry, approach road of polygonal paving stones, the temple itself, and votive dedications. A bewildering variety of stone CAPITALS were used. Some have VOLUTES (spirals) springing from the base with floral PALMETTES, consisting of leaves arranged like a palm shoot, in between. Different floral and leaf motifs decorate other parts of each capital, so that this group of capitals presents a veritable galaxy of ornament. They are called AEOLIC, and, though of various sizes and profiles, are thought

by the excavator to have belonged to the temple itself. Fragments of twenty-four such capitals were found. The ornamental forms are all of oriental derivation, with volutes and vegetal motifs taking their inspiration from Phoenician capitals. Capitals of another shape, the so-called "mushroom" capital (fig. 5.25), either alone or in combination with Aeolic capitals (fig. 5.24), may have formed the tops of votive columns. This is a type of dedication often found later in Greek sanctuaries alongside statues, tripods, and the like. The mushroom capital, named obviously from its shape, was carved in low relief, with a leaf pattern on one register and alternating leaves and flowers on the other. Fragments of some seventeen such capitals were retrieved in the excavation.

By the end of the seventh century BC, architects had turned from mudbrick and wood to stone as the preferred material. They had seen columns with carved capitals and bases elsewhere, and had shown a liking both for them and for the way they were placed around temples. In the East, at any rate, they were enjoying the rich variety of oriental motifs, as they strove to decorate their religious buildings with due ceremony. They favored forms that showed variety rather than uniformity. The Temple of Athena at Smyrna shows how elastic the thinking of Greek planners had become by the turn of the century.

SCULPTURE

The fratricidal conflicts of the Greek city-states, as depicted for example on the Chigi vase (fig. 5.5), insured that the male warrior type would continue to be a favorite subject of dedications in sanctuaries. Similarly, the regular cessation of hostilities to allow the Panhellenic games to take place meant that the athletic male form became a focus of attention for sculptors.

Bronze continued to be a prized material. The tripod-cauldron of the Geometric period was replaced by an arrangement of separate tripods and cauldrons decorated with animal or mythological PROTOMES. Such protomes (the independent upper part – head, or head and neck of an animal or mythological creature) were perched on the necks or rims of cauldron bowls, and normally faced outward (though not always). Protomes of griffins (fig. 5.27)

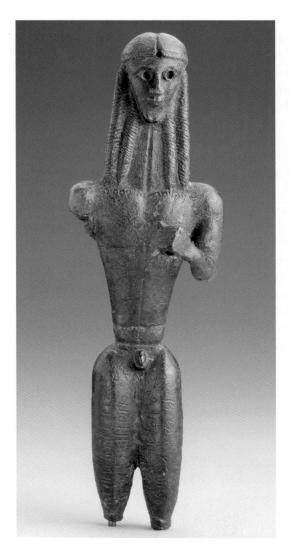

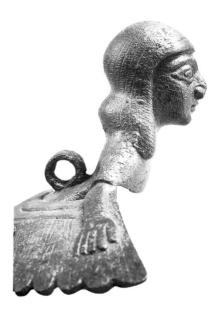

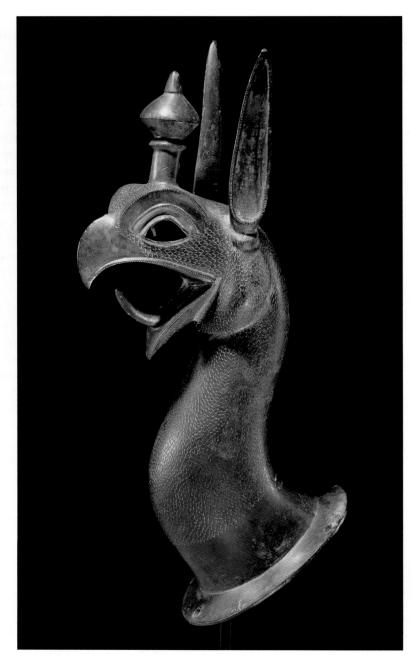

5.26 Above left The Mantiklos Bronze, from Thebes. c. 700–675 $_{\rm BC}.$ Bronze. Height 7½ ins (20 cm). Museum of Fine Arts, Boston

5.27 Above Griffin protome attachment for a cauldron, from Rhodes. c. 700–675 BC. Bronze. Height 12½ ins (32 cm). British Museum, London

5.28 Left Siren head attachment for a cauldron. c. 700–675 BC. Bronze. Height (head and neck) 3½ ins (9 cm). Olympia Museum

and SIREN head attachments (fig. 5.28) were especially popular.

Interpreting anatomy in terms of geometric forms continued at first. The Mantiklos Bronze (fig. 5.26) is a statuette of about 700-675 BC from Thebes in Boeotia which was dedicated to Apollo. It shows cylindrical thighs, triangular torso, pyramidal neck, triangular face, and hemispherical crown. But forms such as this from after 700 BC are less two-dimensional and more rounded than their predecessors. Greek enthusiasm for using the newfound skill of writing knew no bounds, and here the dedicator, Mantiklos, proudly defaced the thighs of his gift with two hexameter verses: "Mantiklos dedicated me to the Far-shooter with the Silver Bow from his tithe; grant, Apollo, something good in return." It is worth noting here the familiarity between mortal and immortal and the pronoun (me) used to suggest the living or lifelike quality of the bronze.

More anonymous is the bronze from the first quarter of the seventh century BC (fig. 5.29) found at Olympia beneath the foundations of the so-called Temple of Hera (see pp. 154–5). A young warrior stands facing the front, wearing only a crested helmet and a wide belt. His right arm, held aloft, originally held a spear. The hair, carefully coiffed in horizontal loops or waves, has a style that was to become, in a more elaborate form, a hallmark of the seventh century BC.

A later bronze, made around 625 BC, comes from Delphi (fig. 5.30). Here the long legs have given way to more naturalistic, though still stretched, proportions. The left leg edges forward; the arms are held by the side, fists clenched, following an Egyptian convention. He wears a belt, of a type familiar on Crete. The face is a narrow triangle; the forehead is low, the nose and eves big, the skull flat. He has no ears! The hair, horizontally hooped and falling in dense masses, looks like a beehive from the back and sides and like triangles on either side of the face from the front. This may originally have been an attempt to copy an Egyptian wig, but became a convention for thick hair, combed and brushed. In many respects he gives a good impression of what the first generation of kouroi, precursors of the New York Kouros (fig. 6.42, p. 176) and his contemporaries, looked like.

The Greek world was also flooded with small mold-made (hence, clearly mass-produced) terracotta female figurines. Some early ones resemble oriental

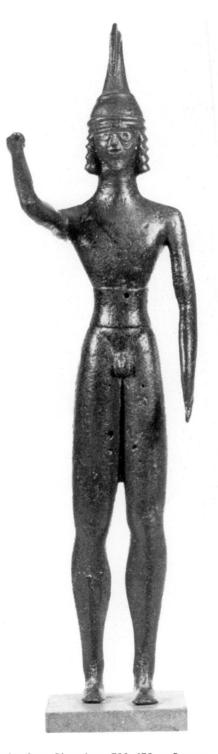

5.29 Warrior, from Olympia. c. 700–675 BC. Bronze. Height 9% ins (23.7 cm). National Museum, Athens

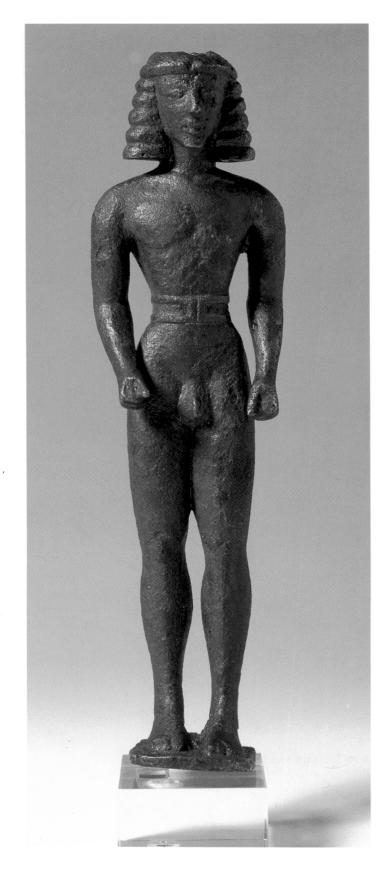

representations of the nude Eastern goddess Astarte, but they were soon dressed and addressed as Aphrodite. Others certainly represented different female deities, and all were used as votive offerings, whether representing donor or divinity, in sanctuaries.

The hairstyle, already seen on the bronze from Delphi (fig. 5.30), and variants of it (forehead curls, divided vertical locks, knoblike endings) are common among many terracotta female figurines produced about 680–625 BC. These figures share the following traits: frontality (they face forward), rigidity, and flatness (the profile view is so compressed that sometimes the ear is not shown); they have triangular faces, low brows, big noses and eyes, and flat skulls. We can be reasonably sure of their chronology, since a number of Protocorinthian vases, firmly dated, terminate in similar terracotta heads. Thus, a stylistic development within the series can be identified. The

5.30 *Left* Figurine of a youth, from Delphi. c. 625 BC. Bronze. Height 7½ ins (19 cm). Delphi Museum

5.31 Above Pendant from Kameiros, Rhodes. The human heads are in Daedalic style. Later 7th century BC. Electrum (a natural alloy of gold and silver). Height 3 ins (8 cm). Musée du Louvre, Paris

5.32 Torso of a female "Daedalic" figurine. c. 650–625 BC. Terracotta. Height 7 ins (17.5 cm). Iraklion Museum, Crete

more detailed the hairstyle, as here (fig. 5.32), and the more clearly defined the anatomy, the later in the series the figurine is likely to come. Though examples were widely distributed across the Greek world, the major centers of production seem to have been at Corinth, Crete, Sparta, and Rhodes. The style they exemplify is called "Daedalic," after the legendary early sculptor Daedalus. Female figurines represent by far the most numerous examples of the style, though beardless youths also appear. Terracotta is the most usual material, but the style found expression also in figures in bronze, as we have seen (fig. 5.30), in ivory, electrum (fig. 5.31), and, most significantly, in stone.

The "Lady of Auxerre" (fig. 5.33), a limestone statuette 25½ inches (65 cm) tall and named after the city in France where she was first exhibited (she is now in the Louvre, Paris), is an enlarged translation of the mold-made terracotta form into stone. She typifies the Daedalic style and probably came originally from Crete. Standing frontally, she wears a long dress, elaborately decorated on the skirt with incised concentric squares that were originally painted. A

5.33 "Lady of Auxerre" statuette. c. 640 BC. Limestone. Height 25½ ins (65 cm). Musée du Louvre, Paris

5.34 "Woman at the Window" relief, from Mycenae. c. 640 BC. Limestone. Height 15¼ ins (40 cm). National Museum, Athens

similar design decorates the upper border of the garment at the neck. A broad belt pinches in the high, narrow waist. (Actual bronze belts like this have been found dedicated in sanctuaries.) A cloak covers both shoulders. Her face is triangular, and her brow is low, while her hair is arranged in vertical strands and horizontal waves, also taking on an approximately triangular shape on either side of the face. Large feet emerge from beneath the shapeless skirt. She holds her large left hand flat against her leg and her large right hand across her body between her breasts, in a gesture often thought to signify adoration.

Her counterparts in architectural sculpture come from Prinias, as we have seen (p. 136), and from Mycenae. The Mycenae relief figure (fig. 5.34), only 15³/₄ inches (40 cm) tall, has hair that, as preserved, is more obviously triangular and wig-like than that of the Lady of Auxerre. Yet, like the latter, the forehead is low and the hair above the brow ends in fancy curls. The Mycenae figure pulls her cloak either over or away from her head in a modest gesture often associated with brides. Some scholars have thought that the relief was a metope, part of a frieze decorating the superstructure of a Doric building (see fig. 6.3, p. 153). Fragments of other limestone reliefs also come from Mycenae and may have belonged to the same frieze. But such a frieze is more likely to have adorned the dado course of a building, as seems to have been the case with the frieze of cavaliers from Prinias (fig. 5.18), in the Eastern manner. Both the Lady of Auxerre and the Mycenae "Woman at the Window" are thought to have been made around 640 BC.

At about the same time, Greek sculptors turned to a new material – marble – and a new scale. As with architecture, the impetus for change came from Egypt. From the early years of the century, visiting Greeks had seen not only gigantic buildings made of stone, but also lifesize and colossal statues of standing and seated figures. Egyptian sculptors frequently used very hard stones – granite and PORPHYRY – which they worked laboriously with abrasives and stone pounders according to an age-old technique.

Up to this point Greek sculptors, working soft limestone, had needed little more than carpentry skills to create statuettes like the Lady of Auxerre. Now, however, Greeks began to use the crystalline white marble with which the islands of the Cyclades, notably Naxos and Paros, were so liberally endowed. Marble quarries on Samos were also open before the end of the century. Though the influence on Greeks of Egyptian buildings and statues is inescapable, the earliest Greek marble-quarrying techniques are most closely paralleled in Anatolia, and not in Egypt.

The blocks themselves were worked with an iron point, a flat chisel, and an abrasive, probably emery, from Naxos. From an early date, a drill, rotated by pushing and pulling a bow or a strap, was used for details and to free arms from bodies. The new large figures were first roughed out at the quarry site, to judge from the unfinished blocks found midway between quarry and harbor on the island of Naxos. This preparatory step would have reduced the cost of shipment from quarry to the site of dedication, though occasionally work was damaged in transit from quarry to port.

The style at first is Daedalic, though, almost at once, the diminutive scale associated with Daedalic

was left behind. A Naxian aristocrat named Nikandre made a lifesize (some say over-lifesize) dedication on Delos, which, though battered, has survived (fig. 5.35). The anonymous sculptor worked edgily on the thin planklike rectangular block, which is nowhere thicker than 8 inches (20 cm), and presented the normal Daedalic forms: a triangular face, wiglike hair, and a frontal and rigid pose. The composition is controlled by the oblong shape of the block from which the figure is carved. Characterized by tight verticals of arms and upright stance, and sharp horizontals of base, waist, and shoulders, it offers a structure which is still geometrically derived. At the same time the thinness, cleanness of form, and easy structure, which the Nikandre kore exemplifies, were to become defining traits of the Naxian workshop in the next century (see p. 185). That workshop's vision of formal beauty finds here its earliest expression.

An inscription boldly placed on the side of her skirt reads: "Nikandre dedicated me to the Far Darter, the Arrow Shooter, outstanding of women, daughter of Deinodikes of Naxos, sister of Deinomenes, wife of Phraxos." The statue shows the Naxian aristocracy's pride in their lineage as well as the originality of the sculptor. At the same time, it is noteworthy that Nikandre, for all her elite status, is defined not by her female self and her virtues, but by her masculine relatives and her implied dependence.

She was found near the Artemision (the Temple of Artemis), and on this evidence, and the language of the inscription, is thought to have been a dedication not to Apollo but to his sister Artemis, who shared the great sanctuary on Delos with him. Who was the statue intended to represent? And what evidence is helpful in deciding this issue? Did the figure represent Nikandre herself, standing in perpetual homage to the deity? Was she simply a generic figure, an *agalma* (a pleasing gift) for a god? Or an image of Artemis herself?

The figure has been variously dated. Though some have said that it dates from pre-650 BC, as a marble figure it would be an oddly isolated example. A date of about 640 BC is more likely, since fragments of larger marble females of about 625 BC

5.35 The Nikandre statue, from Delos. c. 640 (?) BC. Marble. Height 5 ft 9 ins (1.75 m). National Museum, Athens

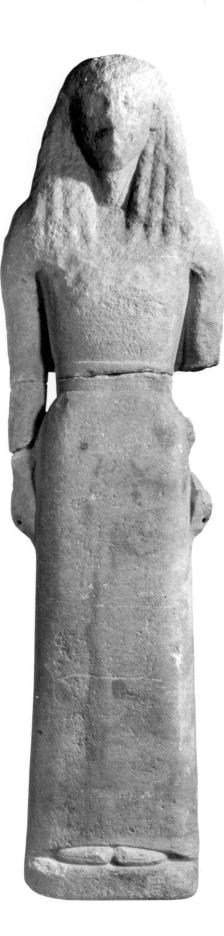

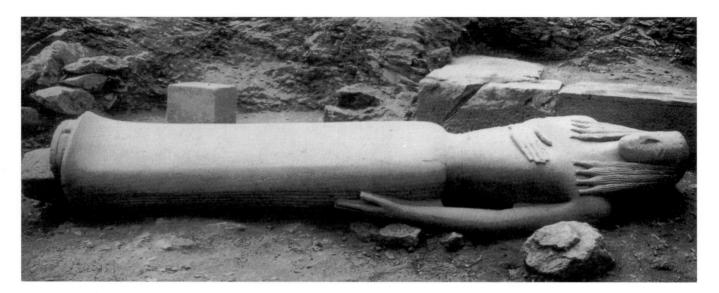

5.36 Over-lifesize Daedalic marble kore from Sellada, Thera. c. 640 $_{\rm BC}$. Height 7 ft 8 ins (2.3 m). Thera Museum

come from Samos, and there is now the newly found (year 2000) standing marble female figure from Thera (fig. 5.36). She displays the usual Daedalic traits, is dated to c. 640 BC by her excavator, and, importantly, is over-lifesize (7 feet 6 inches [2.30 m] high). She was found in an Early Archaic cemetery and had evidently toppled from her base in the course of installation or during the last phases of preparation: final details and the smoothing and painting of the surface had not taken place. This remarkable statue and the Nikandre are the earliest lifesize and over-lifesize marble Greek statues of females that we have. Nikandre did not choose to name the sculptor of her statue, but the debut of the artistic personality was not long delayed. The base of a statue for a male figure, dated about 600 BC, reads: "Euthykartides dedicated me, the Naxian, and he made me."

The first male figures in marble are lifesize or bigger from their earliest appearance. Enough fragments of these huge figures have been retrieved to make a reconstruction of the type. They follow Daedalic conventions for the hair and head. They are naked, except for a belt, and stand with one leg slightly advanced, like their Daedalic precursors – for example, the bronze from Delphi (fig. 5.30). They appear in sanctuaries as dedications (on Delos, for example) and in cemeteries as gravemarkers (as on Thera).

The Egyptian influence on their appearance is striking. Egyptian standing male figures are strictly frontal. Many were wrested from their rectangular blocks by a system of proportions, which was sketched in a grid on all four surfaces of the block. The Greek method of working marble was similar, working inward from the surface all the way round the block at the same time, removing mantle after mantle of stone. Similar "quadrifrontal" figures (figures worked on all four sides) emerge, though there are differences. Egyptian figures stand with one leg advanced, as do the Greek. Yet the Egyptian figure stands more stiffly, back leg locked, while the weight of the Greek figure is more evenly distributed and the pose is not so forced. Egyptian figures are clothed, while the Greeks are naked. Though there are obvious similarities of form (see fig. 6.45, p. 178), it is the method of working stone (the approach from all four sides, working from linear diagrams on each surface) and system of proportions (computer studies have now confirmed the closeness of proportions between the earliest kouroi and Egyptian figurines) that show the influence of Egypt to a greater extent. The sheer size of the Egyptian statues also had an obvious impact.

Sculptors refined their skills by working on a less imposing scale, creating smaller figures of conspicuous beauty. Such is the kneeling youth from Samos (fig. 5.37), who originally formed one arm of a lyre

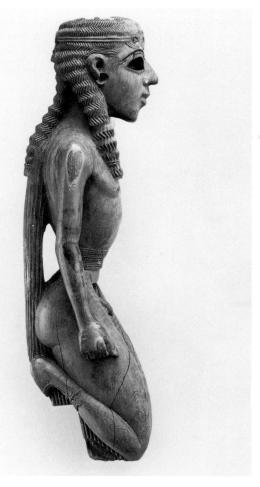

and was made around 625 BC. An ivory figure, he has eyes, brows, earlobes, earrings, and pubic hair that were inlaid in another material, now lost. His triangular torso, long thighs, and ornate belt depend on Daedalic prototypes, yet the head is quite different. Gone is the flatness of features, the wiglike hairdo, the triangular shape of the face, and low-browed skull. Gone too are the fuller, rounded forms, which might have pointed to an Eastern origin and are commonly found among ivories in Greek sanctuaries of the same period. Simply carved major forms of arm, leg, torso, and cheek are matched by the detailed precision of hair, mouth, belt, and hand. Side by side with the marble giants, this small figure exemplifies the close of the Orientalizing period. From now on, all things - vase painting, art, and architecture included – whatever their sources of inspiration may have been, were to be distinctively Greek.

5.37 Kneeling youth, from Samos. c. 625 BC. Ivory. Height 5¼ ins (14.5 cm). National Museum, Athens

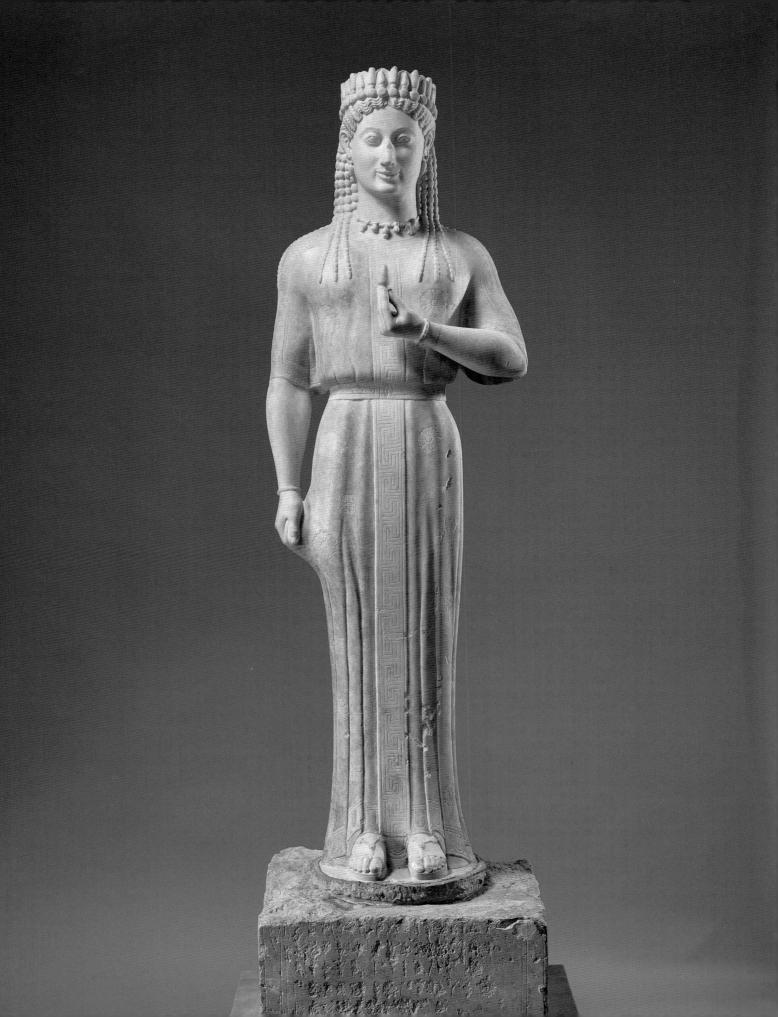

ARCHAIC GREECE c. 600-480 bC

he prosperity of the seventh century BC continued into the sixth; so did the rivalries between states, the intensified interest in commerce, and the energetic expansion of colonies already founded abroad. Commercial enterprise and competition brought the Greek states face to face with other expanding Mediterranean powers: the Etruscans and Carthaginians in the West, and the Persians in the East. Many states continued to be in the hands of tyrants, but by the end of the sixth century BC democratic constitutions had been set up in others: for example, Athens. The Archaic period opens around 600 BC as architects and sculptors in rival city-states thriving on commercial prowess strive for monumentality in stone. It ends around 480 BC with the great battles between East and West: Greece against Persia, and Greeks in the West against Carthage. These military and naval conflicts mark the culmination of dramatic changes in the arts, as shown in sculpture in the round, in vase painting, and in architectural sculpture.

Athens

Athens, which had shown the way ahead in the Geometric period, now came to the fore again. It had not participated in the colonizing ventures of the late eighth and seventh centuries BC, probably owing to a decline in population. This is revealed in the fact that in the Attic cemeteries there are many fewer graves of the early seventh century BC than of the later eighth century BC. There was also half the number of wells in use in what was later the Agora of Athens in the seventh century.

The relative obscurity of seventh-century Athens gave way to a period of intense political, commercial, and artistic activity. In the early sixth century BC, the struggle for power between the aristocrats and the people resulted in the appointment of a citizen called Solon, both politician and poet, as chief magistrate with powers to settle the differences. Aristotle, writing over two hundred years later, says that Solon used pre-existing property classifications to divide the citizens into four classes based on wealth: fivehundred-bushel men (those with land providing five hundred bushels of grain), horsemen, teamsters, and workers. But some commentators believe that Solon himself was the one who introduced these divisions to emphasize the importance of wealth as well as birth, so initiating constitutional progress toward democracy. All agree that he set up an elected council to prepare business for the assembly and allowed all male citizens access to the lawcourts. His reformsaimed to reconcile the populace with the aristocracy. Predictably, perhaps, he pleased no one.

In the second quarter of the century, a tyrant, Peisistratos, appeared on the scene. He and his sons Hipparchos and Hippias controlled the city, more or less continually, until 510 BC. Disagreements between the classes were suppressed, while com-

^{6.1} Phrasikleia, and her inscribed base, from Merenda, Attica. c. 540 BC. Marble. Height 6 ft 1 in (1.86 m). National Museum, Athens

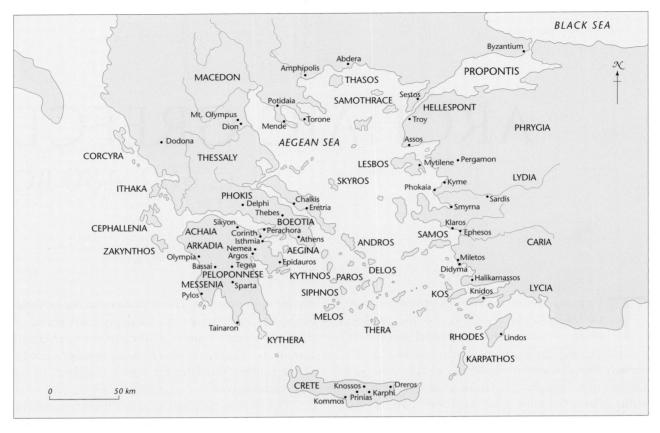

6.2 Map of Greece and the Aegean

merce prospered and the arts were encouraged. Sculpture and vase painting flourished, and largescale building programs were begun. Peisistratos died in 527 BC. Hipparchos was assassinated in 514 BC, and Hippias was driven into exile in 510 BC. Political arguments and civic strife then resumed, until the reins of power passed to Kleisthenes, whose wide-ranging reforms, instituted in c. 508 BC, ushered in democracy. Kleisthenes broke the stranglehold of the old tribes by setting up ten entirely new ones, each consisting of citizens from all three geographical zones of Attica (the city, the coast, and inland). Members of one of the new tribes who lived on the coast might live far from fellow tribesmen living inland, or in the city, and so on. There were other reforms, notably the establishment of a new council of five hundred, fifty from each tribe; but it was the new membership rolls for the ten new tribes that were the constitutional ingredient that forged the new democracy. In this way Kleisthenes strove for the integration of Attica.

New challenges faced the fledgling democracy at once (fig. 6.2). Summoned to support the Greek cities of Ionia in their revolt against the all-conquering Persians in 499 BC, Athens shared in the surprise attack on Sardis, the capital city of a Persian SATRAPY, and burned it down. This became the ostensible reason, the casus belli, for the Persian invasions of Greece that followed. The landing at Marathon, at which the geriatric exiled tyrant Hippias was present on the Persian side, took place in 490 BC. The Athenian hoplites triumphed, almost singlehandedly, over the Persians. Only a small contingent from Plataea arrived at Marathon in time to help the Athenians in their assault. This astonishing victory, long to be remembered, provided a huge boost to the confidence of the young democracy. Moreover, it forced other cities to recognize the power and energy of Athens. Ten years later, in 480 BC, when the Persians returned with another armada, the Athenian general Themistokles and his fleet played an important role in the victory at Salamis, and, though the city itself was laid waste by the Persians, Athens's prestige among the Greeks soared. The land victory over the Persians at Plataea in 479 BC was secured by the traditional land power of Greece, Sparta. From then on, the two city-states became rivals for the leadership of Greece. As the Archaic period ended, most cities of the Greek world found themselves within the political orbit of one of these two states; the only exceptions were to be found in the West, where cities like Selinus prospered independently and where, following their success against Carthage at the Battle of Himera, Syracuse and Akragas nursed their own ideas of grandeur.

The period is everywhere one of excitement, expansion, exploration, and revolutionary change. As sculptors came to grips with the problems of representing ideal forms in observed subjects, so rational advances in philosophy and the natural sciences had to contend with a cultural environment in which the gods were close at hand and to be feared. The notion that the gods resented and punished acts of human self-aggrandizement was keenly felt. So, too, was the sense that human success, whether on the battlefield or in athletics, was only achieved with the assistance of the gods.

ARCHITECTURE AND Architectural Sculpture

The building of temples for the gods continued to command priority. These were now frequently surrounded by colonnades, which formed part of the exterior of the temples and for which the so-called architectural "orders" were designed. The two principal orders in stone, the "Doric" and the "Ionic," dimly discernible at seventh-century Thermon and Samos, find full expression in the Archaic period.

The Orders

The "Doric" order (fig. 6.3) presents columns without bases, but with FLUTES joining in a sharp ridge (the ARRIS) and capitals in two parts, an oblong or square flat slab, the ABACUS, above the cushion-like ECHINUS. There are echoes here of Egyptian and Mycenaean columns (compare the Lion Gate). Above the capital came the entablature in three parts: the architrave, the frieze, and the CORNICE. The architrave

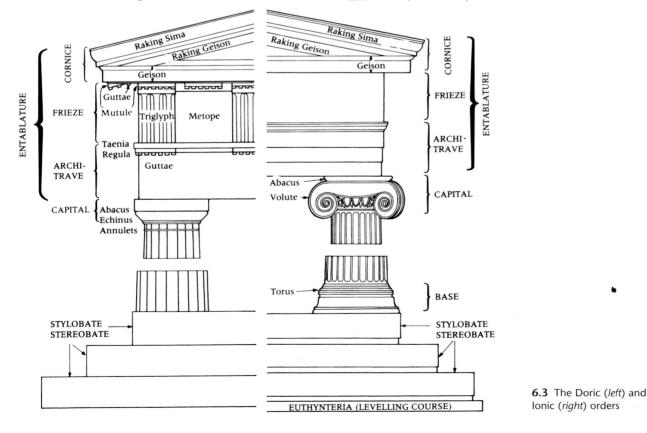

regularly consisted of ashlar blocks, undecorated except for a narrow projecting band (a taenia) at the top, to which were attached small rectangular shelves (regulae) with pegs (guttae) fixed to their undersides. The frieze comprised an alternating series of TRIGLYPHS (upright members, each with three bars conventionally thought to represent the translation into stone of carpentry prototypes) and metopes (frequently decorated). The cornice provided a horizontal capping member on the flanks of the building, and both horizontal and angled members framing the gables at the ends. The end gables (the PEDIMENTS) were often decorated with sculpture, at first in relief, but by the end of the period entirely in the round, standing on the floor of the pedimental triangle.

The "Ionic" order (fig. 6.3), by way of contrast, separated the shafts of the columns from the stylobate (the course of masonry that supported the colonnade) by horizontally fluted bases, and had more vertical flutes on its columns than the Doric. It also, later, separated flute from flute with a flat fillet. The capitals of the order are related to, but distinct from, some of those richly varied capitals (mushroom and Aeolic capitals) used in the Temple of Athena at Smyrna at the turn of the century (figs. 5.23-5.25, p. 140). Aeolic capitals, found mostly in Asia Minor in the coastal area north of Smyrna, often have volutes springing upward and outward from separate stems, with a palmette (a conventionalized palm-leaf ornament) between the two, and collar(s) of leaves below. All the decorative elements (florals and volutes) are drawn from the Eastern vocabulary. In the Near East, these motifs had generally appeared at a small scale in wood and bronze, elaborating, for example, furniture. Where they had appeared on a large scale, in Phoenician volute capitals, they had not belonged to any coherent order.

In the Ionic capital, the two volutes are joined, seemingly pressed down with carved decorative MOLDING beneath, and palmettes are relegated to corners beneath them. Sometimes a narrow abacus above supports the entablature. In the entablature, the architrave is often broken into three horizontal planes (FASCIAE). The most important feature is the frieze, which is continuous, sometimes carved with figures, sometimes denticulated (looking like precisely gapped rectangular teeth). Cornices provide the crowning members. In general terms, the Ionic order is more restless visually, with much ornament and much variety. The Doric seems more integrated and sturdier. Doric is popular on the mainland of Greece and among the Greeks in the West, and Ionic among Greeks in the East (Asia Minor) and in the islands. These orders appeared on the exterior of temples whose plans (fig. 6.4) remained straightforward. A box for the cult statue, the cella, was preceded by a porch (PRONAOS). In the Doric order the temple also had a back chamber (an opisthodomos or ADYTON).

Greek architecture made ample use of paint. Most of this has disappeared today, with the significant exception of some underground tombs (fig. 9.56, p. 329), but traces remain, better preserved on terracotta members than on stone, and new techniques of photography and pigment analysis are restoring faded colors. Colors used were blues, reds, greens, blacks, and yellows; red and blue were popular on stone, red and black on terracotta. In the Doric order, for example, annulets (fig. 6.3) were usually blue and red, the taenia was red, regulae blue, guttae unpainted, triglyphs blue, backgrounds of carved metopes red (otherwise left plain), the background to pedimental sculpture blue, and so on. The sculpted figures in the pediments and friezes were themselves also painted brightly and lavishly (see figs. 6.15 and 6.29). The whole effect was much more varied than the impression we get today.

Doric Temples

Two examples of Doric temples of the sixth century BC can be seen in the Peloponnese. The so-called Temple of Hera at Olympia, built around 590 BC, marks the end of the transition from elementary materials to stone. The plan (fig. 6.5) shows six columns on the front, by sixteen on the flank, porch, and opisthodomos, each with two columns in antis. Porch columns, front and back, are aligned with columns of the façades, thus tying peristyle and central block together. The cella has interior columns and spur walls that no longer obstruct the view of the cult statue. The upper elements of the temple (now lost) were of mudbrick and timber, but stylobate, platform, and lower courses of the walls were of cut masonry. The columns were originally wooden, but were gradually replaced by stone. Many years later, Pausanias wrote that he saw an oak column still

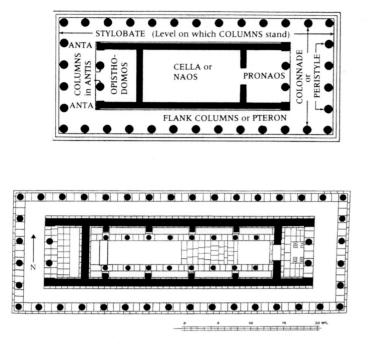

standing in the opisthodomos. This confirms that the temple was transitional in terms of building materials. It is double the area of the seventh-century temple at Thermon.

Better preserved, in terms of the elevation, is the Temple of Apollo at Corinth, built in the second quarter of the century. The plan (fig. 6.6) shows six columns on the façade, by fifteen on the flank (indicating that architects were reducing the more elongated proportions of earlier structures). There is a columned porch and opisthodomos. Porch columns align with those on the façade. It also has the unusual feature of two inner columned chambers. Of these, the eastern one would have accommodated the cult statue. Would the other have sheltered Apollo's treasures, or have been a place for oracular activity? Seven of the columns of this temple stand with an architrave block or two still in place (fig. 6.7). The squatness or slenderness of Greek columns is often described in terms of proportions, with the height stated as a multiple of the lower diameter. At Corinth, the height of these sturdy columns is 4.15 times the lower diameter at the front of the building, 4.40 times on the flank. The columns are monolithic (i.e. carved from a single quarry block) and made of limestone. The echinus of the capital bulges visibly, giving a baggy profile. The profile of Doric capitals

6.4 *Above left* Typical plan of a Doric temple

6.5 *Left* Plan of the so-called Temple of Hera, Olympia. c. 590 BC

6.6 *Right* Plan of the Temple of Apollo, Corinth. c. 560 BC

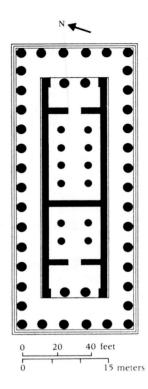

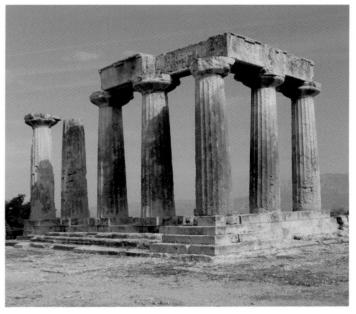

6.7 Temple of Apollo, Corinth, surviving columns from the northwest. c. 560 Bc. Limestone with white stucco surface

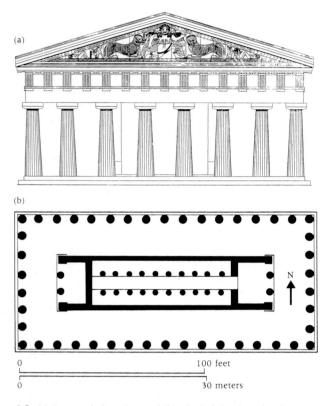

 $6.8\,$ (a) Restored elevation and (b) plan of the Temple of Artemis, Corcyra. c. 580 $_{BC}$

provides a valuable, if relative, chronological marker – the baggier the profile, the earlier the capital.

Planners introduced a number of refinements into the architecture from time to time, and this temple provides the earliest example of curvature on the façade of a building: the upward curvature of the stylobate. This refinement aimed at correcting the optical illusion that straight lines, whether vertical or horizontal, appear to sink in toward the midpoint. Another favored refinement, called ENTASIS, presented columns with a bulging cigarlike contour intended again to correct the optical illusion: this refinement is not present in the Temple of Apollo at Corinth but may be easily recognized in the Temple of Hera I at Poseidonia (fig. 6.36).

The same kind of superstructure that is lost from the temples at Olympia and Corinth is partly preserved among the fragmentary remains of the Temple of Artemis on the island of Corcyra (modern Corfu), a colony founded by Corinth (fig. 6.8a and b). Built around 580 BC, this temple, of which the blocks of the platform, walls, and columns are almost completely lost, showed in plan eight columns on the facades, and seventeen on the flanks. It had a columned porch, cella, and back chamber. New is the broader space between the colonnade and the walls, leaving enough room for a second row of columns, a so-called PSEUDO-DIPTERAL arrangement. A few fragments of carved limestone metopes have survived, and, miraculously, so has the relief sculpture of the limestone pediment from the west end of the building. Much of the triangular space is taken up by a huge central Gorgon figure, almost 10 feet (3 m) tall, flanked by Pegasus and Chrysaor (fig. 6.9), the children born at the moment of her death. This trio is flanked in turn by two enormous felines. On a much smaller scale, Zeus, thunderbolt poised, attacks a giant on one side. On the other, a seated figure, backed by what might be a city wall, stretches out an imploring hand to the lost figure whose spear threatens his throat. Is this Priam, king of Troy? Prostrate dead or dying figures fill in the corners. The composition is symmetrical. Heraldic felines speak of the power of the goddess within (and of the Gorgon), under whose control they are. This power is available to well-wishers and is ready to chastise non-Greek malefactors. Narrative groups stand as

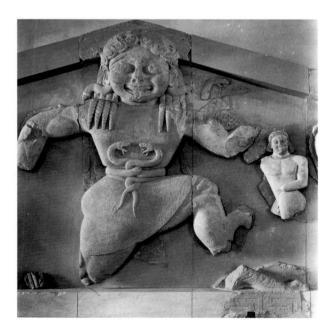

6.9 Temple of Artemis, Corcyra, pediment: central figure of the Gorgon, Medusa, with her son Chrysaor to her left.c. 580 Bc. Limestone. Height (of Gorgon) c. 9 ft 4 ins (2.85 m). Corfu Museum

6.10 Athens Acropolis, pedimental group: threebodied, snaky-tailed monster. c. 550 BC. Limestone. Height c. 3 ft (90 cm). Acropolis Museum, Athens

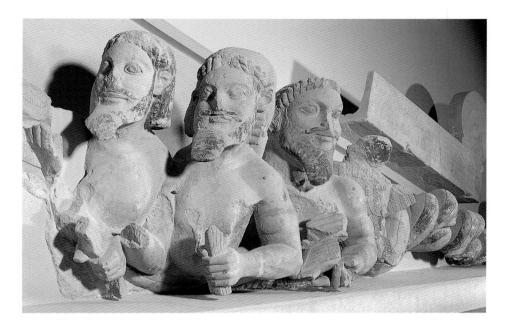

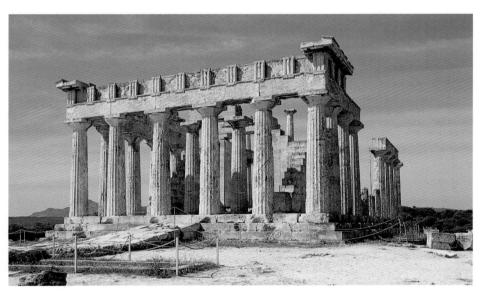

6.11 Temple of Aphaia, Aegina, from the east. c. 500 BC. Limestone. Height (columns) c. 17 ft (15.8 m)

metaphors for the conquest of barbarism by the civilized world of Greek deities and heroes.

The limestone groups that decorated the pediments of a temple of Athena built on the Acropolis at Athens in the early years of the tyranny offered a new solution to the problem of what to do with the corners of a triangular shape. They were filled with snaky-tailed monsters (fig. 6.10), or with struggles between heroes like Herakles and sea deities like Triton, whose fishtail could writhe conveniently into acute angles. These limestone figures were richly painted with blue, white, red, and green to present a brilliant, if not garish, appearance. This temple of Athena may have been an Archaic building beneath the Parthenon. The foundations visible between the Erechtheion and the Parthenon (dotted plan on fig. 8.2, p. 250) belong to another Archaic temple; so the Acropolis was a sanctuary with twin temples from an early date.

Developments in Doric building throughout the century culminate in the Doric Temple of Aphaia on the island of Aegina (figs. 6.11 and 6.12). The plan

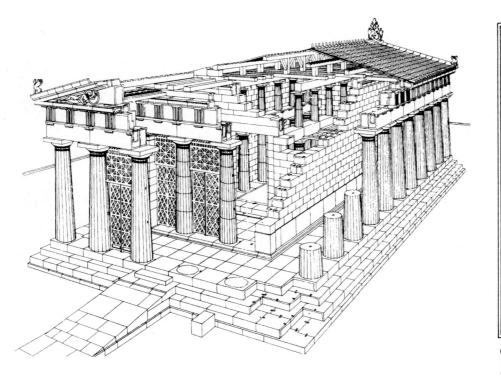

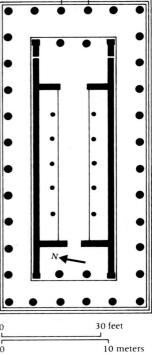

6.12 Reconstruction drawing of the Temple of Aphaia, Aegina. c. 500 $_{\text{BC}}$

(fig. 6.13) has six columns on the façade, with twelve showing on the flank, columned porches front and back, and a columned cella. The temple is accordingly less elongated, and there are Doric refinements. Columns lean inward slightly, and corner columns are thicker than others. Strictly applied numerical ratios govern the heights of members of the elevation. The height of the columns is now 5.33 times the lower diameter, yielding much more slender proportions than in the columns of the Temple of Apollo at Corinth. As a general rule, architects aligned the triglyphs of the frieze with the centers of the columns below, thus preserving the upward visual thrust of the columns. But they faced a problem at the corners of buildings. When they pushed the end triglyphs to the corner to avoid having half-metopes there, they were left with elongated metopes in the frieze between the corner and adjacent columns. The solution was to narrow the space between the corner columns and adjacent columns, thus contracting the whole corner. This Doric refinement is known as angle contraction. It had been used in the so-called Temple of Hera at Olympia, and it was used in the Temple of Aphaia.

6.13 Plan of the Temple of Aphaia, Aegina. c. 500 BC

The temple has left fragments of three pediments, two from the east end, and one from the west. These present certain problems. The somewhat ungainly, stiff, angular style of the figures of the west pediment (figs. 6.14, top, and 6.15) suggests a date of around 500 BC. Those of the replacement east pediment (fig. 6.14, bottom) show more natural movement and realistic expressions and may date from 480 BC. The composition was accorded a pushand-pull treatment, a contrast of centripetal and centrifugal movement in the two pediments. In the west, the action is centrifugal with the battle flying outward; in the east, it moves inward from collapsed figures in the corners (one even beginning to roll out) to striding figures near the center. In both instances, the tableau is of the Aeginetan heroes at war, perhaps at Troy, presided over by Athena, the only figure drawn to a scale larger than others, as befits a divine being. The choice of topic allows for unity of scale, with figures striding, kneeling, lunging, and collapsing, filling the space all the way into the corners. In terms of the pedimental composition and sculptural style, these pediments mark the transition from the Archaic period to the Classical.

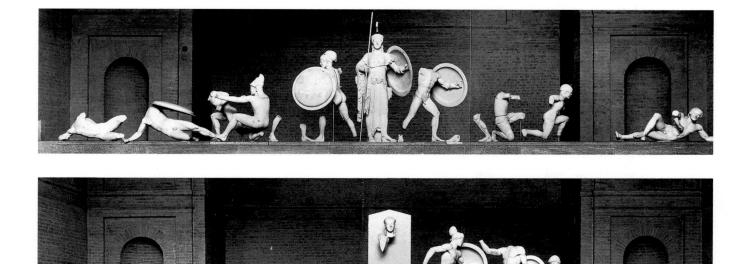

6.15 Archer from the west pediment of the temple of Aphaia at Aegina: reconstructed model (scale 1:3), showing polychromy. Staatliche Antikensammlungen und Glyptothek, Munich, AD 2004

6.14 *Above* Temple of Aphaia, Aegina, pediments: top, west pediment; bottom, east pediment. Marble. c. 500–480 BC. Height (of Athena in west pediment) c. 5 ft 6 ins (1.68 m); width (overall) c. 49 ft (15 m). Staatliche Antikensammlungen, Munich

Ionic Temples

The earliest indisputably Ionic temples were erected on the island of Naxos in the Cyclades, in Asia Minor at Ephesos and Didyma, and in the sanctuary of Hera at Samos.

In the Cyclades we've already noted (pp. 112, 139) the early appearance of sanctuaries and sacred buildings. The earliest temple at Yria on Naxos dates to the ninth century, and the series of temples which follow – temple II c. 750 BC, temple III c. 680 BC and temple IV c. 580–570 BC – trace the increase in use of marble in Cycladic construction and the emergence of the Ionic order. The builders of the fourth temple used characteristic Ionic capitals and bases for their columns, a frieze course, and two rows of columns in the interior (fig. 6.16). The island of Paros did not exploit its marble quarries as quickly as Naxos, but rapidly came into its own in the later sixth century when numerous temples of both Ionic and Doric orders were constructed.

6.16 Reconstruction drawing of the interior of the fourth temple of Dionysos, Yria, Naxos. 6th century BC.

On Samos, a new temple of gigantic size, 55 yards (50 m) wide by almost 109 yards (100 m) long, was built by two Samians, Rhoikos and Theodoros. It is often referred to as the Rhoikos temple; it has recently been suggested, however, that it was Theodoros who was the architect while Rhoikos was the master mason. Begun after 575 BC, it was completed by about 560 BC. There were eight columns showing on the front, with twenty-one on the flanks, and ten at the back (fig. 6.17). A double colonnade encircled the deep porch and columned cella. No capital from this building has survived. This temple was the centerpiece of an elaboration of the sanctuary, with a new monumental gateway, altar, and other outbuildings. When it collapsed or was dismantled around 530 BC, an even bigger and more ambitious replacement was begun (fig. 6.18a), now to be surrounded by a triple colonnade at front and back, and with a double colonnade on the flanks.

Not to be outdone, the Samians' neighbors to the north at Ephesos began a gigantic temple for their

divinity, Artemis, at about the same time. Of the same width, it was nearly 126 yards (115 m) long, with a triple row of columns on the façade. Unlike most Greek temples, which were oriented toward the east, this one faced west. Horizontally fluted bases supported tall columns (fig. 6.19), some endowed with sculptured drums above the base and surmounted by volute capitals, some of which have survived and are to be found in the British Museum. Precious fragments of an inscription, confirmed by the fifth-century Greek historian Herodotos, tell us that the king of Lydia, Croesus, helped to meet the cost. This provides an important chronological marker, for Croesus lost his kingdom in 547 BC. It is probable therefore that the columns to which the inscription refers were in place before that date.

A third example of Ionic gigantism, similarly built in the mid-sixth century BC, appeared at the Sanctuary of Apollo at Didyma near Miletus on

6.17 Plan of the Sanctuary of Hera on Samos. c. 560 BC

6.18 Plans of Ionic temples showing relative sizes

- (a) Temple of Hera, Samos. c. 530 BC and later
- (b) Temple of Apollo, Didyma. c. 550 BC
- (c) Temple of Apollo, Didyma. c. 330 BC and later

the coast of Asia Minor. This temple (fig. 6.18b) had an open-air interior sheltering a small shrine – a temple within a temple. It also had relief sculpture, which decorated not only the lowest drums of exterior columns, as at Ephesos, but also the corners of the architrave above (with gorgons and lions). When the temple was rebuilt in the fourth century BC and later, a similar plan (fig. 6.18c) was followed, though blown up to an even more monstrous scale.

The functions of these temples were varied, and they should not be thought of in the same way as we think of churches, synagogues, or mosques. They were, first and foremost, the houses of the deities and their images. Some were indeed built to shelter preexisting hallowed places, or ancient venerable images

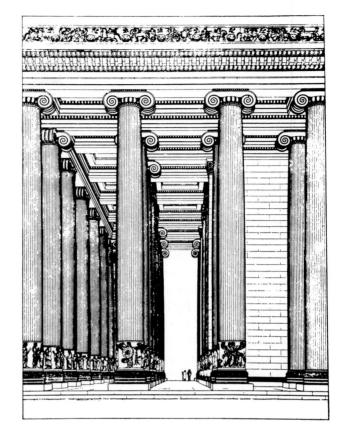

6.19 Restored elevation of the Temple of Artemis, Ephesos. c. 560 $_{\text{BC}}$

with special powers, or an altar, or a tree. Appropriate religious ceremonies were held: the reception of initiates, the consultation of an oracle. Attachment to a particular holy or magical place perhaps explains why temples were often built repeatedly on the same spot: for example, the two sixth-century temples on Samos. Other temples seem to have been purpose-built as houses for new images of anthropomorphic gods (gods having the attributes of humans). These were elaborate and costly offerings from the city to the divinity concerned. Most liturgies were enacted *outside* the temple near open-air altars, though some acts of worship and sacrifice (with an indoor altar) did take place inside.

But temples were not built solely for purposes of worship. They were also used to guard the offerings of other states or individuals, and other possessions of the god. This evidently placed some of them more in the realm of banking and finance than religious ceremony. Since gifts and goods were inventoried, temples became record offices as well. This function was sometimes expanded to include caring for administrative or business archives and citizen lists.

Sanctuaries

We've already seen (pp. 107, 112, 139, 159) that sanctuaries were sacred places where Greeks practiced religion, that some were enhanced with public buildings which became sturdier over time, that they played an important role in the formulation of the polis, and that one or two developed into Panhellenic centers. Sanctuaries are found all over the Greek world, on the mainland of Greece, in the islands wherever, indeed, Greeks settled around the Mediterranean. They were situated both inside and outside the city's walls, deep in the countryside, on mountain tops, on riverbanks and promontories, near springs of water and other natural phenomena. They were numerous, and of different shapes and sizes. The smaller and more remote may be documented archaeologically only by an altar or hearth, scraps of pottery and terracotta figurines, and the residue of sacrifice, the more prestigious by imposing and richly decorated buildings. They served many purposes. Primarily and profoundly religious in character, they acted as social and economic catalysts too, as centers of congregation and communication, of commercial exchange and artistic production.

Two features were indispensable to the definition of the sacred space - an altar and a boundary marker separating the sacred from the profane. The marker could be a wall, high or low, or it could be an imaginary line between two boulders or a boulder and a tree or some conspicuous natural feature. The altar was the focus of ritual activity (see fig. 7.46, p. 245) where participants gathered (most altars were in the open air), animals were sacrificed, and libations were poured: it was the most important place in the sanctuary. Some altars were stone-built and impressive in size, others much smaller, and others only a pile of rocks, or a small hearth, or a heap of ashes and charred bones from earlier sacrifices. All sanctuaries had several altars, some for the use of individuals, others for civic ceremonies. As citystates grew and prospered, more and more structures were added in their major sanctuaries - temples, stoas, dining halls, gateways, treasuries, hotels, and, adjacent to sanctuaries with which athletic contests were associated, training and exercise grounds and stadiums.

Festivals - periods of holy days, sacred time, set aside to please the gods and strengthen ties between mortals and immortals - were at the heart of sanctuary activity. The polis showed off its riches and skills, and individuals enjoyed themselves: they gazed at or took part in religious acts, and they feasted. Processions winding their way through city to sanctuary or through countryside from sanctuary to sanctuary claimed territorial jurisdiction, rode herd on the sacrificial animals, and brought the necessary instruments to the place of sacrifice. They made a brilliant spectacle. Representatives of most groups of society took part and, by so doing, underscored the solidarity of the polis. Yet political implications did not detract from the high religious purpose - that is, to engage the good will of the gods at the level of the individual and ensure divine help in the growth of the state. The best-known Athenian festival was the Great Panathenaia, episodes of which seem to be shown in the Parthenon frieze (pp. 258-63).

Processions culminated in sacrifice. Sacrifice makes the animal sacrificed - sheep, goat, ox, or heifer - sacred, separates it from the world of mortals, and gives it to the gods. The procession delivered the animals to the altar, where prayers were said and ritual dances were performed. Water and grains of barley (symbolizing purification and fertility) were sprinkled on the victims, the altar, and the attendants. The priest then cut tufts of hair from the chosen beast's head and threw them on the altar fire. The consecration was complete. Then came the killing. Struck by a cleaver or an ax, the beast collapsed. The sacrificial knife, hidden in the basket beneath the sacred barley, was taken out and the animal's throat was cut. Blood spilled into basins, the hide was stripped off, the carcass dismembered and butchered on a table nearby. Some parts were given to the priest - the hide, the tail, or the tongue - but the fatty thigh bones, reserved for the gods, were burnt away on the altar, the smoke ascending to the heavens. Oil and wine were poured out over the altar for the gods. The entrails (the heart, liver, and lungs - the most vital parts) were examined for what they could tell of the future (divination), then roasted on spits (fig. 6.20) and distributed. Finally, the rest of the meat was stewed in cauldrons and given to worshipers to be **6.20** Attic red-figure krater by the Pan Painter. Drawing of a sacrifice scene showing an altar (foreground), a herm (background), and three participants: One pours a libation onto the altar (at the left), another (center) holds a container with the sacrificial instruments, while the third roasts the sacrificed animal's entrails on a spit. c. 470 BC. National Museum, Naples

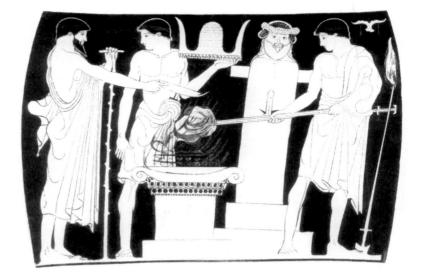

eaten in a communal meal or taken away. Gods and Greeks ate meat from the same beasts and drank the same wine.

States made costly gifts of buildings and statues (fig. 6.64) to the gods, while individuals made less expensive offerings: a few grains of corn, or drops of wine, or fruit, or cakes, or an animal for sacrifice. Or they might bring pieces of pottery or terracotta figurines or roughly carved wooden objects or small painted terracotta reliefs (figs. 7.40 and 7.41, p. 242). More lavish gifts such as marble or bronze statues which drew attention to the donor - and were therefore intended for two audiences, the human as well as the divine - might be made if means allowed. Weapons, too, and items of armor - shields, helmets, cuirasses, greaves - were impressive gifts: on one occasion the Phokians dedicated at Delphi no fewer than two thousand shields taken from the enemy. But all these gifts were removed from the human sphere, dedicated to divine use alone, and were made in the hope of divine reward. Individuals sought help through oracles, divination, dreams, and prayers. They asked for purification and healing, for victory in combat and competition, for good crops and healthy livestock, for good marriages, success in childbirth, and healthy and plentiful children. A system of reciprocity was in place that implied partnership between gods and humans.

It's difficult in the twenty-first century to grasp the intensity of Greek religious life. The gods were many, and they were everywhere. They demanded allegiance and attention; they could be helpful or spiteful. They were all too human. Their sanctuaries saw activity all the time. At Athens, no fewer than 120 days each year were devoted to festivals involving sanctuary use: annual festivals and monthly festivals, festivals linked to the agrarian calendar, festivals focused on the fertility of humans and animals. As well as these public rituals for which the sacred space of sanctuaries was indispensable, there were the countless visits of individuals seeking divine help and bringing gifts. Sanctuaries and awareness of them were a central, inescapable part of ancient Greek life.

Doric and Ionic Treasuries

Altar and temple were the focus of sanctuary life. But, in the more famous sanctuaries, architects also constructed smaller buildings, called treasuries, to safeguard the offerings of individual cities, and to stand themselves as offerings and marks of gratitude and devotion. At Delphi (fig. 6.21), for example, numerous states, including Athens, Sikyon, and Siphnos, built treasuries in the Archaic period. Simple in plan – a small rectangular cella preceded by a porch, often two-columned – such treasuries were built with thick windowless walls and raised on podia. Evidently, their main purpose was to protect the offerings inside and to deter intruders. Nonetheless, several were embellished with rich programs of sculptural decoration.

Around 560 BC, the tyrant of Sikyon, a Peloponnesian state facing Delphi across the Corinthian gulf, commissioned a pair of sacred buildings for Delphi –

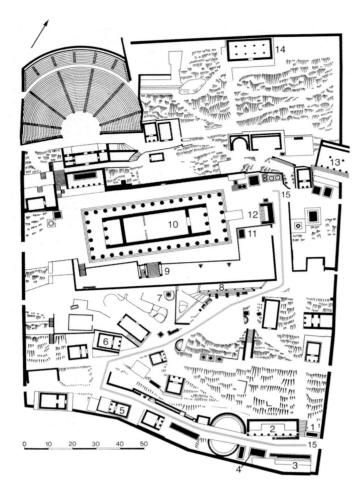

6.22 Metope from the so-called Treasury of the Sikyonians, Delphi: the cattle raid of the Dioskouroi. c. 560 BC. Limestone. Height 2 ft (63 cm). Delphi Museum

a tholos and a monopteros (a structure consisting of columns alone) decorated with sculpted stone metopes. Between fourteen and eighteen metopes (most are fragmentary though four are almost entirely preserved) of an Early Archaic date, which chimes with that of the monopteros, were unearthed in the foundations of the Late Archaic (c. 500 BC) Sikyonian treasury. Because of their findspot they are assumed to have belonged to an earlier Sikyonian structure but in truth it is far from certain that the metopes derive from an earlier building on the same site or that any such structure was necessarily Sikyonian. On the other hand, the subject matter of the preserved metopes is unusual in Greek narrative art of this time owing to the absence of Homeric content and of the exploits of Herakles; it emphasizes rather myths of special interest to Sikyon - the Dioskouroi, the Kalydonian boar, the adventures of the Argo. Paint is used liberally to brighten the figures and for the identifying inscriptions.

The long hair and garments of the Dioskouroi (fig. 6.22) are shown in some detail. Heads of oxen appear engagingly in frontal and profile view. There is a real sense of recessive planes: spears held in the right hands precede the receding heads of the captured cattle, with other spears or goads held in the left hands in the background. Here is the literal petrification of the painted terracotta panels of the preceding century (cf. Thermon, p. 135).

Sometime after the Battle of Marathon, in the decade 490–480 _{BC}, the Athenians dedicated a treasury at Delphi, now wholly rebuilt (fig. 6.24) on its original site in the sanctuary. The Doric order was used in conjunction with sculpted metopes. These depicted the exploits of Herakles at the back and

6.23 Above Metope from the Treasury of the Athenians, Delphi: Herakles and the hind. c. 490–480 Bc. Marble. Height c. 26 ins (67 cm). Delphi Museum

6.24 Above right Treasury of the Athenians, Delphi, from the east. c. 490–480 BC. Marble. Height (columns) 15 ft 9 ins (4.20 m); (entablature) 5 ft 6 ins (1.67 m)

6.25 Below right Perspective reconstruction of the Treasury of the Siphnians, Delphi, c. 530 $_{BC}$

on the northern side, and those of Theseus, hero of the new democracy, on the more visible southern flank. The front of the building, facing the Sacred Way, showed an Amazonomachy (battle between Greeks and Amazons), but the metopes here are so badly damaged that neither Theseus (the more likely candidate) nor Herakles is discernible as leader of the Greeks. In contrast to the earlier Sikyonian treasury, the metopes now show cycles of events rather than isolated incidents. Here (fig. 6.23) Herakles leaps on the back of the hind, his cloak and quiver frozen static behind him. Sharply cut details of patterned beard, ribcage, and abdomen contrast with the natural energy of the pose.

The most dazzling treasury in the sanctuary is the Treasury of the Siphnians (fig. 6.25). Traditional understanding of literary evidence holds that this Ionic building was constructed using the wealth that came to Siphnos from its gold and silver mines, before the island was overcome by Samians in 525 BC

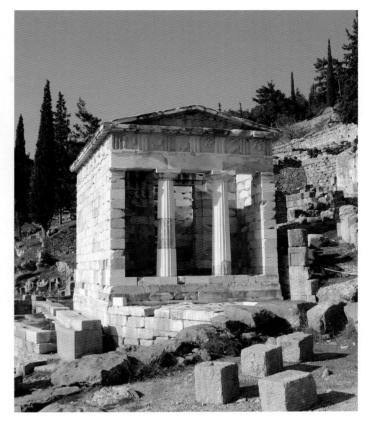

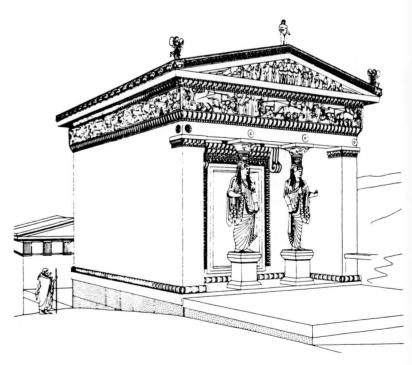

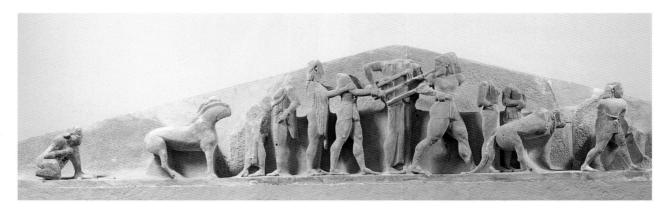

6.26 Treasury of the Siphnians, Delphi, east pediment. c. 530 BC. Marble. Height (at middle) 29 ins (74 cm). Delphi Museum

and before its mines were flooded by the sea. This treasury is highly important, not only for its rich and varied ornament, but also because it is securely dated and can therefore act as a valuable chronological marker for the development of Greek sculpture. The two columns of the porch were replaced by female figures carved in the round, known later to Vitruvius as CARYATIDS, but probably called KORAI (sing. KORE) at the time. The Greeks came to think of religious buildings in terms of the human body, but such literal humanization is unusual. Another city-state, Knidos, had already built a treasury at Delphi with carvatids in the porch, but the most famous example of this phenomenon, the Erechtheion on the Acropolis of Athens (see pp. 268-9), was yet to come. Each gable end of the Siphnian treasury was decorated with PEDIMENTAL SCULPTURES, apexes of the building were enhanced with carved figures (AKROTERIA) standing against the sky, and a continuous frieze ran all the way around the structure (fig. 6.25). The building faced west, so that, paradoxically, the sides of the building most visible to the pilgrim climbing the zigzag Sacred Way were the back and the north flank.

The pedimental sculpture from the back is preserved. The central figure of Zeus arbitrates between Herakles and Apollo, who struggle for the Delphic tripod (fig. 6.26). Chariots and horses flank the central scene, with smaller-scale, standing, striding, and recumbent figures adapting their poses to the triangular space. The composition is unevenly balanced, asymmetrical, and the figures seem motionless and stilted.

The frieze beneath this pediment showed two conflicts, to which equal space was given. There was the verbal argument between divinities, seated on Olympus, over the fate of the heroes at Troy, and an actual encounter at Troy between heroes (fig. 6.27), dismounted from their chariots, over the body of a fallen warrior. The relief is high, the composition symmetrical and unified. New are the three-quarter views of the horses and chariots (the further parts of the latter are shown in paint on the background), the pathos of the dead warrior in his awkward fore-

6.27 Treasury of the Siphnians, Delphi, east frieze: combat of heroes at Troy.
c. 530 BC. Marble. Height 24% ins (63 cm). Delphi Museum

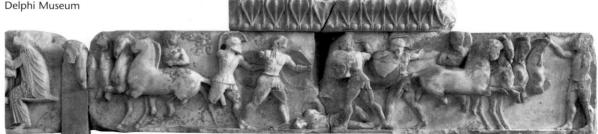

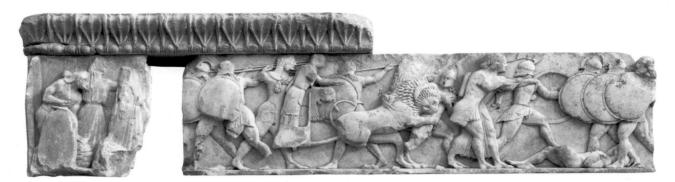

6.28 Treasury of the Siphnians, Delphi, north frieze: gigantomachy. c. 530 BC. Marble. Height 24% ins (63 cm). Delphi Museum

shortened pose, and the dramatic gesture of the end figure closing the composition at the north.

The matching short frieze at the west front of the building was divided into three scenes. A winged Athena mounts a chariot in one of the scenes, while the central panel shows another goddess stepping down from another chariot. The block that carried the third scene is lost. Interpretation hinges on the identity of the goddess in the central panel. If she is Aphrodite, then the whole may have represented a Judgment of Paris, with Hera and Paris appearing on the missing block; if she is Artemis, then the event displayed may have been the birth of Apollo on Delos – a palm tree at the edge of the center block seems to suggest activity on that island.

The long, continuous north frieze showed a gigantomachy, the battle between gods and giants (fig. 6.28). It is thick with overlapping figures, diagonal movement, FORESHORTENING, and continuous variation of posture, attitude, and shape. One incident shows Themis in her chariot and Dionysos attacking giants. In another, Apollo and Artemis are

firing in unison at giants who advance like hoplite infantry, shields abreast. Themis, Dionysos, Apollo, and Artemis are all identified by painted inscriptions. One of Themis's lions munches vigorously on the midriff of an unfortunate giant. The sculptor magisterially combines descriptive detail of the lion's mane with a three-dimensional roundness of body in plastic, somewhat flattened forms. The signature of this sculptor is inscribed around the circular edge of a giant's shield. Though the name itself is lost, the inscription claims that he worked the friezes at north and east, and stylistic similarity between these supports this claim. The style of the south and west friezes, however, is quite different. The sculptor here worked almost fussily in the very front planes, cutting sharply around his figures to the back of the relief.

With every suitable surface decorated with sculpture, enlivened with paint (fig. 6.29), and even metal additions for things like weapons, this was a dazzling building. Complex sculpture in relief gave visual form to narrative themes of enduring power.

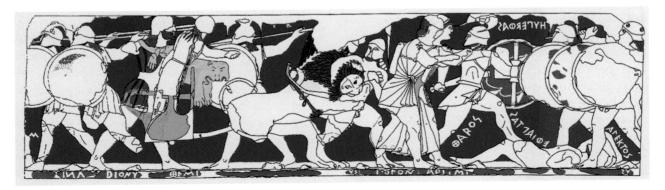

6.29 Treasury of the Siphnians, Delphi, north frieze: gigantomachy. Color reconstruction. Height 24% ins (63 cm)

The topic of the triumph of the Greek gods (Good) over superhuman barbaric giants (Evil), for instance, became a perennial favorite, and had already been used in the pediment at Corcyra. Such themes set amidst such brilliance make this Ionic treasury, jewellike in scale -20×28 feet (6.13 $\times 8.55$ m) – the most compelling document of architectural sculpture of Archaic Greece.

Sicily and South Italy

From the first, Greek architects in the West preferred the elevation of the Doric order for their temples and treasuries, as a rapid glance at any site will show, whether Syracuse or Selinus in Sicily or Metapontum or Poseidonia (Paestum) on the Italian mainland. This apparent emulation of Doric temples in mainland Greece, sometimes disparagingly referred to as provincialism, did not however extend to the layout of temples. With reference to temple plans in particular, but also in their introduction of Ionic elements into the elevations, Greek architects in the West showed considerable flexibility and brilliance. Their buildings demonstrate new thinking, a vitality bordering on exuberance, and a true regional style. At Syracuse, Locri, and Metapontum, moreover, there is evidence of temples built entirely in the Ionic order, once more with great novelties of plan and detail. The Ionic temple at Syracuse was begun in the Archaic period, while the other two were built in the subsequent Transitional period, around 480-450 BC.

In the fifth century BC, Syracuse became a commercial and cultural rival to Athens, and then a bitter enemy. A Doric temple to Apollo, built there between 570 and 560 BC, displays both the ingenuity and limitations of Western builders. The proportions of the plan, HEXASTYLE by seventeen, are long (fig. 6.30) and the elevation is cumbersome; lack of experience in building in stone is shown by the close spacing of the columns. Yet there were innovations. For instance, there was a double row of columns at the front, and secondary stairs to allow access, giving the front of the temple special emphasis. There was a closed chamber, an adyton rather than an opisthodomos, at the back. Moreover, the broad AMBU-LATORY (the side and end passages all the way round) is almost pseudo-dipteral, echoing either the plan at Corcyra or developments in the Ionic order (e.g. Samos, Ephesos, Miletus), or both.

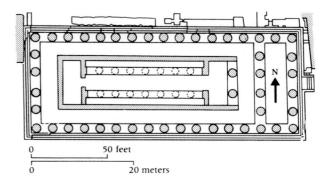

6.30 Plan of the Temple of Apollo, Syracuse. c. 560 BC

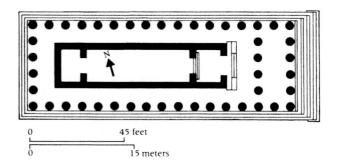

6.31 Plan of Temple C, Selinus. c. 540 BC

Selinus, the westernmost Greek colony in Sicily, witnessed the construction on the Acropolis of two sixth-century temples and a further pair on a ridge to the east of the city. One of these, however, the great Temple G, though begun around 530 BC, remained unfinished at the end of the Archaic period and even at the time of the Carthaginian sack of the city in 409 BC.

On the Acropolis, Temple C (perhaps a temple of Apollo), built around 540 BC, is the oldest and grandest. It displayed both a Doric exterior and a plan (fig. 6.31) similar to that of the Temple of Apollo at Syracuse. However, its columns are more widely spaced and more slender, so that overall proportions are much less squat. A flight of eight steps signaled the front of the building, further emphasized by a second row of columns, as at Syracuse. However, there were no columns in the interior of either the porch or the cella. Thus, alignment of columns of the porch with those of the peristyle was not an issue, and the heart of the temple could accordingly be positioned freely. Sculpted stone metopes decorated the frieze at front

6.32 Above Metope from Temple C, Selinus: Herakles and the Kerkopes. c. 540 BC. Limestone. Height 4 ft 9½ ins (1.47 m). National Museum, Palermo

6.33 *Right* Metope from Temple Y, Selinus: Europa and the Bull. c. 560–550 BC. Limestone. Height 2 ft 9 ins (84 cm). National Museum, Palermo

and back. Of these, three survive, and show Athena, Perseus, and Medusa on one, Herakles and the Kerkopes on another (fig. 6.32), while a third shows a chariot group with Apollo and Artemis. Heads face outward frontally to magnetize the visitor, drawing attention to the deeds of Greek heroes and gods and to the fates that await malefactors. These are not the earliest metopes to appear at Selinus but, together with another series associated with Temple Y and dated to 560-550 BC (fig. 6.33), they point to the existence of a vigorous group of sculptors working in Selinus at the time. Above the frieze course of Temple C, terracotta revetments, bright with painted geometric and floral polychrome designs, enhanced the cornices, while a huge terracotta Gorgon head, 9 feet (2.7 m) tall, stood at the center of the pediment.

Much about the building seems rough and ready. Spacing between columns varies, they have different numbers of flutes, while some columns are monoliths with others comprising several drums. There is no

entasis of the columns and metopes vary in size. Yet there is no gainsaying the novelty of the plan, the impact of the metopes, and the brilliance of the architectural terracottas. The discovery inside the temple of numerous sealings (clay impressions of seals), used to seal official documents, shows that the building functioned partly as an archive, perhaps even of the city itself, and sheds intriguing light on the various functions of Greek temples.

On the eastern ridge, Temple G was of colossal dimensions (fig. 6.34a), some 60 yards (55 m) wide by 125 yards (115 m) long, with columns over 17 yards (16 m) tall. It was evidently intended by its size alone to challenge the gigantic temples of Asia Minor built in the Ionic order. The plan again illustrates the versatility of Greek architects in the West. Pseudo-dipteral, it had a porch with four columns PROSTYLE (forward of the antae) and six columns in all, which was quite unprecedented. It also had a triple entranceway to the cella. The cella had a double colonnade leading to an inner shrine, echoing

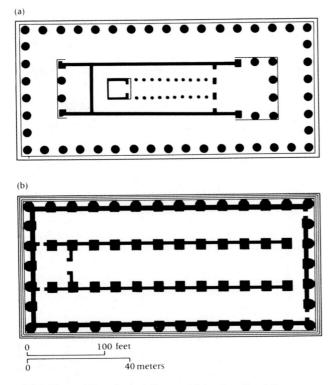

6.34 Plans of Temple G, Selinus, and the Temple of Zeus Olympios, Akragas, showing relative sizes

- (a) Selinus, Temple G. c. 530–409 BC
- (b) Akragas, Temple of Zeus. c. 480-406 BC

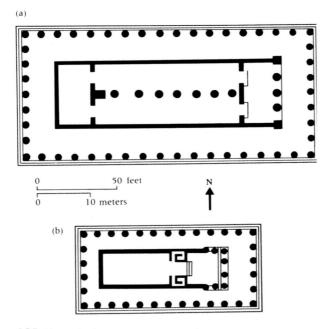

6.35 Plans of 6th-century Doric temples at Poseidonia, showing relative sizes

(a) Temple of Hera I. c. 540 BC

(b) Temple of Athena. c. 500 BC

the arrangement at Didyma (fig. 6.18b), and an opisthodomos. Partially fluted columns show that the building was never finished, while some Doric capitals are Archaic and others early Classical. An inscription found here records thanks for a victory (unidentified) to Zeus, Phobos, Herakles, Apollo, Poseidon, Castor and Pollux, Athena, Demeter, Pasikrateia, and the other gods, but especially to Zeus. This gives a good sense of the local contemporary hierarchy of gods and heroes. The inscription goes on to declare the intention that "a golden tablet with the names of the gods be placed in the Temple of Apollo, and that sixty talents of gold should be spent to this end." The temple is variously identified as a temple of Apollo or Zeus.

On the Italian mainland at Poseidonia (Paestum) stand two important temples of the sixth century BC. The earliest, often erroneously termed the Basilica but now generally known as the Temple of Hera I, was constructed to a novel plan in the middle years of the century (fig. 6.35a). It has nine columns by eighteen, a broad ambulatory, a porch with three columns in antis, an AXIAL colonnade in the cella terminating in a spur wall, and an adyton at the back. This was a new kind of Doric architecture. Unlike in Sicily, the peristyle and cella were closely linked; the columns of the porch and cella were the same size as the columns of the peristyle and aligned with them. The whole building was bisected by the line of the axial colonnade of the cella. This division into two equal parts seems to have served religious purposes and may have provided space and visibility for two statues. Inscriptions and terracotta figurines found in the sanctuary identify the principal divinity as Hera. Accordingly, this temple is for her and perhaps also for her consort, Zeus, for whose presence in this sanctuary there is epigraphic evidence. Yet recent authoritative scholarship contends that the temple was Hera's alone.

The columns (fig. 6.36) display Doric entasis, but introduce ANTHEMION (leaf) decoration onto the necks of the column shafts. At the back of the building, even the actual echinus of the capital is decorated with similar encircling tendrils, rosettes, palmettes, and petals. Such floral ornamentation, more in keeping with the Ionic order, would have been picked out in paint. Nothing is preserved above the frieze course, where recently discovered cuttings for pryholes and dowels suggest the original presence

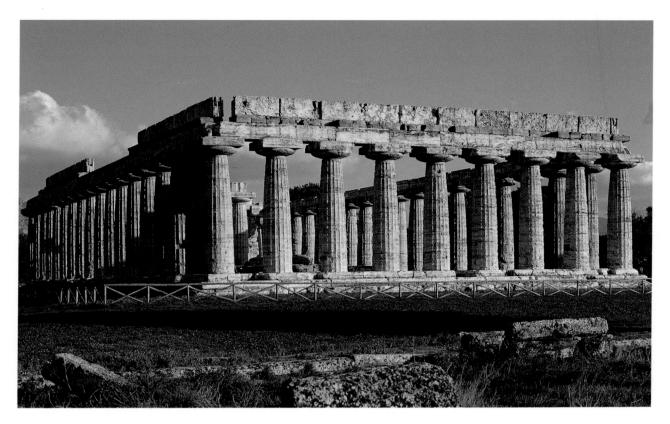

6.36 Temple of Hera I, Poseidonia, from the west. c. 540 BC. Limestone (travertine) and sandstone. Height (columns) 21 ft (6.45 m)

of sculpted metopes, none of which however survives. Many fragments of painted architectural terracottas that decorated the eaves of the building have, however, come to light. Registers of palmettes, tongue patterns, swastikas, and quatrefoils are accompanied by painted gutter spouts in the form of lions' heads.

This temple introduces a new rapport between cella and peristyle, the unusual bisection of the whole building perhaps to serve two different gods, and rich and varied decoration. It suggests an imaginative architectural flair, open to various impulses. In this, it contrasts both with the increasing conformity of Doric in Greece and with the often unbalanced and irregularly aligned plans and plainer elevations of Sicilian architecture.

The other standing sixth-century temple at Poseidonia is the Temple of Athena. Smaller in size than the Temple of Hera I, it displays even more astonishing innovations (fig. 6.35b). The exterior colonnade of six by thirteen columns anticipates the ideal proportions of canonical Doric of the Classical period, and contrasts with the unbalanced proportions of the interior, which provide a very deep porch in front of the cella and no back porch at all.

The columns (fig. 6.37) show distinct entasis. A floral collar decorates the neck of the capital, and the echinus has the baggy Archaic profile. The frieze course above is bracketed by string courses of sandstone (otherwise the stone is the local travertine), decorated with architectural moldings. The frieze itself has no sculptural decoration, nor does either end of the building, since the horizontal cornices are absent. Rather, the architect chose to draw attention to the roof, by projecting the raking cornices forward and decorating them with elaborate SOFFITS (the underside of lintels, arches, or cornices).

The exterior displays plenty of imagination, the interior even more. Here columns of the Ionic order with Ionic volute capitals were introduced for the porch. This is the first building in the whole history of architecture to use both Doric and Ionic columns.

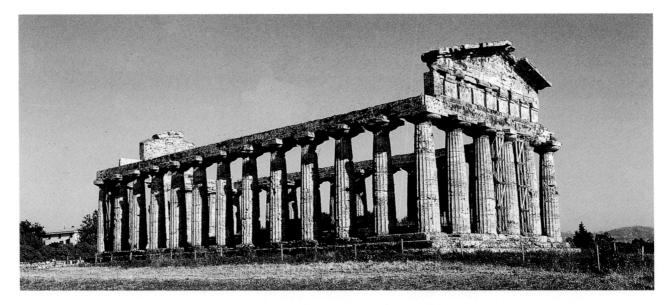

6.37 Temple of Athena, Poseidonia, from the northwest. c. 500 BC. Limestone (travertine) and sandstone. Height (columns) 20 ft (6.12 m); (entablature) 8 ft 8 ins (2.65 m)

As such, it is the clear precursor of developments in Attica some thirty years later. The innovations in the building are numerous: the mix of textures and colors of stone in the frieze; the arrangement of triglyphs and metopes, the triglyphs becoming the decorative elements; the absence of horizontal cornices on the ends; the extended raking cornices with ornamental soffits; the use of the Ionic order in the interior. The profile of the capitals and other architectural details suggest it was built around 500 BC.

The northern boundary of the territory of Poseidonia was marked by the river Sele, and here at Foce del Sele, the mouth of the river, a sanctuary to Hera was built, some 5 miles (8.5 km) from the city. Within the sanctuary a temple, altar, and stoa have been found, together with another building variously identified as a treasury or as another temple. Recent excavation of this building has challenged the original excavators' early sixth-century date for the structure, and has suggested that it may not even be Greek. It is, however, for the quality and quantity of sculpted sandstone metopes, of which over thirty were found in the earlier excavations, that this sanctuary is noteworthy. Some of these metopes may be associated with the late sixth-century temple; but the large majority are to be dated to around 540 BC on stylistic grounds, even though it is now unclear to which building(s) they belonged. Most depict the exploits of Herakles or aspects of the Trojan War, and the decoration was evidently thought of in terms of cycles of events. Although the use of cycles on Doric friezes was to become commonplace in the Classical period, this is the earliest known example that we have. Though most of the metopes show topics familiar to the Greek world of the sixth century BC (Herakles wrestling with the giant Antaios; Herakles bringing the famous boar to Eurystheus), some are less well known. One (fig. 6.38) showing Herakles carrying the Kerkopes bound hand and foot on a pole slung over his shoulder was popular in the West, but was not widespread in its occurrence elsewhere.

Some metopes are in high relief, some in low, while others present figures as two-dimensional contours only (fig. 6.39). These cut-out metopes are evidently unfinished. It is, however, possible to imagine, in this age of experimentation, artists ready to fill in details in paint, evoking the pictorial origins of decorated metopes in TRABEATED architecture (i.e. buildings depending on horizontal wooden beams and vertical posts). The series as a whole documents various artistic approaches, of which high relief ultimately became the most popular, as the metopes of the Parthenon, with some figures almost entirely in the round, demonstrate. Even if this is seen as the victory in the fifth century BC of mass over flat design, paint continued to be lavishly used.

6.38 Metope from the Heraion at Foce del Sele, Poseidonia: Herakles and the Kerkopes. c. 540 BC. Sandstone. Height 32 ins (81 cm). Paestum Museum

6.39 Metope from the Heraion at Foce del Sele, Poseidonia: suicide of Ajax. c. 540 BC. Sandstone. Height 32 ins (81 cm). Paestum Museum

Selinus and Foce del Sele produced far more sculpted metopes in the mid-sixth century BC than the rest of the Greek world combined. Their production is close in date to those of the Treasury of the Sikyonians at Delphi. But if quality and quantity count for anything, it seems that the origins of sculpted stone metopes are to be sought in the Greek West. Moreover, Selinus and Foce del Sele, which produced the vast majority of metopes in the West, were frontier sites. Selinus faced the Carthaginians to the west, Foce del Sele faced the Etruscans across the river Sele to the north. So perhaps these metopes in frontier sanctuaries served not only as pleasing ornaments sending encouraging and admonitory messages to Greek pilgrims, but also as baleful signals to menacing foreigners: "See what happens to those who tangle with Greeks." As with other architectural sculpture of the period, the narratives are outside time. Order is produced from disorder, the Greek gods win out, Greek heroes suffer and survive.

Problems of architecture and architectural sculpture were under close scrutiny in the West. Experimental solutions were advanced, some of which were to become critical components of developed forms (the juxtaposition of Doric and Ionic, sculpted metopes), and some not (an uneven number of columns on façades, abandonment of the horizontal cornice). Though geographically peripheral and representing regional thinking, some of these developments were to be influential in the Greek heartland.

Athens

Access to the Acropolis was improved by building a great ramp, and the sanctuary was graced by two early temples, with one of which the snaky-tailed monsters are associated (fig. 6.10). A second, built on the foundation south of the Erechtheion, was refurbished with marble statuary groups in the last quarter of the century. Almost nothing of these temples can be seen today. The sanctuary also had a number of small treasuries, numerous dedicatory statues, and a small temple to Athena Nike immediately outside the entrance. Much of the glorification of the cult of Athena Polias, tutelary deity of the city, may have been due to the tyrant Peisistratos, who seems even to have lived up on the Acropolis (with the gods!) for part of his reign. A new temple was begun, it seems, after the Battle of Marathon, on the spot where the Parthenon was later to be built. This building, unfinished and surrounded by its scaffolding, was destroyed by the Persians, along with everything else on the Acropolis, when they captured the city in 480 BC.

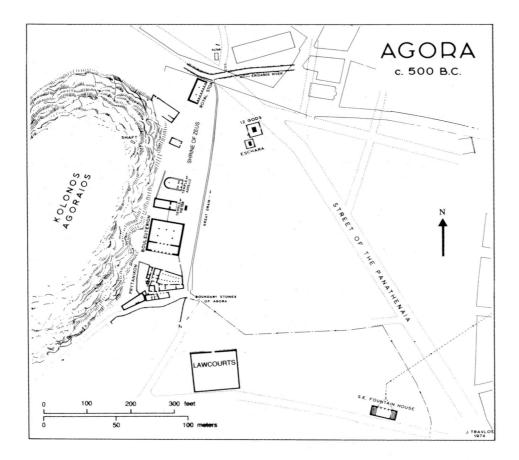

6.40 *Left* Plan of the Agora, Athens. c. 500 BC

6.41 Opposite Attic blackfigure hydria: fountainhouse scene. c. 510 BC. Height 20[%] ins (53 cm). Museum of Fine Arts, Boston

During the Archaic period, an area northwest of the Acropolis, bounded on the north by the river Eridanos, on the west by a slope known as the Kolonos Agoraios, and on the south by the Areopagos hill, was transformed from a zone reserved for housing and cemeteries into the civic center of the city, the Agora (fig. 6.40). This transformation was not instantaneous but gradual, and may have been linked to the activities of the leading political figures of the age, Solon, Peisistratos and his sons, and Kleisthenes. Administrative and religious buildings were to stand along the western edge at the foot of the Kolonos Agoraios. The earliest of these, beneath the later BOULEUTERION, may have been built to accommodate the new council of the four hundred installed by Solon.

The period of the tyranny saw the construction of several new buildings, as houses were pulled down and wells filled in to allow expansion south and east. A large building at the southern end of the buildings along the foot of the Kolonos Agoraios may have been another palace for Peisistratos, while close by a

rectangular walled enclosure was built around midcentury. This has been identified as the site of the early lawcourts or, more recently, as the shrine of the hero Aiakos of Aegina mentioned by the historian Herodotos (5.89). To the north, the Altar of the Twelve Gods, surrounded by a low perimeter wall, was put in place around 520 BC. Famous as a refuge, this altar was also the spot from which distances were measured in Attica, as a preserved milestone tells us. Greek tyrants seem to have favored large public construction programs, among which temples and hydraulic systems were prominent. The Athenian tyrants were no exception. They may have been responsible for at least one of the temples on the Acropolis, and they certainly began the work on the gigantic Temple of Olympian Zeus to the southeast. In the Agora, they built the southeast fountainhouse and the aqueduct that fed it. These installations were popular with the people, as their frequent representation on vases (fig. 6.41) of the later sixth century BC suggests. They offered the rare opportunity of social intercourse for women and slaves, and it was simpler

by far to take water from a spout directly into a HYDRIA (water jar) than draw it up from a well.

In the last decade of the century, the new democracy of Kleisthenes needed fresh administrative buildings. Accordingly, a new bouleuterion was built atop that of Solon. This was a rectangular chamber with provision for seating the five hundred members of the "boule." A stoa known as the Royal Stoa was also built, so called since this was the office of the "archon basileus" (the king archon), the second most powerful official in the state. Other topographical matters may be noted. The principal route across the Agora, the PANATHENAIC Way, ran northwest-southeast and had existed as a thoroughfare before the sixth century BC, when this was a residential area. This road was used for the procession that made its way from the lower city up onto the Acropolis, at the time of the great festival for Athena, the Panathenaia. Inscribed boundary stones – "horoi" – were in position by the end of the century, proclaiming boldly, "I am the boundary of the Agora," and written either left to right or right to left. Their purpose was to define the area of the Agora and to prevent infringement by unauthorized buildings or people.

SCULPTURE

Greek sculptors were at work in marble on the islands of Naxos, Paros, and Samos before the end of the seventh century BC, and, before long, evidence of their work also appears on the mainland. The two major types of sculpture in the round prevalent in the sixth century BC were the standing nude male, the KOUROS (pl. KOUROI; fig. 6.42) and the standing clothed female, the KORE (pl. KORAI; fig. 6.51). Throughout the period, the kouros develops from over-lifesize abstraction to more naturalistic human proportions and scale. On another level, sculptors were attacking the issue of how best to represent divine beauty in human form, the ideal in the real. The kore explores the relationship between garment and body, beginning by completely obscuring the anatomy, and moving through hints of the body beneath to the daring revelations of limbs, in some Late Archaic examples. Paradoxically, the more opportunities there were for rendering drapery folds ornamentally in varied textures, patterns, and colors, the more visible the body became.

The huge kouroi now appear naked, though the influence of Egypt remains (fig. 6.45, cf. p. 148). The belt worn in the seventh century BC is discarded, though one or two old-fashioned figures cling to it, and there are other oddities. A kouros in the Metropolitan Museum in New York (fig. 6.42) – with which compare the recently found Kerameikos kouros (fig. 0.17, p. 24) – made around 600 BC, wears only a neckband, while the twins at Delphi (fig. 6.44) wear boots and nothing else. Male nudity need not cause surprise, since it had occurred in the Geometric period in bronze sculptures (though the figures were

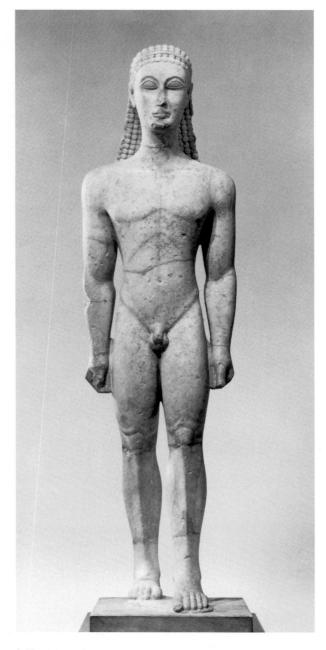

6.42 New York Kouros, said to be from Attica. c. 600 $_{BC}$. Marble. Height 6 ft 4½ ins (1.95 m). Metropolitan Museum of Art, New York

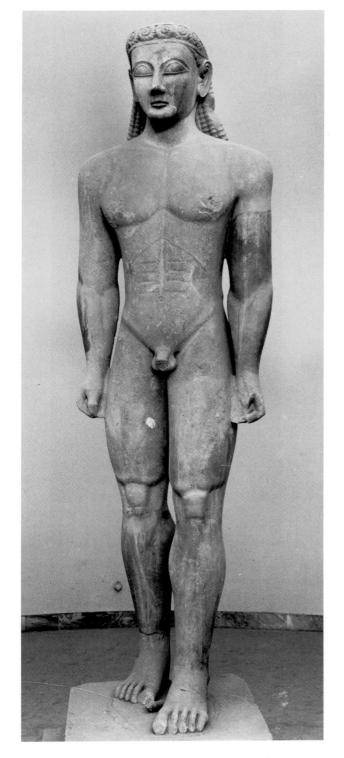

6.43 Sunion Kouros (left arm, left leg, and part of face restored), from Sunion. c. 580 BC. Marble. Height 9 ft 10 ins (3 m). National Museum, Athens

DIODOROS ON GREEK Sculptors and the Egyptian Canon of Proportions

"They say that the most illustrious of ancient sculptors, Telekles and Theodoros, sons of Rhoikos, who made the statue of Apollo for the Samians, spent time in Egypt. They say that half of the statue was made by Telekles in Samos and the other by Theodoros in Ephesos. When the halves were joined, they fitted so well that the statue seemed to have been made by a single artist. The Greeks do not normally do this kind of work, but the Egyptians do. They do not calculate proportions according to the eye, like the Greeks, but when they begin work on the blocks they agree on a modular system, according to which they divide the body into twenty-one parts plus a quarter, and after agreeing on the total size of the figure, they each work different parts commensurate with the others. The Samos statue was made applying the Egyptian system, divided down the center from head to groin, and joining exactly point to point. Accordingly it seems most like an Egyptian work, a statue with hands close by its sides and in the walking stance." Diodoros 1.98.5

belted), and since in everyday life men appeared naked in the gymnasia. But there is probably more to it than that. No other nation with which the Greeks came into contact allowed male nudity, so this may have served to distinguish the Greeks from the rest. At the same time, it allowed the body – shared attribute of gods and men – to be fully revealed.

The kouroi stood in sanctuaries or cemeteries, occasionally as representations of divinities (at one time they were all thought to be images of Apollo). But most often they were there as votive offerings to the gods, or as commemorative markers over graves; in either of these cases they spoke for the power and social standing of the family. Towering, vibrant statues, they stood four-square with one leg advanced and arms held straight or slightly bent by their sides, with fists clenched. The broken fragments of one such kouros were found buried in a pit in the Sanctuary of Poseidon at Cape Sunion (fig. 6.43). His massive head is larger than natural proportions would allow. Huge eyes stare determinedly ahead,

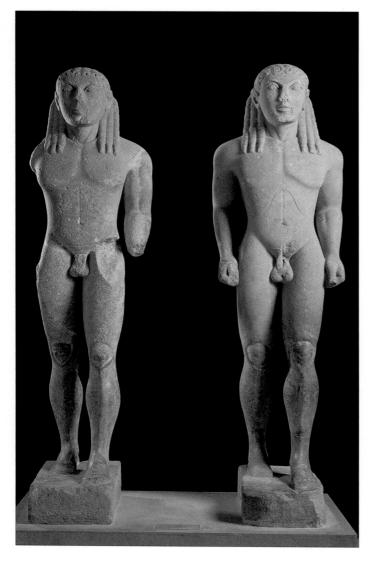

6.44 Twin kouroi, from Delphi. c. 580 BC. Marble. Height 6 ft 6 ins (1.97 m). Delphi Museum

again larger in proportion to the rest of the face than nature would dictate. The anatomical landscape is treated as pure pattern: ears, ribs, and knees are fixed in the surface of the original marble block, the sculptor preferring to define the human form by line rather than by mass. This Sunion Kouros was made around 580 BC.

The twins found in the sanctuary of Apollo at Delphi (fig. 6.44) are shown stepping forward together. They have been identified as Kleobis and Biton, who in one of Herodotos's tales (1.31) took the place of the missing oxen who should have pulled their mother's carriage (a cart) some 6 miles (9.5 km)

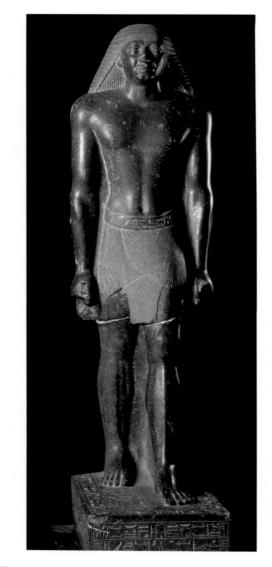

6.45 Mentuemhet, Egyptian prince. Early sixth century BC. Granite. Height 5 ft 6 ins (1.34 m). Cairo Museum

across the plain of Argos to the Sanctuary of Hera. Hence the travelers' boots they wear. Some scholars, however, on the basis of inscriptions detected on the base and (by one scholar) on the heroes' thighs, prefer to identify them as the Dioskouroi (Castor and Pollux). Hairstyle is reminiscent of the Daedalic Style of the preceding century. Anatomy is all pattern and line. Their short, square torsos and stocky proportions are different from those of the New York Kouros or the Sunion Kouros, and are associated with a regional Argive workshop. An inscription gives, infuriatingly, only half the sculptor's signature, "...medes," but says he came from Argos. He made

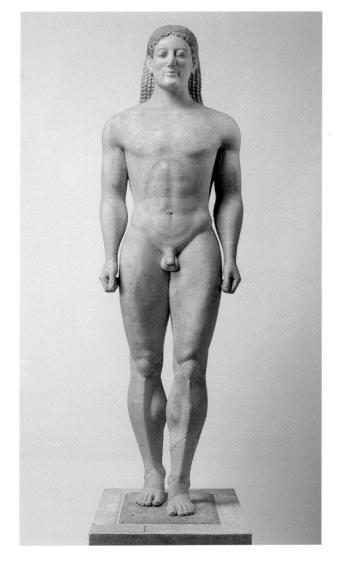

6.46 Anavysos Kouros, from Anavysos, Attica. c. 530 BC. Marble. Height 6 ft 4½ ins (1.94 m). National Museum, Athens

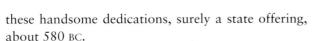

The changing appearance of kouroi through the sixth century BC is often thought of as a progression from abstraction to naturalism. This is indeed part of the story. The Anavysos Kouros, named after the village in Attica where he was found (fig. 6.46) and dating to about 530 BC, shows advances toward more naturalistic proportions and more supple contours. The sculptor has penetrated the block to a greater depth and has thus achieved greater three-dimensionality. The so-called "Archaic smile," not an attempt at representing an emotional state but an

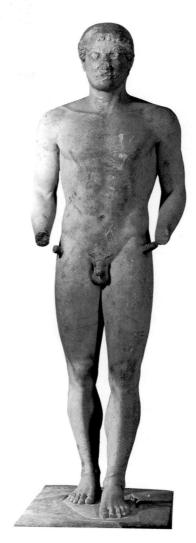

6.47 Aristodikos Kouros, from Attica. c. 500 BC. Marble. Height 6 ft 5 ins (1.95 m). National Museum, Athens

index of vitality, has appeared. Yet posture and gesture, bilateral symmetry, patternized anatomy, and hair have not altered. Some thirty years on, around 500 BC, the Aristodikos Kouros (fig. 6.47), so called since it was the gravemarker of Aristodikos, is yet more naturalistic, with shorter, though still patterned hair, the arms moving away from the flanks, and sinew and bone and knee and shin now appearing more realistic. Yet, though their strivings to find more compelling and worthy images to represent both gods and men were leading them away from superhuman scale and abstract linear form, sculptors were still not emulating in their work the bodies they

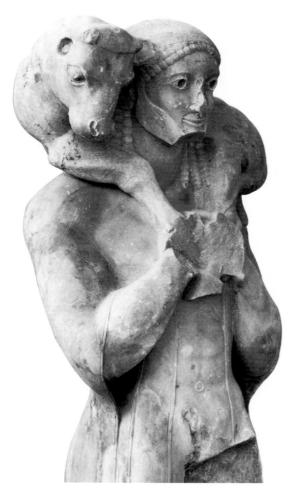

6.48 Moschophoros (Calfbearer), from Athens. c. 560 BC. Marble. Height (restored) 5 ft 5 ins (1.65 m). Acropolis Museum, Athens

saw around them. The tortured struggle to emerge from the conceptual to the representational, or indeed to hold the two ideas in the same figure, continued until the appearance of the Kritios Boy (fig. 7.25, p. 229). In this statue, the capacity for movement inherent in the kouroi, the sense of a functioning anatomy, at last broke loose.

By the middle of the sixth century BC, other male statues in the round were being produced. In about 560 BC, the Moschophoros (Calfbearer) (fig. 6.48) was dedicated on the Acropolis at Athens. The bearded figure, whose beaded hairdo finds parallels among early kouroi, wears a thin cloak and carries the calf, his offering, on his shoulders. Human and animal heads present patterned contrasts. Likewise found on the Acropolis at Athens was the Rampin

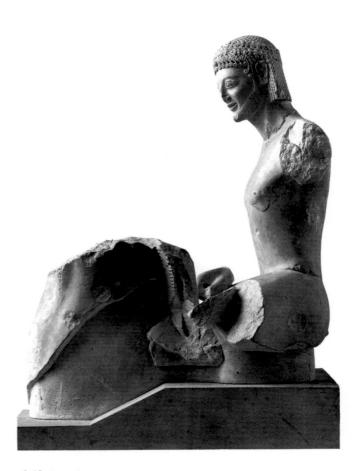

6.49 Rampin Horseman, from Athens. c. 560 BC. Marble. Height (torso) 32 ins (81 cm); (head) 11% ins (29 cm). Acropolis Museum, Athens (torso); Musée du Louvre, Paris (head)

Horseman, dated to around 560 BC (fig. 6.49). The sculptor here wrestles with a complex group of a man and a horse, contrasting broad, flat planes of torso and face with the extravagant heavy-patterned detail of hair and head. The Acropolis at Athens is one of the major sources of Archaic statuary, since the Persians had overturned everything in their onslaught in 480 BC, and the Athenians had gathered up the shattered remains and buried them tidily for archaeologists to discover at the end of the last century.

The female counterpart of the kouros is the kore, the draped standing female figure. As with the kouroi, the functions of the korai were both votive and commemorative; at the same time they also operated as symbols of wealth and family prestige. The kore does not appear until a generation or so after the kouros, which is baffling. Examples continue to the end of the Archaic period, with a specially striking Late Archaic series coming from the Athenian Acropolis. It seems that rich dedications to Athena were popular at the court of Peisistratos and his sons.

With korai, the changes throughout the period are measured more in terms of the rendering of the drapery than of the anatomy. Female dress apparently depended on three major garments, the PEPLOS, the CHITON, and the HIMATION or mantle, all of which amounted to little more than rectangles of cloth, buttoned or pinned, and arranged in different ways (fig. 6.50). The peplos, often made of wool, was folded

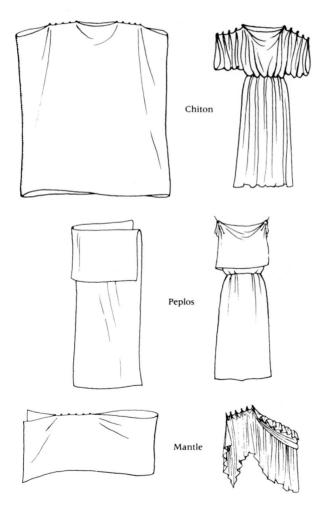

6.50 Diagram of garments

down from the neck and belted. Secured at the shoulder with pins, it was sleeveless and sometimes worn over a chiton. The chiton, often of linen, was, like the peplos, a rectangle of cloth. It was buttoned along the upper edge in two sections to allow holes for head and arms, and was sleeved and belted. The himation, or mantle, was a smaller oblong of cloth, buttoned along one long side, in such a way that it could be worn over the right shoulder and under the left arm. This was most often worn on top of the chiton. Sculptors thrived on the multiplicity of patterns offered by the drapery, and on the ornamental qualities provided by creases, folds, and tucks of different textures of cloth. Sometimes they were so carried away by the richness of the patterns that the logic of actual garments was lost.

In Attica, an early survivor is the so-called Berlin Kore (fig. 6.51), from the decade 570-560 BC. She is notable for her frontal stance, the large features of her face, her big feet and hands, the pomegranate she holds, the simple lines of her garments, and her elaborate jewelry - a bracelet, a necklace, and earrings. She wears a tasseled mantle slung symmetrically over her shoulders, the chiton, and a painted headdress (a polos). Similarly dressed, though without a mantle, and with similar jewelry, is Phrasikleia (fig. 6.1), whose name we know from the funerary epigram written on her base. It reads: "Marker of Phrasikleia. I shall for ever be called Kore, allotted this name from the gods in place of marriage." The use of the term "kore" allows two interpretations. First, it can mean "daughter" and therefore alludes to Phrasikleia's death before marriage; and second, since it was the familiar name for Persephone, who in myth was carried off by Hades to be queen of the underworld, it can allude to Phrasikleia's role in the afterlife as a bride of Hades. Some scholars also see these elegant funerary statues (Phrasikleia comes from a cemetery in the countryside of Attica) as rewards for the dead, objects of compensation or exchange. Others see them simply as symbols of family prestige: women's social status depended on their close male relatives, as Nikandre's dedication (p. 147) shows. Phrasikleia's base also bears the signature of the sculptor, Aristion of Paros. The features of the face are smaller and the figure's proportions slimmer than those of the Berlin Kore, so that, since her sculptor signs as an artist from the island of Paros, she may represent a combination of Attic and Island traits.

THE GETTY KOUROS: IS IT FOR REAL?

The standing, nude, over-lifesize marble figure (fig. 6.55), acquired after an intensive enquiry by the Getty Museum in 1984, provoked immediate controversy on two interlocking issues: authenticity and provenance. Provenance concerns whether or not the statue came out

of the ground illegally or what old collection it came from; and authenticity, whether or not the statue was forged.

The provenance given by the dealer did not stand up to investigation. The revelation that papers associated with the kouros were falsified cast serious suspicion on its provenance. This therefore remains a mystery.

As to its authenticity, scientific analysis was invoked. Isotopic analysis showed that the marble probably came from an Archaic quarry on Thasos. Science also revealed much about the statue's strangely lifeless surface, which did not resemble that of other kouroi. A preliminary conclusion, that the surface had experienced "de-dolomitization," a natural development thought unforgeable, had to be withdrawn when geologists showed that oxalic acids acting on dolomitic marble produce the same effect. The oxalic layers of the surface of the kouros could be either the result of a natural or an artificial process.

In 1992 scholars were invited to a conference where some of the discussion points were as follows: elements of the style of the kouros do not fit with received definitions of regional styles or with traits associated with different phases of the Archaic period – the hair style, for example, appears Early Archaic, details of

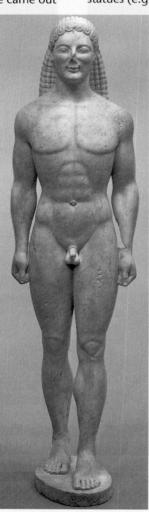

the feet Late Archaic. Yet the appearance in the same object of what were thought to be chronologically distinguishable stylistic traits need not now surprise. This phenomenon has been recognized in recently excavated statues (e.g. the Motya Charioteer, fig. 7.37, p. 239) and

shows how little we know about the phasing, overlapping, and reiterating of Greek sculptural styles.

As to technique, the marble was not carved with chisels held at an angle of forty-five degrees or less, shaving away the marble, as is the modern custom, but by blows struck vertically or at a steep angle. This technique, involving the use of an ax or pointed chisel, is consistent with Early Archaic technique and finds parallels in authentic kouroi. Also, tool use is the same whatever anatomical form the carver was working on (in contrast to the modern preference for a variety of tools) and tool marks are clear. There was no attempt to hide them with acid, a common feature of modern forgeries.

Without an excavated provenance, the figure remains baffling and its authenticity doubtful. Should it be on display? The Getty decided to show it in an exhibition that set out all the evidence, included cases of authentic sixth-century BC kouroi for purposes of comparison, and posed the stylistic, technical, and scientific problems to the general public. What do you think? If it is a forgery, is it without interest? Is it art?

6.55 Getty kouros. Marble. Height 6 ft 9 ins (2.06 m). Getty Museum, California

Complex patterns of coiffure, grouped folds of the chiton, and weightier textured himation folds contrast with the somber expression of the face. At the end of the series, the Euthydikos Kore (fig. 6.56) suggests that the fresh vigor of Archaic Greece is almost at an end and sobriety is at hand. In spite of

increased three-dimensionality, with undercutting of the locks of hair at the temples and pronounced plasticity of eyes, nose, and mouth, drapery folds are rendered almost mechanically. It is the expression on her face, rather than the patterned plasticity of the drapery and hair, that catches the observer's eye. She, too,

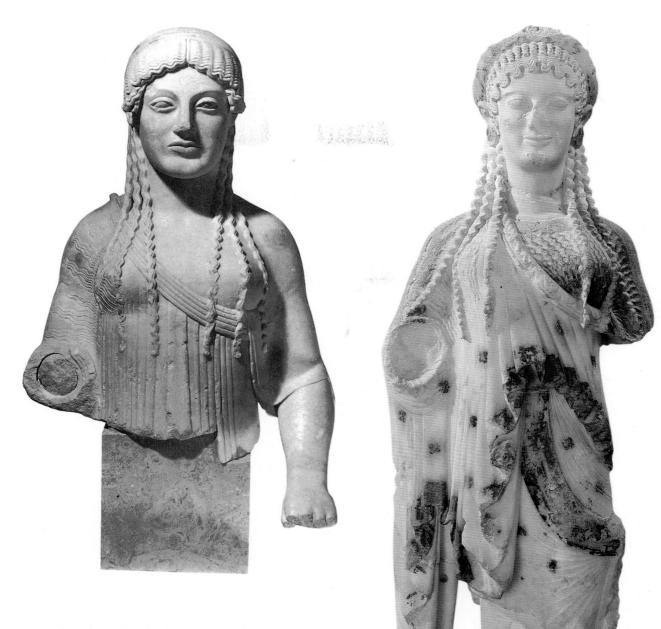

was found on the Athenian Acropolis, where these developments can be most easily followed.

In the earlier part of the century, down to around 540–520 BC, sculptors in different parts of the Greek world took different approaches to the same problems, and it has been possible to assume the existence of a number of regional schools, though these suppositions are based only on stylistic groupings and a small body of evidence. Workshops with distinguishable traits have been identified for Naxos and Paros in the Cyclades, for Chios and Samos, islands off the coast of Asia Minor, and for Argos in the Peloponnese. Examples of Naxian workmanship have been spotted among korai dedicated on the Athenian

6.56 Above left Euthydikos Kore, from Athens. c. 490 BC. Marble. Height 22% ins (58 cm). Acropolis Museum, Athens

6.57 Above right Kore, from Athens. c. 520 BC. Marble. Height 22 ins (0.55 m). Acropolis Museum, Athens

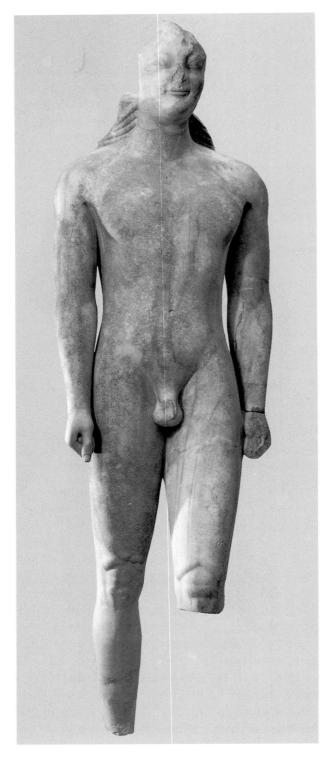

6.58 Ischys Kouros, from Samos. c. 580–570 _{BC}. Marble. Conjectured height 15 ft 5 ins (4.75 m). Samos Museum

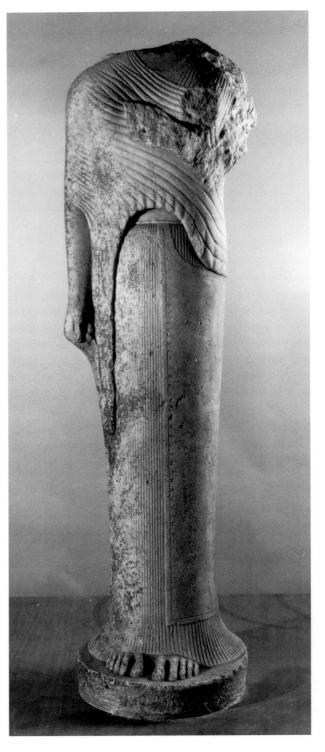

6.59 The Hera of Samos, dedicated by Cheramyes, from Samos. c. 570–560 BC. Marble. Height 6 ft 3½ ins (1.92 m). Musée du Louvre, Paris

acropolis, and another (fig. 6.57) is thought to be Chian. The drapery patterns and head shape are characteristically East Greek; and the marble is said to be Chian.

In spite of the ample evidence of architectural sculpture from Foce del Sele and Selinus, and the presence therefore of workshops in the West, Sicily and South Italy are poorly represented in kouroi and korai. There was no local marble, which may have been an inhibiting factor, and local sculptors seem to have worked more readily in terracotta.

The great Sanctuary of Hera on Samos, however, has yielded much statuary, and indeed is a source of evidence second only to the Athenian Acropolis. Moreover, Samos seems to have been the location of an active workshop of sculptors, who took a sharply different approach from that pursued in Attica. The major types, kouros and kore, are the same. An enormous kouros (fig. 6.58), one of a pair, was dedicated by one Ischys as early as the decade 580-570 BC. Though the hair is patterned into a vertebra-design, the Samian artist eschews other patterning. Posture, gesture, and theme are as in Attica, but the anatomy is treated in a more fluid, almost boneless manner. It is flesh that is sculpted rather than bone, sinew, and muscle. The face, too, has a quite different shape from Attic faces, as do the eyes, mouth, and nose. Later Samian kouroi display spherically shaped heads. Hair is brushed back from the forehead and bunched up into closepacked locks over the ears, following conventions unknown in Attica.

An early headless kore from Samos is the socalled Hera of Samos (fig. 6.59), a contemporary of the Berlin Kore in Attica, with whom she may be compared. Feet together, her right arm by her side, and her left brought across in front of the chest, she stands motionless and frontal. She is conspicuous for the three garments she wears. There is the chiton, whose parallel vertical folds decorate the cylindrical lower body. Then there is the mantle, slung crosswise over her right shoulder and under her left arm, introducing a diagonal line into the composition. Finally, the EPIBLEMA (cloak) covers the back and right flank of the figure, and tucks into the belt at the front. This and similar East Greek figures are the source for the diagonal compositional elements of later Archaic korai in Athens. The sculptor enjoyed the contrasts in texture between the smooth, flat epiblema, the chiton with its pleats, and the heavier folds of the

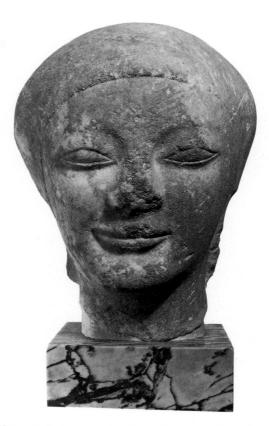

6.60 Head of a kore wearing the epiblema over her hair, from Miletus. c. 550 BC. Marble. Height 8¼ ins (21 cm). Staatliche Museen, Berlin

mantle. The lower part of the body is lost within the treetrunk-like cylinder; in the upper part, however, the contour line takes note of breasts, shoulders, and buttocks, thus initiating an interest in the relationship between anatomy and drapery. The dedicator had his name, Cheramyes, incised along the hem of the epiblema at the front where it was most visible. He must have been a man of substance since he dedicated two other korai in the sanctuary, and two kouroi. Some idea of the head type of these korai is shown in a head from Miletus, a rival state to Samos but quite close by, whose sculptors followed conventions similar to those on Samos. This head (fig. 6.60), though veiled by the epiblema over the crown, is spherical in shape, and is characterized by narrow eyes, prominent cheekbones, full lips, and broadwinged nose. The sphere and cylinder shapes of these korai find parallels in the neo-Babylonian empire, so there may be an Eastern influence at work. While the origin of the kouros is to be sought in Egypt, that of the kore may derive from Mesopotamia.

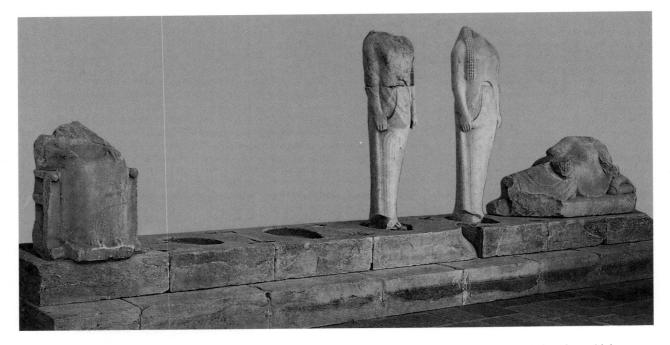

6.61 Marble family group (limestone base) by Geneleos, from Samos, with names inscribed: Phileia (seated); boy, lost; girl, lost; Philippe; Ornithe; . . . arches, the dedicator (reclining). Height (Ornithe) 5 ft 6 ins (1.68 m). c. 560–550 BC. Samos Museum

About mid-century, a sculptor called Geneleos signed a group of figures that all stood together on the same base adjacent to the Sacred Way in the sanctuary at Samos (figs. 6.17 and 6.61). They present a gallery of types: a seated figure, a clothed youth (a so-called "draped kouros"), korai, and a reclining figure. The seated figure, named Phileia, and the reclining male, whose name is partly lost ("... arches"), may be parents of the quartet arranged between them. The draped kouros is an uncommon type which occurs mostly in the Greek East. The korai, two of whom are named, Ornithe and Philippe, wear long, patternized hair and chitons. The folds of the chitons are pulled up to fall over the belt in slack pouches. One hand tugs the dress to reveal the rounded contours of the leg on the other side. This motif would be much used in Athens later. A major characteristic of these sixth-century Samian korai is the hesitant revelation of the body underneath abstract linear drapery. Korai appear in other materials: a bronze (fig. 6.62) from Samos on a smaller scale emulates lifesize marble figures, and a terracotta perfume vase (fig. 6.63) reveals its East Greek origin through its garments, gesture, hairstyle, and the shape of its eyes and nose.

Female figures other than korai were appearing by mid-century. One is the sphinx dedication by the Naxians at Delphi around 560 BC (fig. 6.64). The dedication consisted of tall column, Ionic capital with widely separate volutes, and the sphinx crouching menacingly some 11 yards (10 m) in the air atop the column. Sphinxes often appear in funerary contexts protecting tombs - at Delphi one guards the place where, according to myth, the snake Python, son of Gaia (Mother Earth), died - and there is a good series from the Kerameikos cemetery in Athens (see fig. 0.18, p. 24). Then there is the personification of Nike (Victory) (fig. 6.65), dedicated in Apollo's sanctuary on Delos, shown in the Archaic kneeling/ running posture. Many see her as the earliest example of a winged Nike that has survived, the most striking later example of which is the Hellenistic Nike of Samothrace (fig. 10.27, p. 357). This early Nike wears a peplos over a chiton, the peplos lavishly painted. Dowel holes in earlobes and headdress show that metal attachments also adorned the figure.

Sculptors worked figures in relief as well, not just for decorative friezes and pediments on buildings, but also, like kouroi and korai, for votive offerings to the gods and as grave monuments. The grave

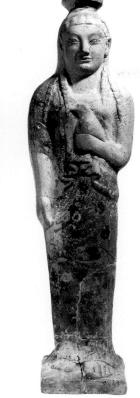

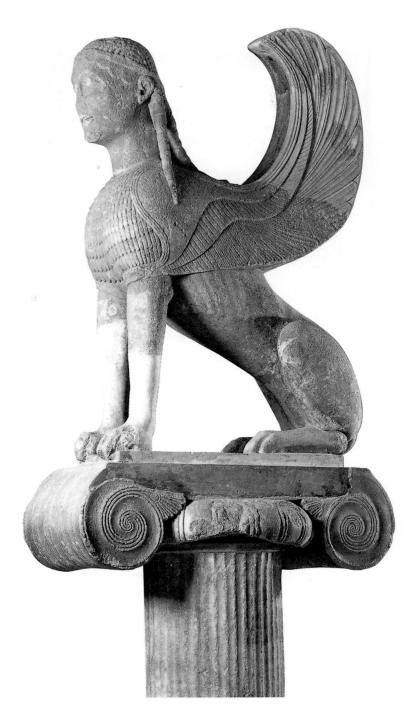

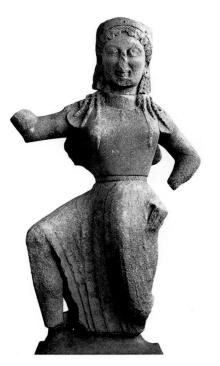

6.62 Above far left Kore, from Samos. c. 560–550 $_{BC}$. Bronze. Height 10% ins (27 cm). Samos Museum

6.63 Above left Alabastron in the form of a woman holding a bird, from Thebes. c. 560–550 BC. Terracotta. Height 10½ ins (26 cm). National Museum, Athens

6.64 Above right Sphinx, dedication of the Naxians, from Delphi. c. 560 BC. Marble. Height (of sphinx) 7 ft 4½ ins (2.25 m). Delphi Museum

6.65 Left Statue of Nike (Victory), or possibly Artemis, from Delos. c. 550 BC. Marble. Height (without base) 2 ft $11\frac{1}{2}$ ins (90 cm). National Museum, Athens

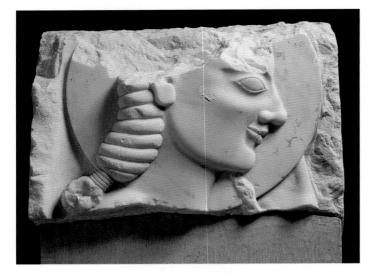

6.66 Fragment of a grave stele, from Athens. c. 560 $_{BC}$. Marble. Height $1\frac{1}{4}$ ins (35 cm). National Museum, Athens

stelai in Attica consist of rectangular slabs surmounted at first by capitals, then by back-to-back volute scrolls, with sphinxes atop. Later the sphinxes were replaced by palmettes. The face of the slab is most often carved in relief with a male figure or, rarely, a group of figures. Sometimes, incised and painted panels appear above and below the main scene. The fragment of around 560 BC from Athens (fig. 6.66) shows the head of the dead youth framed by the discus carried on the shoulder - an athlete, then. A frontal eye in a face shown in profile is a common convention, while the hair bound with a thin cord resembles the Berlin Kore. Another frequent type is the warrior, of which the relief of Aristion by Aristokles (fig. 6.67), identified by inscription, provides a good example. The bearded Aristion wears a helmet, a cuirass, and greaves, and carries a spear in his left hand. The background was painted red, while blue was used on cuirass, greaves, and helmet. The sculpture insists on gentle planar transitions and linear clarity. The overall impression is of a freestanding kouros, now armed. The hairstyle points to a date around 510 BC.

Reliefs appeared in bronze, too. They include the figures decorating the frieze and handles of the enormous bronze krater (fig. 6.68) of around 570–560 BC found in the grave of a Celtic princess at Vix near Châtillon-sur-Seine in France. This gives evidence for

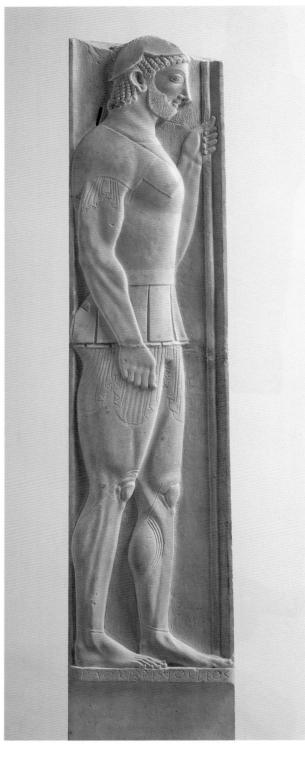

6.67 Grave stele of Aristion, by Aristokles. c. 510 $_{BC}$. Marble. Height 7 ft 10½ ins (2.40 m). National Museum, Athens

a trade network reaching up and down the rivers of France and suggests the interest of non-Greek chieftains in Greek goods. The handles of this huge krater are decorated with gorgons' heads and lions, and there is a continuous scene, in relief, immediately below the rim, like an Ionic frieze on a building. Fourhorse chariots (quadrigas) with charioteers alternate with dismounted warriors in repeated groups. The way the heads of the nearest horses turn downward and outward toward the viewer foreshadows the varied views of horses' heads in the east frieze of the Treasury of the Siphnians at Delphi (fig. 6.27) and the quadrigas of the Parthenon frieze.

Bronze was even more precious than marble, and easier to reuse, for it could be readily melted down and recast. Thus, very little has survived. However, the excavations to put the new Athens subway in place (see Box, pp. 348–9) have produced the remarkable head (fig. 6.69) from the very end of the Archaic period, right on the cusp of the new transitional style.

Bronzesmiths now cast their bronzes hollow, and larger bronzes were made in sections which were then soldered or riveted together. Rather than a core of wax, sculptors used wax only to the anticipated thickness of the metal and placed it upon a core of another material - clay, for example, sometimes covering an armature. This was a refined cire-perdue method. The core was built to almost the needed size of the figure and covered with wax which was then modeled. A clay covering was put on top of the wax and attached to the core with rods. The entire apparatus was then fired so that the clay hardened and the wax melted and ran out. Molten bronze was then poured through apertures to set between clay and core and form the figure or limb. After cooling, the clay shell was broken off and the figure or part of the body appeared.

Another grave monument recently excavated (1994) in northwest Asia Minor (near Troy) is a

6.68 Above right Krater, from Vix. c. 570–560 BC. Bronze. Height 5 ft 4½ ins (1.64 m). Châtillon-sur-Seine Museum

6.69 *Right* Head of a bronze statue (eyes inlaid in bone paste and polished grey-green stone), from Athens. c. 480 Bc. Height 8³/₂ ins (22 cm) as preserved. Originally set in a rectangular stone block and secured by lead, leaving only the face visible.

6.70 Polyxena sarcophagus, from Gümüscay in the Troad, Turkey. Sacrifice of Polyxena. c. 520–500 BC. Marble. Height 6 ft 2 ins (1.78 m); length 11 ft 6 ins (3.32 m); width 5 ft 6 ins (1.60 m). Çanakkale Museum, Turkey

marble sarcophagus, richly decorated with finely executed figural reliefs (fig. 6.70). The sarcophagus itself had been buried 7 yards (6 m) down inside a tumulus of earth, with the wheels and fittings of the funerary carriage placed against one long side, and three broken amphoras against the other. Each long side had been covered with a mass of terracotta rooftiles to the level of the sarcophagus cornice. Robbers had broken through the marble roof, shattering a stretch of glorious Greek architectural moldings but fortunately leaving the figured sides unscathed. Both short sides show groups of women (men are absent), one being interpreted as a symposium, while one long side depicts a seated woman with female attendants and musicians, and dancing warriors. The latter appears to represent a funerary celebration.

The other long side offers the major scene: the sacrifice of Polyxena, daughter of Priam, king of Troy. At one end is a tumulus and a tripod (allusions to the death of Achilles), in front of which four men carry Polyxena; one of them, Neoptolemos, is already thrusting a sword into her throat. Two of the four who hold Polyxena look over their shoulders at a group of mourning women who face them. The women stand or kneel and tear their hair or gesture in dismay. In front of the women the figure at the center of the composition (Nestor?) stands leaning on a stick: gesture, again, signals despair.

The sarcophagus is dated on stylistic grounds to c. 520–500 BC, and is the oldest figured marble sarcophagus found in Asia Minor: it is therefore the forerunner of a series of which the Alexander Sarcophagus (fig. 9.37, p. 314) may be the best known. This part of Asia Minor was under Persian rule in the Late Archaic period, and the sarcophagus therefore provides further evidence for the high quality of sculpture produced by Greek artists in areas under non-Greek control. A second, smaller sarcophagus was found in the same mound. Undecorated, but also unplundered, and containing among other items a fine assemblage of gold jewelry, it dates to the fifth century BC. It also contained the skeleton of an eightto ten-year-old child: by a remarkable feat of folk memory, the hill is known as the "kizöldün" (Turkish for "dead girl") tumulus.

POTTERY

By the beginning of the sixth century BC, Athenian craftsmen were masters of potting and painting. They were using large-scale narrative themes, Orientalizing motifs, and the black-figure technique (as on the Nessos amphora, fig. 5.10, p. 132). Much of this had been gleaned from Corinth, and, having learned the business, Athens was now poised to move in on the markets where Corinthian pottery had previously enjoyed a virtual monopoly. Athens was helped not least by the high quality of its clay, which was malleable and turned a warm deep orange color when fired.

After the clay had been dug up, it needed to be cleaned of natural impurities. This was done by mixing the clay with water and letting the impurities sink to the bottom, a process called "levigation." It was repeated until the clay was clean enough for the pot-

6.71 Above Diagram of a Greek kiln

1 Stoking tunnel

- 2 Firing chamber
- 3 Central post
- 4 Pierced floor
- 5 Stacking chamber
- 6 Spyhole and hatch
- 7 Removable section of the wall to enable loading
- 8 Vent hole
- 9 Cover for stoking tunnel

ter's requirements. A certain amount of clay was then kneaded with the hands, like dough, to the desired consistency (a process known as "wedging"), and placed on the wheel. As the wheel turned at speed, the clay was pulled up by the fingers into the required shape. The pot was made in several pieces: the body, the spout, and the foot, with handles being made by a different method. Sometimes the body of a larger pot was also made in sections. The separate pieces were next allowed to dry until they had the consistency of leather. They were then joined together with SLIP, which is clay in a more liquid form.

Finally, the pot was decorated. The terms "paint" and "glaze" are still used, since they are entrenched and convenient, but in fact Greek vase painters used neither; they used special slips, some of which contained pigments from metal. Black is the critical color, contrasted with the orange-red of the fired clay. The "black glaze" (or, more accurately, "gloss") came from highly purified normal clay

which turned black in the kiln, thanks to a particular firing process. Other colors that continued to be used in the sixth century BC were a purple-red and white. The white was a fine clay, with no iron-oxide impurity which would have colored it when fired. The purple-red was made from slip, which was a mixture of the black-producing clay and red iron-oxide pigment. These color-producing slips were applied with different kinds of brushes and then fired in the kiln – the firing was all-important.

A number of kilns have been excavated in various parts of the Greek world, so we have a good idea of what they looked like and how they worked. The main point is that the body of the pot turned red and the "painted" parts black in the course of firing. This process had three stages. The pots were first placed in the upper part of the kiln, the firing chamber (fig. 6.71); the fire was lit and the temperature was raised to about 800 degrees centigrade, with air allowed free access. These were oxidizing conditions, and the pots became red all over. The second stage called for green wood to be placed on the fire and access for air to be closed off, producing reducing conditions. The temperature first had to go up to about 950 degrees and was then allowed to fall back to about 900 degrees. In the course of this, the pots became black all over. At about 950 degrees, the surface of areas covered with black-producing purified clay became partially vitrified. This seal prevented the re-entry of oxygen and the consequent return to red which would occur on the other parts of the pot in the next stage. In this third phase, air was allowed in again an oxidizing condition - and the kiln allowed to cool entirely. Areas of the pot painted with black gloss remained black, but others turned red once more. By the end of the century, the major shapes of pottery produced by this process were already being made (fig. 6.72).

Athens

In the first quarter of the century, painters were decorating vessels with animal friezes drawn from the Corinthian vocabulary, rampant floral and palmette passages of Orientalizing origin, and mythological stories. Often the scale is small and the black-figure technique is favored. Sophilos, the first Attic vase painter whose name we know (from the signature proudly displayed, "Sophilos megraphsen"), decorated

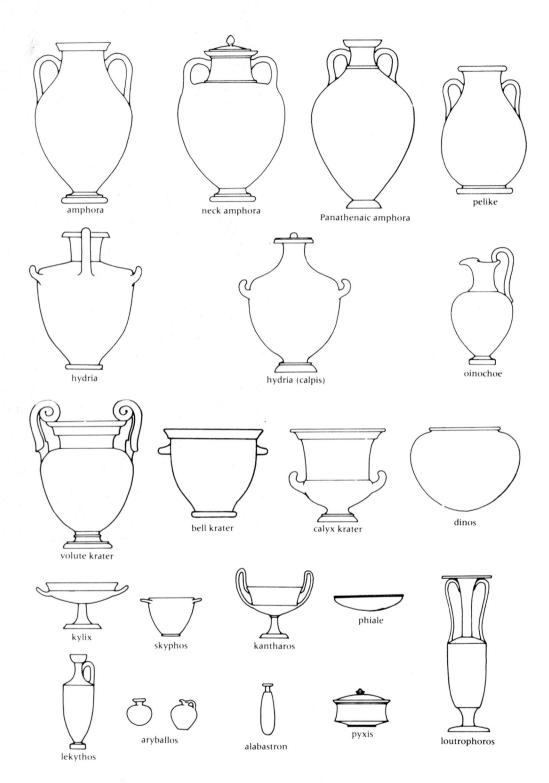

6.72 Shapes of Greek vases

a cauldron (DINOS or LEBES) and its stand in this manner (fig. 6.73). Friezes of tightly drawn animals and florals appear below the main narrative strip. There is much added purple and white, the white always being used for women's faces and exposed limbs. Inscriptions are painted on to identify individual characters. The scene depicts the arrival of guests for the marriage feast at the house of Peleus. Guests include the centaur Chiron and Hebe, conspicuous for her gaily painted peplos, decorated with animal friezes which echo the ornament on the vase itself. Peleus welcomes them, offering the refreshing kantharos, while Thetis bides her time within the house whose façade we see: white Doric columns and metopes, purple door, black antae.

The next quarter-century sees the high point of the Athenian black-figure miniature style. A volute krater, known as the François Vase (figs. 6.74 and 6.75) after the excavator who found it, came to light in the earlier part of the nineteenth century in Etruria. The Etruscans were always fond of Greek vases, and by now the Athenians were displacing the Corinthians as providers of tableware. The krater is decorated with six figured friezes on either side, of which only one shows the old-fashioned animals and florals. From now on, their appearance is relegated to subsidiary, unimportant zones. The other five friezes show over two hundred figures in closely drawn compositions, many of which are identified by inscriptions. Inscriptions also identify the potter (Ergotimos) and the painter (Kleitias).

Kleitias drew his black-filled figures against the orange-red ground, starting with contours, then filling in with black and using precise incision to shape interior details. His figures throw their arms in the air, expressing delight as their boat comes in (fig. 6.75, the top register); they leap ashore; they dance. Below, centaurs and Lapiths fight. On the major frieze between the handles, guests in chariots and others walking approach in another version of the procession preceding the wedding feast of Peleus and Thetis. In the frieze below, Zeus and Hera, seated on Olympus, await another arrival, that of the drunken Hephaistos on his ITHYPHALLIC donkey. The wedding procession is the only scene that travels the whole way around the krater. On the other side, Peleus greets his guests (fig. 6.74).

Kleitias used architecture – the house of Peleus, the fountainhouse, the walls of Troy – to suggest

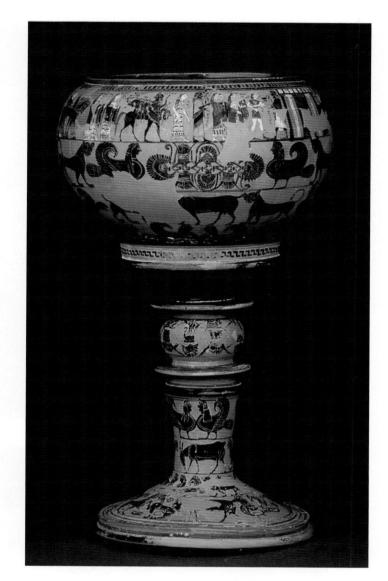

6.73 Attic black-figure dinos and stand by Sophilos: (dinos) Peleus welcoming gods to the wedding feast; (stand) Animal Style registers. c. 580 Bc. Height (of figures) 3% ins (8 cm). British Museum, London

locale and to punctuate compositions. Profile, threequarter, and even frontal views of figures are shown, as the painter tried to depict the human body in varied movement and in space. Figures are massed as many as four side by side in the wedding procession, yet only overlapping suggests depth. Here, Kleitias created a model of draftsmanship and composition, crisp and detailed, and a veritable encyclopedia of mythological events.

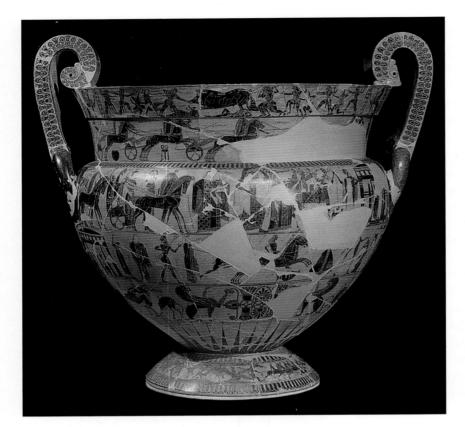

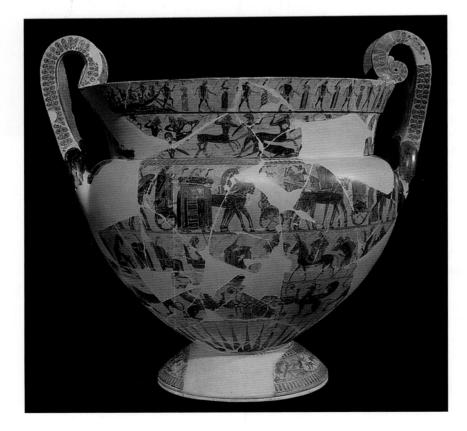

6.74 François Vase, Attic black-figure volute krater, by Kleitias and Ergotimos. From the top: Kalydonian boar hunt; funeral games for Patroklos; marriage of Peleus and Thetis; ambush of Troilos. c. 570 вс. Height 2 ft 2 ins (66 cm). Archaeological Museum, Florence

6.75 François Vase (as above). From the top: arrival of Athenians; centauromachy; marriage of Peleus and Thetis; return of Hephaistos to Olympus

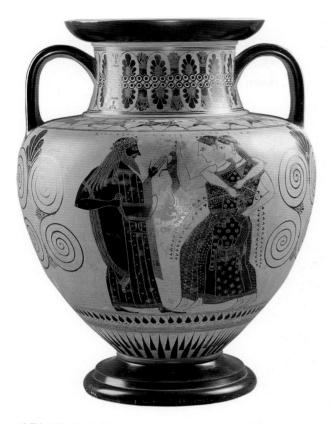

6.76 Attic black-figure amphora by the Amasis Painter: Dionysos and maenads. c. 540–530 BC. Height 13 ins (33 cm). Bibliothèque Nationale, Paris

Two painters led the way in Athens in the third quarter of the century: the Amasis Painter and Exekias. The Amasis Painter decorated both small and large vessels. His pieces have the precision and delicacy characteristic of Kleitias, but on an enlarged scale. An amphora, now in Paris, aptly represents his work (fig. 6.76). The principal surface of the pot is opened up, not cramped by registers, and the major scene is flanked by calligraphic volutes and palmettes. A stately Dionysos (identified by the inscription over his head, the kantharos, and the ivy wreath) greets a pair of dancing MAENADS, female members of his retinue. There is precision of draftsmanship here, in the beard and long, flowing hair of Dionysos, and in the garments and captive animals of the maenads; there is delicacy of brushwork, too, in the contours of faces, fingers, arms, and garments. There is also strength in the successfully enlarged and balanced figures, and an engaging lightness and elegance of tone. Painter and potter may have been the same man. If so, it is strange to us that he does not say so. The name of the potter, Amasis, is a Greek form of the Egyptian name Ahmosis, so it is possible he may have been an Egyptian, or partly Egyptian. The name of another leading painter, Lydos, suggests that he too was a foreigner – a Lydian. So some of the more familiar vase painters of Athens may have been resident aliens. But there was also a vogue for using foreign names or sobriquets in certain classes in Athens in the middle years of the century.

The representation of emotional states, seen in lighter vein in the Amasis Painter's amphora, and glimpsed too in Kleitias's arriving mariners, is taken up more seriously by Exekias. The sadness and resignation of Ajax as he prepares his suicide (fig. 6.77), and the emotional intensity of Achilles and Penthesilea as their eyes lock on each other at the moment of her death (fig. 6.78) are just two themes successfully rendered. Perhaps Exekias's best-known vase is the amphora showing on one side the Dioskouroi at home after

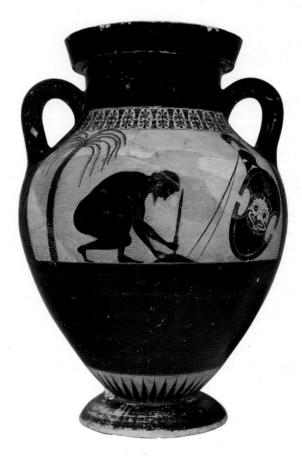

6.77 Attic black-figure amphora by Exekias: suicide of Ajax. c. 540 BC. Height (of field) 9½ ins (24 cm). Musée des Beaux Arts, Boulogne

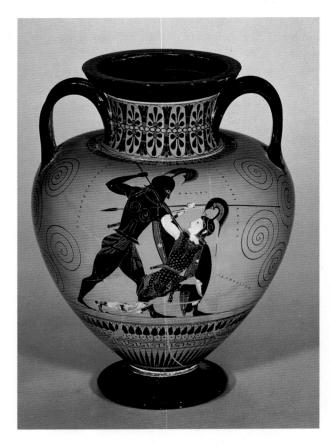

6.78 Attic black-figure amphora by Exekias: Achilles killing Penthesilea. c. 540–530 BC. Height 16% ins (41.6 cm). British Museum, London

the hunt, and on the other Achilles and Ajax playing a game (dice?) (fig. 6.79). Excellence of draftsmanship and brushwork, crispness and control of detail, balance and power of composition are all apparent in this extraordinary example of the vase painter's skill. What is so striking is the way the scene implies the narrative and its emotion. The warriors play their homely game, armed, spears and shields at the ready. They are at Troy. Achilles' anger has taken him out of the combat, but the viewer knows he will return, and knows of the dire events which are to follow. Seemingly peaceful, this scene is full of foreboding, ominous with pent-up rage shortly to be released.

Most of the themes used in the earlier part of the century to decorate pots at Athens involved gods and heroes, scenes of myth and aristocratic conduct. During the second half of the century, the exploits of Herakles became so popular that it has been pro-

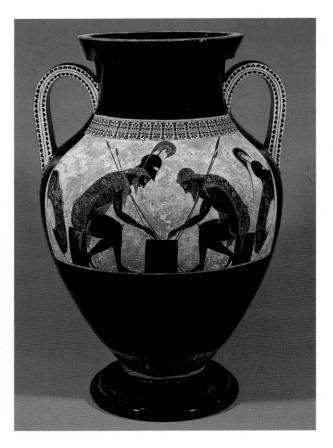

6.79 Attic black-figure amphora by Exekias: Ajax and Achilles playing a game. c. 540–530 вс. Height 2 ft (61 cm). Vatican Museums, Rome

posed that Herakles was used as a propaganda image for the Peisistratid tyranny. Slowly, new motifs of everyday life and social commentary were introduced, alongside more genre scenes of symposia and athletics. By the last quarter of the century, women appear chatting on hydriai (water jars) at fountainhouses (fig. 6.41), conceivably reflecting the newfound enthusiasm for public works (aqueducts and fountains rather than private wells), or even an actual fountainhouse in Athens. Cobblers are shown at work in their shops; fishermen returning with their catches, and butchers plying their trade, also appear.

Corinth

The Animal Style (see p. 127) continued to dominate production but was becoming coarser and less disciplined. Blizzards of fillers packed the background, so that the deterioration of the drawing of the animals

CULTURE AND SOCIETY

CONNOISSEURSHIP

Sophilos painted and signed the dinos (fig. 6.73) and Kleitias the François Vase (figs. 6.74 and 6.75), but many vessels were unsigned. Vases painted by the same artist can nonetheless often be recognized, in the same way that art historians can attribute unsigned works of Renaissance painting to artists. It is easier if there is a signed vase from which to begin, diagnose characteristic traits, and then attribute unsigned works to the same hand on stylistic and technical grounds. But such grouping can take place without a signature. An anonymous artist receives his name for various reasons: from a place where his work was popular, or where his

work is now found, or, like the Amasis Painter (fig. 6.76), because only the potter, Amasis, signed his name.

An Italian connoisseur, Giovanni Morelli, was among the first to develop criteria for the attribution of Renaissance paintings, and his techniques were the inspiration for the work of Sir John Beazley (fig. 6.80), who singlehandedly identified hundreds of Athenian vase painters and concocted names for them, e.g. the Berlin Painter (fig. 6.91). The

identification depends on painstaking observation of details of scenes and figures, and on memory. A particular painter might favor particular scenes, or principles of composition, or shapes of pots. Details of draftsmanship, however, matter most – the drawing of parts of the ear, or the eye, the chin, the knee, very small areas drawn spontaneously, rapidly, and without conscious attention, allow a painter's identity to be recognized. Scrutiny of filler and margin patterns, abstract or floral – designs repeated by the painter in an almost automatic manner – is also helpful. Beazley, who left no aspect of ancient Greek culture unexplored, concentrated on Athenian

> vases, but his methods were followed by others in other areas. Beazley, however, with his legendary aptitude for drawing, and his prodigious memory, was the master of this craft and remains the most famous connoisseur of Greek vase painting.

6.80 Sir John Beazley, formerly Professor of Classical Art and Archaeology at Oxford University, studying pottery. c. 1980. Beazley Archive, Ashmolean Museum, Oxford

was less palpable, but by 575 BC the style was in steep decline and by 550 BC it was obsolete.

In the figure style there are some lively scenes. An oil flask dating to c. 575–550 BC shows the leader of a chorus of dancers jumping joyfully in time with the fluteplayer in front of him (fig. 6.81). Behind him (not shown in the illustration) the six members of his chorus stand stockstill, either about to begin or having just completed their maneuvers. The inscription gives us his name: Pyrrhias. This was a prize for a dancing contest and, found near the temple of Apollo in excavation, was doubtless an offering to the god. But Corinth was soon under great pressure. The Exekias amphora showing Ajax and Achilles at their game was found in Etruria, as were many other Athenian vases of high quality of the middle years of the century. Athenians were busy trading with Etruscans and with West Greeks, and were rapidly depriving Corinthians of their markets. Corinthian artisans reacted sharply. Potters there even began to cover their pots sometimes with an orange-red slip to emulate the more appealing color of Athenian clay. Corinthian painters baulked, however, at the freer compositions of the Athenians and at the plethora of incision, preferring, it seems, richness and variety of color. A krater (fig. 6.82) from around 560 BC shows a chariot scene, dense with figures, single, in pairs, and in groups. The married couple in the chariot are

6.81 Above Middle Corinthian aryballos: flutist, lead dancer, and copious inscription, a prize for a dancing contest. c. 575–550 BC. Height 2 ins (5 cm). American School of Classical Studies at Athens, Corinth Excavations

6.82 *Right* Corinthian krater by the Three Maidens Painter: a marriage procession. c. 560 BC. Height 16³/₄ ins (42.5 cm). Vatican Museums, Rome

surrounded by friends. There is a great deal of added red and white paint. While incision is used for detail on black grounds, on white, details are painted. Such vessels found their way to the West, but Etruscan preference for Athenian wares meant that by the third quarter of the century output for export at Corinth was moribund.

Laconia, East Greece, and the West

In Laconia, the district in the southern Peloponnese whose chief city was Sparta, vase painters who had used the outline technique in the seventh century began to produce black-figure vases from around 600 BC. Most were for local consumption, but some found favor abroad. They were especially popular at Taras in South Italy, a colony of Sparta, and have been found at Cyrene and Tocra in North Africa. The high-stemmed, deep-bowled cup is a familiar Laconian shape. Interiors were decorated with scenes of combat, mythology, or daily life. One interior (fig. 6.83) offers a rare glimpse of history in Greek art: the king of Cyrene, Arkesilas – hence the painter is called the Arkesilas Painter – is shown seated, supervising the weighing and loading of cargo, in a scene full of incident and local color. The Hunt Painter introduced a novel idea, that of showing part of a scene as if through a porthole, simply ignoring the compositional problem posed by the tondo of the cup. So (fig. 6.84) the circular shape (the porthole) is divided into a lower part, which provided the groundline for the main scene, and an upper part. Here, in the lower part, or "exergue," a trio of bulky tunny fish are shown. Fish, dolphins, and other marine motifs were popular among Laconian painters. Above, hunters pursue a boar of which only the wounded posterior and curly tail are visible. Birds, another common ornamental motif in Sparta, dart about vigorously. The style is mannered, with flat figures, but flourished in mid-century and lasted until about 525 BC.

In the East, the Wild Goat Style of the seventh century BC entered into a period of quiet decline, and though black-figure was introduced alongside the use of outline, the drawing of animals became coarser and coarser until it petered out around 560 BC. In the West, communities evidently preferred to import painted pottery rather than make it. At first, Corinthian, then Athenian, imports dominate.

6.83 Laconian black-figure cup (interior) by the Arkesilas Painter: King Arkesilas of Cyrene supervising the loading of cargo. c. 560 BC. Diameter 11½ ins (29 cm). Cabinet des Médailles, Bibliothèque Nationale, Paris

6.84 Laconian black-figure cup (interior) by the Hunt Painter: a boarhunt. c. 550 BC. Diameter 7¹/₈ ins (19.5 cm). Musée du Louvre, Paris

6.85 Above Chalkidian black-figure column krater: cocks and snakes. c. 530 BC. Height 14½ ins (37 cm). Martin von Wagner Museum, Würzburg

Two groups of pottery, however, deserve attention. Somewhere unknown, though perhaps at Rhegium (modern Reggio) in Italy, a number of vase painters, who wrote their inscriptions in Greek and are known as the Chalkidian School, produced elegant designs and energetic figures (fig. 6.85). Their decorative power and precision of drawing are comparable to Athenian black-figure painting. Their production lasted from around 550 to 500 BC, almost all of it retrieved in the West. Another group of pots, hydriai, was produced at Caere in Etruria (see map on p. 123) by an artist (or artists) who wrote in Greek and was familiar with Greek mythology (fig. 6.86). These hydriai are notable for the amount and variety of color used (purple-red, white, and brown) in the black-figure technique, and for their humorous tone.

6.86 Below Caeretan black-figure hydria: Herakles bringing a captive Cerberus to a terrified Eurystheus, who jumps into a jar. c. 530-520 BC. Overall height 17 ins (43 cm). Musée du Louvre, Paris

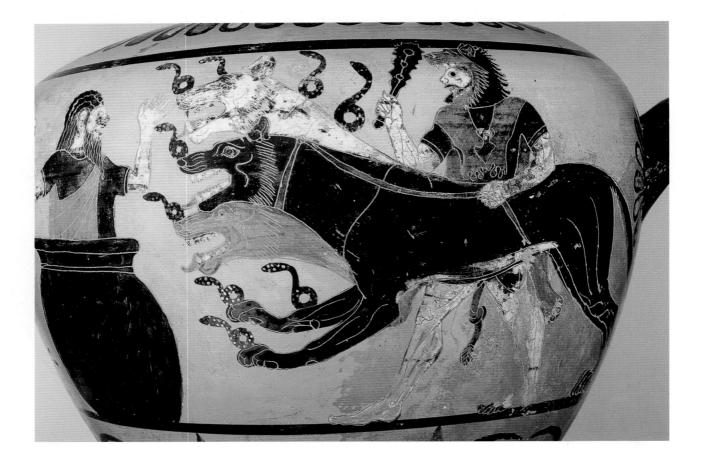

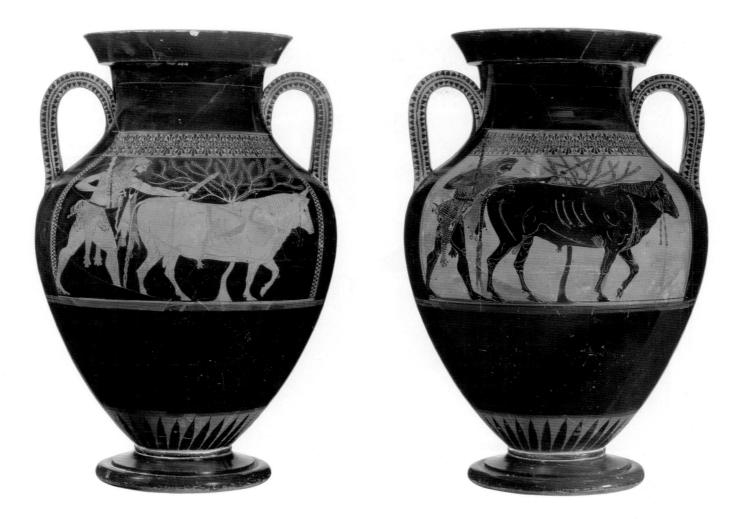

6.87 Attic bilingual (black-figure and red-figure) amphora from Andokides' workshop: Herakles driving a bull. c. 520 BC. Height 21 ins (53 cm). Museum of Fine Arts, Boston

Athenian Red-figure

Around 530 BC, the conventions of black-figure were becoming stale. Black silhouette, incised detail, added red for hair, beards, and on garments, added white for women's faces and limbs and garments, frontal chests and profile contours, frontal eyes in profile faces, emotion shown by gesture, all began to seem inadequate, at least for expressing the body in realistic motion and in various emotional states. A number of new techniques, including experiments with a white ground, were tried, of which the RED-FIGURE technique was the most successful. The method was the reverse of black-figure. The figure now remains the red color of the clay, and it is the background that becomes black. Outlines of figures were drawn with a brush on the surface of the pot, inner details were also drawn, and the background was then "painted" black. Contours (outlines) and salient inner lines were drawn with a strong line, which sometimes stands off the surface and is termed a RELIEF LINE (acquired by using a thicker slip), while details of anatomy and drapery were often drawn with a thinner line, known as a "dilute glaze line," that fired to brown rather than black. The brush allows greater fluidity to line than any BURIN, the instrument used for incising, and obviously made realistic representation of the anatomy in motion, of three-quarter views, foreshortening, garments in motion, and human emotion and moods much easier to portray.

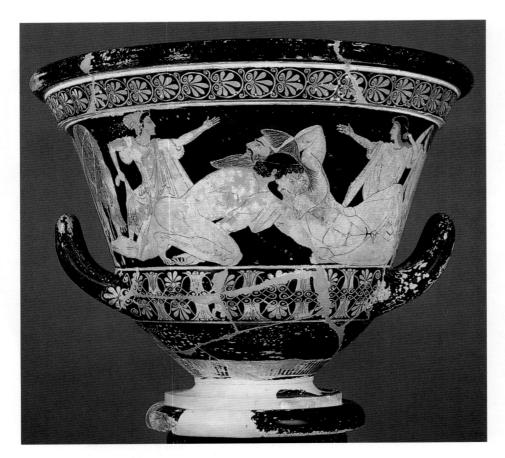

6.88 *Left* Attic red-figure calyx krater by Euphronios: Herakles struggling with Antaios. c. 510 BC. Height 19 ins (48 cm). Musée du Louvre, Paris

6.89 *Opposite* Attic red-figure amphora by Euthymides: revelers. c. 510 BC. Height 23³/₄ ins (60 cm). Staatliche Antikensammlungen, Munich

Added color almost disappears; dress and anatomy now distinguish males from females.

It is the anonymous painter who painted pots made by Andokides, and hence known as the Andokides Painter, who is most often thought of as the inventor of red-figure. To begin with, he and others demonstrated their versatility by decorating pots on one side in the old-fashioned technique and on the other in the new. Such pots are called "bilinguals." Herakles and a sacrificial bull (fig. 6.87) appear on one side in red-figure and on the other in blackfigure. Frequently, however, the front and the back of the pot show different scenes. Sometimes different painters paint different sides of the same pot.

By the late sixth century BC, a group of experimentally minded painters was following the Andokides Painter. They are known as the "Pioneers" because of their daring attempts at new poses and views. One of them was called Euphronios. A panel on one of his kraters (fig. 6.88) shows an apparently serene Herakles wrestling with the giant Antaios in an uncomfortable pose. One of Antaios's arms hangs limp, and he grits his teeth in pain. Euphronios shows awkward postures and emotional states in precisely painted detail and is known for his liking for anatomical detail of bone and muscle, wrinkle of flesh, and vein. Another of the Pioneers was called Euthymides. An amphora by him (fig. 6.89) shows older, bearded men at their revels. Gestures and poses are varied; relief lines and dilute glaze lines explore the body in motion. The three-quarter view is successfully negotiated, even if the twisting back view fails. The Pioneers knew one another's work well enough. They used their rivals' names for characters in their scenes. They even issued challenges: on this amphora Euthymides wrote, "Euphronios never managed anything like this."

The way Euphronios and Euthymides explored various states of motion has suggested that vase painters led the way in showing interest in the body in motion. Contemporary work by sculptors working in the round was still obedient to a static code, as

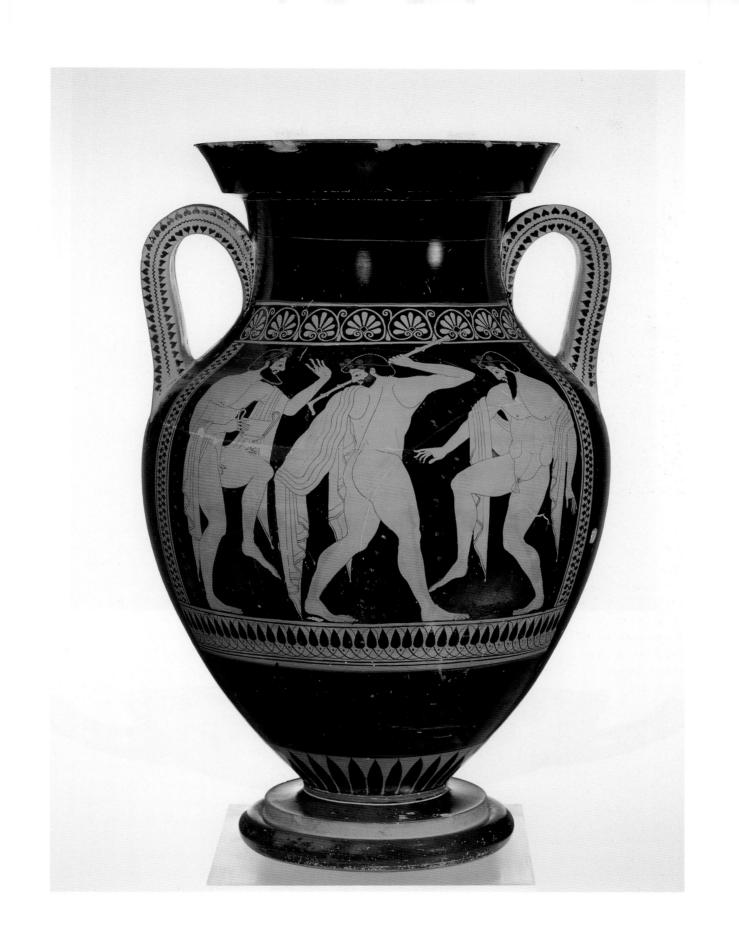

the Aristodikos Kouros (fig. 6.47) shows. Even figures in relief sculpture on grave monuments remained stiff and automatic like Aristion (fig. 6.67). Yet, in architectural sculpture, in figures from the west pediment at Aegina (fig. 6.14), and in reliefs on statue bases, the body is shown in new and varied poses and in motion. So developments in vase painting, in some categories of relief sculpture, and in architectural sculpture appear to have been happening at about the same time. It is plainly the case, however, that enthusiasm for the body in motion was only to come later to sculptors in the round. They preferred the abstract form, and their objectives seem to have gone beyond accurate representation of the anatomy, in motion or not. A kylix found in the Athenian agora (fig. 6.90) exemplifies the state of development at about 500 BC. The exterior shows, on one side, Achilles and Memnon in combat, flanked by two gesticulating women, and on the other, Dionysos and his entourage, a maenad and satyrs, making merry. The interior shows a youth half-kneeling, balancing himself with a stick in his left hand and holding a hare by the ears in his right. He wears only a cloak, which frames the torso, and a wreath. Profile and three-quarter views are confidently drawn with relief and dilute glaze lines. His feet are foreshortened and the eye is no longer completely frontal. Incision is still used for the outline of the hair on top of the head. The potter Gorgos signed on the interior; he may have been the painter,

6.90 *Opposite* Attic red-figure kylix by Gorgos: (exterior) Achilles fights Memnon; (interior) half-kneeling youth with staff and hare. c. 500 BC. Height 2⁷/₄ ins (7.4 cm). Agora Museum, Athens

6.91 *Right* Attic red-figure amphora attributed to the Berlin Painter: a reveler. c. 490 BC. Height 19½ ins (49 cm). British Museum, London

too. The topics he chose to illustrate were those in vogue: an episode from the world of heroes on one exterior side, and on the other a generalized Dionysiac scene of merriment. The scene of everyday life on the interior has erotic overtones (the hare is the lover's gift). The name of "Krates" is written on one side, and the word "kalos" on the other. It means "Krates is handsome." Such "kalos" inscriptions, used to praise a person's good looks (more often male than female), begin in the middle years of the century and last to the end of the fifth. The names change over the years with some rapidity, but serve to identify a favored youth (or courtesan) of the moment.

In the last twenty years of the Archaic period, around 500–480 BC, pupils of the Pioneers came to the fore. Of these, the Berlin Painter concentrated on larger vessels and liked to paint elegant single figures or small groups on groundlines (fig. 6.91) against a background so dark that the effect is one of spotlighting. He continued to explore space, expressions of mood, and the body in motion. Three-quarter views of faces and feet increase the sense of depth in two-dimensional images. His specialization in larger vessels is paralleled by that of others in smaller ones, especially in cups. Of the cup painters, Douris was especially productive, working from about 500 to 470 BC, and painting – it has been thought – as many as ten thousand pots in the course of his career. Another, the Brygos Painter (fig. 6.92), enjoyed decorating some of his cups with mythological scenes, and others with Dionysiac scenes of revelry and drinking – a suitable ornament, obviously, for a cup. One Dionysiac scene shows satyrs so aroused that they attack the gods; another displays in somber mood the unfortunate effects of a night on the town. The Brygos Painter's work is easily recognizable by the dots he sprinkles on the cloaks his characters wear. He paints in crisp, wavy lines and is a master of mood – sometimes sympathetic, sometimes violent.

Conclusion By the end of the period, all the necessary skills had been acquired to render public buildings in stone, dense with sculptural decoration if required, to sculpt realistic human figures that moved naturalistically, either in the round or in relief, and to paint pots with equally convincing figures moving in the illusion of three-dimensional space. The period of experimentation had passed; that of maturity was at hand.

6.92 Detail of an Attic red-figure cup by the Brygos Painter: a reveler and companion. c. 490 BC. Musée du Louvre, Paris

THE PERIOD OF TRANSITION c. 480-450 bc

The Archaic era ends conventionally around the year 480 BC. This is partly because that year marks the critical moment in Greek history when the Persian invasion was halted. Excavations on the Acropolis at Athens have recovered deposits of materials shattered by the Persians and buried by the Athenians in the aftermath. These materials are thus readily datable and mark a point between the Archaic and Classical styles. However, some important stylistic changes had begun to take place before 480 BC – in vase painting even before 500 BC, and in sculpture in the period between 500 and 480 BC.

The years from the end of the Archaic era to around 450 BC are known as the Transitional or Early Classical period. The term Transitional is most aptly applied to sculpture, where human figures were transformed from the stiff Archaic symbols of life into realistic, moving images. This is often known as the Severe Style owing to the uncompromisingly stern expressions of many figures and from the plain, heavy style of the drapery. However, a continued interest in Archaic pattern and measurement was still restraining the new enthusiasm for representing real life. The balance between anatomical accuracy and expression of the ideal in human form, which is

7.1 Mourning Athena relief, from Athens. c. 470 BC. Marble. Height 19 ins (48 cm). Acropolis Museum, Athens

regarded as the mark of the High Classical period, was not achieved until the second half of the century. Similarly, in architecture, experiments continued in terms of proportion and measurement, but it was not until the second half of the century that the need to mix the Doric order with the Ionic was fully realized. In vase painting, innovations in studies of perspective anticipated the more elaborate and sensual renderings of the last quarter of the century. The term "Transitional period" is thus a convenient and meaningful label for the years between the Archaic and High Classical eras.

Athens and the Western Greeks

When the Persians withdrew from Greece in 480 BC, no peace treaty was signed and the war continued. The Spartans had little inclination to follow up the victory at Plataea now that the interlopers were out of Greece, which left the field clear for Athens. By 477 BC the city had set up the Delian League, a consortium of Greek poleis allied against Persia. Its headquarters, ostensibly, and its treasury were on the holy island of Delos in the central Aegean. Member states were to contribute either ships or money for the activities of the League.

The political direction of the League soon became evident. Athens encouraged cities to give money rather than providing their own ships, since it suited the Athenians' purpose to build and man the ships themselves. Cities were badgered into joining the League, while others who wished to leave were not allowed to do so. A democracy at home, Athens practiced empire abroad. All this happened under the leadership of a man called Kimon, son of the great Athenian hero at Marathon, Miltiades.

Operations against the Persians were successful, crowned by a great naval victory at the mouth of the river Eurymedon in the 460s BC, but this was followed by a serious reversal of fortune in Egypt in 454 BC. The Athenians used this setback, and the implied insecurity of Delos, now exposed to Persian interference, as an excuse to transfer the treasury of the League from Delos to Athens. Henceforth Athena herself was allocated one-sixtieth of all monies contributed to the League, while Athens took the rest. The transition from confederacy to empire was complete. The Spartans viewed these developments with distaste, and though they waged land campaigns with their allies against Athens in the 450s BC, they did not succeed in breaking Athens's hold on its empire. Around the middle of the century, a peace, the date of which is uncertain (perhaps 449 BC), was made at last between Greece and Persia. The period ends with Athens's star in the ascendant, with major building programs about to begin in the city and in Attica, and with Sparta keeping a jealous eye on Athenian ambition.

In the West, Syracuse emerged as the leading power. Gelon brought half the population of Gela with him, as well as supporters from Megara Hyblaia and Camarina and ten thousand newly enfranchised mercenaries, when he took up the invitation to become its first tyrant in 486 BC. This new Syracuse was ratified by the victory that he and his fellow tyrant, Theron of Akragas, won over the Carthaginians at Himera in 480 BC. The Carthaginian ships were burned, their troops enslaved, and their leader Hamilcar killed. They were obliged to pay a huge war indemnity. With this, Gelon built a new temple for Athena in Syracuse, much of it still visible today, encased in the cathedral. He also renovated the Temple of Apollo (see p. 168) and built a new agora.

Many Western Greek cities had built treasuries at Olympia, and now Syracuse built its own. A gold tripod was dedicated at Delphi. Gelon died in 478 BC and was succeeded by his brother Hieron, who

favored the literary arts to the same extent Gelon had his building programs. His reign was also strengthened by military success over enemies, this time over the Etruscans at the Battle of Cumae in 474 BC. Hieron patronized the great lyric poets – Pindar, Simonides, and Bacchylides - welcoming them to his court and giving them commissions. Aeschylus, too, was brought to Syracuse to stage his Persians, so that, like Athens, Syracuse became a leading center of both politics and the arts. A third brother, Thrasybulus, succeeded Hieron in 467 BC (a fourth, Polyzalos, remained behind in Gela as tyrant there), only to have his rule supplanted by a democracy in the following year. Rich in land, in natural resources, and in commerce, blessed with two harbors and commanding access to Sicily from Greece, by 450 BC Syracuse, as well as Sparta, was on a collision course with Athens.

The Women's World

The number and power of female deities (Hera, Demeter, Athena, Aphrodite) and the pivotal role of females in Greek literature and myth (Penelope, Helen, Medea), not to mention their prominence in the world of hybrid monsters (gorgons, sirens, sphinxes) and prowess on the battlefield (Amazons), contrasts sharply with the reticent lives of most mortal women. Much of the evidence comes from Athens, where the law drew sharp distinctions between several groups of women. There were citizens and there were metics (foreigners, from another polis); there were freeborn and there were slaves; there were upper-class and there were lower. None of these women, whatever their station in life, had any political rights.

What follows pertains for the most part to the lives of the freeborn at Athens. The home and the family were at the center; marriage, conception, birth, and children were the major concerns. Yet there were moments in a woman's life, particularly if wellborn, when she was in the public spotlight.

Female babies, like males, were raised by their mothers (with the help of slaves if the family was rich enough). A scene painted on a fifth-century BC water jar (fig. 7.2) shows a mother receiving a child from an attendant, while others of similar date show babies crawling or beginning to walk. Terracotta toys – rattles, balls, and dolls – have been found in

excavations, and representations of such playthings appear on grave monuments.

The childhood of a privileged Athenian girl could include periods of public service. Aristophanes, the fifth-century Athenian playwright, created a character who recites what seem to be episodes from her childhood. She says that at the age of seven she was chosen to serve Athena for a year. From other sources we know that her duties would have included living on the Acropolis, looking after the sacred olive tree, and helping to make the new garment for Athena's statue. Aristophanes' character goes on to serve Artemis in her sanctuary at Brauron where (again, we learn from other sources) at the onset of puberty she would have taken part in ritual dances and masquerades, intended to prepare her for marriage. After Brauron, and now of marriageable age, she served as a basket-carrier in civic processions. Aristophanes' congested narrative is unrealistic, but gives a good idea of the kind of educational experiences to which an Athenian girl of higher rank was exposed. Of the poorer classes, the record is silent.

Marriage was the central event in a woman's life, transforming her social status and marking her identity. Marriages were arranged between heads of households, and customarily took place when the young woman was fourteen or fifteen years old. There were elaborate preparations. Sacrifices were made. Childhood toys and clothes were dedicated, often to Artemis, and gifts (figs. 7.40 and 7.41) basically prayers for conception, easy pregnancies, and healthy children - were placed in sanctuaries. The women of the family went in procession to fetch water for the bridal bath, a ritual which involved the use of special vases – for example, the loutrophoros (fig. 6.72, p. 194). Other rituals included wedding songs and the invocation of Aphrodite - as depicted on the face of a small altar from South Italy (fig. 7.3) where the seated bride is shown lifting her veil to face Eros and Aphrodite (emissaries of sexual power). A dowry (returnable if the woman was subsequently divorced) was paid by the bride's father. There was a feast in the bride's home, bride and groom dressed in finery, followed by a torchlight procession to her husband's home. Released from her father's control, she became part of her new family.

The main duty of the new wife was to conceive and bear children. While men went out to work or

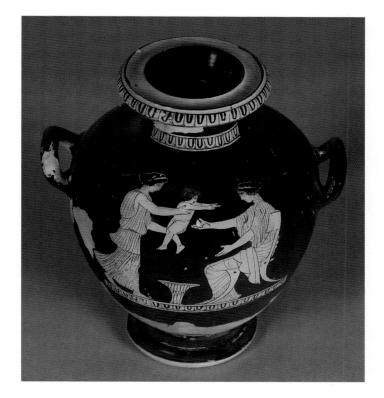

7.2 Above Attic red-figure stamnos: mother, attendant, and child. c. 450 BC. British Museum, London

7.3 Below Marriage Altar from Taras, South Italy: Aphrodite and Eros approach a bride. c. 400–350 BC. Terracotta. Mold-made, finished by hand. Height 9 ins (22.5 cm). National Museum, Taranto

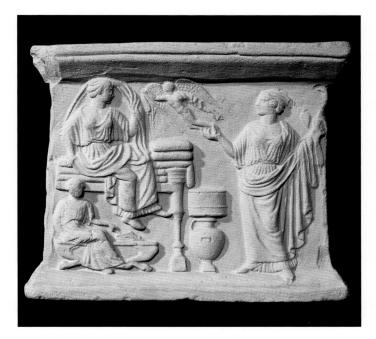

the agora or the council house or the assembly or the gymnasium or the battlefield or social events, the wife spent much of the time at home in her own quarters. She prepared meals, she spun (fig. 8.47, p. 282) and wove linen and wool, she made clothes, she managed the household budget, she organized the slaves. Regularly – if the family could not afford slaves or servants – she went to the fountainhouse to collect water (fig. 6.41, p. 175). She could not vote, go to the assembly, speak in the lawcourts, or attend the theater (though there is some doubt about this, see p. 324).

But the role of some women in public life was neither invisible nor negligible. They could take part in processions at festivals such as the Panathenaia (see fig. 8.22, p. 261). Or they could attend the Thesmophoria, a festival honoring Demeter, goddess of the fertility of the earth, which was restricted in most places (there are exceptions) to married women. They could attend births and marriages and funerals. While ancient Greek writers, predominantly male, lead us to think of women's lives as sheltered, they are more accurately described, in a world where most power was in the hands of men, as segregated.

The most important role played by women in the public sphere was in religion, as priestesses. Some priesthoods ran in families, handed on from one generation to another. After the installation of democracy in Athens, however, many were chosen by lot in the same way that political officers were appointed. Some were young and surrendered their priesthoods - since they were required to abstain from sex when they married; others remained priestesses for life. Usually priesthoods of female deities are held by women, those of male deities by men, the obvious exception being the Pythia, the priestess of Apollo at Delphi. The priestess of Athena takes pride of place in the center of the east frieze on the Parthenon (fig. 8.17, p. 259). A few funerary inscriptions of the fourth century BC record other occupations pursued by women - such as nurse, midwife, doctor, grocer, harpist, woolworker, or wet nurse.

Then there were the entertainers. Prostitutes were normally slaves or foreigners, and varied in their accomplishments. Brothels in the Piraeus did a lively trade, but more engaging for the rich were the flute girls who brightened symposia with their music and took part in various kinds of sexual activities. The most refined were the hetairai (companions or courtesans). Some hetairai amassed considerable fortunes and were as famed for their musical and literary skills and for their wit as they were for their sexual expertise.

ARCHITECTURE AND Architectural Sculpture

Olympia

In the great sanctuary at Olympia (fig. 7.5) the Greeks decided to build a new monumental temple for Zeus to stand close by the earlier sixth-century temple, the so-called Temple of Hera. The Temple of Zeus was built by a local architect, Libon of Elis, in the years between about 470 and 450 BC. The Spartans donated a gold shield to be suspended in one of the gables as a thanks offering for a victory in 457 BC, so much of the exterior must have been completed by then. The temple survived for centuries and was described in detail by Pausanias in the second century AD, before eventually collapsing. Later, a thick deposit of silt

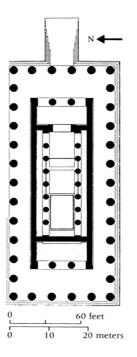

7.4 Plan of the Temple of Zeus, Olympia. c. 460 BC

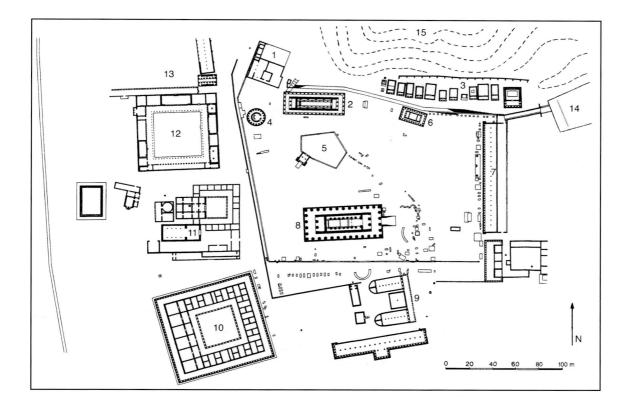

7.5 Plan of the Sanctuary of Zeus at Olympia:

1 Prvtaneion 2 So-called Temple of Hera 3 Treasuries 4 Philippeion 5 Pelopion (the grave mound of the hero Pelops) 6 Metroon 7 Echo Stoa 8 Temple of Zeus 9 Bouleuterion 10 Leonidaion (hotel paid for by Leonidas of Naxos) 11 Workshop of Phidias 12 Palaestra 13 Gymnasium 14 Stadium 15 Mount Kronos

and sand caused by floods from nearby rivers washed over it. The site was lost for many years and as such was little robbed. Thanks to the energetic and careful activity of German scholars, almost all the sculptural decoration of the temple and enough architectural blocks have been recovered for the building to be convincingly restored, at least on paper.

The temple was of the Doric order. It followed the Classical fifth-century rule that the number of columns on the flanks should be one more than double that on the façades. Accordingly, the plan (fig. 7.4) shows six columns on the façade by thirteen on the flank, with a porch, cella, and opisthodomos. Porch columns and antae align with columns of the façade. The proportions of the elevation have evolved from massive Archaic ones toward Classical slenderness, with taller columns and thinner shafts. In height, columns measure 4.64 times the lower diameters on the front and 4.72 times on the flank; they are, then, sturdier than at Aegina, but slimmer than at Corinth. As befitted a temple dedicated to Zeus, it was the biggest to be finished in Greece before the Parthenon. At a length of nearly 70 yards (almost 64 m), however, it was dwarfed by other temples to Zeus in the West (at Akragas, and probably at Selinus). The materials used were local limestone, covered with stucco to hide blemishes, for building blocks, and marble for rooftiles and sculptures. According to Pausanias, both pediments were decorated with groups of figures, but the exterior metopes were blank. However, sculpted metopes did decorate the friezes over the entrance to the porches,

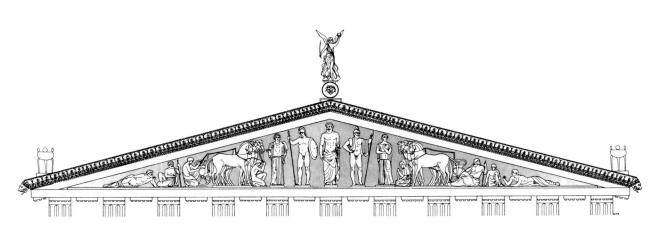

7.6 Temple of Zeus, Olympia, east pediment. c. 460 BC. Height 11 ft (3.35m). © Candace H. Smith

six at the front and six at the back. Pausanias's description of the pedimental figures is helpful but also poses problems. For example, he states that Pelops stood on the left of Zeus, but neglects to say whether he means the left of the statue, or the viewer's left. His account in this respect presents an intriguing example of the utility and difficulty of primary sources.

East Pediment The scene on the east pediment shows the preparations for the chariot race between Pelops and King Oinomaos, who stand on either side

of the central figure of Zeus (but which side? Scholars' views change: compare figures 7.6 and 7.7), flanked by their womenfolk, grooms, and chariots (fig. 7.6). The story was superficially appropriate for Olympia, since Pelops had long been worshiped there, the subject of a chariot race was ideally suited to the site of the Olympic games, and Zeus was present as the judge. But for those who knew the outcome of the race – Pelops's victory by a trick, his killing of the king, and his winning of Hippodamia and the kingdom – the scene was full of foreboding and deeper meanings. The poses of the central group

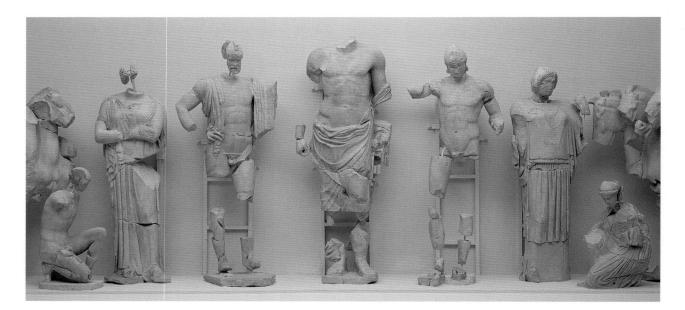

7.7 Temple of Zeus, Olympia, east pediment, central figures. c. 460 BC. Marble. Height (of Zeus) as preserved c. 10 ft 2½ ins (3.10 m). Olympia Museum (most recent arrangement of the figures)

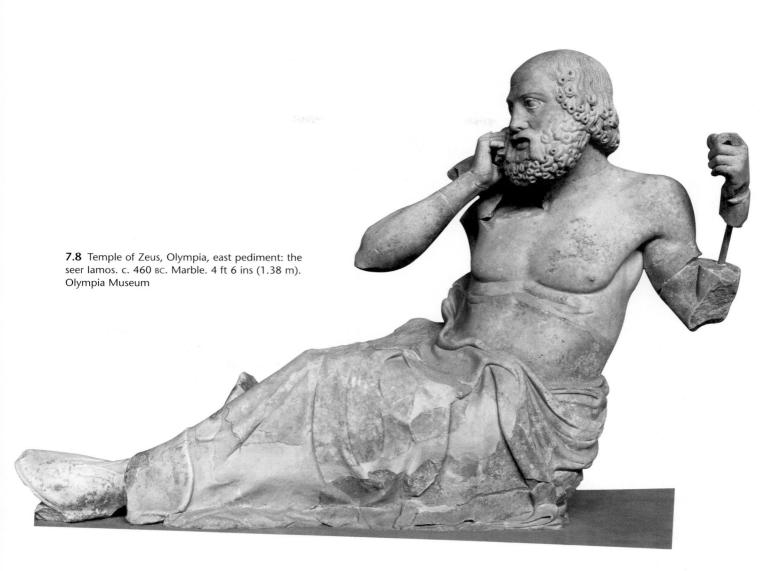

standing separately and still ironically impart a sense of tranquillity; the action is all in the future, direly anticipated. These five figures leave the automatonlike Archaic pose far behind. They are full of movement, which is expressed partly through the way the sculptor throws the weight onto one leg, leaving the other free. Gestures vary. Males use garments to contrast cloth and flesh and show off the body. Females now wear the peplos (showing a change of fashion). The presence of the body is now evoked by posture – the movement of the free leg, for example, draws the drapery against the knee – whereas Archaic sculptors had used the contour to suggest anatomical form.

Zeus is larger than the other figures, reasonably enough, and though Pausanias thought this was a statue of a statue, it is more likely he is an apparition who, unseen, sees all. Folds and creases of his garment flow this way and that, for the most part realistically, though Archaic patterns can still be seen in the folds bunched at the ankle. Beyond the chariots, on either side, are seated and reclining figures. One (fig. 7.8) may be identified as Iamos, resident prophet in Oinomaos's house. The composition is now marred by the loss of the right knee on which the elbow rested and the staff that was once held in the left hand. But age is shown in the full, heavy flesh of the torso and the balding head, and anxiety in the furrowed brow and the gesture of pressing hand to chin. This expressiveness is new in Greek sculpture. Some surfaces are left unworked (mustache, upper part of the beard) for paint and so that major accents of lips and nostrils are unhampered by sculptural detail nearby. In the corner (fig. 7.9), a reclining figure, a personification of one of the local rivers, the Kladeos, lifts himself to witness the events. Drapery contrasts with anatomy, muscle with bone and flesh.

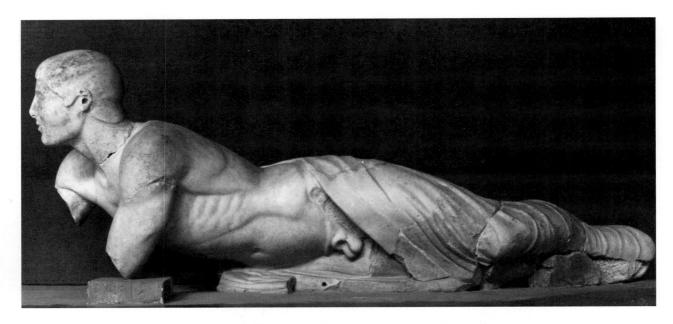

7.9 Temple of Zeus, Olympia, east pediment: reclining corner figure (personification of the river Kladeos). c. 460 BC. Marble. Olympia Museum

The body is lean and young, the hair left undifferentiated to be painted.

West Pediment On the west pediment, LAPITHS and centaurs fight at the wedding of Peirithoos (fig. 7.10). There are references to Athens, perhaps indicating political sympathy. Theseus is here, and Peirithoos's stance echoes that of one of the Tyrannicides (fig. 7.26). All is hot activity, presided over by the central figure of Apollo, again invisible to the fighters. Battle has been joined, and the two sides are apparently equally balanced. But human Lapiths would defeat bestial centaurs, another image of the victory of the civilized over the barbaric, as those who knew their myths were aware. Apollo (fig. 7.11) stands with an impassive expression. His arm is outstretched sym-

bolically, perhaps to signify the range of his control. His torso is framed by drapery. His big chin, flat cheeks, and his eyes bulging between pronounced lids contribute to the stern expression on his heavy face, which is characteristic of this period. Combatants fight in twos and threes, lunging, parrying, grasping, collapsing, biting, and pulling. A centaur grips a Lapith woman (fig. 7.12) with his hands and a hoof. She resists calmly, her left elbow banged against his temple. The corners are closed as at the front by reclining figures.

The gods are almost 11 feet (3.35 m) tall, and other figures are about 1½ times lifesize. All are fastened to the pediment with rods. Most figures are unfinished at the back. Some are sliced flat, and others are hollowed out to save weight. They demon-

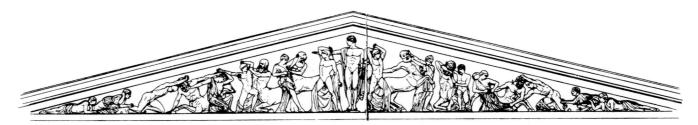

7.10 Temple of Zeus, Olympia, west pediment. c. 460 BC. Height 11 ft (3.35 m). Olympia Museum

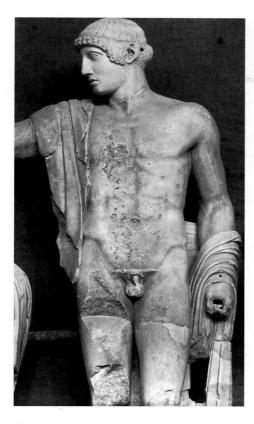

7.11 Temple of Zeus, Olympia, west pediment: Apollo. c. 460 BC. Marble. Height (of entire central figure) c. 10 ft 8 ins (3.25 m). Olympia Museum

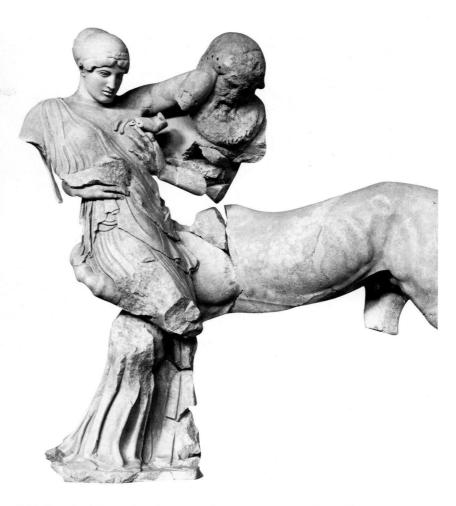

7.12 Temple of Zeus, Olympia, west pediment: centaur grappling with Lapith woman. c. 460 BC. Marble. Height 7 ft 8 ins (2.35 m). Olympia Museum

strate many aspects of the contemporary interest in movement, emotion, narrative, and realism. Faces show character as well as mood. Differences in the body, owing to age and gender, are explored. Limbs, flesh, and muscle react to movement, and drapery reacts to the motion of the body, swinging, twisting, and bunching. The substance and texture of drapery are contrasted with the human body, human bodies contrast with that of the horse, wrinkly veins and joints contrast with hoofs and hocks.

In terms of composition, the two pediments complement one another. The front is symmetrical and the action focuses inward on the central group. At the back, action is contained by movement and counter-movement, presenting the restless struggle in a single, timeless moment. At the front, Zeus ordains the chariot race and its aftermath. At the back, Apollo arbitrates the battle.

Metopes The sculpted marble metopes did not decorate the outside of the building, but were positioned over the front and back porches (fig. 7.13). They illustrate, as Pausanias painstakingly observed, the labors of Herakles, beginning at the back of the building with the young beardless hero overcoming the Nemean Lion and ending at the front with an older, bearded Herakles cleaning out the Augean stables. He is assisted by Athena, who appears four times, twice at the start and twice at the end, and by Hermes. In one episode (fig. 7.14), a seated Athena, perching barefoot on a rock, perhaps her acropolis, turns to receive the Stymphalian Birds from Herak-

7.13 Temple of Zeus at Olympia. Reconstruction drawing of a metope and adjacent triglyphs: Athena, Herakles (supporting the heavens), and Atlas (bringing the apples of the Hesperides). c. 460 BC

les. Her posture - the turning figure - offers a new design, while his presents a profile view of the head and right leg and varying views of the torso turning between the frontal and three-quarter view. His mood is calm, hers gentle. In another episode (fig. 7.15), the action is in full swing as Herakles struggles with the Cretan Bull. The sculptor needed to suggest the gigantic size of the animal, but could not do so by reducing the size of Herakles in comparison with his size in adjacent metopes. An inspired solution was to portray the bull as bigger than the metope by projecting its head from the background and pulling it back toward Herakles in a turning motion. Motion in one direction is countered by motion in the other in this crossing composition. The combatants' heads face one another in confrontation, their bodies balance each other, the heroic torso contrasts with the bovine flank. The bull's head is in the round, the neck foreshortened, and the rump in high relief, the whole metope carved from a block only about 15 inches (38 cm) thick.

The sculptural program was completed by Phidias's gold and ivory (chryselephantine) statue of Zeus, which was not installed, however, for some twenty years. The workshop in which Phidias created this statue, along with scraps of ivory, molds for making the gold drapery, and sculptor's tools, has been found immediately outside the sanctuary to the west. The statue was not designed until after the temple had been built and was positioned on a specially prepared base (fig. 7.16) at the end of the central pas-

7.14 Temple of Zeus, Olympia, metope: Herakles, Athena, and the Stymphalian Birds. c. 460 BC. Marble. Height 5 ft 3 ins (1.60 m). Olympia Museum

7.15 Temple of Zeus, Olympia, metope: Herakles and the Cretan Bull. c. 460 BC. Marble. Height 5 ft 3 ins (1.60 m). Olympia Museum

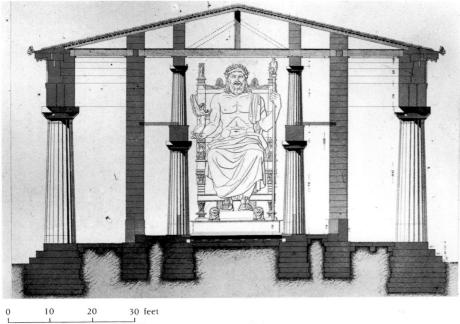

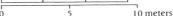

sageway formed by the two interior colonnades. These colonnades, with further columns atop forming a second story, effectively divided the cella into three spaces, the antecedents of the later nave and two aisles of church architecture. We know little of this statue except what can be gathered from written descriptions and later reduced adaptations or representations of it on coins. The seated Zeus reached to the roof and held a statue of Nike (Victory) on its outstretched right palm. Although it cramped the interior of the building, it was said by Quintilian, a Roman critic of the first century AD, to have "added something to religion."

What would visitors have thought as they viewed this temple and its sculptures? The stories were instantly recognizable, and offered several levels of meaning. At the level of mythology, the chariot contest involving Pelops recalled the horrific consequences of oathbreaking plots, the battle between Lapiths and Centaurs affirmed the supremacy of human discipline over unthinking barbarism, and Herakles' exploits in overcoming tremendous troubles by work and will power mirrored the life of man. At the historical level, the defeats of Oinomaos, the Centaurs, and Herakles' antagonists all echoed the recent Greek defeat of the alien Persians at the battles of Salamis and Plataea. At the topical level, the

7.16 Temple of Zeus, Olympia. Section showing the cult statue. Later 5th century BC

chariot race, the wrestling and boxing, and Herakles' feats of strength made clear allusion to the Olympic Games. At the philosophical level the viewer encountered man structured in three manifestations – divine (Zeus and Apollo), human (Lapiths), and animal (Centaur).

Inside, the towering seated figure of Zeus, glittering in gold and ivory, the arm of fate, awaited the apprehensive pilgrim.

The Olympic Games

The traditional date given for the foundation of the games at Olympia is 776 BC. As a precise date this is unlikely to be correct. Yet the increase in the numbers of dedications in the course of the century argues for increased activity of other sorts which may well have included the games. One tradition held that Pelops was the founder, another Herakles. There's general agreement that religious rituals preceded the games but uncertainty about why the games were introduced. Did they emulate funeral games like those for Patroklos in Homer's *Iliad*? Were they a new kind of offering to the gods? Were they initiatory? Since they took place every four years at the same time as a great festival for Zeus it's evident that they were part of the festival and reli-

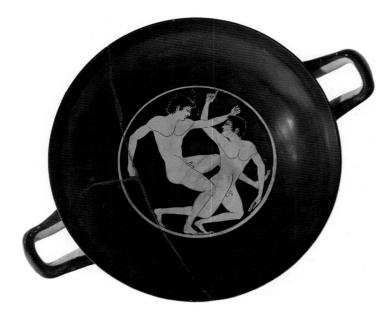

7.17 Attic red-figure cup (interior) by Epiktetos: a boxing match, c. 500 sc. Diameter (of cup) $7\frac{1}{2}$ ins (19 cm). Agora Museum, Athens

gious in character. In no sense, however, did they claim priority. Religion came first, the games second.

Messengers traveled throughout the Greek world announcing when the games would be held and when the sacred truce - allowing visitors to get to Olympia in safety - would be in force. In their heyday the games included footraces, hoplite races (footraces with contestants wearing helmets and carrying shields), chariot and horse racing, boxing (fig. 7.17), wrestling, the pankration (a vicious mix of boxing and wrestling with no holds barred except eye-gouging and biting), and the pentathlon (a combination of five sports: wrestling, long jumping, running, discus, and javelin), plus separate events for boys. The crowds were large, but there was little provision for accommodation or for hygiene. What with sacrificial animals herded into pens, sacrifices burning on altars, spectators gathered under the hot sun, and the sweating contestants, the festival was doubtless pretty smelly. Small wonder there was an altar in the sanctuary to Zeus Apomuios (Zeus, the banisher of flies)!

Only Greek males could compete. Women of mature age were not allowed to attend, though there were exceptions. The priestess of Demeter could be present, and younger unmarried girls could be there. Horse owners didn't need to be at the races and this left room for women owners to enter competitions. A Spartan princess, Kyniska, is a case in point. She won the four horse chariot race in 396 BC and then again in 392 BC, and celebrated by dedicating a bronze statuary group (her horses, her driver, and herself) with a verse epigram written on the pedestal. The bronzes have not survived, but the inscribed stone has. It reads: "My fathers and brothers were kings of Sparta. I, Kyniska, conquered with a chariot of fleet-footed horses, and set up this dedication. I say I am the only woman in all Greece to have won this crown." This dedication was intended to do more than please the gods. It speaks of social prestige, economic privilege, technical prowess, and pride in gender. Sculpture was an impressive feature of the Greek landscape, and it is in sanctuaries that much of it (e.g. figs. 5.35, 6.43, 6.44, 6.48 and 7.25) was displayed.

Participants had to arrive a month before the games began. They were then watched in training by judges who had the authority to deny them permission to take part, not to mention rods with which to whack delinquents. Training was strenuous and involved various regimes, some dietary, some exercise-related. Rumor has it that Milo of Croton (a polis in South Italy) ate 40 pounds of meat and bread at a single sitting and did his resistance training by heaving a growing calf. So there was a professional air about the organization of the games and the training of athletes.

Only those who finished first were winners. There was no second prize; nor were there team games. It was a matter of the excellence of the individual and the glory of defeating the rest. Athletes took an oath in front of a statue of Zeus to obey the rules, but paid little attention to it. Cheating began early and persisted. Runners who started too soon were flogged by referees and heavy fines were levied in other instances. Fines in fact paid for a long row of statues, the so-called Zanes, erected on the approach to the stadium from the sanctuary. The emphasis on winning, the violence of the competition, and the professionalism are all elements worth noting.

The rewards of victory were great. The Olympic prize itself was nothing more than a wreath to be worn around the head, but the contingent benefits were great. The moment of victory was celebrated at once by family and friends with feasts. Later, at home, victors enjoyed positions of influence, cash gifts, free meals, and choice seats at civic events. Great prestige attached to both victor and polis. The athletic success of the individual was taken as a reflection of the superiority in competition (or combat) of the polis itself.

Sicily and South Italy

The exterior appearance of the Doric order continued to please in the West, and though a pair of fully Ionic temples was built at Locri and Metapontum in Italy, perhaps by Greek refugee architects from Asia Minor, the practice of incorporating Ionic elements into otherwise Doric buildings became less and less popular. In Sicily, architects abandoned the reduplication of columns at the front, reduced the pseudo-dipteral plan, replaced the adyton with the opisthodomos, and aligned porch columns with the columns of the façade. Athena at Syracuse, Temple D at Akragas, and Temple E (to Hera) at Selinus show these trends. Sixth-century innovation seems to have been bred out, as planners came more and more to conform to architectural practice on mainland Greece. The same may be said of their counterparts in South Italy. Yet there were some daring and surprising developments.

The Temple of Zeus Olympios at Akragas (fig. 6.34b, p. 170), built to emulate the huge Ionic temples of Asia Minor and the nearby vast Temple G at Selinus, measured about 124 imes 61 yards (113 imes56.5 m) at the stylobate. Though begun before 480 BC, it was doubtless funded by the indemnity that was paid to Akragas's tyrant, Theron, after the victory over the Carthaginians at Himera in 480 BC. The open peristyle was abandoned and replaced by a wall varied with half-columns on the exterior and pilasters on the interior. Halfway up the exterior of the wall, on a ledge, stood sculpted male figures, arms raised aloft to support the architrave (fig. 7.18). They are nearly 25 feet (7.5 m) high and are known as ATLANTES, Atlases, or telamones. The order is Doric, but the columns have Ionic bases. Entrance was from the east, where the altar was, but by two doorways, one at either end of the facade, not by a single axial entry. A local historian, Diodoros, remarks that a battle between gods and giants decorated one pediment and a capture of Troy the other, both suitable metaphors for the victory of the Sicilian Greeks over oriental Carthaginians. But there is no

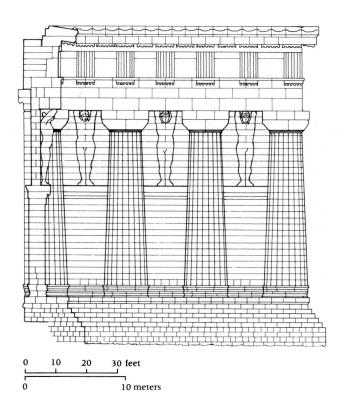

 $7.18\,$ Restored elevation of the Temple of Zeus, Akragas. c. 480 $_{BC}$

firm archaeological evidence for this. The puzzling character of the temple continues in the interior. The cella is formed by two rows of twelve massive rectangular piers, each row linked by a screen wall, while spur walls separate the cella from the opisthodomos. It is unclear where the statue might have stood or whether the building was roofed. The architectural origins of this building also remain obscure. Perhaps they are to be sought in gigantic pillared halls as much as in peristyle temples. It is thought that the temple was almost complete at the time when the Carthaginians took revenge, reducing Akragas to rubble in 406 BC.

Temple E (Hera) at Selinus was built around 460–450 BC in the large extramural sanctuary on the ridge to the east of the city, on the site of two earlier temples. The building measures 74×27 yards (68×25 m), with more elongated proportions than those of the Temple of Zeus at Olympia, though almost the same area is covered. Sculpted stone metopes decorated the frieze over the porches. There were originally twelve – six over each porch – and the figures

were almost lifesize. The material used was local soft limestone, though for exposed female faces and limbs marble was used. Here, in the metope depicting Zeus and Hera (fig. 7.19), Hera's face, arms, and feet are of marble pieced into the limestone. Hera stands in the new post-Archaic posture, with a "weight" leg and a free leg. She wears old-fashioned garments suitable for a divinity: a chiton, a mantle, and an epiblema (cloak) with which she has veiled herself and which she now draws aside to reveal her face to Zeus. Her clothing, rendered in Archaic patterns (zigzags, swallowtails), contrasts with a face that is pure Severe Style: big chin, flat cheeks, swelling eyes, thick eyelids, serious expression. Zeus's hair, shown in fine strands radiating from the crown, is typically Severe. His clothing shelters his lower body and exposes the upper, rather like the Zeus from the east pediment at Olympia, though folds and creases here are more decorative. The sculptor still preferred the profile and frontal formula for showing the body even when turned (profile head and legs, frontal upper torso), and the twisting of the torso toward three-quarter views has little of the complexity and fluidity shown by the Olympia Master (cf. Herakles of the Stymphalian Birds metope, fig. 7.14). Zeus grasps Hera by the wrist, an act often interpreted as a ritual marriage gesture.

Another metope (fig. 7.20) shows a more active scene. Artemis, again with marble face, arms, and feet, sets Aktaion's own dogs on him. He had been unintelligent enough to claim he was a better hunter than the goddess and then rash enough to look at her when she was bathing naked. Artemis's stance and facial features are Severe, and she adopts the new fashion of the peplos. Aktaion offers both frontal and profile views of limbs, his striding posture and gestures full of pathos and motion. Above his head appear the antlers of the deer skin thrown over him to deceive his dogs. The act of arrogance is reaping its reward.

These and other metopes show that this workshop of sculptors continued to work in Selinus through the middle years of the fifth century BC, and that it had absorbed stylistic features that were popular in mainland Greece. What is peculiar to Selinus is the interest in excessively mannered folds and creases of drapery, the texture of which is thin to the point of transparency, as for example in the Hera and the Artemis. More obviously, the technique of using

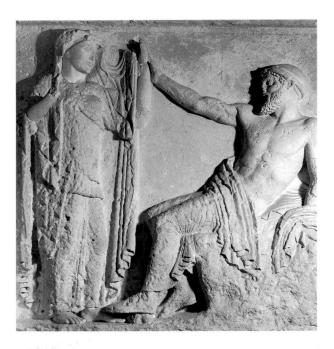

7.19 Temple E, Selinus, metope: Zeus and Hera. c. 460–450 BC. Limestone, with marble for Hera's head, feet, and arms. Height 5 ft 4 ins (1.62 m). National Museum, Palermo

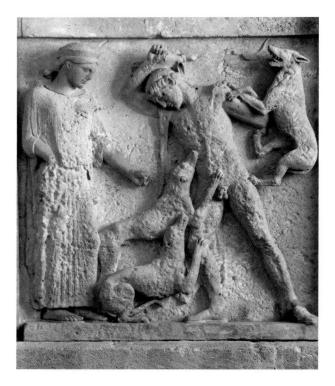

7.20 Temple E, Selinus, metope: death of Aktaion. c.460–450 BC. Limestone, with marble for exposed female flesh. Height 5 ft 4 ins (1.62 m). National Museum, Palermo

marble pieces slotted into otherwise limestone metopes seems especially at home in Selinus.

Almost all the metopes (all but two) show twofigure compositions, male and female. Artemis and Aktaion (fig. 7.20) and Zeus and Hera (fig. 7.19) are just a couple of these: others include Ares and Aphrodite, and Athena and the giant Enchelados. Fifth-century visitors would have understood these figures and the myths they represented at once. They might also have been familiar with the teachings of Pythagoras, the famous philosopher and mathematician who had lived recently in South Italy at Croton. One of his theories was that ten fundamental oppositions, of which male-female was one, controlled the world. So these metopes may be interpreted in that light: as referring both to the myth-stories from which they present snapshot episodes, and to Pythagoras's polarities.

On the Italian mainland, both Locri and Metapontum (see fig. 4.29, p. 123) witnessed the perhaps unexpected construction of large temples in the Ionic order. At Locri, one was built around 480-470 BC. The building displayed long proportions (six columns by seventeen), matching front and back porches, each with two columns between the antae, but with no columns in the cella. Columns have volute capitals with lotus and palmette collars beneath. The high quality of stone used cannot be found in South Italy and came, in fact, from Syracuse. This has prompted the suggestion that Hieron the Syracusan tyrant participated in the project. He certainly assisted the Locrians when they were attacked by Rhegion in 477 BC. Moreover, Pindar records Locrian maidens singing songs of thanks to the Syracusan tyrant in front of a temple of Aphrodite at Locri. Could this have been the temple that he mentions?

The other Ionic temple, in the Sanctuary of Apollo at Metapontum, constructed around 470 BC, had a large peristyle of eight columns by twenty, of which bases and capitals survive. The interior arrangement was old-fashioned, echoing Ionic precursors in Asia Minor, with a deep porch and a cella, but no back chamber at all.

Among the best-preserved temples from antiquity is the second Temple of Hera in the great sanctuary at Poseidonia (Paestum), built around 470–460 BC. It is the largest of the three Greek temples at Poseidonia, measuring 65×27 yards ($60 \times$

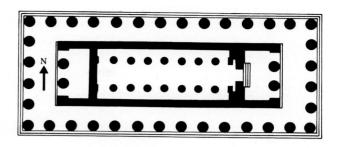

7.21 Plan of the Temple of Hera II, Poseidonia. c. 470-460 BC

25 m) and thus approximating the size of the Temple of Zeus at Olympia. The plan (fig. 7.21) shows a peristyle with six columns by fourteen, columned porches at front and back, and a cella with double colonnade. Steps from porch to cella point to the difference in floor levels. The elevation was conventional Doric, yet without any trace of sculpted decoration, either of metopes or pediments. The stocky columns (fig. 7.22) show entasis and are carved with twenty-four flutes when twenty was the rule in canonical Doric. Proportions of columns are notably old-fashioned, the height at the front of the building measuring only 4.20 times the lower diameter, and on the flank 4.36 times. They were coated with stucco to cover blemishes in the travertine, a common Greek ruse. The echinus of the capital retains a slightly baggy profile. It has not yet become the straight-sided, abbreviated cone of the High Classical period.

Angle contraction is practiced at the corners of the building. Other refinements of the Doric order that were already in play in mainland Greece were used in the temple. These included the upward curvature of the stylobate; the similarly curved horizontal cornices beneath the pediments; and the column shafts that incline slightly inward. The rarity of these refinements in the West suggests that the architects were knowledgeable about developments in mainland Greece, and perhaps even that the temple was the brainchild of a Westerner trained in mainland Greece.

The structure is notably conservative in several respects. A plan of six columns by fourteen is distinctly backward-looking; conventional Doric required six columns by thirteen. Similarly retrospective are the rather squat proportions of columns and entablature, which emphasize the weight and bulk of

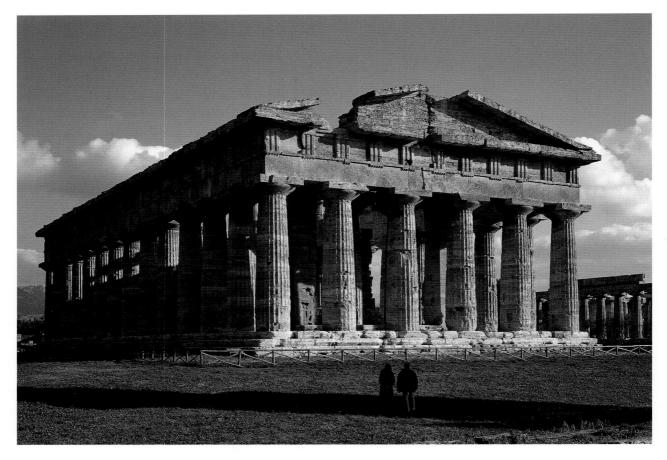

7.22 Temple of Hera II, Poseidonia, from the northwest. c. 470–460 BC. Height (columns) 29 ft (8.88 m); (entablature) 12 ft 4 ins (3.78 m). At right: Temple of Hera I (see fig. 6.36)

the superstructure; there being twenty-four flutes on the columns rather than twenty; and the slightly convex profile of the echinus. All these features point to the Archaic style. Yet the Doric refinements and similarities to the Temple of Zeus at Olympia, in spite of the absence of sculptural decoration, date it to the decade around 470–460 BC.

Athens

The Greeks were so angered by the Persians' destruction of their sanctuaries that, after the Battle of Plataea, they took an oath (the oath of Plataea – the authenticity of which is, however, in doubt) not to rebuild them: their desolation was to be a perpetual reminder of Persian barbarism. This sentiment was very strongly held in Athens, where the Persians had burned all the buildings on the Acropolis as well as smaller temples in the Agora. There is, therefore, little evidence in Athens of building in sanctuaries between 480 BC and 450 BC.

The oath of Plataea, then, prevented the Athenians from reconstructing the temples and treasuries on the Acropolis. Instead they tidied up the debris of the Persian destruction and turned their attention to the Agora, where they repaired the Old Bouleuterion and the Royal Stoa and put up two important new buildings. On the north side, close to the northwest corner, the Painted Stoa (Stoa Poikile) (fig. 7.23) was built sometime in the second quarter of the century. The prestigious location of this building provided splendid views along the Panathenaic Way toward the Acropolis. The Doric order was used for the exterior, while the internal colonnade was Ionic, one of the earliest appearances of order-mixing in Athens. Most of the building was limestone, though the Ionic capitals were marble. The stoa is named after the painted wooden panels with which it was decorated.

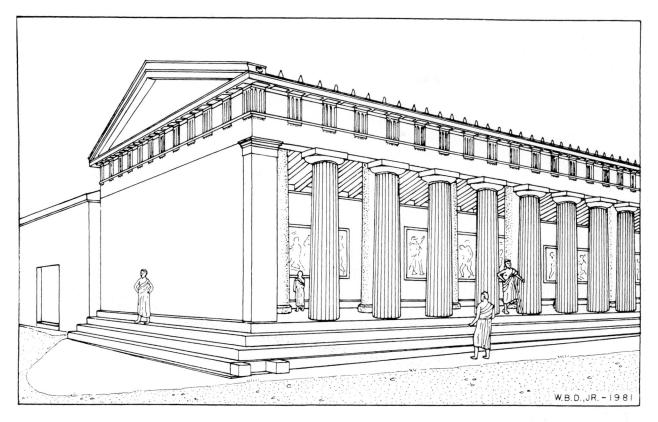

7.23 *Above* Perspective reconstruction of the Painted Stoa (Stoa Poikile) in the Agora, Athens. c. 475–450 BC

7.24 *Right* Plan of the Agora, Athens. c. 400 BC

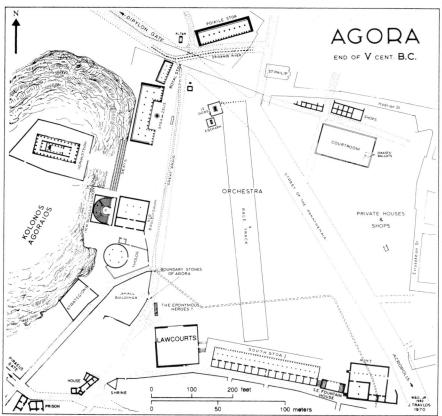

Of these, none survives, but they were described by Pausanias in the second century AD. They depicted episodes of warfare in which Athenians took part, the most renowned painting being that of the Battle of Marathon in which Miltiades himself was shown. The best known of the painters represented here was Polygnotos of Thasos. Somewhat earlier, c. 470 BC, a sanctuary of Theseus was built close to the southeast corner of the Agora and flanking the Panathenaic Way. According to Pausanias, this building was also decorated with paintings, which may therefore be regarded as the pioneers of the genre. The master painter here was said to be Mikon, a colleague of Polygnotos; and, naturally enough, Theseus took pride of place in the paintings. Later in the fifth century BC, other buildings were also decorated with paintings: the Propylaia and the Erechtheion on the Acropolis, and the New Bouleuterion and the Stoa of Zeus in the Agora. We are not certain whether paintings were done on panels or directly onto the walls, but most likely they were first executed on wooden panels that were then attached to walls. Many stoas in Athens had specific uses, but the Painted Stoa's functions varied. Beyond being a picture gallery and a museum where war trophies were deposited, it was used on occasion as a meeting hall or a lawcourt, and was often open to the public. We are told of great throngs of people of all kinds here: entertainers and beggars, fishmongers and philosophers. It is from this stoa that the Stoics, followers of the philosopher Zeno from around 300 BC onward, took their name.

Built at the same time as the Painted Stoa, a circular building, the tholos, was put up at the southwest corner of the Agora (fig. 7.24). This unusually shaped structure is the lynchpin for our understanding of the topography of the west side of the Agora. Thanks to Pausanias, who wrote of his walk along it, we can confidently identify the public buildings at the foot of the Kolonos Agoraios between the Royal Stoa and the tholos. The plan of the tholos is a plain circle, the roof supported by six columns. This was the place where the fifty members of the "boule" or senate, who formed the executive committee, met to conduct the routine and diplomatic business of the city. This was also the place where they received meals for which the democracy paid. These were modest enough by our standards: olives, leeks, barley cakes, cheese, and wine were staples, though fish and meat were occasionally included. Diners probably enjoyed their free meals seated, since there was not enough room for fifty couches in the tholos to allow them to recline, as was the usual domestic custom. Yet, since a third of their number had to spend the night there, so that the city should be always vigilant, these at least must have been provided with couches. Furniture, like crockery and tableware, was easily moved about.

SCULPTURE

The development of Greek sculpture throughout the Archaic period can be followed readily enough from original statues of kouroi and korai, original groups, original reliefs, bronzes, and terracottas and their counterparts in architectural sculpture.

With the fifth century BC, however, our sources of information become complicated by the wealth of news transmitted by ancient writers, on the one hand, and by the later Roman enthusiasm for removing, copying, and adapting famous Greek originals on the other. Ancient writers - among whom Pausanias and Pliny (see p. 26), who lived in the Roman period, are the most informative - tell us about fifthand fourth-century Greek sculptors and their work, and about later sculptors too. Pausanias traveled around the sanctuaries and cities of Greece in the second century AD, describing the monuments and statues he saw. He used written sources and information offered by guides whose accuracy may be doubted. He often makes mistakes and what he says must be treated with caution. Pliny's Natural History contains a long section on bronze statues and a shorter one on marble. He mentions the principal sculptors and their pupils and describes statues individually. These descriptions are sometimes useful in trying to identify from copies or variants what Greek originals would have looked like. They are also useful in telling us what Greek originals may have been seen in Rome in the first century AD.

From the third century BC on, Romans plundered the Greek cities of South Italy and Sicily of their art, and from the second century BC the whole of Greece fell prey to their avarice and theft. They removed Greek statues en masse and copied them en masse. They were, and continued to be, emulators of Greek art. Some of the statues described by these authors may be spotted among Roman copies or adaptations, especially if a Greek statue was so popular that many copies were made. But questions bedevil these studies. How true to the original is the copy we have, especially if the original Greek statue was bronze and the Roman copy/adaptation is in marble? How true to the original is the literary description we have? It is sometimes unsound to attribute a work to a particular sculptor simply because it bears a stylistic similarity to his other work. It is best to deal with original statues, if possible, and to view the progress of Greek sculpture more in terms of type and style than in terms of shadowy personalities, however intrusive these inevitably become. Yet reliance on originals alone would not yield the whole picture, and copies and adaptations help to fill in gaps. Knowledge of how to reconstruct originals from several Roman copies is therefore critical.

As to the originals that have survived, the architectural sculpture from Olympia is foremost in displaying a whole gallery of characters and activities. Yet the preferred material for freestanding statues was bronze, as the unoccupied bases from dedications in the sanctuaries on the Athenian Acropolis, at Delphi, and at Olympia eloquently testify. The statues to which these bases belong have either been melted down and reused, or stolen. A few, however, have survived. Generally, they echo developments in architectural sculpture and show the way sculpture in the round progressed. Yet their quality is so startling, and their presence so compelling, that we can only wonder at the impact that dozens of these figures would have created in the sanctuaries and other public places where they stood.

The Kritios Boy (fig. 7.25), found on the Acropolis in Athens in the debris of the Persian destruction and therefore pre-480 BC in date, is both the last of the Archaic kouroi and the first of the new figures in which the movement of the body is organically explored. Sculpted in marble, and considerably smaller than lifesize, he displays the new posture, with the right leg advanced and free while the weight is on the left. Movement of the horizontal axes follows the pose. The right hip is lowered, the shoulders tilt slightly, the head turns and the body curves a little. The face is characterized by a big chin, flat cheeks, thick eyelids, and a composed expression. The head has hair which radiates in thin strands from the crown and is rolled up over a fillet. Rolled hair like this is a particular trait of the Severe Style,

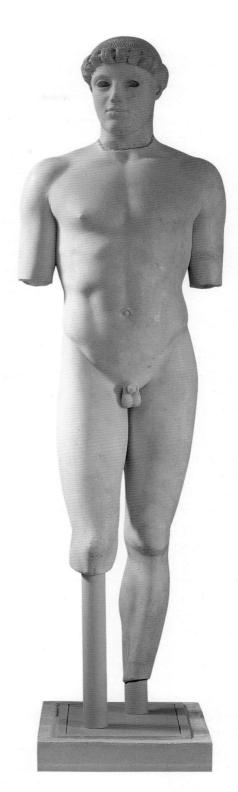

7.25 The Kritios Boy, kouros attributed to the sculptor Kritios. c. 480 BC. Marble. Height 3 ft 10 ins (1.17 m). Acropolis Museum, Athens

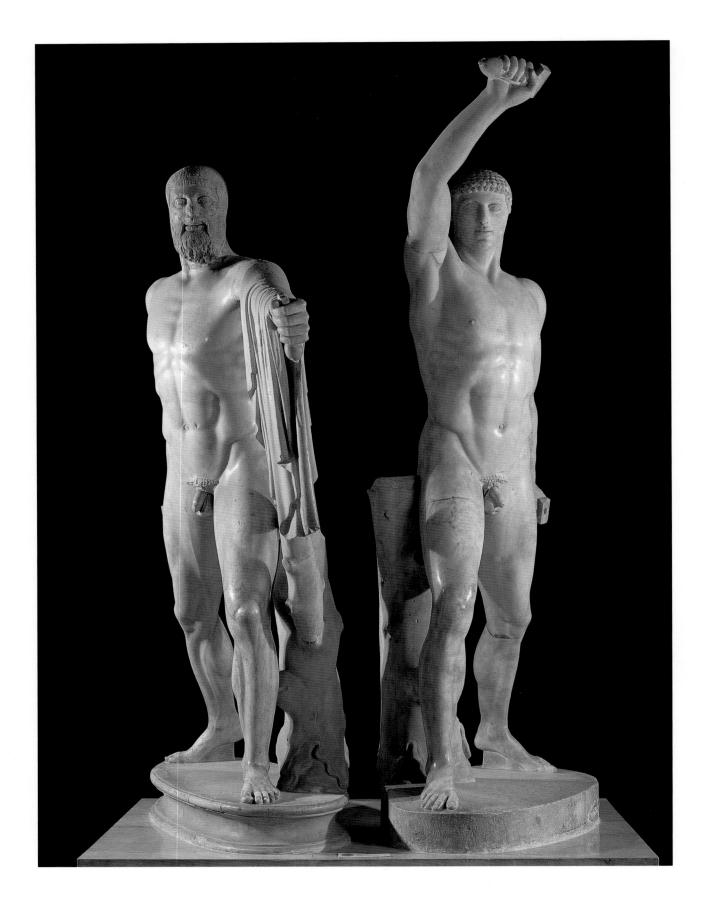

as is longer hair tied in plaits and wound around the head. He is still a frontal figure, but now of realistic bone and muscle, no longer a stiff automaton. He was dedicated on the Acropolis before 480 BC, though there is some argument about the precise date.

The Kritios Boy is so named owing to the similarity of the head to one in a group made by the sculptors Kritios and Nesiotes and set up in the Agora at Athens in c. 477 BC. The precise role of each artist in the partnership remains unclear, but that their collaboration was successful is shown by signed bases for other sculptures found on the Acropolis. The group in question was a bronze called the Tyrannicides, which depicts Harmodios and Aristogeiton, who had assassinated the tyrant Hipparchos. The use of sculpture to honor real people, as well as the gods, was a fresh development, and its exploitation as political propaganda by the new democracy an entirely new idea.

Kritios and Nesiotes' bronze originals are recognizable without dispute in Roman marble copies (fig. 7.26). The arrangement of the two figures is, however, controversial. The older man of the pair, Aristogeiton, lunges forward, one arm outstretched with hanging cloak, the other arm holding the weapon back. Harmodios, the younger man, moves forward with a raised weapon. The striding poses are a common formula and the two might have stepped out of a pedimental composition. The figures at Aegina (fig. 6.14, p. 159) are obvious precursors. The anatomy is treated confidently, in the copies anyway. The head of Harmodios, taken to be similar to that of the Kritios Boy, has a typically Archaic hairstyle (closely packed, patterned curls) juxtaposed with a Severe Style face, while that of Aristogeiton enjoys more consistently Severe Style hair and face.

The more realistic representation of anatomy and mood evident in the Severe Style is emphasized by a first appearance of portraiture. Whether this may be genuinely deemed the arrival of true portraiture is debatable, yet a copy of a portrait of Themistokles (fig. 7.27) provides a compelling example. Individualized traits in the features are unmistakable,

7.26 Opposite The Tyrannicides. Roman copies of c. 477 BC Greek bronzes by Kritios and Nesiotes. Marble. Height 6 ft 5 ins (1.95 m). National Museum, Naples.

7.27 Themistokles. Roman copy, from Ostia, of a c. 450 BC Greek original. Marble. Height (of head) c. 10¼ ins (26 cm). Archaeological Museum, Ostia

as are Severe Style characteristics. However, the idealizing trend in Classical sculpture remained too strong, and the next generation of sculptors rejected any further movement toward realism.

Ancient writers saw Myron as a sculptor whose work was transitional between the Early and High Classical periods, who followed the path toward anatomical realism, while avoiding emotional expressiveness. A description offered by Lucian of his Diskobolos (discus-thrower) has enabled the statue to be identified among Roman marble copies (fig. 7.28). His hairstyle, with its mannered, closecropped curls, seems old-fashioned, reminiscent of some heads from Olympia, but his pose is wholly

7.28 Diskobolos by Myron. Roman copy of a c. 450 BC bronze Greek original. Marble. Height 5 ft 1 in (1.55 m). Museo Nazionale delle Terme, Rome

7.29 Angelitos's Athena. c. 480 BC. Marble. Height 2 ft 6 ins (77 cm). Acropolis Museum, Athens

new and unexpected. The original bronze dates perhaps to about 450 BC. Seemingly free and full of movement, the figure is, however, firmly held in two or three receding planes, allowing only one convincing viewpoint. In antiquity Myron was most famous for his bronze cow dedicated on the Acropolis in Athens. As lifelike as the Diskobolos, to judge from descriptions, this beast was likely admired both as another example of Myron's command of design and as an evocation of sacrifice.

Developments from the Archaic marble kouros and kore types in this period can be studied in their counterparts in the pediments at Olympia, where male figures have the new relaxed pose, their anatomy realistically portrayed, and standing draped female figures wear the new clothing, the peplos, and hence are called PEPLOPHOROI (fig. 7.7). Though fragmentary, they provide more reliable evidence, being originals, than the numerous Roman copies with all their problems of attribution and identification. The Kritios Boy may be said to introduce the Transitional type of standing male nude figure, and, for the standing draped female figure type, the statue known as Angelitos's Athena, another original, marks the change from Archaic to Transitional. She stands (fig. 7.29) with a free right leg in the new pose, the drapery over it revealing the leg's contours clearly. She also wears the new-style peplos beneath her AEGIS, a magic cape or shawl-like garment decorated with the Gorgon's head and fringed with snakes. This cape identifies the statue as Athena, as she was often portrayed wearing it. The right hand held a spear, while the left, free from the Archaic convention of tugging at the skirt, rests flat on the hip. The dedication by Angelitos on the Acropolis at Athens probably took place around 480 BC. Somewhat generalized gravemarkers or gifts to the gods in the Archaic period, these images now become more specific representations, commemorating the prowess of a particular athlete in a dedication in a sanctuary, or representing a specific divinity (most often Apollo or Athena).

A number of bronze originals survive, among them the Charioteer of Delphi (fig. 7.30), identified by modern scholars as a gift of a Sicilian Greek, Polyzalos, tyrant of Gela, to the sanctuary for a victory in the chariot race in 478 or 474 BC. The statue is nearly 6 feet tall (1.80 m) and was originally part of a large group consisting of horses, chariot, charioteer, and groom. With such stupendous dedications

7.30 Charioteer of Delphi. c. 478 or 474 BC. Bronze with copper (lips, eyelashes), silver (teeth, headband), and onyx (eyes). Height 5 ft 11 ins (1.80 cm). Delphi Museum

did the city-states of the West remind other Greeks of their wealth. The Charioteer was cast in eight pieces: two for the head; two for the body; and the four limbs. The left sleeve shows how the bronze arm was socketed in place. The eyes were inlaid in glass and stone, copper was added on the lips, silver was used for teeth and on the headband. As with the use of paint on architecture and stone sculpture, the incorporation of other materials and metals in bronze statues shows how much the Greeks liked colors. The figure's weight was evenly distributed, the lower body, except for the ankles and feet, lost behind the folds of the long racing chiton. There is no trace of the new free leg posture in a composition that is basically static and columnar. Yet the slight movement of upper body and head, the tension of outstretched arm and neck, and the open mouth all breathe life into the figure. Drapery, too, is enlivened by varied bunching of folds and creases caused by belt, shoulder straps, and seams. Heavy features of the face are characteristic of the time, the expression is calm and collected. The moment chosen is after the race, since it was often aftermath or anticipation, as in the east pediment at Olympia, that sculptors during this period preferred.

Another survivor is the Zeus or Poseidon (fig. 7.31) retrieved from the sea off Cape Artemision in Greece. Bronze for the most part, lips and nipples are of copper, eyes and eyebrows are inlaid in ivory/bone and stone. Identification of the god depends on the weapon held in the right hand: was it a thunderbolt (Zeus) or a trident (Poseidon)? Discussion continues. A striding, over-lifesize figure, arms outstretched to aim and hurl his weapon, weight on the front foot and heel of the back foot raised, he is a commanding presence. Yet there are problems. The frontal view of the torso yields no forward movement of the upper body to correspond with the weight being on the front foot - though this improves when the figure is viewed obliquely - and the limbs are very long, especially the front arm. The hair on the crown of his head has a strandlike, flowing arrangement similar to that of the Kritios Boy, but, in contrast to the "roll" treatment of the latter, the long hair is bound in two plaits carried over the front of the head and tied together. Loose bangs of hair across the forehead explore the fluid possibilities of casting and introduce more plastic movement. The expression is resolute and calm. Comparison with the head of the seated Zeus on the Selinus metope (fig. 7.19) is often made and reflects the broad distribution of the type.

The repertoire of original Greek bronze statues of this period was dramatically increased in 1972 when two more large bronze statues were fished out of the sea near Riace in South Italy (figs. 7.32 and 7.33). They may come from a shipwreck, perhaps a merchantman carrying spoils to Italy for Roman patrons. The Riace bronzes (A, the younger man, and B, the elder) adopt the Severe Style lateral stance, offering a weight leg and a free leg, but the representation of the body shows advances in the understanding of the anatomy in action that go beyond anything at Olympia or in any surviving Roman copy. These figures, then, may only just be categorized as Severe and stand on the threshold of the High Classical period. They were probably made around 460-450 BC. The formidable comprehension of the workings of the anatomy, together with the expressions of mood portrayed in face and posture, underscore the gaps in our knowledge of the art and architecture of antiquity and suggest that the Olympia figures may only be rather watered-down versions of contemporary freestanding statues.

Riace A (fig. 7.32) originally carried a shield and spear and may have worn a wreath. His eyes are of ivory and colored stones, his lips and nipples are of copper, and his teeth of silver. His hips tilt one way, his shoulders the other, the head turns challengingly to the right. Riace B (fig. 7.33) also carried a spear and a shield and wore a helmet pushed back (now lost). His eyes were inlaid, his teeth of silver, and his lips and nipples of copper. The figure sways to the right and the left knee advances the front plane. He seems stylistically more advanced, more adventurously engaged in space than his counterpart.

These statues show a sophisticated knowledge of muscle, sinew, flesh, bone, cartilage, and of the body in motion. Sculptors were now interested in the way parts of the body were connected, and in how movement in one promoted movement in others. The body came to be seen as constructed and motivated from the inside, rather than viewed from the exterior to suggest symbolic motion. The mainsprings of this change in viewpoint were twofold. Greek physicians were investigating the relationship of bones and muscles to one another, how the contraction of one set of muscles produced relaxation in another, and how muscular activity resulted in movement of bones and

7.31 Artemision Zeus, or Poseidon, from the sea near Cape Artemision. c. 460–450 $_{BC}$. Bronze. Height 6 ft 10½ ins (2.09 m); finger tip to finger tip, 6 ft 10¾ ins (2.10 m). National Museum, Athens

7.32 Riace Warrior A. c. 460–450 BC. Bronze with copper lips and nipples, silver teeth, and eyes inlaid. Height 6 ft 9 ins (2.05 m). National Museum, Reggio Calabria

7.33 Riace Warrior B. c. 460–450 BC. Bronze with copper lips and nipples, and eyes inlaid (one preserved). Height 6 ft 6 ins (1.96 m). National Museum, Reggio Calabria

sinews. Athletes and warriors were sources of information, and surgery was helping establish the principal systems of movement in the body. Greek philosophers, too, had long been preoccupied with movement. Parmenides had attempted to break down motion into individual arrested moments. Pythagoras saw the world as moving patterns. Abstract and practical spirits alike were concerned with movement.

Not the least striking feature of the Riace bronzes is the way the sculptor(s) explored mood. A, the younger man, appears energetic and challenging, almost arrogant, while B is relaxed and calm, almost resigned. These effects were arrived at not just through the different representations of face and hairstyle, but also through the set of the body and the angle of the head. There has been much searching through Pliny and Pausanias to identify groups to which they might have belonged and the sculptors or workshops that might have made them. Stimulating theories have been advanced and the pair have even been attributed to Phidias himself, but there is no consensus. Probably they represent Greek heroes and were originally dedications either at Delphi or Olympia. Recent scientific analysis of the clay cores inside the statues has shown that the clay is probably from Argos. Dare one mention the name of Hageladas, the teacher of Polykleitos, in association with them?

As well as marble and bronze, sculptors also worked in clay. Zeus and Ganymede (fig. 7.34) from the sanctuary at Olympia originally stood as an akroterion on the roof of a temple. Zeus strides along, clasping Ganymede in his right arm and holding his traveling stick in the other hand. Ganymede clutches a rooster, a love-gift for a lad. Hairstyles are still Archaic, though faces are Severe, so a date of around 470 BC is likely. The group was embellished with much paint: black, brown, red, and yellow. A group like this gives a good idea of what the clay models for bronze statues would have looked like.

Sculptors continued to produce reliefs both for funerary and votive purposes. Sumptuary laws, however, seem to have restricted the production of funerary monuments in Athens, and examples have to be sought instead in the islands and in Asia Minor. The challenge now for artists was to depict more realistic figures foreshortened in a shallow field. With patterned forms left behind, carved drawing would not

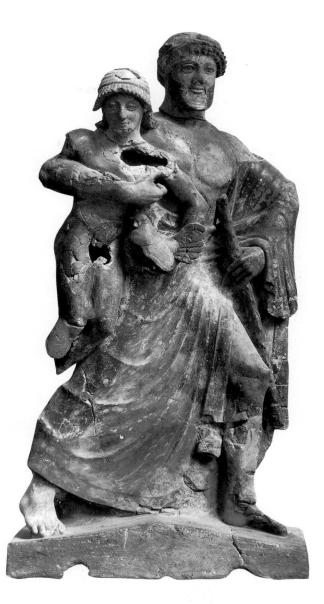

7.34 Zeus and Ganymede, from Olympia.c. 470 BC. Terracotta. Height 3 ft 7¼ ins (1.10 m). Olympia Museum

suffice. But sculptors were equal to the task, gradually detaching the figures more and more from the background, a skill already exercised in architectural sculpture with some success.

A votive relief from the Temple of Athena at Sunion shows a youth (fig. 7.35) crowning himself. His profile head and oblique torso, with his left arm and shoulder pulled back in the front plane, are successfully shown in a relief only about 1½ inches (3 cm) in depth. Another relief from the Acropolis in Athens, the Mourning Athena, shows several hall-

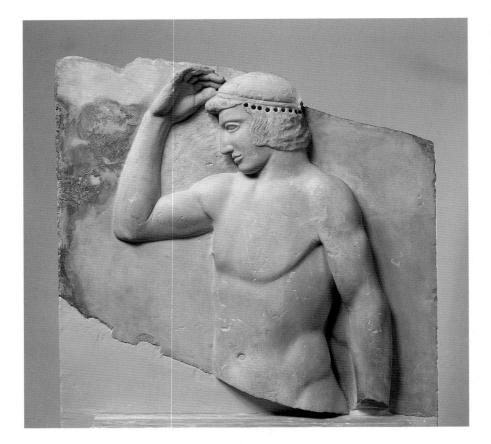

7.35 Relief showing young athlete crowning himself, from Sunion. c. 470 BC. Marble. Height 23¼ ins (59 cm). National Museum, Athens

marks of the Severe Style. The goddess displays a weight leg and a free leg; she wears a peplos; and her face has a serious expression (fig. 7.1). She leans on a spear, gazing at what was probably a list of Athenian dead in battle. Undercutting of the long folds of the peplos contributes to the effect of depth, while her attitude – her head inclined downward, her hand to her brow – produces a sorrowful impression. Both reliefs date to around 470 BC.

Sculptors and their patrons in the West had to import marble from Greece, which may account for their sparing use of it in the metopes of Temple E at Selinus. Yet Pliny tells of renowned sculptors of this period working in the West, and a few examples of marble sculpture from Sicily and South Italy show that costs of shipping marble from quarries in the Aegean islands did not deter ambitious commissions.

From Taras in South Italy comes the marble Enthroned Goddess (fig. 7.36) now in Berlin. The seated figure is an early type already seen in the pediment of the Temple of Artemis at Corcyra (fig. 6.8, p. 156) and in the Geneleos group from Samos (fig. 6.61, p. 188). It is especially popular in the East. Here the goddess retains the frontality of the Archaic period, and like Hera in the Selinus metope (fig. 7.19) wears Archaic garments, the chiton and a transverse mantle. Forms are symmetrically arranged, though the forearms and hands that are now missing may have introduced variety of gesture. The emphasis is on the decorative qualities of her hairdo, the close-set crinkles of the chiton, and the zigzag designs of the mantle. Yet the face is unmistakably Severe, with characteristic bulging eyes, thick lids, and flat cheeks. An unknown sculptor made this figure around 480–470 BC.

This combination of Archaic and Severe traits (cf. p. 224) has been taken by some as an index of provincialism. Such commentators take the view that sculptors in Magna Graecia were behind the times by comparison with artists in Greece proper, and that they mixed the styles either in ignorance or carelessness. Yet the use of a new transparent drapery style, to be seen in the next two pieces discussed, is ahead of developments in Greece, not behind. Accordingly, the use of Archaic traits may reveal a retrospective interest in evoking the past and deploying its charac-

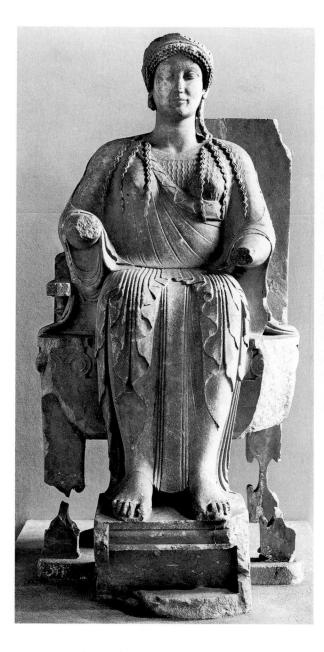

teristics to beautify and dignify. This conservatism the Western Greek sculptors balanced by the introduction of the see-through flimsy drapery, which inaugurated a style not yet seen in mainland Greece.

For a contemporary male figure in marble in the West we turn to the islet of Motya off the west coast of Sicily. Here a Carthaginian sanctuary yielded a big marble draped figure (fig. 7.37). He is a magnificent puzzle. The posture is jaunty, with a weight and a free leg, his right arm raised and his left akimbo, his hand on his hip. He gazes off to the left. His hairstyle is Late Archaic, but the face is distinctly Severe (eyes,

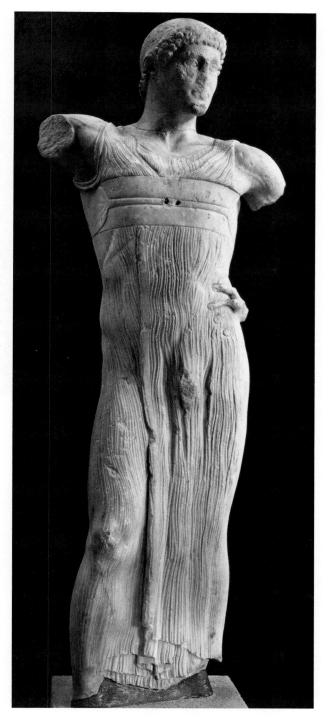

7.36 Above left Enthroned Goddess, from Taras. c. 480–470 _{BC}. Marble. Height 5 ft (1.53 m). Staatliche Museen, Berlin

7.37 Above Charioteer, from Motya, Sicily. c. 480–450 BC. Marble. Height 5 ft 11¼ ins (1.81 m). Motya Museum

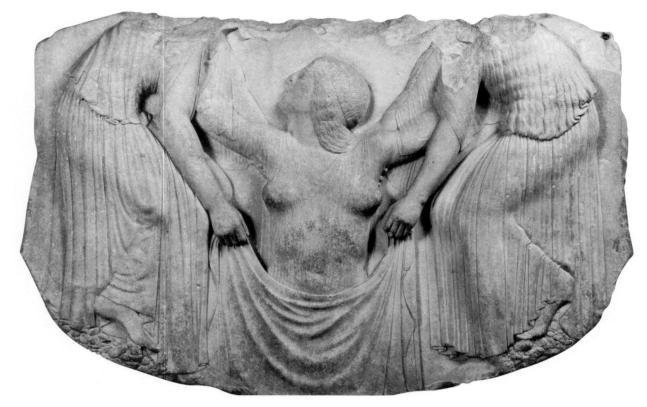

7.38 Ludovisi Throne reliefs. c. 480–470 вс. Marble. Maximum height (of main relief) c. 3 ft 6 ins (1.07 m); (of side reliefs) c. 2 ft 9 ins (84 cm). Museo Nazionale delle Terme, Rome

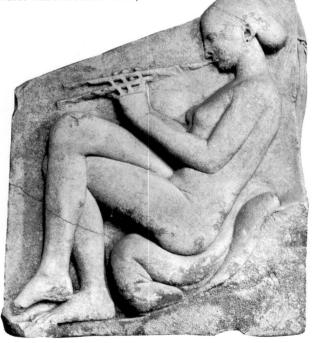

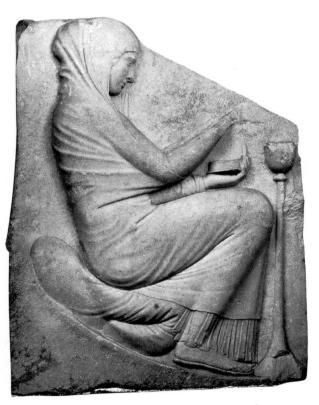

lids, cheeks, chin). It is the treatment of the drapery, however, that has sparked most interest. The fabric clings to the body, revealing the contours of muscled thigh, hip, and buttock. Folds are bunched together, regularly arranged ridges and channels in some passages, unevenly spaced in others. At the ankles, folds overlap in Archaic patterns. Such transparency of garments, not seen in Greece itself until the end of the century, should not necessarily come as a surprise when found at an earlier date in the West. It had already appeared in the metopes at Selinus. It seems possible, then, that this statue was the creation of the workshop of Greek sculptors active in Selinus around 470 BC. Many take the garment he wears to be the racing chiton and identify him as a charioteer, a worthy marble counterpart to the bronze at Delphi (fig. 7.30), another Western Greek dedication. Others prefer to identify the statue as a Phoenician-Punic figure, as a god (Melgart) or a priest or attendant, or even as a general or political leader.

Transparent treatment of the drapery, as a Western Greek trait, occurs also on the so-called Ludovisi Throne (fig. 7.38). This monument consists of three marble slabs decorated with relief sculpture, which either stood around an open sacrificial pit or adorned an altar. It was not a throne. The front panel (opposite, top) seems to show the birth of Aphrodite from the waves (though there are alternative interpretations). Aphrodite is assisted by women who, arms outstretched, prepare to dry her with the cloth they hold between them. One side panel (opposite, right) shows a heavily draped female taking incense from a box to place on the burner before her. On the other (opposite, left), a girl, naked except for the snood that binds her hair, sits comfortably, playing the pipes. The sculptor's interest in transparent drapery and the body beneath is obvious. Aphrodite's garment clings tightly to the torso, the wet drapery dampened by the ocean, revealing her breasts, nipples, and thorax clearly. The attendant to her left wears the sleeved chiton showing the knees and lines of the lower leg, while the other woman wears the peplos through which, though heavier, the thigh and back leg vividly appear. The musician is the first Greek female nude we know of in sculpture since the Geometric ivories from Athens (fig. 4.17, p. 115).

Although the figures show errors in their anatomy, the overall composition is well planned.

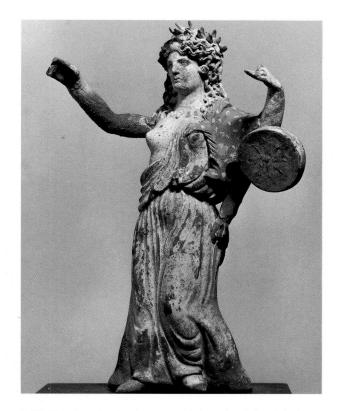

7.39 Figurine of a dancing maenad, from Locri, South Italy. c. 400 BC. Terracotta. Height 7½ ins (19 cm). National Museum, Reggio Calabria

The nude of one panel matches the draped figure (a priestess?) of the other. Aphrodite reaches up to balancing figures who lean toward her, their bare feet gingerly touching the pebbles.

These reliefs were found in Rome in the gardens of Sallust, where much Greek sculpture has been retrieved. Aspects of their themes are found among terracotta reliefs from Locri in South Italy. It may be that the Ludovisi Throne decorated an architectural feature of the Temple of Aphrodite built there in the decade 480–470 BC. This date certainly chimes well with the style of the Ludovisi reliefs.

In the absence of marble in the West, many sculptors turned to clay as a cheap and plentiful medium. This was used to fashion great figures to decorate the superstructure of religious buildings, as had been the case in the Archaic period, and to make cult statues, of which only fragments have survived. Clay was also the medium for the production of thousands of figurines made from molds, which were therefore mass-produced. They were offered as gifts

7.40 Above Plaque, from Locri, South Italy: Hades and Persephone enthroned. c. 460 BC. Terracotta. Height 9 ins (23 cm). Museo Nazionale, Reggio Calabria

7.41 Below Plaque, from Locri, South Italy. c. 460 BC. Terracotta. Aphrodite and Hermes in a chariot drawn by Eros and Psyche. The hole in the top of the plaque was made for attachment to a second surface (a tree?) in the sanctuary. Height 9 ins (23 cm). Taranto Archaeological Museum

in sanctuaries and represented either worshipers or the gods. These figurines were often reduced versions of larger statues and give a good idea of what the large-scale terracotta (or marble or bronze) statues may have looked like.

A good series of such figurines has come from Locri (fig. 7.39), as has, more remarkably, a series of terracotta relief plaques, also votives. Many of these show scenes of divine activity, of Hades and Persephone (fig. 7.40) and of Aphrodite. Here (fig. 7.41) Aphrodite is seen in a chariot drawn by Eros and Psyche and accompanied by Hermes. Others show ritual scenes associated with marriage, so that divine couplings seem to mirror mortal rites of passage. They were offered to Persephone and Aphrodite by young women as their marriage days approached. They sought divine protection at a moment of supreme importance in their lives, when their social status was about to change dramatically. At another level, that of impending pregnancy and childbirth, they affirmed the incomparable importance of women to society.

POTTERY AND WALL Painting

The great success of Athenian black-figure and then red-figure vases in the Greek world of the Archaic period drove other workshops to the wall. At Corinth, a red-figure technique enjoyed a certain local popularity, but did not last long. It is in Athens that the story really continues. One group of painters, among whom the Pan Painter was prominent, preferred old-fashioned conventions and looked back admiringly to the sixth century BC. A bell krater (fig. 7.42) by the Pan Painter shows Artemis drawing her bow to deliver the coup de grâce to Aktaion, whose dogs attack him (cf. fig. 7.20). The design is on the surface, without exploration of space; movement and gesture count in a theatrical moment. Quirks include the pouty lips, the small ear, and the eye rendered as a dot. This vase was painted around 470-460 BC.

Another vase, datable to the same period, exemplifies the work of an innovative potter called Sotades. He favored vases with modeled parts, such as the sphinx vase in the British Museum in London

7.42 *Left* Attic red-figure bell krater by the Pan Painter: death of Aktaion. c. 470–460 Bc. Height 14½ ins (37 cm). Museum of Fine Arts, Boston

7.43 *Right* Attic red-figure sphinx vase (a rhyton: note the spout between the legs) by the Sotades Painter: Kekrops and daughters (below the lip). c. 470–460 BC. Height 12% ins (32 cm). British Museum, London

(fig. 7.43), which was decorated by his painter, the Sotades Painter. This has a running centaur at the foot, and the legendary king of Athens, the snaketailed Kekrops, and his daughters on the red-figure frieze below the lip. It was a pouring vessel, as the hole at the front between the legs of the sphinx shows. Closed by a stopper, it would have contained wine to be poured out through the hole when the stopper was removed. Sotades made numerous "plastic" vases like this, following a practice that had flourished in the Orientalizing period. Just as then, contact with the East was providing stimulation. The Sotades Painter explored difficult techniques such as gilding and used coral red and a lot of white, often as a ground. The work of these two artists was exported far and wide. The British Museum vase was found in Italy, while other examples have come to light in Egypt, Cyprus, and the Greek colonies on the coasts of the Black Sea.

In the same decade, the Niobid Painter attempted to convey space and depth in a new way. A krater (fig. 7.44), now housed in the Louvre in Paris, shows Apollo and Artemis slaughtering the children of Niobe. The latter had boasted of the number of her children to the goddess Leto, who had only two (but what a pair: Apollo and Artemis!). Niobe's act of "hubris," or pride, invited divine retribution, and here we see its enactment. The painter has distributed his figures over the surface of the vase in various postures and on various wavy groundlines. The old convention of a single groundline has been discarded and replaced by multiple ones, obviously intended, with the spectral tree shown at the top of the scene, to suggest landscape and space. Yet there is no reduction in the size of figures that are theoretically in the distance; all remain on the unbroken surface of the vase. The reverse of the krater shows Athena, Herakles, and other heroes (fig. 7.45), similarly

7.44 Above Attic red-figure krater by the Niobid Painter: Apollo and Artemis killing Niobe's children. c. 460 BC. Height 21¼ ins (54 cm). Musée du Louvre, Paris

7.45 Below Reverse of 7.44. Athena, Herakles, and heroes

arranged over the surface, top and bottom. It is rather like the pediments at Olympia, which deliberately contrast a quiet scene full of foreboding at the front of the temple with hot action at the back. Herakles and his companions shown at ease contrast with the active violence of Artemis and Apollo (fig. 7.44). Artemis takes an arrow from her quiver, Apollo draws his bow; one Niobid takes an arrow in the back; others dead or dying litter the field. As to the drawing, three-quarter and intermediate views are shown successfully. A profile eye at last appears in a profile head; the drapery has lost its stiff Archaic patterns and falls more freely. There is much accurately drawn foreshortening.

The arrangement of figures on various groundlines up and down the surface of the vase tallies with the detailed descriptions we have from Pausanias of the scheme used by wall and panel painters to suggest depth and space. Among the most illustrious of these practitioners was Polygnotos of Thasos, some of whose panels hung in the Stoa Poikile in Athens, and others in the Lesche (clubhouse) of the Knidians at Delphi. Though Pliny says that no one gained fame by painting on walls, it is possible that Polygnotos painted on walls as well as panels. It seems that most of his work appeared in the period 480-460 BC. He was regarded as a master painter by the Hellenistic and Roman commentators who saw his work. Renowned for the "ethos" or character with which his figures were endowed, he is said to have used posture and gesture to create these effects. The figures of the Olympia pediments and the Riace bronzes spring to mind as possible parallels. He and his circle used a four-color palette: red, yellow, black, and white. The topics favored were mostly mythological, though a historical event, the Battle of Marathon, painted in the Stoa Poikile, was possibly the most famous. Some innovations - intermediate views of the body, unusual postures of movement and repose - were shared with vase painters. But it is the exploration of space - by putting figures on different levels to suggest depth, without, however, reducing their size (as in perspective) - that seems to mark him out as an innovator. On vases like that shown in figures 7.44 and 7.45, the painter may be drawing on ideas developed by Polygnotos and his circle.

When later writers discuss monumental painting, it is often unclear whether they are speaking of painting done directly on walls (murals) or

7.46 Plaque, from near Corinth: procession approaching an altar. c. 530 BC. Painted wood. Height c. 6 ins (15 cm). National Museum, Athens

executed on wooden panels attached to walls. What is clear is that they held large-scale Greek painting in high regard. So it is ironic that almost nothing of original Greek mural and panel painting has survived. The earliest of any substance were the seventhcentury BC terracotta panels from Thermon (fig. 5.15, p. 135). Their rectangular shape encouraged single figures or small groups painted in outline technique using the colors of the vase painter: red/purple, black, white, and yellow. In spite of the absence of incision, which would have been invisible in their position on the building anyway, the panels can be compared to Corinthian vase painting for style and date. From the second half of the sixth century BC, around 530 BC, come four small wooden painted plaques found in the vicinity of Corinth. The illustration (fig. 7.46) shows a procession of peplophoroi, musicians, and youngsters approaching an altar. Blue, red, black, and brown coloring stands out against the white ground. Whether this small plaque, barely 6 inches (15 cm) high, is a reflection of larger mural painting remains open to question. It is tempting to turn to the plethora of surviving painted scenes with which the Etruscans decorated their tombs. Parallels with representations on Greek vases of drapery, posture, and anatomy are identifiable, but this cannot help isolate traits of Greek mural painting when we have no Greek paintings with which to compare them.

From Poseidonia in South Italy, close to the Etruscans, comes the only substantial and complete example of Greek wall painting of the fifth century BC that has survived. The Tomb of the Diver (fig. 7.47) shows scenes of a typical symposium on its four sides, with a diver on the underside of the ceiling block. The background is white stucco on the TRAVERTINE slabs. Earth tones of brown, black, and vellow are the main colors used. Blue is used sparingly for couch covers and a garment. Music, drinking, and love (fig. 7.48) are the themes of the symposium, the plunge from this life to the next (fig. 7.49) that of the Diver scene. There are evident similarities of pose and profile with figures painted on vases in Athens at the end of the Archaic period. This might suggest that wall painters and vase painters shared the same stylistic vocabulary, or that the symposium here is enlarged from a scene on a vase. It seems anyhow to be as dependent stylistically on vase painting as on any tradition of wall painting, as far as we can judge. The theme of the Diver finds

7.47 Tomb of the Diver, Poseidonia. c. 480 BC. Painted stucco on travertine slabs

analogies in Etruria, so that this painter was clearly open to local influences, and like architects and sculptors in the West was ready to select imaginatively from various sources in his work.

The information we have about monumental painting is tantalizing. There are descriptions of major paintings that survived until the third century AD. Ancient critics thought as highly of paintings as they did of sculptures. The names of leading painters are recorded, unlike the names of vase painters, which we only know through their signatures. From the descriptions, we learn of anatomical views, foreshortening, and spatial arrangements similar to features we see on contemporary vases. Moreover, details of theme, postures, and facial features on the painting in the Tomb of the Diver find parallels in red-figure Athenian vase painting. Vase painters and wall or panel painters will have been aware of one another's work, yet wall painting differed from vase painting in scale, intention, and technique. Thus, any precise sense of what Greek monumental painting of this period looked like and why it astonished critics must remain elusive.

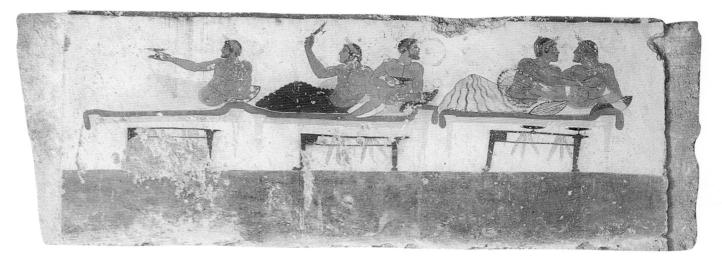

7.48 Painted wall block of the Tomb of the Diver, Poseidonia: a symposium scene. c. 480 $_{BC}$. Painted stucco on travertine. Height c. 31 ins (78 cm). Paestum Museum

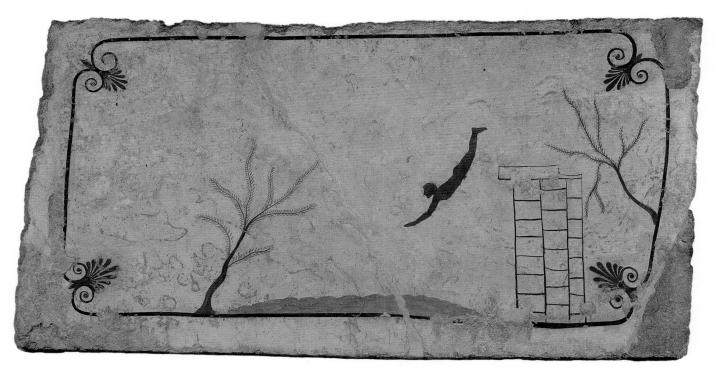

7.49 Painted ceiling block of the Tomb of the Diver, Poseidonia: the Diver. c. 480 BC. Painted stucco on travertine. Height c. 3 ft 4 ins. (1.02 m). Paestum Museum

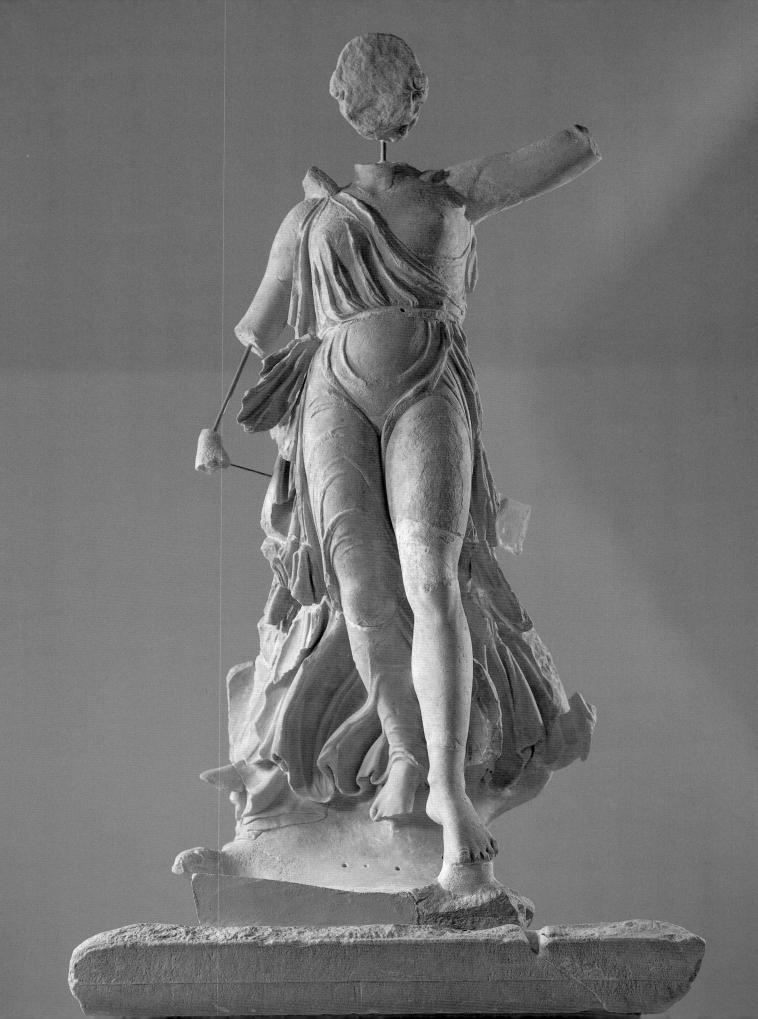

THE HIGH CLASSICAL PERIOD c. 450-400 bc

The Transitional period, with its mature Doric architecture and its Severe Style sculpture, is sometimes also called the Early Classical, preceding as it does the High Classical of the second half of the century. The High Classical period is known above all for the new buildings put up on the Acropolis at Athens, with their sophisticated architecture and rich sculptural decoration. Athens, of course, is not the whole of Greece, but it was the most creative center of cultural activity. It had suffered more damage than most at the hands of the Persians, and at this point in the fifth century BC had the money necessary to pay for the work of restoration and renewal.

The trend in sculpture for expressing emotional states and complicated body movement, and showing different ages and different characters – as seen, for example in the Olympia sculptures (pp. 216–20) – was now checked. Differences of age and anatomy are still shown in some of the figures from the Parthenon, the richest repertoire of High Classical sculpture to have survived, but they are obviously of minor interest to the sculptors. The enthusiasms of the Severe Style were replaced by often uniform representations of young men and young women,

8.1 Nike by Paionios, from Olympia. c. 420 BC. Marble. Height 6 ft 5 ins (1.95 m). Olympia Museum

who share similar physical traits. Many youths have the same head type, with small mouth, big eyes, unbroken profile-line of nose and brow, inattentive expression, and uncombed hair. Musculature is uncomplicated. Drapery undergoes radical change, now being carved more deeply, resulting in a much greater sense of light and shade. It sweeps vigorously against the body, allowing the observer to sense the limbs beneath. In these figures, sculptors sought to express an ideal of youth and beauty acceptable to and shared by the gods: the gods, after all, are shown in human form. And, by their past exploits and recent defiance of the Persians, the Athenians and their heroes seemed to share in the divine. Human anatomy is accurately shown and movement is naturalistic, but expressions are distant and the mood is otherwordly. It is this urge to fuse the real and the ideal that characterizes the High Classical period.

Phidias was the sculptor entrusted with supervising the sculptural decoration of the Parthenon, and he is the one who is likely to have contributed most heavily to the new style and its intentions. But a workshop of sculptors was active in Argos too, and Pliny says that an Argive, Hageladas, was a teacher of Phidias (see p. 237). He probably also taught Polykleitos, the other great Greek sculptor of this period, who is known to have tried to combine ideal and real in single images.

The Peloponnesian War

The great war between Athens and Sparta, which broke out in 431 BC and continued until 404 BC, dominated the period. Sparta and her Peloponnesian and Boeotian allies had watched the growth of the Athenian empire with alarm, and had attempted to check Athens in a number of military campaigns in the 450s and 440s BC. Athens's leader in these years, and until his death in 429 BC, was Perikles. This remarkable man governed the city and empire in a constitutional and legal manner by force of his personality and powers of persuasion. The annual elections by the assembly to the board of generals saw him victorious almost every year. Externally, the member states of the empire were obliged to continue their contributions, by force if necessary, and the Spartans were kept at bay. Internally, the law courts were made more democratic. Jurors were paid, and were chosen by lot, which meant that the poorer citizens could participate in the justice system. The power of the assembly was also increased. Yet Athens could not have functioned without slaves, women had no vote, and resident aliens were only partially enfranchised. Thus, democracy at home was still imperfect and was balanced by a policy of increased force abroad.

The military campaigns of the 440s BC were a sign of the tension between the two camps: Sparta and her allies on one side, Athens and her empire on the other. Though a truce of sorts was hammered out, a more permanent resolution of the question of who was to be the leader of Greece could not be deferred indefinitely. The Peloponnesian War, as it is called, started in 431 BC. Within two years Perikles was dead, killed by the plague that struck Athens. The war went on year after year, Athens relying on her fleet, and Sparta on her army. Each side enjoyed successes, but little was settled. After a decade, a further truce was signed in 421 BC. But Athens was incorrigibly ambitious and war was resumed in 415 BC, the Athenians stimulated by dreams of wealth and glory in Sicily. Their lamentable display of generalship at Syracuse and their defeat at the hands of the Syracusans in 413 BC represented the beginning of the end. But the war dragged on until the Athenian fleet was caught by surprise and destroyed at Aegospotami on the Hellespont in 405 BC. Athens submitted the following year. The long walls connecting the city to the harbors at Piraeus were dismantled, and Spartan troops entered the city.

In the West, the Syracusans had not wanted war with Athens. The tyrants had glorified the city and made it rich in the first half of the century. On the death of Thrasybulus, however, a democracy was installed, which lasted until 405 BC. The democracy enjoyed commercial success, but war was a constant threat: against indigenous tribes, against Etruscans infringing on trade routes, and against Greek neighbors, notably Akragas. In all these encounters, Syracuse was successful. So it was ready when Athens sent an expedition in 415 BC, ostensibly to help Segesta, but with an eye on the wealth of Syracuse and the whole island. But the expedition was a disaster; the fleet was destroyed and the army routed. Seven thousand Athenians were taken prisoner, many perishing in the quarries where they were

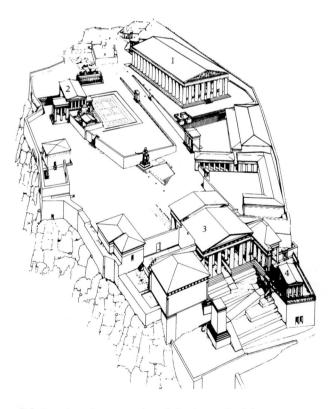

8.2 Drawing of a restoration of the Acropolis, Athens.

- 1 Parthenon
- 2 Erechtheion (dotted plan to the right is of an Archaic temple)
- 3 Propylaia
- 4 Temple of Athena Nike

imprisoned. Only a few survived to tell the tale.

However, in the decades before his death, Perikles set in motion the great program of reconstruction on the Acropolis (fig. 8.2), using money contributed by the states of the empire. The centerpiece was the Parthenon. It was followed by the Propylaia, the monumentalized entranceway left unfinished at the outbreak of the war. These two buildings were certainly the focal points of Perikles' scheme. The other two, the Erechtheion (430s–406 BC) and the Temple of Athena Nike (420s BC), may also have been part of the original design. The four buildings together mark the high point of the glorification of Athens, in the period when the city stimulated all kinds of creative genius – in architecture and sculpture, in the theater, in philosophy, and in historical writing.

The architects at work on the Acropolis were Iktinos, Kallikrates, and Mnesikles. The sculptors are less easy to identify, but the work must have seemed unending, and the decoration of the Parthenon, and perhaps of the other temples, too, was carried out under the supervision of Phidias. In fact, Plutarch says that Phidias was in charge of the whole of Perikles' scheme.

ARCHITECTURE AND Architectural Sculpture

Athens

The Parthenon When the Persians arrived on the Acropolis in 480 BC, they found a temple being built on the site of the later Parthenon. This they burned, leaving little that was reusable for the Temple of Athena Parthenos, the Parthenon itself (fig. 8.3), some thirty years later. Much of the remains from the damage done by the Persians to the building under construction was used in the repair of the fortification walls on the north side of the Acropolis. Only the foundations and some column drums were deemed of use by the Parthenon's architects, Iktinos and Kallikrates. They extended the foundations they found to accommodate a larger plan, since the Parthenon was to house the huge statue of Athena, which required an extra, large cella. Work began in 447 BC, the temple and statue were dedicated to

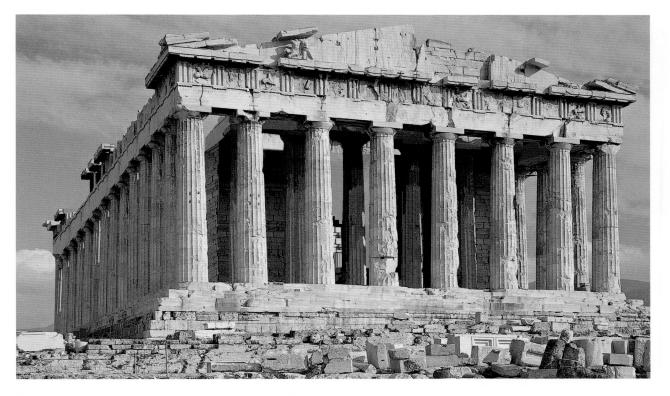

8.3 Parthenon, Athens, view from the northwest. 447-432 BC. PENTELIC marble

8.4 Plan of the Parthenon, Athens. c. 447–432 BC

8.5 Parthenon, Athens, northeast corner detail, showing Doric column and capital, architrave and frieze course (triglyph and metope), and cornices. 447–438 Bc. Marble. Height (of architrave and frieze) c. 9 ft (2.75 m)

Athena Parthenos (Athena the Virgin) in 438 BC, and the pedimental sculptures were finished by 432 BC.

Though the Parthenon is regarded as the epitome of Doric temple building, it actually incorporated unusual features. Eight columns on the façade (fig. 8.3) was unusual, though there were precedents: the Temple of Artemis at Corcyra 150 years earlier (fig. 6.8, p. 156), and, in the West, at Metapontum (Temple A) and at Selinus (Temple G). The seventeen columns of the flank peristyle show that the usual formula for the number of columns was used (fig. 8.4). A ratio of 9:4 was to govern both plan and elevation of the temple. To allow space for a generous cella and for a back room behind, the usual Doric porch arrangement was replaced by much shallower porches, front and back, each with six columns prostyle. Windows were installed on either side of the doorway in the back wall of the front porch. In the cella, a double-storied Doric colonnade surrounded the statue. A row of columns behind the statue was a new development. In the back room, where Athena's treasure was kept, Ionic columns were introduced. Another Ionic feature, a continuous sculpted frieze, encircled the exterior of the cella, the back room, and porches, at a height that rendered it almost invisible. The elevation was standard Doric, with column shafts surmounted by capitals with their now straight-sided echinus, by architrave blocks, a triglyph and metope frieze course, and by cornices (fig. 8.5). All was marble, precisely carved and fitted together.

As the Doric order developed from early Archaic to High Classical, short columns gradually changed to long, thick shafts to thin, the baggy profile of the echinus to a straight-sided cone, and rectangular metopes to square ones. The sheer bulk of buildings was reduced by decreasing the height of the entablature.

The Parthenon's use of Ionic columns in the interior is of special interest. The mixing of orders, introduced into Greek architecture at the Temple of Athena at Poseidonia (pp. 171–2), had had an impact in Greece already; it had been used in Athens in the Stoa Poikile (p. 226) in the Agora. This feature now made its appearance on the Acropolis.

The Parthenon is also unusual for its mass of Doric refinements. The swelling profile of columns (entasis) is used so that columns do not appear pinched. Angles are contracted. The columns lean inward slightly from bottom to top. The antae lean outward. The stylobate falls away slightly either side from its center in a slow curve. (Horizontal lines appear to sink in the middle if not given this upward curvature.) A similar phenomenon occurs in the entablature. Though these modifications to the hori-

zontal and vertical are minuscule, there are nevertheless no true verticals or horizontals in the building, and hence no right angles. At the same time, these refinements impart a sense of mobility to "straight" lines and avoid a boxlike appearance. Dignity of form was thus enhanced by dynamism of forms. The demands on the masons were enormous. All blocks, whether curving or not, had to fit flush; yet everywhere block fits meticulously with block, and only on one or two metopes does the carving betray signs of uncertainty or haste. Precisely proportioned, marvelously constructed without mortar or concrete, held together by iron clamps coated with lead to withstand corrosion, this magnificent structure haunts us today with its astonishing blend of technical know-how and grandeur. The Parthenon in the first decade of the twenty-first century presents a magnificent shell of a building; current restoration work is set to change its appearance dramatically.

The building is famous for its sculptures. There were pedimental groups at front and back and sculpted metopes on every side. There was the continuous Ionic frieze on the interior and the great gold and ivory statue of Athena herself. There may have been another carved frieze over the cella door. Comparison with the Temple of Zeus at Olympia is inevitable. The arrangements for pedimental sculptures there were similar, but sculpted metopes on the Parthenon took the place of the blank exterior metopes of the Temple of Zeus, and the Ionic frieze of the Parthenon replaced the Doric frieze (triglyphs and metopes) there.

The richness of decoration of the Parthenon is exceptional for a temple and is perhaps more fitting for a treasury. In these terms, the Athenians' own treasury at Delphi comes to mind as a parallel and precursor (pp. 164-5). The Parthenon did not replace the old Temple of Athena on the Acropolis, which had been destroyed by the Persians. Nor did it provide a home for the old revered wooden statue of the goddess, which had to await the building of the Erechtheion to be properly housed again. It was not equipped with an altar for sacrifice either. It is almost as if the Parthenon, an elaborate gift to the goddess, was as much a treasury as it was a temple. Athena's money was in fact kept in the back room, and the gold that formed much of the surface of her great statue was removable, so that the figure itself functioned at one level as a repository of wealth.

The Metopes. Of the ninety-two metopes, those on the east, north, and west are seriously damaged. Most of those on the south are better preserved, having suffered less at the hands of Christian iconoclasts when the building was converted into a church. Eight or nine of those in the center of the south side were lost in 1687 when gunpowder kept by the Turks in the Parthenon, then in use as a mosque, exploded. The themes are well known: at the east, gods and giants in combat; at the west, Greeks and Amazons (or Persians); at the north, Greeks and Trojans; and at the south, Lapiths and centaurs (the centauromachy is reminiscent of the back pediment at Olympia). All are vivid metaphors for the conquest of the barbaric by the civilized, and all served as reminders of the Greeks' mythical past and their recent successes.

The ruined condition of the metopes at the west and east may be seen in figures 8.3 and 8.5. On the south side the Lapiths and centaurs series is better preserved. Figures clash in combat, struggle, or collapse. One metope (fig. 8.6) has a Lapith leaping forward and laterally from its rectangular frame. The scene is dominated by the tension of the fight and the drapery folds, originally painted, that form the backdrop to the human torso. It is a daring composition.

8.6 Parthenon, Athens, south metope 27: struggle between Lapith and centaur. 447–438 BC. Marble. Height 4 ft 5 ins (1.34 m)

The virtuoso execution of the heavy veined anatomy of the centaur and the flying, slightly turned Lapith body both catch the eye.

The Pediments. The east pediment was badly damaged when the construction of the APSE of the Christian church destroyed the central figures. The west pediment was almost completely wrecked when the Venetian general Francesco Morosini tried to remove the horse groups from the center in 1687, only to have them come crashing to the ground. They had, however, been seen by Pausanias, who describes them with unbelievable brevity and says nothing of the metopes and the Ionic frieze. They had also been drawn in 1674 by a Flemish artist, sometimes identified as Jacques Carrey. The latter's drawings are immensely valuable. He drew the pediments, the metopes at the south, and some of the frieze. Of the original figures of the pediments, only a few survived. They had been finished all the way round, even though, positioned at a height of some 17 yards (16 m) above ground level, only parts of the figures would ever have been visible. At Olympia, the sculptors had been more economical. Hoisted aloft, the Parthenon sculptures were positioned in the triangular space according to a design probably worked out by Phidias. The composition was crowded with many figures, some of which overlapped, while others pushed limbs out through the front plane of the pediment in a manner first seen in the Temple of Aphaia on Aegina.

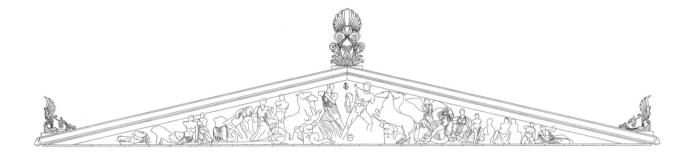

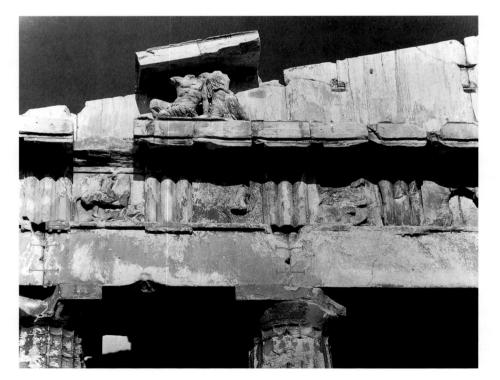

8.7 Above Parthenon, Athens. Drawing of a reconstruction of the west pediment (Professor Ernst Berger)

8.8 *Left* Parthenon, Athens, west pediment: Kekrops and daughter *in situ*. 437–432 BC. Marble. Height 4 ft 6 ins (1.37 m)

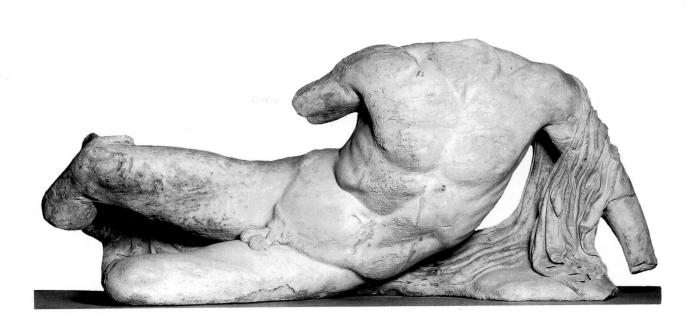

The west pediment shows the contest between Athena and Poseidon as to who was to be the patron deity of Athens. Athena and Poseidon spring apart in a great "X" composition in the center. Their outward movement is contained by the chariot groups behind them (fig. 8.7), while seated and reclining figures continue into the corners. One group (fig. 8.8) is thought to be the early king of Athens, Kekrops, identified by the coiled snake beside him, and his daughter, who leans on him as she shrinks from the central, awe-inspiring incident. A figure (fig. 8.9) in the corner personifies one of the rivers of Attica (fig. 8.10), the Ilissos, and calls to mind the river gods of the Olympia pediment (see fig. 7.9, p. 218). Were these images of river gods the source for the river gods of Renaissance and Baroque Europe?

Another incident crucial to the myth-history of the city, the birth of Athena, appears in the front pediment (fig. 8.11). Again, the central group is lost, though it seems Athena was shown fully armed and standing next to her father, Zeus, from whose head she had just emerged. Hephaistos and Hera must have stood nearby, while other Olympian deities crowded round. The designer specified the time of the event – dawn – by having the heads of the horses of Helios (the Sun) rising above the floor of the pediment (the horizon) at the south end, while in the opposite corner the heads of the horses of Selene (the Moon) are all that can be seen, sinking, as night gives way to day, darkness to light. Surviving figures show varying degrees of awareness of the central event. The reclin**8.9** Parthenon, Athens, west pediment: reclining male corner figure (personification of the river Ilissos). 437–432 BC. Marble. Length 5 ft 1 in (1.56 m). British Museum, London

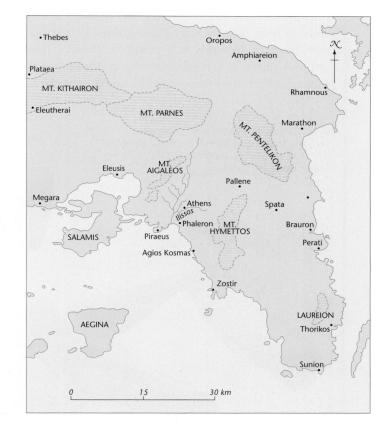

8.10 Attica

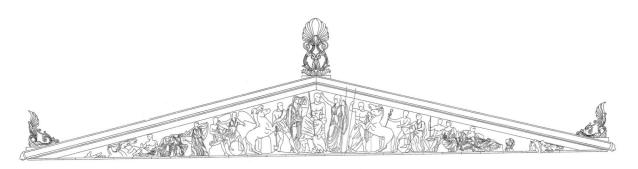

8.11 Parthenon, Athens. Drawing of a reconstruction of the east pediment (Professor Ernst Berger)

ing nude figure (fig. 8.12) gazes at the rising sun, unaware of Athena's birth. He is variously identified as Ares, Dionysos, or Herakles, or even as a personification of Mount Olympus to specify place, just as time had been specified. Next to him (fig. 8.13) sit Demeter and Kore, turning in their seats to hear the news, massive bodies outlined by deeply carved garments. Interest and excitement gather momentum toward the center. In the northern half, a goddess reclining in the lap of another (fig. 8.14) calmly awaits the passing of night, while a third seated figure turns slowly toward the center, relaxation and revitalization side by side. Placing three seated figures together like this is a complete novelty. The sculpture here is a revelation: the goddesses wear thin crinkly chitons pressed tight against upper bod-

8.12 Parthenon, Athens, east pediment: reclining male figure (Ares? Dionysos? Herakles?). 437–432 BC. Marble. Height 4 ft 3 ins (1.30 m). British Museum, London ies to reveal the contours of the breasts beneath. The long flowing lines of the folds of the mantles over the legs produce a continuous rhythmic effect and are so deeply carved that they create a profoundly dramatic sense of light and shade. Here, too, drapery pressed up against the body barely conceals knees, thighs, and lower legs.

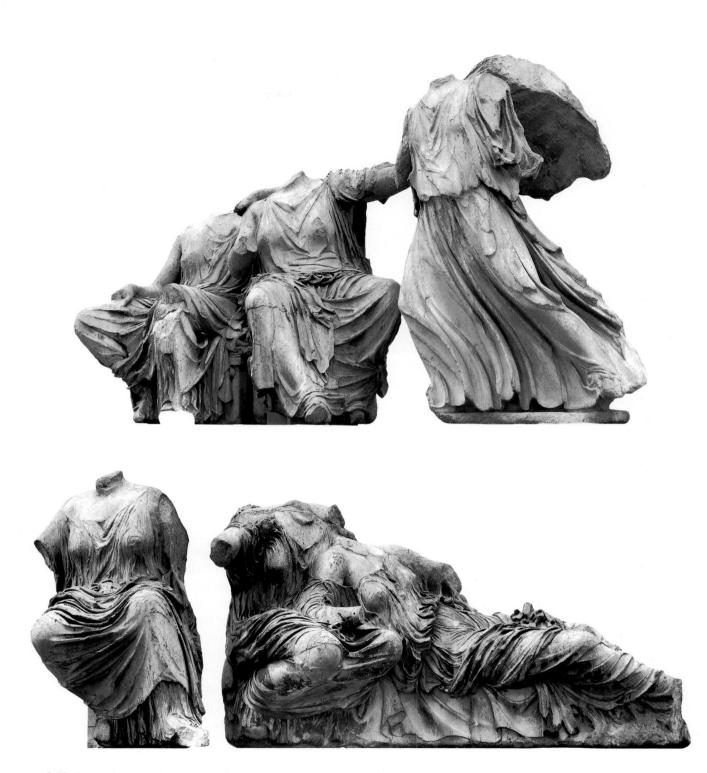

8.13 Top Parthenon, Athens, east pediment: two seated female figures (Demeter and Kore) and a messenger (Iris? Artemis?). 437–432 BC. Marble. Height (of messenger) 5 ft 8 ins (1.73 m). British Museum, London

8.14 *Above* Parthenon, Athens, east pediment: three female figures (Hestia? Dione? and Aphrodite). 437–432 BC. Marble. Height (of Hestia figure) 4 ft 5 ins (1.34 m). British Museum, London

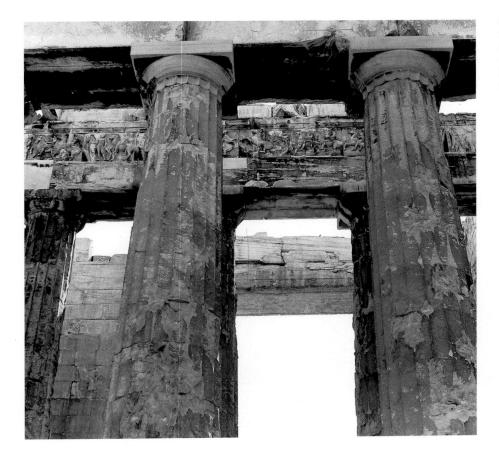

8.15 Parthenon, Athens, west frieze *in situ*, from below: cavalcade in preparation. 447–438 _{BC}. Marble. Height (of frieze) 3 ft 6 ins (1.06 m)

The moment shown is the moment after the birth. It is not one of great activity, but of ignorance contrasting with realization, as figures demonstrate their awareness of the great event through their measured physical responses, and the artist(s) proclaim their skill at portraying thought. Transitions in the two groups of goddesses are subtle, but all are united by superbly sculpted and understood drapery, which balances revelation of the body, covered or not, with its own dynamic texture and weight.

The Frieze. The sculpted frieze runs all the way around the central block of the building above an architrave course at front and back, and uniformly about 39 feet (12 m) above the ground (fig. 8.15). It is just over 3 feet (1 m) high and 525 feet (160 m) long. Its position made it almost impossible to see and it may be that the whole frieze was an afterthought, not contemplated in the original design of the building. To improve visibility, the upper parts of the frieze are carved in higher relief. The sculpture was brightly painted and many metal attachments were used for weapons of men and harnesses of horses. The greatest depth of carving of the frieze is nowhere more than $2\frac{2}{5}$ inches (6 cm). In antiquity, it was best seen from outside the colonnade, different incidents running on in filmstrip-like sequence. Much of the frieze is now in the British Museum in London, other parts of it are in the Acropolis Museum, while a handsome fragment is in Paris.

At the west (fig. 8.16), the frieze depicts thirteen horsemen preparing themselves and their horses for a cavalcade that takes up much of the space of the north and south friezes. The riders of the north and south friezes are preceded by chariots, each with charioteer and warrior, and these in turn are preceded by elders standing about, musicians, and attendants walking forward, and by sheep and heifers, the sacrificial animals. At the east, the frieze shows women, who appear here for the first time, moving slowly forward from either end toward the center. They meet a group of male officials, who are apparently awaiting the arrival of the procession. Next

8.16 Diagram of the Parthenon frieze

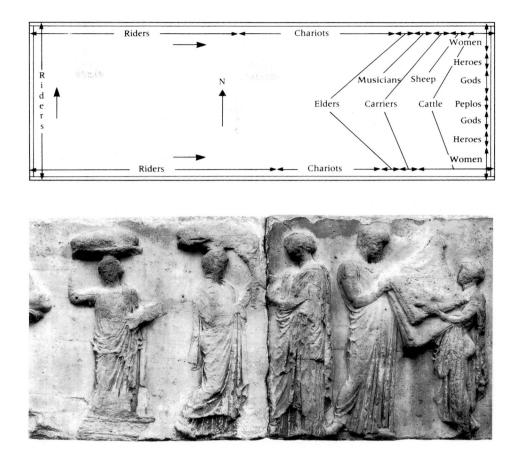

8.17 Parthenon, Athens, east frieze: peplos incident. 447–438 _{BC}. Marble. Height 3 ft 6 ins (1.06 m). British Museum, London

come twelve seated Olympian gods, six on either side of the incident at the very center of the frieze. Here there are five figures: two young women are on one side of a woman who is often identified as the priestess of Athena; on the other, a man, perhaps the Royal Archon or the priest of Poseidon, receives a garment from a girl (fig. 8.17). This may be the peplos woven every four years for Athena and presented to her on the Acropolis on the occasion of the Panathenaic Festival. The procession that begins at the southwest corner of the building has its culmination in this encounter with the seated gods and the peplos incident that they frame. The size and complexity of this frieze imply a single designer, perhaps Phidias, as surely as its execution suggests the need for many sculptors.

At the west, horsemen prepare to mount, adjust their equipment, and begin the ride (fig. 8.18). Pose, gesture, dress, hairstyle, and even hats are all varied. Horses, small enough when compared for size with their riders to be ponies, prance and rear, sometimes with all four hoofs off the ground, while their riders' cloaks flying out behind impart a sense of forward motion. Drill holes show where metal reins and bridles were attached. The cavalcade (fig. 8.19) shows overlapping horsemen, sometimes as many as seven in very shallow relief.

In spite of the large number of riders and horses, there is no confusion or monotony. Variety is achieved by contrasting human limb with horse's flank, or drapery with flesh, or different positions of horses' legs and heads and human heads and dress and headgear. Yet the head type itself is largely the same, with a rounded skull, a large eye, a small mouth, a straight nose, and a distant expression. Horse groups, chariots, charioteers, and warriors exploit the same control of overlapping forms (fig. 8.20) to suggest recession in space. More variety is introduced by standing marshals who face against the direction of the procession, interrupting the forward momentum, and by different spacing as the procession slows to a walk. Youths carrying water

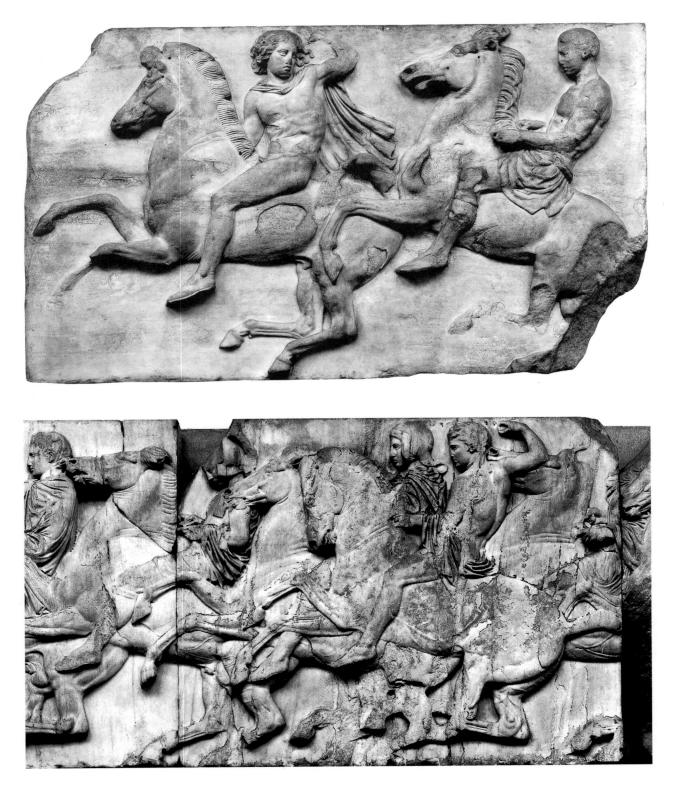

8.18 Top Parthenon, Athens, west frieze: riders. 447–438 BC. Marble. Height 3 ft 6 ins (1.06 m). British Museum, London

8.19 *Above* Parthenon, Athens, north frieze: cavalcade. 447–438 BC. Marble. Height 3 ft 6 ins (1.06 m). British Museum, London

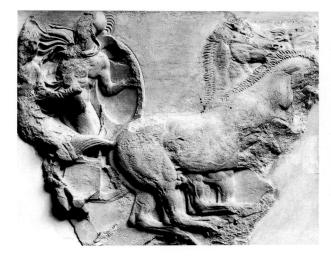

8.20 Parthenon, Athens, south frieze: chariot and four horses. 447–438 BC. Marble. Height 3 ft 6 ins (1.06 m). British Museum, London

jars move forward slowly (fig. 8.21), one after another, in staccato rhythm in front of the hectic cavalcade. Around the corner and on the east frieze, stately women encounter waiting elders (fig. 8.22). Poses are unhurried, the drapery of females heavy and voluminous, that of males clinging and contrasting with exposed arms and chests. The twelve seated Olympian deities are to a larger scale, as was proper,

8.21 Parthenon, Athens, north frieze: water carriers. 447–438 BC. Marble. Height 3 ft 6 ins (1.06 m). Acropolis Museum, Athens

than the standing Athenians on either side. The outermost of the gods turn to watch the procession, but those closest to the peplos incident, Zeus on one side and Athena on the other, turn their backs on the scene. Poseidon, Apollo, and Artemis (fig. 8.23) are seated on stools (only Zeus has a throne), slightly overlapping one another, legs placed in front of furniture to give a sense of space.

8.22 Parthenon, Athens, east frieze: women and elders. 447–438 _{BC}. Marble. Height 3 ft 6 ins (1.06 m). Musée du Louvre, Paris

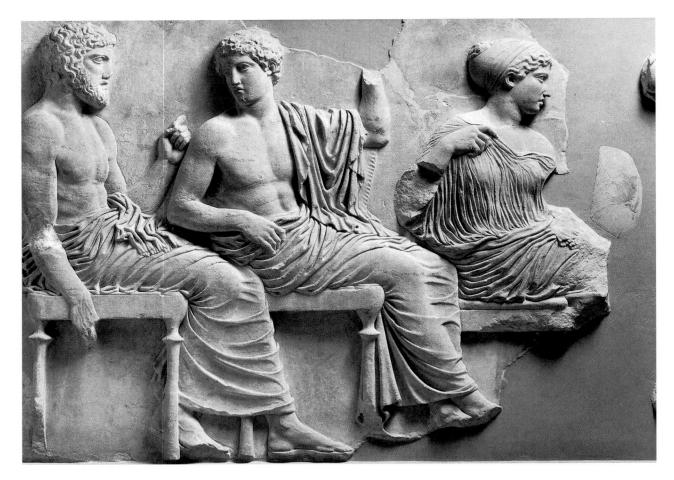

8.23 Parthenon, Athens, east frieze: seated deities (Poseidon, Apollo, Artemis). 447–438 BC. Marble. Height 3 ft 6 ins (1.06 m). Acropolis Museum, Athens

Intense discussion now surrounds the interpretation of this frieze. The traditional view holds that it represents the Panathenaic procession. Important episodes seem to be depicted: the preparations that actually took place outside the Agora, the chariot races that took place down the Panathenaic Way (fig. 8.35), and the handing over of the peplos that happened on the Acropolis. Debate continues as to whether this might be a representation of a specific Panathenaia or whether it stands as an ideal representation of all such processions. What would be new in any case is the representation of mortals in temple sculpture, where mythological subjects would have been expected. If this does indeed show the Panathenaic procession, then it is remarkable for the way Phidias and his colleagues had the audacity to decorate the new temple with figures of Athenians and in the company of the gods. This bold claim that the Olympians lived among the Athenians, though discreetly given form high up under the ceiling of the peristyle, doubtless drew the anger of many Greeks.

Another interpretation juxtaposes a recently discovered fragment of a play by Euripides, the *Erechtheus*, with the frieze, and proposes a mythological reading. In the myth-history of Athens, an important foundation myth records that Erechtheus, an early king, had to ward off the army of a rival, Eumolpos, if the city was to survive. The oracle at Delphi told Erechtheus that to save the city he had to sacrifice a virgin daughter. Accordingly, this interpretation sees the garment being folded (or unfolded) in the center of the east frieze (fig. 8.17) not as Athena's peplos, but as a funerary dress to be worn by Erechtheus's youngest daughter, who is about to be sacrificed. The figure to the left of the small daughter is Erechtheus himself with his wife,

CONTROVERSIES AND ISSUES

LORD ELGIN AND THE PARTHENON MARBLES

With the acquiescence of the Turkish authorities, who controlled Greece at the time, Lord Elgin removed a number of the pedimental figures and large

chunks of the frieze of the Parthenon, and sold them to the British Museum in 1816. Should they stay in Britain or be returned to Greece? Whose heritage are they? Do they belong to Greece or to the world?

Those who defend their retention by the British argue: Elgin had legal title to them from the Turks; his taking of them saved them from looters, private collectors, random potshots from soldiers, and the polluted air of Athens; over time they have become part of British heritage; they are more accessible in London than in Athens; Athens is not equipped to care for them in a climate-controlled environment; their return would set a dangerous precedent that could result in the stripping of the galleries of many major museums.

Those who argue for their return to Athens say: the Turks had no moral authorization to release Greek sculptures; the structure of the Parthenon

> was irremediably damaged by their removal; Athens is preparing a museum to house them within walking distance of the Acropolis; having the marbles in Greece will make it easier for scholars to study them, since the building itself is there; the British Museum cannot refuse the return of unique items of Greek heritage by arguing that the rest of their collection will be claimed by other countries of origin.

What do you think? Will the imminent (2006) completion of the museum, not a stone's throw from the Acropolis, tip the balance? Can you suggest a solution?

8.24 Lord Elgin, aged 32 in 1795. Drawing by G.P. Harding after Anton Graff. British Museum, London

Praxithea, the first priestess of Athens, the central of the five figures. To her left are her two other daughters. This interpretation has the great advantage of offering a mythological reading, but is meeting with more criticism than approval from scholars. To its great credit, it has fruitfully invited close reinvestigation of the frieze, it has demonstrated the vitality of the field, and the continuing charge of these ancient monuments, and in recognizing here the importance of Athenian priestesses and the heroization of women in ancient Athens, it speaks to current interest in the roles of women in antiquity.

The modern debate about the interpretation of the frieze is mirrored in antiquity by the argument about the lavishness of the Athenian architectural program. Plutarch, writing in the first century AD but citing a contemporary source, tells us: "Greece is clearly the victim of a monstrous tyranny: it sees us using what it is forced to contribute for the war to gild and bedizen our city like a wanton woman hung around with costly stones and statues and thousandtalent temples." In reply to this, Perikles invoked the advantages of full employment:

The materials to be used are marble, bronze, ivory, gold, ebony, and cypress woods; the crafts required to work such materials are those of the carpenter, molder, bronzeworker, mason and sculptor, dyer, worker in gold and ivory, painter, embroiderer, metal-inlayer, and the providers and transporters of these – merchants, sailors, and pilots by sea; and by land, wagonmakers, cattlebreeders, and drovers. There are also ropemakers, weavers, leatherworkers, roadbuilders, and miners. And since each craft has its own body of unskilled workers attached to it, practically every able-bodied man is employed and is receiving pay for his work.

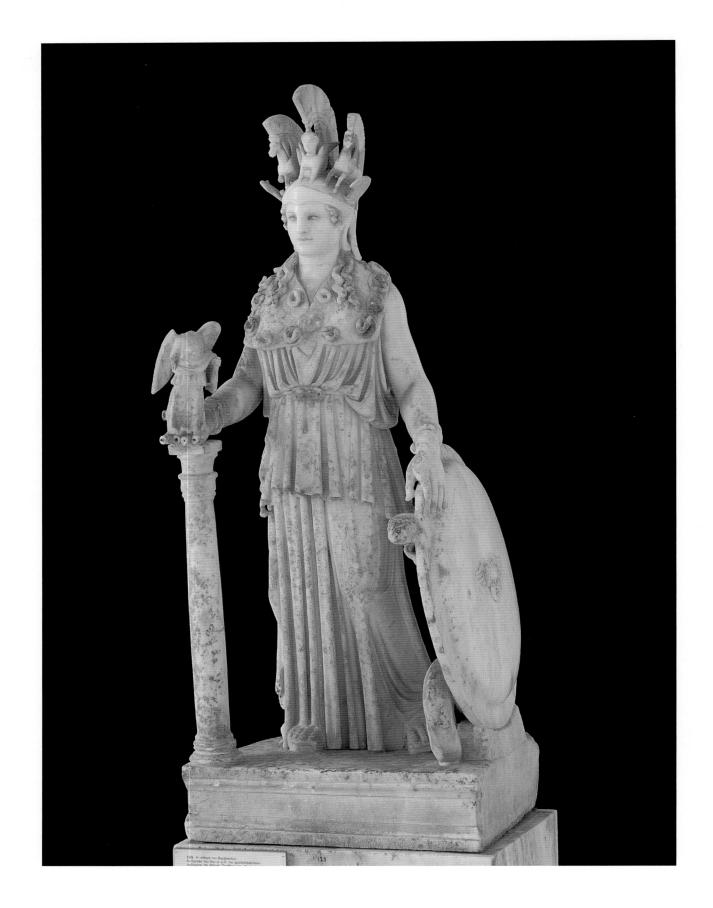

The exceptional character of the democracy was at the bottom of Perikles' belief in Athens, according to Thucydides, who has him speak in the following terms: "We are a democracy in which a citizen is advanced as a reward of merit; a spirit of reverence pervades our public acts; we love the beautiful; we cultivate the mind; Athens is the school of Hellas." For Perikles, the Parthenon may have stood as an emblem of the democracy and as an instrument for the education of Greece.

The Statue of Athena. Phidias's gold and ivory statue of Athena was dedicated in 438 BC. All trace of the original has vanished, but we know about the statue from literary descriptions, from reduced copies and adaptations, and from later copies of parts of it (the shield, for example). Pliny and Pausanias give descriptions of the statue from which we gather essentials: Athena stood 26 cubits tall (nearly 13 yards or 11.5 meters high), wearing an aegis and an elaborate helmet, holding a Nike and a spear, with a shield and snake nearby. A second-century AD marble statuette (fig. 8.25) gives an idea of what the statue actually looked like, though here the image is vastly reduced and there is no sense of the glittering gold and the contrast with ivory flesh. The impact of this huge figure, rendered in the most costly materials, is hard to imagine. A clear sense, however, of

the size of the Athena Parthenos, though not of her gleaming gold and ivory, may be had from the replica statue, equal in scale, installed in recent years in the replica of the Parthenon in Nashville, Tennessee. The combined effect of both statue and building must have been awesome. Compelling messages were being sent concerning the religious power of Athena and the political power of Athens. That artistic skills of the highest quality were at work in the service of Athena and her city was a point that no one would have missed.

The Propylaia (fig. 0.3, p. 14) The architect entrusted with monumentalizing the entrance to the Acropolis was Mnesikles. The Archaic entrance had been small, more in keeping with the old Mycenaean notion of the Acropolis as a fortress. Now, with the emphasis on it as a sanctuary, the gateway was to be both more imposing and more welcoming. The plan was opened up and wings extended toward the visitor. Work began in 437 BC, but was abandoned just before the outbreak of the Peloponnesian War, in 432 BC.

The plan specified a split-level gateway (fig. 8.26), with six columns front and back, and six (two rows of three) on the inside, and a five-doored entranceway, four of which were stepped and one

8.25 Opposite Varvakeion statuette, a Roman version of the statue of Athena Parthenos. 2nd-century AD copy of the gold and ivory statue by Phidias of 438 BC. Marble. Height 3 ft 5½ ins (1.05 m) (with base). National Museum, Athens

8.26 *Right* Plan of the Propylaia, Athens. c. 437–432 BC. Broken lines indicate the pre-Persian structure

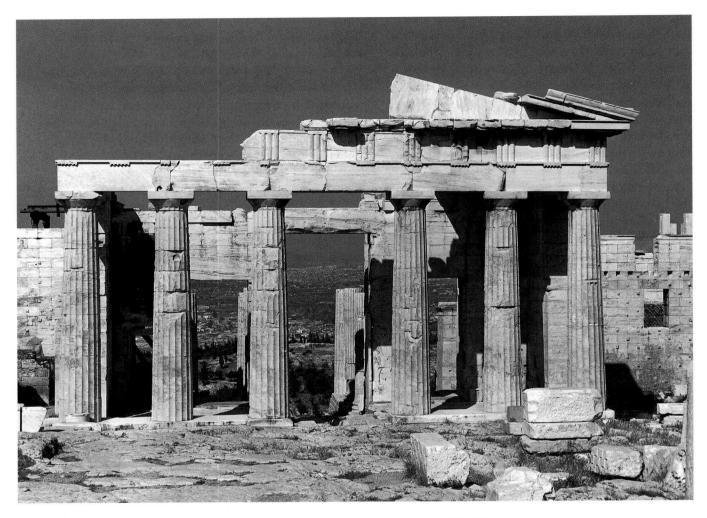

8.27 Propylaia to the Acropolis, Athens, from the east, view of the inner façade. 437-432 BC. Marble

unstepped for animals, with pairs of flanking units to the north and south. The flanking units to the northeast and the southeast, perhaps intended as dining halls, were never completed. What was finished was the split-level gateway, with Doric columns on the exterior and Ionic columns either side of the main passage on the interior. The flanking unit to the northwest, the "Pinakotheke" (Picture Gallery), in which paintings on wooden panels were displayed and dining took place, was also completed, having three columns in antis on the façade. Mnesikles may have intended a similar unit to the south; if so, his plans were frustrated, perhaps by the proximity of a surviving stretch of the Mycenaean fortification wall and of the sanctuary of Athena Nike. He had to content himself with a screen of three columns and a freestanding pier in front of a small space with a backing wall. This screen faced the entrance to the Pinakotheke. To the visitor climbing up the earth ramp to the entrance, it would give the impression of a balancing unit to the south. The six-columned back of the gateway or inner façade shows the metopes here were blank (fig. 8.27), nor was there any other sculpture. The material is marble throughout, finely jointed and finished, even for ceiling blocks and COF-FERS (recessed panels in the flat ceiling) of massive weight. The marble ceiling collapsed under the strain of the bombardment of the Acropolis by the Venetians in 1687, but much of the southwest wing was built into a Frankish tower, which stood until the late nineteenth century.

The Temple of Athena Nike (fig. 8.28) Built high on a bastion overlooking the approach to the Propy-

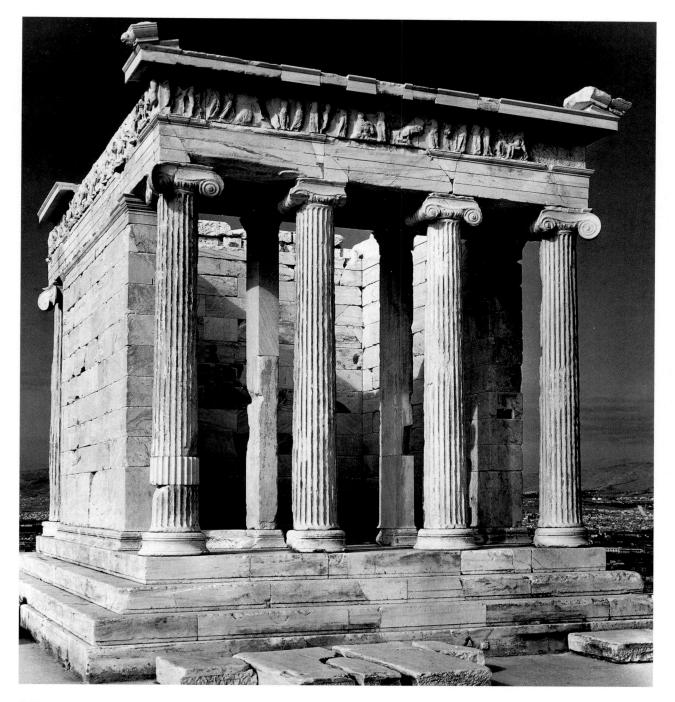

8.28 Temple of Athena Nike, Athens, view from the east showing TETRASTYLE columns of the façade and monolithic columns. 420s BC. Marble. Height (columns) 15 ft 3 ins (4.04 m); (entablature) 3 ft 6 ins (1.06 m)

laia, this temple uses the Ionic order to contrast neatly with the Doric of the gateway itself. The building has four columns prostyle, both at front and back, and a cella, which was almost square. This was entered through a doorway flanked by monolithic pillars, which were linked to antae by bronze struts. The elevation (fig. 8.28) has Ionic bases and volute capitals for the columns, with a continuous Ionic frieze above the architrave. A congregation of divinities, some seated, some standing, and some in motion, make up the east frieze. The south frieze depicts Greeks fighting Persians, and the west Greeks fighting Greeks, itself a hint that the building was constructed after the outbreak of the Peloponnesian War. Billowing drapery, elongated figures, and awkward poses anticipate developments in the next century. A decree of 449 BC authorized the construction, but the temple was not built until the middle to later vears of the 420s BC. A little after, perhaps around 410 BC - though some scholars think it contemporaneous with the temple itself - a sculpted balustrade was added, about 3 feet (1 m) high, around the edge of the bastion on the north, south, and west. The theme was a parade of Nike figures, putting up trophies for victories or cajoling sacrificial animals along, with seated Athenas on each of the three sides. The hands of six different sculptors have been detected in this work. The Nike adjusting her sandal (fig. 8.29) demonstrates clinging drapery at its most transparent. The garment slips from the right shoulder, but the left is equally visible. This new, precarious posture allowed drapery folds swinging across the figure to reveal the legs, while the clothing pressed against the torso makes the breasts visible, though they are covered.

The Erechtheion (fig. 0.4, p. 15) The other Ionic building on the Acropolis was the Erechtheion, built opposite the Parthenon to the north, an unobtrusive Ionic counterweight to the Doric Temple of Athena Parthenos. This split-level building is unorthodox in plan (fig. 8.30). Part of the site was occupied in the LH period by a Mycenaean palace, which might help explain the antiquity of cults of the historical period situated here, and the unusual plan of the building, which was arranged to incorporate several of them. As well as Athena, whose old cult statue was kept here, Poseidon and Erechtheus commanded space in the building, and there were other cults in the vicinity. The building was begun in the 430s BC. Work continued intermittently, but much of the construction took place between 409 and 406 BC. In spite of the disaster of the Sicilian expedition, Athenian confidence persisted, and some building programs were continued.

A conventional Ionic six-columned façade stood at the east in front of the rectangular cella. At a lower level on the north side, an Ionic porch of six more Ionic columns (four prostyle with two on the return)

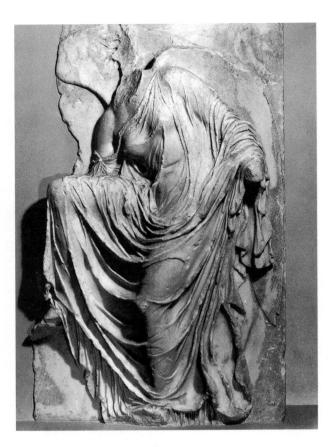

8.29 Nike (Victory) adjusting her sandal, from the balustrade around the precinct of Athena Nike. c. 410–405 BC. Marble. Height 3 ft 6 ins (1.06 m). Acropolis Museum, Athens

8.30 Plan of the Erechtheion, Athens. c. 430s–406 BC. 1 Athena Polias 2, 3, and 4 Erechtheus, Poseidon, possibly Boutes. Interior arrangement conjectural

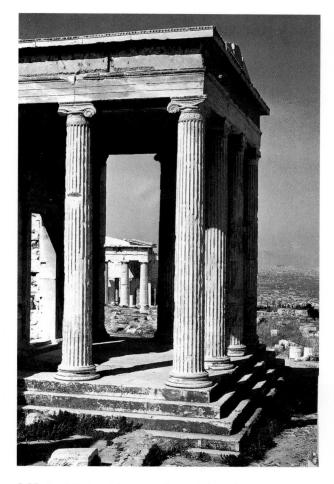

8.31 Erechtheion, Athens, north porch from the east. c. 430s–406 BC. Marble with black Eleusinian limestone for frieze blocks to which marble figures were attached. Height (of columns) c. 25 ft (7.60 m)

signaled the entrance to the lower western part of the building. This was unusual enough, but most unorthodox of all was the porch on the south side. It had six female statues (caryatids – see p. 166) standing on a wall to support the porch's flat roof. Access was from the east.

The Ionic order of the north porch is worth attention (fig. 8.31). The column shaft, with its twenty-four flutes and flat fillets – compared with Doric, which used twenty flutes and sharp arrises – stands on a base and is surmounted by a volute capital. Below the capital and surrounding the neck of the column is an anthemion collar (floral carving). This ornamental motif runs all the way along the top of the north and south walls of the temple, as well as around the columns of the east façade. The channels

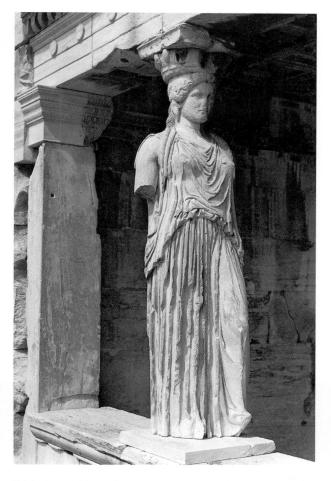

8.32 Caryatid from the south porch of the Erechtheion, Acropolis of Athens. c. 420–410 BC. Marble. Height 7 ft 7 ins (2.30 m). Acropolis Museum, Athens

of the volutes are concave, whereas earlier they had normally been convex. In the Archaic period there had been an EGG-AND-DART molding between the volutes and little more; now the egg-and-dart is flanked by other decorative designs. The richness and complexity of ornament are staggering, while the tall, slender proportions of the columns preserve lightness of appearance. Above the columns, a frieze of white marble figures was pinned against blocks of black Eleusinian limestone. Of this frieze only fragments, which defy interpretation, survive.

The caryatids of the south porch (fig. 8.32) stand with the weight leg lost beneath the vertical folds of drapery, and with the free leg pushing forward. The outer legs carry the weight of the superstructure, while the inner legs are relaxed. These are weighty

figures, big and beautiful, wearing peploi with deepcut, vigorous folds over the weightbearing limbs and with transparent cloth elsewhere shaping or revealing knee, thigh, and breast. As caryatids, they are reminiscent of their counterparts in the Treasury of the Siphnians at Delphi, carved over a hundred years earlier. Stylistically they echo the stately maidens of the east frieze of the Parthenon. The building inscription that mentions them refers to them simply as "korai," maidens. These "korai" may be contrasted with their sixth-century counterparts (figs. 6.53 and 6.54, p. 183) and seen as democratic rejoinders to their elitist predecessors. The Erechtheion was the most elegant of the fifth-century buildings. Care was lavished on it, and the surviving accounts of expenditure reveal how costly it was.

There was plenty of building elsewhere, too, especially before Perikles' death. New temples arose all over Attica, many on the sites of earlier structures, such as the Temple of Poseidon at Sunion. Several were perhaps the work of the same man, who is referred to as the Hephaisteion architect for the temple he built at the west of, and overlooking, the Agora in Athens.

The Hephaisteion (fig. 0.8, p. 17 and fig. 8.33) The Temple of Hephaistos, god of metalworking, surveyed the Athenian agora, the prime political and commercial space of the polis, from the west. It is located on the hill called the Kolonos Agoraios, where bronzeworking pits and foundry refuse indicate that, in the fifth century BC, artisans had their place of work. Thus practitioners and their patron deity shared this ground. The Hephaisteion is the best-preserved example of a fifth-century temple that we have. With the exception of the lowest step of lime-stone, wooden ceiling beams, and terracotta roof-tiles, it was made entirely of marble. Parallel rows of planting pits found along the south side indicate the presence of a garden here in the third century BC.

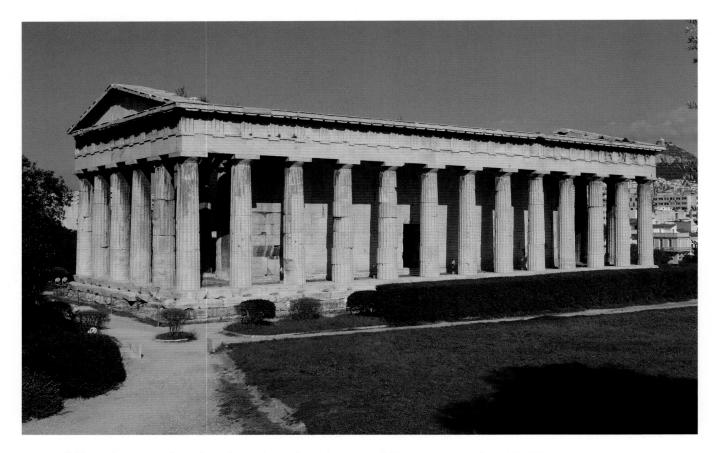

8.33 Hephaisteion, Athens, from the southwest (carved metopes visible at extreme east), c. 450–415 BC. Marble. Height (of columns) 18 ft 9 ins (5.71 m)

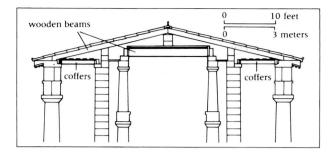

 $\pmb{8.34}$ Hephaisteion, Athens. c. 450–415 $_{\text{BC}}$ Restored section through the roof

The elevation is conventional Doric. It is notable, however, for unusually slender columns and a relatively high entablature. In height, the columns measure 5.61 times the lower diameter, compared to 4.64 or 4.72 in the Temple of Zeus at Olympia. The ceiling and roof arrangements are of special interest. Terracotta rooftiles sat on raked wooden beams (fig. 8.34). Horizontal timbers spanned the widths of the cella from wall to colonnade, and from colonnade to colonnade. The ceiling of the peristyle was, however, made of marble, the slabs cut in coffers to minimize the load on the wooden beams. Coffer lids were made separately and were removable, each coffer having its own lid which would not fit any other coffer. This was an expensive scheme, the justification for which remains obscure.

That the temple was to be approached from the Agora and most often observed from that direction is shown by the arrangement of the sculptural ornament. Carved metopes at the east, now badly worn away, illustrate the labors of Herakles and run all the way across the front. On the flanks, however, only the four easternmost metopes are decorated. Here the exploits of Theseus appear, which led to the building being called the Theseum, a name still sometimes used. The architect saw the need to introduce elements of the Ionic order - as Iktinos and Kallikrates did in the Parthenon - and the most conspicuous of these is the continuous Ionic frieze over the porches. At the east, it extended over north and south ambulatories and depicted a combat witnessed by the gods. At the back, the frieze ran only over the opisthodomos and presented the battle between the Lapiths and the centaurs. Unfortunately, only scraps of the pedimental groups survive.

Bronze statues of Hephaistos and Athena, made by Alkamenes, pupil of Phidias, stood in the interior. An inscription tells us they were made between 421 and 415 BC, when they were dedicated. This gives a date by which the building was finished. The dates for the various stages of construction are based on pottery fragments from the construction fill, the style of the sculpture and architecture, and the shape of letters used in masons' marks on ceiling blocks. From this evidence, it seems that the friezes were perhaps carved in the 430s BC and the metopes, still somewhat Severe in style, in the 440s BC. Construction must have begun in about 450 BC, and the work evidently took a long time to finish. Obviously, the Parthenon took priority.

The Agora In spite of the toll taken by the war with Sparta, building also continued in the Agora itself. During the decade 430-420 BC, two new stoas sprang up (fig. 7.24, p. 227). On the west side, amid the administrative buildings of the democracy and immediately adjacent to the Royal Stoa, the impressive Stoa of Zeus appeared. This unusual stoa - of the Doric order and with two wings projecting forward - was a religious building dedicated to Zeus Eleutherios (of Freedom) and containing a great statue of Zeus. Its façade was partly of marble, itself unusual in the Agora, and the interior was decorated with paintings. Its precise function is unclear, though Plato says that Socrates met his friends there. Was it only a meeting place? The purpose of the other stoa, South Stoa I on the south side of the Agora, is more obvious. This is a long structure, consisting of a double colonnade of the Doric order in front of sixteen rooms. Materials are simple, with walls of roughly squared limestone blocks and much mudbrick. The large number of coins found here suggests that this was a place for commerce, perhaps banking, while the shape of some of the rooms is suitable for dining couches. Since numerous members of official committees were fed at public expense, as in the tholos, this may be the place where those concerned with commercial activities and their regulation, such as inspectors of weights and measures, had their offices and took their meals.

These two stoas, together with the Royal Stoa and the Painted Stoa (see p. 226), served to shape the agora, their columned façades echoing one another and unifying the public space. Their functions were as versatile as their shapes (compare their different plans and sizes). They were places where officials discharged their duties, where philosophical and legal dialogue took place, where personal business and some of the business of the polis was enacted, where citizens gathered for conversation and meetings (and shelter from rain and sun). They were places where significant paintings could be displayed and spoils of war set out for all to see. Each separately had its own particular uses and associations, but collectively the stoas functioned as the apparatus of democracy. They defined and activated the political space.

Somewhere between 415 and 406 BC, a new council chamber was built. This New Bouleuterion (fig. 7.24, p. 227) was put up directly west of its predecessor, which remained standing. It was rectangular, but the interior arrangement and provision for seating are uncertain. These council chambers, together with the tholos (see p. 226–8), were the administrative nerve centers of the democracy. Overall power, however, lay with the Assembly (the Ekklesia), which since the closing years of the sixth century had met on the hill of the Pnyx, some distance southwest of the Agora (fig. 8.35). Prior to the establishment of the Pnyx as their meeting place, the Assembly seems to have met in the Agora. The Agora

is the place too where the political mechanism known as ostracism was practiced. Ostracism was the process used to exile citizens thought dangerous. It went like this. An annual meeting decided by simple majority vote if an ostracism was called for. Two months later, Athenians went to the Agora to hand in their ostraka (fig. 8.37), the sherds of pottery on which they (it was presumed) had scratched the name of the person they wished to exile. Six thousand votes had to be cast; any fewer was inconclusive. If six thousand were cast, the person with most votes was ostracized for ten years. The practice began in the 480s and continued until 417 BC; but it was too open to political manipulation (for example, we have a group of 190 ostraka all bearing the same name and all written by the same man - how's that for ballot-stuffing?) to last and was discontinued.

By the end of the century, a large square building identified as the Mint, where Athens struck its coinage, had been built at the southeast corner of the Agora, while at the northeast one or more of the lawcourts was constructed. The lawcourts are a prominent feature of Athenian participatory democracy. Juries were large: the smallest consisted of 201 men, but the jury for Socrates' trial was 501, and juries of over a thousand are known. There are literally hun-

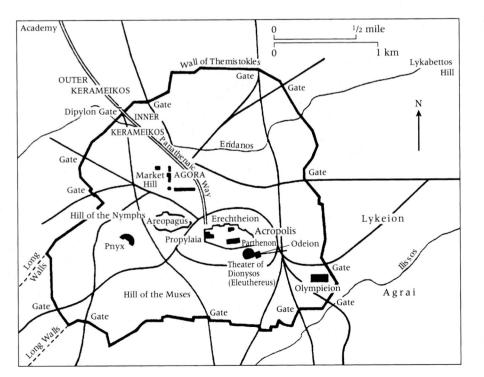

8.35 Plan of Athens. Later 5th century BC

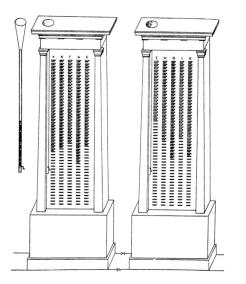

8.36 Reconstruction of allotment machines used for selection of jurors. 5th/4th century BC. Agora Museum, Athens

dreds of references to the lawcourts in the written sources, and they are a favored topic of jest for Aristophanes, the famous Athenian writer of stage comedies. A large rectangular enclosure at the southwest corner of the Agora has been identified either as the shrine of the hero Aiakos or as one of the major lawcourts (fig. 6.40, p. 174), but it is clear that other places, stoas for example, served this function also. The new lawcourts at the opposite corner of the Agora (fig. 7.24, p. 227) have yielded some of the equipment needed for the judicial process: a ballot box and some bronze ballots (fig. 8.38). Jurors' tickets, waterclocks, and fragments of allotment machines (fig. 8.36) have also come to light. These machines were used to determine which jurors should serve on which juries. The complexity of the selection process – which involved the bronze tags of individual jurors being slotted into the machine and different-colored stone balls being cranked out of a bronze tube – ensured the random selection of jurors. Jurors were not chosen till the last minute, and received pay for their work.

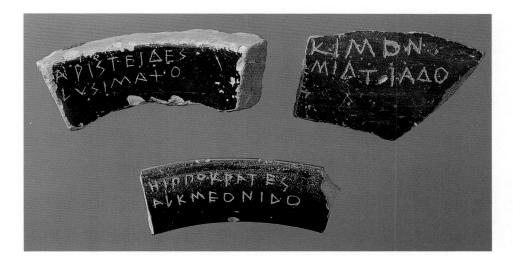

8.37 *Left* Ostraka. Inscribed pottery sherds with the names of candidates for exile. 5th century BC. Agora Museum, Athens

8.38 Below Ballot disks. 5th/4th century BC. Bronze. Used to condemn a defendant. Inscribed psephos demosion (official ballot). Agora Museum, Athens

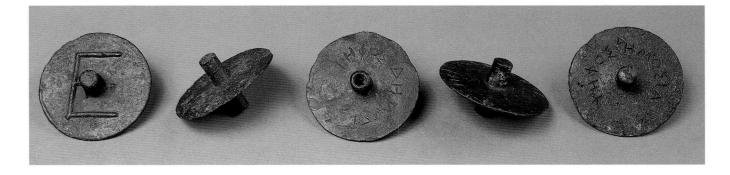

During the sixth century BC, the open space of the Agora had been used for theatrical events, whether dancing, drama, or singing, and part of it was termed the ORCHESTRA, the dancing place. The theatrical contests in honor of Dionysos were watched here by spectators seated on planks, supported by a wooden scaffolding called the "ikria," a temporary structure that could be put up or taken down at will. After the ikria collapsed, however, sometime in the fifth century BC, injuring many people, these events were moved to the new theater of Dionysos on the other side of the Acropolis (fig. 8.35). In moving their dramatic performances to a theater that made use of a hillside, the Athenians were following Greek practice elsewhere. At other sites, suitable hollows in hillsides had initially been used, which were subsequently fitted out with wooden or stone seating. The typical plan was simple: the circle of the orchestra, where the performance actually took place, was partly surrounded by

an auditorium of seats rather more than semicircular in plan. On the side of the orchestra where there were no seats, there was a low stage building, which served as dressing rooms and as backing for scenery. Both orchestra and seating were unroofed.

Sicily and South Italy

Theatrical events were popular in Syracuse, too. Aeschylus is said to have directed a performance of the *Persians* here in around 470 BC and come with a production of the *Oresteia* in the 450s BC. The theater where these were performed was probably on the spot where the enlarged theater of the third century BC may be seen. Its architect was Damocopos, who made good use of a convenient hillside.

The Doric order continued to dominate temple architecture. The best examples may be seen at Akragas, where a magnificent series of structures was built along the southern ridge of the city. The Temple

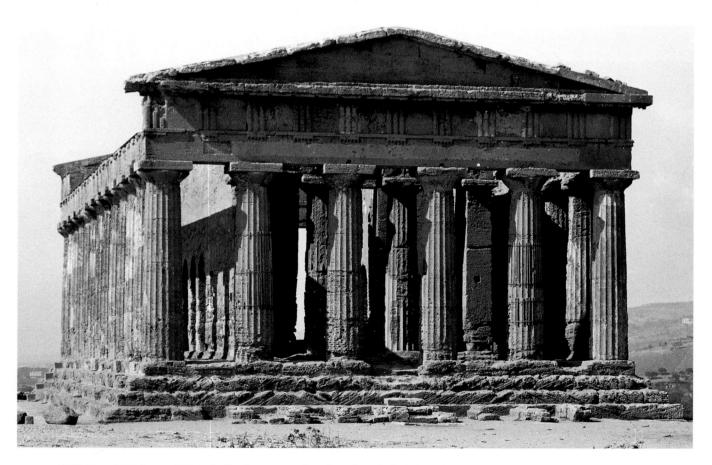

8.39 Temple of Concord (Temple F), Akragas, east façade and south flank from the east. c. 430 BC. Limestone. Height (columns) 22 ft (6.70 m); (entablature) 9 ft 8 ins (2.96 m)

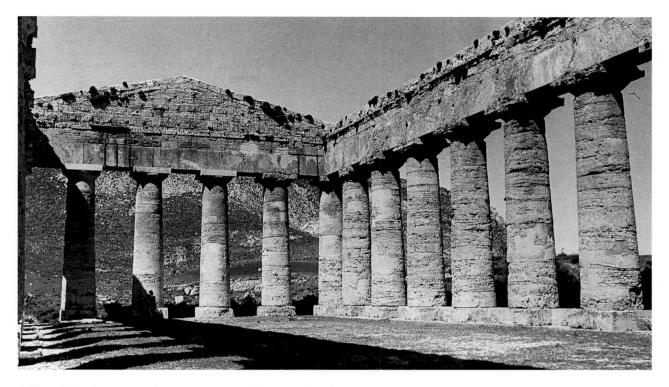

8.40 Unfinished Doric temple, Segesta: interior, showing unfluted columns and missing stylobate blocks. c. 430–420 BC. Limestone. Height (columns) 30 ft 6 ins (9.36 m); (entablature) 11 ft 6 ins (3.58 m)

of Hera (Temple D), built on a manmade spur of the cliff around 450 BC, is a Doric peripteral building with canonical proportions and number of columns (six by thirteen). Balancing porches, staircases for access to the roof, and a columnless cella complete the arrangements. Nearby, the Temple of Concord (a modern name) (fig. 8.39) is another conventional, if remarkably preserved, Doric temple of around 430 BC. It has six by thirteen columns with twenty flutes and entasis, porches front and back, staircases for access to the roof, metopes and pediment without sculpture. Yet another example with conventional plan and elevation of the same date is the Temple of Hephaistos.

More and more architects came to espouse the architectural principles that arrived from Greece, with fewer and fewer following the imaginative ideas of their predecessors in the West. It is ironic that the architectural heirs of those who had had the imagination to juxtapose Doric and Ionic in the same building (as at Poseidonia two generations earlier) should have declined to pursue that solution, while mainland architects, those responsible for the Hephaisteion and the Parthenon, took it up.

At Segesta (fig. 8.40), in the west of Sicily, a Doric temple outside the city was left unfinished. The peristyle (six by fourteen) stands to this day with entablature and pediments; columns were left unfluted. The masonry blocks of the cella walls and some of the blocks of the stylobate have been robbed out. Doric refinements were included: stylobate and architrave curve slightly upward toward the middle, and columns tilt inward. The proportions of the building and the profile of the capitals place the temple somewhere around 430-420 BC. The unfinished state provides valuable evidence about the stages of construction, and it is clear in this instance - and in the Hephaisteion, too - that the outer colonnade and its entablature were put up before the cella. The Doric refinements, so similar to those used in the Parthenon, suggest an architect from Athens. On the other hand, certain Western characteristics that are present argue for a local architect, who may have visited - or been told about - Athenian temples. In view of Athens's alliance with Segesta in the run-up to the Sicilian expedition, neither possibility need surprise.

At Locri in South Italy, sculpted marble figures, either AKROTERIA for the roof or pedimental figures,

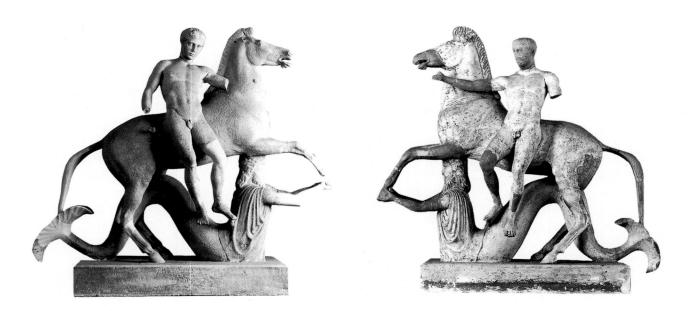

8.41 Akroteria or pedimental figures of a temple, possibly that of Aphrodite, Locri: the Dioskouroi dismounting. c. 420 BC. Marble. Height 4 ft 3 ins (1.30 m). National Museum, Reggio Calabria

were added to the temple (possibly a temple of Aphrodite) in around 420 BC. These take the form of the Dioskouroi leaping down from their horses, the hoofs of which are supported by the outstretched arms of flying tritons (fig. 8.41). Horses and heads are reminiscent of the style of the Parthenon, though the Dioskouroi have lost the ease of movement of the Parthenon figures, and the complicated grouping with tritons below is perhaps a measure of a BAROQUE local taste.

SCULPTURE

The most reliable index to sculpture of the High Classical period is the sculpture from the Parthenon. There are the pedimental figures with the new, deeply carved and revealing drapery which are designed to show a graduated response, physical and psychological, to the events at the center. There are the metopes with sometimes flamboyant compositions and sometimes still Severe Style theatrical expressions. And there is the frieze, with its varied rhythms and its mastery of figures, which display great variety of pose, gesture, dress, and hairdo, as well as typically expressionless heads. For the standing female type, the caryatids (fig. 8.32) of the Erechtheion are also exemplary. Yet the many bases for freestanding statues that are now lost reveal how limited our overall perception is. The favored material was bronze, and while Roman copies give an idea of some aspects (such as the posture, gesture, and expression) of these originals, only the bronzes from Riace (figs. 7.32 and 7.33, p. 236) suggest the power and brilliance of the many bronze freestanding figures of the High Classical time. In the absence of the originals, we are forced to turn to Roman copyists, adapters, and commentators.

The most illustrious sculptor of the period, alongside Phidias, was Polykleitos. As well as practicing sculpture, Polykleitos wrote a book called the *Kanon*, which investigated the ideal proportions of the standing male figure. These proportions were thought to depend on the "symmetria" (commensurability) of the various parts of the body, but this term's exact meaning remains hazy: Did symmetria mean volume, shape, length, breadth, or height of body parts, or some equation involving these dimensions? Polykleitos is said to have made a statue to exemplify his "kanon." More than fifty copies of this bronze, the Doryphoros (Spear Carrier) (fig. 8.42), have survived and are easily recognizable. The literary sources do

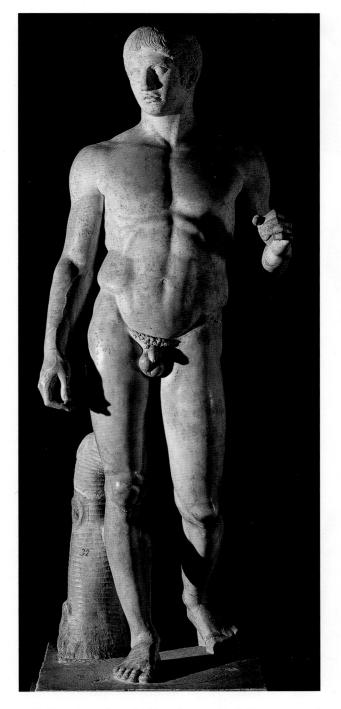

8.42 Doryphoros by Polykleitos, from Pompeii. Roman copy of a bronze Greek original of c. 440 BC. Marble. Height 6 ft 11 ins (2.12 m). National Museum, Naples

not reveal the identity of this figure, but many these days incline to the view that it is a representation of Achilles. The "doru" (spear) after all was a mighty, heroic, war weapon, and Achilles is seen on a contemporary vase (fig. 8.50) with just such a heavy spear. The original was made about 440 BC. The figure vigorously explores the reaction of the body to the weight leg/free leg pose. The free leg is placed both laterally and behind, the heel raised off the ground. This has been called the "walking stance," and motion forward is evidently implied by the balanced figure. Is he standing still or walking? The horizontal axis through the hips tilts as the free leg is withdrawn, and contracted muscles set the torso in motion. The head turns to the same side as the firmly planted weight leg and holds the figure still. The expression is the distanced, tranquil High Classical look, seen in many figures of the Parthenon frieze. The treetrunk and the supportive strut are the contributions of the Roman marble copyist. These would not have been necessary when the statue was a bronze.

Throughout the body, tensed forms balance relaxed ones. Reading the statue vertically, relaxed right arm with weight leg balances tensed left arm (originally holding the spear) with free leg; reading horizontally, weight leg and free leg balance free arm and tensed arm. The term CONTRAPPOSTO is often used to describe this pose of poise and counterpoise in spatial freedom. Realism of bone and muscle, sinew and vein, and hair and flesh of this athletic figure is integrated into a concept of the ideal, which is dependent somehow on a system of mathematical proportions. Thus a figure that represents the ideal is also the most visually accurate, the most real. The ambiguity of whether the Doryphoros is walking or standing still is matched by the ambiguity of whether he is more real or ideal. Polykleitos thus continued Greek sculptors' quest for idealized male beauty. He was inspired perhaps by the belief that human minds could grasp the nature of divinity, and that the gods were anthropomorphic. Nudity (cf. pp. 176-7) seems to have been a key element in sculptors' attempts at the representation of perfection. Did the nude male become the model for every male Greek aspiration: for military and athletic excellence, civic responsibility, sexual desirability, even for immortality? Polykleitos evidently strove for perfected images that could represent either gods or men.

8.43 Diadoumenos by Polykleitos, from Delos. Roman copy of a c. 430 BC bronze Greek original. Marble. Height 6 ft 5 ins (1.95 m). National Museum, Athens

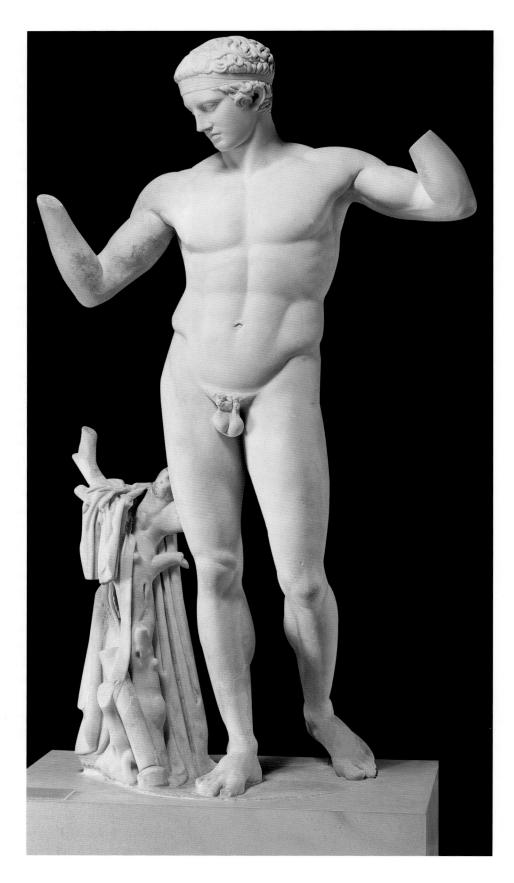

Another work by Polykleitos was the Diadoumenos (the youth binding a fillet round his hair), again recognizable in Roman marble copies (fig. 8.43) of the original bronze. Pliny mentions the statue in his catalog of bronzes by Polykleitos as being molliter juvenis (a soft young man) and famous for having cost 100 talents. In a neat play of words, he describes the Doryphoros as viriliter puer (a manlike boy), drawing attention to the contrast in visual affect between the two. The arms of the Diadoumenos held aloft to tie the ribbon around his head offer a major compositional difference between the two. Yet, the posture of legs and torso, the proportions, the swing of the hips, the curve of motion through the figure, and the shape of the head are close to those of the Doryphoros. The more aggressive turn of the head and richer, more plastic treatment of the hair may suggest, however, that the original of the Diadoumenos was a later work, perhaps of about 430 BC. Two identifications seem plausible: either that he represents an athlete fixing the victor's ribbon around his head; or that, in the Roman version anyway, he is an Apollo.

Two of Phidias's pupils deserve mention. Agorakritos made the cult statue for the Temple of Nemesis at Rhamnus on the east coast of Attica. Alkamenes made numerous statues, according to the ancient sources. His most influential may have been a Hermes Propylaios (literally, "in front of the gates") which may be identical with the statue of Hermes which Pausanias says he saw at the Propylaia to the Acropolis.

This Alkamenes cannot be the same Alkamenes who, according to Pausanias, made the figures of the back pediment of the Temple of Zeus at Olympia (completed in around 460 BC). The chronology does not fit. Nor does it for Paionios of Mende who, Pausanias says, made the figures of the east pediment, but who was active in the 420s BC. This illustrates the difficulties presented by literary sources. Perhaps there were two sculptors of the same name -Alkamenes - a generation or two apart. As for Paionios, an inscription on the base of a statue of a Nike in the sanctuary at Olympia says that he made the Nike and that he was commissioned to make akroteria for the temple. This inscription may of course have been misread or misunderstood, so that Pausanias, or his source, simply made a mistake. Paionios and Alkamenes may have made the akroteria for the temple long after the building came into use, perhaps sometime in the 420s BC, and this information may have become garbled enough by the time Pausanias visited Olympia, or wrote up his notes, to allow him to record that they had made the pediments. Information supplied by the ancient writers must be treated with caution.

Personifications of Victory (Nike), posed as if alighting, were often used as akroteria on the roofs of buildings. On relief panels, they decorate the balustrade around the Temple of Athena Nike on the Acropolis at Athens. They also appeared as independent dedications, an Archaic example of which is the Nike dedicated in the sanctuary on Delos (fig. 6.65, p. 189). The Nike made by Paionios and dedicated at Olympia, though badly damaged, survives. The winged female figure stood out against the sky, about 11 yards (10 m) up, atop a triangular pillar. She was shown (fig. 8.1) at the moment of touching down, still hovering in flight and with wings (now lost) unfolded. Her bared limb and breast contrast with the covered parts of her flesh. Drapery, forced against her body by the rush of her flight, accentuates her anatomy and, billowing out behind, increases the sense of forward motion about to come to a halt. Missing are her face, part of the neck, the rest of the drapery swirling around behind, and the outspread wings. Paionios's Nike was dedicated around 420 BC to celebrate, as the inscription says, a victory of the Messenians and Naupaktians.

The production of grave reliefs was resumed in Attica around 430 BC and may have been stimulated both by the outbreak of the Peloponnesian War and by the decoration of the public state graves prepared for the casualties of war. The tall, single-figured stelai of the Archaic period were replaced in the Early Classical phase by smaller but broader reliefs, decorated with two or more figures, sometimes including seated figures. These were to be found earlier in the islands and in Asia Minor, where architectural elements were also introduced, but not in Attica. These developments were only introduced in the latter when private grave monuments began to be made again.

The aim seems to have been to represent the dead person as he or she appeared when still alive. Some figures are characterized by attributes: a soldier in armor, an old man with his stick, a girl with a doll. Other figures may be depicted with com**8.44** *Below* Cat Stele, from Aegina. c. 430 BC. Marble. Height c. 3 ft 5 ins (1.04 m). National Museum, Athens

8.45 *Right* Grave stele of Hegeso, from Athens. c. 400 _{BC}. Marble. Height c. 5 ft 2 ins (1.58 m). National Museum, Athens

panions during life, seen saying farewell, or shaking hands. Inscriptions sometimes say who the dead person was, though without identifying which of the figures in the relief he or she is represented by. It seems that many gravestones were generic, only individualized by an added epigram or other inscription.

An early example, from around 430 BC, is the so-called Cat Stele, on which the dead youth is accompanied by a mourning boy attendant and an animal, perhaps a cat, seated on top of a stele (fig. 8.44). Above the cat is a birdcage, to which the youth extends his right arm while the left hand holds a bird. Deeply carved drapery pressed flat evokes the style of that of the Parthenon figures, as does the youth's head with its rounded skull, small mouth, large eye, unruly hair, and faraway expression. The grave stele of Hegeso (fig. 8.45), from about 400 BC, provides a good example of the architectural format – with antae and the pediment of a doorway – in front of which figures sit or stand. The figure of Hegeso, well-dressed, hair carefully arranged, and elegantly seated (with a footstool even), is engaged in a familiar pastime: with the help of a servant she chooses jewelry from an opened box. Receding planes and three-quarter and intermediate views are handled with confidence. Garments exemplify the

8.46 One side of a two-sided votive relief: the hero Echelos and the nymph Basile ride off. c. 410 Bc. Height 30 ins (75 cm). National Museum, Athens

transparency of the late fifth century BC; faces are emotionally inexpressive. The mood is of that serenity and otherworldliness associated with the High Classical style of the Parthenon, which is obviously at home here.

Votive reliefs resumed at about the same time as grave reliefs in Attica. They were placed on top of pillars, like their painted wooden counterparts, and were rectangular and low in shape. Themes involved the deities concerned, sometimes depicted being approached by worshipers shown at a smaller scale, and even by the dedicator and members of his family. Sometimes groups of Olympian deities appear, while at others less well-known immortals, Hermes or Pan, for example, take pride of place. Particular attention seems to have been paid to river gods.

Mythological scenes also appeared, some inspired by lesser-known local Athenian myths. In one instance, the hero Echelos makes off with the nymph Basile (fig. 8.46), encouraged by Hermes, in a four-horse chariot. Horses neigh and rear, their heads cocked at different angles. Only two hoofs of all four horses touch the ground, in a group that is a clear echo of the Parthenon frieze. Compositions, postures and gestures predictably follow the styles of more visible contemporary sculpture, occasionally with some flair.

POTTERY AND WALL Painting

Wall paintings such as the Tomb of the Diver at Poseidonia (fig. 7.47, p. 246) were painted against a white background. The white background in vase painting had been tried at the time of the experiments that led to the introduction of the red-figure technique, around 530 BC, but had not become popular. In the first half of the fifth century BC, the whiteground technique was tried again, now using outline drawing rather than the black-figure technique. A jug by the Brygos Painter (fig. 8.47) offers a good example of this. Against the white ground the woman is drawn in outline, with contours in black relief lines. A domestic scene shows her spinning wool, using distaff and spindle, head bent in concentration. Other painters also try out the technique and introduce innovations. Black relief lines give way to brown dilute glaze lines, and a whiter, thicker white is used for female flesh to distinguish it from background white. It is not, however, until the High Classical era that white ground really comes into its own.

The technique is used on several pot shapes, including the krater (fig. 8.48), but the white ground itself is fragile and friable, which was an obvious disadvantage, at least for pots that were designed to be handled a lot. Thus it came to be used especially on LEKYTHOI, tall flasks for holding oils and unguents that were regularly deposited in graves. This meant they did not come in for a lot of use, and so could be decorated with white-ground with impunity. Painters were also tempted to try more colors, which more often than not have unfortunately faded.

By the end of the century, red, black, and brown were in use for contours, and washes of green, purple, and blue were applied for broader swathes of drapery. This polychrome style may reflect the style of contemporary monumental murals and panels. Experiment went beyond color, broken contour lines attempting to suggest volume. A lekythos (fig. 8.49) of about 410–400 BC with a mournful woman seated in front of a tomb uses broken contours (of her arms, for example) to suggest mass. This may be a trick learned from wall painting, since it seems to agree with descriptions of the murals of Parrhasios, who was thought to have depicted volume by line, not by shading. Parrhasios lived in Athens during the Pelo-

8.47 Above left Attic white-ground oinochoe attributed to the Brygos Painter: woman spinning. c. 490–480 sc. Height $8\frac{1}{2}$ ins (22 cm). British Museum, London

8.48 *Left* Attic white-ground krater, from Vulci: Dionysos and Nike. c. 440–430 BC. Height 13³/₄ ins (35 cm). Vatican Museums, Rome

8.49 Above Attic white-ground lekythos: seated woman in front of a tomb. c. 410–400 Bc. Height 20 ins (51 cm). British Museum, London

ponnesian War. Shading, as a device for rendering volume in painting, is attributed by literary sources to two other late fifth-century wall painters, Zeuxis and Apollodoros. It only rarely appears on vases to suggest volume in humans, and then not until the very end of the century, though hatching is used for this purpose in early fifth-century vase painting.

These white-ground lekythoi generally show scenes appropriate to the funerary context, such as departures, tombs, and visitors. Some are almost 20 inches (51 cm) high and challenge the carved stone reliefs for prominence. Some carved reliefs even take the shape of lekythoi.

The practice of painting vases using the redfigure technique continued, but demand slowly declined. There are fewer and fewer signatures of painters in the second half of the century and, by the early part of the fourth century BC, signatures of potters, too, had disappeared. The name-vase of the Achilles Painter, who also painted in white ground, is an amphora (fig. 8.50), now in the Vatican Museums. The hero stands in solitary splendor, highlighted on a maeander groundline, shouldering his spear, with his right hand on his hip. Accurate representation of the anatomy is a striking feature, whether it be the view of the left leg or the profile eye. The deep carving of folds of drapery of the Parthenon figures is matched in painting now by close-packed, irregular, wavy lines of garments (over the left arm), giving a subtle sense of weight and texture, and by broken lines, curls, and hooks (over the upper thighs). The mood is close to the ideal calm of the Parthenon figures, while the stance is close to that of Polykleitos's Doryphoros. The date of this amphora is around 440 BC. Heroic and mythological scenes thereafter become less popular, however, and their place is taken by scenes of daily life. Young women at their toilette appear as a favorite topic, sometimes with the women shown wholly nude and accompanied by numerous Eros figures.

The taste in sculpture for light, flimsy, and transparent drapery – seen on the figures decorating the balustrade around the Temple of Athena Nike on the Acropolis – is followed in vase painting. A practitioner who typifies the taste of the end of the century is the Meidias Painter. A hydria by Meidias, now in the British Museum (fig. 8.51), catches him at his most exuberant. The lower register shows Herakles in the gardens of the Hesperides (the daughters of the

8.50 Attic red-figure amphora by the Achilles Painter: Achilles, in contrapposto Polykleitan stance. c. 440 BC. Height 23³/₂ ins (60 cm). Vatican Museums, Rome

evening), with the tree whose golden apples they and the dragon protected. In the main register, the Dioskouroi and their chariots arrive to carry off the daughters of Leucippos. Pollux, successful, drives off in his chariot, hoofs flying, while Castor's team awaits their master's flirtatious return. The setting is a sanctuary of Aphrodite, identified by various elements: the cult statue above and between the horse groups, the landscape suggested by trees and bushes, and the goddess herself seated below by an altar. Figures with their arms outstretched are disposed over the surface at various levels and in various postures, as with the Niobid Painter earlier. Drapery makes no attempt to conceal the female bodies. Their limbs are plump and soft, their gestures and poses varied. The drawing is luxurious, with gilding used for necklaces and bracelets and for the cult statue. The mood is warm and sensuous rather than menacing. The hydria was painted around 410 BC. The almost voluptuous sense

8.51 Attic red-figure hydria attributed to the Meidias Painter: bottom, Herakles in the garden of the Hesperides; top, rape of the daughters of Leucippos. c. 410–400 BC. Height 20½ ins (52 cm). British Museum, London

8.52 Shapes of plain black gloss tableware, from Athens. 5th century BC. Agora Museum, Athens

8.53 Coarse ware cooking pots and portable stoves, from Athens. 5th century BC. Agora Museum, Athens

of ease of the painted scenes is at odds both with the implied tension of the activities shown and with the rigors of the Peloponnesian War that was then engulfing Athens.

As well as painted pottery, Athenian potters made large quantities of simpler wares. In the High Classical period, vases decorated in a plain, shiny, tough black gloss (often inaccurately referred to as "glaze"; see p. 193) became popular. These came in all shapes and sizes and were used for storage, pouring, and drinking of wine, water, and olive oil. The gloss was also used on other items of tableware – plates and lamps, for example. A selection of such pottery, all found in a well in the Agora in Athens (fig. 8.52), includes cups, jugs, storage pots, a cooler, plates, and lamps. Cooking pots, too, were necessary items in daily life. They were strictly utilitarian, less elegant than the tableware and handmade in coarser clay (fig. 8.53). Such coarse wares had obviously existed before and were produced at Athens throughout antiquity.

Also made of coarse clay and undecorated were the amphoras (storage vessels) in which olive oil and wine were transported around the Mediterranean. Though all have two handles at the top and the knoblike toe at the bottom (fig. 8.54), the profiles

vary and often signal the provenance of an amphora and its contents. The globular amphoras of the middle row in the illustration, for example, come from Mende, a state that was well known for its wine. Since amphoras are valuable indices of economic life and provide evidence of trade connections, the development of their shapes and their patterns of distribution have been closely studied. Moreover, they are often stamped on the handle, especially in the Hellenistic period. This mark includes the symbol of the state where the oil or wine came from, and the name of the magistrate in whose year of office the amphora, and perhaps its contents, were produced. Thus, these amphoras are significant chronological markers. On average, they contained about 7 gallons (26.5 liters) and weighed about 77 pounds (35 kg) when full. They were placed on their sides for trans-

8.54 Transport amphoras of various origins: top row, from Lesbos; middle row, from Mende; bottom row, from Thasos. Agora Museum, Athens

portation, as the discovery of sunk merchant ships and their cargoes on the floor of the Mediterranean has revealed, their holds containing hundreds of amphoras stacked sideways. The knoblike toe acted as another handle to assist with moving it, but was no help when the owner stood the amphora up to get at the contents. To stand upright, the amphora either had to be placed in a tripod or in a hole in the ground.

In the West, in the first half of the century, Greeks had relied on imported painted pottery for their prestige wares, but now they began to produce their own. The appearance of this South Italian redfigure pottery may be related to the foundation of Thurii (see fig. 9.2, p. 291) from Athens in 443 BC. Perhaps potters and painters were involved in this late colonial venture. Their presence is certainly attested at Metapontum, a little further northeast along the coast from Thurii, where some of their kilns have been found.

Their work, simple objects and rather stodgy figures, is undemanding at first, but, by the last quarter of the century, some are attempting more daring and innovative schemes. The calyx krater (fig. 8.55), attributed to the Cyclops Painter, shows the drunken Polyphemos at the bottom of the scene and Odysseus and his companions at the top maneuvering the great stake with which they will blind the giant. The theme goes back to the Eleusis amphora (fig. 5.9, p. 131) painted in Athens in the seventh century BC. The arrangement of figures "up and down" the surface goes back to painters like the Niobid Painter (figs. 7.44 and 7.45, p. 244) and the probable appearance of such a scheme in monumental paintings of the first part of the fifth century BC. So dependence on Athens is clear. New to the scene are the figures of satyrs darting in from the right. Some have suggested that the scene may have been based on satyr plays, lighthearted romps performed after tragic trilogies. This calyx krater was made around 420-410 BC in Lucania.

There is evidence of another workshop that was perhaps located at Taras and that began work around 430–420 BC. From this developed the two main strands of South Italian painting in Apulia (the heel of Italy): the Ornate Style and the Plain Style. This Apulian pottery was to come to the fore in the next century, when vase painters in Italy began to block Athenian work out of the market in the West.

8.55 South Italian red-figure krater by the Cyclops Painter: below, Cyclops (Polyphemos) stupefied; above, Odysseus and companions. c. 420–410 BC. Height 18½ ins (47 cm). British Museum, London

THE FOURTH CENTURY c. 400-300 bc

he defeat at the end of the Peloponnesian War might have been expected to end Athens's political aspirations. But it did not. Within a decade, an Athenian fleet was doing battle with, and even triumphing over, the Spartans, near Knidos. By 390 BC, skirmishes had taken place near Corinth, and the walls of Athens and Piraeus were rebuilt. Though the Persians intervened in the early 380s BC to arbitrate a treaty that supported the claims of Sparta, the Athenians and their allies went to war again in the 370s BC. Finally, in 371 BC, a peace confirmed Sparta's hegemony on land and Athens's at sea, but the old rivalry was still alive. However, this system - of independent city-states grouped in alliances around the two protagonists struggling for the control of Greece - came under challenge, first from Thebes. Employing new military tactics, Thebes overwhelmed Sparta in a land battle fought at Leuctra in 371 BC, and for a period of ten years or so assumed a leadership role. But the death of the great Theban general Epaminondas, at the Battle of Mantinea in 362 BC, put an end to the shortlived Theban hegemony. This was followed by a second, more serious challenge to Athens, Sparta, and the autonomous Greek states, which came from Macedon.

9.1 Relief, from Taras, South Italy: Electra and Orestes at the tomb of Agamemnon. c. 300 BC. Limestone. Height 23 ins (59 cm). Metropolitan Museum of Art, New York

Philip II became king of Macedon in 359 BC. His early years were taken up in consolidating his authority and his kingdom's boundaries. But in 348 BC, he moved east against the city of Olynthos, an ally of Athens, which he destroyed. Shortly thereafter, he moved south and in 338 BC defeated the Greeks, who had put their internal rivalries behind them to face the invasion from the north, at the Battle of Chaeronea. The independence of the Greek city-states was ended. Though Philip treated them leniently, they were now effectively the subjects of the king. However much Demosthenes, the learned orator, and his friends at Athens may have railed against Macedon, and however frequently the enemies of the democracy may have been threatened by Athenian rhetoric and even by legislative decree, the fact was that Greece had become a subject, if now at long last unified, nation.

Two years later, in 336 BC, Philip was assassinated. He was in Macedon at the time, and the finger of suspicion points at his own people. He was succeeded by his twenty-year-old son, Alexander, who was soon to begin the career that earned him the popular title of Alexander the Great. In spite of a rebellion in Greece, which was quickly suppressed, Alexander was well disposed toward the Greeks; he was anyway more interested in Persia.

Alexander entered Asia Minor in 334 BC and, within a short time, had defeated the Persian king,

conquered the Persian empire, and mastered the known world from Macedon in the north to Egypt in the south, and from the Aegean to Afghanistan (fig. 9.2). Within a decade, Greek life and politics had undergone irreversible changes. Alexander's death in Babylon in 323 BC provoked disorder. Fighting broke out between his generals, and the empire of Alexander was ultimately divided into separate kingdoms. Of these, five were to be significant - Macedon still, Egypt, Pergamon, Syria, and Bactria. The history of these kingdoms is largely the history of the Hellenistic period, but three of the five (Pergamon and Bactria being the exceptions) were independent entities by the end of the fourth century BC. The world of the Greek city-states had come to an end. Greece herself retreated to the sidelines, while great nation-states emerged, ruled by military monarchs.

Far from these great happenings in the East, the West Greeks were under pressure too. In Italy, Poseidonia fell into the hands of indigenous peoples, who swarmed down from the hills to capture other prosperous cities as well. But further south, Metapontum and Taras continued to prosper. In Sicily, the Carthaginians had bided their time. But in the aftermath of the disastrous Athenian expedition to Syracuse, they returned to the offensive, and Greek city after Greek city fell into their grasp. In this way, Selinus (in 409 BC) and Akragas (in 406 BC), for example, were overthrown. Syracuse survived thanks to the arrival of a new tyrant, Dionysios, who fortified the city and then carried the war to the Carthaginians in the west of the island. By turns victorious and vanquished, Dionysios battled against Carthage through the first decade of the century. Though besieged, Syracuse never fell. A hiatus of some twenty years followed, in the course of which the philosopher Plato made the first of his visits to Syracuse from Athens. War resumed in 368 BC; Dionysios died the following year. Civil war in Syracuse engaged the attention of his son and successor, Dionysios II, and this strife was not resolved until the arrival of Timoleon from Corinth, summoned by some of Dionysios's enemies.

Timoleon left Corinth in 344 BC and within a year was master of Syracuse. Dionysios II went into exile (at Corinth), and a moderate oligarchy, somewhat modeled after Plato's ideas, was installed. Carthage was defeated again, and under the leadership of Timoleon the damaged or destroyed Greek

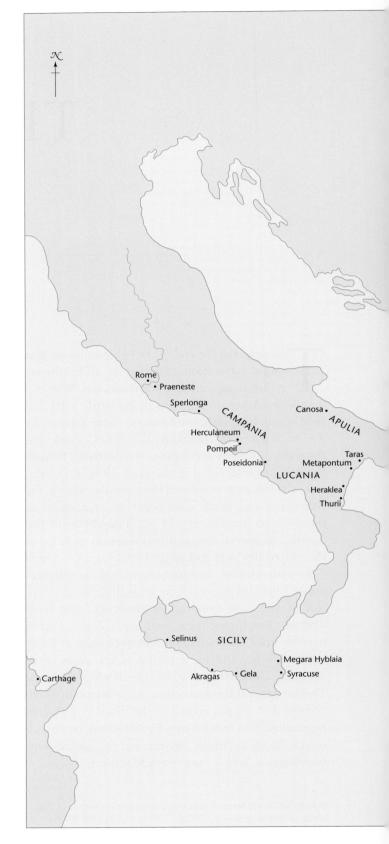

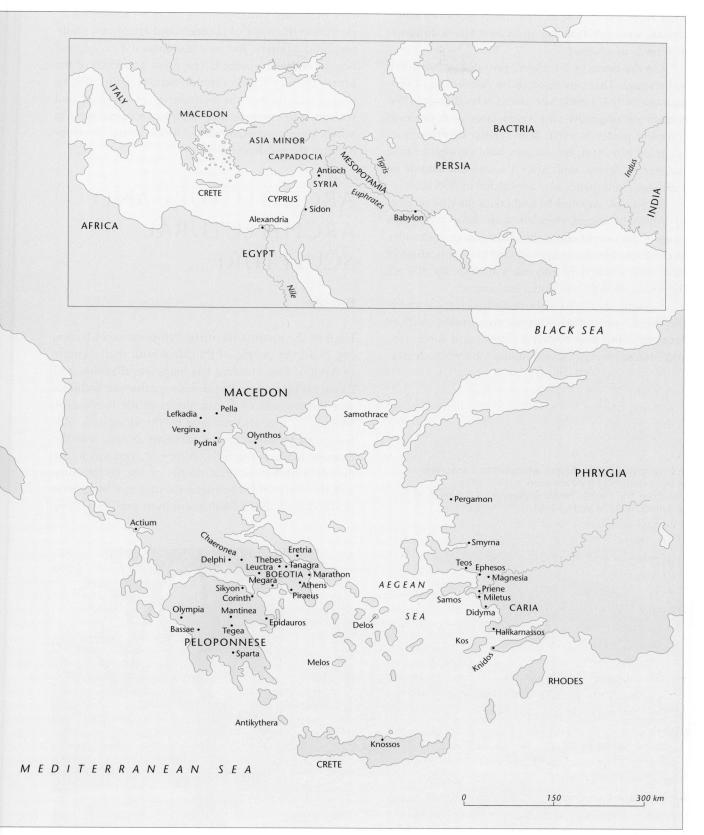

9.2 The Greek world. c. 400–30 BC

cities of Sicily, with their associated blocks of countryside, were inhabited again by new Greek colonists or returning refugees.

On the death of Timoleon, civil discord returned to Syracuse. This was resolved by Agathokles, a protagonist of the democratic party, who dissolved the council of oligarchs two years later and assumed complete power himself. War against Carthage preoccupied him, too, but he was bold enough to take the war to Africa, and, after a successful assault on Carthage itself, peace was concluded in 306 BC.

In 307 BC, Agathokles had taken the title of king, by which he aligned himself with those other new kings of the Greek world, the successors of Alexander, in the East. His program included the unification of Sicily and South Italy into one kingdom. By 304 BC, the whole of Sicily was under his control.

Conditions of dislocation, both in Greece and in the West, prevailed. Almost continuous warfare between states and between Greeks and foreigners, and internal struggles within cities between democ-

9.3 Temple of Apollo, Bassae, attributed to Iktinos, one of the architects of the Parthenon. c. 430–390 BC. Limestone and marble. Height (columns) 19 ft 6 ins (5.95 m); (entablature) 6 ft 4 ins (1.94 m)

rats, oligarchs, and monarchs (as at Syracuse) did little to help the work of planners and architects, sculptors, and painters. But new buildings did go up, and new cities were planned. The great sculptors of the fourth century BC – Praxiteles, Skopas, and Lysippos – explored further the boundaries of idealism and realism, and energetic workshops of vase painters in South Italy competed with Athens in the development of the red-figure style.

ARCHITECTURE AND Architectural Sculpture

Bassae

High in the mountains of the Peloponnese at Bassae (fig. 9.3), the people of Phigaleia built their Temple of Apollo. This building has many peculiarities, and its date is intriguing. Pausanias says that the architect was Iktinos, one of the architects of the Parthenon. Judging by this evidence and by the elongated, old-fashioned peristyle, it was certainly begun, and the exterior built, in the fifth century BC, perhaps in the decade 430–420 BC. But details of the architecture and the sculpted frieze suggest it may not have been finished until around 400 BC, or even until very early

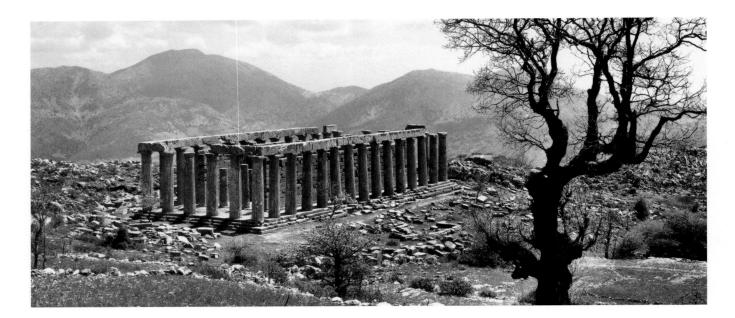

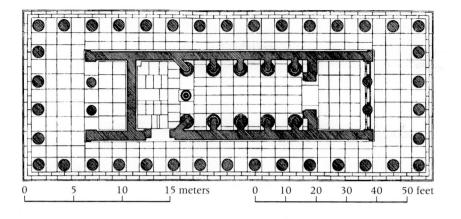

9.4 Plan of the Temple of Apollo, Bassae. c. 430-390 BC

in the fourth century BC. The interior of the temple is so full of innovations and anticipates so many fourth-century developments – non-Doric interior columns that function only as ornament, for example – that it is included in this chapter. This building is evidently transitional in style between the fifth and fourth centuries BC.

The orientation, north-south, is unusual. This and the Archaizing, elongated proportions were dictated by a preceding temple on the site. The new temple was built almost entirely of limestone guarried nearby. The plan (fig. 9.4) called for six columns by fifteen; porches front and back have two columns in antis, though the front porch is deeper than the back. The arrangement behind the porch is highly original: a cella and a kind of adyton with a side door. The transition from cella to adyton is marked by a single column with a capital of completely novel appearance. The exterior order is Doric, but columns of the cella are attached to the wall by masonry spurs, stand on broad bases, and have Ionic volute capitals of unique design. The single column screening adyton from cella introduces the Corinthian capital.

The Corinthian capital (fig. 9.5) has a bellshaped echinus, surrounded by ACANTHUS leaves, spirals, and palmettes, and has small pairs of volutes at all four corners. It provides the same view from all sides and is therefore more useful than the Ionic, whose volutes present problems at the corners of buildings. The use of the Corinthian capital is one of the hallmarks of the fourth century. Its popularity slowly increased until, by the Roman period, its supremacy was assured.

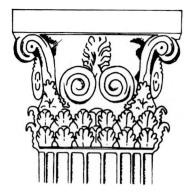

9.5 Corinthian capital from the Temple of Apollo, Bassae. c. 430–390 _{BC}

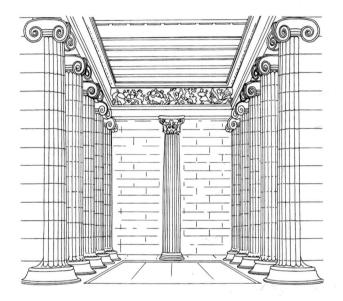

 $9.6\,$ Reconstruction drawing of the interior of the Temple of Apollo, Bassae. c. 430–390 $_{BC}$

Although a Doric structure, this temple, like the Parthenon, was decorated with a sculpted Ionic frieze. Whereas on the Parthenon the frieze had run round the outside of the cella, here it decorated the interior (fig. 9.6). The subjects are commonplace: fights between Greeks and Amazons and between Greeks and centaurs. The quality of workmanship varies from convincing scenes of combat (fig. 9.7) to others showing impossible anatomies in contorted postures. The musculature of the Greeks is emphatic,

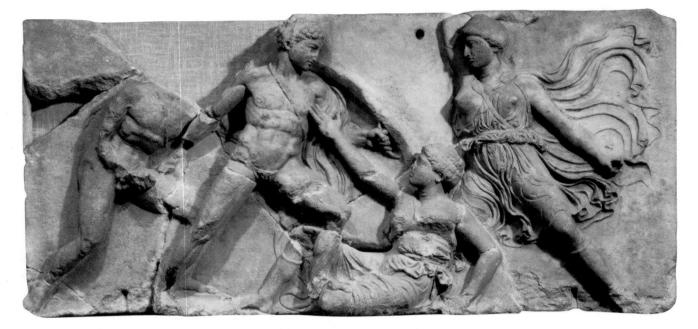

9.7 Temple of Apollo, Bassae, frieze block: Greeks fighting Amazons. c. 400–390 BC. Marble. Height 24 ins (63 cm). British Museum, London

while the limbs and breasts of the Amazons are soft and fleshy, fully visible through the transparent drapery. The "wet" drapery with its billowing active folds, the ends curled into hooks and loops, is typical of Athenian work of the last decade of the fifth century BC. But the highly exaggerated postures and gestures of some figures and their theatrical expressions, with their deep-set eyes, are more at home in the fourth. Some scholars attribute this stylistic inconsistency to provincialism.

Epidauros

Temple-building in the fourth century often involved reconstructing temples destroyed by fire or other catastrophe. The gigantic sixth-century Temple of Artemis at Ephesos, for example, was burned down, but replaced by an equally large building almost at once. Replacement temples or the repair of damaged ones meant there was little scope for innovation. Yet elsewhere, in new complexes, architects experimented with scale, shape, and proportion, and with the new Corinthian order.

The cult of Asklepios, god of healing, medicine, and doctors, had been present at Epidauros since the

later sixth century, and it was from there that the cult was introduced to Athens c. 420 BC. Stimulated in part by memory of the appalling plague which struck Athens c. 430 (see Box, p. 348), the cult's arrival in Athens can also be seen as a gesture of political solidarity between Athens and Epidauros at the time of the Peloponnesian War. At Epidauros it was not till the fourth century that the sanctuary (fig. 9.8) was enhanced with monumental buildings, but from this moment on Asklepios' popularity grew rapidly across Greece.

The architect of the temple, Theodotos, chose the Doric order, but abandoned the usual ratio of façade to flank columns and had only eleven columns by six to give a more square, compact plan. The opisthodomos (back porch) was also abandoned. The pediments were decorated with marble figures depicting battles between Greeks and Amazons and between Greeks and Trojans. The seated statue of Asklepios inside was of gold and ivory. Little of the building remains, but an inscribed record of expenditures incurred has survived, and this yields important evidence about costs for labor, transport, and materials. The temple was built around 380 BC.

The altar was adjacent to the temple, in front of the most imposing structure in the sanctuary.

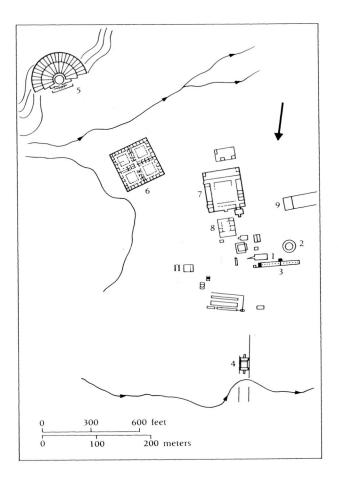

9.8 Left Plan of the Sanctuary of Asklepios, Epidauros. 4th century BC and later 1 Temple of Asklepios 2 Tholos (thymela) 3 Abaton (stoa) 4 Propylon 5 Theater 6 Hotel 7 "Gymnasium" 8 Palaestra 9 Stadium

9.9 *Right* Epidauros, tholos. Plan and reconstruction drawing. c. 360–340 _{BC}

9.10 Below Tholos, Epidauros, abbreviated interior Corinthian order. c. 360–340 _{BC}. Marble. Epidauros Museum

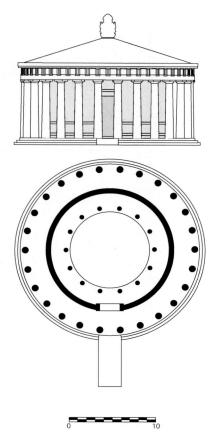

This was a circular building known to Pausanias as a tholos (fig. 9.9), but referred to in inscriptions as a "thymele," a covered hearth. This building, approached by a ramp leading straight to the door, had a diameter of more than 24 yards (22 m), only 1 yard (1 m) less than the length of the temple. The plan consisted of three concentric circles: an outer circle of twenty-six Doric columns, a wall, and an inner circle of fourteen Corinthian columns. The Corinthian capitals (fig. 9.10) display a double row of acanthus leaves, encircling the bell-shaped echinus, which is sharply carved and rich in decorative value, as are the architectural moldings and the ceiling soffits. The architect was Polykleitos the Younger, whose design dates to around 360-340 BC. The purpose of this mysterious building is unclear. It may be a formal precursor to the Philippeion at Olympia, the circular building erected as a votive gift after the Battle of Chaeronea and containing statues of Philip and Alexander. But the tholos is

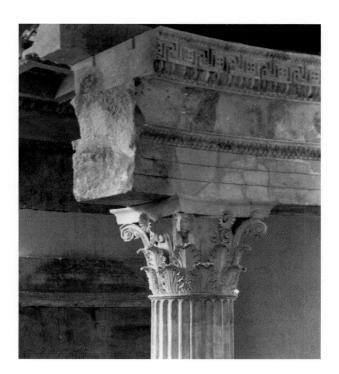

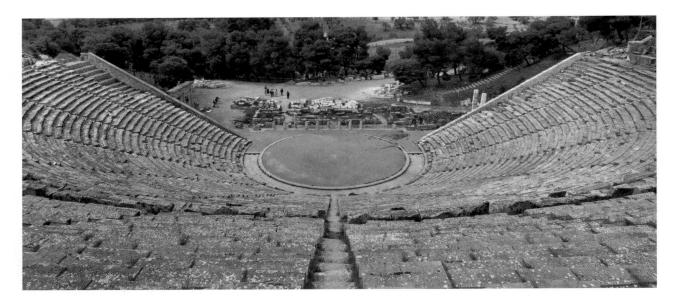

9.11 Above Theater, Epidauros. Early 3rd century BC

placed emphatically in the sanctuary. Was it the tomb of Asklepios? Was it the home of the sacred snakes that cured many illnesses and whose serpentine shape was reflected in the building's plan?

The sanctuary was well equipped with stoas, in one of which, at any rate, the so-called Abaton, patients seeking relief from illness spent the night and enjoyed restorative dreams. The efficacy of these is attested by inscriptions from the site, though Aristophanes, the famous Athenian writer of comedies, referring to an Abaton elsewhere, makes fun of the whole process.

The sanctuary itself, with its temple, tholos, stoas, propylon, and boundary markers, was supported by other buildings clustered on the south side, the most important of which was the theater just over half a mile (1 km) away. These structures, some built later than the fourth century BC, were all for the benefit of pilgrims. A large, two-storied hotel boasted 160 rooms, arranged around four peristyle courts. An equally large "gymnasium" (more probably used for ritual activity) consisted of an open court with colonnades on all sides and rooms behind them for meetings, lectures, storage, and changing. A PALAESTRA (an enclosed exercise ground) and a stadium were provided for exercise and athletics; the palaestra, as was normal, was rectangular in plan.

Asklepios, his daughter Hygeia (Health), and his sacred companions the snakes, who knew how to

find potent herbs and in sloughing off skins symbolized renewal, were later influential among the Romans. But their sacred power slowly waned, and the gradual secularization from healing sanctuary to health resort is shown in the character of subsidiary buildings at Epidauros.

Pausanias says that the theater was built at the same time as the tholos, i.e. in the fourth century BC, but current archaeological investigation places it in the third, with the upper tier of seats not in fact added until the second century BC. It was built into a hillside to make use of the slope and to reduce costs, since theaters were now to be built of stone. The illustration (fig. 9.11) shows the circular orchestra where the dramas were enacted, with the SKENE (dressing rooms for actors and storage for props and scenery) behind. The huge auditorium, about 142 yards (130 m) in diameter, rises up the hillside (the theater is still in use today) in symmetrically arranged wedges of stone seats. Stairs separate wedge from wedge, and an upper section of seats is separated from a lower by a horizontal gangway giving access from the hillside. The fifty-five rows of seats could accommodate up to twelve thousand spectators. Theater was closely associated with the cult of Dionysos (p. 274), so special seats at ground level were reserved for his priests, and at Epidauros there was an altar of Dionysos in the orchestra where sacrifices would have taken place before performances began.

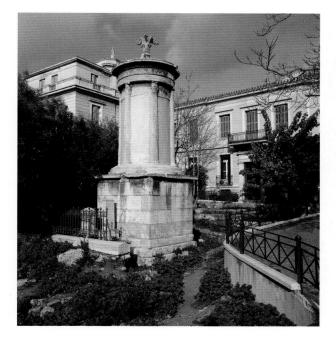

9.12 *Above* Monument of Lysikrates, Athens, showing exterior use of the Corinthian order. 334 BC. Marble and limestone

9.13 *Right* Plan of the Agora, Athens. c. 300 BC

Athens

This circular shape and the Corinthian column appear in a monument in Athens, too (fig. 9.12), commemorating the victory in a theatrical contest of a chorus sponsored by a man called Lysikrates. This was in 334 BC. The circular monument stood on a rectangular base and was the first example of the use of the Corinthian order on the exterior of a structure: six Corinthian columns are engaged in the masonry drum beneath an architrave and sculpted frieze. The APEX of the roof consists of elaborately carved stone foliage and originally supported the prize itself, a bronze tripod.

Elsewhere in Athens, extra revenue from the silver mines at Laurion, first exploited in the 480s BC and now the site of renewed activity, allowed a new stadium to be built, as well as a new theater on the south side of the Acropolis. In the Agora (fig. 9.13),

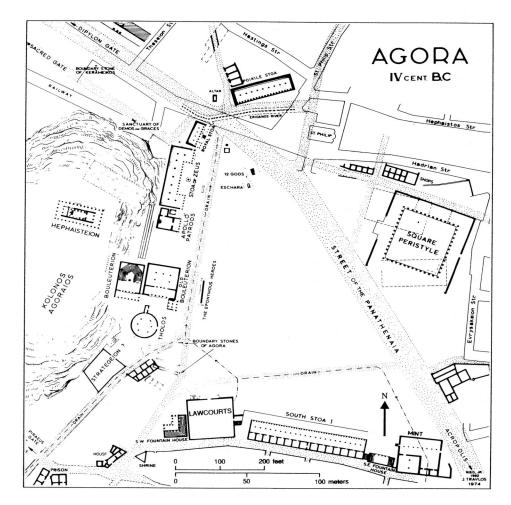

9.14 Plan showing typical domestic architecture, Athens. 5th–4th centuries BC

a fountainhouse, L-shaped in plan, was built at the southwest corner between 350 and 325 BC, and a monumental water-clock was erected nearby, by which the opening and closing of the market and the beginning and end of trials could be timed. The small Temple of Apollo Patroos, replacing an Archaic precursor, was built around 330 BC on the west side, and in about 300 BC construction began on the large Square Peristyle in the northeast corner. This court-yard, with columns on all four sides, measured 38 yards (35 m) square, and was rather sloppily constructed with much reused material. It was built on the site of structures assumed to have been law-courts, and may have served the same purpose.

The enclosed courtyard is a feature of domestic architecture, too. A good many houses of the fifth and fourth centuries BC (fig. 9.14) have been excavated at Athens, particularly in the zone south and southwest of the Agora and on the slopes of the Areopagos to the west of the Acropolis. Their sizes and plans are irregular, especially when compared with the more systematic plans for housing in other cities. Generally, they are small with a single entrance from the street into a courtyard surrounded by several rooms. Occasionally, the courtyard has a colonnade around it. It provided light and air, since windows on the exterior were few and far between for reasons of security, and was the scene of much of the household's activity. It also provided a supply of water reached by wells dug to a depth of some 13 yards (12 m), though by the fourth century BC these were drying up and were being replaced by cisterns, which gathered rainwater from the roof. Other sources of water were the fountainhouses (e.g. at the southeast and southwest corners of the Agora) to which good, clean water for public consumption was piped from springs.

Normally, one chief room opened off the court, and this was used for entertaining. It was called the andron and it was here that men dined reclining on couches. This room was sometimes brightened by a pebble mosaic floor (pebbles set in mortar), though floors elsewhere were simply tamped earth. A kitchen, identifiable by the quantities of crockery and cooking utensils found there, was nearby. There was also a bathroom/latrine, a small room with a drain that emptied into a drain outside the house. Other rooms around the court were storerooms, living rooms (those frequented by women are often identified from quantities of loomweights), or bedrooms, though these were often on the second floor.

The building materials used were unimpressive. A foundation of rubble supported a low rubble socle for walls built almost entirely of unbaked mudbricks, which were then covered with stucco to protect them from rain. Projecting eaves of the roof also provided some protection. Wood was used for roofbeams supporting the terracotta rooftiles and for frames for doors and windows. Furnishings were also modest – little more than couches, wooden chairs and stools, and small chests and tables. The overall impression created by these urban private houses is of cramped conditions, blocks of rather mean houses sharing party walls, amid streets that resembled tortuous alleys more than thoroughfares. In the suburbs and the countryside of Attica, more spacious dwellings existed, equipped with porches, courtyards, verandas on one or more sides of the court, and even occasionally with a tower.

Olynthos

There is little evidence for town planning to be found in Athens, with its rambling, irregularly shaped houses and history more of haphazard than planned growth. Other sites, where excavation has been more widespread and where new cities were planted or new zones planned, offer better information.

Older cities, like Athens, grew up around an easily defensible point, often a hill - an acropolis which was protected by a wall. Houses at the foot of the hill were also protected by a wall, which tended to follow the lie of the land and dictated where future building could take place. Within these walls (or wall), space was required for sanctuaries for the gods (though these could be outside the walls) and for the agora, as well as for housing. By the sixth century BC, provision was also being made for administrative offices of the state, which normally clustered around the agora, and deities were propitiated in sanctuaries in high places (like the Acropolis at Athens) or in otherwise significant locations (by harbors or springs, for example). By the fourth century BC, space was also required for gymnasia, theaters, and palaestras, which were often located outside the walls.

Aristotle (*Politics* 2.5), discussing questions of urban design, put forward the view that Hippodamos of Miletus, who lived in the fifth century BC, was the first man to plan towns rationally, with separate quarters for religious, public, and private use. He planned the new town of Piraeus with zones defined by function and with a grid plan. It is for his use of the grid plan that Hippodamos is most famous. He is said to have employed it at Miletus for the new city, laid out in the fifth century BC after the destruction of Archaic Miletus by the Persians, and at Thurii in South Italy for the new colony planted there from Athens in 443 BC. But the grid layout had actually been used many years earlier, at Megara Hyblaia and Selinus in Sicily, for example, at Smyrna in Asia Minor, and at Poseidonia (see fig. 5.22, p. 139), so Hippodamos did not strictly speaking invent it. His reputation as reported by Aristotle may therefore have grown out of his frequent use of the plan and his enthusiasm for a rational approach to planning, whether in terms of a street plan of roads intersecting at right angles, or of zoning.

Olynthos provides a good example both of orthogonal (right-angled) grid planning (fig. 9.15) and of domestic architecture within a grid. Urban development northward from the old town began in the later fifth century BC; the city was destroyed by

 $^{9.15\,}$ Plan of Olynthos, showing grid layout of streets and housing. 5th–4th centuries $_{BC}$

Philip in 348 BC. Reoccupation of a small part of the site then followed, before its final abandonment in 316 BC, so the street plan is of fifth-century origin, while the houses in their latest phases are fourth-century. North-south avenues intersect with east-west streets; each housing block, measuring around 109×44 yards (100×40 m), has ten houses of equal size. Houses are arranged front to back in two rows of five, separated by a narrow alley. Within each house, individual rooms vary in size. Typically, a narrow doorway opened onto a passage leading to a court-yard, the largest unit of the house. The courtyard may have columns (wooden posts) along one or

9.16 Plan of the Villa of Good Fortune, Olynthos. 4th century BC

more sides, forming a veranda or verandas; in which case, the house may be termed a PASTAS house. The largest room, the andron (dining room), was reached from the court, with which other rooms were also linked. A second story reached by a wooden staircase provided bedrooms. Occasionally, a house reveals a more cosmopolitan flavor (fig. 9.16). The Villa of Good Fortune, so called from an inscribed floor mosaic, had rooms of unusually large dimensions, walls that were stuccoed and painted, and floors decorated with pebble mosaics (fig. 9.17).

Priene

The orthogonal grid plan could be laid out not only on flat terrain, as at Miletus or Olynthos, but also on sloping ground. Such is the case at Priene (fig. 9.18) in Asia Minor (western Turkey), where a new city was planned on a hillside. Geography and geometry combine to provide a logically planned town affording spectacular views southward over the river Maeander and the plain toward Miletus.

The grid was laid out within the wall; broad, paved east-west roads intersected with narrow north-south streets, often little more than stairways up and down the hill. Provision was made for all the requisite elements in a small Greek town, including housing, sanctuaries of the gods, an agora with stoas, a councilhouse, a theater, gymnasia, and a stadium.

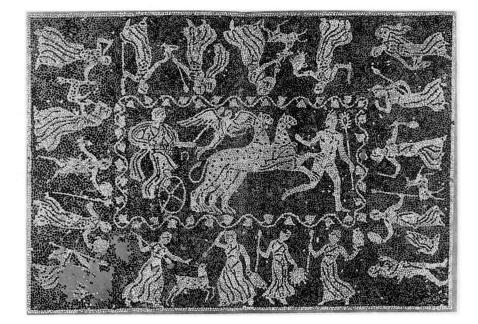

9.17 Villa of Good Fortune, Olynthos, pebble mosaic floor: (central panel) Dionysos and chariot; (the surround) members of his retinue. 4th century BC. c. 13 ft \times 8 ft 2 ins (4 \times 2.50 m)

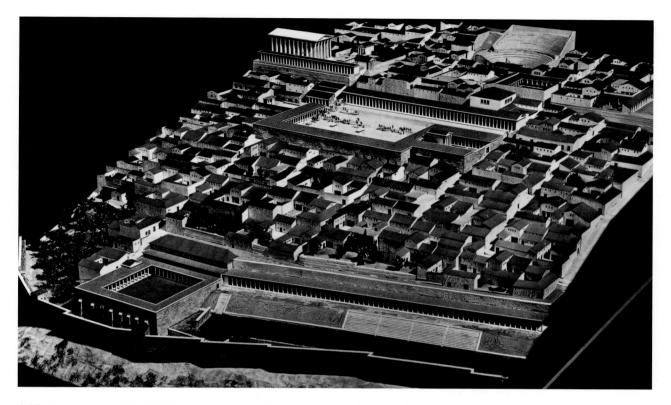

9.18 Priene, model of the hillside town showing grid plan and zoning for agora (center), theater, sanctuaries, council chamber, and other public uses. 4th century BC and later. Staatliche Museen, Berlin

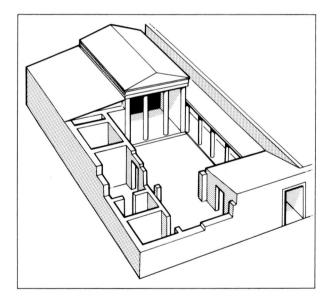

9.19 Drawing of a reconstruction of a "megaron" house, Priene. 4th century $_{\text{BC}}$

The regularity of the spacing of blocks was broken wherever necessary to accommodate large units. Thus, six blocks in the heart of the town were reserved for the agora and adjacent public buildings, and the theater absorbed almost two blocks. The grid arrangement petered out where fortification walls and grid plan met, but irregular terrain and outsize structures were neatly matched to the south, where a stadium and large gymnasium were installed in the later Hellenistic phase.

The inhabitants of Priene numbered about four thousand. The houses they inhabited display various plans. Some are of fourth-century date, others are later. All have courtyards, some with columns, some without. One plan (fig. 9.19) has the main room of the house preceded by a porch with two columns in antis which opens on the court. This arrangement is reminiscent of Bronze Age predecessors and of temple plans, and is therefore sometimes termed a megaron plan. Similar houses have been found in seventh-century Smyrna – so this type may be a peculiarly East Greek manifestation. It is also sometimes

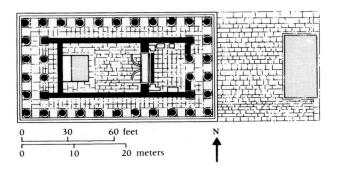

9.20 Plan of the Temple of Athena Polias, Priene. c. 340 BC. The altar is Hellenistic

termed a "prostas" type, but it is the pastas type exemplified in Olynthos that gained in popularity in the Hellenistic period.

Much of the construction in Priene is of Hellenistic date, for example, the Sanctuary of Olympian Zeus, the colonnade to the south of the Temple of Athena, the Sacred Stoa, and the stadium, but the agora and the Temple of Athena itself certainly belong to the fourth century BC. The agora consisted of stoas on three sides - east, west, and south - with the north marked by altars, statues, other dedications, and fountains. The stoas sheltered the offices and shops, while that on the south side also provided access to the agora by means of staircases for citizens arriving from the terraces below. The north side was flanked by the main east-west artery through the town, leading in the west to a city gate beneath the terrace on which the Temple of Athena stood, and in the east to an arched gateway and a residential quarter beyond.

The Temple of Athena Polias (fig. 9.20) was built to the northwest, higher up the hill than the agora. Entrance to the sanctuary was through a monumental propylon. The temple marks the revival of the Ionic order in Asia Minor after the period of Persian conquest and subjugation of the Greek communities. It was thus apt that the temple, begun soon after the middle of the century, should have been dedicated by Alexander the Great, the conqueror of the Persians, in 334 BC.

The Ionic temple at Priene is now modernized and standardized. The gigantism of sixth-century Ionic temple architecture at Ephesos, Samos, and Didyma is replaced by smallness of scale and by precise proportions and ornament. This small temple (only around 40 \times 21 yards [37 \times 19 m]) was given an updated plan: a peristyle of six by eleven columns, and porches front and back, each with two columns in antis. Interior columns were wholly omitted, and the porch and cella were covered with a wooden coffered ceiling. The ceiling of the peristyle, however, was formed of carved marble coffers alternating with wooden crossbeams. These coffers, richly ornamented with polychrome moldings and sculpted relief groups depicting a gigantomachy, broke the unity of the ceiling plane. The architect, Pytheos, relied on easy numerical ratios to arrive at dimensions in his plan. He used multiples of the Ionic foot, and intended to make the building a mathematically derived model for the new Ionic order. An unusual feature is the use of square plinths beneath column bases.

Halikarnassos

Pytheos may also have worked on the Mausoleum at Halikarnassos, a unique structure described by Vitruvius (2.8.11) as one of the Seven Wonders of the World. Halikarnassos is in Caria, south of Miletus and Priene, and was ruled by the Persian satrap (governor) Mausolos until his death in 353 BC. Little of the building remains, though sculpted blocks and fragmentary statues in the round have survived. Descriptions of the building have led scholars to produce various reconstructions (fig. 9.22). There was apparently a high podium supporting a rectangular building with an Ionic colonnade, much decorative sculpture, and a pyramid-shaped roof with a fourhorse chariot on the top. It was huge, some 50 yards (46 m) high, and about 42 yards (38 m) square at the base. Though the design incorporated Egyptian (the roof) and Persian (the podium) elements, similarities to the Athena temple at Priene and the style of much of the sculpture suggest that Mausolos hired Greeks to design and decorate his tomb.

Pliny's claim (*Natural History* 36.30–1) that leading Greek sculptors, named by him, worked on the monument is now regarded as fanciful. And scholars' attempts to assign blocks to individual artists have for the most part been discarded. However, surviving relief blocks show that Greek themes – an Amazonomachy (fig. 9.21), for example – were deployed in the decoration of the building, and much of the style is unmistakably Greek. As with the

9.21 Above left Mausoleum, Halikarnassos, frieze block: Greeks fighting Amazons. c. 350 BC. Marble. Height 35 ins (89 cm). British Museum, London

9.22 Above Conjectured reconstruction of the Mausoleum, Halikarnassos. c. 350–340 $_{BC}$

9.23 *Left* Freestanding male statue from the Mausoleum at Halikarnassos. c. 350 BC. Marble. Height c. 9 ft 10 ins (3 m). British Museum, London

Parthenon, many sculptors must have been at work, and leading Greek artists may well have been employed.

It now seems there were as many as three hundred figures at three different scales on six different levels of this extraordinary structure. Some marble statues (fig. 9.23) are over-lifesize, about 9 feet 10 inches (3 m) tall. The stance and drapery of this male figure are recognizably Greek, but the face and hairstyle are not. The long hair swept back from the forehead over the ears and to the neck is more characteristically Persian, while the broad face, challenging eyes, short beard, and fleshy mouth verge on portraiture.

9.24 Antikythera Bronze. c. 350 BC. Bronze. Height 6 ft 4½ ins (1.94 m). National Museum, Athens

SCULPTURE

With the end of the High Classical period, sculpture moved toward more naturalistic representation of the human figure. There was a growing enthusiasm for expressing an individual's emotion, character, age, or mood, just as there had been in the Early Classical period. At the same time, those sculptors (e.g. Phidias and Polykleitos) who had attempted to represent the ideal in realistic figures, with somewhat characterless and emotionless results, remained influential. So there is both continuity and change. The standing nude male figure remained a dominant type, with interest in movement as it affected balance and in the space surrounding figures growing stronger. Control of accurate representation of the anatomy was securely maintained. Once again, a few bronze originals have survived, but mostly we have to rely on later copyists and commentators. The period down to the death of Alexander the Great in 323 BC is often known as the Late Classical, a term also used for the style of sculpture.

The Antikythera Bronze (fig. 9.24), so called because it was found in the sea close to the island of Antikythera, is an example of a fourth-century BC original. The standing nude youth shows the influence of Polykleitan athletic figures clearly enough in the position of legs and feet, the balance of muscular tension, and the emphatic structure of the anatomy. New are the smallness of the head in proportion to the rest of the body, the outstretching of the arm involving the figure in surrounding space, and the leftward swaying pose, checked by the outstretched right arm and the tilt of the head. This figure has been identified as Perseus, originally holding Medusa's head in his outstretched hand, and a sword in his left, and was cast sometime around 350 BC, while High Classical influences were still strong.

Another bronze original (though much of the right arm is a Roman repair), the Marathon Boy (fig. 9.25), again so called because it was retrieved from the sea near Marathon, adopts a more precarious pose. Under lifesize, he appears to stand with his weight on the left leg, but the S-curve of the body is so pronounced that the volume of the torso, carried over to the right, unbalances the figure. It seems that his balance can only be maintained momentarily. The smooth modeling of the surface and the soft shapes

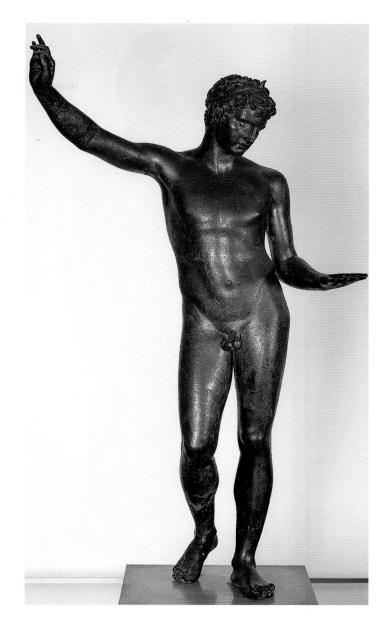

9.25 Marathon Boy, recovered from the Bay of Marathon in 1925. c. 340 BC. Bronze. Height 4 ft 3 ins (1.30 m). National Museum, Athens

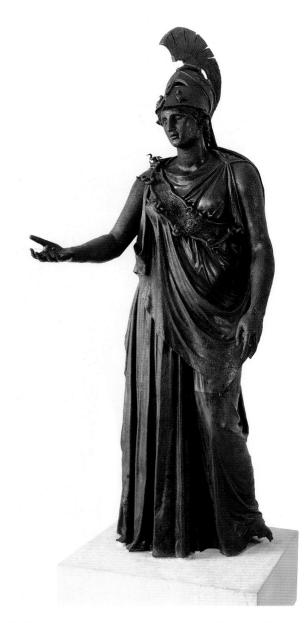

9.26 Athena, from a warehouse in Piraeus destroyed in the 1st century BC, possibly by Sulla. c. 350 BC. Bronze. Height 8 ft (2.44 m). Piraeus Museum

of the limbs suggest the youth of the figure, while his outstretched arms seem to involve the surrounding space on either side. He wears a fillet of a type worn by athletes in the palaestra to secure his hair, but no satisfactory explanation has yet been proposed of the gesture, or of what the object might have been in his left hand. More adventurous in conception and execution than the Antikythera youth, and often associated with the great Athenian sculptor Praxiteles, the Marathon Boy was probably cast sometime around 340 BC.

A bronze original of Athena (fig. 9.26) was found along with other statues in excavations in the Piraeus. The whole group was probably waiting to be shipped from Greece to Rome when the warehouse in which it was stored burned down. The overlifesize Athena wears the new dense drapery of the century, an aegis, and a helmet, and originally held a spear in her left hand. She remains a massive, imposing figure, but, with the head tilted to the right and her gentle expression, she is rendered more approachable than her fifth-century counterpart (fig. 8.25, p. 264). She can be dated to approximately 350 BC.

Around 370 BC, the Athenian state commissioned the sculptor Kephisodotos, perhaps the father of Praxiteles, to make a bronze group of a mother and child - Eirene (Peace) and Ploutos (Wealth) - to celebrate the inauguration of a cult of Peace in Athens. The original is lost, but later marble copies (fig. 9.27) are easily recognized, thanks to literary descriptions and the appearance of the group on datable Panathenaic amphoras and on the coinage of Athens. The mother, Peace, holds the child, Wealth, in the crook of her left arm, while her right hand originally gripped a scepter. Peace's stance and massive form echo precursors of the High Classical style. The drapery, however, is now different. She wears the heavy peplos favored as long ago as the Early Classical or Transitional period (480-450 BC) and a cloak. The clinging wet drapery of the end of the fifth century BC, which left the limbs beneath looking almost naked, is by this time no longer so popular. The density of the drapery describes the weight and texture of the cloth itself and conceals the body. The only anatomical forms (the right knee and both breasts) perceived beneath are those that the fall of the drapery would naturally reveal. Folds are more complicated, as in nature. They stop and start, have creases, and are crumpled. It is an actual, not contrived, relationship between body and cloth that is depicted. Also new, and characteristic of the fourth century BC, is the expression of gentle intimacy between the two figures. This is achieved by the inclination of the mother's head toward the infant and by the infant's eager gesture and upward glance. The personification of abstract ideas in sculpture was

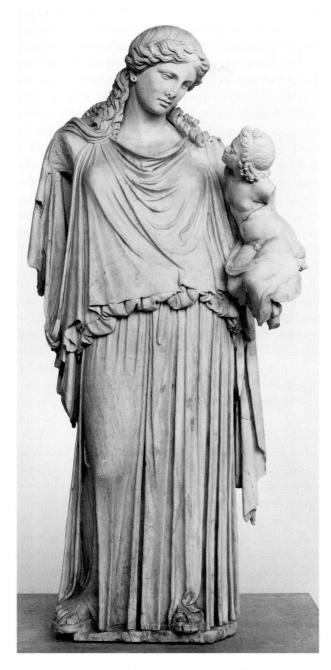

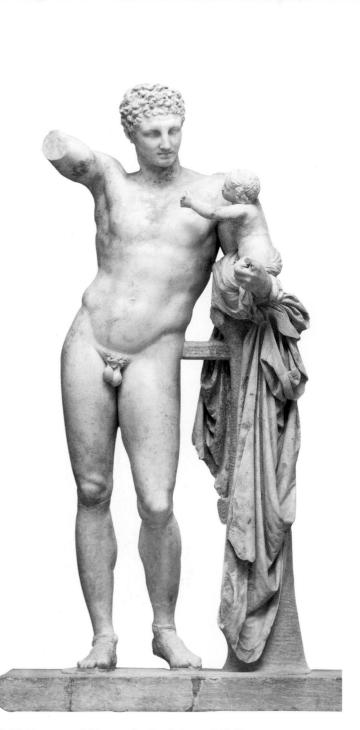

9.27 Eirene (Peace) holding the child Ploutos (Wealth), by Kephisodotos. Roman copy of a c. 370 BC bronze Greek original. Marble. Height 6 ft $6\frac{1}{2}$ ins (1.99 m). Staatliche Antikensammlungen, Munich

hardly an innovation, but the allegorical nature of the group breaks new ground.

Kephisodotos was evidently a leading sculptor of his century, but the three whose names are most familiar are Praxiteles, Skopas, and Lysippos. A marble

9.28 Hermes and Dionysos by Praxiteles. c. 340 (?) _{BC}. Marble. Height 7 ft 1 in (2.15 m). Olympia Museum

group of Hermes and Dionysos (fig. 9.28), found in excavations of the so-called Temple of Hera at Olympia, seems heavily influenced, in terms of composition, by the Peace and Wealth group of Kephisodotos. Hermes holds the child Dionysos in his left

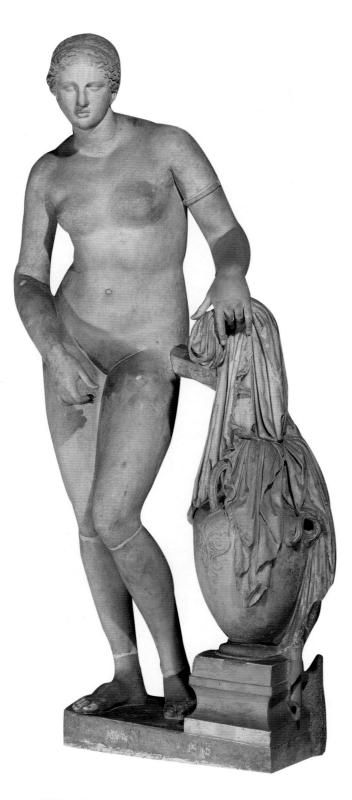

9.29 Aphrodite of Knidos by Praxiteles. Roman copy of a c. 350 BC marble Greek original. Marble. Height 6 ft 8 ins (2.04 m). Vatican Museums, Rome

arm and inclines his head toward the infant. Dionysos looks up at and reaches for the bunch of grapes that Hermes, teasing his younger brother, holds in his right hand. Their gazes intersect, excluding the viewer, in a domestic, personal, and playful moment. They are shown as mortals engaged in mortal activity. The sculptor has used the old myth, well known to sanctuary visitors, to design a composition highlighting both the contrast in age between youth and infant and the humanization of the divine. Such interest in gods as mortals is characteristic of the later fourth century. This group was seen by Pausanias, who described it as the work of Praxiteles. Scholars still debate whether this is an original of the fourth century BC by the master himself, who specialized in the carving of marble, or an original of Hellenistic date, perhaps by another Praxiteles, or whether it is a copy of Hellenistic or Roman date. The strut used between the treetrunk and Hermes' hip, the high polish of the surface, the recutting or miscutting of the back, and the type of sandal worn by Hermes all point to a later date. But whether it is an original or a copy, it tells us much about changes introduced by Praxiteles.

Hermes' stance is High Classical, taken from Polykleitos, and the torso, spare and heavy, is also reminiscent of the fifth century BC. The slender proportions of the long legs and small head, however, are new, as is the S-curve of the awkwardly placed torso and pushed-out right hip, which introduces a note of imbalance. The contours of the body naturally echo this swinging curve, which is a characteristic of Praxiteles' work. Soft modeling of the surface blurs the smooth transitions from plane to plane what the Italians call "sfumato" - and leaves them indistinct. This confident skill in carving and finishing marble, together with the slimmer proportions, gives the figure a certain delicacy. The drapery slung over the treetrunk contrasts with the broad expanses of the body and shows naturalism in the variations of folds and creases, even in a single plane. As to the head, the face is typically Praxitelean, having a tapering shape, narrow eyes, a smiling mouth, detailed modulation of the forehead, and a dreamy expression. Relaxed and idle, languorous and sensuous, Hermes exemplifies a far different aspect of divine life than those depicted by sculptors in the preceding century. If original, this group was made around 340 BC.

Praxiteles' most famous statue was the Aphrodite of Knidos (fig. 9.29). This statue presented a

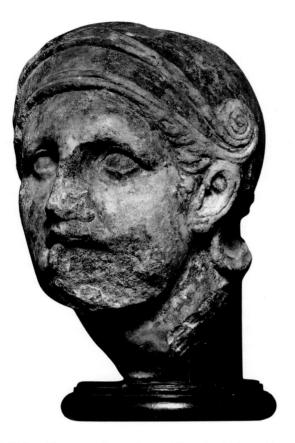

9.30 Head from a pedimental group, Temple of Athena Alea, Tegea (of which Skopas was the architect). c. 340 BC. Marble. Height 11³/₄ ins (30 cm). National Museum, Athens

fullscale female nude for the first time. Literary sources are lavish in their praise of the figure's beauty, and Pliny thought it the best statue in the world. He even suggested that Aphrodite herself must have helped in its creation, though others thought the statue represented Phryne, Praxiteles' mistress. It was copied again and again in Roman times, and many variations of the type developed. The statue also appeared on the coinage of Knidos. Why did it exercise the power it did? Was it just its surprising, and perhaps shocking, nudity? Aphrodite stands naked, caught in a fleeting pose, her left hand resting on the drapery thrown over the adjacent water jar, her right brought across in front in an intuitive defensive gesture. Like Hermes, she has long legs and a small head. Her right hip pushes out, and the S-curve rises slowly through her body. She has soft, wavy hair, and her face has a triangular forehead, shadowy eyes, a straight nose, and a small mouth. The marble original was made around 350

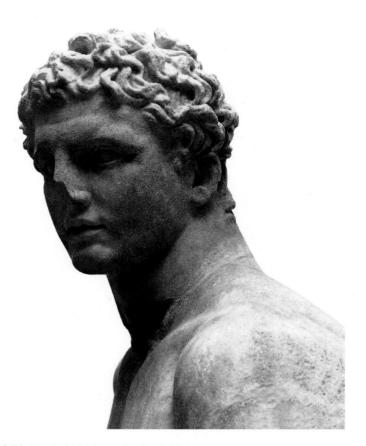

9.31 Head of Meleager. See fig. 9.32

BC and stood in an open shrine visible from every side. Thus, the divine had become accessible, almost personal, captured in an intimate moment.

We learn of Skopas from literary sources and are . told that he was the architect of the Temple of Athena Alea at Tegea in the Peloponnese. A number of fragments of its sculptural decoration in the pediments survive. The somewhat damaged heads from these pedimental figures, known as the Tegea heads (fig. 9.30), reveal a new stylistic current in the fourth century BC. This was the fashion for depicting stressed emotional states by treating facial features in a pronounced way: the inner corner of the eye is deep-set, there is a bulge of the eyebrow over the outer corner of the eye, the forehead is in two planes, the lower of which projects markedly, the cheeks are flat, and the hair is tousled. The power and tension in these heads are undisguised. Skopas, sources say, definitely made the freestanding marble figures that stood beside the cult statue, but we do not know for

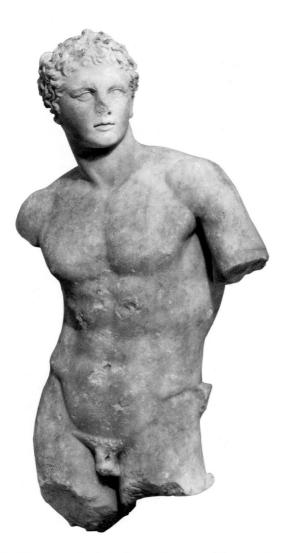

9.32 Meleager, probably by Skopas. Roman marble copy of a c. 340 BC Greek original. Height 4 ft 1 in (1.23 m). Arthur M. Sackler Museum, Harvard University, Cambridge (Mass.)

sure that he made these pedimental ones as well.

This sculptural style is new and vigorous, and it is recognisable elsewhere. Some heads from the Mausoleum at Halikarnassos (fig. 9.21) and from the Temple of Artemis at Ephesos (where Pliny's sources claimed, perhaps erroneously, that Skopas worked), display similar traits to those of the Tegea heads. So it is clear that this new and different style is widespread and popular and, on the available evidence, it seems logical to ascribe its origins to Skopas.

The characteristic traits of the style – the squarish skull, the squarish forehead in two planes, the deep-set eyes, bulging brows, open mouth, and

the expression of intensity and strain - are found in the statue of the celebrated hunter Meleager (fig. 9.32), of which some twenty copies are known. The type is identified by the presence of a boar's head next to the figure in several copies: Meleager was one of the leaders in the hunt for the Kalydonian boar. The number of copies argues its popularity among Roman patrons, for whom subject matter and intended placement of a sculpture were major criteria. No literary source mentions a Meleager by Skopas, but the number of copies also suggests a famous Greek original (as with the many copies of the Doryphoros of Polykleitos - fig. 8.42, p. 277 and its known Greek reputation), and the style of the head is consistent with that of the Tegea heads. The torso of Meleager shows strong modeling, with soft transitions from plane to plane and more abrupt, clearcut musculature, the line of hip and groin clearly demarcated. A slow torsion pulls the left shoulder forward to balance the rightward thrust of the hip and to emphasize the importance of the intermediate view. The "full-frontal" view of Classical sculpture, still shown in the broad expanse of torso, is now on the wane. It is the intermediate, three-quarter view, shown by the direction of the head's gaze, that coordinates movement and brings out the full power of the head.

There is an ambiguity of expression in the face, which to some seems to suggest a self-absorbed, faraway look, while to others it appears more determined and humanly involved (fig. 9.31). The Meleager was made close to the end of the Classical era, when the standing nude athletic type was able to

PLINY ON LYSIPPOS

"Lysippos, from the abundance of his skill, as I have already remarked, made more works of art than anyone else. Among them is a man scraping himself (*apoxyomenos*) which M. Agrippa dedicated in front of his baths to the wondrous delight of the emperor Tiberius. People say that the most important ideas he brought to sculpture lay in his rendering of the hair, in making heads of figures smaller than earlier artists had made them, and bodies thinner and harder, by which means he made his figures seem taller." Pliny, *Natural History* 34.62 and 65

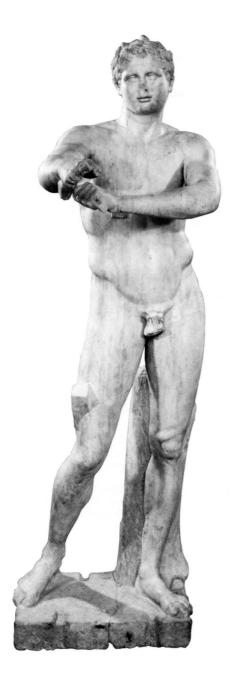

9.33 Apoxyomenos (Man Scraping Himself). Roman copy of a c. 350–325 BC bronze Greek original by Lysippos. Marble. Height 6 ft 8½ ins (2.05 m). Vatican Museums, Rome

display increasingly varied movements, as well as individualizing traits. Meleager is still an image of a generic powerful hero, not an individualized portrait. Skopas's original statue was probably made around 340 BC.

The third great sculptor of the fourth century BC was Lysippos. Since several sources connect him with Alexander the Great and state that he made portraits for the king, we can say with certainty that he was active in the period 336–323 BC. Less certainly, it seems that his career may have lasted from about 350 to 310 BC. He preferred to work in bronze and advocated a new canon of proportions, already more modestly adopted by Praxiteles. Slenderer bodies and smaller heads were to give an appearance of greater height. A comparison of a copy of the Apoxyomenos (Man Scraping Himself; fig. 9.33), with a copy of the Doryphoros of Polykleitos (fig. 8.42, p. 277) makes the point. The Apoxyomenos seems taller, but they are in fact almost the same height.

The Apoxyomenos shows Lysippos directly challenging the conventional Classical four-sided approach. The athlete is using a strigil to scrape the oil off his body. One arm is stretched out directly in front of the figure, with the other (holding the strigil) at right angles to it. Thus, the broad front of the torso has been broken, the visual space of the figure vastly extended, and the viewer invited, almost compelled, to contemplate views other than frontal and profile. Moreover, the torsion introduced into the lower part of the figure by the out-turned foot, bent knee, and shifting horizontal axis is continued in the upper part by the position of the arms. Structured Classical frontality is here giving way to three-dimensional movement.

Alexander the Great

Portraits of Alexander were numerous, and the sources tell of characteristics – unruly hair and a certain set of the head – by which he might be recognized. Inscribed busts and coins help. Yet there is nothing to identify a portrait by Lysippos. The different heads of Alexander (fig. 9.34) have hair that varies in length but that is always recognizable by the characteristic off-center parting, the ANASTOLE, and by plentiful curls. The set of the head also varies and does not always have the challenging upward turn, and different heads suggest different ages. Yet

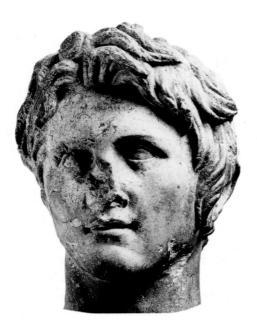

Alexander still appears idealized as a superhuman regent type. Individualized, physical traits do not predominate.

The difficulty in arriving at a secure sense of what Alexander looked like is matched by the difficulty in attempting to assess his temperament. The written sources are not eyewitness accounts and are invariably biased one way or another. Yet Alexander's achievements (see pp. 289–90) during his decade of marching and fighting are almost beyond belief. He was thought to be descended from Herakles (hence the lionskin helmet he wears in figure 9.39) and in appearance to have resembled Helios, the sun god. Lion-like in the blaze of his eyes and the strength of his presence, he was not averse to bouts of heavy drinking. His temper was quick. He liked to hunt and kill; the more formidable the quarry, animal or human, lion or Persian, the better.

> **9.34** Above left Head of Alexander. Roman copy of a c. 330 BC Greek original. Marble. Height 15½ ins (39 cm). Dresden Museum, Germany

9.35 *Left* Grave stele of Dexileos: battle scene. c. 390 BC. Marble. Height 4 ft 7 ins (1.40 m). Kerameikos Museum, Athens

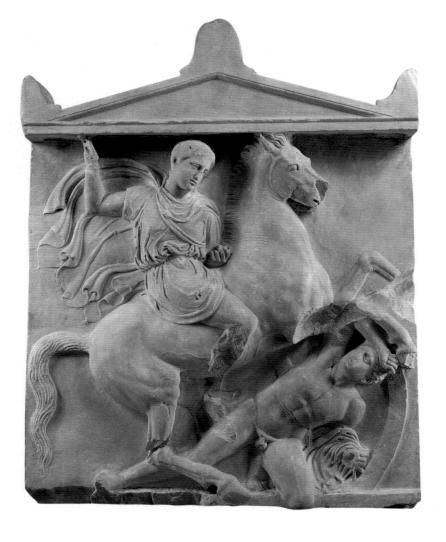

The Macedonian boy became a man by hunting and killing a Macedonian wild boar: this entitled him to recline, not sit, at symposia. Another badge of manhood was a special belt that could be worn after killing an enemy. In passing both these tests by the time he was only sixteen years of age, Alexander established himself as the model of Macedonian male virtue. This was a reputation to be honored and polished.

Scenes of hunting and battle are common in the art of the Macedonian world (see p. 333) and it is tempting to see Alexander in some of them. He is there in the thick of the battle on the Alexander Sarcophagus (fig. 9.37) and on the Alexander Mosaic (fig. 9.46), and has been identified in the hunt scenes on the façade of the Tomb of Philip (fig. 9.56) and on the Alexander Sarcophagus and, somewhat ambiguously, in the Lion Hunt mosaic from Pella (fig. 9.65). He seems not only to have subscribed wholeheartedly to the Macedonian ethos of the hunt and the kill, but to have relished these emblems of status and enjoyed the sight of blood.

Relief sculpture, other than architectural, is most commonly seen in grave reliefs, which were produced in great quantity in Athens throughout the century, until sumptuary laws forbade their production in around 310 BC. Quality varies greatly, from stock pieces turned out by hacks to be personalized by the addition of inscriptions and epigrams, to others that demonstrate the skills of master sculptors. Many of these stelai have an architectural framework of antae and pediment within which figures are shown. The figures are worked in relief, which gets higher and higher over the century, until by the end some figures are almost entirely in the round. Figures on the stele of Dexileos (fig. 9.35) are already in high relief. An inscription identifies this gravestone as that of a young man killed in action against the Spartans in 394 BC. Here he lunges from horseback at a fallen enemy; spear and reins were added in bronze. The horse and horseman are reminiscent of the Parthenon frieze, and the billowing drapery echoes that of the Nike balustrade (fig. 8.29, p. 268), but Classical restraint - both physical and mental - is now replaced by all-out violence and collapse.

In the Ilissos Stele from later in the century, figures are more fully in the round (fig. 9.36). Notable for the number and variety of figures, including

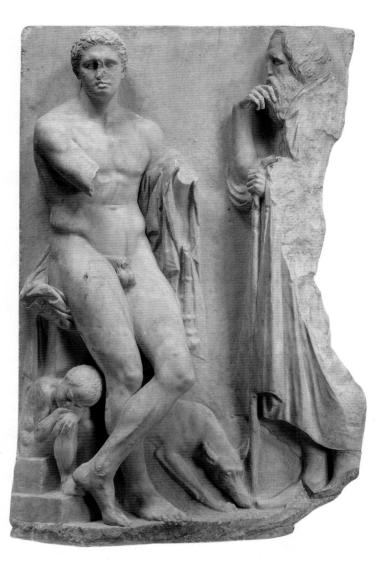

9.36 Ilissos Stele, found near the river Ilissos: father, son, boy, and dog. c. 330 BC. Marble. Height 5 ft 6 ins (1.68 m). National Museum, Athens

a grieving old man, a dead youth, a sleeping boy, and a dog, and for spatial effects, the relief is split vertically in two down the middle. The dead youth, isolated from his companions in life, gazes evenly at the visitor. The youth is in style close to the work of Skopas: he has a squarish head with deep-set eyes and bulging brows. Varied views of the torso, legs, and feet introduce torsion into the body. The pathos of the scene is blatant. Sorrow and loss in this personal and domesticated scene are openly stated by powerfully modeled expressive figures. The relief was made around 330 BC.

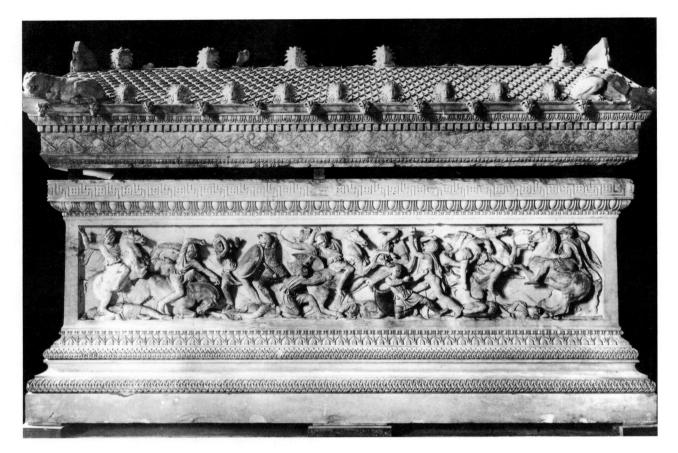

9.37 Alexander Sarcophagus (more likely the sarcophagus of Abdalonymos), from Sidon: battle scene. c. 320 BC. Marble. Height (of frieze) 10³/₂ ins (27 cm). Archaeological Museum, Istanbul

The influence of the Athenian grave reliefs may be detected in the West. From Taras comes a series of softstone reliefs, the style and mood of which are close to developments in Greece. These reliefs decorated miniature temples erected above the chamber tombs of the fourth-century aristocracy. One relief shows Electra and Orestes at the tomb of Agamemnon (fig. 9.1). The posture of Orestes has similarities with the sculpted column drum from the new Artemision at Ephesos and hence with the style of Skopas. The inclined heads and sorrowful expressions, speaking of profound sadness and the brevity of life, derive from Athenian grave reliefs. It is apparent that these Tarentine sculptors were wholly familiar with the major workshops of Greece. At the same time, the dramatic gestures and intense expressions of their figures anticipate Hellenistic sculpture. These reliefs were made around 300 BC.

Panels with sculpted figures in relief appear on a group of marble sarcophagi (coffins) found at the

other side of the Greek world in the tombs of the kings of Sidon, the famous city on the Phoenician coast. One of these, the so-called Alexander Sarcophagus, carries the only original contemporary representation of Alexander himself. The coffin (fig. 9.37) is shaped like a temple, rich with architectural moldings framing the frieze panels on all four sides of the rectangular chest, and resplendent with akroteria, waterspouts, and watchful lions at the corners of the roof. The lid of the coffin, which was worked separately, had sculpted figures of Greeks fighting Persians in the pedimental gabled ends. The short sides of the chest show a hunting scene and a battle scene in full throng. One long side shows Greeks and Persians hunting together, while the other depicts Greeks and Persians fighting. Some Greeks are nude; Persians wear traditional costume. Figures were carved with great precision and painted. The colors are well preserved and include purple, blue, yellow, and various shades of red for garments (fig. 9.38). **9.38** Detail of the Alexander sarcophagus, hunt scene; color reproduction by F. Winter (1912)

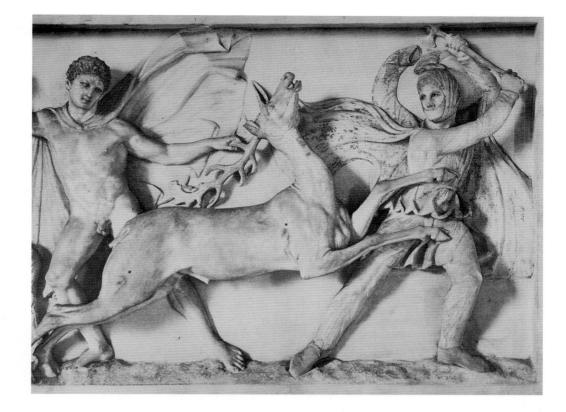

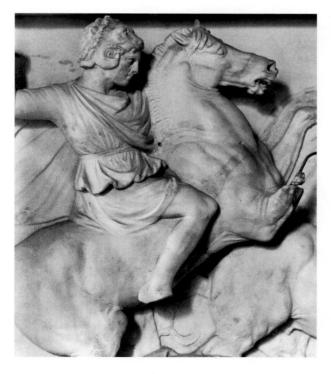

9.39 Detail of the Alexander Sarcophagus: Alexander with lionskin helmet

Flesh is painted in a light yellow wash for Greeks and a darker yellow for Persians, while hair is often accentuated with color, as is sometimes the iris of the eyes. The compositions are dense with crowded figures in closely interlocking groups. In the hunting scene, rearing horses, brandished weapons, and fluttering drapery all emphasize the action of the overlapping figures. In the battle scene, Alexander is on horseback and wearing the lionskin helmet of Herakles (fig. 9.39) that he wears on contemporary coins. With spear poised, he attacks a Persian whose horse collapses beneath him. Alexander's face is young and smooth, his eyes painted with highlights. The intensity with which he charges is matched only by his expression. Alexander alone of the figures can be identified with certainty. The prominently placed man in the middle of the hunting scene was probably the person buried in the sarcophagus. He has been identified as Abdalonymos, who was made king of Sidon by Alexander after the Battle of Issos in 333 BC. The sarcophagus was probably made around 320 BC.

POTTERY

In spite of disruptions following the end of the Peloponnesian War, potters continued at work in the Kerameikos in Athens and painters continued with decoration using the red-figure technique. A leading exponent of the early years of the century was the Meleager Painter, a good example of whose work is provided by the interior of the cup (fig. 9.40) with figures of Dionysos, a woman with a tambourine, perhaps Ariadne, and Eros. This was painted around

9.40 Attic red-figure cup by the Meleager Painter (interior): Dionysos, Eros, and female. c. 390-380 BC. Width $9\frac{1}{2}$ ins (24 cm). British Museum, London

390–380 BC. His Dionysos is a beardless, helpless stripling, with little apparent divine authority. Except for Eros in flight, the painter keeps his figures on a single groundline, and ignores many of the luxuriant characteristics of the Meidias Painter (pp. 283–4).

The florid style of the latter is, however, followed in what is known as the Kerch Style, so called from the site in southern Russia where numerous Athenian vases of the fourth century BC have come to light. The style used added color to great advantage, especially yellow, white, and gold, but also blue and green, and its figures were drawn in a less detailed and fussy way than those of the Meidias Painter.

This last flowering of Athenian red-figure took place in the years either side of the middle of the century; a PELIKE (storage jar) by the Marsyas Painter

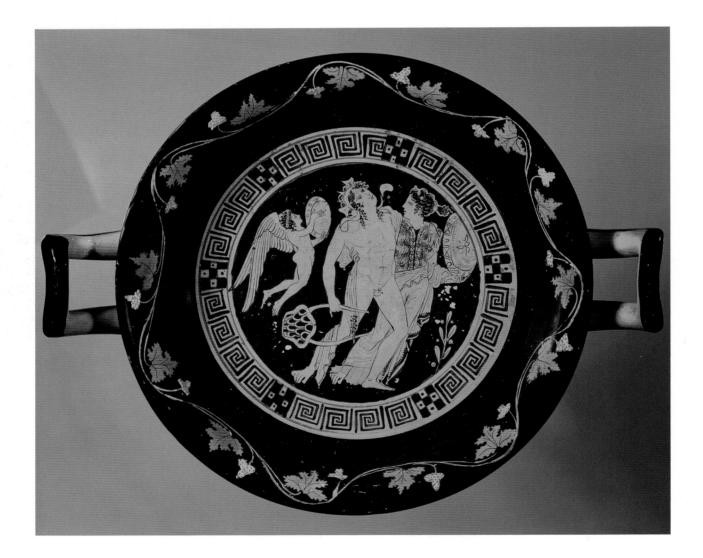

provides a good example. The scene (fig. 9.41) shows Peleus about to capture Thetis. Eros is crowning Peleus, who is surrounded by NEREIDS and is being attacked by a snake. The postures are striking in their originality. The crouching figure of Thetis wheels toward her captor, revealing her body in several views, her head upturned. Meanwhile a naked Nereid, fleeing away, twists her body to show a full view of her back, her legs almost in profile, and a back view of her head. Here is a master at work. Everywhere there is added color. White is used for Thetis and for Eros, gold for Peleus's hat, for the fillet that binds Thetis's hair, and for part of Eros's wings. Other parts of the wings are blue, while green appears on the drapery over Thetis's knees. Drapery is no longer transparent, but has the same renewed solidity and texture as the drapery of sculpted figures of this time. This pelike was made around 360-350 вс.

In spite of the virtuosity of painters like the Marsyas Painter, by the third quarter of the century pottery production in Athens was weakening, and around 320 BC it stopped altogether. Exports to the West had been checked by the success of the South Italian workshops, and soon after 325 BC other markets – North Africa, for example – began to take South Italian, not Athenian, products.

From the middle of the sixth century BC, the Athenians had awarded amphoras of olive oil as prizes in the Panathenaic games. These are known, predictably enough, as Panathenaic amphoras and were decorated in black-figure, with Athena on one side and a scene from the games on the other. Even after the introduction of red-figure, black-figure continued to be used for these specialized vessels. By about 375 BC, painters were inscribing the name of the "archon," chief magistrate, of the year on these pots, so that many can be dated precisely. The example shown (fig. 9.42) has the name of "Niketes," archon in 332-331 BC, inscribed on it, a handsome striding armed Athena on one side and on the other a scene from the "pankration" (wrestling and boxing, with no holds barred, except for biting and eye-gouging).

These amphoras give some idea of the value of the prizes at the games, and allow speculation about the motivations of athletes. The prizes were large quantities of olive oil (in the amphoras): for example, the winner of the boys' 200-metre sprint took away

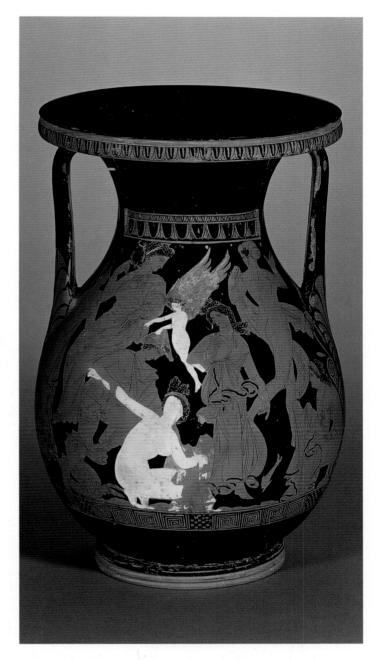

9.41 Attic red-figure pelike by the Marsyas Painter: Peleus, Thetis, Eros, and nymphs. c. 360–350 BC. Height 16½ ins (42 cm). British Museum, London

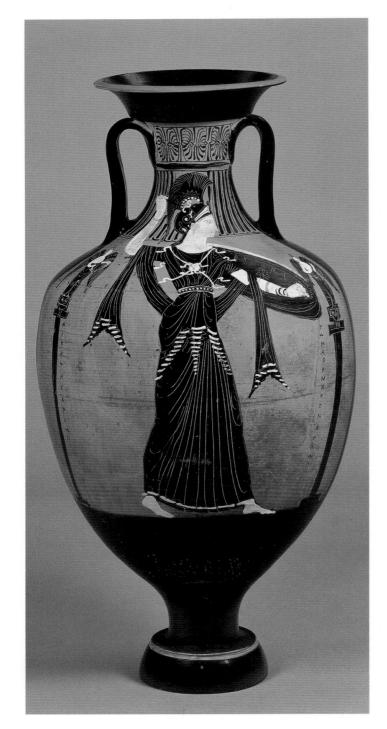

9.42 Attic Panathenaic amphora: striding Athena. c. 332–331 _{BC}. Height 30 ins (77 cm). British Museum, London

five hundred gallons of oil, and the winner of the men's a thousand. These quantities were too large for the individual winners and their families to use; but they could be resold. At a rate of twelve drachmas for a ten-gallon container, a winner might collect as much as 1,200 drachmas. Inscriptions from the Athenian Acropolis tell us that in the fifth century BC a wage for a mason or a carpenter was one drachma a day. So an athletic winner might earn the equivalent of three years' wages very rapidly: these contests evidently brought not only glory and status to the winner, but money too.

As for undecorated tableware, black gloss wares remained popular, while coarse wares for cooking vessels and transport amphoras continued in widespread use.

In the West, the production of red-figure vases increased. Vases continued to be imported from Athens, but in much-reduced numbers. There were four major domestic workshops, of which two, the Apulian and the Lucanian, had been active in the fifth century. Around 380 BC, another workshop was set up in Campania, and, around 350 BC, a fourth came into being at or near Poseidonia (Paestum). Of these four, the Apulian and the Paestan are perhaps the most significant.

The Apulian painters practiced two styles: the Plain and the Ornate. The Ornate tended to be used on large vases, such as the volute krater, which was often associated with burials. About 375 BC, an imaginative painter, often thought to be the Ilioupersis Painter (so called from a Sack of Troy painted on one of his vases - Ilion = Troy, Persis = sack), introduced the notion of decorating these funerary vases with funerary scenes. A volute krater in the British Museum in London (fig. 9.43) provides an example. The principal scene shows a miniature temple building of the same shape as contemporary tombs in Taras, in front of which the dead youth leans on a PERIRRHANTERION, a ritual water basin. Seated and standing figures round about have brought offerings to the tomb. There is much added white: for the building, the youth, the perirrhanterion, for gifts, and for dotted groundlines. Figures in low relief cavort on the handles. Most notably there are varied viewpoints: the seated youth, the stool on which he sits, and the gable of the building (including the coffered ceiling) are seen from below, while the perirrhanterion and the lower step of the building

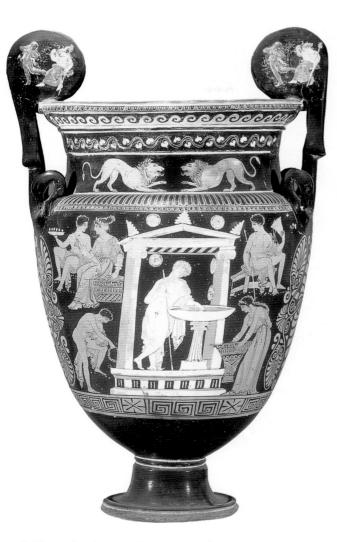

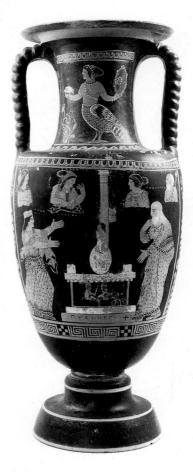

9.43 South Italian (Apulian) red-figure krater attributed to the Illioupersis Painter: visitors at a tomb. c. 380-370 BC. Height 2 ft 3 ins (69 cm). British Museum, London

9.44 South Italian (Paestan) red-figure amphora by Python: birth of Helen from the egg. c. 350 BC. Height 24⁴/₂ ins (63 cm). Paestum Museum

are seen from above. Such attempts at spatial depth and perspective remind us that the latter had been investigated in fifth-century Athens, where the pioneer, the literary sources say, was Agatharchos of Samos.

The workshops at Poseidonia were active around the middle of the century. Around 400 BC, the city had been taken over by peoples from the surrounding hills, the Lucanians, but Greeks continued to live and prosper here, as is evident not least from the red-figure pottery produced mid-century. Two of the principal artists are known to us from their signatures, and they alone of all South Italian potters and painters signed their work. Their names are Greek: Assteas and Python. They signed in Greek on their vessels, and they used episodes of Greek myth and theater as the subjects of the scenes they painted. Vase shapes, too, are Greek: the hydria, krater, LEKANE (a lidded dish or plate), lekythos, and amphora.

An amphora by Python (fig. 9.44) shows the birth of Helen, who emerges from a large white egg, placed on an altar, while bystanders look on with expressions and gestures of astonishment and surprise. Divinities above smile in amusement and seem to forget Helen's destiny and the fate of Troy. A

9.45 A phlyax vase. A South Italian (Paestan) red-figure krater by Assteas: scene from a phlyax (burlesque) play. c. 350 BC. Height 14½ ins (37 cm). Staatliche Museen, Berlin

master of irony, Python signed his name prominently on the plinth below the altar.

Other scenes derive from contemporary colonial comic theater and typically highlighted tubby, grotesque, oddly clad male actors on a wooden stage. These PHLYAX plays often parodied the heroic tales that had been the staple diet of the Athenian tragedians. The phlyax vase illustrated (fig. 9.45) is a calyx krater painted and signed by Assteas. On a stage supported by columns, burglars attempt to separate a miser from his strongbox. The actors all wear masks, padded tunics, and leggings, and are equipped for comic effect with exaggerated genitalia. These vases may provide a glimpse of what the comedies of Aristophanes in fifth-century BC Athens looked like.

WALL PAINTING AND MOSAICS

Alexander's court sculptor was Lysippos, who came from Sikyon in the northern Peloponnese. His court painter was Apelles, an Ionian who had studied at Sikyon, where Pamphilos began a school for painters in the middle of the fourth century BC. Pamphilos was instrumental in introducing painting into the educational curriculum for Greek youths and insisted on the study of geometry and arithmetic as integral to it. Apelles was famous for his portraits and for his paintings of Aphrodite. Once again, literary authors are the principal source of information

9.46 Alexander Mosaic: the culminating moment in the Battle of Issos between Greeks and Persians, the confrontation between Alexander and Darius. Floor mosaic from Pompeii, an adaptation of a Greek wallpainting of c. 310 BC by Philoxenos of Eretria. 1st century BC. 8 ft 10 ins \times 17 ft (2.7 \times 5.2 m). National Museum, Naples

about painting and painters in this period. The archaeological record is thin, only enlightened by the wall paintings which decorated Macedonian tombs, more and more of which are coming to light.

Suitable topics for wall paintings in the fourth century were often mythological, showing scenes such as Hades carrying off Persephone, or Perseus freeing Andromeda (fig. 9.49). Landscape elements were entirely secondary, used only to suggest setting, though painted stage sets in the theater, which certainly depicted architecture, may also have shown landscape. As in the fifth century BC, wall paintings still used a four-color palette: black, white, red, and yellow. But what the paintings were actually like is still, and is likely to remain, problematical.

Like statues, however, important Classical paintings were copied by the Romans, and though probably differing from their originals in several ways, wall paintings and mosaics from Pompeii and Herculaneum may help us understand what Greek painting was like. The so-called Alexander Mosaic (fig. 9.46) from the House of the Faun at Pompeii, of Hellenistic date, is taken by many scholars to be derived from a monumental wall painting by Philoxenos of Eretria of about 310 BC, of which we are told by Pliny. This floor mosaic, and the wall painting on which it draws, seem to depict the turning point in the Battle of Issos. This is seen by Philoxenos as a personal duel between Alexander and Darius, the Persian king. Alexander charges forward toward Darius, transfixing with his lance a Persian who stood in his way. Wild-haired, helmetless, with shining armor and eyes alight, his attack is irresistible. Darius in his chariot stretches out an arm toward the conqueror, while his dark horses speed away. The background is empty, articulated only by lances held aloft and a blighted tree, which balances Darius in the composition. Except for the debris of battle, the foreground is equally empty. Attention concentrates on the figures, modeled with foreshortening and bold use of light and shade. Persian garments are rendered accurately in fourth-century terms, a strong suggestion that the mosaic is a reliable facsimile of Philoxenos's painting.

The small cubes (TESSERAE) of which the Alexander Mosaic is made are of colored glass and stone. In earlier centuries, mosaics were made of pebbles, as seen in the houses at Olynthos. But the art of deco-

9.47 Bellerophon and the Chimaera (central medallion) with floral, maeander, and wave surrounds, from Olynthos. Early 4th century BC. Pebble mosaic. 9 ft 10 ins \times 9 ft 10 ins (3 \times 3 m)

rating floors with mosaic had begun much earlier than this. As early as the late eighth century BC, floors at Gordion in Phrygia had been made of pebbles arranged in simple patterns of black, white, and, very occasionally, red stones. Phrygia was a kingdom of central Anatolia – modern Turkey – so these are not really Greek mosaics. But we know of connections between Greeks and Phrygians, and these mosaics may be thought of as precursors of Greek mosaics. The earliest examples so far recovered of Greek pebble mosaics date to the end of the fifth century BC. They are basically black-and-white, carefully planned, and make use of easy, abstract designs, such as squares and maeanders, alongside floral patterns. Very occasionally they feature human and animal figures.

At Olynthos, these simple black-and-white pebble mosaics predominate, but some are more advanced, and show figures of animals and humans and mythological scenes. In one example (fig. 9.17), the central panel, rectangular in shape, shows Dionysos and his chariot drawn by leopards and is itself surrounded by dancing and hunting members of his retinue. Another example (fig. 9.47) has a circular central medallion with a mythological scene, Bellerophon and the Chimaera, surrounded by florals, a maeander pattern, and a wave pattern. The design is carefully planned, but the drawing is disappointing, the contours of bodies and the folds of drapery being clumsily executed.

The later part of the fourth century BC shows great advances with the series of pebble floor mosaics from Pella, the capital of Macedon. A particularly good example shows a stag hunt (fig. 9.48) and was signed by the artist, Gnosis. The outer border, as at Olynthos, is a wave pattern, while the inner one is a riotous, curling floral design which frames the central scene. The comparatively small figured panel in the middle, surrounded by its dense patterned foliage, is termed an "emblema." As at Olynthos, this has light figures against a dark background, but now they have musculature modeled by shading, varied views of the body confidently dis-

9.48 Stag hunt, signed by Gnosis, from Pella (Macedon). c. 300 BC. Pebble mosaic. Height 10 ft 2 ins (3.10 m)

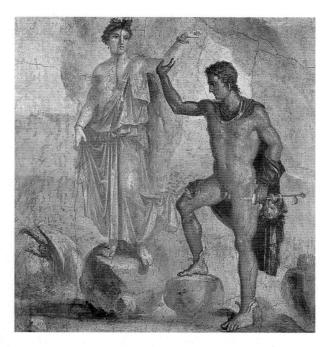

9.49 Perseus freeing Andromeda. From the House of Dioscourides at Pompeii, after a Greek original of the 4th century BC, perhaps by Nikias. 1st century AD. Wall painting. National Museum, Naples

played, and contours strengthened by strips of terracotta or lead. Pebbles are now much more closely packed and uniform in size. Colors other than black and white are used: yellows, browns, and reds are liberally added to highlight important details and contribute to the shading. All mosaics of the fourth century BC are pebble mosaics; the first mosaics made of tesserae did not appear until about 250 BC.

The sources for the mosaics' designs, techniques, and themes is a topic of eager debate. The great painter Apelles visited and worked in Pella, so his paintings may have provided one source for the Pella mosaics. Already in the fifth century, Apollodoros, Zeuxis, and their contemporaries had introduced the use of shading in monumental painting to express volume, so that knowledge of this technique, to name but one, must have been widespread among artists. Mythological themes were in common use for wall paintings, a case in point being the scene of Perseus freeing Andromeda which appears more than once on walls at Pompeii and may well go back to a fourthcentury original by a painter called Nikias (fig. 9.49). It is when there are only minor variations between paintings with the same subject that scholars suspect

THE THEATER AT ATHENS: WERE WOMEN IN THE AUDIENCE?

he choruses of song and dance from which Greek drama developed were first performed in honor of Dionysos in the Agora. During the fifth century BC the competitions were moved to the south side of the Acropolis to an actual theater of Dionysos, where the plays of the great tragedians (Aeschylus, Sophokles, and Euripides) were first put on. These competitions were an integral part of the festival of the Great (or City) Dionysia (so called to distinguish it from many other Dionysias held in the countryside), second only, at Athens, to the Panathenaia in importance. It was held annually in March. The festival began with a procession carrying an ancient statue of Dionysos across Athens to his main sanctuary on the south side of the Acropolis. The procession was followed by the sacrifice, and the sacrifice by the distribution of the meat and the feasting: we're told that in 334 BC no fewer than 240 cattle were sacrificed. Only when the rituals were all complete could the dramatic performances begin, three days devoted to tragedies and one to comedies.

Comedy was recognized as a competitive event as early as 486 BC, though no plays survive from this early date. The surviving plays of the famous dramatist

Aristophanes date from between 425 and 388 BC. Aristophanes drew on old traditions of song and dance which used choruses of dancers dressed as animals, birds, and insects. Some scholars think that the dancers costumed as birds that decorate a calyx krater now in the Getty Museum in California (fig. 9.50) depict characters from his comedy Birds, first performed in 414 BC.

Dramatic scenes appear on many Greek vases: for instance, Odysseus and Polyphemos (fig. 8.55, p. 287). The presence of satyrs in this scene suggests that the play that inspired the painting was a satyr play, perhaps the Cyclops by Euripides.

But who got to see these plays? Were the wives and daughters of Athenian citizens in the audience? There is no direct evidence beyond the lines of the plays themselves which make occasional (and often ribald) reference to the audience. Some of the jokes depend on double meanings (for example, the Greek krithai can mean either "oats" or "penis," haha), so it's pretty broad humor, and scholars vary in their interpretations. Some claim that references to the audience loaded with sexual innuendo argue the presence of women, others the opposite.

A recent hypothesis takes a different tack. Since the theater, the general assembly, and the lawcourts are all institutions ascribable to the political reforms of the later sixth and early fifth centuries BC, are they comparable? Women were not citizens and were not allowed in the assembly, nor could they speak in the lawcourts either as witness or juror. Does it follow that they weren't at the theater? What about other spectator events? At the Great Panathenaia they took part in the procession, they wove the peplos for Athena, but they did not enter the competitions. Did they watch? At the theater itself the

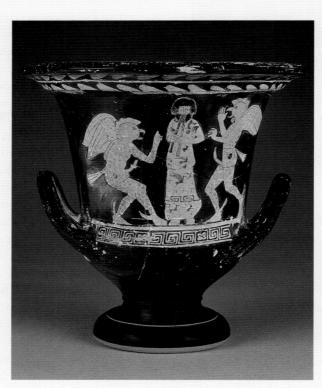

actors were males, and the competition was judged by males. Seating was arranged according to civic status. There were special seats for the military, priests, ambassadors, and members of the council; everyone else was seated according to tribal affiliation. Did women sit at the back? Were they there at all? What conclusions do you draw?

9.50 Attic calyx krater: dancers costumed as birds cavort on either side of a flute-player. Phalluses attached to their costumes are prominently displayed. Such props were only used in comedies. c. 420–410 BC. Getty Museum, California a common Greek original. It then becomes likely that Roman versions, whether paintings or mosaics, derive from Greek prototypes.

The question of tapestries, carpets, and rugs, however, also comes into play. About these homespun perishable objects, and the arts they represent, we are ill-informed, but know that textiles of all kinds existed and were valued, and it may be that the more striking of the woven textiles were influential and also provided a stimulus to the creation of mosaics, particularly border designs.

MACEDON

At the beginning of this chapter, we noted the impact of the Macedonians on the military and political history of Greece and of the eastern territories they conquered. We also made reference to the advent of the institution of kingship and its two most famous exponents, Philip, father of Alexander the Great, and Alexander himself.

In what ways does this Macedonian kingship manifest itself in the artistic and archaeological record? How and with what purposes in mind did kings and other powerful members of Macedonian society use art? What innovations did they introduce, and what borrowings of style, theme, and concept did they make? Did they and their artists and architects draw on earlier Greek traditions? Did they make use of ideas from other cultures? Much of the evidence comes from two major sites, Vergina (ancient Aegae, the first capital of the kingdom) and Pella (the city to which the capital was transferred c. 400 BC). Since the three critical areas of evidence (architecture, wall painting, and mosaics) are structurally inextricable, this section is divided by site rather than by medium.

Vergina

Kingship called for an architecture of status and spectacle for monarchs while they were alive, and of commemoration and glorification after death. As such, palaces and tombs became prime sites of royal patronage and architectural energy.

The palace of Vergina (fig. 9.51) was built in the western part of the city as the central structure of a complex that also comprised the agora and the theater (the latter was the site of the assassination of Philip in 336 BC). The whole sector was constructed in the second half of the fourth century. The palace's huge size – around 115×100 yards (105×90 m) – shows that it functioned both as a residence and a reception/administrative center. The plan consists of a large Doric peristyle court, with sixteen columns

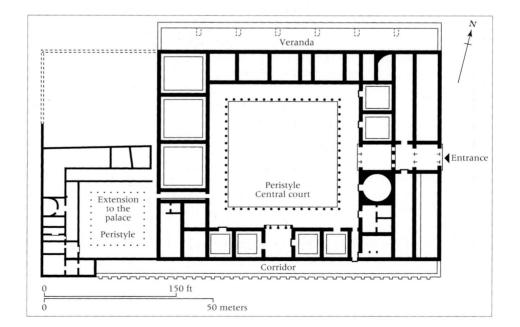

9.51 Plan of the palace at Vergina. Later 4th century BC and Hellenistic

on each side, surrounded by systematically arranged rooms. A smaller peristyle unit to the west, added in the Hellenistic period, provided space for kitchens, storage, and related service activities. On the south side of the large peristyle court two pairs of formal dining rooms with mosaic floors were the location for the celebrated Macedonian SYMPOSIA, while three larger chambers on the west offered yet grander spaces for banqueting. A veranda along the north side gave spectacular views across the city, the river Aliakmon and over the plain, while entrance was from the east through an impressive deep porch furnished with white marble thresholds. Flanking the entrance to the north was another pair of reception/dining chambers, and to the south the circular shrine of Herakles Patroos, the deity claimed as a forefather by Philip and indeed by Alexander himself. Mosaic floors, marble thresholds, and stuccoed walls combined with the sheer size of the complex to create an overwhelming impression of wealth, authority, and raw power.

The palace functioned as the residence of the king, his family, and entourage; a second story over the east wing perhaps contained the royal apartments. But the size of the complex and the room shapes point to banqueting as well as residential activities. Did the size of the chambers indicate the rank of those who used them, and was the Macedonian practice of communal dining and drinking by members of the elite a conscious emulation of earlier Greek usage? The architects drew on the traditional Greek peristyle house for the plan; but this was much more than an enlarged house, and the veranda to the north, for example, was unprecedented. Whether they also drew on Eastern and more specifically Persian impulses is not clear. Many Persian ideas were current in the Greek world (e.g. in the Mausoleum at Halikarnassos, see p. 302), but several architectural elements (e.g. the hypostyle hall) used in Persian palaces were not used in Macedonian ones, although they do appear in other buildings in the Macedonian and Hellenistic world.

This impressive and elaborate palace catered to the royal appetite for splendor and grandeur; it also provided for the comforts of the royal family and their retinue, and offered imposing and dazzling perspectives for their visitors.

The king's wish to create symbols of success and power was not confined to home, and the fourthcentury BC building at Olympia known as the Philippeion (fig. 9.52) provides a conspicuous example of royal propagandistic skill outside Macedon. This structure was entirely politically motivated: it was erected in the most important panhellenic sanctuary, and its message was the necessary acceptance of Greece's subservience to Macedon. Pausanias says that the portrait statues of Philip's family inside the building were made of gold and ivory, gleaming luxury materials often reserved for images of deities, as the huge Pheidian Zeus in the adjacent temple of Zeus would have reminded visitors. A recent study suggests, however, that the figures were made of gilded marble and not of gold and ivory. Were they intended to lend heroic status to the Macedonian kings? Was the Philippeion erected adjacent to the Pelopion, the grave mound of Pelops, the local hero, merely by chance?

The cemeteries of Vergina stretch northward from the city, burials there ranging in date from c. 1000 BC to the Roman period. Several early burials are found inside and beneath mounds of earth (tumuli), each one containing within its defining cir-

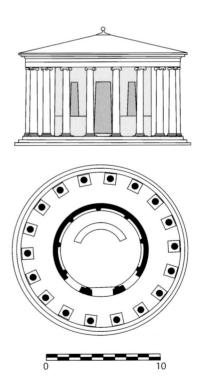

9.52 Olympia, Philippeion. Plan and reconstruction drawing. c. 330 $\mbox{\tiny BC}$

cle of stones between five and fifteen inhumations, both male and female. Grave goods of jewelry, weapons, and pottery suggest the social status of the dead. Graves of the sixth and fifth centuries BC again reveal a stratified society with increased trading links to the south: much Attic and Corinthian pottery and copious amounts of jewelry have been found, reflecting the prosperity of the settlement and the wealth of the individuals buried. It is against this background that the built chamber tombs, the so-called "Macedonian" tombs of the fourth century and Hellenistic period, should be seen. Their appearance and their contents both commemorated and glorified the royal and aristocratic dead they sheltered.

These tombs appear to have developed from plain burial pits, sometimes lined with stone (cist burials) and with wooden or sometimes stone roofs, concealed inside a tumulus. In the fourth century they become stone-built chambers with stone barrel vaults, elaborate façades, and imposing doorways. The technical innovation of the self-supporting barrel vault was of prime significance, since it effectively resisted the pressure of the earth mound above. An antechamber and a passageway, filled with earth after the burial, often preceded the tomb chamber.

There are upwards of a dozen of these Macedonian tombs in the neighborhood of Vergina, but they appear elsewhere in Macedonia too, and more and more are coming to light (at Pella, 1994; at Aghios Athanasios, with a painted frieze above the lintel depicting a Macedonian symposium, 1995; at Phagris, 1998). The type was evidently used by regional chiefs as well as by royalty and court members. The best-known examples of the type, however, were found between 1976 and 1980 during the excavation of the manmade mound known as the Great Tumulus (around 330 feet [100 m] in diameter and 42 feet [13 m] in height) at Vergina. Within the tumulus were found two plundered tombs, two tombs that had not been robbed, and the remains of a heroon: the mound of earth had been piled above these monuments as a protective measure some fifty years after their construction.

One of the plundered tombs, the Tomb of Persephone, provides a splendid example of fourth-century wall painting. A frieze on an interior wall depicts the mythological scene of Hades carrying off Persephone (fig. 9.53). Persephone flings herself sideways to escape, arms outstretched toward her kneeling and

9.53 Hades carrying off Persephone. Tomb of Persephone, Vergina. c. 340 BC. Wall painting. Height (of frieze) c. 3 ft 4 ins (1 m)

terrified companion, who is being left behind (fig. 9.54). The painter used perspective to create an illusion of depth (the wheel of the chariot) and shading to lend volume to the faces and the drapery. Brush strokes are rapid; color, fine composition, a sense of movement, and deft drawing, especially of facial features, combine to create a moment of high drama. As was fitting, the painting deals with death, but the myth promised life too to Persephone, so the message was of hope as well as separation. A comparison with the painting of the Tomb of the Diver (figs. 7.48 and 7.49, p. 247) suggests how far painting has changed in the interim.

9.54 Persephone's companion, kneeling to gather flowers when surprised by Hades' capture of Persephone. Tomb of Persephone, Vergina. c. 340 Bc. Wall painting

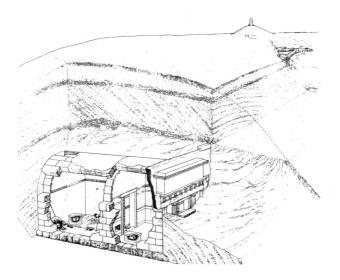

 $9.55\,$ Perspective drawing of part of the Great Tumulus at Vergina. Tomb of Philip. c. 340-310 $_{BC}$

The Tomb of Philip, which some scholars identify as that of Philip III Arrhidaios, half-brother and successor to Alexander, rather than of Philip II, father of Alexander, provides an exceptionally fine example. Hidden beneath the mound (fig. 9.55), an approach passageway, an antechamber, and a main chamber comprise the tomb. Each chamber was approached through a two-leaved marble door and was covered by a barrel vault, the combined length of the two vaults being about 11 yards (10 m). None of the interior walls features figurative paintings. The façade (fig. 9.56) is decorated with Doric columns and a Doric frieze, thus echoing the appearance of some temple architecture – and perhaps that of palatial façades too, of which we know little as yet.

A painted course above the frieze provides the most eye-catching feature of the façade. The scene depicts young men hunting. Some are naked, some are clothed, some are mounted on horses, some are on foot. They are chasing different animals: a lion and a boar in the center of the painting, a deer to one side and a bear to the other. These activities take place among many landscape elements: trees, hills, and boulders. The composition is enlivened by diagonal lines that give a convincing sense of receding space, and by the varied postures and views of horses and humans. Yet the background is flat; the topography is important as setting, but it is the hunters and their quarries that are the focus of attention. This is hardly an image of a real hunt, but rather a complex amalgamation of heroized aristocratic activities. The Vergina painting gives us an inkling of the techniques and skills deployed in earlier Classical Greek mural painting. At the same time, the theme of the hunt is more at home in the world of the Persians and, introduced here from a traditional Near Eastern iconography, gives a good example of cultural borrowing. The size of the tomb and the appearance of the façade were the external signs of the majestic riches found within.

A marble sarcophagus in the antechamber contained a gold LARNAX, or chest, the lid emblazoned with a star. Inside the burnt bones of the deceased were found wrapped in a gold and purple cloth. The metal, emblem, and colors are all regal, and along with the mode of burial are reminiscent of Homer's description of the shroud and golden larnax for the bones of Hector (*Iliad* 24.795–6). Another, larger marble sarcophagus **9.56** Tomb of Philip at Vergina. Doric façade, with painted course showing hunt scene. c. 340–310 BC

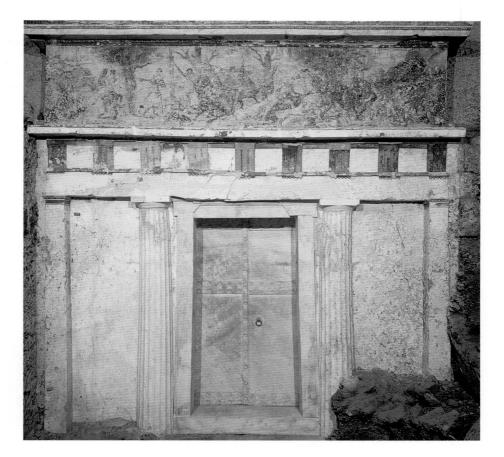

in the main chamber contained a more elaborate gold larnax (fig. 9.57) decorated with lotus-andpalmette and rosette registers and with lion's-paw feet; the symbol on the lid is the great raved star well known from Macedonian shields and coins. Inside were the burnt bones of the dead. Atop them was a heavy gold wreath of oak leaves and acorns (fig. 9.58), undoubtedly a crown. Offerings for the dead were found on either side of the sarcophagus: bronze and iron weapons, armor, tripods, and bronze vessels on one side, silver vessels (fig. 9.59) and pottery on the other. Noteworthy is the silver container (fig. 9.60) with the head of Herakles, favored hero-deity of Macedonian kings, in relief. It is doubtless the assertion of kinship with Herakles that justified the kings' claim to rule: it was divine right.

In front of the sarcophagus were the remains of a funerary couch to which a number of small ivory heads in relief had been attached. Over a dozen of these were found, and the excavator believed, by comparison with other known or conjectural images of the royal family, that some could be identified

9.57 Larnax, containing bones of the dead, from the Tomb of Philip, Vergina. c. 340–310 _{BC}. Gold. $16\frac{2}{3} \times 13\frac{3}{3} \times 8\frac{3}{3}$ ins (40 \times 33 \times 21 cm). Archaeological Museum, Thessaloniki

9.58 Above Oak leaf and acorn crown, from the Tomb of Philip, Vergina. c. 340–310 sc. Gold. Diameter 7¼ ins (17 cm). Archaeological Museum, Thessaloniki

9.59 *Below* Banqueting vessel, from the Tomb of Philip, Vergina. c. 340–310 BC. Silver. Archaeological Museum, Thessaloniki

9.60 *Right* Vessel, with head of Herakles, from the Tomb of Philip, Vergina. c. 340–310 _{BC}. Silver. Archaeological Museum, Thessaloniki

with specific individuals: Philip and Alexander, for example. The heads certainly exemplify the emotional and expressive tendencies in fourth-century sculpture and effectively describe both age (fig. 9.61) and youth (fig. 9.62). Their individuality allows their interpretation as portraits.

If the Vergina heads do represent members of the royal family, they provide another example of their patrons' interest in emphasizing dynastic continuity and creating royal imagery for propaganda purposes. These buried images would not have been visible for long, but the funeral and the preceding events offered ample time for spectacle. For Macedonian interest in funerals and ceremony generally as instruments of propaganda we have only to think of the sumptuous and impressive cortege honoring the dead Alexander himself – the carriage combining Macedonian and Persian elements in a display of the intended harmony of Alexander's world – wending its long way homeward from the East. **9.61** Head of an older male, from the Tomb of Philip, Vergina. c. 340–310 BC. Ivory. Height 1½ ins (3.4 cm). Archaeological Museum, Thessaloniki

9.62 Head of a younger male, from the Tomb of Philip, Vergina. c. 340–310 BC. Ivory. Height 1½ ins (3.4 cm). Archaeological Museum, Thessaloniki

9.63 Krater, from Derveni. c. 330 BC. Gilded bronze, copper, and silver. Height 3 ft (92 cms). Archaeological Museum, Thessaloniki

Other examples of cultural borrowing and amalgamation, and of conspicuous expenditure, abound in Macedon: the krater from Derveni (fig. 9.63), now in Thessaloniki, is a good example. This 3-foot (1-m) tall vessel of gilded bronze (? - the color may be due to the amount of tin in the bronze rather than gilding), copper, and silver was found in a tomb: the materials used and the extravagant decoration of handles, neck, shoulder, and body speak of the wealth and status of the patrons. At the same time the style of the principal figures, Dionysos and Ariadne, is wholly fourth-century Greek, while the drapery of the dancing maenads echoes in stylized fashion that of the personifications of Nikai from the parapet on the Acropolis in Athens (fig. 8.29, p. 268). Here Greek style is appropriated and manipulated for Macedonian delight.

Pella

The capital of Macedonia was moved from Vergina to the small township of Pella around 400 BC. The site benefitted from being in the eastern part of the realm, offering improved communications north and further east where serious Macedonian interest lay. A large city was planned on the Hippodamian model (see p. 299) which included a large agora, sanctuaries, private houses, and a palace of generous proportions. The latter was sited on a hill to the north overlooking the city, and occupied about 15 acres (60,000 sq m). It was built in five architecturally independent groups of structures on different terraces linked by corridors, passageways, and colonnades. Each unit was planned around a traditionally Greek peristyle court: one such unit served as the residence of the royal family, another as apartments for the staff. There are rooms for banqueting and for religious activity, for storage and for workshops; there is a gymnasium and a swimming pool. The palace presented a long colonnaded façade to the city, an impressive sight; while the view from the palace over the city and countryside underscored the rulers' all-encompassing power. With its emphasis on spectacular perspectives from within and without, this palace may be thought to anticipate the Hellenistic penchant for architectural theatricality so carefully exercised later by the kings of Pergamon (pp. 339–40).

Residential architecture at Pella is important for the scale of some of the houses and for the luxurious decor, best exemplified by pebble mosaic floors. The houses are arranged in the city's grid plan in accordance with their size, the largest to the south of the agora. There are two principal types, both drawn from the Greek tradition: the peristyle courtyard house and the pastas courtyard house (see pp. 301–2). Two of the largest are the House of Dionysos and the House of the Abduction of Helen, both named for the subjects of floor mosaics. The plan of the House of Dionysos is based on two peristyle courtyards, one of which uses Doric colonnades and the other Ionic; each is surrounded by living rooms and banqueting rooms. One of the latter is decorated with a floor mosaic showing Dionysos seated on a panther, thyrsos in hand (fig. 9.64). Was this a purely decorative theme for the reclining diners to gaze at? Or did it evoke the triumph of Dionysos returning from India, riding a panther, and in so doing allude to Alexander's conquests in the East? Did it draw on the

9.64 Pebble mosaic, from Pella: Dionysos riding a panther. c. 325–300 _{BC}. 9 ft 4 ins \times 9 ft 2 ins (2.70 \times 2.65 m). Archaeological Museum, Pella

same tradition as the Olynthos mosaic, which shows Dionysos in a chariot, drawn by panthers and surrounded by his retinue (fig. 9.17)? Another room in this house was decorated with a scene showing a lion hunt (fig. 9.65). Here, the hunters echo the striding and lunging figures of earlier Greek iconography and in particular the swordsman to the right resembles in posture and gesture the Harmodios of the Tyrannicides group (fig. 7.26, p. 230). For style, this hunt scene may be compared with the contemporaneous stag-hunt mosaic (fig. 9.48) from the House of the Abduction of Helen. The lion-hunt scene has little overlapping of figures and little use of shading;

9.65 Pebble mosaic, from Pella: lion hunt. c. 325–300 BC. 11 ft $1\frac{1}{3}$ ins \times 17 ft (3.2 \times 4.9 m). Archaeological Museum, Pella

9.66 Pebble mosaic, from Pella: the Abduction of Helen, better-preserved part showing a four-horse chariot and Theseus's charioteer, Phorbas. c. 325-300 Bc. 14 ft \times 9 ft 4 ins (4.20×2.80 m). Archaeological Museum, Pella

emphasis is given rather to diagonal lines and contours, with the result that there is little sense of space. By contrast, that of the stag hunt employs much overlapping (hound overlapping stag overlapping hunters), and subtle shading to produce illusionistic effects of mass and space. Thus, these two mosaics represent two different stylistic traits at work at the same time in the Macedonian capital. Yet in subject both refer to royal activities, and the hunt theme belongs unequivocally to royal iconography.

The mosaic of the Abduction of Helen from which the house derived its name is fragmentary but huge (c. 28 feet \times 9 feet 4 inches [8.40 m \times 2.80 m]). The four-horse chariot with its charioteer, Phorbas (fig. 9.66), explores the use of shading to express volume to full advantage (e.g. Phorbas's arms and drapery; the horses' withers) and the overlapping of horses to create an illusion of depth. The artists capture the drama of the moment: the horses rear and leap, eager to be off; Phorbas glances coolly to his left at Helen, who has fallen into the clutches of Theseus. This part of the mosaic is seriously damaged (and not shown in figure 9.66), but enough remains for Helen to be seen turning with imploring outstretched arms to a companion, in much the same way as Persephone gestures to Kyane in the wall painting from Vergina (fig. 9.53). May we detect the same motif at work and suggest a common source?

Macedonian mosaics and frescoes repeatedly depict hunts, rapes, and battles. These phenomena have recently been linked imaginatively with the hero-worshiping lifestyle of the local elite, though whether they are to be regarded primarily as reflections of reality or as projections from fantasy is unclear.

Lefkadia

The site of Lefkadia is located northwest of Vergina, and southwest of Pella, almost equidistant between the two. It is often identified with ancient Mieza, where sources tell us Alexander was taught by Aristotle. A further series of Macedonian chamber tombs has been found here which carries this tradition of richly painted tombs down into the second century BC (the Tomb of Lyson and Kallikles).

The most elaborately decorated of these (fig. 9.67) is important both in its architectural aspects and for its paintings. The architecture of the façade mixes the Doric and Ionic orders, and alludes certainly to earlier temple architecture and conceivably to contemporary palatial exteriors. It is highly ornate, almost baroque, but it does not lead to an imposing shrine within; it hides only a relatively simple tomb consisting of a pair of barrel-vaulted chambers.

The façade itself was made of stucco over limestone ashlars, with architectural and sculptural forms both molded and painted. Below the pediment stood Ionic half-columns with false (i.e. illusory) paneled doors between them, an architrave and denticulated frieze above, and a continuous Ionic frieze in painted relief depicting an Amazonomachy (Greeks fighting Amazons) below. The Doric half of the façade below was topped by an architrave and frieze with painted metopes showing Lapiths battling centaurs. While figures in the Ionic frieze were rendered in sculpture and paint, in the Doric portion only paint was used; the upper part of the façade was thus intended to appear more ornamental than the lower. Powerful Greek imagery derived from reli-

9.67 Façade of the tomb at Lefkadia. c. 300 BC. Height (of façade) 27 ft (8.20 m)

gious architecture (cf. the Parthenon) thus continued to be expressed in this new Macedonian façade architecture.

The lowest register of the façade consisted of Doric half-columns on either side of the actual door, with four painted figures arranged on an illusionistic platform between the columns. One of the figures depicts Rhadamanthys (fig. 9.68), a Judge of the Dead, cloaked and leaning on a staff. This is a figuretype well known in the Greek repertoire, deriving from an earlier male type seen on fourth-century BC Athenian grave monuments. The other figures are Hermes, who guided souls to Hades, the dead man himself, and another judge, Aiakos. They are painted on the plain stucco ground, without indication of setting, and hence with little suggestion of pictorial space. The range of colors is impressive: black, red, white, yellow, blue, mauve for garments and shoes, and gray and red-brown for hair and weapons. Rhadamanthys, for example, has shoes of blue and mauve, and a cloak of yellow. His hair and beard are reddish, while the wreath in his hair is green.

9.68 Façade of the tomb at Lefkadia: Rhadamanthys, a Judge of the Dead. c. 300 Bc. Wall painting. Height (of figure) c. 4 ft 1 in (1.25 m)

This elaborate façade was created for a single event, the funeral and burial of the dead person, and was then itself buried beneath a great tumulus of earth. How are we to explain the brief life of these extravagant façades? Are we to think of them in relation to actual palatial façades that they may have echoed? Are they thus the equivalents in death of the authoritarian exteriors of the apartments of living princes? The difference is clear: while palatial façades lead to substantial rooms and courts, these lead only to burial chambers. To that extent they are essentially illusionistic.

The architecture and painting that Macedonian kings and nobles used to dignify their lives and glorify their deaths reflect the opulent new society they had created in northern Greece, and at the same time point forward to artistic currents that would be influential in the Hellenistic kingdoms. So the art of Macedon stands both as cultural and chronological watershed between fourth-century Greece and the Hellenistic world.

THE HELLENISTIC PERIOD c. 323-31 BC

onventionally, the Hellenistic period begins at the death of Alexander in 323 BC and concludes in 31 BC with the Battle of Actium. This watershed event saw the Romans of the West led by Octavian - shortly to become Augustus, the first Roman emperor - defeat the Romans of the East and their Egyptian allies led by Antony and Cleopatra. The preceding period is called Hellenistic because it witnessed the dissemination of Greek and Macedonian ideas throughout what had been Alexander's empire. These ideas were taken in with varying degrees of enthusiasm. In Syria, for example, the customs, institutions, and language of the Greeks were received well in the older towns and were introduced in the new settlements, while in Egypt, Hellenism centered on the new city of Alexandria, but its influence was severely challenged by the traditions of the pharaohs.

At his death, Alexander's generals divided the empire among themselves. The new kingdoms were hostile to one another and, with upstarts and mountebanks everywhere, the bickering and warfare continued. Syria was the biggest of the new kingdoms and had its capital at Antioch, where the Seleucid dynasty established itself. Its control extended over most of the Asian provinces, though the easternmost ones fell away almost at once. Alexandria was the capital of Egypt under the Ptolemies. Many Greeks came to live here and naturally looked northward, across the Aegean, over which Egypt, along with Cyprus, frequently had control. Another kingdom grew up in the third century at Pergamon in western Asia Minor. This included the area of the old Ionian cities, and was therefore as open to Greek ideas as any other center. The Attalid dynasty at Pergamon was philhellene (Greek-loving), and the architecture and sculpture of Pergamon are fine examples of Hellenistic developments directly related to Greek precursors. Macedon remained its own kingdom.

Greeks in Greece continued to fight one another, and though, on the death of Alexander, they revolted against Macedon, their revolt was crushed, and their last hopes of autonomy were snuffed out. In Athens in the first part of the third century BC, civil war between pro- and anti-Macedonian parties was almost continuous. Though the city had fallen into political insignificance in the new, larger world, it continued to enjoy cultural and academic prestige, which it turned to advantage in the second century BC. The philosophers and logicians, who could claim descent from Socrates, Plato, and Aristotle, attracted many foreigners to the city for their education. These included members of royal houses. Antiochos IV, shortly before he became king, was in Athens in 176

^{10.1} Nike (Victory) of Samothrace alighting on the victorious ship, perhaps by Pythokritos of Rhodes. c. 180 BC. Marble. Height 8 ft 1 in (2.45 m). Musée du Louvre, Paris

BC and was followed by others in the second century BC. Before long, these princely students became benefactors who funded architectural projects, and there is evidence of gifts to Athens from the royal houses of Pergamon, Egypt, Syria, and Cappadocia. With the expansion of the Greek world, however, Greece itself had ceased to be the focus.

In the West, Syracuse enjoyed prosperity in the third century BC under the leadership of its longestliving autocrat, Hieron II. He ruled during the period 275-216 BC, proclaiming himself king in 269 BC. Projects of urban development in the district known as Neapolis were begun, and the theater there was enlarged. With the assistance of Archimedes, wideranging improvements, which included wheeled catapults on rails, were made to the fortifications, and an enormous altar was constructed for Zeus. Hieron's interest in the enormous extended even to shipping. He built a super-freighter, described by Athenaeus as a floating city. Among literary figures who visited his court was Theokritos, a poet renowned for his pastoral verse. At Taras, too, in South Italy, there is evidence of a prosperous early period, with cemeteries in the region yielding many precious metal (silver and gold) items, jewelry, and other costly objects of ivory, worked bone, amber, and bronze. But always now there loomed the power of Rome. By the middle of the third century BC, Taras had succumbed, and the whole of South Italy was under Rome's control. By the end of the century, Sicily too was absorbed, and the Carthaginians were at long last overcome - by Romans. A Roman praetor (a senior magistrate) was installed in Syracuse in 201 вс.

Rome and Greece

In the course of the second century BC, Rome was drawn across the Adriatic into Greece, at first in struggles with the Macedonians under their king, Philip V. Though he was defeated in 197 BC, enmity continued off and on until Macedon was finally broken at the Battle of Pydna in 168 BC. Later, the Romans had to contend with the Achaean League, which their general, Mummius, defeated, before then sacking the League's leading city, Corinth. From this moment (146 BC) Rome ruled Greece. (This is the very same year in which Rome razed Carthage to the ground.) Then began the large-scale removal of statuary and paintings, presumably as booty, from Greece to Rome. About a decade later, in 133 BC, the last of the kings of Pergamon, Attalos III, bequeathed his kingdom to Rome. By the end of the next century, the other kingdoms of the Macedonian inheritance, Syria and Egypt, were in Roman hands. The Battle of Actium signaled the end of the absorption of the Hellenistic kingdoms into the unfolding Roman empire, and with it the end of the Hellenistic age.

The Hellenistic period is different from preceding periods in many ways. Huge kingdoms replaced the city-states of Greece, which now retreated into semi-obscurity. Mighty kings required new types of architecture for which there was literally no space in cities like Athens. So the new centers of architectural innovation were outside traditional Greek lands, as were the vital centers of sculptural production. Yet the legacy of Greece was evident everywhere. The world changed rapidly, with new interests and new outlooks emerging. Realism in sculpture, even to the point where caricature in portraiture was possible, came to the fore, as did individualism and interest in psychological portraits. Architects and townplanners explored dramatic effects, while sculptors investigated new and extravagant views of figures in motion and themes of violence. Renewed interest in science and scholarship led to the foundation of the great libraries of Alexandria and Pergamon. There were new religions, great increases in population, and intensified commercial contacts. This great world, with its diversity of peoples, traditions, and attitudes, was unified by the language of its all-too plentiful bureaucracies: Greek.

ARCHITECTURE

Pergamon

In the early years of the third century BC a certain Philetairos took over the citadel of Pergamon in western Asia Minor and established the Attalid dynasty. He and his successors, whose names were all either Eumenes or Attalos, right the way down to the bequest of the kingdom to Rome in 133 BC, radically altered Pergamon and established it as the capital of a Hellenistic kingdom of great power and wealth. They were philhellenes to the core. They defeated the invading Gauls, and built a city distinguished enough

10.2 Plan of the upper city, Pergamon. 3rd–2nd centuries BC (Temple of Trajan 2nd century AD)

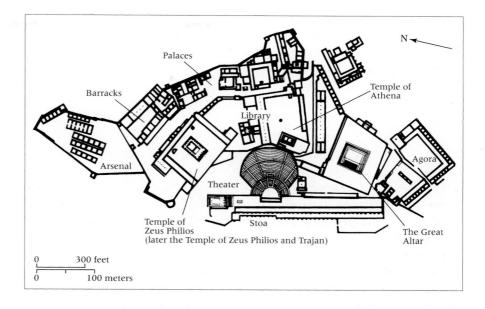

to challenge Athens and Alexandria for architecture, sculpture, and learning. This city, or its upper part on the crown of the hill, was built, not according to the rules of Hippodamos of Miletus, but following new precepts. Lower down the hill was a huge gymnasium, a sanctuary of Demeter, and much domestic architecture, but it is the architectural treatment of the top of the hill, 333 yards (300 m) high, that is of most interest.

Here, in the upper city, the Attalid planners used the dramatically steep landscape to frame and show off important buildings. In the plan (fig. 10.2), the theater is prominent. This aptly underscores the theatricality of the setting that governed the position and appearance of the major buildings. Visibility of structures was important. Equally so were the views from buildings over the impressive landscape (fig. 10.3). Panoramas of mountains spread in one direction, of rolling plains in another. The theater with its vertiginous seating faced west. Behind it rose the buildings of the upper city, on terraces rising from south to north.

On the lowest terrace was a colonnaded agora, with stoas on three sides, surrounding an open space. These provided sheltered walkways in front of shops and offices on two stories. (It was Attalos II of Pergamon who saw the value of a stoa at the east end of the Agora in Athens and paid for it.) On the next terrace up was the monumental Great Altar, built in an open court. This was an enlargement of a type

already well known in the Greek East, consisting of a wide flight of stairs between projecting wings and leading to a level platform. The altar was lavishly decorated with relief sculpture, and though several sculptors worked on it, its style is uniform. This is a critical monument in the history of Hellenistic sculpture, which will be examined in the next section (see pp. 354-6, figs. 10.23-6). The third terrace supported the Temple of Athena, one of the earliest buildings of this citadel complex, and a colonnaded court. The temple stood at the west side, at an oblique angle to the court but in line with the (later) Great Altar one terrace below. From this court, access was possible to the great library. This housed many books and a collection of Classical Greek paintings and sculpture, and challenged the library at Alexandria for preeminence. A statue of Athena presided over the library. In this context, it was evidently not a cult statue, but rather represented Athena as a patron saint of scholars and students. On the fourth terrace, at the very top, were located the modest palaces, the barracks for the garrison, the arsenal, and, much later, a temple built by the Roman emperor Trajan.

A great fortification wall protected the citadel. The urban plan within, which arranged buildings on different lines on a terraced hilltop, was entirely new. It was the planning of the terraces, the co-ordination of the natural setting with manmade spaces, and the placement of buildings that made the upper city of

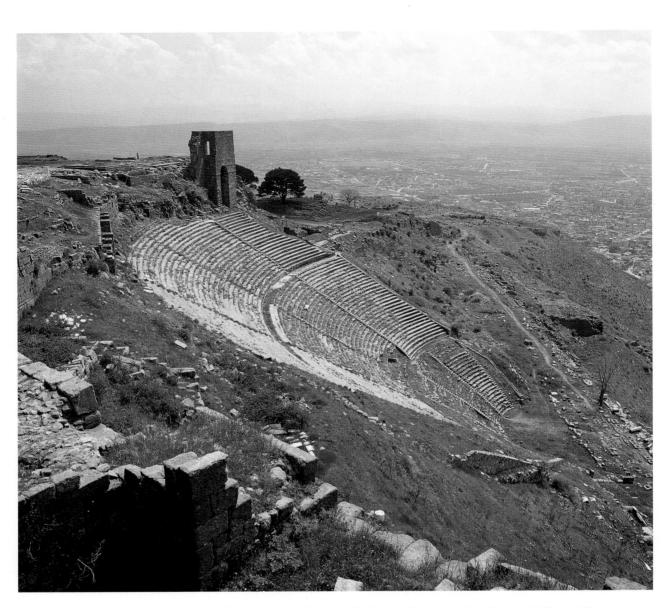

10.3 Above Pergamon, view southwestward from the top of the theater overlooking the lower town and surrounding terrain

Pergamon so dynamic and novel. Terraces and colonnades appeared to lead upward to the skies; the more down-to-earth realized that they led not only to the Temple of Zeus Philios but also to the palaces of the kings and the barracks of their soldiers.

The Temple of Athena was built in the second quarter of the third century BC. It is a small Doric building measuring only about 24×13 yards (22×12 m), but there are new features. Columns of the peristyle are set further apart than before and are slimmer. Column heights are now 6.98 times greater than the lower diameters. Thus the bulk of the build-

10.4 *Below* Elevation of the Temple of Athena Polias Nikephoros, Pergamon, north front. c. 275–250 BC. Height (of columns) 17 ft 3 ins (5.26 m)

10.5 Sanctuary of Asklepios, Kos. Restoration of fully developed plan. c. 160 BC

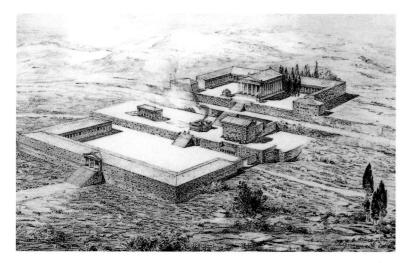

ing is diminished, and the airiness and lightness of the elevation are stressed. Notable is the innovative use of double triglyphs in the intercolumniations (fig. 10.4). This is of great significance for the history of the order, since it marked conclusively the break with the carpentry-derived tectonics of the seventh century. The columns were left unfluted, except directly beneath the capitals. The Doric order is rarely found in Hellenistic temple architecture, the Ionic being more popular. However, it was the Corinthian that would gradually become the order favored by Roman architects.

Kos

The site of Pergamon offered a landscape readily adaptable to architectural drama. But even where the geography was less amenable, architects created dramatic effects. Asklepios, the god of health, had been worshiped in his mainland sanctuary at Epidauros (pp. 294-6) since the sixth century. Now, on Kos, an island off the coast of Asia Minor, he received devotees at another center of worship (fig. 10.5). Here, architects built co-ordinated terraces with the help of ramps and stairs, and created varying visual effects by means of gates and colonnades. The lowest terrace (which was also the earliest, dating to the late fourth/early third century) was furnished with a monumental entrance gate at the head of a flight of stairs, and with a three-sided stoa and a fountain: here the sick were introduced to the therapeutic waters and regimes. The next terrace (of the third century) had a stoa on one side, an Ionic temple on

the other, and an altar in between. The Doric Temple of Asklepios (c. 150 BC) stood on the top terrace flanked on three sides by a stoa, and was approached again by an ascending flight of stairs. Here the temple was surrounded by a sacred grove of trees, while the whole terrace offered striking views of the sea. Thus, the elaborately contrived climbing architecture led worshipers to the culminating terrace where they were to sleep and be cured.

Magnesia and Didyma

For temple architecture of the Ionic order, we turn to two other sites in Asia Minor, Magnesia and Didyma. Creative architects working in the Ionic order tended to write about their systems of proportions and methods of planning in learned commentaries, passages of which have come down to us in the writings of the first-century BC Roman critic Vitruvius. One of these scholarly architects was Pytheos, who built the Temple of Athena at Priene in the fourth century BC (p. 302). Another was Hermogenes, famous for his temples at Teos, another site in Asia Minor, and at Magnesia.

Hermogenes' Temple of Artemis at Magnesia (fig. 10.6) was raised above ground level by a podium of seven steps, and yet more light and air were admitted to the peristyle by wide spaces between the columns and by their slender form. Hermogenes was keen to relate the plan of the cella building to the peristyle columns, and these are aligned on the axis of the cella walls, not on their outer faces. Such precision could only have derived

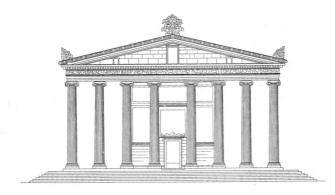

10.6 Elevation of the Temple of Artemis. Magnesia. c. 175 BC

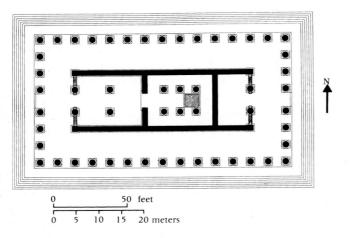

10.7 Plan of the Temple of Artemis, Magnesia. c. 175 BC

from a drawing on a drafting board. Vitruvius was probably not the first to insist that an architect must be able to draw. The plan (fig. 10.7) was eight columns on the façade by fifteen on the flank, and left room for another row of columns between colonnade and walls, which again allowed for more air and light. The pairs of central columns at front and back were more widely spaced than other columns, emphasizing the entrances. Most radical was the treatment of the central block, having a deep porch which was the same size as the cella and had interior columns. The opisthodomos had the normal two columns in antis.

The elevation had a continuous Ionic frieze as well as DENTILS, but there was no sculpture in the pediments. Instead, the back wall of the pediment was provided with three rectangular, windowlike openings, perhaps intended to reduce the weight of the superstructure. It is thought that the temple was built in the early second century BC.

More complex was the new Temple of Apollo at Didyma (fig. 6.18c, p. 161), begun around 330 BC but left unfinished. Work on the building was intermittent (the lintel, for example, went up in 182/1 BC), but the plan was Early Hellenistic. This huge and surprising temple replaced the gigantic Archaic temple burned down by the Persians in 494 BC. It was raised high on a podium of steps (fig. 10.9) and measured about 120×56 yards $(110 \times 51 \text{ m})$. The Ionic columns of the peristyle stood almost 22 yards (20 m) tall, with ten showing on the façade and twenty-one on the flank in a double colonnade. A dozen more columns, with variously carved bases, stood in the porch. These screened a central doorway, not at the level of the floor of the porch, but about 6 feet (2 m) higher, at the level of the floor of the chamber behind. The threshold was therefore more of a rostrum than an entrance, and may have been the place where ORACULAR responses were pronounced. There is no access here to the interior a doorway exists, but it is a false entrance.

The forest of columns and temple walls hid an open court with a small shrine and a sacred grove

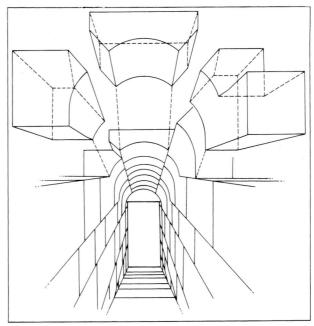

10.8 Perspective view, partially exploded, of barrel-vaulted passage in the Temple of Apollo, Didyma. c. 330 BC and later

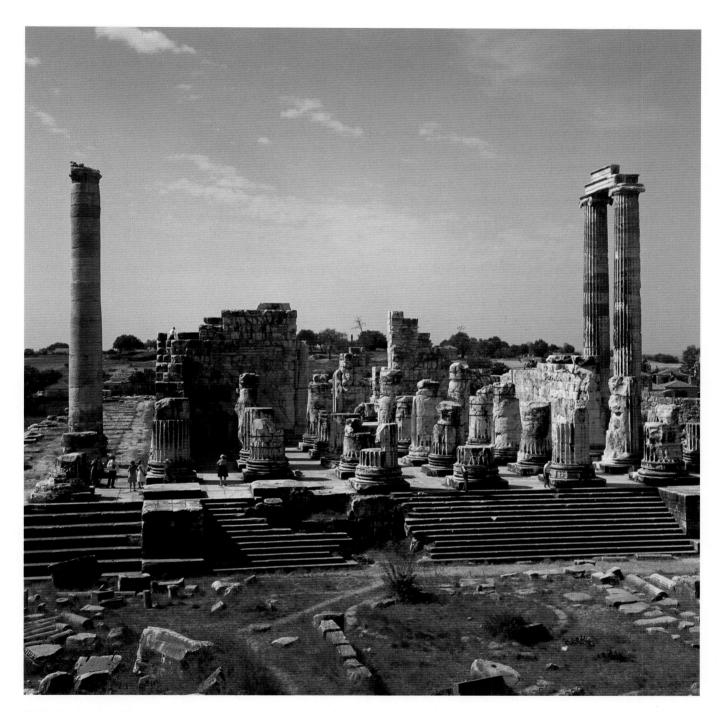

10.9 Temple of Apollo, Didyma, from the east: note front steps of podium, deep pronaos, and carved column bases. c. 330 BC and later. Height (columns) 64 ft 6 ins (19.70 m)

inside. The whole plan was predicated on the idea that the temple should surround and protect this interior grove. This court provides another example of the arrangement of space to present dramatic surprises. There are more. What looks like the entrance to the interior is not; the approach is in fact hidden and roundabout, being through a pair of sloping, barrelvaulted corridors (fig. 10.8) leading downward from the columned porch into the interior court, where the small shrine for the cult statue of Apollo stood. These barrel-vaulted corridors, together with the vaulted tunnel to the stadium at Nemea in Greece, signal an innovation in masonry construction which is employed more and more throughout the Hellenistic period and becomes a feature much favored by Roman architects.

Dramatic effects, whether in urban planning or spatial organization in individual buildings, are a hallmark of Hellenistic architecture. So is the detailed interest in the proportions of architectural members and their relationships to one another, and the recording in scholarly commentaries of the preferred solutions. This seems to be the case, at any rate, with the Ionic order. Doric seems to have been out of favor for big new temples, though it remained popular among architects for large utilitarian buildings like stoas, where its simple forms could be repeated rapidly and easily. The potential convenience and brilliance of the Corinthian order was only slowly being realized.

Athens

The Corinthian order was used for the first time on the exterior of a fullscale building on the Temple of Olympian Zeus at Athens, the Olympieion (fig. 8.35, p. 272). This temple had been begun as a Doric building by the Peisistratid tyranny in the sixth century BC, but it had advanced no further than the stylobate before their demise. In the second quarter of the second century BC, King Antiochos IV commissioned a Roman architect, Cossutius, to complete it using the Corinthian order. The enormous building (fig. 10.10), measuring around 118×45 yards (108 \times 41 m), was planned to show triple rows of eight columns at front and back, with two rows of twenty columns on either flank. Examples of the Corinthian capitals were carried off to Rome after the Roman general Sulla sacked Athens in 86 BC (after the Athenians' reckless support of the revolt of King Mithri-

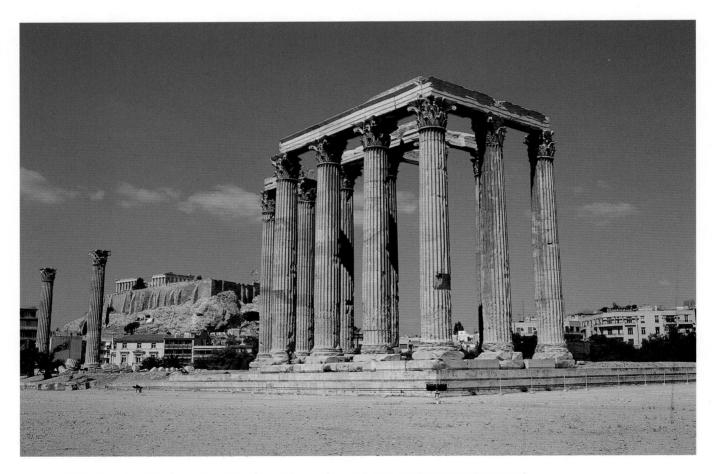

10.10 Temple of Olympian Zeus, Athens, surviving columns from the southeast with the Acropolis in the background. 2nd century BC–2nd century AD. Height (columns) 55 ft 5 ins (16.89 m)

10.11 Plan of the Agora, Athens. c. 150 BC

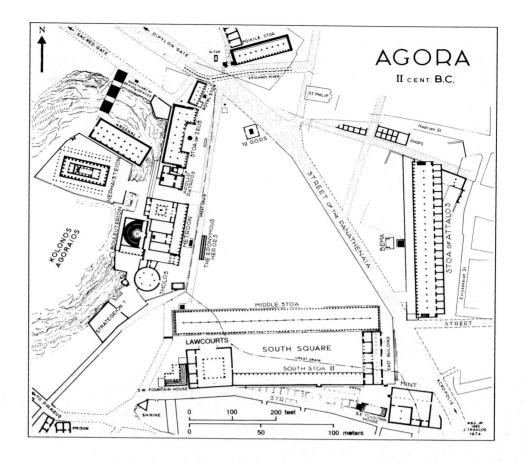

dates of Pontus), and may have influenced the development of Roman Corinthian. Work was not finished on this huge temple project until the emperor Hadrian's rule in the second century AD.

Antiochos's generosity was matched by that of others, and during the second century BC Athens enjoyed a period of prosperity. Architectural growth was particularly apparent in the Agora (fig. 10.11). The Square Peristyle, of late fourth-century date at the northeast corner, and South Stoa I, built during the Peloponnesian War, were both pulled down to make way for new structures. At the south, materials from the Square Peristyle were recycled in the new South Stoa II, which was differently aligned from its predecessor. It was an unimpressive building consisting of a single Doric colonnade in front of a back wall, but it has to be thought of in conjunction with the new Middle Stoa. Together these formed the two long sides of a new square, a mini-agora in itself. The Middle Stoa was a big building, about 164×20 yards $(150 \times 18 \text{ m})$ in dimensions, which faced both north and south. It was built almost entirely of limestone. The so-called East Building closed the square at the east. The function of this square has been much discussed, but many now agree that it probably had a commercial use, similar to that of its precursor, South Stoa I. The mosaic floor of the East Building was punctuated by a series of marble base blocks with cuttings to take the feet of several tables. Accordingly, it may have served as a banking house for money changers and, with the Mint nearby, these tables may have witnessed the introduction into circulation of brand-new bronze coins.

The east side of the Agora saw the construction of the Stoa of Attalos, king of Pergamon from 159 to 138 BC, a gift from him and his wife to the Athenians (fig. 0.9, p. 17; fig. 10.12). A large (about 126×22 yards $[115 \times 20 \text{ m}]$), two-storied structure, it was purpose-built for shopping. There were twenty-one shops behind the double colonnade on each floor, so forty-two in all. Marble – for the façade and the columns – and limestone were the materials used. There was wide spacing of the columns for ease of access and to

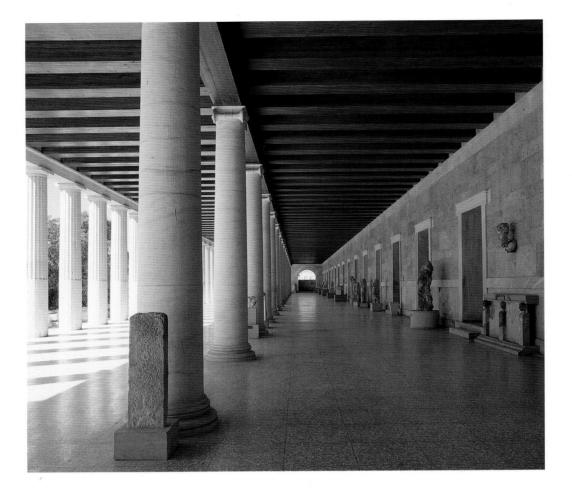

10.12 Above Agora, Athens, Stoa of Attalos, reconstructed in 1956 AD largely through the generosity of John D. Rockefeller: ground-floor interior from the south showing use of Doric order on the exterior, Ionic on the interior. c. 150 BC

10.13 Left Agora, Athens, Stoa of Attalos: Pergamene capital from the interior order of the upper floor. c. 150 BC

accommodate crowds, and variety in the use of the orders. Doric was used for the exterior on the ground level, Ionic for the interior. On the second level, Ionic columns on the exterior were linked by a balustrade, while the interior colonnade introduced a new capital type called Pergamene (fig. 10.13), which was derived from the Egyptian palm capital. Columns of the interior colonnades were left unfluted, as was the lower part of the Doric colonnade, since commercial traffic was likely to damage the flutes. Enough of the stoa was preserved in later structures for it to be accurately restored. It now serves as a museum. The other new building in the Agora was on the west side. Here a Metroon (Temple of the Mother of the Gods) was constructed. It consisted of four rooms side by side, linked by a continuous colonnade across the front. Thus, the whole of the west side of the Agora was given a colonnaded façade (admittedly interrupted between buildings), which, together with the new stoas running the length of the south and east sides, defined more precisely the commercial and administrative heart of the Hellenistic city.

Miletus

In the zone set aside for commercial and public buildings in the rebuilt city of Miletus, a large agora with colonnaded stoas on all four sides was matched to the north by a more complex market arrangement. Here (fig. 10.14), an L-shaped colonnade, with shops and offices behind, faced the harbor. Behind the short side of this stoa stood another with two projecting wings, while behind the long side were two rectangular courts. One was a peristyle market, the other an open court with colonnades on three sides (the north agora). This whole complex is a fine example of the one-time planning of a major urban market area, and of the adaptability of the stoa form in the organization of space. Differing locations, shapes, and sizes of commercial zones are all regularized by the use of the flexible colonnaded stoa. These particular buildings were erected in the middle years of the second century BC.

Miletus also provides a good example of the Hellenistic bouleuterion (council chamber). Built around 170 BC and located between the North Market area and the huge agora, the complex consisted of a monumentalized gateway, an open peristyle court, and the chamber itself. The gateway and forecourt were innovations and were absent from the bouleuteria of fifth-century Athens. As the real power of local government diminished with the disappearance of autonomy, its architectural manifestation became paradoxically more striking. The chamber itself (fig. 10.15) was arranged rather like a theater, with rows of seats arranged in concentric semicircles around the floor, from which principal speakers could address the council. Theaters in Greek cities, incidentally, were also used for political meetings. The Bouleuterion itself was roofed, and was decorated only with PILASTERS on the inside upper walls (above

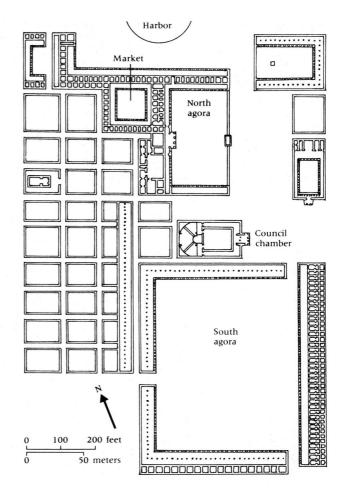

10.14 Plan of the commercial and public buildings in the city center of Miletus. 2nd century BC

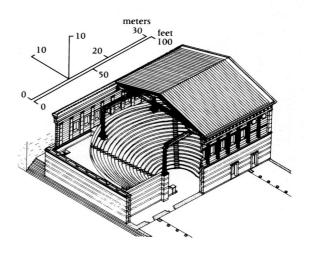

10.15~ Isometric drawing, cut away, of the Bouleuterion, Miletus. c. 170 $_{BC}$

SALVAGE ARCHAEOLOGY

The rapid growth in recent decades of urban sprawl, the renewal of older buildings in city centers, and widespread improvements in communication systems have necessitated the development of a specialized kind of archaeology. This archaeology comes into play when systematic excavation is required, not by the problems of antiquity, but by the imminent destruction of historical material in the interest of modern development. A spectacular example of such salvage archaeology is provided by the work in the heart of Athens which prepared the ground for the new stations and subway lines of the Athens metro.

In this instance, teams of archaeologists worked ahead of, and then alongside, construction engineers for a period of over six years. They identified the more vulnerable historical areas and collaborated with the engineers in planning the excavation and construction work. They protected and recorded the archaeological evidence retrieved as the new ventilation shafts, metro stations, and rail tracks were built. Ancient streets and houses, cemeteries, sanctuaries, public buildings, workshops, foundry pits, kilns, aqueducts, wells, cisterns, drains, and sewage tunnels were revealed as previously unknown aspects of the topography of the subterranean city were brought to light.

The life of the ancient city was revealed in numerous strata reaching all the way from the present day to the prehistoric period. The densest layers of material were recovered from the Greek, Hellenistic, and Roman periods. For example, excavation at the site of the Kerameikos station discovered over 1000 burials dating

the seats). Outside, the walls were decorated with engaged Doric half-columns, a notable feature of which was the carving of the echinus with an Ionic ornament, the egg-and-dart molding. Thus, order-mixing, typical of Hellenistic architecture, was practiced even in a single architectural member. Ionic columns helped support the roof, but the interior remained bleak, and architects seem always to have been more interested in exterior spaces than interiors.

As to domestic architecture, housing of this period continued the introspective emphasis of the

from the early seventh century down to the Roman period, and in particular recovered a mass burial of more than 100 people – men, women, and children all interred together. The corpses were not arranged in a careful manner, but lay on top of one another and in many different positions, evidently deposited in haste. They were accompanied by only a very few small pots, all of the period c. 430–420 BC, which therefore date this one-time inhumation. It seems logical to connect this to the horrendous plague, so vividly described by the historian Thucydides (II. 47–54), which struck Athens in the early years of the Peloponnesian War (see p. 250).

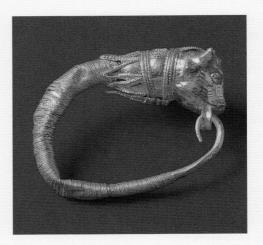

10.16 Bull's-head earring, from the metro system excavations, Athens, c. 300-250 BC. Gold. 1 x $\frac{3}{4}$ in (2.4 x 1.9 cm)

preceding years. The interior courtyard is found everywhere, often with columns on all four sides. Occasionally, as at Priene (fig. 10.18), houses of the fourth century BC were amalgamated in the second. At Priene, the amalgamation provided larger courts and plentiful rooms, though each house still had only a single entrance. Elsewhere, where a Hippodamian plan like that at Olynthos or Priene was not possible, private houses elbowed one another in close quarters. On the island of Delos, which became an important trading center in this period, Hellenistic houses were crowded together in unsystematic Huge quantities of materials, including items of jewelry (fig. 10.16), artifacts of ivory, faience, and glass, terracotta figurines, stone and bronze sculptures (fig. 6.69, p. 191), and intact pottery dining sets were recovered. Humbler materials included needles, toys, lamps, cosmetic spoons, terracotta sewage pipes, and broken pottery. Some ancient structures (or parts of them) were preserved where they were found; others were moved lock, stock, and barrel to other sites.

With sensitivity to the ancient remains and awareness of the needs of public education, the Greek authorities have decorated the corridors and walls of the new metro stations with display cases (fig. 10.17). The objects are accompanied by plans and sections, drawings of archaeological features, panels explaining the sequences of habitation, and drawings to illustrate findspots or to show how objects were used in antiquity. Each metro station is, so to speak, a museum gallery. The success of this innovative idea was amply demonstrated by the crush of visitors the moment the new metro was opened and its continuing impact is shown by the attentiveness of passers-by today. The whole program has resulted in renewed excitement among observers – both citizens and tourists – about Greek archaeology and Greek history.

In this remarkable instance of salvage archaeology, the installation of a modern communications system advanced at a rapid pace hand in hand with the attentive study and preservation of archaeological data. Immense difficulties were overcome. The linking of forward-looking technological skills and archaeological expertise has resulted in the most creative alliance imaginable.

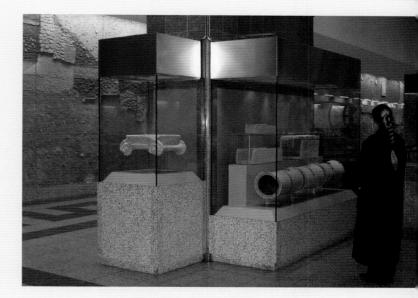

10.17 Athens metro station. Balconies between station levels act as museum galleries displaying ancient objects from the excavations, and panels illustrating stratigraphy, road systems, and so forth. Opened to greet the new millennium, AD 2000

10.18 Priene. Plan of house XXXII

(a) In the 4th century BC

(b) Amalgamated with contiguous building

in the 2nd century BC

blocks separated by winding streets. Congested residential areas in major cities like Alexandria may have had tall apartment blocks like those that stood in later Roman towns such as Ostia.

Syracuse

In the Greek West, Syracuse emerged from a century of almost endless warfare and internal struggle (see pp. 290, 292) to flourish in the third century BC. Writing in the first century BC, Cicero, the famous Roman orator, politician, and literary figure, described the city as "the largest Greek city, and the most beautiful of all cities." He spoke of a city which by his time was under Roman control but which had existed as an autonomous Greek city-state till the end of the third century BC. Its last tyrant, Hieron II (275–216 BC), initiated several architectural projects.

To the north, in the district known as Neapolis, a new residential zone took shape, planned with streets arranged in Hippodamian grid fashion. The nearby theater, first constructed in the fifth century BC, was extended. New tiers of seats were added at the top, with different sections named after the gods (and members of Hieron's family!), so that the diameter of the building increased to over 153 yards (140 m) and the theater could accommodate around fifteen thousand spectators. One of the largest theaters in the Greek world, this structure had a distinctive design. The semicircular CAVEA (auditorium) was partially framed at the top by a stoa. This also incorporated an artificial cave, into which water was brought from the uplands behind the city by a system of aqueducts. This grotto was flanked by niches for statuary and, as well as providing water for the theater's hydraulic system, may have been the seat of the actors' guild.

With the advice of Archimedes, Hieron improved and extended the fortifications of the city. These impressive defences, put in place in the early fourth century, consisted of walls, towers, artillery emplacements, enfilades, and ditches, and ran for some 20 miles (32 km). Hieron also built a vast altar for Zeus. This rectangular structure measured about 208×25 yards (190×23 m) and was decorated with statuary. At the festival of the Eleutheria, no fewer than 450 bulls were sacrificed, a number that might explain the size of this mammoth altar, which dwarfed its counterparts in Greece.

SCULPTURE

Diversity in form and psychological presentation, executed in a realistic manner, is the hallmark of Hellenistic sculpture. The great variety of types, new and old, of poses and gestures and groups, taken in some instances to the point of caricature, has been explained by the influence of the new worlds opened up to Greek artists by the conquests of Alexander. Yet much of what is new in Hellenistic sculpture was already implicit in the work of the great fourth-century sculptors - Praxiteles, Skopas, and Lysippos who had consistently striven toward greater realism in portraying human experience and expression. Lysippos's interest in emphasizing new views of human figures, in mental states, in surprise, dramatic postures, portraiture, and personification became especially influential.

The period may conveniently be divided into three chronological phases, though there is much difficulty in dating some pieces and agreement between scholars is often hard to find. The first phase, down to about 250 BC, may be seen as a period of transition, in which revolutionary approaches appear alongside the derivative. The High Hellenistic phase, spanning a century from around 250 to 150 BC, follows and is typified by the style of sculptures from Pergamon. This is often described as "Hellenistic baroque." The whole period from around 300-150 BC was seen by some ancient critics, cited by Pliny (Natural History 34.52), as a dreadful mistake in terms of art. Thus, the phases of Hellenistic sculpture perhaps most admired today seem to have been least admired by later critics. The Late Hellenistic phase, from around 150 BC onward, saw a resurgence of Classicism, which corresponded with the Roman conquest of Greece and the shipment of countless Greek statues from Greece to Italy. This was now a wholly new age. Copies, adaptations, and variants of Greek originals then proliferated in answer to the demands of Roman patrons. At the same time, the baroque trend continued vigorously. Pliny himself speaks admiringly of the Laocoön group (fig. 10.42), and rich Romans evidently took pleasure in the use of the Hellenistic baroque style when it suited them.

As to subject matter, the standing male figure remained in use for images of gods and for commemorative statuary, and the draped female figure continued to be popular. But these were no longer the

dominant types. Variety and diversity were called for, and the sculptors' vocabulary expanded accordingly. Interest in realism produced true-to-life portraits and images of characters as individual as the aged fisherman and the drunken old woman, as well as focusing on natural states of mind, the striving athlete or the sleepy satyr. Interest in eroticism produced sensuous statues of the nude Aphrodite, images of coupling satyrs and nymphs, and even hermaphrodites. There were humorous caricatures of dwarfs, slaves, and hunchbacks - considered in this brutal age to be amusing - and statues of smiling, almost laughing, children. Personification and allegory grew in importance. Interest in the theatrical produced statues in their settings: Eros asleep on a rock, or Nike alighting on the prow of a victorious ship in a water basin on a hill high above the sea. Interest in emotion produced intense images of suffering, anguish, pain, brutality, anxiety, or pleasure. Thus, the range of subject matter was enormously wide.

The period of transition in the first half of the third century BC saw several innovations, of which the image of Eutychides' Tyche (Fortune) of Antioch was one. Eutychides, a pupil of Lysippos, made the statue shortly after the foundation of the city. c. 300 BC. The original was bronze, of which smallscale copies in marble and other materials (fig. 10.19) survive. The Tyche appears as a draped female seated on a rock. She wears a crown, which represents the fortifications of the city, and in her right hand carries a wheatsheaf, symbolizing the fertility of the land. At her feet swims a youth, who represents the river Orontes. The personification of the city and the allegorical nature of the content are new, as is the design, which offered three principal views in a pyramidal arrangement.

Also new is the posthumous portrait of the Athenian orator Demosthenes by Polyeuktos (fig. 10.20), erected in the Athenian Agora around 280 BC. This period is the first in Greek art to try to express, through portraiture, the mental states as well as the characters and recognizable external features of individuals. These distinctions are sometimes hard for us to grasp. Complete verisimilitude is not the issue, since we cannot know precisely what the ancients looked like, and since portraitists would only intentionally include such physical features as would make their subjects recognizable. Earlier portraits concentrated on representing their subjects in

10.19 Tyche of Antioch by Eutychides. Roman copy of a c. 300 BC bronze original. Marble. Height 38 ins (96 cm). Vatican Museums, Rome

 $10.20\,$ Demosthenes by Polyeuktos. Roman copy of a bronze portrait statue erected in Athens c. 280 BC. Marble. Height 6 ft 7½ ins (2.02 m). Ny Carlsberg Glyptothek, Copenhagen

10.21 Gaul and his wife. Roman copy of a c. 220 BC Hellenistic group. Marble. Height 6 ft 11 ins (2.11 m). Terme Museum, Rome

terms of status and character, as ideal examples of, for instance, the poet or the philosopher, but with sufficient individual quirks of feature (e.g. Socrates' broad nose) to identify them. These have been termed "role" portraits. Now Polyeuktos went beyond this in striving to present a recognizable image of Demosthenes that would offer an insight into the workings of his mind. The original was bronze, but again it is marble copies that have survived. Demosthenes faces forward with his arms lowered and his hands joined in front of him. The pose is hesitant, the composition enclosed, the mood nervous. The shoulders slump, the head inclines; furrowed brow and downcast eyes all reveal Demosthenes' introverted and anxious state of mind. The psychological portrait reveals the personality of the individual both by the posture, set, and condition of the body, and by the facial expression. The portrait of Demosthenes stands at the head of a long series of such "psychological portraits." Others include portraits of philosophers, whose cast of mind is suggested sometimes by posture, sometimes by facial details, and sometimes by both. At the same time, in this early Hellenistic phase, heroic portraiture, as exemplified by the portraits of Alexander, continued.

The baroque style of the High Hellenistic phase is characterized by dramatic effects, achieved by complex postures, gestures, and groupings, and by the intensity and variety of emotional representation. The tendency is first shown in the softstone funerary reliefs of about 300 BC at Taras in South Italy, with their intensified expressions of sorrow and pathos (fig. 9.1, p. 288).

The group of the Gaul and his wife (fig. 10.21) is a Roman marble copy of a bronze original associated traditionally with the dedications made by King Attalos I (241–197 BC) at Pergamon to celebrate victories over the Gauls. The defeated Gaul prefers suicide to surrender. He has already killed his wife in order to prevent her becoming a slave. The barbarian is portrayed as the noble hero. The group is completely carved in the round, affords many viewpoints, and effectively contrasts the vigorous and still vital male body with the female collapsing in death. Baroque is the twisting posture, the exaggerated musculature of the torso, and the high drama of the moment. The original may date to around 220 BC.

Similar in subject and style is the Dying Gaul, again a Roman marble copy of a bronze dedicated c. 220 BC at Pergamon, this time a trumpeter (fig. 10.22), identified by his instrument lying broken on the ground. (The original probably formed part of a larger group, together with the suicidal Gaul and his wife; this group of dedications is known as the Large Gauls.) The slow twist of the torso, the various views of the limbs, and the careful framing of the wound suggest that the figure was to be observed from several viewpoints. The shock of hair brushed back, the untidy mustache, the torque around the neck, and the hornshaped trumpet find correspondences in

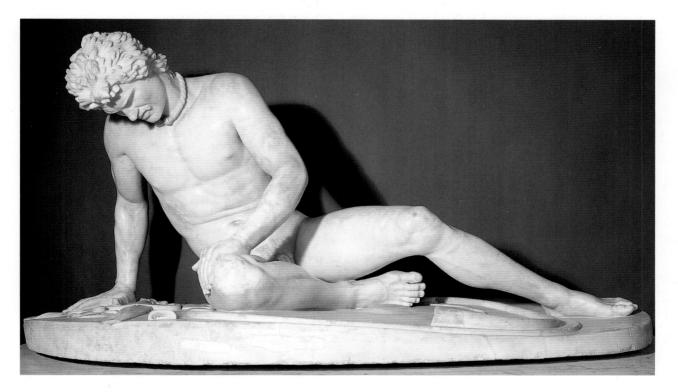

10.22 The Dying Gaul (Trumpeter). Roman copy of a c. 220 BC Hellenistic original. Marble. Height 36½ ins (93 cm). Capitoline Museum, Rome

descriptions of Gauls in literary texts (e.g. Diodoros 5.28).

The high point of this style is reached in the decoration of the Great Altar at Pergamon, traditionally assigned to the reign of Eumenes II (197-159 BC) (fig. 10.23). Recent research, based on inscriptions and on pottery from the foundations, suggests that the altar was built to mark the successful crushing of a revolt of the Gauls in 167 BC, and proposes that the altar was dedicated in gratitude to all the gods. This altar was much smaller than Hieron's altar at Syracuse, and took a different form. At Syracuse, the deity was honored by size and utility, at Pergamon by theme, quality, and style of ornament. The altar stood on a platform, with wings projecting forward at north and south on either side of a broad staircase (fig. 10.24). The platform supported an Ionic colonnade, while the podium below was decorated with a sculpted frieze 7 feet 7 inches (2.30 m) high. Here a colossal battle of gods and giants was depicted in local marble. The frieze consisted of some two hundred figures in such high relief and so sharply undercut that they appear almost in the round. Figures writhe and struggle, even spilling out onto the steps up to the altar. Moments of physical and emotional intensity are emphasized by tense bodies, violent postures, exaggerated muscles of torsos, legs, and arms, open mouths, and deep-set eyes, furrowed brows, and shocks of unruly hair. Swirling drapery enhances the dramatic effect. Zeus (fig. 10.25) and Athena (fig. 10.26) overthrow giants, whose faces are grim with horror and anguish.

The Pergamene kings had defeated the Gauls, just as the Greeks of Greece had warded off the Persians centuries before. In choosing to depict the great battle between gods and giants, a theme known to all Greeks, the designer of the altar frieze both evoked those great Greek victories over barbarians and deliberately linked philhellene Pergamon with Greece, and with Athens especially. There were other links to Athens. Motifs were borrowed from the Parthenon itself: the X-composition arrangement of Athena overpowering a giant on the altar is adapted from the Athena and Poseidon of the west pediment, while the Athena itself is thought to be an adaptation from the Athena of the east pediment, and Zeus an adaptation from the Poseidon of the west. These learned references point to the rise of Classicism, so that in this altar, with its confident interweaving of massive dramatic figures and horrified expressions of pain and passion, both Classicizing and baroque tendencies appear side by side.

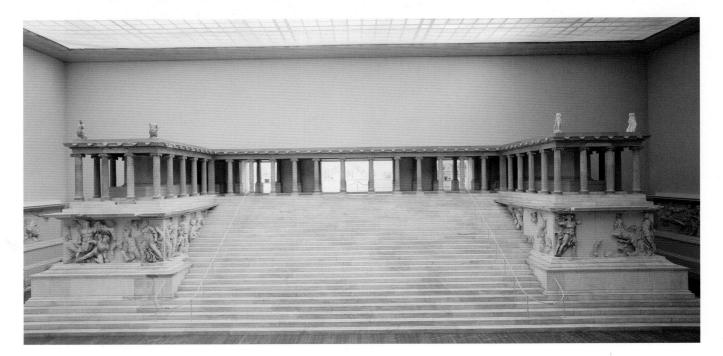

10.23 The Great Altar, Pergamon, west side as reconstructed in Berlin. c. 175–150 BC. Marble. Width c. 102 ft (31 m). Staatliche Museen, Berlin

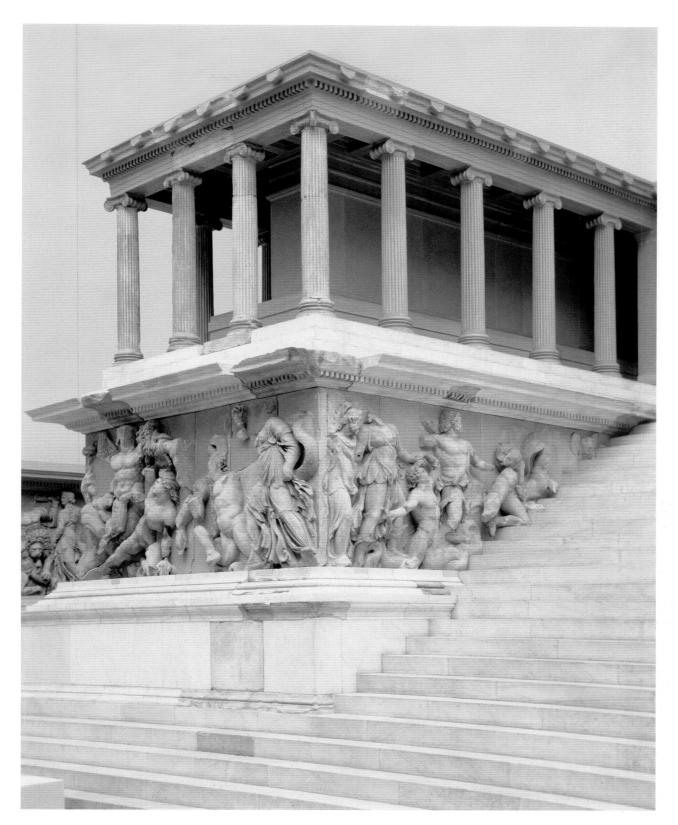

 $10.24\,$ The Great Altar, Pergamon, north wing. c. 175–150 $_{BC}.$ Marble. Height (of frieze) c. 7 ft 7 ins (2.30 m). Staatliche Museen, Berlin

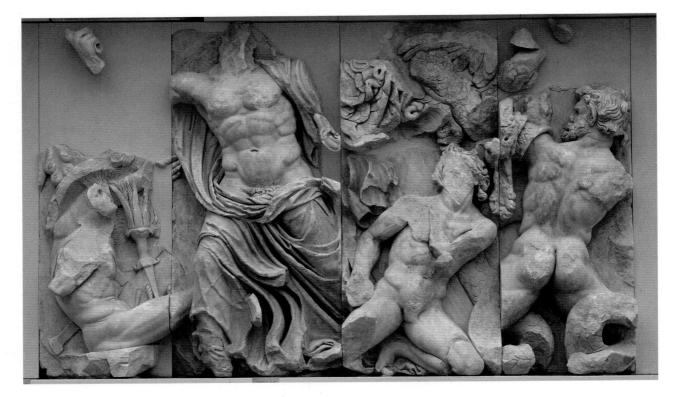

10.25 The Great Altar, Pergamon, east frieze (detail), Zeus fighting giants. c. 175–150 _{BC}. Marble. Height (of frieze) 7 ft 7 ins. (2.30 m). Staatliche Museen, Berlin

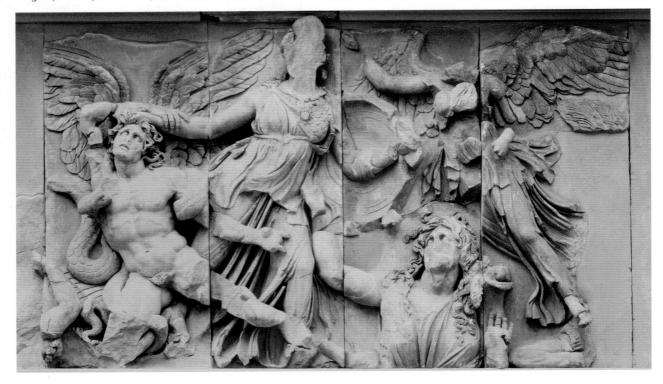

10.26 The Great Altar, Pergamon, east frieze (detail): Athena fighting giants. c. 175–150 BC. Marble. Height (of frieze) 7 ft 7 ins (2.30 m). Staatliche Museen, Berlin

The twisting pose, swirling drapery, and dramatic setting of the famous Nike of Samothrace (fig. 10.27) find parallels in the Pergamon altar. This personification of Victory, a marble original around 8 feet (2.45 m) in height, harks back to iconographic precursors such as the Nike by Paionios (fig. 8.1, p. 248), and hence enjoys both Classical resonance and baroque vitality. She is shown landing from flight, wings still outspread. Originally she stood in a sanctuary building, open at the front, on a base in the shape of a ship's prow (fig. 10.1). According to the excavators, the entire group was set in a reflecting water basin opposite another water basin jagged with rocks, suggesting the Nike's guidance of the vessel (the Ship of State?) through perilous seas. This theatrical setting was enhanced by the location of the sanctuary itself at the top of a cliff. The body lands heavily, the torso twisted slightly to the right and upward, while there is a new torsion in the drapery. A spiral rises in the thick folds between the legs toward and over the right leg, checked and balanced at the hips by another spiral system moving in the opposite direction around the left hip. The treatment of areas of drapery is paralleled in the garments of figures such as Athena from the Pergamon frieze. The swirling folds of drapery express the rapidity of movement, while twisting of body and drapery and the theatrical setting render the Nike a supreme example of Hellenistic baroque, brilliant but brittle.

Contemporary with this baroque style are studies in the bizarre (caricatures and grotesques, for example) and in realism. The athlete is now shown, not like the Charioteer from Delphi of the fifth century BC (fig. 7.30, p. 233) in his moment of glory after the race, but in the throes of the competition. The bronze Boy Jockey (fig. 10.28), recovered from a shipwreck off Cape Artemision and doubtless intended for the art market or a patron in Rome, is shown mid-contest. Astride his horse, he leans forward, one hand holding the reins and the other perhaps a whip as he urges his mount forward. There is no exaggeration of anatomy or expression: the lightframed, wiry, boyish body and the concentration of mind are rendered with equal success. The name of the artist is unknown, but the jockey and his horse were probably made around 200-150 BC.

Just as a sculptor could realistically represent the emotional condition of an energetic young jockey, so keen observation of the world and its variety enabled

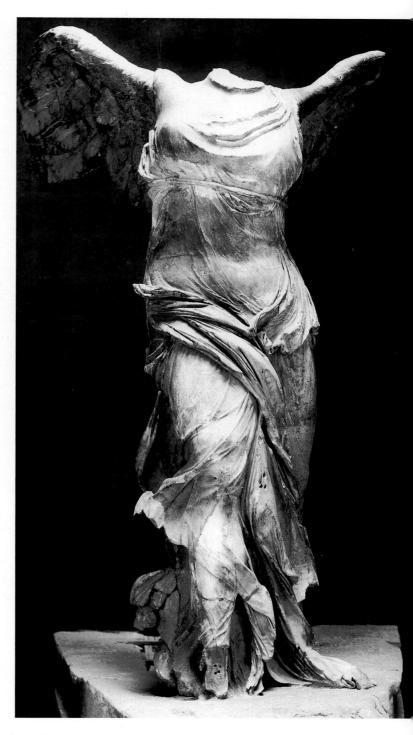

10.27 Nike (Victory) of Samothrace, perhaps by Pythokritos of Rhodes. c. 180 Bc. Marble. Height 8 ft 1 in. (2.45 m). Musée du Louvre, Paris

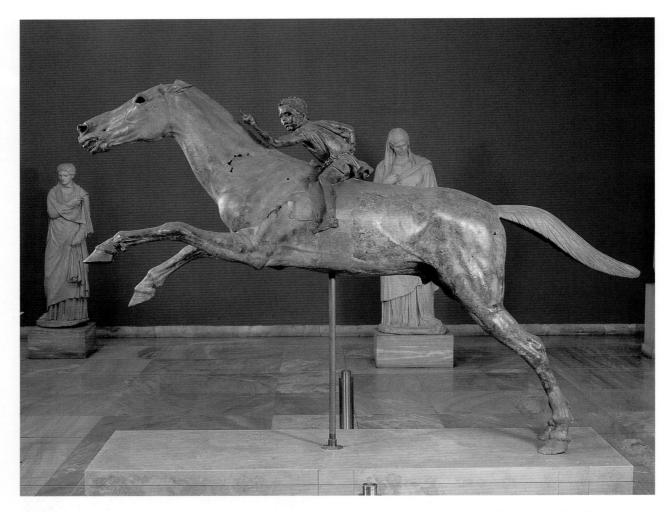

10.28 Horse and Boy Jockey, from the sea near Cape Artemision. c. 200–150 BC. Bronze. Height (of jockey) 2 ft 9 ins (84 cm). Length (of horse) 8 ft 2½ ins (2.5 m) (tail and passages of body restored). National Museum, Athens

sculptors to show other real mental states and to explore the relationship between mental and physical states. Thus, the Sleeping Satyr, or Barberini Faun as it is often called (fig. 10.29), is a portrait of a mind at rest and a body relaxed. But there is no mistaking the vitality of this mythological follower of Dionysos, or the detailed realism of veins, muscle, and sinew. The satyr was probably made around 200 BC and was found in Rome in 1625; it was restored by Bernini, who may have been tempted to give the figure a more baroque flavor than it originally enjoyed.

Realistic psychological portraiture flourished even in the remotest parts of the Greek world. Greek kings of Bactria in Central Asia continued to speak Greek and enjoy things Greek. A portrait of Euthydemos I (230–190 BC) tells the tale. A Roman copy (fig. 10.30) of an original of around 200 BC, Euthydemos appears wearing an impressive Macedonian hat and no-nonsense expression. Wrinkles around the eyes and brows, large nose (though heavily restored), deep furrows on either side of the nose, unsmiling mouth, firm jaw, and thick neck suggest individual and recognizable features, confirmed for us by representations of him on contemporary coins. His mental state, too, is clear: tough, determined, relentless.

The Late Hellenistic phase witnessed a renewed interest in Classical sculpture. With the Roman conquest of Greece came Roman enthusiasm for Greek culture, and not least for statuary of the fifth and fourth centuries BC. Statues were shipped off to Italy; Roman patrons commissioned agents to find pieces

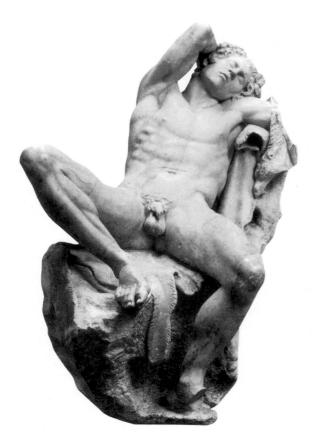

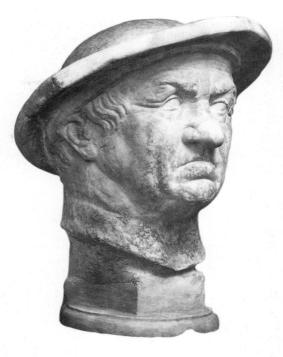

10.30 Portrait of Euthydemos of Bactria. Roman copy of an original of c. 200 Bc. Marble. Height 13 ins (33 cm). Villa Albani, Rome

10.29 Sleeping Satyr, often known as the Barberini Faun, found in Rome, possibly a Hellenistic original. c. 200 BC. Marble. Height 7 ft (2.15 m). Staatliche Antikensammlungen, Munich

suitable for their gardens, libraries, and gymnasia. Wealthy Romans came to Greece to see the sights and to be educated. Less wealthy Romans and Italians came to Greece and the East to make their fortunes, and the island of Delos became a center for their activities. Trade of all kinds flourished, and Greek sculptors turned their attention and skills readily to the Roman market and its taste.

On Delos, the marble statues of two citizens, Cleopatra and Dioskourides (fig. 10.31), now unfortunately headless, have survived in their original positions in a courtyard of the couple's house. These honorific statues, put up by Cleopatra around 140 BC when her husband Dioskourides dedicated tripods to Apollo, are standard types, heavily draped and conservative in appearance. Folds of cloth, seen through Cleopatra's upper garment, run counter to the upper folds, which lead the eye around the figure and thus suggest various viewpoints. To this extent

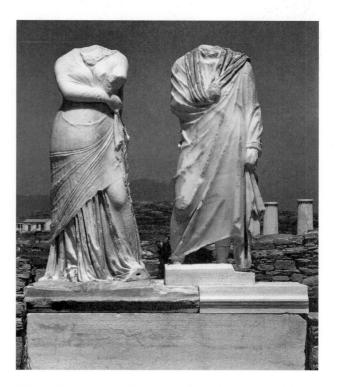

10.31 Cleopatra and Dioskourides, from the peristyle of their house on Delos. c. 140 BC. Marble. Height 5 ft 6 ins (1.67 m). Delos Museum

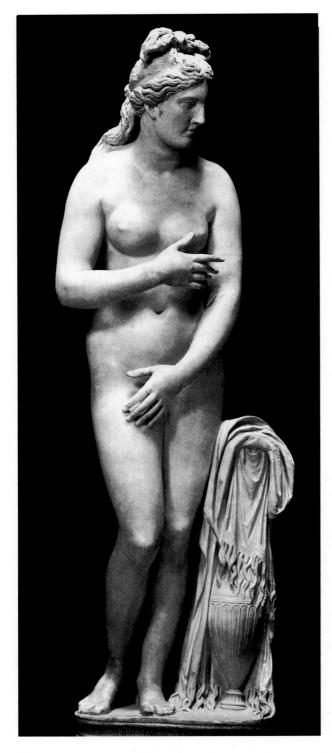

10.32 Capitoline Venus. Roman copy of a c. 250–150 BC Hellenistic variant of the Aphrodite of Knidos. Marble. Height 6 ft 4 ins (1.93 m). Capitoline Museum, Rome

we are in the realm of the new. But the drapery has none of the devices of the deeply cut, swirling drapery of Pergamene baroque, and is markedly retrospective. The figures themselves are reminiscent of Classical calm and control, a far cry from the exuberance and extravagance of Hellenistic baroque.

Debate continues as to the immediacy of the impact on Hellenistic sculptors and patrons of Praxiteles' startling Aphrodite of Knidos (fig. 9.29, p. 308). Praxiteles had finally uncovered the essence of the goddess of love: her body. During the Hellenistic period, this exciting theme, not unnaturally, provoked many variations; it is difficult, however, without further evidence, to date the originals of all the variants, known to us only in Roman copies. Some scholars maintain that the revealed female body - so captivating was its appearance - gave rise to adapted poses in sculpture in the later fourth century, and that the creation of modified views continued during the third. Others, however, think that while Praxiteles' Aphrodite provided the formal platform for the development of the female nude, it was not until the second half of the second century BC (i.e. coinciding with increased, indeed dominant, Roman presence in Greece) that the type became popular, and variants began to proliferate. The Capitoline Venus (fig. 10.32), a Roman copy of an original of the third or second century BC, changes the goddess from a distant, confident figure into a more immediate, selfconscious, and seductive type. The gestures of arms and hands, rather than cloaking the female parts of the anatomy, actually draw attention to them. The Crouching Aphrodite (fig. 10.33), a Roman copy of a second-century original, presents an altogether new sculptural pose. The nude goddess at her bath offers various views of various limbs and roundly emphasizes the appeal of the flesh. This crouching, bathing beauty is dependent on a well-known Classical figural type, exemplified in this book on the fourthcentury red-figure pelike by the Marsyas Painter (fig. 9.41, p. 317). Would sculptors or patrons have waited two hundred years before again making use of this pose?

Eros too, and studies in the erotic, gained in popularity. Eros, who in the fourth century became a means for expressing Aphrodite's power, and figured as an intermediary between the human and the divine, now assumed tormenting powers of his own. Asleep (fig. 10.34), he is, like the Barberini Faun (fig.

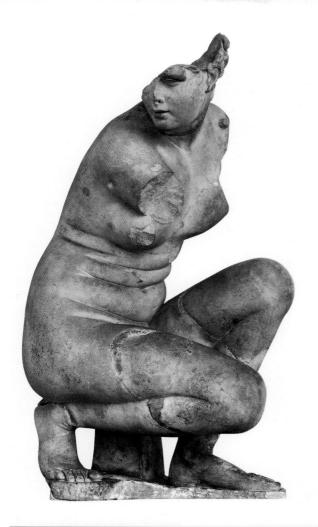

10.29), apparently powerless, a study in the relationship between mental and physical states. This is also a study in paradox. Asleep, how can he stimulate desire, and thus fulfill his role?

In groups, he is more active. In the guestroom of the clubhouse of the Poseidoniasts (an association of merchants) on Delos, given to Athens by the Romans in [#] 166 BC, he appears in a famous group with Aphrodite and Pan (fig. 10.35), the so-called "slipperslapper" group. A nude and jaunty Aphrodite rebuffs an importunate Pan, one hand shielding her genitals, the other holding the slipper with which she halfheartedly threatens him. Eros hovers between the two, smiling playfully and pushing Pan away. While the Aphrodite is a witty formal reminder of the Aphrodite of Knidos, the mood of the group is quite different: good-humored, telling a story, and gently

10.33 *Left* Crouching Aphrodite. Roman copy of a c. 200–150 BC Hellenistic original. Marble. Height 2 ft 8¼ ins (82 cm). Terme Museum, Rome

10.34 Below Eros Asleep. c. 150–100 BC. Bronze. Length34 ins (78 cm). Metropolitan Museum of Art, New York

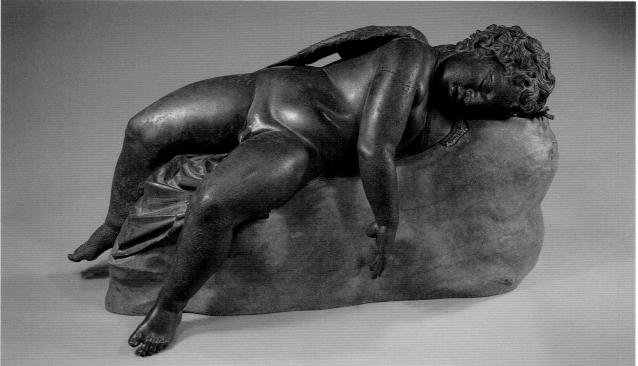

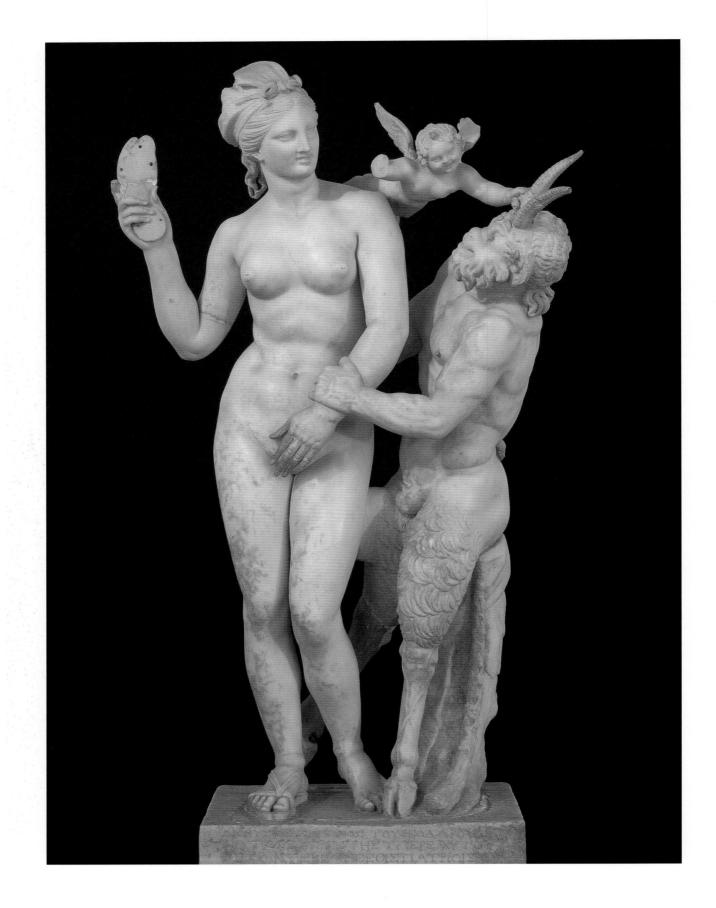

10.35 *Opposite* Aphrodite, Pan, and Eros. From the Establishment of the Poseidoniasts of Berytos (Beirut) on Delos. c. 100 BC. Marble. Height 4 ft 4 ins (1.32 m). National Museum, Athens

10.36 *Right* Eros and Psyche. Roman copy or version of an original of c. 150–100 _{BC}. Marble. Height 4 ft 1 in (1.25 m). Capitoline Museum, Rome

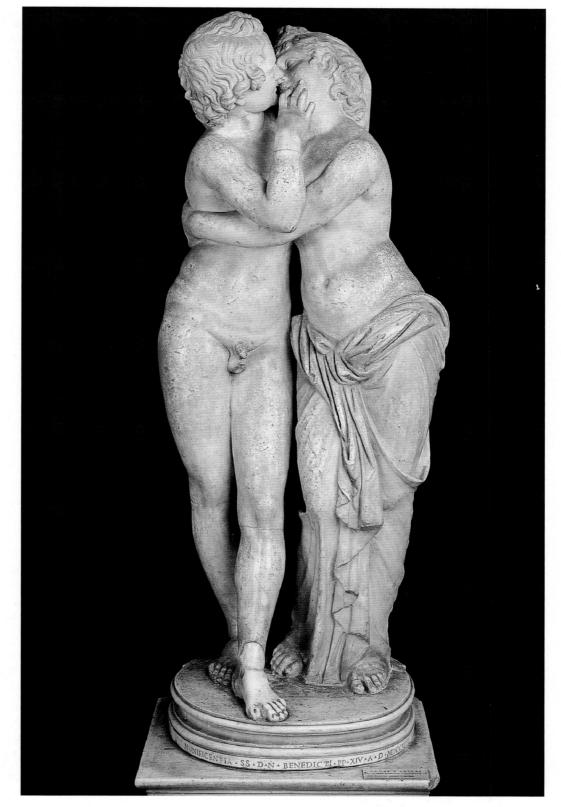

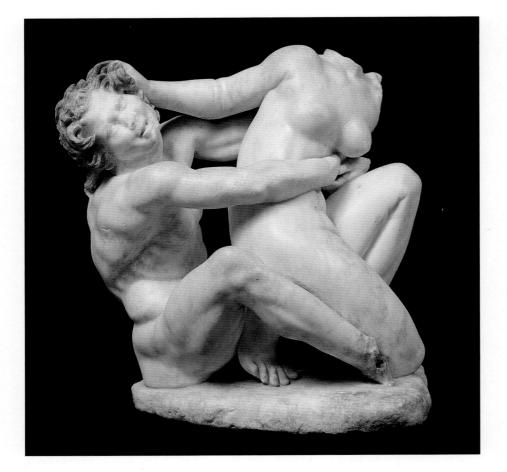

10.37 Nymph and Satyr. Roman copy of an original of c. 100 BC. Marble. Height 23³/₂ ins (60 cm). Capitoline Museum, Rome

erotic. As such it presents a sharp contrast to contemporary neo-Classicism. Parallels to the group are found in miniatures in Syro-Phoenicia, which accordingly confirms the influence of Eastern taste on the Greco-Roman market at this time. An inscription gives a date of c. 100 BC, and records that the dedicator was an Easterner, one Dionysios of Berytos (Beirut), and that the group was dedicated to Dionysios's "native gods." Thus, Greek sculptors found new patrons, and images of deities found new purposes.

Another group, probably created in the period c. 150–100 BC and widely copied in the eighteenth century, shows Eros with Psyche (fig. 10.36). Here, Eros appears in a more powerful and sexually charged role. The two figures embrace; the awkward postures, with legs placed frontally and arms curling around head and torso, underscore the physical and sexual strain. Eros first torments Psyche; then Psyche seeks revenge. Blameless(?), playful children are shown in adult situations.

The erotic or would-be erotic embrace appears with other players, often drawn from the retinue of Dionysos. Satyrs attempt to couple with hermaphrodites, Pan lusts after a shepherd boy, a satyr makes overtures to a nymph. One nymph and satyr group (fig. 10.37) shows the satyr's sexual attack and the nymph's resistance. There are echoes here of earlier work, of the Crouching Aphrodite (fig. 10.33) in the posture of the nymph, and of the Great Altar of Pergamon (fig. 10.26) in the musculature and style of the satyr. Is this serious? Is it a rape, or is it play? Is it deliberately ambiguous? What purpose would it have served? More obviously at home in the Roman world, was it perhaps an ornamental piece for a Roman villa?

The Aphrodite of Melos (Venus de Milo) (fig. 10.38), found on the island of Melos and now in the Louvre in Paris, was also made at about this time. She is over-lifesize (around 6 feet 8 inches [2.04 m] tall), and stands with the left leg sharply forward, bent at the knee and turning. The Praxitelean S-curve

10.38 Aphrodite of Melos (Venus de Milo). c. 125–75 BC. Marble. Height 6 ft 8¼ ins (2.04 m). Musée du Louvre, Paris

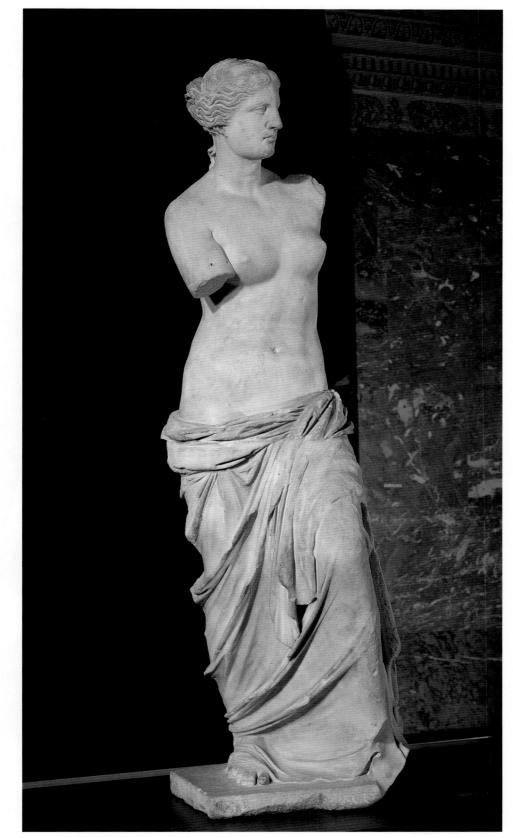

rises through the body, while the drapery is suggestively poised. The face is Late Classical in type, as is the anatomy. Though the proportions are changed and she is higher-waisted than the Aphrodite of Knidos, the similarity is nonetheless there. The new proportions, the twisting spiral of the figure between feet and hips, and the precarious drapery introduce new and distinctly Hellenistic notes, but the influence of the Classical is clear.

With its expanded formal horizons, Hellenistic sculpture was always interested in grotesques, caricatures, genre pieces, and the otherwise exotic. The repertoire of types was wide, including, for example, phallic dancers, dwarfs, and shepherdesses; such images were produced fullscale in marble and in terracotta and bronze miniatures. One example, in bronze, of a grotesque dwarf dancer (fig. 10.39) comes from the Mahdia shipwreck off the coast of Tunisia of around 90 BC. Is this an entertainment piece, or does it reflect the new interest in all facets of humanity? The cargo, from Greece and most likely intended for a destination in Italy, included a variety of architectural members, inscriptions, votive reliefs, and sculptures in both marble and bronze. Accordingly, it provides important evidence not only for aspects of Hellenistic art but also for commerce and more generally for chronology.

Increased interest in the individual meant increased interest in portraiture, and, with the greater number of Greek kingdoms following the break-up of the empire of Alexander the Great, there

10.39 Dwarf from the Mahdia shipwreck. c. 150–100 BC. Bronze. Height 12% ins (32 cm). Bardo Museum, Tunis

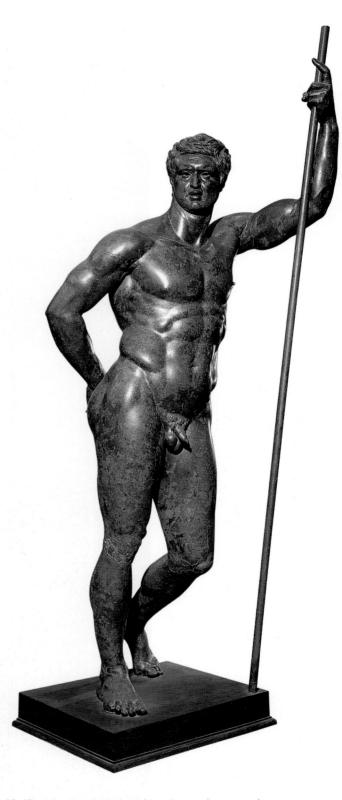

10.40 Hellenistic ruler, found in a Roman house on the Esquiline in 1884. c. 150 BC. Bronze. Height (without lance) c. 7 ft 9 ins (2.37 m). Terme Museum, Rome

were more opportunities for regal portraiture. Rulers could be shown as identifiable individuals, like Euthydemos (fig. 10.30), or in a more heroic manner. The bronze over-lifesize portrait of a Hellenistic ruler (fig. 10.40) made around 150 BC offers a good example. The Classical walking stance of the nude heroic figure is modified by the Hellenistic spiral of the arms and torso, right arm twisting behind the body and the left arm around the staff on which he leans. The small head turns sharply to the right, introducing more tension, while the

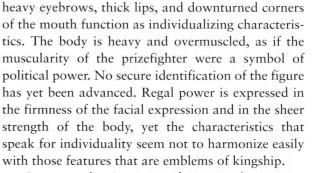

Less complex in terms of content, but not so in terms of style, is the Seated Boxer (fig. 10.41), a bronze original of the first half of the first century BC, now in the Terme Museum in Rome. The realistic representation both suggests a recognizable type of the period, and deliberately contrasts the reality of the Hellenistic fighter with the heroic "ideality" of Classical athletes. The broken nose, the swollen ears, the bleeding wounds, and swelling muscles of thigh and torso present a grim, if resilient, reality - a reality made more immediate by the use of copper inlays for lips, and patches of blood. With this is contrasted the simple pose and the hair and beard tidily arranged in linear locks and curls, reminiscent of Classical styles. Thus, interest in aspects of Hellenistic baroque continued, which in figures like the Seated Boxer were blended with more obviously Classical echoes.

The group known as the Laocoön (fig. 10.42) firmly asserts a continued commitment to the baroque trend. Discovered in Rome in 1506 and seen by Michelangelo, this group, consisting of Laocoön, his two sons, and two attacking serpents, has been the subject of much scholarly debate. Pliny names the sculptors as Hagesandros, Athenedoros, and Polydoros of Rhodes. The subject is not in doubt: the Trojan priest Laocoön was about to warn the Trojans against the wooden horse when he and his sons

1055

10.41 Seated Boxer, found with the bronze Hellenistic ruler (fig. 10.40). c. 100–50 BC. Bronze. Height 4 ft 2¼ ins (1.28 m). Terme Museum, Rome

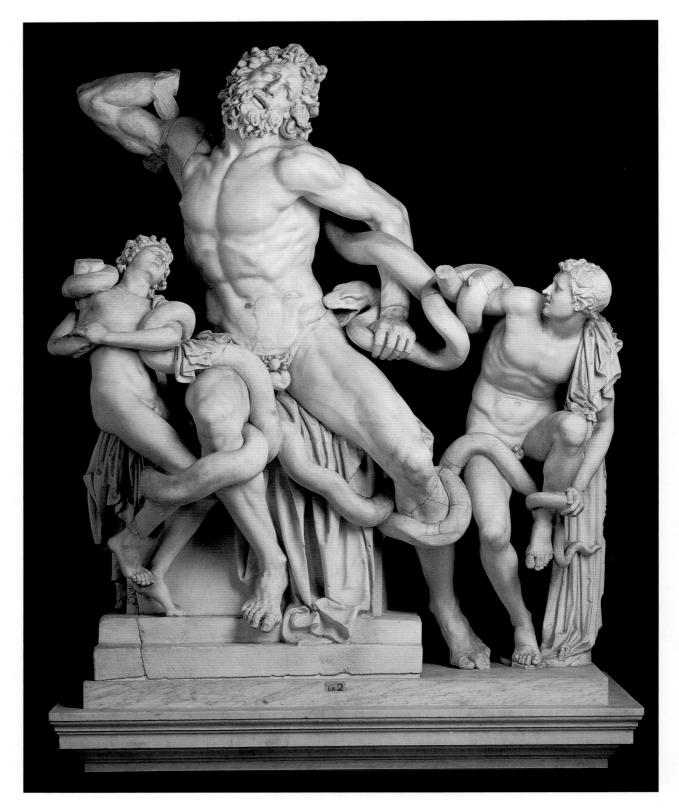

10.42 The Laocoön group: Laocoön and his sons battling the serpents (earlier restoration). Attributed by Pliny to the Rhodian sculptors Hagesandros, Athenedoros, and Polydoros. 2nd century $_{BC}$ or 1st century $_{AD}$. Marble. Height 6 ft $\frac{1}{2}$ in (1.84 m). Vatican Museums, Rome

PLINY ON THE Laocoön group

"Nor are there many more famous sculptors, since the number of artists at work on a piece hampers the individual reputation. In such a circumstance, no single artist gains fame, nor is the group able to claim the fame which an individual might get. This is the case with the Laocoön which is in the house of the emperor Titus, a work of art to be preferred to all other paintings and sculptures. For the most consummate artists, Hagesander, Polydoros and Athenedoros of Rhodes, created him and his children and the miraculous intertwining of serpents out of a single slab of marble, from their combined talents." Pliny, *Natural History* 36:37 were attacked and silenced by Poseidon by means of the sea serpents. The date of the group has, however, proved controversial. The twisting, contorted figures, the exaggerated anatomy of Laocoön, the anguished, fearful expressions, and the high drama of the struggle have helped place the group in many scholars' minds close to the great frieze of the Pergamon altar.

Yet the discovery in 1957 of more figures (fig. 10.43) executed in the Hellenistic baroque style, in a cave at Sperlonga transformed into a dining grotto belonging to an imperial villa and dated to the first century AD, has thrown the chronology into doubt. At Sperlonga, the groups depict scenes from Greek myth in large compositions. The blinding of Polyphemos, Odysseus's sailors consumed by Scylla, and the shipwreck convert the narrative from poetry to sculpture in dramatic settings and in a style similar to that of the Laocoön. Connection with the Laocoön

10.43 Odysseus and Palladion (statue of Athena) from one of the groups found in the cave "of Tiberius" at Sperlonga, some 60 miles (96 km) south of Rome. Roman 1st-century AD version of Hellenistic original or Hellenistic original of the 2nd century BC. Marble. Archaeological Museum, Sperlonga

10.44 Apotheosis of Homer, by Archelaos of Priene. c. 125 BC. Marble. Height 3 ft 9 ins (1.14 m). British Museum, London

group seems confirmed by the presence of the names of Hagesandros, Athenedoros, and Polydoros inscribed on the ship in the grotto. Were they originals of the second century BC brought to Italy from the East to adorn the emperor's underground dining room? Modern opinion inclines more to the view that both they and the Laocoön group represent concoctions of the first century AD, which drew freely on Hellenistic prototypes, emulating both the style of Hellenistic baroque, the subject matter, and its compositional arrangements. If so, one is tempted to think that the Late Hellenistic period, with respect to sculpture anyway, with its versatile adaptation of this High Hellenistic baroque style, may have continued well into the Roman empire of the first century AD. However that may be, the Laocoön is an excellent example of Hellenistic one-view composition

(like a relief) and of Hellenistic spiraling figures. In Hellenistic fashion, the pathos of the moment is high: Laocoön's struggle was doomed and Troy's fate was sealed.

We have seen examples of architectural relief sculpture in the gigantomachy of the Pergamene altar. Other reliefs were votive. The relief known as the APOTHEOSIS of Homer (fig. 10.44), a work of Archelaos of Priene that is dated to around 125 BC, combines scholarly references with allegory, a theatrical setting (literally), landscape elements, and numerous sculptural types. Figures are arranged in registers up the relief, which is only 3 feet 9 inches (1.14 m) high. At the bottom, on the stage – the backdrop for which is visible, slung along in front of columns – appears Homer, being crowned by personifications of Time and the World. The *Iliad* and the

10.45 Votive relief with sacrificial scene. 2nd century BC. Marble. Height 31 ins (79 cm). Glyptothek, Munich

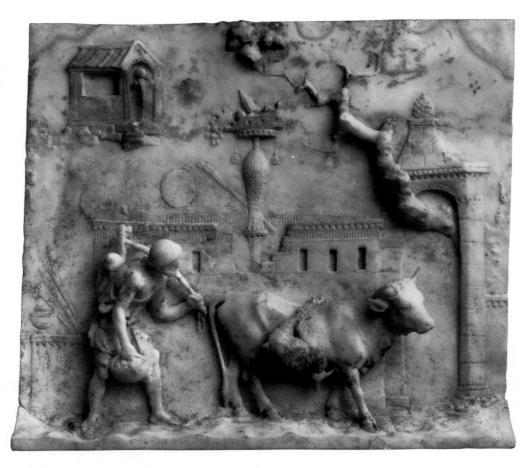

10.46 Relief with peasant driving a cow to market.1st century BC. Marble. Height 11¹/₄ ins (30 cm). Glyptothek, Munich

Odyssey kneel by his side; Myth and History sacrifice; other actors represent Poetry, Tragedy, Comedy, Human Nature, and four Virtues. All are identified by inscriptions – and all salute Homer – except Human Nature, the child who prefers to contemplate the Virtues. This cluttered scene is full of learned reference, clever allusion, recognizable attributes, and personified abstractions. Above, in the registers on the hillside, or in a cave, are the Muses, Apollo (in the cave), Zeus (at the very summit) with his eagle at his feet, and a statue of a poet to the right. Hellenistic sculptural types are used in the representation of the Muses. This complex relief speaks to the Hellenistic love of symbol, learning, sophistication, allegory, allusion, abstraction, the theater, and poetry.

Sometimes a relief encloses a picture in an architectural frame (fig. 10.45). Here, two deities (the male seated, the female leaning against a pillar) receive families of worshipers at an altar in a sanctuary. The humans are drawn to a smaller scale, fittingly, while a great garlanded tree provides the outstretched limb from which a cloth backdrop offering privacy for the deities is suspended. Two statues on a pillar watch the event. This relief, now in Munich, is said to come from Corinth.

Over time, these pictorial reliefs come to pay less and less attention to human figures, and more and more to landscape and architecture. Another relief (fig. 10.46), also in Munich, shows a farmer driving a cow, on whose back two sheep are tied, to market. Most of the space, however, is taken up with the wall and gate of a sanctuary, ceremonial details (tambourines, etc.), a large tree, and a smaller shrine further away. This tendency to de-emphasize humans in pictorial composition may find its culmination in the Odyssey Landscapes (fig. 10.53). These reliefs have traditionally been interpreted as votive in character, as gifts or prayers to gods; yet several have come to light in Roman villas where they were embedded as ornaments in marble-faced walls. As such, a further decorative function cannot be ruled out.

One group of relief panels of the first century BC demonstrates the interest of sculptors and patrons in echoing the styles of earlier times. The relief illustrated (fig. 10.47) shows a scene with two Nikai (personifications of Victory) and a bull. Both in style and subject matter, it is a clear evocation of the sculptures of the balustrade of the fifth-century Temple of Athena Nike on the Acropolis in Athens (fig. 8.29, p. 268). The theme, a procession of Nikai, is the same, while precarious postures (note the position of the left leg of the Nike at the left), clinging transparent drapery, and calligraphic rendering of folds are, if anything, even more pronounced. Thus, forms from earlier Greek art were adapted for Roman use. Since the Greek works most often used were Athenian of the Classical period, and since one center of production of such work in the first century was Athens, these reliefs are often termed "neo-Attic."

This retrospective paraphrasing or quoting of earlier styles was not confined to reliefs, nor to Greece. Another center of production, active by the middle years of the century, was Rome. Here, two artists, Pasiteles and Arkesilaos, known to us from literary sources, led the way. A pupil of Pasiteles called Stephanos created and signed a standing male athlete which enjoyed great popularity. No fewer than seventeen replicas have survived (imagine how many there may have been!), either singly or in combination with other figures. Here (fig. 10.48), the Stephanos athlete is joined by a beefy female companion who drapes her right arm over his right shoulder. How many styles (Archaic, Transitional, High Classical, Late Classical, Hellenistic) are

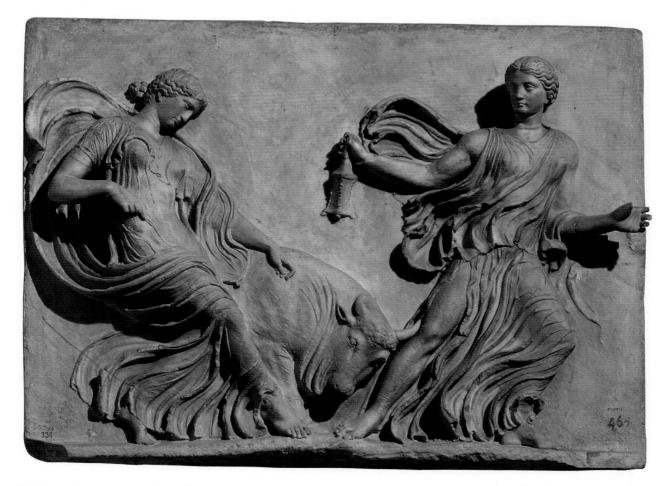

10.47 Relief showing two Nikai and a bull. Neo-Attic version of the balustrade of the Temple of Athena Nike, Athens. c. 100 BC. Marble. Height 26³/₂ ins (67 cm). Uffizi, Florence

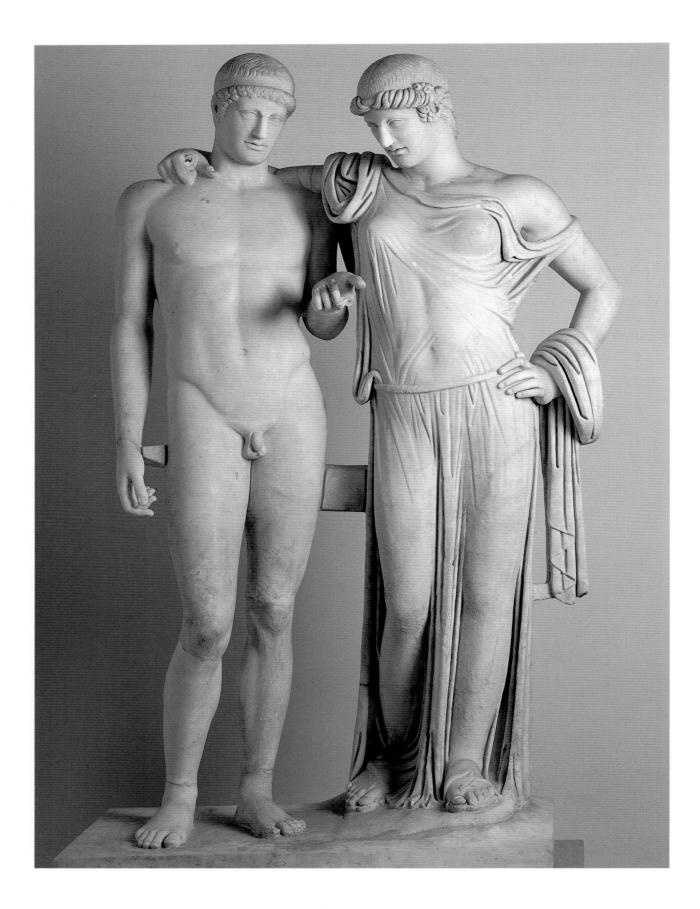

detectable in these Classicizing figures? Sometimes taken to represent a mythological pair, Electra and Orestes, their identity and meaning doubtless varied according to their Roman context.

From the very earliest periods, artisans had produced small figurines in terracotta, many for use as votive offerings. South Italy continued to be a conspicuous center of production, along with Asia Minor and Athens. In Italy, the appearance of terracotta figurines of actors (fig. 10.49) neatly complements their appearance on the phlyax vases (fig. 9.45, p. 320), and gives us a splendid idea of what these performers looked like. Toward the end of the fourth century BC, a new series of terracottas, the socalled Tanagra figurines, made their appearance. They take their name from the town of Tanagra in Boeotia, where they were first found. Most come from graves and therefore carry some specific meaning, weightier in intention than the phlyax figures. The best-known Tanagra type is the standing draped female (fig. 10.50), which enjoyed great popularity in the Hellenistic period.

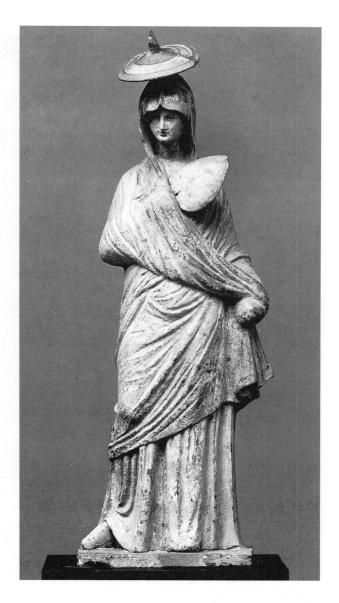

10.48 *Opposite* Group including the Stephanos athlete, perhaps Orestes and Electra. Later 1st century BC. Marble. Height 4 ft 11 ins (1.50 m). Archaeological Museum, Naples

10.49 Left Figurine of an actor dressed as an old woman, a character in a phlyax play.c. 350 BC. Terracotta. Martin von Wagner Museum, Würzburg

10.50 *Above* Female figurine, from Tanagra. 3rd century BC. Terracotta. Height 13 ins (33 cm). Staatliche Museen, Berlin

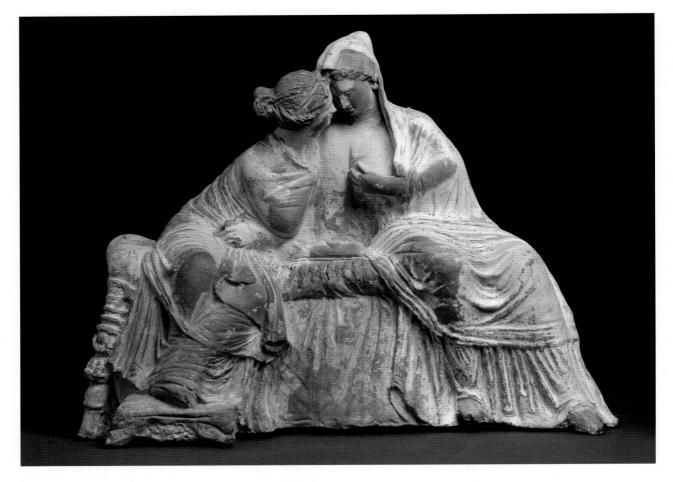

10.51 Pair of women conversing, from Myrina. c. 200 BC. Terracotta. Height 8¼ ins (21 cm). British Museum, London

The use of several molds - to make different parts of figures in different postures - and the addition of handmade sections made production of differing types easier. Thus, these artefacts readily met the Hellenistic desire for variety and realism and the draped female appeared seated (fig. 10.51) as well as standing, playing games, or dancing. The standing figure typically adopts a stylized, easy stance, is heavily draped, and often gazes downward. A small head, slim shoulders, and broad hips are characteristic. Hundreds of these figurines have been found, and often the paint with which they were decorated is preserved. Blue paint and gilding are used on an elegant woman (fig. 10.50) of the third century BC from Tanagra, who carries a fan and wears a sunhat. Male figures were also made, but in far fewer numbers; of these, the flying Eros figure enjoyed some favor.

The whole of this period is full of puzzles, not least in sculpture, and there are serious uncertainties of attribution, chronology, regional style, and even of subject identification, but the broad outlines are reasonably clear.

WALL PAINTING AND MOSAICS

Direct evidence for Hellenistic wall paintings is almost as scarce as it was for those of the fifth and fourth centuries BC, and we may reasonably suspect that what has survived is not necessarily of the first rank. However, the Macedonian chamber tombs are giving us a much clearer picture of developments, both in the fourth century and the Hellenistic era. **10.52** Painted dome of circular tomb at Kazanlak, Bulgaria: work of a Greek artist. c. 300 BC. Wall painting. Diameter of tomb. c. 11 ft (3.35 m)

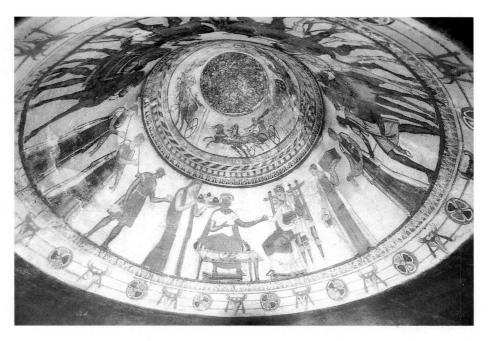

On the edge of the Greek world, at Kazanlak in Bulgaria, a vaulted tomb also from about 300 BC has been found, the vault painted with friezes of figures and chariots (fig. 10.52). The standing and seated figures are drawn from the vocabulary of Greek types, while the enthroned figure to the right, placed diagonally to the foreground, is an important forerunner to a similar motif in the Roman paintings from Boscoreale. The chariot and horses careering around the dome show experiment in illusionistic perspective, and precede their counterparts in Roman paintings at Pompeii by some three hundred years. Yet the figures are flat, the use of color is unimaginative, and the draftsmanship is clumsy. This is the work of a provincial Greek artist, but is nevertheless an important survivor.

Perhaps the most important innovation of Hellenistic wall painters was their greater use of landscape. There were landscape elements on the fourthcentury tomb at Vergina and schematic landscape features appear even earlier, for instance in the Tomb of the Diver wall painting (fig. 7.47, p. 246); literary sources tell of an important Hellenistic painter at this time called Demetrios Topographos (the landscape painter). But because of a lack of direct archaeological evidence, the topic is controversial and is anyway overshadowed by a magnificent series of paintings, known as the Odyssey Landscapes, found in a house on the Esquiline in Rome. These show episodes from Odysseus's adventures set in the most dramatic landscapes. They are Late Hellenistic (first century BC) in date. But are they Greek or Roman? What precursors can be found? The elements in the painting of Macedonian tombs are evidence that landscape themes were under study, but nothing yet found prepares us for the vastness of scale and the brilliance of the conjunction of narrative and illusion in the Odyssey Landscapes. Odysseus (fig. 10.53) journeys through the countryside encountering many challenges and companions. But he and his human counterparts are diminutive by comparison with the mountains, rocks, trees, the sky, and the sea. Nature herself is the real focus for the painter, so that the physical world itself becomes as important as the myth that Odysseus represents. Strong accents of light and shade emphasize the grandeur of nature, the brushwork is rapid and impressionistic. Figures are painstakingly identified, in the old Greek fashion, by inscriptions. It is difficult to believe that this phenomenon made its first appearance, fully mature, in the first century BC. Many sensitive commentators take the view that these landscapes are Roman adaptations of earlier, second-century BC Hellenistic paintings and that the three-dimensional representation of landscape as a grand setting for narrative or for its own sake began then.

Literary sources tell us that Romans copied Greek paintings, but it seems they preferred paint-

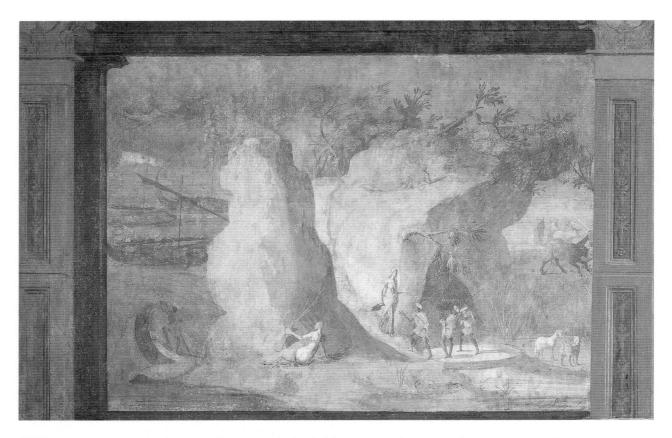

10.53 Odyssey Landscape: Odysseus and his men in the land of the Laestrygonians. From a house on the Esquiline in Rome. c. 50 BC. Wall painting. Height (of frieze) 5 ft (1.52 m). Vatican Museums, Rome

ings of the fourth century BC, since Hellenistic paintings of the third and second centuries BC are seldom mentioned. Among Hellenistic painters who did, however, attract Roman attention were Epigonos, Artemon, and Demetrios Topographos. The presence on the walls of Pompeii and Herculaneum of several versions, different in details, of a particular painting both argues the existence of a prototype and suggests the difficulty of identifying what the original looked like.

As with the search for fourth-century Greek painting, the search for Hellenistic mural or panel painting may be illuminated by the work of Roman emulators at Pompeii and Herculaneum. Hellenistic features need to be identified. Evidence for recognizing a Hellenistic prototype in a Roman painting includes the following: large-scale landscape elements; Hellenistic sculptural types; Macedonian military equipment and garments; similarities to head types and facial features on Hellenistic coins; genre scenes from South Italian vases; and other aspects of Hellenistic culture, such as New Comedy (a genre of comic theater that developed after about 320 BC and relied on stock characters, serious plots, and personal ridicule). Obviously, the presence of any purely Roman features in combination with Hellenistic ones will mean that a Roman painter is creatively using older material.

There is some agreement that a painting from Herculaneum showing Arkadia, Herakles, and Telephos (fig. 10.54) reflects a Hellenistic original. A majestic, seated Arkadia greets a standing Herakles, who turns to look down at Telephos being suckled by a hind while being watched over by an eagle. The scene is an episode from the life of Telephos, the legendary founder of Pergamon; and elements of the style of the painting – the posture and musculature of Herakles, and the rendering of Arkadia's drapery – are indeed reminiscent of the style of the sculptures of the Great Altar at Pergamon (figs. 10.24–10.26). There is nothing specifically Roman in the painting, which therefore has a good chance of being a copy of a Hellenistic original.

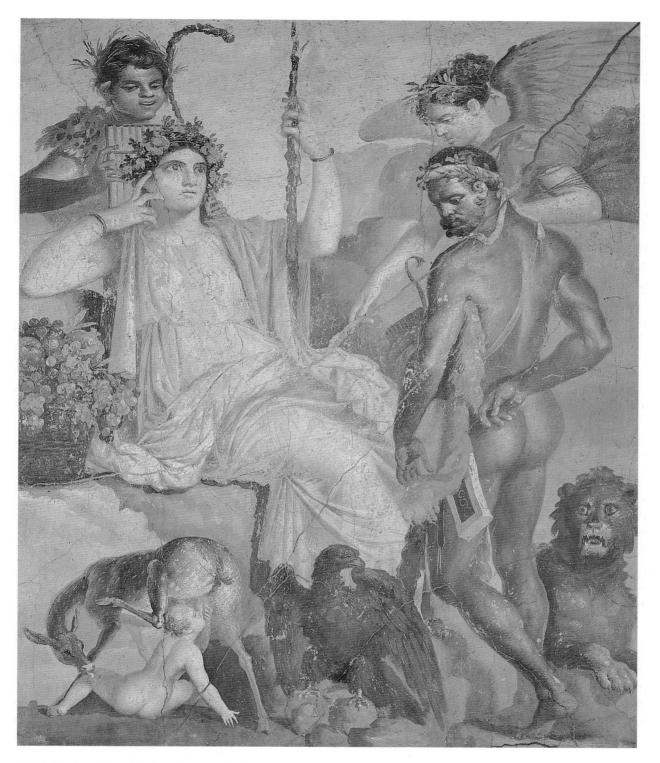

10.54 Herakles, led by Iris, finds his son Telephos. From Herculaneum. Roman version of a Greek original of the 2nd century BC. Wall painting. National Museum, Naples

10.55 Preening doves. Perhaps based on an original by Sosos in the 2nd century BC. 2nd century AD. Mosaic. $38\frac{1}{3} \times 33\frac{1}{2}$ ins (98 × 85 cm). Capitoline Museum, Rome

Tessellated mosaics had replaced pebble mosaics by about 250 BC. Examples from Pergamon show panels with figures shaped with strong accents of light and shade. One master craftsman here, Sosos by name, became famous for his illusionistic panels, notably one of birds drinking at a basin, and another of an unswept floor.

Such themes became popular in the Roman world and were frequently used in floor mosaics. A panel of doves (fig. 10.55) perched on the rim of a basin, drinking, preening, and billing and cooing, which comes from second-century AD Tivoli, may reflect Sosos's composition. Another, of an unswept floor, found in Rome and signed by a certain Herakleitos, may well be a version of Sosos's image of the debris of a dinner party.

Scenes from the theater also appear. Two small mosaics from Pompeii signed by Dioskourides of Samos show excerpts from the New Comedy. One (fig. 10.56) shows three street musicians and a boy, all wearing theatrical masks and performing on a narrow stage. The lettering of Dioskourides' signatures point to a date of c. 100 BC, while the technique of shading, highlighting, and polychromy seem to suggest an earlier Hellenistic painting from which this mosaic may have been adapted.

10.56 Comic scene, by Dioskourides of Samos. c. 100 BC. Mosaic. Height 19 ins (48 cm). Archaeological Museum, Naples

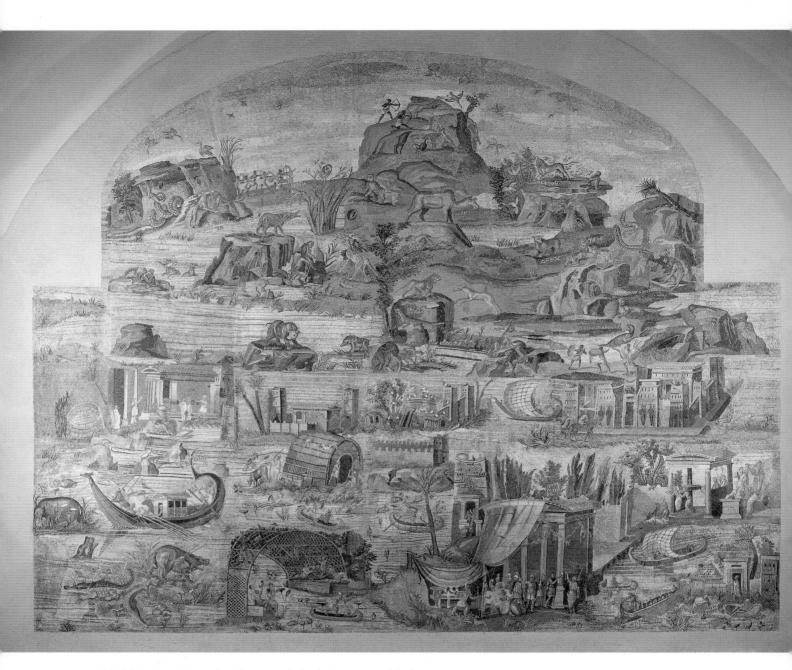

10.57 Nile Mosaic (now heavily restored), in the Sanctuary of Fortuna, Praeneste. c. 100 BC. c. 19 ft 8 ins \times 16 ft (6 \times 4.9 m). National Museum, Palestrina

Much larger mosaics decorated the floors of public buildings. At Praeneste (Palestrina), some 25 miles (40 km) east of Rome, is the Sanctuary of Fortuna. Built in the second century BC, it echoes developments elsewhere in the Hellenistic world. Multiple terraces on a hillside and extensive use of colonnades remind one of Pergamon; and its (almost) symmetrical hillside plan, stepped terraces, and axial approach to the temple at the summit are very similar to those of the Sanctuary of Asklepios on the island of Kos. A great mosaic, measuring about 20×17 feet (6 \times 5 m), decorated the floor of an apsed hall. This is the so-called Nile Mosaic (fig. 10.57), which dates from around 100 BC and shows a Hellenistic adaptation of an old Egyptian motif. It was probably copied in Praeneste from

a prototype created in Alexandria. The Nile and its denizens, human and animal, are the subject of this polychrome mosaic. The southern regions of Egypt are shown at the top (in the apse), and the more populated estuary at the bottom. The river winding its way through the landscape is the thread that unites the whole scene. The interest in the life of the river is panoramic. The lower part depicts ships of all kinds; oared warships, sailing boats, fishing boats, and skiffs on a river populated by crocodiles, hippopotamuses, birds of all kinds, fish large and small, and water buffalo. Many buildings viewed from different angles stand on the banks. Soldiers gather under an awning outside an imposing columned building, a bugler sounds off, women loiter in a pergola, a peasant rides by on a donkey. In the upper, more distant part, landscape elements take precedence over architecture, boats, and humans. Though there are hunting parties made up of tiny figures, this is the domain of wild animals, real and fantastic, most identified by Greek inscriptions. Rocks, trees, bushes, birds, and serpents are their companions. The knowledge of the river and the range of life it sustains is both encyclopedic and fanciful. Scholarly interest in detail, the enthusiasm for landscape motifs, the great variety of boats and buildings, and the varied views are all characteristically Hellenistic.

POTTERY

At the end of the fourth century BC, painted pottery gave way to mold-made bowls with relief decoration. These pots at first probably imitated bowls made of precious metals. They are conventionally called Megarian bowls, but were in fact manufactured all over the Hellenistic world and enjoyed great commercial success from the third century BC down into the first. The decoration is usually floral, but occasionally figures and even mythological scenes appear. The illustration (fig. 10.58) shows part of a bowl and part of the mold from which it was made, both from Athens. This technique of making pottery was picked up by the Romans in the first century BC and resulted in the production of the most successful of all Roman tablewares, Arretine.

Painted pottery did not, however, fade out entirely. Gnathian ware, which had flourished in South Italy in the second half of the fourth century, continued in the third. It had originally come in the same shapes as simple black-gloss ware and was decorated in white, yellow, and red. Animal and, in particular, vegetal motifs were popular. Gnathian is the only South Italian ware to have found much favor abroad and has turned up in Egypt and even as far afield as sites on the Black Sea coast. Production continued until the end of the third century BC. Its counterpart in Greece and the East was West Slope Ware, named after material found on the

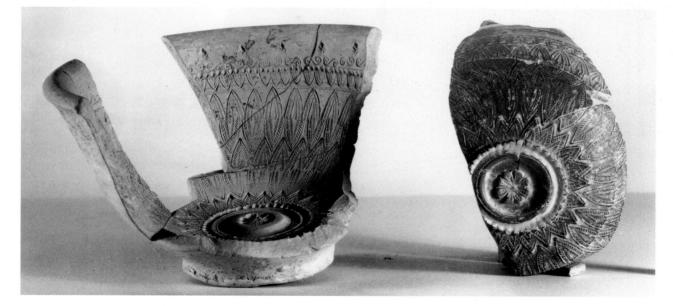

10.58 Part of a mold-made Megarian bowl, and the mold from which it was made, from the Athenian Agora. 3rd–2nd century BC. Agora Museum, Athens

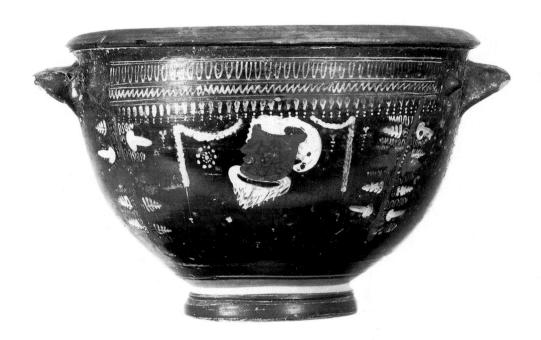

10.59 Gnathian ware bowl, made in South Italy: a comic mask and garlands. 3rd century BC. Height 7 ins (18 cm). Rijksmuseum van Oudheden, Leiden

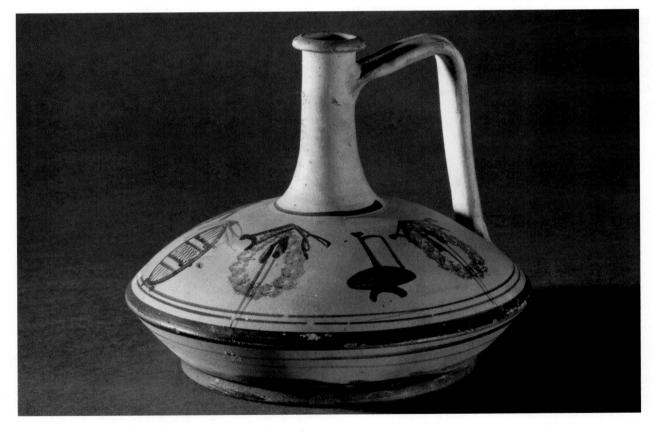

10.60 Lagynos made near Pergamon and decorated with a lagynos and festoons. 2nd century BC. Height 6% ins (16 cm). British Museum, London

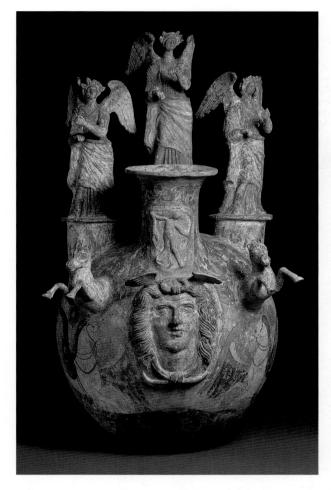

10.61 Canosan askos, made in Apulia: Medusa head in relief, forepart of horses and winged Nikai attached, and elaborate painting. 3rd century BC. Height 2 ft 6 ins (76.5 cm). British Museum, London

west slope of the Acropolis in Athens. The black surface of Gnathian was painted over in whites and browns with wreaths, floral scrolls, and ribbons. Occasionally, a female figure or head, an Eros, even a musical instrument appear as decorations. Here (fig. 10.59) the bowl is painted with an actor's mask surrounded by decorative abstract registers and garlands. West Slope Ware typically decorated the black surface with floral designs in white and continued into the first century BC.

Painting on a light ground continued on Panathenaic amphoras until the end of the third century BC, and a new shape, the LAGYNOS (a squat jug with a long neck), is habitually decorated with brown paint on a thick white slip. The decoration most often shows garlands or wreaths, but sometimes also

10.62 Centuripe vase, made in Sicily: a polychrome funerary vase, painted after firing. 3rd century BC. Height 22 ins (56 cm). Catania University, Sicily

different objects related to feasting (fig. 10.60). The shape may have originated in Asia Minor, perhaps near Pergamon, and lasted till the first century BC. More ambitious were vases, essentially white-ground with molded additions. At Canosa in South Italy in the third century BC, burials often included unusual pottery shapes to which fully three-dimensional attachments (horse heads and necks, for example) were fixed, and atop which stood terracotta Tanagra-like Nike figures, all painted in blue, pink, and vellow on a white ground (fig. 10.61). At Centuripe in Sicily, also in the third century BC, a similar practice was followed. The polychrome burial vase (fig. 10.62), extravagant in shape and with molded additions (heads, architectural moldings), shows a seated woman flanked by two attendants. Pink, blue, yellow, and red are painted over the white ground. All the painting was done after the vessel was fired, so that these colors are notoriously fugitive. This technique was quite different from the Greek red-figure of the fifth and fourth centuries BC, and the style represented, in fact, the final episode in the history of Greek vase painting.

11.1 St. Pancras Parish Church, London. Caryatid porch at entrance to crypt. AD 1822. The design, inspired by the Erechtheion at Athens, includes a six-column lonic façade and demonstrates the continuing impact of Greek art and architecture

CONCLUSION

Though archaeology comprises much more than art, it is the major developments in Greek art from the Bronze Age to the Hellenistic era – in architecture, sculpture, pottery, and wall painting – that have been emphasized in this book. These developments continued through the Roman period and the Renaissance and can be seen as the foundation on which much of Western art came to be based.

The Greeks' interest in the representation of the human figure is evident in the Cyclades as early as the third millennium. It comes to the fore again in the two-dimensional and sticklike figures of the Geometric period and later in the increasingly realistic but stereotypical forms that prevailed until the Hellenistic period. In the fifth century BC, it culminated in an understanding of natural appearances that enabled sculptors and painters of the Classical period to express accurately not only anatomy, but also human emotion, character, age, and mood. Artists had continued to struggle with the conflict between realistic and conceptual representation, and their triumph in imposing external order on the representation of nature was a major achievement of the High Classical period. From the beginning of the fourth century BC, however, balanced forms started to fragment and the exploration in art of states of mind advanced rapidly, until in Hellenistic times individualized and exaggerated postures, gestures, and expressions became common.

The desire to represent the human figure as an object of beauty was accompanied by other forms of creative expression, most notably in architecture. Architects and planners studied measurement and scale to impose harmonious proportions on temples and more secular buildings, and to create spaces and structures suitable for sacrifice and ritual, as well as for administrative, political, and commercial life. The landscape – and the relationship between architecture and landscape – was always important, whether in early sanctuaries sited on hallowed land, or in later citadels such as that at Pergamon, where geography and geometry were juxtaposed in theatrical display.

The victory of Octavian at Actium in 31 BC can be said to mark the end of the Hellenistic era, but the influence of Greek art continued. With the absorption of the Greek cities in Italy and Sicily into the world of Rome, and with the Roman conquest of Greece, a new era had opened. Greek ideas, objects, and materials had already begun to flow into Rome. Roman generals and entrepreneurs looted Greek sites and carried off important works to decorate villas, gardens, and public places in Italy; Greek statues and paintings were copied repeatedly. Roman architects followed the Greek orders, making use of Doric and Ionic, but openly favoring Corinthian. The political Romanization of the Hellenistic world went hand in hand with the artistic Hellenization of Rome. Rome thus became the intermediary for Greek ideas that passed into the Italian Renaissance and modern times.

Over a thousand years later, Renaissance artists, looking back to the ancient Greek traditions, again took up the challenge of realistically representing the structure and proportions of the human body. Renaissance architects, wishing to use ancient shapes and rules of proportion in new churches and city palaces, grappled with problems posed by the Classical orders. Renaissance painters often depicted still visible ancient monuments and sought in other ways to evoke the world of antiquity. The art and architecture of this world, far from dying out, has been emulated repeatedly (fig. 11.1). It was a major influence at the dawn of the modern age and may fairly be considered a mainspring of Western civilization.

CHRONOLOGY

900 b	sc Gr	eeks i	n Sy	ria

- 800 BC Greek settlements in South Italy and Sicily
- 700 BC Greeks in Egypt and Libya Greeks by the Black Sea Further settlements in South Italy and Sicily Tyrannies in Greece Population decline in Athens, growth elsewhere

600 BC Reforms of Solon at Athens Tyranny of Peisistratos and his family at Athens Persians conquer Lydia and reach the Aegean coast Tyranny of Polykrates on Samos Kleisthenes and democracy in Athens

500 BC Persian invasion of Greece and war, 490-479 BC Battle of Marathon, 490 BC Battle of Salamis, 480 BC Battle of Plataea, 479 BC Western Greeks defeat Carthage at Himera, 480 BC Western Greeks defeat Etruscans at Cumae, 474 BC Delian League formed (becomes the Athenian Empire) 477 BC Tyrannies in the West: Syracuse, Akragas, Gela Delian League treasury transferred to Athens, 454 BC Aeschylus, Sophocles, Euripides Perikles

Peloponnesian War between Sparta and Athens, 431–404 BC Athens's expedition to Sicily, 415–413 BC Athens's defeat at Syracuse, 413 BC Sparta victorious, 404 BC Aristophanes, Thucydides

400 BC Socrates, Plato Carthage again active in Sicily Dionysios tyrant in Syracuse Timoleon and oligarchy in Syracuse Demosthenes, Aristotle Macedonians defeat Greeks at Chaeronea, 338 BC Alexander the Great, 336–323 BC End of city-states in Greece Emergence of nation-states: Egypt, Syria, Macedon

300 BC Hieron II rules Syracuse, 275–216 BC Kingdom of Pergamon established Gauls invade Asia Minor Rome controls South Italy and Sicily by the end of the century

200 BC Rome defeats Macedon, 197 BC and 168 BC Corinth sacked by Romans, 146 BC Kingdom of Pergamon bequeathed to Rome, 133 BC

100 BC Greece becomes a Roman province Athens sacked by Rome, 86 BC Battle of Actium, 31 BC

GLOSSARY

Words in *italics* indicate other terms in the Glossary

- **ABACUS** The square-shaped flat slab forming the top of a column *capital*.
- ACANTHUS A plant, the leaves of which resemble the principal decorative element of the Corinthian *capital*.
- ACROPOLIS A generic term for a high place or citadel in a Greek city. ADYTON An inner chamber at the back
- of a temple.
- AEGIS A magic cape or shawl-like garment decorated with the Gorgon's head and fringed with snakes, often worn by Athena.
- **AEOLIC CAPITAL** An early architectural *capital*, confined geographically to Aeolis (see map, fig. 4.2) and characterized by upward-springing *volutes*.
- AGORA The market place; the commercial and administrative center of a city.
- **AKROLITH** A statue with head, hands, and feet of stone, with the rest often of wood.
- **AKROTERION** (pl. **AKROTERIA**) The ornament at the corner of the roof of a temple or at the *apex* of the gable.
- ALABASTRON (pl. ALABASTRA) A small pot with a narrow neck, and generally without a foot, used for holding oil or perfume.
- holding oil or perfume. **AMBULATORY** The side and end passages around a temple.
- AMPHIPROSTYLE With columns at the front and back, but not on either flank.
- AMPHORA A tall, normally two-handled vessel used for storage or, when decorated, as a container (of wine, for example), or as a prize in the games.
- ANASTOLE An off-center parting of the hair with locks brushed up and back near the parting.
- ANDRON A principal room of a Greek house, often the men's dining room.
- **ANTA** (pl. **ANTAE**) The broadened end of a wall often terminating a series, or pair, of columns.
- **ANTHEMION** A *frieze* of floral decoration, frequently alternating lotus and *palmette*.
- **IN ANTIS** Positioned between the *antae*. **APEX** The highest point.
- **APOTHEOSIS** The moment of transformation of a person or hero from human or semidivine to divine nature.
- **APSE** Vaulted semicircular end of a building. **APSIDAL** A plan that ends in an *apse*.
- ARCHITRAVE The course of masonry running atop the column *capitals* and supporting the superstructure.

- **ARRIS** In the Doric order, the join of the *flutes* of a column normally forming a sharp ridge.
- **ARYBALLOS** A small globular or ovoid flask for holding oil or perfume.
- ASHLAR A masonry style of dressed and coursed rectangular blocks.
- ATLANTES Or atlases or telamones. The Greek (atlantes) and Roman (telamones) terms for male figures used in architecture in place of columns or piers. Atlas, in myth, was a Titan. After the defeat of the Titans (older gods who preceded the Olympians) by Zeus, the Titans were incarcerated in Tartaros, with the exception of Atlas, whose punishment was to hold up the heavens for ever.
- AXIAL Adjective derived from "axis." In sculpture, an imaginary line around which the human body rotates, or on either side of which the parts of the body are arranged. In architecture, a straight line that divides spaces and forms equally.
- **BALDRIC** A belt or sash worn over one shoulder by a warrior.
- BAROQUE Characterized by curved, elaborate, dynamic forms.
- BLACK-FIGURE A technique for painting pottery that depended on figures in black silhouette, incised detail, and added color.
- **BLOOM** A mass of wrought iron from a forge or furnace.
- **BOULEUTERION** The meeting place for the members of the boule (the council); the councilhouse.
- BUCRANION A frontal ox head or skull.
- BURIN An incising instrument.
- **CAPITAL** The upper, spreading element in a column, forming a transition between the vertical shaft and the horizontal elements of the *architrave*.
- **CARYATID** A female figure supporting the *entablature* of a building.
- CAVEA The seating in a Greek theater. CELLA The main room of a Greek temple
- where the cult statue was placed.
- CHALCEDONY A translucent variety of quartz. Agate and carnelian are varieties of chalcedony.
- **CHAMBER TOMB** An irregularly shaped room or complex of rooms, used for burial, often approached by a corridor.
- CHEVRON An inverted-V ornament. CHIAROSCURO The use of light and shade to create effects of shape and mass in painting and sculpture.

CHITON A lightweight, single-piece garment, belted and with buttoned sleeve. CHLAMYS A short cloak.

- CHRYSELEPHANTINE Of gold and ivory.
- CHTHONIC An adjective meaning "of the earth" and often referring to the gods of the underworld.
- CIRE PERDUE The "lost-wax" method of making bronze statues (see pp. 72, 191).
- CIST A shallow rectangular grave cut in the earth or rock, sometimes stone-lined or slab-built.
- COFFERS Recessed panels in a flat ceiling. COLONNADE A range of columns supporting an *entablature*.
- CONTRAPPOSTO A term applied to a pose of the human figure in which tensed forms are balanced with relaxed forms.
- CORBELING (corbel a kind of bracket) A system for supporting courses of masonry or wood by extending successive courses beyond the face of the wall.
- **CORNICE** The horizontal course of the *entablature* of a building immediately above the *frieze*; either raking (sloping) member of a gable.
- CUIRASS Metal armor worn to protect the chest and back.
- CYCLADES The southern islands of the Aegean, especially Delos, Paros, Naxos, Siphnos, and Melos.
- **CYCLOPEAN** Of the Cyclopes, mythical primitive giants; an adjective applied to the huge, irregular masonry fortifications of the Bronze Age.
- **DADO** The lower part of a wall, often formed of a distinctive ornamental stone.
- DENDROCHRONOLOGY A means of reckoning dates and intervals of time by the examination of growth rings in trees or dead wood.
- **DENTILS** Small rectangular blocks used below the Ionic *cornice*, one after the other, as decoration; originally used as an alternative to, but later incorporated in, the *frieze*.
- **DIAZOMA** A walkway dividing the upper tiers of seats from the lower in a Greek theater.
- DINOS An open vessel with a rounded base needing a pedestal, used for mixing wine and water.
- **DROMOS** A corridor leading to a chamber tomb or *tholos*.
- ECHINUS The lower member of a column *capital.*

EGG AND DART A carved ornament used in architecture, so called since its continuously alternating shapes resemble eggs and darts.

EKPHORA A ritual carrying away of a coffin; a funeral procession to a cemetery.

ELEVATION One side or face of a building; a measured drawing of such a side, or part of a side.

EMBOSSING A technique of decoration that raises the surface into projecting knobs or studs (bosses).

ENGAGED A half- or three-quartercolumn appearing to project from a wall.

ENTABLATURE The horizontal architectural members forming the superstructure of a building above the columns: the *architrave*, *frieze*, and *cornice*.

ENTASIS The cigarlike swelling of columns.

EPIBLEMA A cloak.

EPIGRAPHY The study of inscriptions.

EPIPHANY The appearance of a god.

EPISTYLE The architrave.

FAIENCE A quartz-based ceramic-like substance fired at a high temperature and covered with a shiny, glasslike glaze.

FASCIA (pl. FASCIAE) An undecorated band on an Ionic *architrave*.

FIBULA A brooch.

FILIGREE A metalsmith's technique using thin wire for decorating.

FLUTES Shallow grooves running vertically on the shaft of a column.

FORESHORTENING An illusionistic trick to suggest depth on a flat surface by representing forms as shorter in length than they actually are.

FRESCO A wall painting made by rapid application of colors to plaster while still damp.

FRIEZE The architectural course between the *architrave* and the *cornice*.

GORGON In mythology, one of three hideous female monsters (of whom Medusa is the most famous) endowed with wings and large fangs, and having snakes for hair.

GORGONEION The head of a Gorgon. GOURD A large fruit whose tough skin

was used to hold liquid. GRANULATION A metalsmith's technique of soldering globules of gold or silver onto jewelry.

GREAVES Armor worn to protect the shins.

GRIFFIN A mythological beast with the body of a lion and the wings and head of an eagle.

GROUNDLINE In art, the line on which figures stand.

GYPSUM A sparkling limestone.

HEKATOMPEDON A temple one hundred feet (30.5 m) long.

HERM A rectangular block with a head atop (and sometimes with an erect penis below).

HEROON The shrine of a hero, a semidivine person.

HEXASTYLE With six columns at the front, or at the front and back.

HIMATION A mantle worn over the *chiton* or *peplos*.

HIPPODAMIAN Of Hippodamos, an architect and townplanner of the fifth century BC.

HOPLITE A heavily armed (helmet, *cuirass, greaves*, shield, spear) footsoldier.

HORNS OF CONSECRATION Stylized representations of bull's horns which marked a sacred place.

HYDRIA A water jar with three handles. ICONOGRAPHY The study of the subject

matter of sculpture, painting, and the other visual arts.

INCISION The scratching of lines into a surface to form contours or patterns, especially used of the decoration of pottery, perhaps in that instance derived from the engraving of metals.

INGOT A plate of metal cast in a mold.

ITHYPHALLIC With penis erect. KANTHAROS (pl. KANTHAROI) A

deep drinking cup with high vertical handles.

KERAMEIKOS The potters' quarter at Athens which intruded on the famous cemetery, also so named.

KERNOS A multiple vase for making simultaneous offerings to a deity.

KORE (pl. KORAI) A standing, draped female figure.

KOTYLE A deep drinking cup with small horizontal handles.

KOUROS (pl. KOUROI) A standing nude

male figure. KRATER A large open vessel used for

mixing wine and water. KYLIX (pl. KYLIKES) A shallow drinking cup with horizontal handles.

LAGYNOS A squat jug with a long neck.

LAPITHS In myth, a Thessalian people whose king was Peirithoos and whose main antagonists were the centaurs. The centaurs, invited to the wedding feast of Peirithoos, tried to carry off the Lapith women but were overwhelmed in the violent struggle that ensued.

LARNAX A chest, often used as a coffin. LEBES See *dinos*.

LEBES See *amos*. **LEKANE** A lidded dish or plate.

LEKYTHOS (pl. **LEKYTHOI**) A tall flask with a narrow neck and a single handle,

used for containing oil or unguents. LIGHT-WELL A small courtyard or shaft inside a building, uncovered to let in light and air.

LINTEL A horizontal block or beam bridging a door or other opening.

LUSTRAL BASIN A small rectangular space, conventionally thought sacred, accessible from above by a short flight of steps.

MAEANDER A rectilinear decorative motif, winding backward and forward continuously.

MAENAD A female member of Dionysos's retinue.

MAGNA GRAECIA "Great Greece" (Latin). The Greek settlements in South Italy, often including those of Sicily as well. **MEGALITHIC** A style of construction characterized by massive, irregularly shaped blocks.

MEGARON (pl. MEGARA) A type of long house, characterized by a porch, a long hall, and a storage room of either *apsidal* or rectangular plan. Common at Troy, they appear in Greece by c. 2000 BC. In the Late Bronze period, they are characterized on the mainland of Greece by a columned porch, a vestibule, and a main room with a large hearth; on Crete, by *pier*-and-door construction.

METOPE In a Doric frieze a space between two *triglyphs*, sometimes filled with a block carved with relief sculpture.

METROON A temple of Meter, mother of the gods.

MOLDING In architecture, a continuous decorative motif.

NAOS The main room of a Greek temple (see *cella*).

NEOLITHIC The cultural period characterized by primitive farming and the use of polished stone and flint tools and weapons.

NEREID A daughter of the sea god Nereus.

NIELLO A technique for decorating metal; a black amalgam of sulphur, borax, copper, and lead inlaid in an engraved design.

NILOTIC Adjective, perhaps derived from the "Nile," meaning of river life.

NUMISMATICS The study of coins.

OBSIDIAN Volcanic glass.

OCTASTYLE With eight columns at the front, or at the front and back.

OIKOS The house of a god, a temple; generally, any house, dwelling, or room.

OINOCHOE A pouring jug, often with a trefoil mouth.

OLPE A jug with a broad lip.

OPISTHODOMOS The back porch of a Greek temple.

ORACLE An answer given by a deity, the place where such an answer is given, or the person delivering the answer.

ORACULAR Relating to an oracle.

ORCHESTRA The level, horseshoe-shaped space between audience and stage, reserved for the chorus, in a Greek theater.

ORTHOSTATE An upright slab, taller than normal wall blocks and usually at the foot of a wall; a course of masonry of such blocks.

PALAESTRA A training and exercise ground for boxing and wrestling, etc. Smaller than a gymnasium.

PALMETTE A floral design, consisting of leaves arranged like a palm shoot.

PANATHENAIC Of Panathenaia, the major festival of Athens. The Greater Panathenaia was held every fourth year, the Lesser Panathenaia annually.

PANHELLENIC All-Greek. Most frequently used to describe either *sanctuaries* or games.

PASTAS A house type characterized by an inner courtyard with a veranda or verandas.

- **PEDIMENT** The triangular space formed by the gable at either end of a Greek temple.
- **PEDIMENTAL SCULPTURES** Sculpted figures, carved either freestanding or in relief, that fill the pedimental space.
- **PELIKE** A storage jar with two handles; a container for wine or other supplies.

PENTELIC Of Mount Pentelikon. PEPLOPHOROI Women who wear the

peplos. PEPLOS A single piece corment

PEPLOS A single-piece garment, sleeveless, fixed at the shoulders with pins and belted.

- **PERIPTERAL** Surrounded by a row of columns.
- **PERIRRHANTERION** A ritual water basin.
- **PERISTYLE** A *colonnade* surrounding a building (an external peristyle) or a court (an internal peristyle).
- **PHLYAX** A comic play popular in southern Italy; an actor who participated in such a play.

PIER A freestanding, rectangular mass of masonry supporting the superstructure of a building.

- **PILASTER** A rectangular architectural member, part of which is bonded into a wall (like an *engaged column*) and part of which projects from it.
- PITHOS (pl. PITHOI) A large clay storage vessel.

POLOS A tall headdress.

- **PORPHYRY** A very hard, purple and white stone.
- POSTERN A small gate or door at the back of a building or complex.

PRONAOS The front porch of a Greek temple.

- **PROPYLAIA** A monumental entrance, having more than one doorway, to a *sanctuary*. Most frequently used of the High Classical gate building to the Acropolis at Athens.
- PROPYLON (pl. PROPYLA) A monumental entrance to a sanctuary or other architectural complex.
- **PROSTYLE** The arrangement whereby columns are placed in front of a building.

PROTHESIS The lying in state of a corpse. **PROTOME** An independent head, or head and upper members, of an animal or human.

PRYTANEION An administrative center including committee meeting rooms, a reception area, a dining hall and archival space.

PSEUDO-DIPTERAL In architecture, a plan of a building showing a row of columns on all sides with unused space for a second row of columns (see p. 156).

- **PUMICE** A kind of volcanic glass, very light in weight.
- **PYXIS** A lidded cosmetics or jewelry box; occasionally a knitting basket.
- QUADRIGA A chariot with two wheels drawn by four horses.

RADIOCARBON DATING A scientific method for arriving at absolute dates for organic objects by measuring the amount of carbon 14 (C14) surviving in the object.

- **RED-FIGURE** A technique for painting pottery that was the direct opposite of *black-figure*: the background was painted black with figures left the color of the clay. Contours and interior details were added with *relief lines* or dilute *slip*.
- **REGISTER** In painting, a horizontal band or *frieze* decorated with ornament or figures.
- **RELIEF LINE** In *red-figure* vase painting, a strong line which stands up off the surface and is used for contours of figures and important interior details.
- **RELIEVING TRIANGLE** A triangular space left in the masonry above the *lintel* of a door to relieve the lintel of some of the weight.
- **REPOUSSÉ** Metalwork decoration in relief, achieved by beating the metal from behind.
- **RESISTIVITY SURVEY** A survey measuring the varying resistance of subsurface areas of land to an electrical current passed between electrodes stuck in the ground, and thereby revealing the presence or absence of ancient remains.
- **REVETMENT** In architecture, a facing of stone, brick, or wood; a wall built to hold back earth.
- RHYTON (pl. RHYTA) A ritual pouring vessel, sometimes in the shape of an animal head; a drinking horn.
- ROSETTE An ornament shaped like a rose.
- **RUBBLE** Masonry, the stones of which are broken or in a rough condition.

SANCTUARY A sacred, defined space, characterized by a boundary wall, temple(s), altars, stoa(s), treasuries, and other architectural dependencies, in which religious activities took place.

- SARCOPHAGUS (pl. SARCOPHAGI) A coffin, of stone, terracotta, or wood.
- **SATRAPY** A province of the Persian empire, governed by a satrap (governor).
- SCARAB In Egyptian religion, a sacred beetle; seals made in this shape.

SERPENTINE A dullish green stone, often mottled.

SHAFT GRAVE A grave for multiple burial, cut as a rectangular shaft in the rock.

SIREN A mythological beast combining the body of a bird with the head of a woman.

- **SISTRUM** A musical instrument held in the hand and shaken, like a rattle.
- SKENE In the theater, the dressing rooms for actors and the storage rooms for scenery and props.
- SKYPHOS A two-handled drinking cup, not as deep as a *kotyle* or *kantharos*, but deeper than a *kylix*.
- SLIP A coat of clay applied to cover the surface of a pot, of a different constitution from the clay of the pot itself; also used to join together parts of a pot fired separately.

- **SOFFIT** The underside of a *lintel*, arch, or *cornice*.
- **SPHYRELATON** (pl. **SPHYRELATA**) A technique for making sculpted figures, either by hammering thin metal sheets over a wooden core, or by hammerembossing from the inside.
- **STELE** (pl. **STELAI**) A vertical slab of stone (normally) used as a grave marker, and often decorated.
- **STIRRUP JAR** A vessel, usually globular in shape, with a small double handle like a stirrup and a thin spout, common in the Late Bronze Age.
- **STOA** A long, rectangular, *colonnaded* building familiar in *sanctuaries* and *agoras*.
- **STUCCO** A plaster made of lime and/or sand, used to cover the surface of walls to render them smooth.
- **STYLOBATE** The course of masonry on which columns stand.
- **SYMPOSIUM** A private gathering for drinking and dining, and for competition in music, singing, storytelling, sexual allure, manners, taste, and argument.
- TERRACOTTA Baked clay.
- **TESSERA** A small square piece of stone or glass used in making a mosaic pavement.
- **TETRASTYLE** With four columns at the front, or at the front and back.

THERMOLUMINESCENCE A method of dating clay objects by measuring radioactively accumulated energy since the clay was fired. Reheated (thermo-) clay emits energy as a form of light (luminescence).

- **THOLOS** (pl. **THOLOI**) A circular building; a built tomb (of the Bronze Age) circular in plan.
- **TIEBEAM** A timber tying together rafters (in a roof) or securing masonry (in a wall).
- **TORSION** In figural art, the turning or even twisting of the body.
- **TRABEATED** In architecture, a term for a building depending on horizontal beams and vertical posts.
- **TRAVERTINE** A calcareous limestone formed by the precipitation of calcium carbonate from springwaters.
- **TRIGLYPH** In a Doric frieze, an upright grooved block with three vertical bars in relief, conventionally thought to represent the translation into stone of carved carpentry prototypes.

VOLUTE A spiral (one of two) on the face and back of an Ionic or Aeolic capital.

- **VOTIVE OFFERING** An object dedicated or vowed to a deity.
- XOANON (pl. XOANA) An early carved wooden statue of great venerability.
- **ZOOMORPHIC** Having or suggesting the form of an animal.

THE BRONZE AGE

GENERAL

- Davies, W.V., and L. Schofield, eds. *Egypt*, *the Aegean and the Levant*. London, 1995.
- Dickinson, O.P.T.K. *The Aegean Bronze Age*. Cambridge and New York, 1994.
- Hood, S. *The Arts in Prehistoric Greece*. Harmondsworth and New York, 1978.
- Preziosi, D., and L. Hitchcock. Aegean Art and Architecture. Oxford, 1999.
- Warren, P. The Aegean Civilizations from Ancient Crete to Mycenae. 2nd ed. Oxford, 1989.

CRETE

- Betancourt, P.P. The History of Minoan Pottery. Princeton, 1985.
- Fitton, J. The Minoans. London, 2002. Graham, J.W. The Palaces of Crete. 3rd ed. Princeton, 1987.
- Hamilakis, Y., ed. Labyrinth Revisited: Rethinking Minoan Archaeology. Oxford, 2000.
- Lapatin, K.D.S. Mysteries of the Snake Goddess: Art, Desire, and the Forging of History. Boston, 2002.
- MacGillivray, J.A. Minotaur: Sir Arthur Evans and the Minoan Myth. New York, 2000.
- Marinatos, N. *Minoan Sacrificial Ritual*. Stockholm, 1986.
- Warren, P. Minoan Religion as Ritual Action. Göteborg, Sweden, 1988.

CYCLADES

- Barber, R.L.N. *The Cyclades in the Bronze* Age. London, 1987.
- Barrett, J., and P. Halstead, eds. *The Emergence of Civilization Revisited*. Oxbow, 2005.
- Broodbank, C. An Island Archaeology of the Early Cyclades. Cambridge, 2000.
- Getz-Preziosi, P. Personal Styles in Early Cycladic Sculpture. Madison, 2002.
- ——. Sculptors of the Cyclades: Individual and Traditional in the Third Millennium BC. Ann Arbor, 1987.
- Palyvou, C. Akrotiri, Thera: An Architecture of Affluence. California, 2004.
- Renfrew, C. *The Cycladic Spirit*. London and New York, 1991.
- —. The Emergence of Civilization: The Cyclades and the Aegean in the Third Millennium BC. London, 1972.

SELECT BIBLIOGRAPHY

GREECE

- Blegen, C.W., et al. *The Palace of Nestor at Pylos in Western Messenia*. 3 vols. Princeton, 1966–73.
- Chadwick, J. The Mycenaean World. Cambridge, 1977.
- Furumark, A. Mycenaean Pottery: Analysis and Classification. Stockholm, 1941.

Nordquist, G. Asine: A Middle Helladic Village. Uppsala, Sweden, 1987.

Vermeule, E. *Greece in the Bronze Age*. Chicago, 1964.

TROY

- Allen, S.H. Finding the Walls of Troy. California, 1999.
- Blegen, C.W., et al. *Troy.* 4 vols. Princeton, 1950–8.

——. Troy and the Trojans. London, 1963. Mellinck, M., ed. Troy and the Trojan War. Bryn Mawr, 1986.

AFTER THE BRONZE AGE

BACKGROUND

- Cartledge, P. The Greeks. Oxford, 1993.
- Dunbabin, T.J. The Western Greeks. Oxford, 1948.
- Ferrari, G. Figures of Speech: Men and Maidens in Ancient Greece. Chicago, 2002.
- Garnsey, P. Food and Society in Classical Antiquity. Cambridge, 2000.
- Langdon, S., ed. New Light on a Dark Age. Missouri, 1997.
- Lemos, I. *The Protogeometric Aegean*. Oxford, 2002.
- Lewis, S. The Athenian Woman: An Iconographic Handbook. London, 2002.
- Munn, M. The School of History: Athens in the Age of Socrates. California, 2000.
- Murray, O. Early Greece. Glasgow, 1980, 1988.
- Neils, J., ed. Worshiping Athena: Panathenaia and Parthenon. Wisconsin, 1997.
- Osborne, R. *Greece in the Making*, 1200–479 BC. London, 1996.
- Podlecki, A.J. *Perikles and His Circle*. London, 1998.
- Pomeroy, S. Spartan Women. Oxford, 2002. Scanlon, T. Eros and Greek Athletics.
 - Oxford, 2002.
- Shipley, G. The Greek World after Alexander. London, 2000.

Stewart, A. Faces of Power: Alexander's Image and Hellenistic Politics. Berkeley, 1994.

Woodford, S. Images of Myth in Classical Antiquity. Cambridge, 2002.

GENERAL ART AND ARCHAEOLOGY

- Belozerskaya, M., and K.Lapatin. Ancient Greece: Art, Architecture, and History. Los Angeles, 2004.
- Biers, W. *The Archaeology of Greece*. 2nd ed. Cornell, 1996.
- Boardman, J. Greek Art. 4th ed. London and New York, 1997.
- —. The Greeks Overseas. New and enlarged ed. London and New York, 1999.
- Burn, L. Hellenistic Art from Alexander the Great to Augustus (London 2004)
- Coldstream, N. Geometric Greece. London, 1977.
- Donohue, A., and M. Fullerton, eds. Ancient Art and Its Historiography. Cambridge, 2003.
- Fullerton, M. Greek Art. London, 1999.
- Hurwit, J.M. The Art and Culture of Early Greece 1110–480 BC. Cornell, 1985.
- ——. The Acropolis in the Age of Pericles. Cambridge, 2004.
- Koloski-Ostrow, A., and C. Lyons, eds. Naked Truths: Women, Sexuality, and Gender in Classical Art and Archaeology. London, 2000.
- Langlotz, E., and M. Hirmer. *The Art of Magna Graecia*. London, 1965.
- Morris, S. Daidalos and the Origins of Greek Art. Princeton, 1992.
- Onians, J. Classical Art and Cultures of Greece and Rome. Yale, 1999.
- Osborne, R. Archaic and Classical Greek Art. Oxford, 1998.
- Parlama, L., and N. Stampolidis. Athens, the City Beneath the City. New York, 2001.
- Pollitt. J. Art in the Hellenistic Age. Cambridge, 1986.
- —. Art and Experience in Classical Greece. Cambridge, 1972.
- ——. The Art of Greece: Sources and Documents. New Jersey, 1965; Cambridge, 1990.
- Robertson, M.A. A History of Greek Art. Cambridge, 1975.

- Snodgrass, A.M. *The Dark Age of Greece*. New York, 2001.
- Sparkes, B. Greek Art. Oxford, 1991.
- Spivey, N. Greek Art. London, 1997.
- Stewart, A. Art, Desire, and the Body in Ancient Greece. Cambridge, 1997.
- Whitley, J. The Archaeology of Ancient Greece. Cambridge, 2001.
- ARCHITECTURE
- Barletta, B. The Origins of the Greek Architectural Orders. Cambridge, 2002.
- Beard, M. The Parthenon. London, 2003.
- Camp, J.M. *The Archaeology of Athens*. Yale, 2002.
- Cahill, N. Household and City Organization at Olynthus. Yale. 2002.
- Coulton, J.J. Ancient Greek Architects at Work. London, 1977.
- Cosmopoulos, M., ed. *The Parthenon and Its Sculptures*. Cambridge, 2004.
- Dinsmoor, W.B. *The Architecture of Ancient Greece*. 3rd ed. New York, 1975.
- Hurwit, J.M. The Athenian Acropolis. Cambridge, 1999.
- Lawrence, A.W. *Greek Architecture*. 4th ed. Revised with additions by R.A. Tomlinson. Harmondsworth, 1983.
- Mazarakis Ainian, A. From Rulers' Dwellings to Temples: Architecture, Religion, and Society in Early Iron Age Greece (1100–700). Jonserat, 1997.
- Neils, J., ed. The Parthenon: From Antiquity to the Present. Cambridge, 2005. Nevett, L.C. House and Society in the
- Ancient Greek World. Cambridge, 1999.
- Spawforth, A., The Complete Greek Temples. London, 2006.
- Wycherley, R.E. *How the Greeks Built Cities.* 2nd ed. London, 1962.
- SCULPTURE
- Ashmole, B. Architect and Sculptor in Classical Greece. London and New York, 1972.
- Bieber, M. The Sculpture of the Hellenistic Age. New York, 1954; 2nd ed., 1961.
- Boardman, J. Greek Sculpture, the Archaic Period. London and New York, 1978.
 Greek Sculpture, the Classical
- Period. London and New York, 1984. —. Greek Sculpture, the Late Classical
- Period. London and New York, 1995. Carpenter, R. Greek Sculpture. Chicago,
- 1960.
- Corso, A. The Art of Praxiteles: the Development of Praxiteles' Workshop and Its Cultural Tradition. Rome, 2004.
- Dillon, S. Ancient Greek Portrait Sculpture: Contexts, Subjects and Styles. Cam-

- bridge, 2006.
- Donohue, A. *Greek Sculpture and the Problem of Description.* Cambridge, 2005.
- Hemingway, S. Horse and Jockey from Artemision. Berkeley, 2004.
- Jenkins, I. Cleaning and Controversy: The Parthenon Sculptures. London, 2001.
- Lapatin, K.D.S. Chryselephantine Statuary in the Mediterranean World. Oxford, 2001.
- Mattusch, C.C. Classical Bronzes: The Art and Craft of Greek and Roman Statuary. Cornell, 1996.
- ——. Greek Bronze Statuary from the Beginnings through the Fifth Century BC. Cornell, 1988.
- Neils, J. *The Parthenon Frieze*. Cambridge, 2001.
- Palagia, O. The Pediments of the Parthenon. Leiden, 1998.
 —, ed. Workshops of Hellenistic
- Sculpture. Oxford, 1999.
- —, ed. Greek Sculpture: Function, Materials and Techniques in the Archaic and Classical Periods. Cambridge, 2006.
- Richter, G.M.A. Korai, Archaic Greek Maidens. London, 1968.
- —. Kouroi, Archaic Greek Youths. 4th ed. London, 1970.
- ——. Portraits of the Greeks. Oxford, 1984.
- Ridgway, B.S. Archaic Style in Greek Sculpture. Princeton, 1981.
- —. Fifth-Century Styles in Greek Sculpture. Princeton, 1986.
- ——. Fourth-Century Styles in Greek Sculpture. Wisconsin, 1997.
- ------. Hellenistic Sculpture I: The Styles of ca. 331-200 BC. Bristol, 1990.
- ——. Hellenistic Sculpture II: The Styles of ca. 200–100 BC. Wisconsin, 2000.
- of ca. 100–30 BC. Wisconsin, 2002. ——. Prayers for the Gods. Berkeley, 1999.
- ——. The Severe Style in Greek Sculpture. Princeton, 1970.
- Smith, R.R.R. Hellenistic Sculpture. London and New York, 1991.
- Spivey, N. Understanding Greek Sculpture. London and New York, 1996.
- Stewart, A. Attalos, Athens, and the Acropolis. Cambridge, 2004.
- ——. Greek Sculpture: An Exploration. New Haven, 1990.
- PAINTED POTTERY
- Amyx, D. Corinthian Vase-Painting of the Archaic Period.
 - 3 vols. Berkeley, 1988.
- Beazley, J.D. Attic Black-Figure Vase Painters. Oxford, 1956.

- —. Attic Red-Figure Vase Painters. Oxford, 1963.
- —. The Development of Attic Black-Figure. Berkeley, 1951.
- Boardman, J. Athenian Black-Figure Vases. 1974. Reprint with corrections, London and New York, 1991.
- —. Athenian Red-Figure Vases: The Archaic Period. 2nd ed. London and New York. 1988.
- —. Athenian Red-Figure Vases: The Classical Period. London, 1989.
- Coldstream, N. *Greek Geometric Pottery*, London and New York, 1968.
- Cook, R.M. Greek Painted Pottery, 2nd ed. London, 1972.
- —, and P. Dupont. *East Greek Pottery*. London, 1998.
- Marconi, C., ed. *Greek Painted Pottery: Images, Contexts, and Controversies.* New York, 2004.
- Neer, R.T. Style and Politics in Athenian Vase-Painting. Cambridge, 2002.
- Oakley, J., et al, eds. Athenian Potters and Painters. Oxford, 1997.
- Payne, H. Necrocorinthia. Oxford, 1931. Reprint, College Park, Maryland 1971.
- Rasmussen, T., and N. Spivey, eds. Looking at Greek Vases. Cambridge, 1991.
- Robertson, M. The Art of Vase Painting in Classical Athens. Cambridge, 1992.
- Rouet, P. Approaches to the Study of Attic Vases: Beazley and Pottier. Oxford, 2001.
- Sparkes, B.A. *The Red and the Black: Studies in Greek Pottery*. London, 1996.
- Trendall, A.D. *Red Figure Vases of South Italy and Sicily*. London and New York, 1989.

OTHER

- Boardman, J. Greek Gems and Finger
- Rings. London, 1970; New York, 1971. Bruno, V.J. Form and Color in Greek Painting. New York, 1977.
- Cohen, A. The Alexander Mosaic: Stories of Victory and Defeat. Cambridge, 1997.
- Garrison, D.H. Sexual Culture in Ancient Greece. Oklahoma, 2000.
- Higgins, R.A. Greek Terracottas. London, 1963; New York, 1966.
- Kraay, C.M. Archaic and Classical Greek Coins. London, 1976.
- Snodgrass, A.M. Arms and Armour of the Greeks. London, 1967.
- Strong, D.A. Greek and Roman Gold and Silver Plate. London, 1966.

PICTURE CREDITS

Laurence King Publishing, the author, and the picture researchers wish to thank the institutions who have kindly provided photographic material for use in this book, and in particular Dr. Helmut Jung of the Deutsches Archäologisches Institut and Mary Jane Bright of the Fototeca Unione at the American Academy in Rome for their personal assistance. Collections are given in the captions alongside the illustrations. Sources for illustrations not supplied by museums or collections, additional information, and copyright credits are given below. Numbers refer to figure numbers unless otherwise indicated. Many of the line drawings in this book have been drawn by Technical Art Services, Stanstead Abbots and by Taurus Graphics, Abingdon. The maps were drawn by Paul Butteridge. Laurence King Publishing are grateful to all who have allowed their plans and diagrams to be reproduced. Every effort has been made to contact the copyright holders, but should there be any errors or omissions, they would be pleased to inset the appropriate acknowledgements in any subsequent edition of this publication.

The following abbreviations have been used:

Agora Excavation: American School of Classical Studies at Athens, Agora Excavation

American School: American School of Classical Studies at Athens

Barnaby: Barnaby's Picture Library, London

BPK: Bildarchiv Preussischer Kulturbesitz, Berlin

DAI: Deutsches Archäologisches Institut, Athens

Ekdotike: Ekdotike Athenon, Athens

Foglia: Fotografica Foglia, Naples

Frantz: American School of Classical Studies at Athens, Alison Frantz Collection

Hirmer: Hirmer Verlag Fotoarchiv, Munich

Kontos: Studio Kontos Photography, Athens

Mauzy: Craig & Marie Mauzy, Athens mauzy@otenet.gr

Levin: Aaron M. Levin, Baltimore

Pedley: Professor John G. Pedley

Pirozzi: Vincenzo Pirozzi, Rome fotopirozzi@inwind.it

RMN: Réunion des Musées Nationaux, Paris

Scala: Scala Archives, Florence

TAP: T.A.P. Services (Archeological Receipts Fund), Athens

half title page, see figure 7.34, © Mauzy; title page, see figure 6.92, © RMN; page 7, see figure 6.54, © Mauzy; 0.1 © Towneley Hall Art Gallery and Museum, Burnley, Lancashire/The Bridgeman Art Library; 0.3 © Hirmer ; 0.4 © Mauzy; 0.5 © Pedley; 0.6 © Barnaby Photo Library; 0.7 © Scala; 0.8, 0.9 © Agora Excavation; 0.10 © Smith College Archives, Northampton, Massachusetts; 0.11 © Mauzy; 0.13 © University of Syracuse, Sicily; 0.14, 0.15 © Professor Mazarakis Ainian, Athens; 0.16, 0.17, 0.18 © German Archeological Institute Athens, D-DAO-ATH-Kerameikos N1, N2, N3; W.D.Niemeier; 0.19 © The Cleveland Museum of Art, photo Howard Agriesti; 0.20 Athens the City beneath the City, 2001. Greek Ministry of Culture-Museum of Cycladic Art, page 134. Reproduced with Permission; 1.1 © Mauzy; 1.4 © AKG photo, London; 1.7, 1.9 C Mauzy; 1.11 C Metropolitan Museum of Art, New York (Rogers Fund); 1.12 © Copenhagen National Museum # 4697; 1.13 © Goulandris Foundation, Museum of Cycladic Art, Athens; 1.15 © TAP; 1.19, 1.20 © American School; 2.1, 2.2 © Mauzy; 2.3 © Frantz; 2.5 © Hirmer; 2.6 © Frantz; 2.7 © Hirmer; 2.8 © Museum of Classical Archaeology, Cambridge; 2.9 © TAP; 2.10 © Ekdotike; 2.12, 2.13 © Mauzy; 2.14 © RMN; 2.15 © Kontos; 2.17 © American School, by kind permission of Dr. Martha Wiencke; 2.18 © BPK; 2.20 © The Art Archive Ltd, London; 2.21 © Peter Clayton, Hemel Hempstead; 2.22 © DAI, Athens; 3.1, 3.3

© Mauzy; 3.4 © Hirmer; 3.5 © Frantz; 3.6 © Mauzy; 3.7 Restoration after Sir Arthur Evans from the Knossos Fresco Atlas © Gregg Press 1967; 3.8 © Princeton University Press, Princeton (from James Walter Graham, Palaces of Crete, 1962); 3.9 C Mauzy; 3.10 © McGraw-Hill Publishing Co., New York (from Sinclair Hood, The Home of the Heroes: The Aegean before the Greeks, 1967, by permission of Thames and Hudson); 3.12 © British School at Athens by permission of the Management Committee (Courtesy of the Department of Classics, University of Columbia USA, photo © L.H.Sackett); 3.13 © Hirmer; 3.14, 3.15 © Frantz; 3.16 © Hirmer; 3.17 © National Museum of Athens; 3.18 © Hirmer; 3.19, 3.20 © Mauzy; 3.21 © Hirmer; 3.22 © Topham Picturepoint; 3.23 © Kontos; 3.24 © British Museum Publications, London (from John Chadwick, Reading the Past: Linear B and Related Scripts, 1987; 3.25, 3.26 © Mauzy; 3.27 © Hirmer; 3.28 © Peter Clayton; 3.29 © TAP; 3.30 © National Museum, Athens; 3.31 © TAP; 3.32 © Scala; 3.33 © Thames and Hudson (from Reynold Higgins, Minoan and Mycenaean Art, 1981); 3.34 © TAP; 3.35 © Mauzy; 3.36, 3.37 © TAP; 3.38 © Roger-Viollet Photos, Paris; 3.39 © University of Cincinnati, Department of Classics (By kind permission of Dr. Elizabeth Schofield); 3.40 © Thames and Hudson (from Reynold Higgins, Minoan and Mycenaean Art, 1981); 3.41 © Mauzy; 3.43 from E.Matz, The Art of Crete and Early Greece, New York, 1962; 3.44 © Mauzy; 3.45 © University of Cincinnati, Department of Classics (courtesy professor C.W.Blegen); 3.46, 4.37 © University of Cincinnati, Department of Classics (Watercolours by Piet de Jong reproduced from Blegen and Rawson, The Palace of Nestor at Pylos, Vol. I © Princeton University Press 1966); 3.49 © TAP; 3.53 © Metropolitan Museum of Art, New York (Louisa Eldridge McBurney Gift Fund 1953); 3.54 © Mauzy; 4.1 © The Metropolitan Museum of Art, Rogers Fund, 1921 (21.88.24). Photograph © 1996 The Metropolitan Museum of Art, New York; 4.3 © British School at Athens (from J.D.S Pendlebury et al., "Excavations in the Plain of Lasithi, III. Karphi: A City of Refuge of the Early Iron Age in Crete." *Annual of the British School at Athens* 3: 1939; 4.4 © Hirmer; 4.5 © Edinburgh University Press, Edinburgh (from A.M.Snodgrass, The Dark Ages of Greece, 1971, by permis sion of the British School at Athens); 4.8 © DAI, Athens; 4.10 © From Spyridon Marinatos, "Le temple geometrique de Dreros," Bulletin de Correspondence Hellenique 60 (1936) pl.31; 4.11 © Mauzy; 4.12 © R.Piper Verlag, Munich (from Hans Walter, Das Heraion von Samos, 1976); 4.13 © Mauzy; 4.14 © DAI, Athens; 4.15 © TAP; 4.16 © DAI, Athens; 4.17, 4.18 © TAP; 4.19 © DAI, Athens; 4.20 © Agora Excavations; 4.21 © American School; 4.22 © Agora Excavations; 4.23, 4.24 © TAP ; 4.25 © Scala; 4.26 a&b © Agora Excavations; 4.27 © The British Museum, London. Vase 1899.0219.1; 4.28 C McGraw-Hill Publishing Co., New York (from R. Brilliant, Arts of the Ancient Greeks, 1972); 5.1 © TAP; 5.2 © The British Museum, London. Vase 1969.1215.1; 5.3 © Staatliche Antikensammlungen, Munich; 5.5, 5.6 © Scala; 5.8 © RMN, Paris-Hervé Lewandowski; 5.9, 5.10 © TAP; 5.11 © Staatliche Antikensammlungen, Munich; 5.12 © The British Museum, London. Vase 1873.0820.385; 5.13 © W.W.Norton & Co Ltd, New York (from W.B.Dinsmoor, The Architecture of Ancient Greece, 1975); 5.15 © Mauzy; 5.16 © DAI, Athens; 5.17 © Frantz; 5.18 © Mauzy; 5.19 © R.Piper Verlag, Munich (from Hans Walter, Das Heraion von Samos, 1976); 5.20 © RMN/Chuzeville; 5.23, 5.24 © Professor Ekrem Akurgal (from Alt-Smyrna I: Wohnsichten und Athenatempel, Turk Turih Kurumu Basimevi, Ankara, 1983); 5.26 © Museum of Fine Arts, Boston. Francis Bartlett Donatin of 1900,03,997; 5.27 © The British Museum, London 1871.3-15.16; 5.28 © DAI, Athens; 5.29, 5.30 © TAP; 5.33 © RMN; 5.34 © TAP; 5.35 © Frantz; 5.37 © DAI, Athens; 6.1, 6.2 © Mauzy; 6.8 © Harry N. Abrams, Inc (from Frederick Hartt, Art, 1989); 6.9 © DAI, Athens; 6.10 © Kontos; 6.11 © Mauzy; 6.15, 6.17 © Dr. Vinzenz Brinkmann, Bunte Gotter: Die Farbigkeit Antiker Skulptur (Glyptothek Munchen 2004); 6.18c © W.W.Norton & Co Ltd, New York (from W.B.Dinsmoor, The Architecture of Ancient Greece, 1975); 6.19

© Thames and Hudson (from John Boardman, Greek Art, 1985); 6.23, 6.24 © Mauzy; 6.25 from G.Daux, Fouilles de Delphes, II: Les Deux Trésors, Paris, 1923; 6.26 C Mauzy; 6.27, 6.28 C Hirmer; 6.29 © Dr.Vinzenz Brinkmann, Bunte Gotter: Die Farbigkeit Antiker Skulptur (Glyptothek Munchen 2004); 6.32 © Alinari, Florence; 6.33 © Scala; 6.34 © Cornell University Press, Ithaca (from J.J.Coulton, Ancient Greek Architects at Work, 1977); 6.36 © Foglia; 6.37 © Levin; 6.38 © Hirmer; 6.39 © Levin; 6.40 © American School; 6.41 © Museum of Fine Arts Boston. William Francis Warden Fund, 61.195; 6.42 © Metropolitan Museum of Art, New York (Fletcher Fund 1932); 6.43 © Frantz; 6.44 © TAP; 6.45 © Andrea Jemolo, Rome; 6.46 © Mauzy; 6.47 © Frantz; 6.48, 6.49 © Hirmer; 6.49 © Hirmer; 6.50 © Thames and Hudson (from John Boardman, Greek Sculpture: The Archaic Period, 1978); 6.51 © BPK, Berlin; 6.52, 6.53, 6.54 © Mauzy; 6.55 © The I.Paul Getty Museum, Malibu, California (82.AA.40); 6.56 © Frantz; 6.56 C Mauzy; 6.58 C John S. Hios/Apeiron, Athens; 6.59 C RMN, Paris; 6.60 © Frantz; 6.61 © John S. Hios/Apeiron, Athens; 6.62 © DAI, Athens; 6.63 © Frantz; 6.64 © French Archeological School, Athens; 6.65 © Frantz; 6.66, 6.67 © Mauzy; 6.69 Athens the City beneath the City, 2001. Greek Ministry of Culture-Museum of Cycladic Art, page 199. Reproduced with Permission; 6.70 © courtesy Mrs Nurten Sevinç, Archeological Museum Canakkale, Turkey; 6.71 © British Museum Publications, London (from D. Williams, Greek Vases, 1985); 6.72 © Gerald Duckworth & Co., Ltd, London (from Susan Woodford, An Introduction to Greek Art, 1986); 6.74, 6.75 © Quattrone, Florence; 6.80 © Beazley Archive, Faculty of Classics, University of Oxford; 6.82 © Vatican Museums, Rome; 6.83 © Cabinet des Medailles, Bibliothèque Nationale de France, Paris; 6.84 © RMN/Gérard Blot/Hervé Lewandowski; 6.86 © RMN; 6.87 a&b © Museum of Fine Arts, Boston. Henry Lillie Pierce Fund 99.538; 6.88 © RMN; 6.90 a&b © Agora Excavations; 6.91 © The British Museum, London. Vase E266; 6.92 © RMN/Hervé Lewandowski; 7.1 © Mauzy; 7.2 © British Museum, London; 7.3 © Photograph by Bruce M.White, 2006, courtesy of Cleveland Museum of Art; 7.4 © Hirmer Verlag Munich (from Gottfried Gruben, Die Tempel der Griechen, 1966); 7.6 © Harry N. Abrams, Inc (from Frederick Hartt, Art, 1989); 7.7 © Mauzy; 7.8, 7.9 © Frantz; 7.11 © Hirmer; 7.12, 7.14 © Frantz; 7.15, 7.16 © DAI, Athens; 7.17 © Agora Excavations; 7.20 © Hirmer; 7.22 © Foglia; 7.23 © Thames and Hudson (from J.M.Camp, *The Athenian Agora*, 1986); 7.24 © American School; 7.25 © Mauzy; 7.26 © Foglia; 7.27 © Hirmer; 7.28 © Pirozzi; 7.29 © Kontos; 7.30 © Hirmer; 7.31 © Mauzy; 7.32, 7.33 © Scala; 7.34 © Hirmer; 7.35 © Mauzy; 7.38, 7.39 © Hirmer; 7.40 Courtesy of the Ministero per i Beni e le Attività Culturali, Reggio Calabria; 7.41 © Hirmer; 7.42 © Museum of Fine Arts Boston. James Fund and Museum purchase with funds donated by contribution 10.185; 7.44, 7.45 © RMN; 7.48 © Levin; 7.49 © Foglia; 8.1 © Mauzy; 8.2 © Gerald Duckworth & Co., Ltd, London (from Susan Woodford, An Introduction to Greek Art, 1986); 8.3, 8.5 © Mauzy; 8.6 © Hirmer; 8.7, 8.11 © Professor Ernst Berger, Antikenmuseum Basle und Sammlung Ludwig (drawings by Mirian Cahn); 8.13, 8.14 C Hirmer; 8.15 C Frantz; 8.16 C Thames and Hudson (from John Boardman, Greek Sculpture: The Classical Period, 1985); 8.18, 8.19 © Hirmer; 8.21 © TAP; 8.22 © RMN; 8.23 © TAP; 8.24 © British Museum 1898-2-15-28; 8.25 © Mauzy; 8.26 © Praeger Publishers, New York (from John Travlos, Pictorial Dictionary of Ancient Athens, 1971, by permission of John Travlos and Verlag Ernst Wasmuth, Tübingen); 8.27, 8.28, 8.29 © Frantz;

8.30 © McGraw-Hill Publishing Co., New York (from R. Brilliant, Arts of the Ancient Greeks, 1972); 8.31, 8.32 © Frantz; 8.33 © Mauzy; 8.36 © From John M. Camp, *The Athenian Agora*, Thames & Hudson, 1986; 8.37, 8.38 © American Agora; 8.39 © Barnaby; 8.40 © Frantz; 8.41 © Soprintendenza Archeologica di Calabria; 8.42 © Foglia; 8.43, 8.44, 8.45 © Mauzy; 8.46 © TAP; 8.50 © Scala; 8.52, 8.53, 8.54 © American Agora; 8.55 © The British Museum, London. Vase 1947.0714.18; 9.1 © The Metropolitan Museum of Art, Rogers Fund, 1929 (29.54). Photograph © 1982 The Metropolitan Museum of Art, New York; 9.3 © Hirmer; 9.4 © By permission of Yale University Press, Pelican History of Art; 9.8 C Liverpool University Press (from Alison Burford, The Greek Temple Builders at Epidauros, 1969); 9.10 © Bildarchiv Foto Marburg; 9.11 © A.F.Kersting, London; 9.12 © Mauzy; 9.13 © American School; 9.14 © Thames and Hudson (from J.M.Camp, The Athenian Agora, 1986); 9.15, 9.16 from D.M.Robinson and others, Excavations at Olynthos, VIII and XII, Baltimore, 1938, 1946); 9.17 © Reproduced from David Robinson's 'Mosaics, Vases, and Lamps at Olynthos' Vol. V @ John Hopkins University Press; 9.19 © McGraw-Hill Publishing Co., New York (from R. Brilliant, Arts of the Ancient Greeks, 1972); 9.20 from M.Schede, Die Ruinen von Priene, Berlin, 1964; 9.23 © Barnaby; 9.24, 9.25, 9.26 C Mauzy; 9.28 C Hirmer; 9.29 C Vatican Museums; 9.30 © DAI, Athens; 9.31, 9.32 © Harvard University Art Museums (Bequest of Mrs K.G.T.Webster); 9.34 © Staatliche Kunstsammlungen Dresden; 9.35, 9.36 © Mauzy; 9.37 © DAI, Athens; 9.38 © from Franz Winter, Der Alexandersarkophag aus Sidon ..., 1912, plate 12, British Library K.T.C.123.a.1; 9.39 © Hirmer; 9.40 © The British Museum, London Vase E129; 9.41 Vase E424; 9.42 Vase B60; 9.44 © Levin; 9.45 © BPK; 9.46 © Foglia; 9.47 © Kontos; 9.48 © Ekdotike; 9.49 © Foglia; 9.50 © The J.Paul Getty Museum, Villa Collection, Malibu, California (82.AE.83); 9.53 © Ekdotike; 9.54, 9.56, 9.57, 9.58 © Kontos; 9.59 © TAP; 9.60 © Kontos; 9.61 © TAP; 9.62 © Kontos; 9.63, 9.64, 9.65, 9.66 © TAP; 9.67 © Kontos; 9.68 © TAP; 10.1 © RMN; 10.3 © Mauzy; 10.5 © From Herzog, Schazmann, and others, Kos. Ergebnisse der deutschen Ausgrabungen und Forschungen (Berlin, 1932); 10.6, 10.7 from C.Humann, Magnesia am Maeander, Berlin, 1904; 10.10 © Mauzy; 10.11 © American School; 10.12 © Mauzy; 10.13 © Agora Excavations; 10.15 © Harry N. Abrams, Inc (from Marvin Trachtenberg and Isabelle Hyman, Architecture: From Prehistory to Post-Modernism, 1986); 10.16 © Athens the City beneath the City, 2001. Greek Ministry of Culture-Museum of Cycladic Art, page 168. Reproduced with Permission; 10.17 © Mauzy; 10.18 © Gerald Duckworth & Co., Ltd, London (from Susan Woodford, An Introduction to Greek Art, 1986); 10.19 © Vatican Museums; 10.21 © Araldo De Luca, Rome; 10.22 © Pirozzi; 10.23, 10.24, 10.25, 10.26 © BPK; 10.28 © Mauzy; 10.30 © DAI, Athens; 10.31 © Hirmer; 10.32 © Alinari, Florence; 10.34 © The Metropolitan Museum of Art, Rogers Fund, 1943 (43.11.4). Photograph © 1985 The Metropolitan Museum of Art, New York; 10.35 © Mauzy; 10.36, 10.37 © Araldo De Luca; 10.38 © Photo Josse, Paris; 10.40 © Pirozzi; 10.41, 10.42 © Araldo De Luca; 10.43 © DAI, Rome; 10.45, 10.46 Blow up, Munich; 10.47 © Quattrone, Florence; 10.48 © Foglia; 10.50 © Antonello Perissinoto, Padua; 10.51 © The British Museum, London. Terracotta 2274; 10.54 © Foglia; 10.55 © Araldo De Luca; 10.56 © Foglia; 10.57 © Pirozzi; 10.58 © Agora Excavations; 10.61 © The British Museum Terracotta D185; 11.1 © Dominic Cole, London

INDEX

order.

Artists' names are in curved brackets, following the name or title of the work, e.g. calyx krater (Euphronios)

Page references in **bold** refer to figure numbers, e.g. Cat Stele 279-80, 8.44 Entries are arranged in word-by-word

Abdalonymos 315 Abduction of Helen, House of, mosaics 323, 332-3, 9.48, 9.66 Achilles Painter, red-ground amphora 283, 8.50 Acropolis, Athens 11, 13, 19 Archaic period sanctuary 173-4 sculpture 157, 173, 6.10 kouroi/korai 180, 182-5, 6.48-6.49, 6.52-6.54, 6.56-6.57 Geometric period pottery 116 warrior figurine 115, 4.15 High Classical period Parthenon 251-65, 8.3-8.23 Propylaia 265-6, 0.3, 8.26-8.27 Transitional period Angelitos's Athena 233, 7.29 Mourning Athena relief 237-8, 7.1 see also Athena, temples of; Erechtheion; Propylaia Actium, Battle of 337, 338, 387 Aegina Cat Stele 279-80, 8,44 griffin jug 133, 5.12 shrine of Aiakos 174, 5.89 stirrup jar 99, 3.52 Temple of Aphaia 19, 157-8, 6.11-6.15 Aeolic capitals 141, 5.24-5.25 Aeschylus, Persians (drama) 212, 274 Aghia Triadha 71 Harvester Vase 73, 3.14 sarcophagus 79–80, 82, 3.25–3.26 Aghios Onouphrios ware 37, 1.1 Agora, Athens 13 Fourth Century 297-8, 9.13 Geometric period, pottery 117-18, 4.20-4.22, 4.26 Hellenistic period 345-7, 10.11-10.13 statue of Demosthenes 351-3, 10.20 High Classical period 271-4, 8.35-8.36 pottery 285-6, 8.52-8.53 Transitional period 226-8, 7.23-7.24 Agorakritos 279 Akragas (Agrigento), Sicily Temple of Concord 275, 8.39 Temple of Zeus 169, 223, 6.34, 7.18 temples 16, 274, 8.39 akroteria, Locri 275-6, 8.41 see also caryatids; figure sculptures alabastra 99, 188, 6.63 Alexander the Great 289–90, 311–15, 321, 325, 337, **9.34**, **9.39** Alexander Mosaic 313, 321-2, 9.46 Alexander Sarcophagus 192, 313, 314–15, 9.37–9.39 Alexandria 337, 338, 339

altars 162, 245 Great Altar, Pergamon 354-5, 364, 10.23-10.26 marriage altar from Taras 213, 7.3 Amasis Painter, black-figure amphora 197, 199, 6.76 amphoras Archaic 197-8, 204, 209, 6.76-6.79, 6.87, 6.89, 6.91 Dark Age 117 Fourth Century 317-18, 319-20, 9.42, 9.44 Hellenistic 385 High Classical period 283, 285-6, 8.50, 8.54 Minoan 77, 3.21 Minyan 91, 3.37 Orientalizing period 130, 132-3, 192, 5.1, 5.8-5.10 Analatos amphora 130, 5.8 Anavysos Kouros 179, 6.46 Andokides' workshop, bilingual amphora 204, 6.87 Angelitos's Athena 233, 7.29 animal paintings Dark Age 116, 4.23 Early Corinthian 130, 5.7 Protocorinthian 127, 5.3 Wild Goat style 133, 200, 5.11 animal sculptures Dark Age 112, 3.14, 4.1 Early Cycladic 40, 1.15 Animal Style 127, 198–9, 5.3, 5.7 Antikythera Bronze 305, 9.24 Antiochos IV 337, 344, 345 Apelles 320, 323 Aphaia, Temple of, Aegina 19, 157-8, 6.11-6.15 Aphrodite statues Aphrodite, Pan and Eros 361-4, 10.35 Crouching Aphrodite 360, 10.33 of Knidos (Praxiteles) 308-9, 360, 9.29 of Melos (Venus de Milo) 364-6, 10.38 see also Venus Apollo sanctuaries of Delphi 6.21 Metapontum 225 statue of, Olympia 218, 7.11 temples of Corinth 155-6, 6.6-7 Didyma 161, 342-4, 6.18, 10.8-10.9 Syracuse 168, 212, 6.30 Thermon 134–6, 5.13–5.15 Apollo Belvedere 16, 0.7 Apotheosis of Homer (Archelaos of Priene) 371-2, 10.44 Apoxyomenos (Lysippos) 311, 9.33 Apulia, pottery 318-19, 385, 9.43, 10.61 Archaic Greece 151-3 architecture 153-76 pottery 192-209 sculpture 176-92 Archimedes 338, 350 architects 11, 160, 214, 223, 275, 341

Alkamenes 271, 279

see also painters; sculptors; names of

architects architectural sculpture

Archaic period Doric temples 156-7, 158, 6.9-6.10 Sicily/South Italy 168-9, 172-3, 6.32-6.33, 6.38-6.39 treasuries 164, 165, 166-7, 6.14-6.15, 6.22-6.23, 6.26-6.29 Fourth Century 292-315 High Classical period 249, 251-81 Orientalizing period 136, 141, 146-8, 5.17-5.18, 5.23-5.25, 5.34-5.36 Transitional period 214-28, 223-5, 7.6-7.16, 7.18-7.20 see also capitals; friezes; metopes; orders; pediments; sculpture architecture Archaic Greece 153–76 Bronze Age Cycladic 37, 54 Helladic 41-3, 54-5 Minoan 34-6, 65-72 Mycenaean 91-6 Trojan 59 Dark Age 107-12 Fourth Century 292-315, 333-5 Hellenistic 338-50 High Classical period 249, 251-81 Orientalizing period 134-41 Transitional period 214-28 see also architectural sculpture Argos 91, 237, 249 Sanctuary of Hera 110, 178 Aristodikos Kouros 179, 207, 6.47 Aristokles, grave stele 190, 6.67 Aristophanes 11, 213, 273, 320, 324 Aristotle 299 Arkesilaos 373 Arkesilas Painter, black-figure cup 200, 6.83 Artemis, temples of Corcyra 156, 238, 6.8-6.9 Ephesos 160, 6.19 Magnesia 341-2, 10.6-10.7 Artemis Orthia, temple of, Sparta 111 Artemision Zeus, or Poseidon 234, 7.31 artists see architects; painters; sculptors aryballoi 127, 199, 5.2, 5.4, 6.81 Asklepios, sanctuaries of Epidauros 294-6, 9.8-9.10 Kos 341, 10.5 Assteas, phlyax vase 320, 9.45 Athena, statues of 182-3, 191, 306, 6.69, 9.26 Angelitos's Athena 233, 7.29 by Phidias 265, 8.25 Mourning Athena relief 237-8, 7.1 Athena, temples of Pergamon 340-1, 10.4 Poseidonia Archaic period 170, 171-2, 252, 6.35, 6.37 Transitional period 225-6, 7.21-7.22 Priene 302, 341, 9.20 Smyrna 141, 154, 5.23-5.25 Sunion 237-8, 7.35 Syracuse 212, 223 see also Acropolis Athena Nike, Temple of, Athens 266-8, 373, 8.28-8.29 Athenians, Treasury of, Delphi 165, 6.23-6.24

the city 11, 13 Archaic period 151–3 Fourth Century 297–9, 9.12–9.14 Hellenistic 337-8 High Classical period 272, 8.35 Transitional period 211–12, 8 226–8, 7.23–7.24 architecture Archaic 173-6, 6.40 Hellenistic 345–7, 10.11–10.13 High Classical 13, 251–65, 8.3-8.23 Transitional 226-8, 7.23-7.24 Peloponnesian War 250-1 salvage excavation 28, 348-9, 0.20, 10.16-10.17 sculpture Archaic 180, 182–6, 190, 191, 6.48–6.49, 6.52–6.54, 6.56–6.57, 6.66–6.67, 6.69 Dark Age 115, 4.15-4.17 see also Acropolis; Agora; Attic pottery; Kerameikos cemetery; Parthenon Atreus, Treasury of 93-4, 3.41-3.42 Attalid dynasty of Pergamon 337, 338, 353 Attalos, Stoa of, Agora, Athens 13, 345-6, 0.9, 10.12-10.13 Attic pottery Archaic 174–5, 193–8, 203–9, 6.41, 6.73–6.79, 6.87–6.92 Fourth Century 316–18, 324, 9.40–9.42, 9.50 Geometric burial pots 117-18, 4.20-4.22 High Classical 281-6, 8.47-8.53 Protoattic 130-3, 5.8-5.10 Transitional 242-4, 7.2, 7.42-7.45 see also Athens Attic reliefs 373, 10.47 Attica 255, 8.10 kouroi/kore 178, 181, 6.46-6.47, 6.51 authors see literary sources; names of writers, e.g. Pliny the Elder Barberini Faun 358, 360-1, 10.29 baroque (Hellenistic) sculpture 350, 353-8, 367-71, 10.21-10.30, 10.42-10.43 Bassae, Temple of Apollo 292-4, 9.3-9.7 Beazley, Sir John 199, 6.80 bell krater (Pan Painter) 242, 7.42 Bellerophon and the Chimera mosaic 322-3, 332, 9.47 Berlin Kore 181, 6.51 Berlin Painter 199, 209, 6.91 bilingual amphora (Andokides' workshop) 204, 6.87 black gloss ware 285, 318, 8.52 black-figure pottery Archaic 174–5, 195, 197–202, 6.41, 6.73-6.74, 6.76-6.79, 6.83-6.87 Panathenaic amphoras 317-18, 9.42 production of 193 Protoattic 132, 5.10 Protocorinthian 127, 5.2-5 Blegen, Carl 20, 78 bouleuteria Agora, Athens 174, 175, 226, 228, 272

Athens

Miletus 347-8, 10.15 boundary markers 162, 176 bowls, Hellenistic 383-5, 10.58-10.59 Boyd Hawes, Harriet 18, 20, 0.10 bronzes Archaic period 6-68-9, 190-1 Dark Age 114-15, 4.1, 4.14 Fourth Century 305–6, 9.24–7 Hellenistic 357–8, 366–7, 10.28, 10.39-10.41 High Classical period 271, 276-9, 8.42-8.43 Orientalizing period 141-3, 5.26-5.30 Transitional period 229, 233–7, 7.30–7.33 Brygos Painter red-figure cup 209, 6.92 white-ground oinochoe (attrib.) 281, 8.47 burial see cemeteries; cremation; funerals; graves; sarcophagi; tholoi; tombs Caere, Etruria, black-figure hydria 202, 6.86 Calvert, Frank 19 calyx kraters 204, 286, 324, 6.88, 8.55, 9.50 canon of proportions, Egyptian 177 Canosa, askos 385, 10.61 capitals Aeolic 141, 5.24-5.25 Corinthian 293, 9.5 Doric 154 Pergamene 346, 10.13 see also columns Capitoline Venus 360, 10.32 caricatures 366, 10.39 Carthage/Carthaginians 151, 153, 168, 212, 223, 290–2, 338 caryatids 269–70, 386, 8.32 see also akroteria; figure sculptures; korai Cat Stele, Aegina 279-80, 8.44 cauldrons 114, 141, 143, 4.14, 5.28 cemeteries Cycladic 37 Helladic 42 Iron Age 108-10, 119 Kerameikos 23-5, 117-18, 119, 0.18 Lefkandi 108–10, **4.6–4.7** of Vergina 326–30, 377 see also cremation; funerals; graves; sarcophagi; tholoi; tombs centaur (terracotta), Lefkandi 112, 4.13 centaur grappling with Lapith woman 218, 7.12 Centuripe, funerary vase 385, 10.62 Chadwick, John 78 Chaeronea, Battle of 289, 295 Chalkidian School, black-figure column krater 202, 6.85 chamber tombs 35, 376-7, 10.52 Charioteer, from Motya 21, 239-41, 7.37 Charioteer of Delphi 233-4, 241, 357, 7.30 charioteer figurine, Olympia 115, 4.16 Chigi vase (olpe) 127–9, 141, 5.5 children and childhood 212–13 chronology, Bronze Age 20, 32-4, 1.3 Cicero 26, 350 Cieto 26, 550 cist graves 35, 37, 42, 55, 327 citadels, Mycenaean 91–2, 94, **3.38–3.39, 3.43–3.44** city-states (poleis) 107, 125, 151, 153, 162, 289, 338 Classical period see High Classical period; Transitional period Cleopatra and Dioskourides 359-60, 10.31 colonization, Dark Age 122-3

columns Aeolic, Orientalizing period 141, 5.24-5 Corinthian, Fourth Century 297, 9.12 Doric Archaic period 155-6, 215, 6.7 Hellenistic 340-1, 10.4 High Classical period, Parthenon 252-53, 8.5; Hephaisteion 271, 8.34 Transitional period 223 see also capitals Comic scene (Dioskourides of Samos) 380, 10.56 Concord, Temple of, Akragas (Temple F) 275, 8.39 Corcyra, Temple of Artemis 156, 238, 6.8-6.9 Corinth Archaic pottery 198-200 Orientalizing period pottery 126-30 Corinthian capitals 293, 295, 9.5, 9.10 Corinthian order 297, 344 Corinthian style 129–30, 5.7 cremation burial 105, 117, 4.21 Crete Dark Age 107-8 Iron Age temple 111, 4.10 Minoan Crete and Aegean 31–2, 1.2 see also Minoan civilization; Mycenae Crouching Aphrodite 360, 10.33 cults, Minoan 81-2 cups Archaic 200, 209, 6.83-6.84, 6.92 Cycladic 85, 3.29 Fourth Century 316, 9.40 Late Helladic 99, 3.51 Minoan 37, 52, 73, 74, 1.9, 2.12, 3.17 Transitional 222, 7.17 Cyclades 20, 31, 33, 112, 139 Ionic Temples 159–62 Late Bronze Age (LC) 83-7 Middle Bronze Age (MC) 54 Third Millennium (EC) 37-40 Cyclops Painter, red-figure krater 286, 8.55 Daedalic style 146–7, 5.36 Damocopos, theater 274 Dark Age/Geometric Age 105-23 Delian League 211-12 Delos 212 Nikandre statue 147-8, 181, 5.35 statue of Nike 188, 6.65 Delphi architecture 163-8, 6.21-6.29 kouroi 178, 6.44 sphinx 188, 6.64 Demetrios Topographos 377, 378 Demosthenes, statue of (Polyeuktos) 351-3, 10.20 Derveni, krater from 331, 9.63 Dexileos, stele of 313, 9.35 Diadoumenos (Polykleitos) 279, 8.43 Didyma, Temple of Apollo 161, 342-4, 6.18, 10.8-10.9 dinos, black-figure (Sophilos) 195, 199, 6.73 Diodoros 177, 223 Dionysios I of Syracuse 290 Dionysos, Temple of, Naxos 159, 6.16 Dioskourides of Samos, Comic scene 380, 10.56 Dipylon cemetery, pottery 119, 4.24–4.25 Diskobolos (Myron) 231-3, 7.28 Diver, Tomb of 129, 245-6, 327, 377, 5.6, 7.47-7.49 dome of circular tomb, Kazanlak 377, 10.52 domestic architecture see houses

domestic life *see* lifestyles Doric order 153-4, 215, 333, 340-1, 344, 6.3, 10.4 Doric temples Archaic period 154-8, 168-71, 6.4-6.14, 6.30-6.37 Fourth Century 294-6, 9.8-9.9 Hellenistic Kos 341, 10.5 Pergamon 340-1, 10.4 High Classical period Parthenon (Athens) 252-3, 8.5 Sicily 274-5, 8.39-8.40 Transitional period 214–21, 225–6, 7.4–7.16, 7.21–7.22 Doric treasuries 163-8, 6.22-6.29 Doryphoros (Polykleitos) 8, 42, 276-7, 310 drama 11, 274, 296, 324 drapery, sculpted Archaic 181, 183-4, 187, 6.50 Hellenistic Baroque 357, 10.27 High Classical 249 Transitional 224, 233, 238–41, 7.37–7.38 Dreros statuettes 111, 4.11 temple 111, 4.10 Dying Gaul (Trumpeter) 353-4, 10.22 Early Classical period see Transitional period Early Corinthian style 130, 5.7 Early Cycladic (EC) period 37-40 Early Helladic (EH) period 40-3 Early Minoan (EM) period 34-7 Egypt 13, 101-2 artifacts in shipwreck off Uluburun 64 canon of proportions 177 Canon of proportions 17/7 chronology 20, 32, 33, 1.3 Greeks in 134, 337 influence of 39, 47, 52, 90, 125 palm capital 346 pottery 77, 122 sculpture 143, 146, 148, 176, 177, 178, 6.45 wall paintings 20, 69 Eirene (Peace) (Kephisodotos) 306-7, 927 ekphora 118 Eleusis amphora 130, 5.9 Elgin marbles 16, 19, 263 entertainment High Classical period 274 Orientalizing period 129, 138, 5.6, 5.20 Transitional period 214 see also lifestyles; theater Ephesos, Temple of Artemis 160, 6.19 Epidauros Sanctuary of Asklepios 294-6, 9.8-9.10 theater 296, 9.11 Epiktetos, Attic red-figure cup 222, 7.17 Erechtheion, Athens 13, 15, 268-70, 0.4, 8.30-8.32 Erechtheus (Euripides) 262 Eretria, temple (reconstruction) 110, 4.9 Ergotimos 195, 6.74-6.75 Eros, Aphrodite and Pan 361-4, 10.35 Eros Asleep 360-1, 10.34 Eros and Psyche 364, 10.36 Euphronios, red-figure calyx krater 204, 6.88 Euripides 26, 262, 324 Euthydemos of Bactria 358, 367, 10.30 Euthydikos Kore 184, 6.56 Euthymides, red-figure amphora 204, 6.89 Eutychides, Tyche of Antioch 351, 10.19

Evans, Arthur 18, 20, 50, 78 Exekias, black-figure amphoras 197-8, 6.77-6.79 faience, Minoan 48, 49, 81, 2.1, 2.6 family group, marble, Samos 188, 6.61 farmland, South Italy 21–2, 0.12 female deities 212 see also women female figurines Daedalic 144, 146-8, 5.32-5.36 Hellenistic 375, 376, 10.50 see also kore festivals 162, 214 figure sculptures 25–6, 387, 0.19 Archaic period, Treasury of the Siphnians 166-7, 6.26-6.29 Fourth Century Bassae 293–4, 9.7 Halikarnassos 302–3, 310, **9.23** Hellenistic 350–76, **10.1**, 10.19-10.51 High Classical period 249, 276-81, 8.42-8.46 Athena Nike Temple 268, 313, 373, 8.29 Locri 276, 8.41 Olympia 279, 8.1 Parthenon 253, 255, 255–63, 8.6, 8.9, 8.11-8.14, 8.17-8.23 Orientalizing period 146-8, 5.35-5.36 Transitional period sculpture 229–42, 7.25–7.39 Temple E, Selinus 223–5, 234, 7.19-7.20 Temple of Zeus 216-21, 223, 7.6-7.16, 7.18 see also akroteria; caryatids; figurines; kore figurines Cycladic 37–9, 1.10–1.11, 1.13 Dark Age 108, 112, 114–15, 4.4, 4.13, 4.15–4.17 Hellenistic 375, 10.49–10.50 High Classical 265, 8.25 Late Minoan 72–5, 3.12, 3.18 Middle Minoan 48-51, 81, 2.1, 2.5 - 2.8Mycenaean 98-9, 3.48-3.50 Orientalizing period 144-5, 148-9, 5.26, 5.29, 5.30, 5.32-5.33, 5.37 Transitional 237, 7.34 see also akroteria; caryatids; figure sculptures; kore Floral Style 75, **3.19** Foce del Sele, Heraion metopes 172, 173, **6.38–6.39** food 138, 228, 5.20 forgeries 50, 228-9, 2.8 fortifications 25, 37, 59, 91-2, 2.21, 3.38-3.39 fountainhouses 214, 298, 341 Fourth Century 289-92 architecture and architectural sculpture 292-303 pottery 316-20 sculpture 304-15 wall painting and mosaics 320–5 Franchthi Cave 31 François Vase (Kleitias and Ergotimos) 195, 199, **6.74–6.75** frescoes see wall paintings friezes Archaic period 166–7, **6.27–6.29** Fourth Century 293–4, **9.**7 Hellenistic, Great Altar, Pergamon 354-5, 364, 10.24-10.26 High Classical period, Parthenon 258-62, 313, 8.15-8.23 Orientalizing period 137, 5.18 funerals, Dark Age 118-19 see also cemeteries; cremation;

graves; sarcophagi; tholoi; tombs funerary statues, Archaic 181, 6.1 funerary vase, Hellenistic 385, 10.62 garments 181, 183-4, 187, 6.50 see also drapery Gaul and his wife 353, 10.21 Gazi, goddess statuette 75, 108, 3.18, 4.4 Geneleos 188, 6.61 Geometric Age/Dark Age 105-23 Geometric style pottery, Agora, Athens 117, 4.20-4.22 Gnathian ware 383-5, 10.59 Gnosis, stag hunt mosaic 323, 332-3, 9.48 goddesses Gazi statuettes 75, 108, 3.18, 4.4 Mother Goddess 31, 81 snake goddesses 44, 49, 2.1, 2.6 Transitional period 212 goldwork cup from Vapheio 74, 3.17 Tomb of Philip 329, 9.57-9.58 see also metalwork Gournia 18, 71-2, 3.10-3.11 Granary Style 100, 3.52 grave reliefs see stelai graves Archaic artifacts 190-2, 6.68-6.70 at Vergina 327 Bronze Age 35, 37, 42, 54–5, 63 Mycenaean 88–91, 3.33 see also cemeteries; cremation; funerals; sarcophagi; tholoi; tombs Great Altar, Pergamon 354-5, 364, 10.23-10.26 griffin jug, Aegina 133, 5.12 griffin protome, Rhodes 141-3, 5.27 grotesques 366, 10.39 Hageladas 237, 249 Hagesandros, Laocoön Group 367, 10.42 Halikarnassos 302-3, 310, 9.21-9.23 Hamilton, Sir William 16 Harvester Vase 73, 3.14–3.15 hedgehog, Syros 40, 1.15 Hegeso, grave stele of 280, 8.45 Helladic periods 33 Early (EH) 40-3 Late (LH) 63-4, 88-103 Middle (MH) 54-6 see also Greece (mainland); Mycenaean Civilization Hellenistic period 290, 302, 326, 337-8 architecture 338-50 mosaics 380-3 pottery 383-5 sculpture 350-76 wall paintings 376–9 Hellenistic Ruler 367, 10.40 Hephaisteion, Athens 13, 270-1, 0.8, 8.33-8.34 Hera sanctuaries of Argos 110, 178 Samos 160, 6.17 temples of Foce del Sele 173, 6.38–6.39 Olympia 154, 6.5 Poseidonia Archaic period 170-1, 6.35-6.36 Transitional period 225-6, 7.21-7.22 Samos Archaic period 160, 6.18 Iron Age 111-12, 4.12 Orientalizing period 137, 5.19 Selinus, Temple E 223-5, 7.19-7.20 Hera of Samos 187, 6.59

Herculaneum, wall paintings 373, 378, 10.54 Hermogenes 341 Herodotos 83, 118, 160, 174, 178 heroon, Lefkandi 110, **4.6–4.7** Hieron I of Syracuse 212, 225 Hieron II of Syracuse 338, 350 High Classical period architecture/architectural sculpture 249, 251-81 Peloponnesian War 250-1 pottery/wall paintings 281-6 sculpture 276-80 High Hellenistic (baroque) sculpture 350, 353-8, 367-71, 10.21-10.30, 10.42-10.43 Himera, Battle of 153, 212, 223 Hippodamian plans 348, 350 Hippodamos of Miletus 141, 299, 339 Hisarlik see Troy History of the Art of Antiquity (Winckelmann) 27 Homer Apotheosis of Homer (Archelaos of Priene) 371-2, 10.44 Iliad 19, 20, 25, 63, 64, 107, 119, 221 Odyssey 122, 130, 138 horse, Dark Age bronze 4.1 Horse and Boy Jockey 357-8, 10.28 horses of St Mark's 13, 0.6 household goddess statuette 75, 108, 3.18, 4.4 houses, domestic Bronze Age 41–2, 47–8, 1.17, 2.3–2.4 Dark Age 108, 4.5 Fourth Century 298–301, 332, 9.14-9.19 Hellenistic 348, 10.18 Hunt painter, black-figure cup 200, 6.84 hydriai 174-5, 198, 202, 283, 6.41, 6.86, 8.51 Ialysos, cup from 99, 3.51 Iamos, the seer 217, 7.8 Iktinos 11, 251, 292 Ilissos Stele 313, **9.36** Illioupersis Painter, red-figure krater 318, 9.43 Ionic order 153, 154, 302, 333, 6.3 Ionic temples Archaic 159-62, 6.16-6.19 Fourth Century 302, 9.20 Hellenistic 341–4, 10.6–10.10 Transitional 223, 225 Ionic treasuries 163-8, 6.22-6.29 Ischia, Geometric krater 122, 4.28 Ischys Kouros 187, 6.58 Italy see South Italy ivories Minoan 37, 50, 72, 1.8, 2.7, 3.12 Orientalizing period 148-9, 5.37 Tomb of Philip 329-30, 9.61-9.62 jewelry Geometric 117-18, 4.22 Hellenistic 349, 10.16 Kythnos 22, 0.15 Minoan 51, 2.10 Mycenaean 88-90, 3.34-3.35 Orientalizing period 145, 5.31 Kallikrates 251 Kamares ware 52-3, 2.12-2.13 Kameiros, pendant from 145, 5.31 Karphi 107-8, 4.3 Kazanlak, dome of circular tomb 377, 10.52 Keos 83 figurine 98, 3.48 Kephisodotos, Eirene (Peace) 306-7, 9.27

119, 348, 0.18 Kouros from 24-5, 176, 0.16-0.18 pottery from 119, 4.23-4.24 Kerch Style 316 kilns 193, 6.71 Kimon 118, 212 Kladeos, personification of 217-18, 7.9 Kleisthenes 152, 174 Kleitias 195-7, 199, 6.74-6.75 kneeling youth, Samos 149, 5.37 Knidos 166 Knossos, Crete archaelogical evidence 18, 20, 26, 32-3 architecture 63, 65-9, 3.2-3.7 faience 48, 49, 2.1, 2.3, 2.6 ivories 49–50, 2.7 rhyton 74, 3.16 terracottas 48–9, 2.4–2.5 korai 147–8, 180–8, 270, 5.35–5.36, 6.1. 6.62 see also akroteria; caryatids; figure sculptures; kouroi Kos 341, 10.5 kouroi Archaic period 143, 176-80, 184, 6.42-6.47, 6.55 Kerameikos cemetery 24-5, 176, 0.16-0.18 kraters Archaic period 190-1, 195, 199–200, 202, 204, 6.68, 6.74–6.75, 6.82, 6.85, 6.88 6.74-6.73, 6.62, 6.63, 6.66 Fourth Century 318-19, 320, 324, 331, 9.43, 9.45, 9.50, 9.63 Geometric 117, 119-20, 4.23-4.24, 4.27-4.28 High Classical period 281, 286, 8.48, 8.55 Late Helladic 99-100 Orientalizing period 129, 130 Transitional period 242, 7.42 Kritios, Tyrannicides 231, 332, 7.26 Kritios Boy 180, 229-30, 7.25 Kyniska, princess of Sparta 222 Kythnos 22, 0.14 pendant from 0.15 Laconia figurine 98-9, 3.49 pottery 200, 6.83-6.84 "Lady of Auxerre" statuette 145-6, 5.33 landscapes Hellenistic 372, 377-8, 382-3, 10.53, 10.57 importance of 387 Laocoön group 16, 350, 367-9, 10.42 Late Bronze Age 63–5 Crete (LM) 65–83 The Cyclades (LC) 83–7 Greece (LH) 63, 88–103 Troy 101-3 Late Hellenistic sculpture 350, 358-67, 371-5, 10.31-10.41, 10.44-10.51 lawcourts 214, 228, 272-3, 324 Lebena, tholos at 35, 1.6 Lefkadia, tombs at 333-5, 9.67-9.68 Lefkandi cemetery 108-10, 4.6-7 centaur (terracotta) 112, 4.13 lekythoi 281–3, 319, 8.49 Lerna 31, 37, 1.16 house 1.17 pottery 56, 1.18-20, 2.17 Lesche 26, 164, 244, 6.21 Libon of Elis 214 lifestyles Third Millennium 31 of women 212-14, 222, 262-3, 324 see also entertainment; public life; theater

Kerameikos cemetery 23-5, 117-18,

Linear A 71, 77, 79, 83 Linear B 20, 26, 56, 64-5, 77-9 Lion Gate, Mycenae 19, 0.11 Lion Hunt mosaic, Pella 313, 9.65 literary sources 26, 228, 320-1 Locri akroteria 275-6, 8.41 dancing maenad 242, 7.39 Temple at 225 Ludovisi Throne reliefs 241, 7.38 Lysikrates, Monument of, Athens 297, 9.12 Lysippos 292, 307, 310, 320, 350 Apoxyomenos 311, 9.33 Macedon 289–90, 325–35 chamber tombs 376–7, 10.52 "Macmillan" aryballos 127, 5.4 Magnesia, Temple of Artemis 341–2, 10.6-10.7 Mahdia shipwreck, Dwarf statue 366, 10.39 Major, Thomas, City of Poseidonia (engraving) 13, 0.5 male sculptures see kouroi Mallia, sculpture and jewelry 51, 2.9-2.10 Man Scraping Himself (Lysippos) 311, 9.33 Mantiklos Bronze, Thebes 143, 5.26 maps Athens, late fifth century 272, 8.35 Attica 255, 8.10 Greece and Aegean (Archaic period) 152, 6.2 Greek world 13, 0.2 Greek world to c. 400 BC 105, 4.2 Minoan Crete and Aegean 31-2, 1.2 South Italy and Sicily (Dark Age) 105, 123, 4.29 Marathon 42 Battle of 11, 152, 228, 244 Marathon Boy 305–6, 9.25 Marine Style 75–6, 3.20 marriage altar, Taras 213, 7.3 Marsyas Painter, Attic red-figure pelike 317, 360, 9.41 Mausoleum, Halikarnassos 302–3, 310, 326, 9.21–9.23 Megara Hyblaia 139–40, 299, 5.21 Megarian bowl 383, 10.58 Meidias Painter, red-figure hydria (attrib.) 283, 316, 8.51 Meleager (Skopas, attrib.) 310, 9.31-9.32 Meleager Painter, Attic red-figure cup 316, 9.40 Melos 83, 87 figurines 99, 3.50 pottery 54, 2.14 wall painting 83, 3.28 metalwork Dark Age 4.1 Middle Bronze Age 57, 2.18 Minoan 51–2, 72, 74–5, 2.9–2.10, 2.11, 3.13, 3.17 Mycenaean 88-91, 3.34-3.36 Third Millennium 32 Tomb of Philip 329, 330, 331, 9.57-9.60, 9.63 see also bronzes; jewelry Metapontum coinage 22, 138, 0.13 survey of 21-2, 0.12 temple at 225 metopes Archaic period 153, 164-5, 169, 172-3, 6.3, 6.22-6.23, 6.32-6.33, 6.38-6.39 High Classical period 253-4, 8.3, 8.5-8.6 Transitional period 219–21, 7.13–7.15, 7.19–7.20 Metroon, Agora, Athens 347

Middle Bronze Age 45 Crete (MM) 46-54 Cyclades (MC) 54 Greece (MH) 54-6 Troy 56-61 Middle Corinthian aryballos 199, 6.81 Middle Stoa, Agora, Athens 345 Mikon 228 Miletus 347-50, 10.14-10.15 kore 187, 6.60 Miltiades 118, 212, 228 Minoan civilization (Crete) chronology 20, 33, 1.2 Early (EM) 34-7 Late (LM) 65-83 Middle (MM) 46-54 religion 79-82 Minos 83 Mint, Agora, Athens 272 Minyan ware 55-6, 91, 2.16, 3.37 Mnesikles 251, 265 Mochlos, stone jug 36, 1.7 Morelli, Giovanni 199 mosaics Fourth Century 300, 320–5, 332–3, 9.17, 9.46–9.49, 9.64–9.66 Hellenistic 380-3, 10.55-10.57 Moschophoros (Calfbearer) 180, 6.48 Motya, Charioteer, 21, 239-41, 7.37 Mourning Athena relief 237-8, 7.1 multiple granary (model) 42, 1.18 "mushroom" capital, Temple of Athena, Smyrna 141, 5.25 musician figures, Cycladic 38, 1.11 Mycenae 11, 91-4, 3.38-3.42 dagger blades 90, 3.36 female head sculpture 63, 3.1 grave circles 88-91, 3.33 jewelry 88-90, 3.34-3.35 Lion Gate 19, 0.11 Minyan ware 55–6, 2.16 Warrior vase 99–100, 3.54 Mycenaean civilization 11–13, 20, 63-4, 105-6 architecture 91-6, 3.38-3.47 metalwork 88-91, 3.34-3.36 pottery 99-100, 3.51-3.54 sculpture 63, 96-9, 3.1, 3.48-3.50 wall paintings 96, 3.46 Mykonos, relief amphora 5.1 Myrina, pair of women conversing 376, 10.51 Myron, Diskobolos 231–3, 7.28 Myrtos 35, 1.5 Naukratis 134 Naxos 139, 146-7 Temple of Dionysos 159, 6.16 "neo-Attic" reliefs 373, 10.47 Nesiotes, Tyrannicides 231, 332, 7.26 Nessos Amphora 132-3, 192, 5.10 New Comedy 378 New York Kouros 25, 143, 176, 6.42 Nikandre statue, Delos 147-8, 181, 5.35 Nike (Victory) from Olympia (Paionios) 279, 357, 8.1 of Samothrace (Pythokritos (?)) 357, 10.1, 10.27 statue of (Delos) 188, 279, 6.65 from Temple of Athena Nike, Athens 268, 313, 373, 8.29 see also Athena Nike Nikias, Perseus freeing Andromeda 323, 9.49 Nile Mosaic 382-3, 10.57 Niobid Painter 243-4, 7.44-7.45 Nymph and Satyr 364, 10.37 Odysseus and Palladion 369-71, 10.43

Odyssey Landscapes 372, 377–8, 10.53 oikos, of Naxians at Delphi 139 oinochoe

Geometric 117, 119, 4.26 High Classical period 281, 8.47 Orientalizing period 130, 133, 5.11 Olympia charioteer figurine 115, 4.16 Nike (Paionios) 279, 357, 8.1 Philippeion 326, 9.52 Temple of Hera 154, 6.5 Temple of Zeus 214-21, 7.4-7.16 warrior figurine 143, 5.29 Olympian Zeus, Temple of, Athens 344–5, 10.10 Olympic Games 221-3 Olvnthos architecture 299-300, 9.15-9.17 mosaic 322–3, 332, 9.47 orders, architectural 153–4, 215, 297, 333, 344, 6.3 see also columns Orientalizing period architecture 134-41 pottery 125-34 sculpture 141-9 ostraka 272, 8.37 Paestum see Poseidonia painted panels Temple of Apollo, Thermon 135, 245, 5.15 see also wall paintings painted pottery Hellenistic 383-5, 10.59-10.62 see also black-figure pottery; redfigure pottery; white-ground pottery painted sculpture 182-3, 314-15, 376, 9.38, 10.50 Painted Stoa, Agora, Athens 226–7, 244, 271, 7.23 painters Attic 195-7, 199, 204, 207-9 Fourth Century 319–20, 323 Hellenistic 377, 378 Transitional 228, 242-3, 245-6 see also architects; sculptors; names of painters paintings see painted sculpture; vase paintings; wall paintings Paionios 279 Nike, from Olympia 279, 357, 8.1 Palace Style 77, 3.21 palaces Crete Middle Bronze Age 46–7 Minoan 63, 65–72, 3.2–3.11 Fourth Century, Vergina 325–6, 9.51 Mycenaean 92–3, 95–6, 3.47 Palaikastro pottery 75-7, 3.19-20 statuette 72, 3.12 palm capital, Egyptian 346 Pan Painter, bell krater 242, 7.42 Panathenaic amphoras 317-18, 385, 9.42 Panathenaic Way 175-6, 228, 262 Parthenon, Athens 13, 251-65, 8.3-8.23 Elgin marbles 16, 19, 263 Pasiteles 373 Pausanias 20, 26, 34, 154-5, 215-16, 219, 228, 244, 279, 292, 296, 326 pebble mosaics 322-3, 332-3, 380, 9.48, 9.64-9.66 pediments Archaic period 19, 156-7, 158, 166, 6.9-6.10, 6.14-6.15, 6.26 High Classical period, Parthenon 254–8, 276, 8.7–8.9, 8.11–8.14 Transitional period 216-19, 233, 7.6-7.12 Peisistratos 151-2, 174

pelike (Marsyas Painter) 317, 360, 9.41

Pella 331-3

mosaics from 313, 323, 332-3, 9.48, 9.64-9.66, 9.65 Peloponnese 43, 126, 154 Peloponnesian War 250-1, 279, 285, 289 pendants Kameiros 145, 5.31 Kythnos 22, 0.15 Mallia 51, 2.10 Peplos Kore 182, 6.52 Pergamene capital 346, 10.13 Pergamon 337, 338-41, 10.2-10.4 Great Altar 354-5, 364, 10.23-10.26 Perikles 250, 251, 263-5 Perseus freeing Andromeda (Nikias) 323, 9.49 Persian Empire, overthrow of 289–90 Persian styles 303, 326 Persian wars 11, 24, 151, 152–3 attack on Athens 173, 180, 211, 226, 249, 251 peace with Greece 212 Phaistos 46, 70-1, 2.2, 3.8-3.9 beak-spouted jug 52, 2.13 Phaistos disk 79, 3.23 "phi" and "psi" figurines 99, 3.50 Phidias 11, 249 statue of Athena 265, 8.25 statue of Zeus 220–1, 7.16 Philip II of Macedon 289, 295, 325, 326 Tomb of 313, 328-30, 9.55-9.56 Philip III Arrhidaios 328 Philip V 338 Philippeion, Olympia 326, 9.52 Philoxenos of Eretria 321 phlyax vase (Assteas) 320, 9.45 Phrasikleia (kore) 181, 6.1 Phylakopi 54, 83, 87 pithoi 35, 66, 103, 3.4 plaques from Locri 242, 7.40-7.41 from near Corinth 245, 7.46 Plataea Battle of 11, 152, 153, 211, 221 oath of 226 Platanos, ivory seal from 36-7, 1.8 Plato 290 Pliny the Elder, Natural History 26, 228, 238, 244, 302, 310, 321, 350 on Laocoön Group 350, 367, 369 Plutarch 263 poleis (city-states) 107, 125, 151, 153, 162, 289, 338 Polydoros, Laocoön Group 367, 10.42 Polyeuktos, Demosthenes statue 351-3, 10.20 Polygnotos of Thasos 228, 244 Polykleitos 249, 276 Diadoumenos 279, 8.43 Doryphoros 8, 42, 276-7, 310 Polykleitos the Younger, tholos at Epidauros 295, 9.8-9.10 Polyxena sarcophagus 191-2, 6.70 Pompeii mosaics 321–2, 323, 380, **9.46**, **9.49** paintings 377, 378 sculpture 276–7, **8.42** portraiture 231, 311, 338 Fourth Century ivory heads 329-30, 9.61-9.62 Hellenistic sculpture 351–3, 358, 367, 10.20, 10.30, 10.40 Poseidonia (Paestum) 13, 141, 0.5, 5.22 red-figure pottery 319–20, 9.44 Temple of Athena 170, 171-2, 252, 6.35, 6.37 Temples of Hera Archaic period 170-1, 6.35-6.36 Transitional period 225-6, 7.21-2 Tomb of the Diver 245-6, 327, 377,

7.47-7.49

potterv

as archaeological evidence 27, 32-3 processes and techniques 37, 192-3, 383 red-figure 203-4 Archaic Greece 174-5, 192-209 Bronze Age Cycladic 40, 54, 83-5 Helladic 43, 55–6, 99–100 Minoan 36–7, 48, 52–4, 75–7 Minyan 55-6, 91 Mycenaean 99-100 Trojan 59, 102-3 Dark Age (Geometric) 105, 106-7, 116 - 22Fourth Century 316-20, 324, 9.50 Hellenistic 383-5 High Classical period 281-6 Orientalizing period 125–34 Transitional period 242–7 Praxiteles 292, 350 Aphrodite of Knidos 308-9, 360, 9.29 Hermes and Dionysos 307-8, 9.28 Preening doves 380, 10.55 Priam's Treasure 56, 2.18 Priene 300-2, 341, 9.18-9.19 housing 348, 10.18 priesthood 214 Prinias, Temple of 136, 5.16–5.18 Propylaia, Athens 13, 252, 265–6, 0.3, 8.26-8.27 prothesis 118 Protoattic pottery 130-3, 5.8-5.10 Protocorinthian pottery 127, 5.2-5.3 Protogeometric style 106 pots, Kerameikos 116-17, 4.19 Pylos 94-5, 3.45-3.47 Pytheos 302, 341 Python, red-figure amphora 319-20, 9.44 radiocarbon dating 34 Rampin Horseman, Athens 180, 6.49 red-figure pottery production processes 203-4 Archaic period 163, 193, 203-9, 6.20, 6.87-6.92 Fourth Century 316-17, 318-20, 9.40-9.41, 9.43-9.45 High Classical period 283, 286, 8.50-8.51, 8.55 Transitional period 212–13, 222, 242–4, 7.2, 7.17, 7.42–7.45 relief sculpture Hellenistic 371-3, 10.45-10.47 High Classical period 281 Transitional period 237–8, 241, 7.1, 7.35, 7.38 see also stelai religions Archaic period 162-3, 6.20 Minoan 79-82 Transitional period 214 Rhadamanthys 334, 9.68 Rhodes Griffin protome 141-3, 5.27 Wild Goat style oinochoe 133, 5.11 Rhoikos 160 rhyta 72–3, 81, 242–3, 3.14–3.16, 3.27, 7.43 Riace Warriors 234-7, 7.32-7.33 Romans as collectors of Greek art 13, 350 copies of Greek mosaics 323-5, 9.49 paintings 377-8 statues Fourth Century 306-7, 308-9, 9.27, 9.29 High Classical 228-9, 231, 276-9, 8.42-8.43 Roman empire 337, 338, 387

Royal Stoa, Agora, Athens 175, 271 sacrifices 162-3, 6.20 St. Pancras Church, London 386 Salamis 25 Battle of 11, 152, 221 salvage archaeology 28, 348–9 Samos 21, 186, 6.58 first Temple of Hera 111-12, 4.12 kore 187, 188, 6.58-6.59, 6.62 marble family group 188, 6.61 second Temple of Hera 137, 5.19 sanctuaries 222 Archaic period 159, 162-3, 6.20-6.21 Dark Age 107, 111-12, 113-14, 4.12 Fourth Century, Epidauros 294-6, 9.8-9.10 Hellenistic, Asklepios 341, 10.5 Orientalizing period 137-9, 5.19 Transitional period 214–15, 225, 228, 7.5 sarcophagi Aghia Triadha 79-80, 82, 3.25-3.26 Alexander Sarcophagus 192, 313, 314-15, 9.37-9.39 Polyxena 191-2, 6.70 Tomb of Philip 328-9 Sauroktonos (Lizard-Slayer) 25-6, 0.19 Schliemann, Heinrich 19-20, 33, 34, 56-8, 1.4 scripts *see* Linear A; Linear B sculptors 3, 11, 249, 276, 279 Fourth Century 292, 302–3, 305, 307, 350 Hellenistic 373 see also architects; painters; names of sculptors sculpture Archaic Greece 176-92 Bronze Age Cycladic 37-9 Helladic 16, 19, 42–3, 3.1 Minoan 48–52, 72–9 Mycenaean 96–9, 3.48–3.50 Dark Age 112–16, 112–17 Egyptian 143, 146, 148, 176, 177, 178, 6.45 Fourth Century 304-15 Hellenistic 350-76 High Hellenistic (Baroque) 350, 353-8, 367-71, 10.21-10.30, 10.42-10.43 Late Hellenistic (Classical) 350, 358-67, 371-5, 10.31-10.41, 10.44-10.51 High Classical 276-80 Orientalizing 141–9 Transitional 228–42 see also architectural sculpture seals, Minoan 36, 51-2, 1.8, 2.11 Segesta, Doric temple 275, 8.40 Selinus Temple E (Hera) 223-5, 7.19-7.20 temples 168-70, 173, 6.31-6.34 Severe Style 229-31 shaft graves 63 Sicily 290, 338 Archaic period 168-70 Dark Age 105, 123, 4.29 Hellenistic funerary vase 385, 10.62 High Classical period 274-6, 8.39-8.41 Transitional period 223-6 Sikyon, Treasury of 163, 164, 6.22 Siphnos, Treasury, Delphi 165-7, 6.25-6.29 siren head, cauldron attachment 143, 5.28 Skopas 292, 307, 309, 350 Meleager (attrib.) 309-10, 9.31-9.32

surveys, archaeological 21–2, 28 symposia 129, 138, 5.6, 5.20 Syracuse 13, 250, 274, 290–1, 338, 350 Temple of Apollo 168, 212, 6.30 Temple of Athena 212, 223 Syros, terracottas from 40, 1.14–1.15 tableware 285, 318, 8.52 Tanagra female figurine 375, 376, 10.50 Taras 338

Taras 338 Enthroned Goddess 238, 7.36 marriage altar 213, 7.3

Sleeping Satyr (Barberini Faun) 358,

Temple of Athena 141, 154,

snake goddesses 44, 49, 2.1, 2.6

snaky-tailed monsters 157, 173, 6.10

Sotades Painter, sphinx vase 242-3,

Fourth-century pottery 318–20, 9.43–9.45

High Classical period 274-6, 8.39-8.41, 8.55

Transitional period 223-6, 238

South Stoa I, Agora, Athens 271, 345

Temple of Artemis Orthia 111

sphinx vase (Sotades Painter) 242-3,

stag hunt mosaic (Gnosis) 323, 332-3,

stamnos, Attic red-figure 212-13, 7.2

of Athena 265, 306, 8.25, 9.26

see also caryatids; figure sculptures;

figurines; kore; kouroi

Fourth Century 313-14, 353, 9.1,

Painted Stoa 226-7, 244, 271,

Stoa of Attalos 13, 345-6, 0.9,

Samos, Temple of Hera 137-9,

226-7, 244, 271, 7.23

young athlete, sculpture 237–8, 7.35 Sunion Kouros 177–8, 6.43

Archaic period 190, 6.66-6.67

High Classical period 279-80, 8.44-8.45

Stephanos Athlete 373-5, 10.48

Royal Stoa 175, 271

South Stoa II 345

10.12-10.13

Stoa of Zeus 271-2

sanctuary at 25, 177, 6.43

South Stoa I 271, 345

9.35-9.36

Sperlonga cave sculptures 369–71, 10.43

sphinx, Delphi 163, 188, 6.64

7.43

9.48

bronze 191, 6.69

painted 182-3

Agora, Athens

7.23

5.19 Stoa Poikile (Painted Stoa), Athens

Stoics 228

Sunion

Stuart, James 16

statues

stelai

stoa

South Stoa II, Agora, Athens 345 Sparta/Spartans 200, 215, 289

Peloponnesian War 250-1

princess Kyniska 222

Hellenistic pottery 383, 385, 10.59,

360-1, 10.29

oval house 108, 4.5

5.23-5.25

Sophilos 193-5, 199, 6.73

Archaic period 170-3 Dark Age 105, 123, 4.29

7.43 South Italy 290, 338

10.61

Smyrna

Socrates 11

Solon 174

Sosos 380

relief sculpture 314, 353, 9.1 temples Archaic 154-8, 159-62, 168-71, 6.4-6.14, 6.16-6.19, 6.30-6.37 Dark Age, Sparta 111 Fourth Century 294-6, 302, 9.8-9.9, 9.20 Hellenistic 340-4, 10.4-10.10 High Classical 252-3, 266-8, 274-6, 8.5, 8.28, 8.39-8.40 Iron Age 110-12, 4.9-4.10 Kythnos 22, 0.14 Orientalizing 134-6, 141, 5.13–5.19, 5.23–5.25 Transitional 214–21, 223–6, 7.4-7.16, 7.18-7.22 terracottas Cycladic 40, 1.14-1.15 Dark Age 108, 112, 4.4, 4.13 Hellenistic 375-6, 10.49-10.51 Minoan 47-8, 72, 75, 79, 2.3-2.5, 3.18, 3.23-3.24 Mycenaean 98, 99, 3.48, 3.50 Orientalizing period 143-5, 5.1, 5.32-5.33 Transitional period 213, 237, 242, 7.3, 7.34, 7.39–7.41 theater/theatrical events 274, 296, 324, 9.50 depicted in art 320, 378, 380, 9.45, 10.56 see also entertainment; lifestyles theaters Epidauros 296, 9.11 Pergamon 339, 10.3 Syracuse 350 Thebes 289 alabastron 188, 6.63 Geometric krater 119-22, 4.27-4.28 Mantiklos Bronze 143, 5.26 Themistokles 231, 7.27 Theodoros 160 Theodotos 294 Thera 85-7 frescoes 3.31-3.32 pottery 54, 2.14, 3.29-3.30 Theron of Akragas 212, 223 Third Millennium chronology 20, 32–4, 1.3 Crete (EM) 34–7 The Cyclades (EC) 37-40 Greece (EH) 40-3 tholoi Bronze Age 35-6, 93-4, 1.6, 3.41-3.42 Fourth Century 295, 9.9-9.10 Transitional period 228, 272, 7.24 Thucydides 11, 83, 265, 348 Timoleon 290-1 Tiryns 94, 4.43-4.44 Tomb of the Diver 129, 245-6, 327, 377, 5.6, 7.47-7.49 Tomb of Persephone 327, 333, 9.53-9.54 Tomb of Philip 313, 328-30, 9.55-9.56 tombs Macedonian 327-30, 333-4, 376-7, 9.53-9.63, 9.67, 10.52 see also cemeteries; cremation; funerals; sarcophagi; tholoi town planning Agora, Athens 174, 228, 297–8, 345–7, 6.40, 7.24, 9.13, 10.11, 10.14 Fourth Century 299-302, 331-2, 9.15 Hellenistic 339-40, 350, 10.2 Transitional period architecture/architectural sculpture 214-28 Athens and Western Greeks 211-12 pottery and wall painting 242-7 sculpture 228-42 women 212-14

treasuries of Atreus 93-4, 3.41-3.42 Doric and Ionic 163-8, 6.22-6.29 tripod cauldrons 114, 141, 4.14 Troy (Hisarlik) 19, 20, 32, 37 Late Bronze Age 101-3, 3.33 Middle Bronze Age 56-61, 2.19-2.22 tumuli at Vergina 327, 328, 377, 9.55 Bronze Age 55 twin kouroi, Delphi 176, 6.44 Tyche of Antioch (Eutychides) 351, 10.19 Tyrannicides (Kritios and Nesiotes) 231, 332, 7.26 Uluburun, shipwreck off 64-5 underwater archaeology 27-8, 64 Vapheio, cup from 75, 3.17 Varvakeion statuette 265, 8.25 vase paintings 13, 37, 193 Archaic period 163, 174-5, 193-209, 6.20, 6.41, 6.73-6.92 Dark Age 116, 118-22, 4.23-4.27 Fourth Century 316-20, 9.40-9.45 High Classical period 281-5, 8.47-8.51 Orientalizing period 126-33, 138, 5.20 Transitional period 242-4, 7.42-7.45 Vasilike ware 37, 1.9 Ventris, Michael 20, 77, 78, 3.22 Venus, Capitoline 360, 10.32 Venus de Milo (Aphrodite of Melos) 364-6, 10.38 Vergina 325–31, 377 Villa of Good Fortune, Olynthos 300, 9.16–9.17 Vitruvius 26, 302, 341, 342 Vix, krater from 190, 6.68 votive reliefs see relief sculpture; stelai Vulci, white-ground krater 281, 8.48 wall paintings Cycladic 85-6, 3.31-3.32 Egyptian 20, 69 Fourth Century 321, 327, 328, 333-4, 9.49, 9.53-9.54, 9.56, 9.67-9.68 Hellenistic 376-9, 10.52-10.54 High Classical 281 Minoan 50, 68-9, 82, 83, 3.6-3.7, 3.28 Mycenaean 96, 3.46 Orientalizing period 135, 245, 5.15 Transitional period 244-7, 245-7, 7.48-7.49 Warrior Vase 99-100, 3.54 West Slope ware 383, 384 white-ground pottery 281-3, 385, 8.47-8.49 Wild Goat style 133, 200, 5.11 Winckelmann, Johann Joachim 16, 27 women 212-14, 222, 262-3, 324 see also female figurines; kore writing/inscriptions 26, 70-9 see also Linear A; Linear B Zakro, rhvton from 81, 3.27 Zeus, statue of 220-1, 7.16 Zeus, Stoa of, Agora, Athens 271-2 Zeus, temples of Akragas 169, 223, 6.34, 7.18 Athens 344-5, 10.10 Olympia 214-21, 7.4-7.16 Zeus and Ganymede, from Olympia 237, 7.34 Zeuxis 323 Zoffany, Johann, Charles Townley and Friends... 11, 0.1

Skyros 107, 110